THE SOCIETY FOR
MEDIEVAL ARCHAEOLOGY
MONOGRAPH 23

Series Editor
CHRISTOPHER GERRARD

ABLE MINDS AND PRACTISED HANDS
Scotland's Early Medieval Sculpture in
the 21st Century

THE SOCIETY FOR MEDIEVAL ARCHAEOLOGY MONOGRAPHS
ISSN 0583-9106

1. G Bersu and D M Wilson (1966) *Three Viking Graves in the Isle of Man*
2. F W B Charles (1967) *Medieval Cruck-building and its Derivatives*
3. P A Rahtz (1969) *Excavations at King John's Hunting Lodge, Writtle, Essex, 1955–57*
4. A L Meaney and S C Hawkes (1970) *Two Anglo-Saxon Cemeteries at Winnall, Winchester, Hampshire*
5. H E J Le Patourel (1973) *The Moated Sites of Yorkshire*
6. G T M Beresford (1975) *The Medieval Clay-land Village: Excavations at Goltho and Barton Blount*
7. H Clarke and A Carter (1977) *Excavations in King's Lynn, 1963–1970*
8. J G Hurst (general ed) *Wharram. A Study of Settlement on the Yorkshire Wolds, vol I*: D D Andrews and G Milne (eds) (1979) *Domestic Settlement 1: Areas 10 and 6*
9. C M Mahany, A Burchard and G Simpson (1982) *Excavations at Stamford, Lincolnshire, 1963–69*
10. P Mayes and K Scott (1984) *Pottery Kilns at Chilvers Coton, Nuneaton*
11. J G Hurst and P A Rahtz (general eds) *Wharram. A Study of Settlement on the Yorkshire Wolds, vol III*: R D Bell, M W Beresford and others (1987) *The Church of St Martin*
12. D Austin (1989) *The Deserted Medieval Village of Thrislington, Co Durham: Excavations 1973–1974*
13. V L Yanin, E N Nosov, A S Khoroshev, A N Sorokin, E A Rybina, V L Povetkin and P G Gaidukov (1992) *The Archaeology of Novgorod, Russia*
14. K Parfitt and B Brugmann (1997) *The Anglo-Saxon Cemetery on Mill Hill, Deal, Kent*
15. D Gaimster and P Stamper (eds) (1997) *The Age of Transition: the Archaeology of English Culture 1400–1600*
16. D A Hinton (2000) *A Smith in Lindsey: the Anglo-Saxon Grave at Tattershall Thorpe, Lincolnshire*
17. S Lucy and A Reynolds (eds) (2002) *Burial in Early Medieval England and Wales*
18. S T Driscoll (2002) *Excavations at Glasgow Cathedral 1988–1997*
19. P Mayes (2002) *Excavations at a Templar Preceptory: South Witham, Lincolnshire 1965–67*
20. J Hines, A Lane and M Redknap (eds) (2004) *Land, Sea and Home*
21. W D Klemperer and N Boothroyd (2004) *Excavations at Hulton Abbey, Staffordshire 1987–1994*
22. K Giles and C Dyer (eds) (2005) *Town and Country in the Middle Ages: Contrasts, Contacts and Interconnections, 1100–1500*

The Society for Medieval Archaeology Monographs are available from
Maney Publishing, Hudson Road, Leeds LS9 7DL, UK
For further information, including prices, or to order online, visit www.maney.co.uk

ABLE MINDS AND PRACTISED HANDS
Scotland's Early Medieval Sculpture in the 21st Century

Edited by
SALLY M FOSTER
and
MORAG CROSS

2005

In celebration of the centenary of Joseph Anderson and J Romilly Allen's
The Early Christian Monuments of Scotland,
this volume is respectfully dedicated to
Ian Fisher, Isabel Henderson and Ian G Scott
for their outstanding professional and personal achievements in the recording, study
and understanding of Scottish early medieval sculpture

© 2005 The Society for Medieval Archaeology and Authors

This publication has been made possible by a grant from Historic Scotland
and the Hunter Archaeological Trust
in collaboration with The Society for Medieval Archaeology

ISBN 1 904350 74 7
978–1–904350–74–3
ISSN 0583–9106

FRONT COVER
Hilton of Cadboll cross-slab (detail)
(Crown copyright: Historic Scotland)

BACK COVER
Whithorn monuments: the 'Petrus' Stone, a Whithorn School cross-slab and the
'Latinus' Stone (left to right)
(Crown copyright: Historic Scotland)

Published by The Society for Medieval Archaeology

Produced by Maney Publishing, Leeds, UK

Typeset, printed and bound in the UK by The Charlesworth Group

CONTENTS

PAGE

FOREWORD
 By Lisbeth M Thoms viii

PREFACE x

EDITORIAL NOTE xii

CHAPTER 1
Introduction. *Able Minds and Practised Hands*: historical fact, 21st-century aspiration
 By Sally M Foster 1

CHAPTER 2
Sculpture in action: contexts for stone carving on the Tarbat peninsula, Easter Ross
 By Martin Carver 13

CHAPTER 3
'That stone was born here and that's where it belongs': Hilton of Cadboll and the negotiation of identity, ownership and belonging
 By Siân Jones 37

CHAPTER 4
'Just an ald steen': reverence, reuse, revulsion and rediscovery
 By Iain Fraser 55

CHAPTER 5
Fragments of significance: the whole picture
 By Isabel Henderson 69

CHAPTER 6
Christ's Cross down into the earth: some cross-bases and their problems
 By Ian Fisher 85

CHAPTER 7
Pictish cross-slabs: an examination of their original archaeological context
 By Heather F James 95

CHAPTER 8
Hic memoria perpetua: the early inscribed stones of southern Scotland in context
 By Katherine Forsyth 113

CHAPTER 9
The Govan School revisited: searching for meaning in the early medieval sculpture of Strathclyde
 By Stephen T Driscoll, Oliver O'Grady and Katherine Forsyth . . . 135

CHAPTER 10
Scotland's early medieval sculpture in the 21st century: a strategic overview of conservation problems, maintenance and replication methods
 By INGVAL MAXWELL 159

CHAPTER 11
The containment of Scottish carved stones *in situ*: an environmental study of the efficacy of glazed enclosures
 By COLIN MUIR 175

CHAPTER 12
The runic inscriptions of Scotland: preservation, documentation and interpretation
 By MICHAEL P BARNES and R I PAGE 187

CHAPTER 13
Understanding what we see, or seeing what we understand: graphic recording, past and present, of the early medieval sculpture at St Vigeans
 By JOHN BORLAND 201

CHAPTER 14
The bulls of Burghead and Allen's technique of illustration
 By IAN G SCOTT 215

CHAPTER 15
'A perfect accuracy of delineation': Charlotte Wilhelmina Hibbert's drawings of early medieval carved stones in Scotland
 By DAVID HENRY and ROSS TRENCH-JELLICOE 221

CHAPTER 16
Bird, beast or fish? Problems of identification and interpretation of the iconography carved on the Tarbat peninsula cross-slabs
 By KELLIE S MEYER 243

CHAPTER 17
Figuring salvation: an excursus into the iconography of the Iona crosses
 By JANE HAWKES 259

CHAPTER 18
The role of geological analysis of monuments: a case study from St Vigeans and related sites
 By SUZANNE MILLER and NIGEL A RUCKLEY 277

CHAPTER 19
The early medieval sculptures from Murthly, Perth and Kinross: an interdisciplinary look at people, politics and monumental art
 By MARK A HALL, ISABEL HENDERSON and IAN G SCOTT . . . 293

CHAPTER 20
Know your properties, recognise the possibilities: Historic Scotland's strategy for the interpretation of early medieval sculpture in its care
 By SALLY M FOSTER 315

CHAPTER 21
Proposals for the re-display of the early medieval sculpture collection at Whithorn: the evolution of an interpretative approach
 By Peter Yeoman 325

CHAPTER 22
Curators of the last resort: the role of a local museum service in the preservation and interpretation of early medieval sculptured stones
 By Norman K Atkinson 335

CHAPTER 23
A museum curator's adventures in Pictland
 By Mark A Hall 343

CHAPTER 24
The missing dimension: future directions in digital recording of early medieval sculptured stone
 By Stuart Jeffrey 353

CHAPTER 25
Three-dimensional recording of Pictish sculpture
 By Alistair Carty 367

CHAPTER 26
Towards a 'New *ECMS*': the proposal for a new *Corpus of Early Medieval Sculpture in Scotland*
 By John Higgitt 375

ABBREVIATIONS 381
BIBLIOGRAPHY 381
LIST OF CONTRIBUTORS 413
INDEX 415

FOREWORD

The publication, in 1903, of *The Early Christian Monuments of Scotland* (ECMS) by J Romilly Allen and Joseph Anderson was a milestone in the publishing history of the Society of Antiquaries of Scotland. It gave me great pleasure therefore, 100 years later, both to be present at the celebratory seminar, *Able Minds and Practised Hands*, and to write the Foreword to this volume.

The title of the seminar and the volume is taken from the Rhind Lectures given to the Society in 1879–80 by Joseph Anderson, but to summarise the major undertaking which culminated in the 1903 publication we have to move to the year 1890. It was then that the Council of the Society, fully appreciating the importance and interest of the study of the art and history of Early Christian monuments in Scotland, received a proposal from its Sub-Committee on Sculptured Stones. They realised that many new examples had been discovered since the issue in 1856 and 1867, by the Spalding Club, of the last work on the subject, edited by Dr John Stuart. More importantly perhaps, they recognised that examples described by Stuart had been removed or lost sight of. A scheme was therefore proposed for obtaining a general survey and description of the monuments with the view of issuing, under the auspices of the Society, a work embodying the whole knowledge of the subject obtainable at that time. The objective was to provide, 'a complete register of every monument or fragment now existing in Scotland whether previously described or not'. This was to be achieved by three processes: survey, academic study, and publication.

In the first instance Romilly Allen, a Welsh engineer and antiquary who had already published in the Society's *Proceedings* on the St Madoes cross-slab (Perth and Kinross), undertook the survey work and descriptive register. Then in 1892 Joseph Anderson again delivered the Rhind Lectures, the text of which was to be the introduction to *ECMS*. At the time of those Rhind Lectures, however, Allen's general survey reports and drawings were incomplete. As might be imagined, the amount and nature of the survey work proved to be far greater and more onerous than anyone had anticipated, and Allen was still working on it in 1896. Obtaining the illustrations was not easy, and photography was often hampered because stones were covered in lichen, were weathered or in difficult situations. In the end the total number of illustrations assembled (diagrams, drawings, photographs and rubbings) was in excess of 2500, and the survey included over 120 stones not previously described.

Finally, it was at its meeting in April 1903 that the Council of the Society first saw a specimen copy of the finished work. By the end of the year 400 copies of *ECMS* had been produced, of which 300 had been sold, mostly to Fellows of the Society who paid the princely but special price of two guineas, with other subscribers paying three guineas.

The production of *ECMS* was a wonderful achievement for Allen and Anderson, and demonstrated vision and responsibility on the part of the Society in encouraging

the protection of a valuable part of Scotland's heritage. Providing as it did the first national overview and catalogue, it was a major triumph for its time, and it has proved to be a seminal work constantly used and referred to by scholars during the last 100 years. With the surviving copies of the original 400 residing for the most part in private and public libraries, it has perhaps not always been easy for modern scholars to access *ECMS*. It is appropriate, therefore, to acknowledge the more recent wonderful achievement of the *ECMS* reprint in 1993, by David Henry and his Pinkfoot Press, with its new and updated introduction written by Isabel Henderson.

The aim of *ECMS* was 'to deal scientifically with the stones in the hope that some advance may be made towards a systematic knowledge of their peculiar characteristics, their sequence in time, and their relations to other classes of antiquities within or beyond their own special area'. This exemplified an early awareness that in order to fully protect the built heritage there must not only be adequate recording but also academic study. It also provided a good example of principle and practice that we still uphold today. Sound principles and practices should be acknowledged whenever they were laid down, and today we should learn from them, re-evaluate them and build on them for the future.

Indeed the papers in this splendid volume admirably explore our current state of knowledge of early medieval sculpture in Scotland at the beginning of a new century. They also identify needs and priorities for the future, and hopefully should also influence the further development of good conservation practice and policy.

All who were involved with the planning and organisation of the seminar are to be congratulated as are those who presented papers, all of which, and others, are presented here. Collectively they therefore provide a tangible, permanent and most appropriate marker of the centenary of *ECMS*.

An abiding memory of the seminar however, will be Isabel Henderson's clarion call for those present to become protagonists for an *ECMS* for the 21st century — that would be the ultimate tribute — and this volume is one step in that direction.

Lisbeth M Thoms
President, Society of Antiquaries of Scotland

PREFACE

This publication is the outcome of the *Able Minds and Practised Hands* seminar organised by Historic Scotland (the seminar sponsors), the Society for Medieval Archaeology and the National Committee on Carved Stones in Scotland. This took place at The Hub, Edinburgh, on 3–4 April 2003, where it was attended by more than 180 people from all over the British Isles. Marking the centenary of the publication of Scotland's first and only corpus of early medieval sculpture, Allen and Anderson's *Early Christian Monuments of Scotland*, the more detailed rationale behind this event is described in the introductory paper. John Higgitt's concluding contribution builds on what was the key and unifying outcome of the presentations and discussions at the seminar, the need for a 21st-century corpus.

 Thanks are due to the speakers, all of whom have contributed a paper to this volume, as well as the authors who have kindly provided additional papers. Dr Stephen Driscoll, John Higgitt, Dr R Michael Spearman, Dr Katherine Forsyth and Emma Carver ably chaired the various sessions, aided by Nick Bridgland, Dr Nancy Edwards, Dr Charles Mount, Professor Rosemary Cramp and Dr David Clarke as discussants. The organisation of the seminar was made possible through the help on and behind the scenes of Ian Fisher, Dr Katherine Forsyth and John Higgitt (programme content); Gareth Wells (co-ordination of bookstalls and displays); Ailsa MacTaggart (audio-visuals); Professor David Breeze, Audrey Dakin, Anne Emerson, Nicola Jones, Rod McCullagh, Richard Strachan, Sabina Strachan, Richard Welander and Dr Allan Rutherford (support, advice and direct input during seminar itself). Catriona Tytler (The Hub) and Timothy Blow (Edinburgh Castle) facilitated the arrangements for the seminar and evening reception (the latter kindly sponsored by Historic Scotland and the Society of Antiquaries of Scotland). The seminar would not have been so lively and so much fun without the bookstalls and displays that were willingly and enthusiastically provided by so many individuals and organisations, and thanks are due to all those who contributed. We would also like to acknowledge the input of the seminar's attendees who demonstrated through their sheer presence and contributions to informal and formal discussion just how important, for a whole host of reasons, Scotland's early medieval sculpture is. The stimulating discussions and subsequent written feedback can be found reflected in many of the published contributions that follow.

 Special thanks are due to Ailsa MacTaggart and Bryony Coombs, Historic Scotland Photographic Library, for their hard work with the illustrations.

 John Higgitt's contribution is particularly welcome, coming, as it does, at the end of his 10-year-plus role as first chairperson of the National Committee on Carved Stones in Scotland. This is a task for which considerable thanks are owed.

 SMF thanks Rod McCullagh for his customary patience and support during the preparation for this seminar and publication.

Reproductions from *ECMS* are with kind permission of the Society of Antiquaries of Scotland, and are not individually acknowledged.

Historic Scotland and the Hunter Archaeological Trust are to be thanked for their generous grants towards the costs of this publication.

Sally M Foster
Morag Cross

EDITORIAL NOTE

Individual sculptures can be known by several names or numbering systems. We have followed the numbering system of *ECMS*, as augmented in the National Monuments Record of Scotland (NMRS). Where a different numbering scheme has been used for stones bearing inscriptions we have sought to provide a cross-reference. The Index can hopefully be used to find a sculpture you may know by a name different to that employed in the volume. Capitalisation of the names of individual monuments can vary (cross or Cross, for instance), or be misleading (for example, 'Cross' for a cross-slab) and we have simply sought internal consistency, with clarification where appropriate (see Index).

Some authors have adopted the British Academy numbering of sides of a sculpture (A-F) (Cramp 1984b), but we have not sought to standardise this throughout.

To find out where a sculpture comes from, please use the Index to locate the appropriate map (key examples only). To find out more about an individual sculpture, including details of its location, we recommend that you log onto http://www.rcahms.gov.uk and consult CANMORE, the electronic NMRS.

Internal references within this volume are cited in the body of the text; additional references are listed under *Notes* at the end of each chapter. A single consolidated Bibliography has been provided.

Unless stated, illustrations are not to scale.

CHAPTER 1

INTRODUCTION. *ABLE MINDS AND PRACTISED HANDS*: HISTORICAL FACT, 21ST-CENTURY ASPIRATION

By SALLY M FOSTER

Here, then, we have a very remarkable group of monuments — remarkable alike as regards their number and the character . . . If we picture this group of thirty such monuments clustered around the pre-Norman Church on its isolated mound — if we consider the quality of their art, the interest of the one fragmentary inscription that remains, and the mystery of the symbolical representations that occur among them — we cannot but regret that a group of memorials so singularly interesting, impressive, and instructive, should thus have suffered irretrievable destruction. We judge of what we have lost by what remains of these mutilated products of a national school of sculpture, to which the special culture of the present day does not disdain to turn for instruction and for inspiration . . . I only ask attention in the meantime to the obvious fact that they are neither poor in design nor feeble in execution; that they are, on the contrary, the productions of able minds and practised hands [my emphasis].

This is how Joseph Anderson described the collection of 30 or so Pictish sculptures from St Vigeans (Angus) in his Rhind lectures for 1880.[1] 'Able minds and practised hands' encapsulates what is so significant about our inheritance of early medieval sculpture — what it tells us about the inhabitants of Scotland 1500 to 1000 years ago — as well as the skills and imagination that we today need to apply to the challenges of its research, conservation and presentation. Hence the title of this publication and the 2003 seminar from which it arose, and the subtitle of this introductory paper: historical fact, 21st-century aspiration.

BACKGROUND TO 2003 SEMINAR

Joseph Anderson was co-author with J Romilly Allen of *The Early Christian Monuments of Scotland* (*ECMS*) published in 1903. The centenary of the publication of this first national overview of the early medieval sculpture in Scotland provided Historic Scotland, the Society for Medieval Archaeology and the National Committee on Carved Stones in Scotland with the excuse and reason to organise their seminar.[2] The credit for Allen and Anderson's remarkable historical undertaking must rest with

the Society of Antiquaries of Scotland (see Foreword). We need look no further than Isabel Henderson's Introduction to the Pinkfoot Press 1993 reprint of *ECMS* for a detailed assessment of Allen and Anderson's achievements and their legacy with regard to recording of early medieval sculpture in Scotland.[3] For the organisers of the seminar the centenary of this landmark event provided us all with the opportunity to meet and share our passions, interests and responsibilities for the future of a resource that has been recognised since the 19th century to be a cultural asset worthy of a national effort.[4]

The aim of this introductory chapter is to set the scene for this event and its objectives. In doing so I will also say a little about Historic Scotland's interest in early medieval sculpture, namely the history of our policies and present practices as the government agency responsible for the protection and management of the built heritage in Scotland. I will then conclude with a few observations on what appear to be the key themes arising from the seminar and this publication.

The aim in organising the two-day seminar was to bring as wide a range of people as possible together to review past practice and explore all aspects of present approaches to early medieval sculpture in Scotland, from what we know of it, to its conservation and interpretation. We sought to do this in a variety of ways. The papers themselves presented a series of overviews and case studies. Through these, the discussion periods at the seminar, as well as subsequent feedback, we hoped to tease out ideas for the agenda for the 21st century, identify priorities and provide direction and encouragement to everyone who wants to work with this material. Through this we also sought to inform the development and implementation of future conservation practice, in Scotland and beyond.

THE DEVELOPMENT OF HISTORIC SCOTLAND'S APPROACH TO EARLY MEDIEVAL SCULPTURE

In 1992 Historic Scotland produced a formal policy statement on carved stones, recommending a range of actions and precepts for the protection of all carved stones (Appendix 1.1).[5] Scotland was the first country in the British Isles to have a government policy specific to carved stones. I believe that we can attribute Scotland's stance, indeed lead in this field, to two factors. Firstly our wealth of carved stones of all periods, but particularly those of the early medieval period, that have been of interest to antiquarians and the wider public for many centuries. Secondly, the personal interests of General Pitt Rivers, the first Inspector of Ancient Monuments for the British Isles. He had a keen interest in early medieval sculpture, particularly that in Scotland. As a result a significant proportion of the first monuments to come into State care in 1882 were early medieval sculptures,[6] and the ideas that he developed for the protection of these and related monuments still underpin our present philosophy.[7] We have therefore been operating to widely discussed principles since the time of our first ancient monument legislation.

Historic Scotland's policies and much of our published guidance have tended to address the needs and interests of carved stones of *all* periods and types as a whole, rather than distinguishing prehistoric rock-art, Roman, early medieval and medieval

sculpture, *in situ* architectural sculpture, *ex situ* architectural sculpture and gravestones.[8] The reason is that a number of attributes are common to each. Firstly, and most obviously, is that these types of monuments are often prone to the same range of threats. Formed from stone which has been worked by human hands, to a greater of lesser degree, they share the same vulnerability to environmental erosion, and hence demand the same repertoire of specialised conservation. The fact that they are often ornate and beautiful monuments in their own right increases their past and present value in monetary as well as cultural terms. Many, particularly those that are already portable, are unfortunately vulnerable to theft. They can also be vulnerable to other equally inappropriate management practices. Secondly, such sculptures can have a schizophrenic identity — are they monuments or artefacts? This is a question of both personal perception and legal identity and it also raises issues of ownership, which has a similar duality (Chapter 3). Carved stones can be both monuments in their own right and parts of a larger monument — a gravestone and a part of a graveyard, a decorated archway and part of a church. Either way, sculpture has a strong association with its place of use. But, once sculptures become portable, the law regards them as artefacts, which will have implications for how/if they can be legally protected, who then owns them, where and how they are administered and by whom. The situation is highly complicated.[9]

The future of early medieval sculpture has a history of being a thorny issue. When the first ancient monuments legislation was introduced in 1882, this led in the late 1880s–early 1890s to a collision of respective interests between the predecessor bodies of the National Museums of Scotland and Historic Scotland on this very topic. In bald terms, this tension can be summarised as a disagreement about whether the prime value of the sculpture lay in its recognition as an artefact in a museum or a monument associated with its place of creation.[10]

Pitt Rivers's views are essentially those that Historic Scotland follows today, these events are contemporaneous with the production of *ECMS* and they also involve one of its authors (Figure 1.1), hence it is appropriate to say a little more about this here. The National Museum of Antiquities' first Keeper of Archaeology, Joseph Anderson,[11] was a zealous champion of the centralised collection of early medieval sculpture, both original material and casts. We should remember the influence of the cast-sculpture courts of the Victoria and Albert Museum in London which appeared in 1873. In 1882 moveable sculptures, such as had previously been presented to, or acquired by, the National Museum of Antiquities, came within the scope of the Ancient Monuments Protection Act 1882. This led to a public debate about where sculpture should be curated, a dialogue that is documented in the writings of Anderson and Pitt Rivers. Their diametrically opposed views stem from radically different philosophies about how the value of this material could be best appreciated, although both had the common aim of raising public awareness and support for the sculpture. But their dialogue must also be set against the prevailing background. Anderson was Assistant Secretary of the Society of Antiquaries of Scotland and had a very considerable influence on Scottish archaeology for 40 years.[12] He and the Society of Antiquaries were put out by the England-centric arrangements for the implementation of the 1882 Act and there was hence tension between the Society and the Office

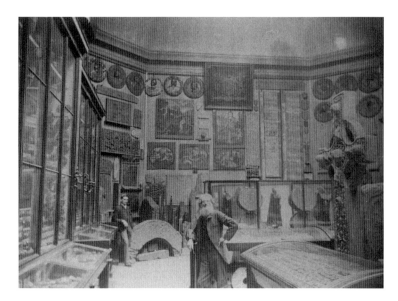

FIGURE 1.1 Joseph Anderson (front) and his assistant, George Black, in the National Museum of Antiquities, around 1890. (© Trustees of the National Museums of Scotland)

of Works. Anderson was concerned about the state of this 'ancient art' if left in its present location, 'a possession of which any nation might well be proud'. He was a strong advocate for greater public interest in these monuments and saw a national collection as the vehicle for achieving this: 'it would be difficult to estimate the influence which the formation of such a representative collection in the National Museum might exercise both on the study of archaeology and on the decorative arts of the country'. He felt that local museums might protect the sculpture from weathering but that they downplayed national significance, and meant that the sculpture's general context as an art form was obscured. Pitt Rivers, in contrast, viewed sculpture as a monument in its own right rather than an artefact and felt strongly that it should be retained locally. His widely espoused views developed their expression through his involvement about what should be done with the Pictish sculptures from Dyce (Aberdeen City).[13] Pitt Rivers was instrumental in ensuring that these were not removed to Old Aberdeen, but protected and displayed within a specially built shelter on the church site on which they were found. He had a reluctance to deprive country places of their old associations and of things that draw people to visit them. This was also expressed in terms of robbing or sacrificing country places in the interests of towns and foreigners. He also felt that patterns of local diversity could not be appreciated, and monuments would be overlooked if collected together in a single place. Pitt Rivers was a major English landowner and undoubtedly also of the opinion that responsible landowners were more than capable of looking after such monuments, if with a little persuasion.

Returning to the present, I am a firm believer in the benefits that accrue from taking a wider perspective when considering the needs of early medieval sculpture. What, for instance, might we learn from the approach that prehistorians take to the study of rock-art, notably their sensitivity for where and why individual carvings or

types of carvings are placed in the landscape (cf Chapter 9)? Or what of the Council for Scottish Archaeology's ongoing initiative to secure the better preservation and management of Scottish graveyards through its Carved Stones Advisor Project?[14] The formation of the National Committee on Carved Stones in Scotland was a direct outcome of a recommendation in the 1992 Policy.[15] Again, this Committee does not limit itself to the carved stones of any one period, although it has formed the model by which the Ancient Monuments Board for Wales has recommended the establishment of a national committee to investigate the problems facing the survival of Welsh early medieval inscribed sculpture.[16]

CARVED STONES: HISTORIC SCOTLAND'S APPROACH

In 2005 Historic Scotland published a refreshed policy that can apply to carved stones of cultural significance of all periods: *Carved Stones: Scottish Executive Policy and Guidance*. In parallel, Historic Scotland has considered its strategy at its own hand for carved stones in general, and specific categories of carved stones in particular, and has produced an Action Plan (see http://www.historic-scotland.gov.uk/carvedstones). The policy (operational and strategic) and guidance is laid out under five headings: legal protection; raising awareness of the vulnerability of carved stones; conservation strategies and practice, including intervention; research and information; and Historic Scotland setting an example of best practice. It also contains information on aspects of the ownership of carved stones and their legal protection, guidance on the rubbing of carved stones for scientific purposes, a bibliography and further reading, as well as an extensive list of contacts.

Legal protection

Here we wish to ensure that statutory provisions are appropriate and fully utilised to protect and manage carved stones, where applicable.

Raising awareness of vulnerability of carved stones[17]

By this we mean ensuring that all relevant parties are aware of the threats to carved stones and are encouraged to take measures to address this. The predominant threats are vulnerability to environmental erosion, inappropriate management practices and theft or vandalism.[18]

Conservation strategies and practice, including intervention

Under this heading we wish to ensure that the highest standards of conservation strategies and practices are adopted, and that these are in the best interests of the carved stone. The aim of the conservation of carved stones is to retain their cultural significance, and must include provisions for their future needs, including security and maintenance.

Research and information

Our fourth objective relates to research and information, promoting understanding and enjoyment of carved stones by all, targeting provision to the needs and

opportunities of the different audiences. We recognise the continuing need for us and others to advance knowledge of this subject.[19]

Historic Scotland setting an example of best practice

Finally, we acknowledge that Historic Scotland must set an example of best practice by ensuring all our own work with carved stones follows best practice and sets an example for others to follow, not least for those sculptures in our own care.

21ST-CENTURY AGENDA AND PRIORITIES

I suggest that five key, interrelated themes can be identified: the interdependence of conservation, research and access; inventorisation; context and significance in general; research; and conservation. Cross-reference is made in brackets below to the individual contributions that follow.

Interdependence of conservation, research and access

If we do not protect and conserve the early medieval sculpture resource it will not survive for us to record, study and enjoy; if we do not record, study and assess it, we cannot identify priorities for management action or present the sculpture in an intelligent and informed way; if we do not share and allow access to our knowledge and enthusiasm, who in society will ensure that there is support for its very survival? A single concept — cultural significance — and its application in conservation planning combines all these considerations. Conservation plans seek to define the most appropriate strategies for the conservation and/or presentation of a place, informed in the first instance by an assessment of what is culturally significant about the place in question.[20] A sculpture's significance is embodied in its fabric, design and its setting; in associated documents; in its use; in people's memories and associations with it. This, as we can all appreciate, is best understood through a methodical process of research.

The *Able Minds and Practised Hands* seminar aimed to bring the areas of conservation, research and access together, and in this it was successful (see Chapter 2). For purposes of seminar programming there were sessions with the titles of Policies and Practice, Understanding Setting and Context, Conservation, Approaches to Study, and Interpretation and Presentation, but we have eschewed such divisions in the presentation of this publication.[21]

The 21st-century challenge is to identify how any future work can simultaneously optimise the benefits to conservation, research and access (see Chapter 20, for instance). Access is used here to embrace all aspects of interpretation and presentation, or how we can make the resource better appreciated.

Inventorisation

The urgent need for a new inventory of early medieval sculpture in Scotland fit for 21st-century needs was made over and over again (see, for instance, Chapters 5, 10 and 23). The challenge that this presents is discussed in the concluding paper (Chapter 26).

Cultural significance and context: gaining access to meaning and relevance

Perhaps the most important development over the last 100 years has been the increase in awareness of the range of values and significances that attaches to early medieval sculpture (see Chapter 21, for instance). In part this is a factor of the ever-diversifying, interdisciplinary academic approaches that are taken to its study. Recognition of the need to address context and setting of monuments is also very much a product of the second half of the 20th century, reflecting wider trends in approaches to archaeology[22] and today's society in general. We now live in a world where the value that society as a whole places on the historic environment, a local community on the historic fabric of the place it lives, is recognised as being important if the practice of conservation at any one place is to be successful, and if there is to be public support for conservation work in general. Carver makes a helpful distinction between social context, intellectual context and local legacy. Without an understanding of these, and their interrelationship, our understanding and appreciation of early medieval sculpture is severely diminished. A significant number of the papers that follow pick up different aspects of such contexts.

If social context is about understanding where monuments stood in their historic landscape and why there in particular, then this is an area where much remains to be done. Carver, Driscoll *et al*, Forsyth, Hall *et al* and others show the potential that exists for us to begin to understand the societies, communities and individuals that created and used these monuments. Early medieval sculpture is of course one of the main resources for study of early medieval Scotland as a whole, and it is therefore incumbent on us to research it and its context to the full. A wide range of tools exists to explore this, and we certainly have not made sufficient use of many of them to date (see, for instance, Chapter 7 on archaeological excavation; Chapter 18 on geological analysis).

Intellectual context, the means of gaining an insight into the early medieval world through its artistic legacy, is the more 'familiar' approach to sculpture, but this is to underplay the significant changes there have been in how art-historians look at their source material. Art-historical analysis now places more emphasis on establishing the context and function of both ornament and subject-matter, rather than simply being concerned with individual motifs, style and the availability of models. It studies works of art in conjunction with literary evidence, and it recognises the monument as an artefact rather than simply a bearer of art.[23] Art-historians can bring a range of approaches to the sculpture and some, although well-established elsewhere in the British Isles, are still only just beginning to be employed in Scotland (Chapters 16 and 17 on iconology, for instance).

Carver's 'local legacy' embraces the issue of social value, including how a sculpture affects the personality of a place and its value to the modern community (see Chapter 3), as well as those who earlier inherited such monuments (see Chapter 4). This emphasises the importance of understanding the individual biography of monuments. Addressing social value for monuments of any type and period is still a relatively young discipline in the UK, but that this is an important consideration for early medieval sculptures in Scotland can be traced from the time of Pitt Rivers (see

above), through to modern case histories, as at Dunnichen (Chapter 22) and Hilton of Cadboll (Chapter 3).

The priorities therefore are being able to make full and informed assessments of all aspects of the cultural significance of any monument, and for this to underpin our conservation and access strategies.

Research: tools for understanding

A noticeable trend in recent years has been the appearance of more interdisciplinary study in early medieval studies as a whole, sculpture in particular (e.g. Chapter 19), significant research by non-historical, archaeological or art-historical disciplines (e.g. Chapter 18 for geology), as well as methodological developments in how the material may be recorded, analysed and reconstructed (e.g. Chapters 24 and 25). The range of sources waiting to be recognised and tapped remains enormous (e.g. Chapter 15 on a 'new' archival source), while some areas have scarcely been studied at all, such as toolmarks.[24] As yet, there is still all too little landscape-based study, an approach that requires not only vision and an interdisciplinary team, but also a significant investment of resources if to be pursued on any meaningful scale.

The priorities are therefore establishing what the key research questions are, marrying the agendas of the different disciplines,[25] and establishing the logistic and financial mechanisms for taking such interdisciplinary research forward (see Chapters 20 and 23). The relationship of the undertaking of such research to the production of any inventory clearly requires to be explored (see Chapter 26), as does the nature of recording fit for each purpose (see, for instance, Chapters 12, 13, 14, 24 and 25).

Conservation: how and where?

The tools at our disposal for physical conservation (Chapter 10) and ensuring the efficacy of modern interventions (Chapter 11) have increased significantly in the last 100 years. A key issue throughout, however, has been the question of where sculpture is best preserved in the interests both of the sculpture itself and of modern society. Local museums (Chapter 22), and indeed the National Museums of Scotland, have played a vital historical role in the conservation of early medieval sculpture, and will continue to do so, not least for new discoveries. It is also recognised that preservation within the 'landscape' can sometimes impose physical and practical limitations (Chapters 23 and 25). Nonetheless, the overriding message is that an understanding and appreciation of the landscape context of a sculpture and its biography gives it enormous value, wherever the sculpture may now be displayed.[26] The important thing is to reconnect these intellectually, where physical unity is not feasible or necessarily desirable.

The clear priority lies in establishing which sculptures have conservation needs, which are the most serious and most urgent, and to identify an appropriate conservation strategy to address such needs on a case-by-case basis, as informed by a full prior assessment of cultural significance.

CONCLUSIONS

I have sought, above, to tease out what appear to be the key issues and priorities for the 21st century. The devil will be in the detail of how all the organisations and individuals with an interest in early medieval Scotland, its sculpture in particular, can pull together to progress this. Robert Stevenson observed how *ECMS* had the effect 'by its thoroughness... of inhibiting further constructive study of its subject for more than a generation'.[27] A repeat of this is certainly undesirable and can be avoided by ensuring that future initiatives engage a large number of experts from a wide range of disciplines. We must also recognise and nurture the cyclical relationship between research, conservation and access, for the possibilities are more than any one generation can realistically achieve.

ACKNOWLEDGEMENTS

I would like to thank Professor David Breeze, former Chief Inspector of Ancient Monuments, for his support of the seminar as a whole, and his advice on the content of this paper.

NOTES

[1] Anderson 1881, 55–6.
[2] This inventory was produced at a time when little else was inventorised in Scotland (Baldwin Brown 1905, 61).
[3] Henderson 1993a.
[4] Anderson 1881, 134–5.
[5] This was published as an appendix in Maxwell 1994 and is reproduced here at Appendix 1.1. The core principles of this have been enunciated in Historic Scotland's widely disseminated free leaflet, *The Carved Stones of Scotland, A guide to helping in their protection* (copies available free from 0131 668 8638, hs.conservation.bureau @scotland.gsi.gov.uk; see also http://www.historic-scotland.gov.uk/carvedstones).
[6] One-third of the 21 monuments protected under the Ancient Monuments Protection Act 1882 were early medieval carved stones, and all but two of these sites (the 'pillar and stone' at Newton, Aberdeenshire, and the Cat Stane) are now in State care.
[7] Foster 2001.
[8] A departure has been the production of extensive literature related specifically to graveyards and gravestones, namely Maxwell *et al* 2001, and a series of Graveyards and Gravestones Electronic Leaflets on http://www.historic-scotland.gov.uk
[9] Historic Scotland 2003.
[10] Foster 2001.
[11] From 1869–1913.
[12] Stevenson 1981; Clarke 2002.
[13] Foster 2001, 8–14.
[14] http://www.scottishgraveyards.org.uk
[15] http://www.carvedstonesscotland.org
[16] CADW 2001.
[17] 'A representative government cannot tax people for interests that the people care nothing about' (Pitt Rivers 1891, 175–6).
[18] Through its Monument Warden Programme, Historic Scotland can continue to make owners and occupiers of scheduled ancient monuments aware of the threats to carved stones, and the options for their improved protection and management. But we would also like to encourage all those with a moral and statutory responsibility, particularly local authorities, to develop their own policies for carved stones and to devote sufficient resources to fulfilling these.
[19] Pitt Rivers appreciated that protection of monuments also involved their academic study (Saunders 1983, 13).
[20] See, for instance, Historic Scotland nd b; Heritage Lottery Fund 1998.
[21] The order of presentations is followed faithfully in this publication, however, with the exception of bringing Martin Carver's contribution to the beginning, since it sets the scene for many of the following papers. Contributions made after the seminar are inserted in the most appropriate place.
[22] See Saunders 1983, 22; Darvill 1997.
[23] Henderson 1995, 17.
[24] Hill 2001; 2003a; 2003b.
[25] See, for example, the art-history agenda defined by Henderson 1995, 19.

[26] 'The monuments would not impress the mind so much as when they are seen on their own sites in the regions that gave birth to them' (Pitt Rivers 1891, 175).

[27] Stevenson 1981, 175.

Appendix 1.1

CARVED STONES: HISTORIC SCOTLAND'S 1992 POLICY

Carved stones and, in particular, Pictish Symbol Stones, are one of the most important groups of monuments forming Scotland's cultural heritage. The increasingly rapid deterioration in the condition of many stones is a source of considerable concern and emphasises the immediacy of the problem. This paper is concerned with the protection of carved stones of all periods: prehistoric rock carvings and cup-marked stones; post-Roman and medieval stones; other carved stones, including 17th- to 19th-century gravestones.

The following actions and precepts are recommended as forming the basis of Historic Scotland's policy for the protection of all carved stones. It is accepted that the protection of stones can be best achieved through co-operation with other appropriate bodies in Scotland and it is not envisaged that all the actions suggested below should be undertaken by Historic Scotland.

GENERAL

1. Establish a national committee including officials of HS, NMS, RCAHMS/NMRS, CSA and ARIA to co-ordinate preservation and publication.
2. Each case should be taken on its merits and the primary aim should be to act in the best interests of the stone itself. In every case the lowest form of intervention should be undertaken.

PREHISTORIC ROCK CARVINGS AND CUP-MARKED STONES

3. A programme of recording, monitoring and covering (if and as appropriate) of carvings on bedrock and earth-fast boulders, such as cup-and-ring marks, should be started and, when sites are confirmed as being at risk, remedial measures should be urgently undertaken.

POST-ROMAN AND MEDIEVAL CARVED STONES

4. Monitor the damage to carved stones. This itself will be a complex and long-term exercise if an adequate and usable record is to be achieved. The exercise should:
 a. continue the present monitoring programme at Aberlemno and other stones in the care of HS;
 b. extend the monitoring to an adequate proportion of stones, using the NMS and RCAHMS surveys as the basis for the choice; the period of monitoring should be at least 10 years (but may be interrupted if urgent remedial action is required);
 c. improve the recording of the treatment undertaken on stones, copying records to NMS and RCAHMS;
 d. ensure that surveys of carved stones include information relating to their present state of preservation.

5. Measures should continue to be taken to protect stones at risk. The aim would be to concentrate on those stones known to be most at risk, otherwise the better preserved stones should have priority over poorly preserved stones unless the latter are typologically important. The precepts governing actions to protect stones should be:
 a. there should be a presumption in favour of retaining stones *in situ* where possible; in particular all possible attempts should be made to retain *in situ* stones believed not to have been removed from their original location;
 b. when stones are retained *in situ* and protective enclosures require to be provided, each protective enclosure should be purpose-designed to create the correct environment for the stone with due regard for the surrounding conditions and location;
 c. those stones which require to be moved should normally stay locally;
 d. when stones have to be moved, consideration should be given to their relocation within an existing local structure though the long-term stability of, and public access to, such a building should be taken into account;
 e. movement of stones to more remote locations, including museums, should be a last resort;
 f. consideration should be given to replacing stones with casts where movement of the original is essential. In coming to a decision, the possibility of damage to the stone through casting, and the difficulties of achieving a successful replica, will need to be taken into account.
6. Wherever possible, every stone should be protected from rising damp by enclosing the tang in a damp proof membrane. A programme of lifting and treating stones in this manner should be prepared.
7. The removal of stones from their sockets should always be accompanied by excavation.

OTHER CARVED STONES

8. Consideration should be given to the protection of other carved stones such as gravestones of the 17th to 19th centuries by putting them under protection from the elements and other threats.

GENERAL

9. Education:
 a. notices should be erected at monuments at risk, advising visitors not to rub stones, bedrock carvings or sculptured detail;
 b. consideration should be given to providing and marketing good quality survey drawings in order to try to provide an alternative to rubbing (these could be taken from photogrammetric surveys);
 c. articles should be prepared for appropriate publications on the problems of rubbing in the hope of deterring people wishing to rub stones. Appropriate locations for such articles include *Welcome*, *CSA Newsbulletin*, *SAS Newsbulletin*, *Proc Soc Antiq Scot*, *Council of Europe Heritage Newsletter*;
 d. consider ways of educating the public, including schoolchildren, on proper respect for carved stones;
 e. hold a seminar/conference(s) in order to increase awareness and give wider consideration to the problem.

10. Training and research:
 a. there is a requirement for the continuing training of staff working in this area and for increasing the number of trained personnel;
 b. there is a requirement to continue and improve research into conservation techniques and to develop appropriate protective measures.
11. Consideration should be given to revising the legislation to improve protection for carved stones, including gravestones of the 17th to 19th centuries.

© Historic Scotland
January 1992

This is now superseded by the 2005 *Carved Stones: Scottish Executive Policy and Guidance*

CHAPTER 2

SCULPTURE IN ACTION: CONTEXTS FOR STONE CARVING ON THE TARBAT PENINSULA, EASTER ROSS

By MARTIN CARVER

SOME PRINCIPLES

Carved stone monuments are robust creations which carry prominent symbolic messages. They have an impact on their landscape which is immediate and continuing. As with a high-status burial mound, a stone sculpture has the attributes both of an artefact and a site, the individual and the communal, and meanings for those who made it, those who first saw it and for those who came after. The search for context is thus a multi-dimensional affair, requiring the definition of a number of different values and involving a package of related enquiries.

The values associated with monuments in general may be abbreviated as *research*, the value of knowing more, *conservation*, the value of keeping what we have, and *access*, the value of making it widely appreciated. The *Able Minds and Practised Hands* seminar was unusual in that these aspects were explored all together in the same sessions by the same audience. It was thus possible to see how the three values were interdependent: conservation is not possible without the public support that comes from access, and access only gives satisfaction when illuminated by research, which in turn relies on conservation for its continuing operation. My paper concerns itself only with research and the new knowledge that can be won from early medieval sculpture, and in particular from the study of its context. I suggest firstly how that context may itself be defined and then the kind of result that may obtain, using the Tarbat peninsula in Easter Ross (Highland) as a case study.

The research contexts associated with carved monoliths may also be divided into three types (Figure 2.1). The monuments in question, if not always designed to stand upright, were intended to be seen. They performed a role in their contemporary societies, showing degrees of status and investment and directions of political alignment — signals aimed at both internal and external viewers. This *social context* might be investigated by discovering the location of the monument in the landscape, which way it faces, its relation to settlements and the resources needed to produce it. The area from which a monument may be viewed I have here termed *vista* — since 'viewshed' has a more technical meaning in geographic information systems. A

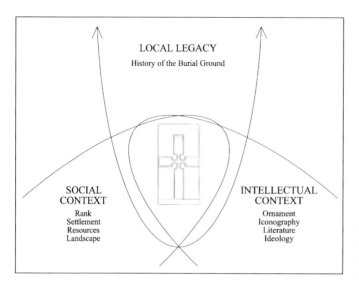

FIGURE 2.1 The contexts of early medieval carved stone monuments. (© M Carver and University of York)

monument has a relationship with the land in its vista, which may be ancestral, proprietorial or ideological, and, as such, vista is a key attribute. The social context of a monument is not automatically offered: the original location of the monument is often uncertain, the settlement in which it was erected is often undefined, and the source of the stone for carving may not be known. Nevertheless without these attributes, the monument will be destined to have a diminished historical meaning, a stray find bearing art from an earlier age, at risk from artificial sentiment and spurious modern myths.

Even isolated art from an earlier age does, however, have a rich value of its own, one which has long generated its own agenda. The ornament and images, especially those that are figurative, open a window onto the broad arena of the artists' contemporary world. Iconography 'quotes' from an ideological corpus which can include both archaic elements and new ideas. This *intellectual context* may be investigated by studying similar art and iconography elsewhere, and also by digging into early literature to try and source ideas which have become reified in stone. This world of ideas has both global reach, in which nothing contemporary should be excluded, and time-depth, in that all human knowledge up to that point provides a potential hunting ground for sources. The cross-slabs of the type we shall be visiting are more than a stone page from a sacred book: they represent a palimpsest of imprinted thought, as full of allusions as the furnished graves of a previous generation.[1]

Once installed, a carved stone monument begins to affect the personality of its place: other, later, monuments copy it, refer to it, defer to it or attempt to erase it, giving us a narrative of monumental use, a sequence of shifting opinion. While they remained visible, early medieval *stelae* determined later settlement and landscape in the way that Richard Bradley has taught us to expect of prehistoric henges and tombs.[2] For carved stone memorials of the Early Middle Ages this *local legacy* is

particular (though not exclusive) to churchyards, where we may anticipate some continuity of function. The investigation of context thus includes the study of the monument's aftermath, the later history of the site in question. The later economic and ideological highs and lows provide the most appropriate analogies for the earlier societies and the key to a monument's initial rationale. Within this broad study the burial ground has pride of place, since it was here that later monumentality was principally focused.

THE TARBAT PENINSULA — THE SOCIAL CONTEXT

The Tarbat peninsula has a set of monuments which well demonstrate the context of sculpture as an active force in the landscape. On this small piece of land, four places are known to have been the locations of monumental stone cross-slabs in the 8th-9th centuries AD (Figure 2.2). At Shandwick the cross-slab is still likely to be *in situ* (see Figure 7.1; for discussion of the ornament and iconography, see Chapter 16), while that at Nigg is now inside the church (see Figure 4.6). The main, upper portion of the famous Hilton of Cadboll monument, now in the National Museums of Scotland, stood in the 18th century and earlier beside St Mary's Chapel (Figure 2.3). At Portmahomack there was once a fine series of stone monuments which had been thrown down, buried and reused. Some have been rediscovered over recent centuries, while the recent research campaign has brought the total to more than 150 pieces representing at least three and probably four major standing cross-slabs.[3] The Tarbat peninsula was thus a place of exceptional monumentality in the Early Middle Ages.

Portmahomack — the character of the site

The historic focus of Portmahomack is the church of St Colman, or Tarbat Old Church (Figure 2.4). During the 18th, 19th and early 20th centuries pieces of early medieval sculpture had from time to time been unearthed by grave-diggers in the churchyard there or extracted from neighbouring walls, among them a fragment (Portmahomack 10) carrying an inscription in Latin (Figure 2.9c). The inscription, which is in Insular majuscules rendered in relief, suggested the presence of a literate community in the 8th century.[4] In 1984 a cropmark photographed from the air by Ian Keillar and Barri Jones excited further attention since it resembled in form the C-shaped enclosure which surrounds the church at Iona (Argyll and Bute) (Figure 2.5). A test trench across this buried ditch in 1991 produced organic matter radiocarbon dated to between the 2nd and 6th centuries AD.[5] At the invitation of Tarbat Historic Trust, the site was then adopted as a research project by the University of York under the direction of the present author. The new project, designed after a season of evaluation in 1994, incorporated the excavation of 0.6ha of the Portmahomack site and a survey of the Tarbat peninsula to provide the excavations with their context.[6]

Excavations and structural analysis inside the church and in the fields beyond it offer both an overview of the early medieval settlement and the subsequent history of the place to the present day (Figure 2.6).[7] The sequence began with a series of 67 burials with stone cists or head-support stones, of which the majority were the graves

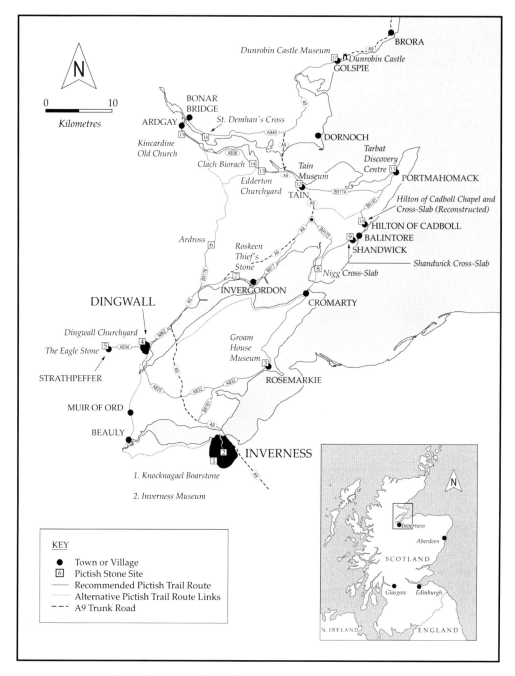

FIGURE 2.2 The Tarbat peninsula and immediate environs, showing the sites of Nigg, Shandwick, Hilton of Cadboll and Portmahomack, as well as related places and modern routes of communication. (Drawing by A Mackintosh, from Jones 2004. © Siân Jones)

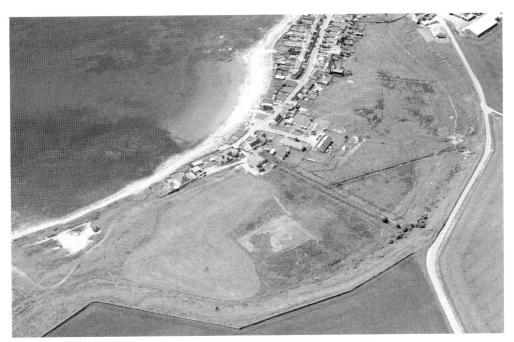

FIGURE 2.3 The site of St Mary's Chapel at Hilton of Cadboll. (Photograph by Barri Jones. © University of York)

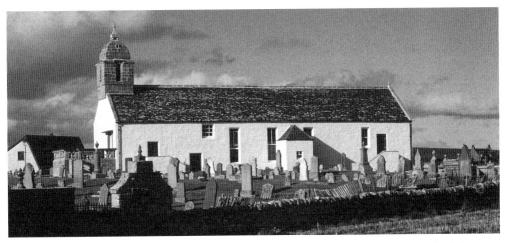

FIGURE 2.4 The church of St Colman, Portmahomack, after restoration in 1999. (© M Carver and University of York)

of men. One of the earliest cist graves has been radiocarbon-dated to the later 6th century AD, and two others to the 9th century. A stone church is hypothesised for this period, represented by a single wall out of alignment with those of the later churches

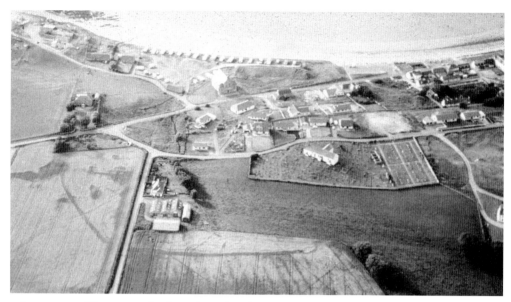

FIGURE 2.5 The cropmark of a C-shaped enclosure at Portmahomack in 1984. (Photograph by Ian Keillar and Barri Jones. © University of York)

(Church 1). West of the church, a paved road ran through an area of workshops, indicated by traces of walls, hearths and a rich assemblage of debris. Crucibles, moulds and whetstones show that bronze and possibly silver and gold were being cast, and mostly applied to ecclesiastical rather than secular objects. Glass and wood were also used in manufacture, and there is evidence for the fine working of leather: stretcher frames, a tanning pit, a crescent-shaped knife and pumice-stone rubbers, material from which Cecily Spall has been able to make a persuasive case for the preparation of vellum.[8] Among the finds was a silver porcupine *sceat* originating from Frisia and dating to about AD 715. Further down the hill was a dam which formed a pond, probably to drive a mill, and further south still, adjacent to the enclosure ditch, were the foundations for a large timber-frame and turf building identified as kiln-barn, which had doubled as a smithy. The enclosure ditch seems to have functioned primarily as a water-collector.

Without calling on the sculpture it is possible therefore to assert that St Colman's Church was the site of an early medieval monastery, active from some time in the 6th century to the 9th. Contributory to this interpretation are the sex and age of the burials, the nature of the objects being manufactured in the workshops and the penannular form of the enclosure. By the 8th century, the settlement was at its busiest, with a church and cemetery on the hill, a workshop area beside it to the south-west, an agricultural area to the south near the enclosure perimeter, and between them, a stream feeding a mill-pond, driving a mill. This settlement was also served by the best landing beach on the peninsula. The objects and structural parallels point to connections with Iona in the west and Northumbria in the south. The site is proposed

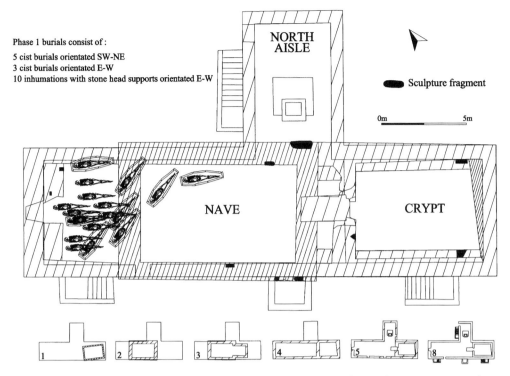

FIGURE 2.6 The sequence of churches at St Colman's, Portmahomack. (© M Carver and University of York)

as a foundation of Columba, chosen during his expedition up the Great Glen in AD 565. It flourished throughout the next 250 years, to become a major monastic centre in the north-east, comparable with and complementary to Iona. The circumstances in which the Portmahomack monastery was abandoned and forgotten are unknown. But, at a given moment between the 9th century (the latest date of the sculpture) and the 11th (the probable date of Church 2), the workshop area was destroyed by fire, and some sculpture was deliberately broken up and dumped among the debris.

The sculpture at Portmahomack

The previous passage attempted to provide a context for the early medieval sculpture without drawing on the evidence of the sculpture itself. However, the sculpture on its own undoubtedly suggests that it served a learned and literate ecclesiastical community, or, in terms of current usage, a monastery. The corpus of sculpture from Portmahomack (site code TR) now exceeds 200 pieces, most of it fist-size or larger. Nineteen of these were found during grave-digging or in the churchyard, 14 were found during excavations in the church, mainly built into the foundations, and the remainder, generally smaller pieces, have been retrieved from the excavations of the destruction phase of the workshops in the Glebe Field.[9]

The material overall has a stylistic date-range of not more than 300 years, from about AD 550 to 850. The carved stones belonging to this period can be grouped into three main types. First are simple grave-markers with a scratched cross or crosses in low relief of different types, many of which recall examples from Iona (Figure 2.7).[10] Pieces of this type were found only in the churchyard or church foundations, and it seems reasonable to associate them with the monastic cemetery. The second group includes pieces which may have had architectural functions. A stone post with grooves, removed from the churchyard, recalls the stone posts known from Iona which supported panels forming the edges of a shrine or the *cancellum* which separated nave and chancel (Figure 2.7). The 'calf stone' (Portmahomack 28/35; Figure 2.8a) may have belonged to such a panel. It carries a charming vignette of a family of cattle, surmounted by composite beasts, and limited below by a double border, beneath which the stone is only roughly worked. Alternatively, it may have been part of an architectural frieze set in a wall. Imperfections in the stone matrix and of the tooling above and below the double border allow the alternative possibility that this was an experimental or trial piece. Uncertainties of function also attend the interpretation of the 'boar stone' (Portmahomack 22; Figure 2.8b), which features three animals, a lion, a boar and an unidentified animal, executed in relief within rectangular niches. There is an equal-armed cross carved in relief at one of the short ends and a rebated ledge on the underside. This very heavy stone might have functioned as a wall panel, in which case it could be situated on the right hand side of a chancel arch or opening (to accommodate the cross on the short end as part of the soffit). Alternatively, we may be looking at the lid of a sarcophagus, where the rebated ledge fits into the stone coffin (it has the weight). A third possibility is that it is part of an altar.

The remaining pieces of sculpture at Portmahomack are attributed to large monumental cross-slabs (Figure 2.9). At least one piece, Portmahomack 20, was carved on four sides, and therefore stood upright. It shows, on one face, a composite beast ('the dragon') within the arm of a complex cross on one face, and on the other a frieze of apostles bearing books surmounted by two lions devouring a deer. The Latin inscription already mentioned (Portmahomack 10) is associated with this piece by virtue of the spiroform terminal which is replicated beneath the dragon. The inscription announces that this was a 'cross of Christ' and commemorates an individual whose name began with the syllable *Reo*.[11] Assuming that it featured Christ and twelve apostles, this cross-slab was originally over a metre wide and must have stood some 3m high. It is likely to have stood west of the church.[12] A second cross-slab is implied by the base-stone Portmahomack 1, which features Pictish symbols and a scene interpreted as an incident in the life of Daniel. It is ornamented with vinescroll closely comparable to Hilton of Cadboll.[13] A third cross-slab is implied by the 'Danish Cross' and its remains (above, n9) which also stood east of the monastic church. These monuments must be directly comparable to those erected at the neighbouring sites of Nigg, Shandwick and Hilton of Cadboll, which are in general much better preserved. All are closely related in their ornament and date and refer to the apogee of the monastic establishment at Portmahomack, a period around AD 800.

SCULPTURE IN ACTION

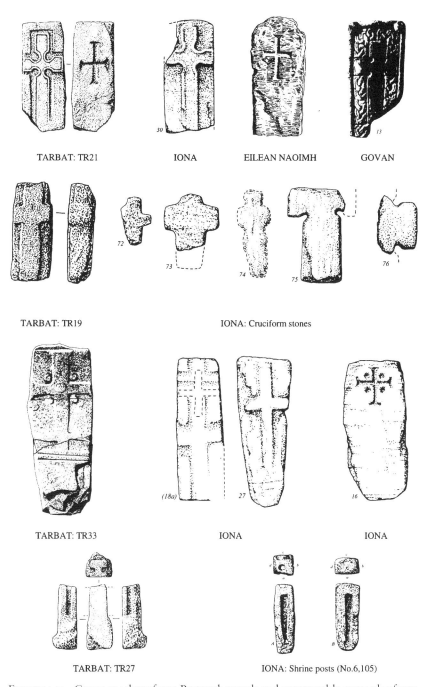

FIGURE 2.7 Grave-markers from Portmahomack and comparable examples from western sites (TR numbers refer to Portmahomack, that is, Tarbat). (© M Carver and University of York)

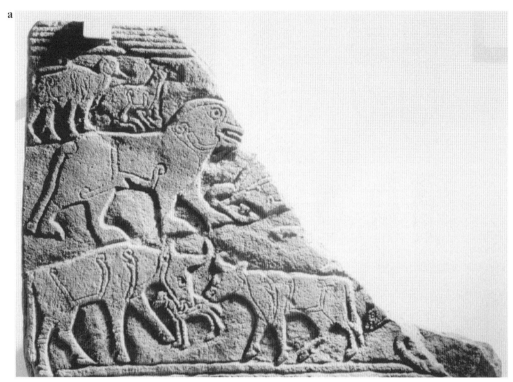

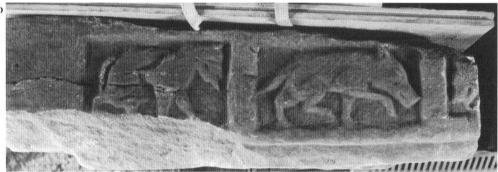

FIGURE 2.8 Possible architectural forms: (a) the 'calf stone (Portmahomack 28/35) (© Tom Gray. Tom and Sybil Gray Collection); (b) the 'boar stone' (Portmahomack 22) after lifting. (© M Carver and University of York). These stones are on exhibition at the Tarbat Discovery Centre, Portmahomack.

Nigg, Shandwick and Hilton of Cadboll — the character of the sites

The monumental sculpture known from Nigg, Shandwick and Hilton of Cadboll relates (so far) only to the final phase of the monastery at Portmahomack, and little is known about the sites at which they were erected. The cross-slab at Nigg originally stood in the churchyard until thrown down during a violent storm in 1727. It was

SCULPTURE IN ACTION

FIGURE 2.9 Elements belonging to one or more monumental cross-slabs: (a) Portmahomack 20, side 1; (b) Portmahomack 20 side 2 (thickness 178mm); (c) inscribed stone Portmahomack 10 (thickness 167mm; incomplete); (d) reconstruction of monument 1 giving it a width of about 1.25m; (e) lower part of Portmahomack 1 cross-slab, with tenon and Pictish symbols (thickness 153mm, incomplete; width 1.13m); (f) central panels from a shaft, Portmahomack 2. (Drawings a, b, and d by Elizabeth Hooper; c, f and e by Ian G Scott)

then placed against the liturgically east (actually north) end of the church. It was removed in around 1800 to gain access to the family vault of Ross of Kindeace, and broken in the process, then re-erected with the larger piece upside down, and then re-erected again by Stuart. It was repaired with cement and iron clamps. It has now been re-erected again at the liturgically west (i.e. south) end of the church in a specially modified room, and at the time of writing is under the care of Nigg Old Trust. In 1999, a missing piece bearing part of the Pictish beast was retrieved by Niall Robertson from the adjacent stream during a field trip. The monument measures 2.15m x 1.05m x 0.13m. One face carries a cross decorated with zoomorphic interlace and key-pattern, and in the pediment above it a composition containing two praying clerics, two crouching beasts and a raven with a circular disc in its beak. This tableau is thought to represent Paul and Antony in the desert, fed by a raven and supported by two lions (see below). The other face (Figure 4.6) shows two Pictish symbols, the eagle and the Pictish beast (perhaps intended as a dolphin), and below them attributes of the biblical King David, a favourite among early medieval secular leaders.[14] Nigg therefore alludes to both monastic and secular power. Nigg Church was built in 1626 and is now in a wooded setting with a burn running down the north side and a landscaped garden to the south. If the trees and church were removed, the site would be seen to be a promontory, approached by a deep hollow way, with an outlook over the Cromarty Firth; this no doubt provided the initial vista for the Nigg cross-slab.

Among the surviving Tarbat monuments, Shandwick has the best claim to be in its original position (Figures 7.1 and 16.2). It blew down in 1846 and broke in half, and was then clamped together and re-erected. It measures 2.85m x 1.0m x 0.23m and is now protected by a glass box (Chapter 7). The 'jewelled' cross, said to have originally faced inland, is flanked by angelic figures, cherubim, lions and serpents,[15] all thought to be symbols of Christ's mission (Chapter 16). The other face has two Pictish symbols, the double disc and the Pictish 'dolphin', below which is a panel featuring three horsemen and a hound hunting a stag, a man riding a goat, a man on foot wearing a large hat and holding a horn, two men fighting with swords and shields, a lamb, and a man in a cowl shooting an indignant stag. I suggest that this extraordinary scene may constitute an aristocratic vision of a warrior paradise. In any event it contrasts with the learned and ethereal symbolism of the other side. The cross-slab is positioned on the forward slope of high ground looking south-east. On a clear day Burghead, Kinnedar and Portknockie are visible across the Moray Firth. These are places where Pictish settlement was established between the 6th and 9th centuries.[16] Burials were said to have taken place near the cross-slab, according to Allen and Anderson,[17] but no church or burial ground has yet been located.

The Hilton of Cadboll cross-slab is justifiably one of the most famous examples of Pictish sculpture that survives (Figure 3.1). One face is surrounded by a border of inhabited plant scroll and carries two Pictish symbols at the top, the double disc and Z-rod and the crescent and V-rod. Below is a panel showing a prominent equestrian, probably female, preceded by the mirror and comb symbols, with a male escort just visible beyond, accompanied by trumpeters, and horsemen and hounds pursuing a deer. This has understandably been claimed as one of the most evocative pictures of contemporary life to have survived from 6th–9th century Britain,[18] although others

have seen it as laden with doctrinal symbolism.[19] The lower portion has been broken off, part of which, together with two collar-stones, has been recovered in small-scale excavations by Historic Scotland and other funding partners at the site of St Mary's Chapel in 2001 (Chapter 7). The other face, which should have carried a cross, was erased with a claw hammer or chisel to make way for an inscription in 1676, commemorating Alexander Duff and his three wives. The stone was subsequently removed, and followed a turbulent itinerary before arriving in its present resting place at the Museum of Scotland in Edinburgh (Chapter 3).[20]

The original location of the Hilton stone — that is, its location in the 8th century — is still debatable. It was already standing at the site of St Mary's chapel by 1676, since the Historic Scotland excavations recovered numerous small fragments which were most likely the result of redressing the cross-face for Alexander Duff's memorial (Chapter 7). Alexander Duff was buried at Fearn, and in explanation of the separation of the man and his memorial, Allen and Anderson suggest that, while the stone was made at Hilton, it proved 'too heavy' to carry to Fearn.[21] However, the stone was moved without machinery at least three times (after 1780, in 1811, and before 1903), so it could theoretically have been taken to Fearn, or indeed have arrived at St Mary's from another place of origin before 1676. The seashore site of St Mary's Chapel cannot have been the original site of the Hilton (Hill-town) of Cadboll: by 1478 the names Catboll-fisher, Cadboll-abbot and Wester Cadboll apparently refer to the present Hilton, Balintore and a settlement to the west, respectively.[22] In 1561–66 the seashore site was known as the Fishertown of Hilton, and furnished fish to Fearn Abbey, suggesting that the foreshore had been specially developed as a fishing village some time in the Middle Ages. By 1610 it was known as *Bail' a'chnuic*, 'cliff town'.[23] The Cadboll Estate maps of 1813 show a 'Hilltown' located 'behind the eroded cliffline at the back of the raised beach' with 'Fishertown of Hilltown' on the present site of Shore Street. It thus seems likely that there was once an older settlement above the cliffs called Cadboll, which became known as Hilltown after it had spawned Fishertown.

The excavations by Historic Scotland in 2000–2001 gave good reasons for believing that the Hilton stone stood at the west end of St Mary's Chapel from as early as the 12th century and during the life of Catboll Fisher, and was presumably still a visible monument in 1676. However, given the example of the removal (and demolition) of the Portmahomack monuments before the 12th century, it remains possible that Hilton too had had an earlier existence at a different site. On analogy with Shandwick, Nigg and Portmahomack, that original site might have been on higher ground further north, perhaps at Cadboll Castle or Cadboll Mount, one of which could equate with the former 'Hilltown'.

The 8th-century social context

The original position of the Hilton of Cadboll cross-slab is an important factor for the interpretation of the scheme represented by the sites of Nigg, Shandwick and Hilton of Cadboll and their relationship to the early monastery at Portmahomack. A number of models may be considered. In one, Nigg, Shandwick and Hilton may each represent a secular estate, with a cross erected in memory of a prominent ancestor. In

another, they may have been cells or daughter-houses of the Portmahomack monastery, perhaps beginning as hermitages. In a third, they may be boundary-markers of a wider monastic estate that encompassed, at least by the 8th century, the whole Tarbat peninsula (compare, for example, the ring of crosses around Kilmalkedar on the Dingle peninsula).[24] Such markers would have provided a natural choice for the location of later parish churches, although all were to lie in the parish of Tarbat (with its headquarters at Portmahomack) until 1626.[25]

The monuments are of similar date and were made of stone from the same source, most probably from the eastern seaboard of the peninsula.[26] Together they suggest a massive and centralised investment, such as would require a royal power. The planned character of this investment is also suggested by the sites chosen for the monuments on the peninsula: all four were located so as to look out onto a different piece of sea, Nigg over Cromarty Firth, Shandwick and Hilton over the Moray Firth and Portmahomack, with its large and sheltered sandy beach, across the Dornoch Firth to Golspie and Sutherland. The breadth of the vista depends in each case on where the cross-slab originally stood. The likely positions for Nigg, Shandwick and Portmahomack would allow them to have functioned as sea marks, guiding travellers to good sandy beaches, at least in the case of the latter two. A little geomorphic manipulation (i.e. raising the sea-level) shows the peninsula as more nearly an island, and a likely portage route (implied by the name Tarbat) emerges, connecting the Dornoch and Cromarty Firths (Figure 2.10).[27]

Provisionally, the whole peninsula may be seen as a single monastic establishment, founded in the 6th century, possibly by Columba himself at the opposite extremity of the Great Glen from Iona, on the nearest thing he could find to an island. By the 8th century, the Tarbat estate had developed into a mighty centre, with a port (Portmahomack, Colman's or Columba's port) in active contact with the west and south, and massive and complex monuments, probably in monastic outstations, on its estate boundaries. But we need not suppose that this represents part of a now-uniform Christian Pictland. From the evidence of the sculpture, similar establishments might be suspected at Rosemarkie (on the Black Isle, Highland) and Kinneddar (near Elgin, Moray). But at Golspie and Burghead across the firths to west and south, there is occupation of a different character in the 7th-8th century, the Pictish material here being rich in the symbol-incised stones which are so far absent from the peninsula. New work on the processes of conversion leaves us readier to believe that contrasting ideologies could co-exist as neighbours through a lengthy period of political experiment, without necessarily coming to blows.[28] This 'patchwork model' can show us Picts who were warriors, pagans, monks and hermits in dynamic equilibrium, and all negotiating the future as they saw it.

INTELLECTUAL CONTEXT

The products of the Tarbat *atelier* clearly offer a very special opportunity to investigate the range of intellectual contacts of a Pictish community. In the early part of our sequence (6th-7th centuries) we are perhaps less well-informed, since the pictorial investment is at a basic level (Figure 2.7). Such indications as we have suggest

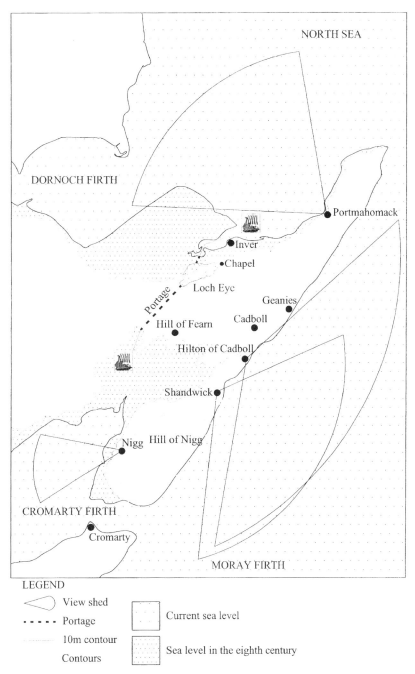

FIGURE 2.10 Model of the Tarbat peninsula, showing the possible portage route and the viewsheds for the four monuments, with the sea level raised to the 10m contour and the Hilton of Cadboll cross-slab on Cadboll Mount.
(© M Carver and University of York)

strong links with Iona — from which we could expect the Tarbat establishment to be monumentally modest but philosophically rich.[29] It is hoped that the completion of the excavation will throw more light on the monastic establishment at this early period and the brains behind it.

By the 8th century, the intellectual outreach of the Tarbat inhabitants is truly remarkable. The Nigg, Shandwick, Hilton of Cadboll and Portmahomack monuments show ornamental contact with Ireland and Northumbria, an understanding of an already-complex Mediterranean Christianity, and an ability to embed the ancestral symbols of their own culture within it. The figurative art of these monuments is currently the subject of a doctoral thesis by Kellie Meyer at the University of York. She is using literary and artistic sources to reveal something of the depth of learning, sophistication of thinking and originality of expression practised in the Tarbat atelier (Chapter 16).

Pending the outcome of Meyer's investigations, we can note that the social context, as assembled on mainly archaeological terms (above) shows that the Tarbat community was not marginal or peripheral. Contact with the east coast of Britain, perhaps as far south as the Rhine mouth, and west to Ireland is evident. Contact is needed to explain the practice of a religion which certainly came from the eastern Mediterranean via the ruins of Rome. But the construction made from this broad arena is special to the Tarbat peninsula. It blends Irish and Northumbrian motifs and Pictish symbols with learned Christian allusions in at least four different schemes. The artistic commissions are therefore not derivative, eclectic or dependent but creative and done to order.

Ideally, the intellectual investment in the stone carving of the Tarbat peninsula should reveal something of the social context too. This is no easy task. The hunting party portrayed on Hilton, the 'warrior paradise' at Shandwick, the King David images at Nigg, and perhaps the lions with the deer carcass at Portmahomack point to an aristocratic ethos, which in turn suggests secular commissions. By contrast the row of book-bearing clerics at Portmahomack endorses the monastic milieu, and a still more powerful ecclesiastical message emanates from Nigg, where the figures in the pediment may be identified as Antony and Paul,[30] since 'it is with Antony (251–356) that the story of Christian monasticism begins'.[31] Antony and Paul represented two streams of eremitic development in the 4th-century Egyptian desert, and their reported meeting was of profound significance for the monastic ideal. The *Life of Antony* (attributed to Athanasius) and St Jerome's *Life of Paul the First Hermit* remained influential in the Christian Church for the next millennium, and should have been known to the Picts by the 8th century. The equality of the two desert fathers was expressed by neither being able to break bread for the other; accordingly, they grasped a circular loaf together. The scene was carved on the Ruthwell Cross (Dumfries and Galloway) where it is identified by a Latin inscription and on St Vigeans 7.[32] William Dalrymple rejoiced to find the same scene on an icon in the Coptic monastery of St Antony in 1994.[33] The scene on the Nigg pediment may evoke the description of the death of Paul as described by St Jerome: the circular loaf of bread is brought by a raven to feed both men, and when Paul dies, the lions use their strength to help Antony to bury him. The representation of such an event can be

taken as evidence of an awareness of the historical roots of monasticism and the continuing matter of its wider relationship with society.

The iconographical signatures on the stones thus speak of both secular power and the kind of erudition that is hard to locate outside a monastic community. If we accept the most recent (and most persuasive) interpretation of the Pictish symbols,[34] the pairs of double disc and Z-rod, and crescent and V-rod (Hilton), double disc and Pictish dolphin (Shandwick), eagle and Pictish dolphin (Nigg) and the quadruple of crescent and V-rod, snake and Z-rod, 'tuning fork' and Pictish dolphin at Portmahomack 1 represent and probably commemorate the names of four different individuals. Some endorsement that this was their intention is given by the Latin inscription, which is certainly commemorative and occupies the same position on Portmahomack 20 as the Pictish symbols do on Portmahomack 1 (i.e. on the edge). None of these factors comes down conclusively on the side of an exclusively monastic or aristocratic context. On the contrary, they all speak of a closely integrated world in which aristocrats are personally involved in co-operative monastic endowment.

THE LOCAL LEGACY

My third and final research context is provided by the local legacy of the Portmahomack site, where people continued to be buried for another 1200 years after the monastery had disappeared. The present church was found to be the last in a series of earlier buildings (Figure 2.6), and documentary records and archaeological analogies offer us eight principal dated phases.[35] The first east–west building (Church 2/3) is attributed to the 11–12th centuries, from the date of a bell-founding pit (radiocarbon dated to the later 11th century) and by association with the ecclesiastical developments of David I from about 1130. Church 3 was extended probably in the 13th century to make Church 4, with a tower at the west end and a crypt at the east. At the Reformation of around 1560, the axis of worship rotated through 90°, so that the congregation now faced the minister's pulpit in the south wall, and a north aisle was added (Church 5). The church was rebuilt from its foundations in 1756 (Church 6). At the Disruption of 1843, the axis returned to the east, and the church was equipped with box pews (Church 8).

Head-support burials were cut by the west wall of Church 2, suggesting that by the date of its construction the monastic cemetery had ended. After Church 2, and aligned with it, graves of men, women and children, with a normal distribution of age and sex, filled the nave, with some in coffins and others in shrouds. At first sight the relevance of later burial practice to the early medieval monastery might seem a little contrived, since the behaviour patterns of 8th-century Tarbat could very well depend on the past, but not on the future. One reason for studying the later story of monumentality is certainly opportunist: the Tarbat project has offered a sequence of church and settlement from the 8th century to the 20th which is of unusual value. But modern archaeological thinking suggests that knowledge of the later experience will also contribute something valuable to the interpretation of the early medieval site (which remains our principal concern). Interpretation makes routine use of analogy, and later practice, particularly within the arena of Christian politics, may well provide

FIGURE 2.11 The 'calf stone' (Portmahomack 28/35) on its discovery *in situ* as a medieval drain cover. (© M Carver and University of York)

good analogies for earlier practice. The history of the church in Scotland, as elsewhere, is one in which the Crown, the aristocracy, the Pope, bishops and monks competed for intellectual leadership. In Scotland there are very particular solutions in which major roles are played by local alliances between landowners and clergy, right up to the present day. There is therefore some possibility of identifying Peter Brown's 'microchristendoms' in more recent times.[36]

The changing relationships between people and their clergy and aristocracy are reflected in the changing configuration of the church building, and also by the changing investment in memorials. The story is by no means a continuous narrative, but one of investment alternating with redundancy, indifference and destruction. The monastic cemetery is associated with the simple grave-markers (above) which date to the 6th-9th centuries.[37] The cemetery might itself conform to these same dates, in which case there will have been an interruption to burial of about 250 years between, say, 850 and 1100. Alternatively, burial may have continued until 1100, but without grave-markers. A hoard of silver coins from England and Frisia, with Viking silver 'ring-money' was buried at the edge of the churchyard in around AD 1000,[38] suggesting that the settlement was still active at that point. Some time between the 9th century and the 11th, the monastic stone monuments were removed, smashed and scattered (Figure 2.11). Some pieces were still lying on the surface of the churchyard, or had been dug up by grave-diggers when they were seen by Cordiner (1776), Stuart (1856),

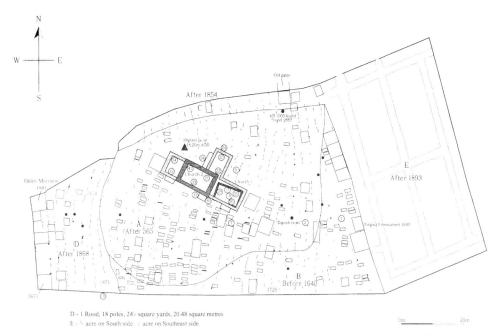

FIGURE 2.12 Map of the churchyard at St Colman's Church, Portmahomack, showing its development and the probable positions of findspots of pieces of 8th-century sculpture and the hoard of around 1000 AD. (© M Carver and University of York)

Hugh Miller (1889) and Allen and Anderson (1903) (Figure 2.12). Whether due to a Viking raid, a later battle between the earl of Orkney and the mormaers or some local religious reform,[39] the monastic context must be deemed to have been lost when the monuments were broken up and incorporated into the foundations of the new east–west church (Church 2).

Picking up the sequence inside the church (Figure 2.6), the post-monastic cemetery, with about 99 burials, is likely to date from the 11th century until the Reformation of c 1560. However, memorials of this period seem to be very rare. It may be that they were not employed inside the church (where the excavations have taken place), or that grave-diggers have not collected their fragments as assiduously as those from the Pictish period (since they were not as strikingly ornamented). At present it appears that between the 11th and 16th centuries most people were buried without grave-markers. But there were some. From the 14th century we have a recumbent cross-slab with an incised image of a sword and the letters initials AMRM. From the 15th century, there is, still buried outside the east wall of the chancel, a recumbent slab bearing a floriate cross.

The 16th-century Reformation began a period of major investment in personalised memorials, with a new repertoire of iconography and inscriptions (Figure 2.13). The church itself was comprehensively refurbished. A stone floor was laid in the nave and the injunction that no more burial should take place there seems to have

FIGURE 2.13 (a) Cartouche commemorating James Cuthbert, Provost of Inverness, who died 1623, set into the west wall of the north aisle; (b) memorial to the Revd William Forbes, Minister of Tarbat who died in 1838. (© M Carver and University of York)

been followed. However, this injunction did not apply to the privileged space of the new north aisle, where the grave of the minister William Mackenzie (died 1642) was marked with an elaborate headstone let into the west wall of the aisle. A small vault was also provided in the north aisle and the eastern crypt was refashioned with a vault, also for burial. Until the 18th century, the memorials we have refer to the aristocracy and ministers (in so far as these were different). The heads of the Mackenzie family, who acquired much of Tarbat in 1623, and who were styled Lords Tarbat by 1626 and Earls of Cromartie in 1703,[40] were the patrons of the church and the occupants of the laird's loft in the first storey of the north aisle. After 1750, memorials greatly multiply, and become varied and idiosyncratic, increasingly reaching into the less wealthy echelons of society who accessed the benefits of empire to invest in their immortality. This corpus of carved stone represents, as has often been noted, a priceless social document.[41]

The long period that elapsed between the founding of the early medieval monastery in the 6th century and the creation of the Tarbat Discovery Centre in 1999, is not marked as far as we know, by any enormous variation in population, either in numbers or distribution. However, the variation of investment in memorials is very great, both in numbers and in the social groups concerned. We can identify five periods of memorial use (Figure 2.14) which do not (however) coincide with the phases of churches (Figure 2.6). In the earliest Period (1) from around AD 650, the graves of monks are marked by simple stone crosses. Around 800 the sculptural effort is focused on single individuals who merit a large, erect cross-slab. For the next 500

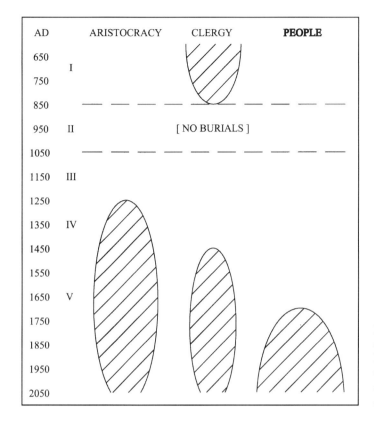

FIGURE 2.14 Stone memorials at Portmahomack: the rhythm of investment from around 650 to 1999. (© M Carver and University of York)

years (850–1350; Period II) there is apparently very little investment in memorials, although for the last 300 years at least (Period III) there are many graves. It must be assumed that during this period investment is targeted more on the church and on prayers than on monuments to the individual. From 1350 to 1560 (Period IV), members of the aristocracy (and perhaps priests), are remembered, rarely, with relatively plain incised carving on recumbent slabs. With the Reformation and particularly from the 17th century, interest in personal monumentality returns for the aristocracy and the clergy (Period IV). Some of the more prominent of such monuments are displayed on the walls of the nave and the north aisle. After 1750, the practice of erecting stone memorials spreads ever more broadly, and exhibits great variety. On analysis this period will undoubtedly break down further into many sub-periods reflecting the rise and fall of different parts of society.

We can use this sequence (only very briefly evoked here) to reflect on the early monastic site. First, the investments of the 8th century were never surpassed, either in size or in the use of both the faces and the edges of the stone, or in the ornamental and iconographic detail that was lavished on them. The Tarbat peninsula in *c* 800 represents a cultural peak that has never been attained since, and achieved a special conjuncture between intellectual and political leaders. The later memorials used a vocabulary that might provide an analogy with, if not precisely explain, the earlier

monuments. Named individuals and their spouses are routinely commemorated, both in words and in the form of heraldic achievements. Many of the same families are involved, so that at least two words are necessary to identify a person. Some Celtic motifs are revived from time to time, but less often and with less emphasis than on the west coast. The Pictish symbols never reappear. In the non-literate carving on memorials, sword and cross are the new icons, replaced at the Reformation by a new kind of symbolic vocabulary, which is down-to-earth and ironic. This, while not antipathetical to Christianity, does not directly refer to its liturgy. For example, the skull and cross-bones, the spade and coffin of the grave-digger, and the worms, all signify death without a necessarily homiletic intent. There is a language of the grave which is less grave than words: more universal and perhaps deeper than that of eschatological morality.

ENVOI

The corpus of memorials at Portmahomack, now recorded, is still being studied. Collectively, they tell us of 1500 years of monumental stone carving, varying in its skill, emphasis, purpose and intensity, and above all in its context. If the overall rationale is 'Christianity', the archaeological evidence shows that this is a crude and inadequate rubric: the carved stones lead us into a world of varied thought, political aspiration and social structure, much of it quite unsuspected. In its next phase of research, the Tarbat Discovery Programme hopes to complete the excavations at Portmahomack and to further the exploration of the sites at Nigg, Shandwick and Hilton. To some extent these latter sites now hold the key to the context in which the remarkable stone carvings on the Tarbat peninsula were produced.

ACKNOWLEDGEMENTS

The Tarbat Discovery Programme was initiated at the invitation of Tarbat Historic Trust, and has been carried out as a partnership between Tarbat Historic Trust, Highland Council and the University of York (Department of Archaeology). The evaluation was funded by Highland Council, and funding of the integrated projects (archaeology, restoration and display) is owed to Highland Council, Ross and Cromarty Enterprise, Tarbat Historic Trust, the University of York, the European Regional Development Fund, the National Museums of Scotland, Historic Scotland, and the Heritage Lottery Fund. Research by the University of York has been supported by the National Museums of Scotland, Historic Scotland, the Hunter Trust, and the Russell Trust. The evaluation at Hilton of Cadboll was commissioned from the University of York by Jane Durham through Tain and Easter Ross Civic Trust and Highland Council. Permission to excavate at Portmahomack is owed to Tarbat Historic Trust, the Church of Scotland and James and Douglas Gordon. The Tarbat Discovery Centre was designed by Higgins Gardner, opened by Prince Charles in 1999 and is managed by Tarbat Historic Trust.

The excavations at Portmahomack are managed by Field Archaeology Specialists Ltd of York and co-directed by Justin Garner-Lahire and Cecily Spall.

The author is grateful to his co-directors, to Kellie Meyer for her penetrating research on the iconography of the Tarbat sculpture, and to Annette Roe, David Clarke, Andy Heald, Jane Hawkes, Tom Clancy, Alex Woolf, Nigel Ruckley, Suzanne Miller, Derek Hall, Sarah King,

Madeleine Hummler, Anna Ritchie, Isabel Henderson, Sally Foster, Finlay Munro, Monica Clough, Sabina Strachan, Graham Watson, Roy and Faith Jerromes and to many volunteers and students for their valued contributions to the research programme, and to Caroline Shepherd-Barron, Anthony Watson, James and Douglas Gordon, Jim Paterson, Jane Durham, Richard Durham, Kate Collard, Douglas Scott, Dave and Jill Scott, Donald and Cath Urquhart and the people of Portmahomack for their unstinting encouragement, hospitality and support.

NOTES

[1] Hawkes 1999; Carver 2000; 2001; see now Henderson and Henderson 2004.
[2] Bradley 1993.
[3] *Tarbat Discovery Progr Bull* 1–7 (1995–2002); studies by Cecily Spall and Kellie Meyer in Carver forthcoming.
[4] Higgitt 1982.
[5] Harden 1995a; 1995b.
[6] *Tarbat Discovery Progr Bull* 1–7 (1995–2002). The large surface area of the excavation is aimed at revealing the internal geography and multiple functions of a type of site notoriously difficult to understand in a trench. Cf O'Sullivan 1999, 235.
[7] *Tarbat Discovery Progr Bull* 1 (1995–2002); and see Carver 2004, for what follows.
[8] Carver and Spall forthcoming.
[9] Ten fragments of early carved stone were recorded before 1903 as having been found in Tarbat churchyard, cited here at Portmahomack 1–10 (cited in archaeological reports as TR 1–10). Some were believed to have formed part of a 'Danish Cross' which stood to the east of the church (OS 1907; NMRS NH98 SW14). Fragments have probably survived as the panel Portmahomack 2 and the bosses Portmahomack 5 and 6. In addition, a 'Class II cross-slab' is marked east of the 'Danish Cross' by the Ordnance Survey (1907) at NH 9151 8402. This is likely to refer to Portmahomack 1, the only carved stone so far known from Portmahomack to carry Pictish symbols. In their survey (published 1903), Allen and Anderson list two fragments in the NMAS [NMS] (Portmahomack 6 and 7; IB130, 131, Fig 5.5), seven in Invergordon Castle (Portmahomack 1, 2, 4, 5, 8, 9 and 10), and one in Tarbat Church (Portmahomack 3). Portmahomack 1 (IB190) was subsequently presented to the NMAS by Captain R W Macleod in 1922 (*Proc Soc Antiq Scot* 1922, 63), and in 1956 the remaining fragments comprising Portmahomack 2, 4, 5, 8, 9 and 10 were presented to the NMAS by Lt Col R B Macleod of Cadboll (*Proc Soc Antiq Scot* 1956, 239), where they became IB280–86. Few carved stone fragments came to light in the following 90 years: Portmahomack 12 (IB209) was found and given to the NMAS in 1927 and Portmahomack 13 (IB250) was unearthed during grave-digging and given to the NMAS in 1939. Portmahomack 15 was a cross-slab seen in the churchyard briefly by James Ritchie in 1914 before it was destroyed. Portmahomack 14 was seen during an inspection of the church by Geoffrey Stell (RCAHMS) in 1956, incorporated into the relieving arch of the west tower where it remains. Four fragments of carved stone were found by Jill Harden in the crypt when it was cleared out for Tarbat Historic Trust (Portmahomack 17–18). Portmahomack 19 and Portmahomack 27 were seen in the churchyard and extracted between 1991 and 1994. Two further pieces (Portmahomack 39, 40) were noticed in 1999 in a pile of building stone originating from the Manse steading. The University of York's excavations have located 13 fragments of monuments in or near the church (Portmahomack 20–22, 24–27, 29–34) and more than 100 in the Glebe Field where they had been broken up and dumped in antiquity (*Tarbat Discovery Progr Bull* 4; a full catalogue, with rationalised numbering, appears in Carver forthcoming).
[10] Cf Henderson 1987b; Fisher 2001; *Tarbat Discovery Progr Bull* 3, Fig 9.
[11] E W B Nicholson suggested REOTETII as the probable reading of the person commemorated on Portmahomack 10, and identifies him with *Reothaide* or *Reodaide* whose death is recorded under the year 762 in the *Annals of Ulster* and 763 in the *Annals of Tigernach*. In both he is called '*Ab. Ferna*'. Fearn is the name of the monastery known to have been in existence in the neighbourhood (probably at Mid-Fearn near Edderton) before 1227 when it was refounded as New Fearn a few kilometres south of Portmahomack. The *Reodaide* reference may however be to Ferns in Ireland (*ECMS* III, 95).
[12] See Carver forthcoming.
[13] Kellie Meyer pers comm.
[14] *ECMS* III, 75–83.
[15] *ECMS* III, 68–73.
[16] Ralston 1997.
[17] *ECMS* III, 68.
[18] Alcock 1993.
[19] *ECMS* I, xlvii.
[20] Cordiner 1780, 65; Stuart 1856, 10; *ECMS* III, 61; Macdonald and Gordon nd, 15.
[21] *ECMS* III, 62n.
[22] Graham Robins in Carver 1998b.

[23] Macdonald and Gordon nd, 18.
[24] Ó Carragáin 2003.
[25] Fraser and Munro 1988, 35.
[26] Information from Barry Grove, sculptor, who has in recent years sought and used matches from local stone for making replicas. The *Old Statistical Account* (Balfour 1793, 435) is probably not far off the mark: 'At Tarbat-Ness and around it, and in almost every corner of the parish, there is an inexhaustible fund of freestone, easily wrought, durable and of a beautiful colour'.
[27] The portage route is currently being traced by fieldwork.
[28] Carver 2001; 2003.
[29] Clancy and Márkus 1995.
[30] *ECMS* I, liv.
[31] Frend 1965, 202.
[32] *ECMS* III, 268, 445.
[33] Dalrymple 1997, 421.
[34] Samson 1992; Forsyth 1995a.
[35] Carver and Roe 1997; Fraser and Munro 1988.
[36] Brown 1997, Ch 13.
[37] Fisher 2001.
[38] Graham-Campbell and Batey 1998, 70.
[39] See Carver forthcoming.
[40] Clough 1990.
[41] For example, Willsher 1985a; 1985b.

CHAPTER 3

'THAT STONE WAS BORN HERE AND THAT'S WHERE IT BELONGS': HILTON OF CADBOLL AND THE NEGOTIATION OF IDENTITY, OWNERSHIP AND BELONGING

By SIÂN JONES

EARLY MEDIEVAL SCULPTURE: CONTROVERSY AND CONFLICT

> The experience of [. . .] alienation from part of our patrimony [. . .] stands at the core of our dilemmas over group identity and cultural property. However, paradoxically, it is always the case that being alienated from the identity or cultural property of one's group helps precipitate our sense of belonging or ownership. These observations, admittedly provisional, may suggest why claims on cultural property are only made in hindsight, after loss [or in the face of perceived threat of loss]. This phenomenon is not, as sceptics sometimes insinuate, simply proof of the fraudulence of such claims. Only after being appropriated by outsiders or by establishment (or even dissenting) insiders does cultural property disclose its field of force. Its positive existence has a dialectical relation to deprivation, and its significance cannot be clear except in the experience of alienation.[1]

In their introduction to *Claiming the Stones, Naming the Bones*, Barkan and Bush highlight the role of heritage, conceived as cultural property, in the production of group identity. Claims on cultural property are, they argue, a fundamental aspect of identity construction in the modern world, but paradoxically some form of alienation, or threatened alienation, seems to be a key component in this relationship. This paper will explore some of these issues in relation to early medieval sculpture. Scotland possesses a rich body of such sculpture, which has become a highly valued part of its archaeological heritage. Many such monuments have been attributed national and international significance by museums and heritage bodies. However, attempts to conserve, manage and present this body of sculpture, which is particularly vulnerable to weathering, storm damage and human action,[2] have been characterised by controversy and conflict.

In her history of the conservation of early medieval sculpture, Foster shows that the question of whether sculpture should be classed as artefact or monument, has influenced whether the context for conservation and presentation was museum or

landscape-based (Chapter 1).[3] Here, there are tensions between national and local values, interests, and identities. On the one hand, removal to museums is often criticised for depriving landscapes of their specific archaeological heritage and ignoring local interests and attachments.[4] On the other, a 'monument approach', preserving *in situ* in the landscape, may be deemed to privilege local attachments over conservation demands and the national 'public good'.[5]

The history of particular monuments reveals a complex picture with regard to the conservation and presentation of early medieval sculpture, depending on the physical condition and location of specific monuments, the individuals and organisations involved, the speed at which scheduling was carried out, and so forth.[6] Broadly speaking, however, it was common practice until relatively recently to incorporate sculpture into museum collections where it was often much sought after by curators. During the late 19th and early 20th centuries, prior to the establishment of a strong local museum network, the National Museum of Antiquities in Edinburgh was often regarded as the appropriate repository for such sculptures by the landowners, antiquarians and officials involved. Lately though, this trend has declined, and early medieval sculpture has increasingly been incorporated into local museum collections, moved to nearby historic buildings, or actively conserved within the landscape (e.g. through the use of glass shelters). Nevertheless controversy still reigns, even in the context of local solutions to conservation needs. The broader public, particularly local communities, often voice concern and dissent in response to a range of conservation strategies, suggesting that they impinge upon, or conflict with, the current cultural meanings and social values surrounding such sculpture.

The specific issues raised by early medieval sculpture in Scotland are echoed worldwide, in debates surrounding the management of carved stone and parietal rock art. Preservation of cultural heritage has been encoded in international legislation which presents such protection as a moral obligation held by the present 'guardians' in respect to unspecified future generations.[7] With sculptured stone and parietal rock art, conservation measures have often involved artificial shelters, on-site heritage centres, or removal of the material to museums or other buildings. However, attitudes to permanency, ageing, decay, restoration and modification, are culturally defined and vary according to the materials concerned, as well as the social and historical context.[8] Furthermore, there is debate about whether the meaning, value and authenticity of sculptured stone, rock art, or cultural heritage generally, is inherent in the monument itself or whether it lies in its relationship with broader landscapes and indeed living cultural traditions.[9]

Thus, the conservation of cultural heritage is by no means restricted to practical and technical considerations, but also involves complex questions of authority, ownership, and cultural identity in the present. Such observations are commonplace in a wide range of literature dealing with cultural heritage,[10] but have had less impact upon heritage management practice, particularly in Europe. Here the traditional concern with historic, aesthetic and scientific values prevails, partly because methodologies for assessing contemporary cultural meanings and social values have not been developed and incorporated into routine heritage management.[11] Heritage management's continuing emphasis on professional authority thus means that the

diverse meanings and values that contemporary populations attach to cultural heritage still have little impact on specific conservation and presentation strategies. Furthermore, as Walderhaug Saetersdal points out: 'Though the rhetoric of heritage management in general is suffused with statements concerning responsibilities towards an abstracted, faceless 'public', there is less clearly stated resolve towards the face-to-face claims of individuals challenging our authority'.[12]

This paper explores the contemporary cultural meanings and social values attached to the Hilton of Cadboll cross-slab in some depth, to gain insight into the controversy and competing claims surrounding early medieval sculpture in Scotland. The Hilton of Cadboll cross-slab is especially controversial, being considered one of the finest pieces of 'Pictish' sculpture. Recently, the ownership and presentation of the monument has been the focus of dispute between residents of the seaboard villages of Easter Ross where the monument derives from, and two national heritage organisations, the National Museums of Scotland and Historic Scotland. Based on ethnographic research involving in-depth, qualitative interviewing and participant observation,[13] it will be argued that this conflict is founded on the divergent, sometimes incommensurable, meanings and values attached to the monument by these different interest groups. In turn, I will suggest that these divergent meanings and values are embedded in the expression of different kinds of identity and relationships to place. As argued by Barkan and Bush in relation to portable artefacts and human remains, it will be shown that alienation is a crucial aspect of these *active* processes of producing meaning, identity and place.[14] Where extracts from field notes or interviews are used to illustrate these arguments, pseudonyms are used to protect the identity of the individuals concerned.

HILTON OF CADBOLL: BIOGRAPHICAL FRAGMENTS

The Hilton of Cadboll sculpture is a Pictish symbol-bearing cross-slab dating to around AD 800 (Figure 3.1). The cross-slab has a complex and fragmented biography, having been subject to considerable damage during its life. It was broken into three sections, an upper portion containing approximately three-quarters of the carving, a lower carved portion, missing until 2001, and an uncarved tenon, most of which is still missing. In addition, the cross-face of the upper portion was completely defaced when the stone was inscribed with a burial memorial in 1676, resulting in thousands of carved fragments. Its original location is debatable, although there is now increasing evidence that the cross-slab was located in the vicinity of St Mary's Chapel in Hilton of Cadboll, Easter Ross, at an early date, quite possibly when it was first erected (Figure 2.2) (Chapter 7). The upper part of the cross-slab was taken to Invergordon Castle in the mid-19th century by the landowner, Robert Bruce Aeneas Macleod (Figure 3.2).[15] From here his son, Captain Roderick Willoughby Macleod, offered it to the British Museum in 1921. The removal of the upper portion to London resulted in widespread protest from Scottish antiquaries and politicians and in response Macleod withdrew his offer, donating it instead to the National Museum of Antiquities in Edinburgh within the same year.[16] It now features prominently in the

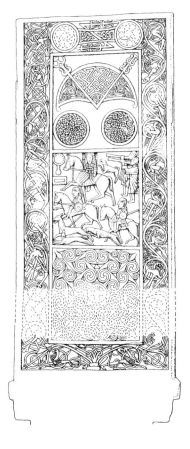

FIGURE 3.1
Reconstruction of the Hilton of Cadboll cross-slab. (Drawing by Ian G Scott. Crown copyright: Historic Scotland)

Early People exhibition in the new Museum of Scotland (Figure 3.3), where it plays an iconic role in the production of a national story.[17]

Meanwhile, the missing lower portion containing elaborate carving, and thousands of the fragments making up the cross-face prior to its removal in 1676, has been discovered during excavations at St Mary's Chapel during 1998 and 2001.[18] The excavations were stimulated in part by an intensification of local interest in the cross-slab during the 1990s, and grievance about the sculpture's removal. During the mid-1990s, a full-scale reconstruction had been commissioned from sculptor Barry Grove, and erected next to St Mary's Chapel in 2000 (Figure 3.4). The reconstruction provides a means to 'presence' the monument in the absence of the original, which is strongly felt in the local area. Nevertheless, despite the value placed on the reconstruction locally, the subsequent excavation of the missing fragments provided the locus for conflict between heritage organisations and local inhabitants.[19] This conflict concerned the ownership of the new remains, essentially whether they should be placed in the Museum of Scotland with the rest of the monument, or whether they should remain locally within the village of Hilton of Cadboll. St Mary's Chapel is a scheduled ancient monument and a guardianship monument cared for by Historic Scotland on

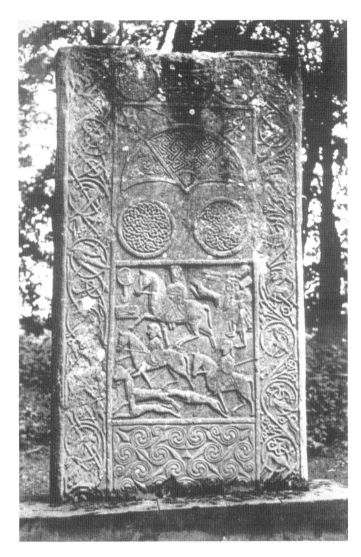

FIGURE 3.2 The Hilton of Cadboll cross-slab in the American Gardens at Invergordon Castle. (Photographer unknown. Courtesy of Richard Easson)

behalf of Scottish Ministers. The organisation's normal policy regarding early medieval sculpture under its jurisdiction is to maintain it *in situ* within the landscape or in the immediate vicinity. However, where a museum has already acquired part of an object, as in this case, the integrity of the object is prioritised and new discoveries are usually allocated to the same museum.[20] Thus, it had been anticipated that the fragments and lower portion would be allocated to the National Museums of Scotland, as suggested in the public information leaflet produced by the funding bodies prior to the excavation in 2001. However, local residents contested this position, claiming that ownership of the newly excavated material rightfully belongs to the village.

FIGURE 3.3 The upper portion of the Hilton of Cadboll cross-slab in the Museum of Scotland.
(Siân Jones, © Trustees of the National Museums of Scotland)

FIGURE 3.4 Hilton of Cadboll cross-slab reconstruction standing to the west of the chapel site,
with the 2001 excavations to the rear. (© Siân Jones)

A public meeting provisionally resolved the stand-off when Historic Scotland's Chief Inspector of Ancient Monuments agreed that, once lifted, the large decorated lower portion of the cross-slab would not be removed from the village until ownership had been legally established. To date (October 2003), the lower portion remains in Hilton of Cadboll in a secure location where it is the focus of a small exhibition open to the public at set times. Ownership and (re)presentation are still subject to negotiation and debate between the National Museums of Scotland and the Historic Hilton Trust (formed in December 2001), who have subsequently acquired ownership of the chapel site (in March 2002).[21] However, I wish to move beyond the specific legal and procedural issues surrounding ownership of the cross-slab, to examine the reasons underlying competing claims of ownership and 'belonging'. Analysis of the meanings and interests embedded in, and negotiated through, the cross-slab reveals that, at heart, the conflict is about tensions between national and local narratives of identity and place.

DISSONANT MEANINGS: THE PRODUCTION OF COMMUNITY AND PLACE

The meanings attached to the Hilton of Cadboll cross-slab range from the academic to the popular. Historical, scientific and aesthetic perspectives on its meaning and value stress that it is a major 'document' in the history of Early Christian and Pictish art, a 'masterpiece' even.[22] Popular accounts fuel familiar images of the heroic Picts who successfully resisted the Romans, whereas in Easter Ross folklore it is interpreted as a memorial to one of three drowned Danish princes.[23] However, the cross-slab is also associated with metaphorical and symbolic meanings that are not immediately evident from these perspectives, but are nonetheless crucial to understanding the recent controversy surrounding the monument.[24]

As already intimated, the Hilton of Cadboll cross-slab has considerable symbolic capital in representing national heritage. Along with other examples of early medieval sculpture (e.g. the Dupplin Cross, Figure 14.3, and the St Andrews Sarcophagus) it is regarded as the high art associated with what many argue was a formative period in the history of the Scottish nation; a period when the Gaels (*Scoti*) and the Picts formed an increasingly close alliance between the mid-8th to early 10th centuries.[25] Newspaper articles concerning the upper portion's donation to the British Museum in 1921, repeatedly stressed the importance of the cross-slab as national patrimony, and its temporary removal from Scotland was greeted with widespread protest.[26] Furthermore, interviews with heritage professionals during 2001 underlined its continuing significance, as an iconic object that can 'stand for a great section of Scotland's artistic heritage'. Indeed, to reinforce Barkan and Bush's argument regarding alienation,[27] it is clear that its removal to London and rapid repatriation added to the cross-slab's symbolic capital in respect to Scottish national identity. As one museum professional put it during an interview for this research: '. . . It's a very important stone, and not just important in the sense of being iconic, it's very important because it's also one of the symbols of the nation's rights to its own treasures, . . . taking it to London and bringing it back . . . reflected a feeling which we still have very strongly you know that the British Museum should not be collecting

our stuff without our agreement'. In the new Museum of Scotland the upper portion helps create a unified national story which both educates Scots about their heritage, and also, importantly, projects an image of Scotland to visitors from other parts of the UK and abroad.[28]

The significance of the Hilton of Cadboll cross-slab in the representation of Scottish national heritage is thus unquestionable, but why then is its display in Edinburgh a cause of such grievance in Easter Ross? And why is there such conflict over the ownership of the recently discovered lower portion? After all, if the nation is a homogeneous site for the production of an imagined cultural identity, then the authority of national heritage organisations over the management of such monuments would be accepted, and the Museum of Scotland would be seen as the appropriate context for their display. To understand the conflict surrounding the 2001 excavations we must therefore examine the symbolic and metaphorical meanings surrounding the monument in local contexts.

Notably, in local discourses, the cross-slab and reconstruction are conceived of as 'living things'. Sometimes such meaning is produced through the use of metaphors. For instance, the cross-slab and the reconstruction are both referred to as having been 'born', 'growing', 'breathing', having a 'soul', 'living' and 'dying', having 'charisma' and 'feelings'. A few informants were more explicit about this symbolic dimension drawing direct similes rather than relying on metaphor. For instance, one local resident, Christine, noted that the cross-slab: 'was like something that was born there and it should go back [. . .]. It's, it's like people who emigrate or go away, they should always come back where they were born and I feel that that stone should go back'.

Another, Duncan, remarked that if the main part of the cross-slab returned from Edinburgh:

> There'll be a party maybe and there'll be things going on here that'll be absolutely unbelievable like a, how would I put it now, an ancient member of the village coming back, if that came through here on a trailer and everybody would be here. . . . Coming home where it's always been. . . . If the stone had a soul it would be saying oh there's the Port Culac you know, there's so and so's house you know. I'm going over to the park and there's, there's the other bit of the stone and it broke off a hundred and fifty years ago or whatever.

Furthermore, as the last quote highlights, the monument is conceived of as *a living member of the community*. Not only is a direct analogy drawn between the cross-slab and an 'ancient member of the village', but it is also attributed the kind of social knowledge which is essential to establishing a person's membership within the community.

The application of discourses of kinship and 'belonging' also reinforces the cross-slab's place as a living member of the community. 'Belonging' is a key concept in the identification of kinship relationships, particularly amongst people who were born and brought up in Hilton.[29] Thus the term regularly crops up in conversation, for instance, in an interview with Maggie: 'she *belongs*, they're both Sutherland in their name', or 'it was the first of the Sutherlands that *belong* to my granny' (my emphasis). Such statements do not simply relate to actual kin, but are also extended

to others who are considered part of the community. Indeed rather than a reflection of static relationships they provide a means of articulating and negotiating 'who is and who is not "part of the place", and who is and is not authentically "local"'.[30] Given such usage, the extension of the concept of belonging to the cross-slab carries a connotation of kinship. For instance, one woman noted in an interview, 'I still think that the stone *belongs* to the people here' (Mary, my emphasis), and another, '. . . it's still not where it should be, it should be back up home where it *belongs*' (Janet, my emphasis). Birthplace is also important in 'placing' people and negotiating degrees of 'belonging'. Being born in Hilton, or related to someone who was born there, is central to being accepted as an insider or a 'local'. Again, like people, the cross-slab 'belongs' in Hilton because, as Christine puts it, it is 'like something that was born there', and 'that's where it was created'. The close association between the monument and the soil revealed by the recent excavations was also important in terms of the life-force metaphorically attributed to the cross-slab, by references to it being able to 'breathe' and 'grow'.

The body of metaphorical and symbolic meaning surrounding the monument in local discourse, concerns its place within the community. In this way the monument facilitates the negotiation of identities and the expression of boundaries. However, it should not be assumed that categories of identity are simply reproduced through peoples' engagement with the monument. On the contrary, the categories of 'local' and 'incomer', and through them the boundaries of community as a whole, are fluid and continuously subject to negotiation.[31] As well as being conceived as a living member of the community, and therefore acting as a mechanism for the negotiation of personal identities and relationships, the monument is also an icon for the village as a whole. This iconicity was expressed metaphorically by one local activist in the statement: 'that stone is the heart of Hilton'. Here, rather than the 'living' monument being attributed organs, it is itself portrayed as one of the bodily organs of the larger community, the heart. Thus, the cross-slab is both a member of the village community and an icon of it as a 'whole'; symbolism which is central to its role in producing a sense of place.

Given the way it provides a mechanism for the symbolic construction of community, it is perhaps not surprising that the Hilton of Cadboll cross-slab also plays an integral role in the production of a sense of place on the seaboard of Easter Ross. Conceived of as a living member of the community, the monument provides a medium for expressing the relationship between people and place. Place is very important to the seaboard villages, and people are said to 'belong' to places as well as to each other. For instance, someone might comment, 'she belonged over to the Nigg area', or ask 'did he belong to here, or did he belong to Portmahomack' (a village about 8km from Hilton; see Figure 2.2 for locations). Thus statements of belonging frequently incorporate a spatial dimension, and in relation to the cross-slab, serve to conflate community and place. This conflation is captured, for instance, in the statement: 'it belongs to the village, it is Hilton'.

The monument not only 'belongs' to the place, it is simultaneously constitutive of place and therefore part of the fabric of people's existence. Associations between the monument and features such as rocks and sea, serve to place it as an integral

component of the landscape. For instance, one interviewee, Màiri, commented 'The Hilton stone, you almost feel attached to it, it's almost like being attached to rocks or the sea or it's always been here, it's part of the place and for generations, I don't know, it was a close community you know'. Here she captures the strength of connection between people, monument and landscape, as well as the closeness of the community as a whole.

However, there is a tension underlying the process of place-making in Hilton and the other seaboard villages; they are not the locales of timeless, stable relationships to place often implied by stereotypes of rural communities. Although there was prehistoric, early medieval and medieval habitation along the seaboard, the contemporary villages are largely the product of population movements during the late 18th and early 19th centuries. Between 1750 and 1850 the Highlands underwent fundamental change in the name of agricultural 'improvement'. One of the most overriding transformations was the massive depopulation of the region to make way for sheep farming, a process referred to as the Clearances. As Richards points out, the phrase 'Highland Clearances' has come to act as an umbrella for any kind of displacement of occupants by Highland landlords: 'small and large evictions, voluntary and forced removals, ... outright expulsion of tenants and resettlement plans'.[32] Nevertheless, acts of clearance were often brutal and resulted in a widespread sense of dislocation and loss that is still a prominent aspect of oral history and social memory today, both within Scotland and amongst Scottish diaspora communities.[33]

The Clearances resulted in mass migration to urban industrial centres and the New World. One further aspect, however, was the resettlement of the remnants of Highland communities on the most marginal land, often coastal fringes where it was assumed they would take up fishing or kelp working. The seaboard villages of Hilton of Cadboll, Balintore and Shandwick provided a refuge for displaced people, and grew rapidly as a result.[34] The economies of these villages were tied to the fishing industry, and, following its decline, the North Sea oil industry.[35] However, since the recession of the 1980s, employment opportunities have significantly declined, as has the socio-economic infrastructure of the villages.[36]

These particular social and historical contexts make processes of 'place-making' in Hilton, and the seaboard generally, distinctly fraught and problematic. There is an ambivalence associated with local residents' consciousness of place, for Hilton is both a significant and cherished place and a marginal one associated with deprivation. Furthermore, current concerns about decline, marginality, and the need to combat them, are framed by past events and injustices, such as the Clearances.[37] The cross-slab's history means that it is eminently suited to the task of metaphorically dealing with dislocation between people and place, fragmentation of communities, and the pervasive sense of loss thus generated. Many of the inhabitants perceive the forcible alienation of the upper portion in the mid-19th century, and the possible further alienation of the newly excavated fragments, as representing the power of certain individuals and organisations, notably landowners and national institutions, to move things/people around against their will. Furthermore, the fragmented and displaced nature of the monument can provide a metaphor for the fragmentation of communities wrought by processes of alienation from land. The Highland Clearances provide the

main historical reference point for these processes of displacement and fragmentation in terms of people's social memory and the frequent unprovoked references to them in conversations about the Hilton of Cadboll monument highlight its symbolic role in this respect. Such references take the form of a slippage between those with power and authority today and their perceived counterparts in the past, namely landlords and ministers. Or sometimes they even seem to involve a direct relationship between people's longing to reconstitute or reconstruct the Hilton of Cadboll cross-slab, and their desire to destroy other monuments associated with Clearance landlords.

It can therefore be argued that opposition to the excavation of the lower portion of the cross-slab, and subsequently to its removal to Edinburgh, provides a means for people to symbolically resist the historic processes of displacement encompassed by the Clearances; displacement which ironically contributed to the modern development of the villages. However there is also a redemptive or restorative dimension to the role of the monument in place-making. The historical association of the monument with a wealthy Pictish aristocracy in archaeological and art-historical accounts, as well as the sculpture's national significance in heritage discourses, are actively appropriated in making Hilton a 'place of significance', worthy of such a 'fine stone'. Equally important is the way in which, when conceived as a living member of the community, it metaphorically makes the community 'whole' once again. For instance, reflecting on the carved reconstruction erected next to St Mary's Chapel in 2000, one woman (Christine) suggested that 'I think people in Hilton were proud although they hadn't got the original stone, they had something at last that they could associate with the Hilton stone. Because they had nothing and all they could say was oh, it's in Edinburgh. But now they've got something, they can go and look at it and it is part of them. [. . .] I think Hilton became whole. Something was missing'.

CONTESTED TERRAIN: LOCATION, OWNERSHIP AND 'BELONGING'

The recent controversy surrounding the location and ownership of the lower portion of the Hilton of Cadboll cross-slab is partly determined by the complex biography of the monument. The removal of the upper portion to Invergordon Castle in the mid-19th century had produced a palpable sense of loss and anger perpetuated through oral historical narratives. It also prefigured the eventual incorporation of the upper portion within the collection of the National Museum of Antiquities in 1921. Following the discovery of the missing lower portion, archaeologists and curators have largely been guided by the principle that the integrity of an object or assemblage should be maintained as recommended by the policies of the Crown and Historic Scotland regarding allocation of finds.[38] On this basis, Historic Scotland anticipated that normal allocation procedures (where collections or objects from one site already exist in a museum) would result in the newly discovered fragments being allocated to the National Museums of Scotland.[39] As discussed above, this brought heritage managers into conflict with local residents; had the upper portion not already existed then local and national museums could have openly bid for it to be allocated to them, in line with allocation policies.[40]

On the surface, local opposition to the decisions and arguments of heritage managers seemed to revolve around these historical and legal contexts, focusing on issues such as Treasure Trove legislation and conservation policy.[41] The importance placed on local ownership, in addition to presentation, is also informed by a widespread mistrust of centralised government in rural areas, and a polarisation between centre and periphery.[42] However, it is its role in the production of community and place in local contexts which is key to understanding conflicts. As an icon of place it clearly informs local resistance to the lower portion's removal to Edinburgh, or for that matter its relocation anywhere outwith with the village. As one local resident commented, 'It's part of the village, really, and let's look at it this way, if you take the stone away from the village, the village is no different from any other village in the country, but that's why if you put the stone there then that's Hilton stone and Hilton village'. Furthermore, the power of the lower portion, effectively a fragment of the cross-slab, to act as an icon of place is reinforced by the removal of the upper portion to Invergordon Castle in the mid-19th century. This aspect of the biography of the cross-slab discloses, and indeed produces, its 'field of force', allowing it to act as a metaphor for the population displacement which remains such a prominent aspect of people's social memory in the Scottish Highlands. In this respect, as argued by Barkan and Bush in the opening quote, the positive existence of the monument as cultural heritage, and its role in the production of community and place, exists in dialectical relation to deprivation and alienation both literally and metaphorically.

The cross-slab's role in the production of community and place, and also in resisting historical processes of displacement, explains why it is important to many local residents that the lower portion is displayed within the socially accepted boundaries of the village of Hilton. However, it is not merely the physical removal of the lower portion which threatens its role in embodying the relationship between community and place, but also the fraught question of ownership. The crux of the conflict over ownership lies in the distinct meanings and values attached to the monument in local contexts, in contrast to the spheres of heritage management and national patrimony. Strong resistance to allocation of the lower portion to the National Museums of Scotland, and claims such as 'it is our stone' and 'it belongs to the village', must be understood in terms of the discourses of 'belonging' in which the monument is embedded in local contexts. In light of its symbolic status as a living member of the community, it becomes clear that claims such as 'the Stone belongs to us' are primarily an expression of a social relationship, rather than a fixation with property, or a failure to grasp the implications of long-term care.[43] These local discourses of belonging create an inalienable relationship between the monument and the community for those involved; a relationship which is symbolically defined in terms of birth, soil and kinship. As a consequence, attempts by heritage managers to promote a distinction between ownership (often presented as 'stewardship') of the monument and the place where it will be displayed, have been less than successful. For there is an integral relationship between belonging to a community, and belonging to a place. People belong to a place *by virtue of* belonging to the community embodying that place. The idea that the monument can be owned by (i.e. belong to) a national organisation based in Edinburgh (i.e. a distant community), and still

maintain an authentic relationship with Hilton as a place is thus problematic, even if the lower portion were physically displayed in the village. In short, ownership outwith the village threatens the perceived inalienable relationship between the monument and Hilton as both a community and a place.

CONCLUSIONS

The excavation of the missing lower portion and thousands of carved fragments of this cross-slab during 2001 provided a locus for the expression and negotiation of diverse meanings, values and interests in relation to the monument. In local contexts, these meanings and values are intimately tied up in the production of a sense of community and place, against a historic background of displacement and marginality. The historical alienation of the upper portion of the cross-slab, and the further threat of the lower part's removal are key aspects of the *active* processes involved in the production of meaning, identity and place. Furthermore, a grasp of the monument's symbolic value and its role in the production of community and place are essential to understanding the concern over ownership and the very different meanings encompassed in the concept of 'belonging'. These processes surrounding the cross-slab are, in part, socially and historically specific. The monument also raises heritage management issues which are peculiar to its complex and fragmented biography.[44] Nevertheless, some of the insights derived from this research have a bearing on the wider conflict surrounding early medieval sculpture and its conservation.

In her article on the conservation of early medieval sculpture, Foster argues that ambiguity over whether sculpture be defined as monument or artefact is the most common cause of tension in disputes over the location of such material.[45] Clearly the categories of 'monument' and 'artefact' do not carry the same weight of significance, nor the associated technical and policy implications, for those outside the world of heritage management and archaeology as they do for those inculcated within it. Nevertheless, people seem to conceive of early medieval sculptures as objects designed to be erected in specific locations within the landscape, and intended to remain earthfast thereafter. This conception accords more closely, in professional terms, with the concept of monument rather than that of artefact. Even the lower portion of the Hilton of Cadboll cross-slab, whose whereabouts was unknown prior to excavation, is very much conceived as having an integral relationship with its setting. Wider discussion of the Shandwick and Nigg cross-slabs during fieldwork at Hilton of Cadboll, suggests that similar attitudes surround these monuments, and no doubt others further afield. One important corollary is that people's perception of the authenticity of such sculpture is bound up in its relationship to place, rather than confined to the object itself.[46]

Conceived as something created for, or 'born' in, a particular place it seems likely that, as with Hilton of Cadboll, such monuments elsewhere may have a complex, dynamic relationship with the production of community and place. Pitt Rivers hinted at this when he argued that removing such sculpture to museums deprives country places of their 'traditions and old associations'.[47] It is important to emphasise, however, that such associations are far from static. Indeed, for at least

some of their history, crosses and cross-slabs were probably a subliminal aspect of everyday life, subconsciously informing people's sense of identity and place. The more active and self-conscious engagement that is often provoked by attempts to preserve such monuments is in large part a product of the objectification and perceived alienation often produced by conservation strategies.[48] This objectification and alienation may be produced through the mere erection of signage, fencing, or a shelter surrounding the monument *in situ*, or most radically through the actual removal of the monument to another repository. As emphasised throughout this paper, the sudden emergence of an explicit concern with such monuments amongst local communities should not be taken as evidence that the ensuing claims of attachment and ownership are somehow fraudulent.[49] Rather we should recognise that active curation reveals, and reinforces, the symbolic power of these monuments. Furthermore, in a world where population displacement, decline of village institutions, and blurring of community boundaries are commonplace even in apparently stable rural settings, it is likely that this symbolic potential will become even more significant. As wider ethnographic research has shown, people respond to this flux by deliberately, and laboriously, attempting to construct a deep-rooted sense of place in particular locations.[50]

The case of Hilton of Cadboll reveals the immense social value derived from retaining items of early medieval sculpture *in situ*, or as close as possible to their historic locality, at least from the perspective of those who live with them.[51] It also shows that far from being a mere legal technicality that ensures expert stewardship by heritage organisations, ownership is also likely to be of immense symbolic importance. However, the arguments presented in this chapter are not intended to provide a unequivocal rationale for the maintenance of medieval sculpture within the landscape. Rather the insights gained from this study underline a pressing need for further research on the contemporary cultural meanings and social value of such sculpture, whether it be in the landscape, or contained within historic buildings and museums. Moreover, it is essential that more effective mechanisms for assessing social value are integrated into the practice of heritage management so that contemporary meanings can be taken into account in devising conservation strategies.[52] While heritage management policies and charters increasingly highlight social value, in practice 'high' art and historic value tend to eclipse other criteria, simply because the means of evaluating them are long-established, and subject to continuous academic assessment.[53] Indeed, at present social value is often unsatisfactorily defined in terms of an academic interpretation of cultural significance, rather than an understanding of 'the benefits which the population might be able to gain from the cultural heritage by and for themselves'.[54] This study highlights the need to redress this imbalance, not only to accommodate the significance of specific sites and monuments to present-day communities, but also as a crucial step in effectively negotiating conflict between local communities and heritage organisations.[55]

ACKNOWLEDGEMENTS

I am indebted to many people and organisations without which this paper would not have been possible. Thanks to Historic Scotland and the University of Manchester for funding

the fieldwork and to the AHRB who funded my research leave. I am particularly indebted to Dr Sally Foster for introducing me to the fascinating biography of the Hilton of Cadboll cross-slab and for her unflagging support. Thanks also to individuals in the following organisations for their important contributions: Groam House Museum, GUARD, The Highland Council, National Museums of Scotland, RACE, Seaboard 2000, Tain Museum, and Tarbat Discovery Centre. Finally, and most importantly, thanks to Dolly Macdonald, and the other residents of Hilton and the seaboard area of Easter Ross, for their insight, generosity, and thoughtful reflections. In writing this chapter, I have benefited greatly from discussion with Helen Rees Leahy, Colin Richards and Thomas Dowson at the University of Manchester. Any remaining shortcomings are of course entirely my own.

NOTES

[1] Barkan and Bush 2002, 15.
[2] Historic Scotland 2001; Muir 1998.
[3] Foster 2001, 3–14. It can also be argued that debates about the conservation of early medieval sculpture are underpinned by whether it is conceived of as an art object in its own right, or as an archaeological artefact whose meaning and value are inextricably linked to context. This distinction between art and archaeological artefact is discussed at length by Lyons (2002), regarding the ownership of a 3rd-century BC Sicilian gold *phiale*. These debates also intersect with long-standing issues in the theory and philosophy of conservation, e.g. the importance of *in situ* preservation, versus preservation of fabric. For further discussion see Stanley Price *et al* 1996; Riegl 1903.
[4] For instance, the first Inspector of Ancient Monuments, Augustus Henry L F Pitt Rivers offered such criticisms as early as 1889 in a letter arguing that: 'the concentration of antiquities [specifically sculpted stones] in one place is objectionable on many grounds; firstly, as depriving the country places of their old associations, and of the objects of interest which serve to draw people to the localities'. The source is reproduced in full in Foster 2001, 36–9.
[5] An early exponent of such 'national interest' was Joseph Anderson, Keeper at the National Museum of Antiquities in Edinburgh between 1869 and 1913. Anderson was in favour of the formation of concentrated museum collections, which he saw as both protecting sculpture, and facilitating scholarly study and public education. Thus in his Rhind Lectures he argued that: 'the formation of such a gallery of art materials [i.e. of early medieval sculpture] in the country to which they are indigenous would . . . restore to the native genius of the Scots the original elements of that system of design which are its special inheritance' (Anderson 1881, 134).
[6] For detailed discussion, see Foster 2001.
[7] For instance, as established by the Venice Charter (ICOMOS 1964) and later re-iterated by the *Charter for the Protection and Management of the Archaeological Heritage* (ICOMOS 1989), amongst others. In Scotland similar imperatives are outlined in the *Stirling Charter* (Historic Scotland 2000).
[8] See Hall and Jeppson 1989; Loubser 1990; Walderhaug Saetersdal 2000 in relation to rock art. A detailed historical perspective on European philosophy of conservation is provided by Stanley Price *et al* 1996. Contributions to Larsen 1995 provide a wider cross-cultural perspective.
[9] As highlighted by, amongst others, Foster 2001; Walderhaug Saetersdal 2000.
[10] For example, Barkan and Bush 2002; Bender 1998; Carman 2002; Herzfeld 1991; Layton 1989.
[11] Bell 1997, 9–17.
[12] Walderhaug Saetersdal 2000, 173.
[13] The field research for this article was carried out over three months between August and November 2001, with follow-up research trips in 2002 and 2003 amounting to a further three months. The research was grant-aided by Historic Scotland, and aimed to investigate the meanings, values and interests associated with the Hilton of Cadboll cross-slab. Funding was also provided by the University of Manchester. See Jones 2004 and 2005; for more in-depth analysis and interpretation than can be offered in the confines of this article.
[14] Barkan and Bush 2002, 15.
[15] The exact date of its relocation to Invergordon Castle is unknown, but it was subsequent to Stuart's 1856 reference to the cross-slab in the vicinity of the Hilton of Cadboll Chapel, and prior to the production of the Ordnance Survey *Object Name Book for Ross-shire* in 1872, which refers to the cross-slab at Invergordon Castle.
[16] In the protests published in newspapers, opinion was divided about the issue of to where the cross-slab should be repatriated. Some argued that it should return to Ross-shire (either to the 'ancient site', to Invergordon Castle, or to a regional

[17] museum) and it is notable that this position was most strongly evident in the local Highland press, particularly the *Ross-shire Journal* and *Inverness Courier*. But many commentators, particularly members of antiquarian societies based outside of the Highlands, clearly felt that the National Museum of Antiquities was a fitting location for national patrimony of such significance.

[17] For further analysis of the presentation of the cross-slab in the Museum of Scotland, see Jones 2005.

[18] See James 2002; Kirkdale Archaeology 1998a; 2001.

[19] Four organisations had funded the excavations: Historic Scotland, National Museums of Scotland, Ross and Cromarty Enterprise, and the Highland Council. Local protest in Easter Ross largely focused on the former two Edinburgh-based (as opposed to Highland) organisations. As Withers (1996, 328) points out, these two regions maintain a core-periphery relationship associated with oppositions in many aspects of social and political life. This relationship is also central to the historiography of Scottish identity (Withers 1996, 328; see also Devine 1999, Ch 11).

[20] Each case is treated individually, but this latter response follows guidelines for the allocation of excavated finds, where the integrity of the object or assemblage is privileged (see, for example, Scottish Executive 1999, 6)

[21] Initially it had been anticipated by heritage managers that future ownership would be legally determined by Treasure Trove. However, in early 2002 the Queen's and Lord Treasurer's Remembrancer (the Crown's representative regarding Treasure Trove) declared it to be outwith Treasure Trove, as he did not regard the new finds as 'ownerless'; in 2003 he clarified that this was because the NMS owns the upper portion.

[22] Carver 1999, 51; see also Ritchie 1989, 9 where the sculpture is described as 'exquisite'.

[23] Miller (1835, 30) narrates the story of the Danish princes, lured on to the rocks offshore by the Earl of Ross, whom they were pursuing to avenge his ill-treatment of their sister. The folktale figured in a number of newspaper accounts in 1921 and was frequently recounted by local interviewees during this research project.

[24] As Fernández and Herzfeld (1998, 90) point out, '... rather than asking which narratives about a historical site are "correct", we can learn a great deal more by examining how the various interpretations of that site are used by interested factions and individuals'. Furthermore, studies of meaning should not be restricted to 'the obvious', as meaning is not exhausted by a list of explicit referential correspondences. It is necessary to grapple with the metaphorical, symbolic, ironic and other connotative meanings which are a dynamic and often contradictory part of everyday life.

[25] For instance, see Foster 1996, Ch 7. The *Kingdom of the Scots* gallery in the Museum of Scotland also provides a representation of the 'birth' of the nation in which Pictish symbol-bearing cross-slabs figure prominently; the Dupplin Cross, for instance, was a centrepiece to the gallery before its return to Perth and Kinross, for display at St Serf's Church, Dunning.

[26] For instance, one article in the *Scotsman* described historic relics like the Hilton of Cadboll cross-slab as 'the tangible expressions of the national soul' (*The Scotsman*, 14 February 1921).

[27] Barkan and Bush 2002, 15.

[28] One of the stated aims of the Museum according to National Museums of Scotland is 'to present Scotland to the World', and this point was stressed by a number of heritage professionals during interviews for this project. Visitor research carried out in the Museum during August and September 2002 (involving interviews and tracking) illustrated that, for many, their experience of particular examples of early medieval sculpture was subsumed within a broader picture of Scottish national heritage. For further discussion of the role of the Museum in the creation of national narratives, see Crooke and McLean 2002; Jones 2005.

[29] See Macdonald 1997, for a discussion of 'belonging' in a Western Isles context.

[30] Macdonald 1997, 131.

[31] Once symbolically conceived as a living member of the community, the cross-slab itself (through its various fragmented forms) becomes a medium for the reproduction and negotiation of relationships. Thus, in the debates over the new discoveries in 2001, 'locals' could negotiate relative positions of authority and status through their association (and their parents' and grandparents' connections) with the biography of the monument. 'Incomers' on the other hand, could negotiate greater degrees of 'insiderness' through adopting, or respecting, the socially constructed authoritative community position, demanding that the new discoveries remain in Hilton. Indeed, those 'incomers' active in the local action group established during the excavation became almost honorary 'locals'. Their position was subject to special comment, such as, 'she's only lived in the village for [x] number of years but she feels for the stone as much as we do'. In contrast, the few local residents who asserted that the lower portion of the cross-slab should go to Edinburgh were cast as 'incomers', thus questioning the authority and authenticity of their stance. For other studies illustrating similar processes, see Macdonald 1997; Mewitt 1986; Nadel 1984; Nadel-Klein 1991.

[32] Richards 2000, 6.
[33] See Ascherson 2003; Basu 2002; Richards 2000; Withers 1996.
[34] A plan of Hilton in 1813, for instance, shows two streets with 24 houses, but by 1832 there were 58 families (Macdonald and Gordon 1971, 18). Shandwick is said to have provided a haven for the Rosses evicted from Glencalvie near Ardgay, and Hilton for the MacKays displaced from Sutherland (Macdonald and Gordon 1971, 18). Furthermore, many people born in the villages can recount genealogical connections with Clearance histories, at least as they are manifested in social memory.
[35] The oil industry also resulted in an increase in the population, attracting new residents to the north-east from the central belt and elsewhere.
[36] On the basis of the 1991 census, the Highland Council and Ross and Cromarty District Council identified the seaboard as the second-most deprived area in the Region and District respectively (Barr 1996). As a result the seaboard villages have been the focus of numerous development initiatives over the last decade. This socio-economic disadvantage is also reflected in residents' concerns about the lack of services, and a pervasive sense of marginality. As one local resident explained, 'Hilton is a backwater on a backwater on a backwater'.
[37] See Nadel-Klein (2003, Ch 5) for an analysis of the ways in which north-east fishers' experience of crisis is conditioned by specific social and historical processes, particularly the memory of injustice and stigma, and a continuing experience of marginality. As she points out, the past as remembered and reconstructed becomes 'an interpretive guide for action and inaction' (Nadel-Klein 2003, 161).
[38] See Scottish Executive 1999, 6.
[39] See Foster 2001, 16.
[40] Sally Foster pers comm.
[41] See Jones 2004, 52–6 for how local residents and the Historic Hilton Trust have engaged with Treasure Trove, and more broadly with principles of conservation.
[42] See Shucksmith *et al* 1994 for a broader study of perceptions of disadvantage and marginality in rural Scotland.
[43] These latter points were the most frequent interpretations offered by heritage professionals in their attempts to engage in dialogue with local residents during 2001 and subsequently.
[44] Although the body of early medieval sculpture, in Scotland and elsewhere, which has been broken, moved, and even reassembled, is far from insignificant (see Burström 1996; Foster 2001; Hall *et al* 2000; Orton 1998).
[45] Foster 2001.
[46] The importance of the relationship between such sculpture and the place it was designed for came up repeatedly during interviews in Easter Ross (see Jones 2004, 56–60). Furthermore, interviews with visitors to the Museum of Scotland revealed that even when people have no knowledge or experience of the actual place where a sculpture derives from, they still have a strong feeling that it has 'a proper place' or 'home' outwith the Museum. Thus, whilst the same visitors may appreciate its presence in the Museum for their consumption and its protection, they also hold an impression that its authentic location lies in a hazy and imagined location within the landscape.
[47] Pitt Rivers 1889.
[48] A similar point is made by Johnston (1994, 4) in her report on *Social Value* for the Australian Heritage Commission.
[49] As was implied by a number of commentators at the seminar from which this volume derives.
[50] See contributions to Gupta and Ferguson 1997; Olwig and Hastrup 1997; and Amit 2002.
[51] It should be noted, however, that it complicates Historic Scotland's emphasis on the original location of the monument in its 1992 *Carved Stones Policy* (see Appendix 1.1). A monument in a secondary location may be equally significant in terms of the social value attached to it today, as one in its primary location.
[52] An understanding of the specific meanings and values attached to particular monuments is especially pertinent, for instance, in relation to Foster's (2001) question about how local 'local' needs to be when devising conservation strategies that involve some kind of relocation. If such monuments are involved in the construction of community and place, relocation outside the perceived boundaries of that community will inevitably result in controversy and resistance. However, the nature and extent of the symbolic boundaries defining community and place, will vary on a case-by-case basis.
[53] Bell 1997, 17.
[54] Bell 1997, 14.
[55] See Johnston 1994.

CHAPTER 4

'JUST AN ALD STEEN': REVERENCE, REUSE, REVULSION AND REDISCOVERY

By IAIN FRASER

INTRODUCTION

Looking at stones such as the Meigle 2 cross-slab (Perth and Kinross), it is clear that its carvings tell a story. In this case, it is a religious message — the story of Daniel in the Lion's Den. In the case of Aberlemno 2 (Angus), the story is evidently a political statement, and tells us of a battle — a victory of Picts over their enemies. Yet the carvings borne by the stone are not the only story it can tell. The stone itself can acquire a story of its own.

In its simplest form, this may be no more than the history of its movement around the country. Since the late 1970s the Monymusk cross-slab has been displayed in the secure and accessible surroundings of Monymusk Parish Church, Aberdeenshire. It is one of the great truths of early medieval sculpture that over the centuries stones have experienced varied fortunes. Monymusk is no exception to this rule.[1] Prior to its removal to the church, the sculpture spent the better part of a century displayed by the Grant family as a curiosity in the billiards room of Monymusk House (Figure 4.1). Before that it stood beside the road at the farmstead of Nether Mains, 1.5km to the south-east. While there it was encountered by the Ordnance Survey in the 1870s, during their preparatory work for the 1st edition map.[2] To the existing symbols the Ordnance Survey added a potent symbol of their own, the broad arrow of the OS benchmark. Prior to this the stone is recorded as having lain nearby, in a field by the River Don, 'from time immemorial'.[3]

It is this 'time immemorial' at which this paper looks — the gulf of largely unrecorded time, a period of between 700 and 1000 years or more between the creation of the stones, and the beginnings of sustained antiquarian speculation in the 18th century. During this period the carved stones shed their original significance, endured damage and decay, and became the objects of archaeological study that we know today. In this paper I am going to look at how they were perceived in early writings, and at the evidence provided by the sculptures themselves as to how they were regarded.

EARLY REFERENCES

What is perhaps the earliest reference to the discovery of a piece of early medieval sculpture in Scotland appears in the writings of the 14th-century chronicler Fordun.

FIGURE 4.1 The Monymusk Pictish cross-slab on display in the billiards room of Monymusk House. Photograph by James Ritchie, around 1910. (Crown copyright: RCAHMS)

According to Fordun in the year 1261 'a magnificent and venerable cross' was discovered at Peebles (Scottish Borders). Underneath the cross was found a stone, said to have been inscribed with the words: *locus sancti Nicolai episcopi*.[4]

If the reading of the name Nicholas is improbable, nevertheless, perhaps here we have an Early Christian stone, similar to the Neitan Stone, which was discovered in Peebles in 1967 (Figure 4.2).[5] Its apparent use of the word *locus* also conjures up images of the 'Petrus' Stone at Whithorn (Dumfries and Galloway). The stone recorded by Fordun is long gone, but whatever it may have been, we can still see the physical aftermath of its discovery. This was clearly a subject of wonder, a minor miracle, and to mark this Alexander III caused a church to be built upon the site in honour of God and of the Holy Rood. The ruins of the church, the Trinitarian Church of the Holy Cross, still stand in Peebles today. A shrine built to house the relics was

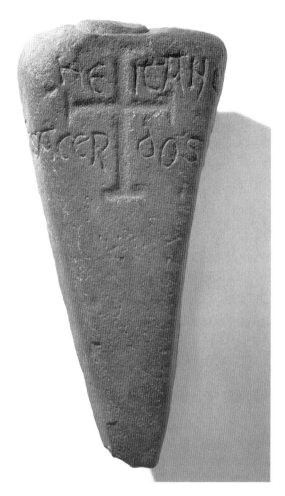

FIGURE 4.2 The Neitan Stone, Peebles, found in 1967, perhaps similar to an inscribed stone whose discovery in 1264 was recorded by the 14th-century chronicler Fordun. (Crown copyright: RCAHMS)

established as a focus of pilgrimage, and this was still attracting pilgrims 40 years after the Reformation.[6]

Medieval references to sculptured stones are not uncommon, but they are at best inconclusive. Crosses appear in numerous medieval charters serving as boundary markers. A medieval description of the marches of Maryculter parish, Aberdeenshire, names both 'ye cors of Brechmont', and the cross of 'Drumdarach'.[7] Yet in the absence of surviving physical evidence, we can only speculate as to their form, age, and the relative chronology of cross and boundary.

There are a number of particularly intriguing references. One is a fragmentary 15th-century document that refers to a boundary between the lands of the bishop of Aberdeen and the earl of Atholl. One of the markers is described as 'The stannand stain merkit lik a hors scho'.[8] This conjures up images of Pictish symbol stones such

as the symbol-incised stones at Percylieu, Huntly, Drimmies and Clatt (Aberdeenshire).[9]

Whatever the 'hors scho' stone's actual antiquity, in this document it appears simply as an element of the contemporary landscape. Whatever its original purpose, it had come to serve a useful function as a boundary marker. For the purposes of legal documentation the medieval notary had no further interest in the stone, and its carving is left unexplained.

REUSE

Of the many early medieval stones that we know today only a tiny minority have stood *in situ* since they were first set up. The majority of stones have undergone reuse in some form. This is a practice with a long history. In a number of cases Pictish stones, such as the Dingwall symbol-incised stone (Highland), and Meigle 1 and Aberlemno 1, themselves reused earlier cup-marked stones. The Picts were also not averse to reusing earlier symbol stones, as at Logie Elphinstone (Aberdeenshire), where a pair of symbols overlies an earlier double-disc and Z-rod rod.[10] Stones from both Inchyra (Perth and Kinross) and Kintore (Aberdeenshire) similarly show successive phases of use and reuse.[11]

The great medieval boom in ecclesiastical construction projects undoubtedly accounted for many more stones than we know. To pre-industrial age masons working with hand tools, the availability of shaped sandstone cross-slabs proved an especially convenient source of ready-dressed masonry. These were clearly too good an opportunity to ignore, and resulted in a number of cases of wholesale clearance of obsolete sculptured stones. In the 12th century a series of seven cross-slab fragments was reused in the construction of the lower courses of the east gable of St Andrews Cathedral (Fife) (Figure 4.3). In addition to those built into the gable, another was found built into the cathedral's western boundary wall and another five in the foundations of the Lady Chapel.[12]

Some of the most important collections of early Christian sculpture in Scotland, such as those from Kirriemuir (Angus) and St Vigeans, survive largely in reused condition. A cross-slab can still be seen built into the 15th-century south aisle wall of the latter church. John Stuart's plate shows the extent to which many of the slabs recovered from the 17th-century church at Kinneddar (Drainie, Moray) were cut down to serve as building stone (Figure 4.4).[13] Numerous references occur to symbol-incised stones being found intact in the foundations of parish churches during their reconstruction in the late 18th or early 19th centuries, as at Tyrie and Kinellar, and at Bourtie (all in Aberdeenshire), where the 1806 church itself incorporates a stone high up in its south wall.[14]

Not all the reuse was ecclesiastical. A further wave of quarrying can be identified with the 16th-century boom in tower-house construction. The large Pictish cross-slab from Woodwray (Angus) was apparently used as flooring in the kitchen of a tower.[15] Nevertheless it would be wrong to see early medieval sculpture as particularly vulnerable or targeted. At Lethendy (Perth and Kinross) a 16th-century tower-house

FIGURE 4.3 The 12th-century builders of St Andrews Cathedral appropriated numerous early medieval stones during its construction. Here a group of cut-down crosses can be seen incorporated into the base of the west face of the Cathedral's east gable. From Hay Fleming 1931, Fig 30. (Crown copyright: Historic Scotland)

incorporated both an early medieval cross-slab and an early 16th-century grave-slab.[16] It is likely that these were quarried from one of the religious houses of Perth or from Scone Abbey, following their demolition in the aftermath of the Reformation.

Examples of stones reused as building material can be multiplied endlessly. A further significant threat emerged with the increasing popularity of personal funerary monuments from the 17th century. Numerous of the recumbent grave-slabs at Govan were appropriated, areas of sculpture erased and inscriptions added, bearing dates ranging from 1634 to 1807.[17] It has been suggested that this appropriation may have been seen by the wealthy merchants of Govan as a way of identifying themselves with the social elite of the past.[18] If so, the motivation may commonly have been more utilitarian. Probably the most blatant treatment was that meted out to the Hilton of Cadboll cross-slab, which, appropriated to serve as a recumbent grave-slab, was felled like a tree and then had its cross-bearing face painstakingly erased to make way for the 1676 inscription (Chapter 7).

ICONOCLASM

There is a small body of evidence for the infliction of more considered damage. In the case of St Orland's Stone (Angus), an irregularly shaped, but carefully finished, panel has been cut out of the reverse.[19] On Meigle 11, a panel on the foot of the recumbent slabs appears also to have been carefully removed.[20] In these cases the

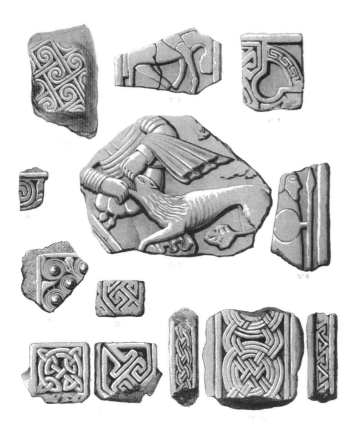

FIGURE 4.4 Reused cross-slabs and sculptured stones from Kinneddar (Drainie). From Stuart 1856, I, Pl cxxx. (Crown copyright: RCAHMS)

work appears to have been a careful editing of the iconography of the monument, which would suggest that it happened fairly early in its existence.

The Woodwray Cross displays deliberate and considered damage of a later date (Figure 4.5). The reverse has suffered considerable wear, presumably from its reuse as a paving slab, and apparently during this time a chisel was used to cut back an area along one edge. In contrast to this utilitarian modification, the cross on the slab's face has clearly been specifically targeted and deliberately chiselled off. The contrast between its well-preserved low-relief interlace and fauna, and the carefully directed obliteration of the cross, is a conspicuous feature of the stone, and indicates that the motive was not the simple utilitarian removal of the cross to provide a level surface. Why the cross on Woodwray was seen as objectionable is unclear, for within only a short distance the two Aberlemno cross-slabs suffered no damage. It has been suggested that the cross may have been particularly offensive in bearing a depiction of the crucifixion.[21]

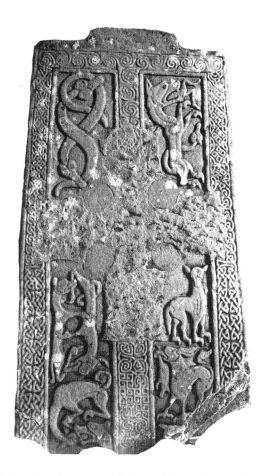

FIGURE 4.5 The face of the Woodwray cross-slab. The interlace and beast-inhabited panels are well preserved, while the cross has been deliberately erased. (Crown copyright: RCAHMS)

Although the cross-slab at Nigg has suffered both accidental damage and weathering, it is clear that it also has been deliberately defaced. The key-pattern and interlace panels that frame the reverse of the stone are crisp and well defined. In contrast, it appears that someone has taken a blunt instrument to the low-relief figures they frame. If so, the figures of St Antony and St Paul escaped, possibly overlooked in their position high up on the stone's face. The damage to the reverse could have been simple vandalism, and would probably not have taken long to achieve (Figure 4.6). On the other hand it may have been a victim of an official campaign of iconoclasm in which all religious imagery was seen as potentially obnoxious.

The period at which this damage was inflicted is uncertain, and in both cases it pre-dates the carved stones' earliest documentary appearance. In the case of Woodwray, there appears to be no suggestion that the damage was incurred between the demolition of the tower in 1819 and the sculpture's transfer to Abbotsford. As it is the reverse of the slab that displays clear signs of wear from its reuse as paving, the face was presumably permanently concealed after its incorporation in the castle fabric. However, little is known of either the date of construction or the form of the

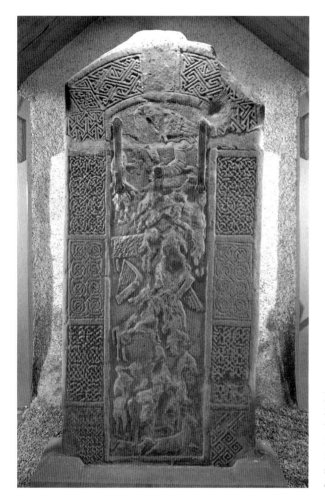

FIGURE 4.6 The reverse of the Nigg Stone, showing the contrast between the weathering of the key- and interlace-panels and the apparent impact damage and chisel marks suffered by the figures. (Crown copyright: RCAHMS)

tower, or whether the stone was an original incorporation or later introduction. Nevertheless, on the whole it is likely that the obliteration of the cross can be attributed to the later 16th or mid-17th centuries. In contrast to Woodwray, the cross-slab at Nigg appears to have formed a prominent feature in the parish kirkyard until its collapse in the late 18th century. Although the earliest depiction, by Charles Cordiner, is impressionistic rather than accurate, there is some suggestion that the reverse of the stone had already suffered prior to his visit.[22]

If the precise date of this damage remains unknown, its character also points to the prevailing spirit of religious intolerance of the mid-17th century. In 1640 the Aberdeen Assembly was 'informed that in divers places of the Kingdome, and especially in the North parts of the Same, many Idolatrous Monuments, erected and made for Religious worship are yet extant — Such as Crucifixes, Images of Christ, Mary, and Saints departed'. The Assembly duly ordained that these should be 'taken down, demolished and destroyed, and that with all convenient diligence'.[23]

Two years later a specific case is recorded in the minutes of the Assembly at St Andrews, which passed an *Act anent the report of idolatrous monuments in the Kirk of Ruthwell*, and called upon the Presbytery to execute the Acts of Parliament regarding the abolition of such monuments.[24] The Ruthwell Cross was duly thrown down. Fortunately the minister preserved the lower and upper portions of the shaft, utilising them as seating within the church, while the central portion was tucked away underneath the table tombs in the kirkyard.

Successive episodes of Protestant iconoclasm inflicted significant damage on ecclesiastical fabric, fittings and sculpture during the troubles of the Reformation and of the 1640s. However, with the exception of the three cases above there is little clear evidence of early medieval sculpture suffering deliberate damage at this time. It may be, of course, that subsequent reuse of stone fragments as building material obscures the motivation for their initial breakage. An additional handicap is that the precise context for the discovery of a stone, and thus the date of its reuse, is rarely known. However, even if it could be assumed that cross-slabs were targeted by reforming iconoclasts, these were evidently content with the breaking of the stone rather than the mutilation of the cross itself or of any accompanying figures. With the exception of the Nigg and Woodwray sculptures there is an absence of such telltale selective defacement.

An archaeologically better-documented case of deliberate destruction has been identified at the other major Easter Ross site of Portmahomack. York University's excavations here have revealed numerous fragments of Christian sculpture, associated with a possible monastic site (Chapter 2). Distinctive features of much of this sculpture are both its fragmentary condition and the relative freshness of its carving. This has been interpreted as indicating its deliberate destruction at an early date, before the stones had suffered significant weathering. In turn, this has led to the further suggestion that the stones may have been destroyed in the course of a Viking raid on this coastal settlement, possibly in the early 11th century.

A second group of sculptures that survives only in an extremely fragmentary condition is that of the Little Ferry Links symbol-incised stones (e.g. Figure 5.1) (Highland).[25] Unfortunately, little is known of the context of their discovery, but there appears to be no indication that they were in reuse. The nature of the stones and their present condition indicates that they have been deliberately shattered. In view of their presumed original location on the sandy peninsula at the mouth of the natural harbour of Loch Fleet, is it possible that these too may have been targeted by coastal raiders as conspicuous symbols of the native elite? Where instances of iconoclasm can be identified, these were evidently localised: the damage done to Woodwray was not extended to the Aberlemno monuments, at least one of which is documented as forming a well-known and conspicuous landmark since the early 16th century. Shandwick and, despite its other sufferings, Hilton of Cadboll, did not suffer the mutilation of Nigg at the southern end of the Tarbat peninsula, nor that of Portmahomack at its northern end. Similarly, the Dunrobin, Golspie and Craigton sculptures, not far remote from Little Ferry, escaped its stones' putative fate.

If violence is one characteristic attributed to the Norse, yet so too is their adoption and adaptation of other cultures and traditions, as is illustrated by the

evolution of their relationship with Iona, from a source of plunder to a focus of reverence.[26] Our ignorance of the relative proportions of lost and surviving sculpture handicaps any attempt to assess the impact of episodes of destruction. In contrast, a further insight to early attitudes towards sculpture is provided by the apparent care with which the St Andrews Sarcophagus was disposed of.[27] Although redundant, possibly following its stylistic or political obsolescence, and the transfer of its contents to a more modish container, the shrine evidently retained some value, either intrinsic or attributed, that encouraged its burial and preservation rather than mutilation and reuse.

ANTIQUARIANISM

Early medieval sculptured stones were not regarded solely with a cold utilitarian eye or else with Calvinist disapproval. They were also recognised as a remarkable element of the local landscape. We cannot be sure how the minister of Ruthwell regarded the cross, yet, that it had survived intact until the 1640s and thereafter escaped further mutilation may indicate that it was held in some respect. A clearer example of concern and of changing attitudes can be seen only a few decades later. On his visit to 'Sueno's Stone' (Moray) in the 1720s, Alexander Gordon found that it had already been the subject of a basic programme of conservation, carried out in the early 1700s by Lady Ann Campbell, Countess of Moray, who had provided the stone with a set of steps, apparently in an effort to prevent its collapse.[28]

The existence of such remarkable monuments demanded explanation, and this both folklore and antiquarianism attempted to provide. Pennant related that Glamis 2 (Angus), at the manse, was locally known as King Malcolm's gravestone, and that it was supposed to have been erected in memory of his assassination.[29] According to local tradition the figures and symbols expressed both the chain of events and their character. A wild beast, centaur and a wolf's head denoted the barbarity of the conspirators, who are shown holding battle axes, and clasping hands in token of their confederation. The fish on the reverse of the stone told how the conspirators, fleeing from the scene of the crime, lost their way on the frozen Loch of Forfar, and drowned.

Sueno's Stone and the Glamis 2 cross-slab each survive intact and more or less *in situ*, and each became the focus of legend. It may be that mythology served a prophylactic role in helping to deflect hostile intentions. If so, however, it failed to save Hilton of Cadboll (Chapter 3), or to prevent damage to the Golspie cross-slab (Highland). According to Sir Robert Gordon, writing in the early 17th century, tradition related that the Golspie cross-slab was a monument erected to commemorate a daughter of the Lord of the Isles who was shipwrecked at the Little Ferry, and then murdered by a vagrant.[30] Nevertheless, only a few years after Gordon recorded this story, this stone too was appropriated as a recumbent grave-slab, and a marginal inscription cut along the edge of the cross-face.

The Golspie cross-slab may provide an example of tradition relatively uncontaminated by antiquarian and historical influences, but from the 16th century it is clear that written sources were beginning to inform folkloric interpretations. Such was the influence of the antiquarians that it becomes difficult to disentangle tradition from

antiquarian-inspired pseudo-history. Most of the traditions that are recorded were collected no earlier than the late 18th or early 19th centuries, and many of these show antiquarian influence.

The most influential writer was Hector Boece. Writing in the early 16th century he drew archaeology into his history of the mythical early kings, evidently with reference to sites of which he had personal knowledge. According to Boece, King Rutha was the first that caused monuments to be set up in memory of the valiant deeds of noble men. Rich tombs were built for their bodies, surrounded by standing stones to denote the number of Britons that they had slain — perhaps a reference to Clava-type cairns. As writing had not yet been introduced, the deeds of noble men were commemorated by (in Bellenden's translation) 'ymageris of dragonis, wolffis and vther bestis' carved on the stones.[31] Boece claimed that after the funeral of King Ewyne 'ane grete ymage of stayn gravin to his similitude' was raised, to which the people were commanded to offer wine and incense.[32]

Boece's writings were to become the most readily accessible Scottish historical source available up to the 19th century, and it was against the chronological framework he presented that the antiquarian tourists of the 18th century attempted to find a context for the archaeology and sculptured stones they encountered.

It is hard to exaggerate Boece's influence. His explanation of Aberlemno 2 as a monument to commemorate the defeat of a force of invading Danes was one that came to be applied almost as a standard to other stones throughout eastern and northern Scotland. His interpretation of the stones as 'ingravin with crafty letteris', as a means of communicating information in a pre-literate age appears in one form or another in the writings of each of Gordon, Pennant and Cordiner.[33]

Despite their reliance on Boece, from Alexander Gordon the tourists began to recognise the shared characteristics of early medieval stones as a group, and began to analyse what they saw. Pennant believed that he could discern a chronological sequence, from early plain or roughly-carved stones to later highly-accomplished cross-slabs.[34] Whereas Pennant had believed the carved pillars to be restricted to the area between the Moray Firth and the Firth of Forth, Cordiner, who travelled to Ross, Sutherland and Caithness, found that their distribution stretched much further north.[35] He too began to classify the stones that he encountered, and began to distinguish a sequence in their development. The Cariblair, or Edderton symbol-incised stone (Highland), he sensed to be of great antiquity, while the better-executed Edderton cross-slab, in the churchyard, he believed to be the most modern in date.[36] Cordiner also sought to trace the derivation of the various sculptures and, in a series of engravings, he made the first attempts at comparative analysis (Figure 4.7).[37]

The tourists were handicapped by the limited number of sources available and by the absence of any real notion of either prehistory, or of pre-medieval cultures. They were almost wholly unconscious of the sheer depth of archaeological and historical chronology with which they were dealing. Between Boece and Cordiner, however, an evolution of emphasis is apparent. Boece used stones and other antiquities simply as a passing verbal illustration to his historical narrative. In the *Itinerarium* Gordon's interest was in the stones as physical antiquities, yet he attempted to explain them by fitting them into this established narrative. With

FIGURE 4.7 Revd Charles Cordiner was the first to attempt and publish a comparative analysis of the imagery found on the symbol stones. This plate from *Remarkable Ruins and Romantic Prospects of North Britain* (1788–95, ii), illustrates Pictish elephants from Brodie, the Maiden Stone and Nigg. (Crown copyright: RCAHMS)

Charles Cordiner the emphasis shifted. He instead began to see the sculptures as evidence of an unrecorded history, and as valuable documents in their own right. It was this attitude that ultimately laid the foundations for the more systematic compilation and analysis of a national corpus in the following century (Figure 4.8).

CONCLUSION

It has only been possible to touch upon a few of the diversity of attitudes towards early medieval sculpture and their influence upon its survival or destruction. Much of the evidence has been anecdotal, and a closer examination of individual cases would doubtless reveal a more involved story. The sculptures tell us of patterns of belief and their obsolescence. They are evidence of the religious reforms of the 12th century, and equally of the iconoclasm of the Protestant Reformation. They tell us of cultural change in medieval and early modern building fashions, of changing attitudes to

FIGURE 4.8 Vignette from the title page of Cordiner's *Antiquities and Scenery of North Britain*, 1780. (Crown copyright: RCAHMS)

folklore and antiquity and of the sense of identity of past generations. Just as the content of the sculptures can be interpreted as telling a story about the lives and beliefs of the patrons that commissioned them, so the stones themselves have another tale to tell — that of the wider history of the country as a whole and of attitudes to the landscape within which they stood.

ACKNOWLEDGEMENTS

I am grateful to all those who have offered comment and advice on this paper and the various issues touched upon, in particular Strat Halliday, Adam Welfare, Mark Hall, John Borland, Ian Fisher and Ian Scott. Thanks are also due to my wife, Veronica.

NOTES

[1] *ECMS* III, 192–4.
[2] OS Name Book (*Aberdeenshire*), No 64, 63.
[3] Forbes 1845, 463–4.
[4] RCAHMS 1967, 203–4.
[5] Steer 1969.
[6] RCAHMS 1967, 204.
[7] Innes 1842, i, 247.
[8] Innes 1842, i, 246.
[9] *ECMS* III, 181, 162, 166; Ritchie 1910, 207–9.
[10] *ECMS* III, 176–7, Fig 189.
[11] Stevenson 1959, 33–9; *ECMS* III, 172–3.
[12] *ECMS* III, Fig 376; Hay Fleming 1931, 1.
[13] Stuart 1856, Pl CXXX.
[14] *ECMS* III, 187, 170, 157.
[15] Jervise 1857, 194.
[16] Fisher and Greenhill 1972.

[17] Stirling Maxwell 1899.
[18] Ritchie 1999, 14.
[19] Alcock 1993, 232.
[20] Ritchie 1997b, 22.
[21] Henderson 1993b, 213.
[22] Cordiner 1788–95, ii.
[23] Hewison 1914, 13.
[24] Hewison 1914, 15.
[25] Close-Brooks 1989, 6, 14–15.
[26] Jennings 1998.
[27] Foster 1998a, 46.
[28] Gordon 1726, 158; McCullagh 1995, 700.
[29] Pennant 1774, ii, 173.
[30] Close-Brooks 1989, 16.
[31] Boece 1938–41, ii, 67.
[32] Boece 1938–41, ii, 88.
[33] Boece 1938–41, ii, 137; Gordon 1726, 160; Pennant 1774, ii, 168; Cordiner 1780, 67.
[34] Pennant 1774, ii, 166.
[35] Pennant 1774, 166; Cordiner 1780, 65.
[36] Cordiner 1780, 119–20.
[37] Cordiner 1788–95, ii.

CHAPTER 5

FRAGMENTS OF SIGNIFICANCE: THE WHOLE PICTURE

By Isabel Henderson

In her lecture to the Antiquaries of Scotland commemorating the centenary of the publication of *ECMS*, Rosemary Cramp remarked on the number of Pictish monuments that were more or less complete.[1] This is so, in so far as a high proportion of the approximately 250 symbol-bearing monuments are substantially complete, but for the 200 or so non-symbol-bearing but artistically related monuments, the reverse is true.[2] An objective of this paper is to encourage a new respect for fragments based on their status as evidence for a whole range of matters, including the character of their production site, art-historical contacts, creativity and quality of craftsmanship. Museums and heritage centres should be proud of them and interpret them as fully as practicable for the public who enjoy looking and understanding; often it is easier to interact with a fragment than with a large complex monument.

QUALITY INDICATORS

The value and significance of fragments is perhaps most appreciated by art-historians and archaeologists who like detail, and draughtsmen who have to make a visual record of that detail. J Romilly Allen was appreciative of fragments. Listen to him on the V-rod terminal on Little Ferry Links 4: 'Although a mere fragment, this stone is valuable as affording one of the most perfect and beautiful examples of the ornamental termination of the V-shaped rod yet found in Scotland. The artistic feeling exhibited in the drawing of the subtle curves is unquestionably great'.[3] The terminal is a quality fragment (Figure 5.1). Some would regard Allen's description as irrelevant and subjective, but control of hand and eye when incising a fluent line, and the expression of rhythm and balance in composing a design are observable facts, and something which is characteristic of much Pictish sculpture. Not to accept that some symbol designs are superior to others is to close the mind to tangible evidence. Allen's eloquent enthusiasm was justified not only when a fragment of the crescent itself was located, but in later exceptionally fine finds made in the district. In 1942, the Golspie symbol-incised stone (Highland) was found, with its complex crescent design on which Robert Stevenson based his general analysis of the interior decoration of the crescent. In 1977, the symbol stone Dunrobin 2 (Highland) was excavated by Joanna

FIGURE 5.1 Little Ferry Links 4, Highland, Dunrobin Castle Museum. (Crown copyright: RCAHMS)

Close-Brooks, with its unique double-crescent symbol and patterned serpent.[4] Without these finds, Allen had already detected in the Little Ferry Links fragment a clue to the quality of incised carving in this area.

The predominantly fragmented sculpture at St Vigeans, recently re-examined, photographed and drawn by the RCAHMS, should reveal much that is new about Pictish sculpture (Chapter 13). Many of the line drawings in *ECMS* convey admirably the quality of the sculpture, but not all. The fragment St Vigeans 19 showing a stag at rest, its head looking over its shoulder with its fine antlers held high, needs photography to illustrate it adequately, and thanks to the recent survey a photograph is now available (Figure 5.2). Awareness of the quality of this fragment strengthens recognition that sculptors at St Vigeans had a particularly rich series of stag poses and themes, carved by a master — the full-bodied slender-limbed antlered stag being pursued by hounds, the hind suckling her fawn, both on St Vigeans 1, and the family of deer, stag, hind and fawn, fleeing from a predator on the recumbent St Vigeans 8.[5]

For *ECMS* Allen used the engraving in an earlier publication by Anderson to illustrate the fragment of a boar from Dores, near Inverness, Highland. Allen described it, rightly, as being accurate, but inevitably the dimensional quality of the incision is not conveyed. The Dores boar, when complete, would have had a fair chance of being the most accomplished of the markedly accomplished series of profile animals in incision carved by the Picts.[6] Much less well known, but surely significant, is the fragment of key-pattern found close to the site where the boar was found (Figure 5.3).[7] It is safe and accessible in the National Museums of Scotland, but whereas the boar fragment is a centrepiece in the display of symbol stones, the fragment of relief-sculpture is understandably in store and easily forgotten. Taken together, the pieces at least raise the possibility of a site producing sculpture across the technical divide of sculpture in incision and in relief — a site comparable, in this respect, to Burghead, Moray. The Dores key-pattern is on a large scale, so that the size of the relief monument it came from could have been considerable. The

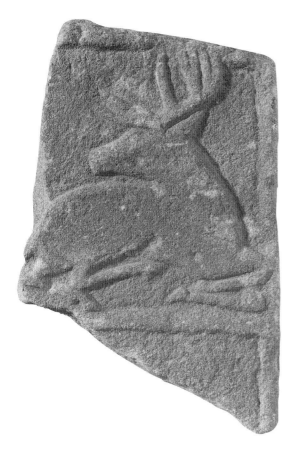

FIGURE 5.2 Reverse of St Vigeans 19, St Vigeans Museum, Arbroath. (Crown Copyright: RCAHMS)

combination of the two pieces is thought-provoking and indeed the presence of relief-sculpture in this area is unprecedented.[8] The whole picture of the production sites of Pictish sculpture must be slightly modified.

STATUS INDICATORS

Other fragments are important for their evidence of knowledge of art styles used in book illumination and precious metalwork. These could be termed status fragments. Such fragments can significantly alter the perception of the artistic resources available at a site and so of the assessment of the importance of the site itself. J Romilly Allen went out of his way in his descriptions to note the presence of spiral ornament, where the connections of spirals consisted of 'trumpet-shaped expansions and vesica-shaped spots as in the best Celtic illuminated MSS. and on the enamelled handles and mountings of the metal bowls of the "Late Celtic" and Anglo-Saxon periods'. The quotation comes from Allen's description of St Vigeans 6, a fragment with a maximum dimension of 25cm, which has a double-disc symbol

FIGURE 5.3 Dores, Highland, National Museums of Scotland (XIB 177). (© Trustees of the National Museums of Scotland)

FIGURE 5.4 Kinneddar 6, Elgin Museum, Elgin (Drawing by Ian G Scott. Crown copyright: RCAHMS)

carved on the back with this type of spiral decoration carved within each disc.[9] The fragment affords a particularly fine example of the Insular style fully assimilated, literally within the native symbolism. To this artistic synthesis can be added a surviving portion of an ogham inscription considered to be 'probably' present in the 19th century and recently confirmed (Figures 13.7 and 13.8; Chapter 13).[10]

A similar status fragment is found among the sculpture from Kinneddar. This large collection, now in Elgin Museum (Moray), covers every format known to Pictish sculpture. Nevertheless, its status in terms of the quality of the carving has to a large extent depended on a large fragment showing David rending the lion (Figure 4.4), thought by a few, including Allen, to be Romanesque, but now more generally accepted as so close in detail to the representation of the David figure on the St Andrews Sarcophagus as to be contemporary with it.[11] A difficulty has been the failure to detect carving of a similar quality to the David in the rest of the collection. A

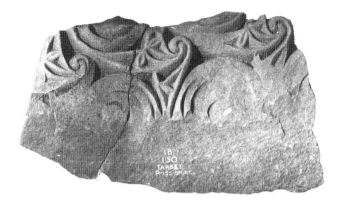

FIGURE 5.5 Portmahomack 7 before restoration of fragment of triple spirals top left. (© Trustees of the National Museums of Scotland)

fragment roughly 15cm square, however, is carved with a corner of a panel of spiral ornament with the distinctive trumpet-shaped expansions and almond-shaped dots. Allen was so interested in this ornament that he omitted to draw the fine interlace which formed a broad border to the panel. This framing of the motif, now recorded in a drawing by Ian G Scott, enhances its importance (Figure 5.4; see also Figure 4.4). The small fragment confirms that in the 8th century, high-grade sculpture compatible with the David fragment was being produced at the site. It adds to the status of Kinneddar just as Inchmarnock 10, off Bute, does for the sculpture at that site. Here a fragment of a cross-shaft, 43cm x 30cm, has spiral ornament of this type. Ian Fisher cites as parallels carving on the Ahenny (Co Offaly) crosses in southern Ireland, and the brilliant fragment of spiral ornament, Portmahomack 7 (Figure 5.5).[12] It was Allen's authoritative description of this Portmahomack fragment as a 'most exquisitely finished piece of spiral ornament more nearly resembling that in the best Irish MSS. than that on any other stone in Great Britain' that led to its being taken out of store in Queen Street and put on display in the 'Aftermath' section of Stuart Piggott's *Early Celtic Art* exhibition in the Royal Scottish Museum in 1970.[13] This remarkable fragment, discovered by a grave-digger, lay on a windowsill under the tower of the Portmahomack church, until its importance was recognised by Hugh Miller of HM Geological Survey, son of the famous Cromarty geologist and writer.[14] Those Portmahomack fragments found in the 19th century are now spaciously displayed on a wall in the Museum of Scotland. Among them, Portmahomack 9 is yet another example of spiral work of this quality produced at the site. Unlike the other fragments displayed, carving has survived on both sides of Portmahomack 9. Its back, hidden by its attachment to the wall, had a trace of a panel of interlace, according to Allen. The fragment has now been drawn by Ian G Scott for the Tarbat Discovery Programme. He has shown that it is a portion of a circular panel of interlace, slightly domed.[15] Portmahomack 9 is not only a status fragment but a fragment which has physical importance, for it is a through-stone, 20cm thick, the standard thickness for large cross-slabs in the area. Moreover, raised circular panels often mark focus-points on a cross — the centres of the arms, or at the crossing. In the effort to piece together the Portmahomack fragments, 9 may therefore be an important guide.[16]

FIGURE 5.6 Birnie 2, Elgin (lost). From Stuart 1856, Pl XLII. (© The Trustees of the National Library of Scotland)

Interlace constructed with double strands is another ornamental pattern of particular significance. This is not to be confused with single-strand interlace where the strand is lightened by giving it a median-incised line. In double-strand interlace the two strands move in the same direction but pass over and under each other independently. Double-strand interlace is a feature of the decorative repertoire of Insular manuscripts. For example, it is used for the whole of the background of the cross on folio 94 verso of the Lindisfarne Gospels, and features in the frames of the David as a Warrior miniature, in another Northumbrian manuscript, the Commentary on the Psalms by Cassiodorus.[17] The complexity of the interlace patterns on Pictish sculpture is generally acknowledged to be exceptional in Insular art but examples of double-strand interlace are comparatively rare. The fragment, Kinneddar 10, with a maximum dimension of 27cm, is one of the handful of examples.[18] Here, only one broad face preserves traces of carving. It has a passage of double-strand interlace and rings, with both strands median-incised. One narrow edge is decorated with median-incised single-strand interlace (Figure 4.4). That this is a significant fragment is confirmed by the ornament on the other narrow edge described by Allen as a key-pattern 'finished off throughout with triangular sinkings'.[19] These sinkings, as with the almond-shapes in spiral ornament, are found picked out in black in key-patterns in manuscripts. This small, seemingly run-of-the-mill 'late' fragment, when examined closely, takes its place beside the other status fragments at the site.

The carving of spirals terminating either in birds' heads, or other zoomorphic and anthropomorphic endings, is well known as a link between the cross-slab St Vigeans 7 and the Birnie 2 fragment from near Elgin (Moray) (Figure 5.6). In his description of St Vigeans 7 Allen notes that while these were the only examples sculptured in stone that he knew of, the motif was 'not uncommon in the MSS.'.[20] The large fragment of a cross-slab removed from the wall of a building at Applecross (Highland), recorded long after the publication of *ECMS*, has a full version of the motif with differentiated terminals including birds' heads. Here the motif is used for the background of what was a ringed cross, whereas on the St Vigeans slab it decorates the shaft.[21]

Allen recorded four fragments of relief sculpture as being now 'preserved' on a windowsill on the north side of the pre-Reformation church at Birnie.[22] Three were

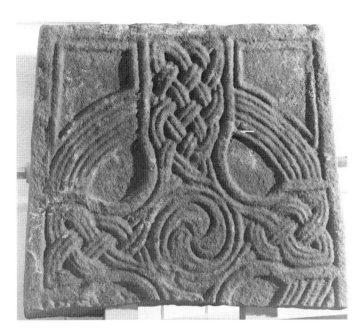

FIGURE 5.7 Kirriemuir, the Meffan Institute, Forfar. (© Tom Gray)

published by him for the first time. Birnie 2, with the spirals terminating in birds' heads, according to Allen, was 'not well illustrated' in Stuart, but unusually he did not provide an alternative illustration. All four fragments are now lost. The Birnie 1 symbol stone with its well-designed symbols, closely related to those on a symbol stone taken from the foundations of the old parish church at Tyrie, is now virtually illegible as a result of lichen obscuring the incisions on the granite. The presence of high quality Pictish sculpture, with far-flung connections, is virtually lost sight of at the interesting site of Birnie. No mention of any relief-sculpture associated with the site is made in the current leaflet *Moray's Pictish Trail*. How different if the fragments had been taken to Elgin Museum.

The many fragments recently discovered at Kirriemuir (Chapter 22) include yet another example of bird-head termination to spirals, taking the number of known examples of this high-status ornament to four, two south of the Grampians and two to the north.[23] At Kirriemuir the motif is placed at the centre of an elaborately ringed cross-head carved on the surviving upper portion of a cross-slab with many other interesting features (Figure 5.7). Birds' head spirals feature prominently in the decoration of the Barberini Gospels, an 8th-century English manuscript, for example, in the decoration of Christ's monogram 'Xpi' in St Matthew, and the opening page to St John. It is equally common in the Book of Kells.[24]

Another high-status motif in the sense that it appears in Insular and Continental manuscripts, are naked figures pulling their beards and hiding their genitalia. The figure on the end of a cross-arm at Strathmartine (Angus) was lost at the time that Allen was working on his gazetteer, but its whereabouts are now known.[25] There is a figure related to this type on a narrow edge of the Applecross fragment mentioned above, and a related figurative motif on Forteviot 1 (Perth and Kinross).[26] It was the

FIGURE 5.8 Reverse of Monifieth 3, National Museums of Scotland. (© Trustees of the National Museums of Scotland)

recovery of this Strathmartine fragment that raised consciousness of this theme in Pictish sculpture for it bears such a close resemblance to a figure within a Canon Table in the Barberini Gospels.[27]

The sadly truncated and battered fragment Monifieth 3 (Angus), with its motif of a man sitting with raised knees interlaced with a bird that bites his neck, is another significant fragment (Figure 5.8). This is up-to-date anthropomorphic ornament also used in the Book of Kells.[28] The man attacked by a bird is also a motif on the side of the recumbent Meigle 9, but this need not mean that the Monifieth sculptor was merely dependent on the contents of a Meigle 'school' repertoire. There are many other aspects of this ruined fragment, both in content and design, which added to other sculpture at Monifieth, provide ample evidence for a production centre taking on distinctive, ambitious commissions in varied formats.[29] All the sculpture surviving (three out of the four pieces are fragments) was discovered in the foundations of the old church, built into the walls of the new church, and subsequently went to the National Museums of Scotland.

These high-status fragments carved with ornament found in 'Irish manuscripts of the best type' are evidence not for vaguely termed 'artistic influences', but for actual knowledge of contemporary works of art in other media acquired through direct contacts, an interaction which can be regarded as having historical implications, even though their specific nature may be irretrievable. The network of connections Insular

and Continental opened up by the study of the recently recovered Pittensorn fragment provides a typical example (Chapter 19).

FORMAT INDICATORS

It is inevitable that not all sculpture in the national collection can be displayed, and that a worn fragment like Monifieth 3, in spite of its significance, remains safe, but in store. Apart from other considerations, it is ill-suited to the current thematically orientated display. Often fragments are small enough to be portable so that they have to be fixed to a wall. Such fixings are not always sensitively placed, and museum records of the appearance of the back of fragments, and indeed of complete panels recorded by Allen as carved on one face only, are often incomplete. It is important to know if the treatment of the back is rough, or dressed, or gives an indication of function or reuse. When the sculpture in Groam House Museum was catalogued for SCRAN — the Scottish Cultural Resources Access Network — the opportunity was taken to remove all the sculpture from the walls. The result was the discovery of clear evidence that an unsuspected amount of it had formed sections of composite constructions.[30]

A particularly interesting small fragment, Rosemarkie 5, belongs to the National Museums of Scotland. It was published by Allen for the first time.[31] Like so much of the Rosemarkie sculpture it is beautifully dressed, the surfaces totally flat and smooth. The only carving consists of decorative borders on two faces. The broader face has a border filled with loose broad band interlace carved in relief. The narrow edge is filled with an incised, tightly constructed, four-cord interlace. The comparatively large, dressed, but uncarved area on the broader face, not conveyed in Allen's drawing, would be unusual for a cross-slab. The careful selection of different weights of interlace in distinctive techniques reveals high quality design and execution. The fragment could be part of an upright screen decorated on two visible faces, but the layout would be more suitable for a horizontally-laid slab. It may therefore be a remnant of an altar slab, forming part of church furnishing, rather than of a construction made up of space-defining panels. The significance of a fragment of this sort, when arguing a case for an early church at Rosemarkie, is obvious, and its loan for display at Rosemarkie's Groam House Museum is an admirable example of the location of a fragment where its value and significance can best be appreciated.

The experience at Rosemarkie certainly highlighted the question of Pictish sculpture carved on one face only. Did the Picts have a unique predilection for the carved panel — whether or not forming part of a composite monument? Are such panels in all cases really carved on one face only? When drawing the sculpture from Kinneddar Ian G Scott discovered that two fragments of slabs described separately in *ECMS* (under Drainie 3 and 8) as carved on one face only, not only fitted together, but when the conjunction was turned over, revealed a section of a relief cross carved on the reverse.[32] This was all the more surprising for the subject matter, a rider and a foot-soldier respectively (Figure 4.4), was just what one might have expected to have been part of a panel carved on one face.

The fitting together of the fragments of the 'calf stone' panel at Portmahomack (28/35) had a very different result. The format of the fragment discovered first, which included the unprecedented pastoral scene of adult cattle licking a calf, was hard to interpret, and indeed for a time was thought to be a trial piece. When in a subsequent season a second conjoining fragment was found, it preserved a top edge smoothly rolled and finished off with beading. This top edge brought with it the clear conclusion that the rough area under the carving of the first fragment was a tenon for fixing into a base or into the earth. The nurturing of the young calf was also seen to have an iconographic counterbalance in the upper fragment, which showed a collapsed lamb being approached from behind by a long-beaked monstrous animal. The reverse shows no trace of dressing or carving. The Portmahomack calf stone is still fragmentary, but it is without doubt a panel carved on one face only.[33]

A classic example of the results obtained by joining together two unpromising looking fragments was the conjunction of St Andrews 28 and 29. Allen published them, perfunctorily, without illustration, for the first time. In his catalogue of the St Andrews Museum, Hay Fleming provided photographs and some details of their find circumstances and repeated words from Allen's description.[34] It was not until 1977, after they had been bonded together and subsequently studied closely, that it was realised that the smaller of the two fragments preserved on its straight edge a portion of a tongue provided with a bead moulding. This ensured that it both entered a groove to the correct depth, and served as a frame for the carving on the panel. These constructional details are paralleled on the St Andrews Sarcophagus, and the conjoined fragments are evidence that there was another monument of this type in early medieval St Andrews.[35]

Fragments, like small slabs, cannot compete with large impressive complete monuments in general assessments of the nature of Pictish sculpture. We do not hear much of the distinctive figure style of the clerics carved on Meigle sculpture (Figure 5.9), or of the fragments of small slabs at the same site which share features with the undervalued and poorly displayed St Andrews cross-slabs.[36] Fragments can also hint at lost narratives which should not be forgotten in the effort to account for what motivated Pictish figural art. What heroic tales lie behind the depiction of a human figure tied to the neck of a horse on the fragment St Vigeans 25 (Figure 5.10), or the man wrestling with a horse on Meigle 4? Such scenes, and there are many others, could shed light not so much on the secular side of Pictish society, but on the existence of Pictish vernacular literary culture.[37]

COMMUNICATION INDICATORS

Two other fragments are of particular interest because they question the perception of a division between the sculpture of the north and south. A small fragment was found when levelling the churchyard at Murroes (Angus). It is the only piece of sculpture found so far at the site. By Allen's time it was in the collection of the National Museums of Scotland. Murroes, as Allen noted, is an example of the motif of the boss or circular element covered with a mesh of reptilian bodies with beast heads and fish tails. Allen rightly compared it to decoration on the cross-slab at

FRAGMENTS OF SIGNIFICANCE

FIGURE 5.9 Reverse of Meigle 14, Meigle Museum, Meigle. (Crown copyright: RCAHMS)

FIGURE 5.10 St Vigeans 25, St Vigeans Museum, Arbroath. (Crown copyright: RCAHMS)

Shandwick, Easter Ross, which has both bossed and low-relief versions of similar motifs.[38] To date, the Murroes fragment is the only example found in southern Pictland other than those on an end panel of the St Andrews Sarcophagus.

The sharing of repertoire by the north and south is also evident on a fragment, comprising an arm and central boss of the Edzell 1 free-standing cross (Angus), published by Robert Stevenson.[39] Stevenson, whose consistent methodology for the study of sculpture was to try to establish a logical line of development, described it as 'of considerable importance as being a fragment of probably the earliest known free-standing cross in the areas where Pictish cross-slabs predominated, and the only one in the style of their most elaborate monuments'. Not only did Stevenson make the obvious comparisons to Pictish slabs and the free-standing crosses of Iona for the close-mesh interlace which covers the Edzell 1 boss, but he also demonstrated how the organisation of the spiral ornament on all these monuments resembled spiral illumination in the Book of Kells.

Stevenson also had interesting observations to make on the way in which the cross-head must have rested on the shaft — a hollow immediately behind the boss being cut to receive the round tenon on the shaft. Deep marks in the hollow provided a further valuable indication of the tool used — a round-nosed punch which sculptors call a point. Stevenson's description and analysis brings out clearly the importance of the fragment for format, construction, technique, and artistic context. It ought to be a key exhibit in a museum setting.

SIGNIFICANT FRAGMENTS AND THE WHOLE PICTURE IN THE 21ST CENTURY: THE NEED FOR A NEW CORPUS

So, ought examination of such fragments and the many others like them, be restricted to carefully researched notes in journals, to be used when appropriate as detailed underpinning for specialist art-historical studies? Perhaps so. But the ever-pressing requirement to make the sculpture accessible to the public, and its interpretation simple and relevant, does run the risk of failure to build into scholarly interpretations this detailed level of evidence, which affects the veracity of the whole picture. This is particularly unfortunate since the sculpture is currently being used to some effect by scholars in other disciplines which require a less simple approach. At present, we have the awkward combination of thematically-arranged museum displays created to highlight relevance over the ages for the public, and archaeologists, and other disciplines, stressing the importance of the landscape context of the find site.

In interdisciplinary studies, the significance of the art carved on the monuments tends to be reduced to quite superficial perceptions of subject matter — such as whether it is pagan, secular or Christian, symbol or non-symbol-bearing. The only way that awareness of the detailed complexities of the whole picture can be laid before workers in other disciplines is by the production of a new scholarly corpus, where all the sculpture at one site is described and analysed together. The English, Welsh and Irish used to envy Scotland its *ECMS*, but Scotland is falling behind in

terms of the basic provision of an up-to-date, descriptive and analytic gazetteer with full photographic coverage supported where necessary by drawings.

Stevenson once wrote that *ECMS* did such a good job that it halted work on the monuments for a generation. The experience of being able to buy the reprint was a great advance for everybody interested in the subject, but if it is 100 years since *ECMS* was published, it is nearly 10 years since the reprint was produced. Those living in Scotland who have ready access to the monuments know how to use *ECMS*. They have experienced for themselves or heard about where it is inadequate. They can still benefit from its great store of knowledge, accurate observation, and good sense, but they know that it is not infallible. The temptation for scholars outside Scotland to reproduce the drawings in *ECMS* is understandable, but seriously undervalues the sculpture.[40] Every time one of the RCAHMS's draughtsmen, of which Scott is the *nonpareil*, draws the sculpture, corrections and refinements of the *ECMS* drawn record abound.

Indeed, in terms of drawing, a national archive is underway.[41] The addition of the *Tom and Sybil Gray Collection* to the photographic collections of the NMRS has greatly increased photographic coverage. One does not have to argue a case for a new corpus publication. Only one reason is focused on here, that significant fragments cannot be given the attention they merit in schemes driven by access for all. But this lack of the means of systematic study of the whole picture affects understanding of all Pictish sculpture.

Sculpture published for the first time abounds in *ECMS* — a direct result of Allen's fieldwork. The number and the nature of finds of sculpture since 1903 mean that *ECMS* no longer represents what we now know of the whole picture. A corpus without the new Portmahomack sculpture, without the lower portion of Hilton of Cadboll, or the additions to the collections at St Andrews, Rosemarkie and Kirriemuir, without the new finds of incised portraits of heroic figures, without the bear from Old Scatness (Shetland Islands), or proper coverage of the cross-marked stones, is no longer adequately representative of the material.

The recent RCAHMS volume on the material in the West Highlands and Islands is a model for texts, catalogue entries and illustration.[42] Detailed research accompanied by photography of professional standard has been done on the sculpture of the south-west. We have an acclaimed corpus of ogham inscriptions, and definitive studies of Latin inscriptions. The considerable efforts of the last ten years made by regional archaeologists, local societies (not least the Pictish Arts Society), by private researchers, many backed by the commitment of the Pinkfoot Press, by the national and regional museums, university departments, Historic Scotland, the RCAHMS, and the Society of Antiquaries of Scotland, should be pooled and presented in a uniform format for use in a new *Corpus of Early Medieval Sculpture in Scotland*.

It was a great disappointment to read in the report to the Scottish Medievalists Conference for January 2003, that the Glasgow Corpus project, launched in 1997, was in abeyance while a further attempt to acquire funding is planned. Of course such a project needs manpower as well as money, and planning for this should be going on side by side. Two authors, even if they could be found with the encyclopaedic knowledge of Early Christian art and the early medieval art of the British Isles

possessed by Allen and Anderson, can no longer be expected to do the work. We will certainly need more trained art-historians.

In my view, little can be done in the way of achieving such matters as 'conveying a sense of the monumentality, original function and historic setting of this material' without first considering what is carved on the monument.[43] Evidence for function is best found in format, style and subject matter. The monument's art-historical setting must have a bearing on the contemporary setting. Study of the art can help release the subject from old frameworks, and allow new findings in other disciplines to be used more sensitively.

Other disciplines must be aware of the intellectual contacts that art implies. It has been said that art-historians provide dates when no other better dating method is available. That may be so, as long as one is thinking of very wide date-brackets and is aware that 'the art-historians' do not find dating any easier than anybody else. They have, however, moved on from the chronology provided by Anderson in *ECMS*.[44]

Pictish sculpture of this period is part of mainstream contemporary art, and comparison to Insular art should inform all aspects of the care, display and study of the sculpture. When that happens there may be more attention to the detail, to the significant 'Class III' fragments, to the whole picture, and not just to the perpetual reinforcement of the broad stereotypical view of what viewers are thought to find attractive and easy to relate to. A new corpus would facilitate looking closely at all the sculpture, not just at the popular monuments in national care, or those with the excitement of recent discovery. Not least, it would act as an inventory revealing the extent to which there have been additions, losses and deterioration. It would make possible the systematic addressing of new questions about the sculpture not covered at all in *ECMS*. In spite of the continuing usefulness of *ECMS*, our database needs to be renewed, in a way that takes advantage of what has been achieved over the last decades, and which avoids duplication of effort.

To back the new powerful theoretical base of cultural resource management, interpretation and access, we still need knowledge. It is this knowledge which will allow the true value and significance of the sculpture at the time of its production to be better understood and to be fully effective as part of the equally powerful theoretical bases of current archaeological and historical study. *ECMS* has been, for 100 years, a splendid showcase for a unique cultural asset. Unfortunately it is now suffering from ignorance both of its enduring merits and of its inevitable limitations. It is ignored by some who consider it too old to be worth consulting, and over-depended upon by others, who are unaware of the degree of updating available in the modern literature, but in widely dispersed sources. The importance of the art has been at the centre of this paper, but the overriding aim must be to elucidate the value and significance of the nature of the art at a particular site. Attitudes to ownership of sculpture in the past, and the present inevitable compromises involved in attractive public presentation, stand in the way of achieving something that approximates to the whole picture. It can best be done in a co-ordinated scholarly publication that would be the first point of reference for academic study in all disciplines (Chapter 26). Only such a publication can ensure progress in reassessing this unique early medieval source material to a standard required by the 21st century.[45]

ACKNOWLEDGEMENTS

I should like to thank the following: Tom E Gray for providing illustrations for the lecture, and photographs for this paper; Norman Atkinson for commissioning a full photographic record by Tom E Gray of the Kirriemuir fragment discussed above, and for allowing me to write about that monument in advance of a full study; Ian Fisher for information about sculpture at Strathmartine; Ian G Scott for helpful discussion and permission to publish results of his work.

NOTES

[1] Cramp 2003.
[2] Statistics for symbol-bearing monuments are based on Mack 1997 (updated by pers comm in March 2003). For 'Class III' statistics, see the Pictish Sections in ECMS II, 10.
[3] ECMS III, 47–8.
[4] Stevenson 1955, Fig 15; Close-Brooks 1980.
[5] ECMS III, Figs 250, 252B, 279.
[6] Henderson 1967, Pl 36.
[7] ECMS III, 517–18, Fig 567.
[8] Proc Soc Antiq Scot 1901, 106–7. The carving is described as 'boldly incised', but in fact the key-pattern is expressed in relief.
[9] ECMS III, 242.
[10] RCAHMS 2000, 19.
[11] Henderson 1998, 130–1.
[12] Fisher 2001, 78–9.
[13] ECMS III, 91–3; Piggott 1970.
[14] Miller 1889, 440, Fig 3. The engraved illustration, also used in ECMS, shows a fragment which completes a triple spiral in position. Modern photographs are missing this fragment, which however was restored in time for the display of the fragment in the Museum of Scotland.
[15] Tarbat Discovery Progr Bull 3 (1997), with a drawing by Ian G Scott.
[16] Ian G Scott has drawn a reconstruction of the front face of a large slab which incorporates a number of the Portmahomack fragments. In it Portmahomack 9 is located at the crossing. Scott (pers comm) points out that until the geological compatibility of the fragments involved can be established such a reconstruction can only be regarded as a hypothetical exercise.
[17] Alexander 1978, Illus 35 and 75.
[18] ECMS III, 146–7, and ECMS II, 223, No 576. For another example of double-strand interlace on a slab with a number of manuscript derived traits, see a section of interlace on the right side of Skinnet, ECMS III, 30–2, Figs 29A-C, and ECMS II, 221, No 570.
[19] ECMS III, 146, Fig 152A, recte key-pattern No 928. For the manuscript analogies see ECMS II, 341, Nos 928 and 929.
[20] ECMS III, 268, n1.
[21] MacLean 1997, 177–8, Illus 1a and b; Fisher 2001, 89.
[22] ECMS III, 136–7; Stuart 1856.
[23] The writer was only made aware of this fragment when Norman Atkinson showed a slide of it in his lecture at the seminar.
[24] Alexander 1978, Illus 170 and 172; Henderson 1982, Pls xiii a and b.
[25] ECMS III, 267, Fig 277B. Allen does not make it clear whether his Strathmartine 8a (thought by him to be part of the same cross) was also lost.
[26] ECMS III, 324, Fig 335B (a drawing). Photograph in Alcock and Alcock 1992, 223, Illus 4.
[27] G Henderson 2001, 163–4, col Pl xii.
[28] Henderson 1982, Pl xii a-c.
[29] ECMS III, 228–30, 265; Trench-Jellicoe 1999.
[30] Henderson 2000, 43.
[31] ECMS III, 87–8, Fig 86. Ian G Scott drew the fragment for the SCRAN survey.
[32] Scott has completed the drawing of all the Kinneddar sculpture.
[33] For the two conjoined fragments see a drawing by Elizabeth Hooper in Tarbat Discovery Progr Bull 4, 1998, 10.
[34] ECMS III, 361–2; Hay Fleming 1931, 30, Fig 46.
[35] Robertson 1977.
[36] The extent to which the repertoire of the St Andrews slabs can elucidate aspects of a phase of Pictish sculpture is beginning to be appreciated. See, for example: Ritchie 1995; Robertson 1997; Henderson forthcoming.
[37] On this topic see Henderson and Henderson 2004, Ch 5.
[38] ECMS III, 266, Fig 276.
[39] Stevenson 1959, 42–3.
[40] For example, Harbison 1992, 3, Fig 954, where the uniquely expressive carving of Saints Paul and Antony on the Nigg cross-slab is illustrated by a section of Petley's drawing of c 1810, 'after R Allen 1903' which had been reproduced by Allen for its evidence of lost bosses.
[41] Work towards a Visual Index of Early Medieval Carved Stones, supported largely by RCAHMS, but also by the Society of Antiquaries of Scotland, has been advancing steadily.
[42] Fisher 2001, with measured drawings by Ian G Scott, John Stevenson and John Borland, and photographs by Geoffrey Quick and others.
[43] Foster 2002, 167.

[44] Cox 1999, 169, who is content to use the 'traditional dating'.

[45] Henderson 2003. The difficulty of writing a general book on Pictish sculpture without the support of a modern corpus demonstrated that the view expressed by Henderson in *ECMS* (1993 repr, I, thirty-five), that there was no need to start afresh, was mistaken. Nonetheless many aspects of all three parts of *ECMS* will remain indispensable.

CHAPTER 6

CHRIST'S CROSS DOWN INTO THE EARTH: SOME CROSS-BASES AND THEIR PROBLEMS

By IAN FISHER

The basal structures of Scottish crosses and cross-slabs were not of great interest to Romilly Allen. Indeed, more is to be learned from their incidental appearances in the illustrations of *ECMS* than from the great archaeologist's descriptions, so meticulous for the ornamented sculptures themselves. Such attention as he gave to this material often concerned the display and conservation of the sculptures rather than the archaeology of their supports. In a rare piece of negative information, Allen noted that the Maiden Stone was 'not erected on a base', but the existence of other structures often passed without comment. The only ancient bases for which he recorded dimensions were the massive irregular slab supporting the Mugdrum Cross and the stepped plinths of St Martin's (Figure 10.2) and St Matthew's Crosses, Iona, whose statistics were reproduced from Sir Henry Dryden's papers.[1] All other references to old and new bases combined were outweighed by the two pages of correspondence on the re-erection of the St Madoes cross-slab in 1853. These reports from the parish schoolmaster to the antiquary T S Muir, who commissioned the work, concluded with the once-neglected slab standing 'in state majestic' on a new plinth of Bannockburn stone.[2] A report on the construction of a 'built foundation' for Aberlemno 2 (the churchyard slab) in 1898 was again provided by a local participant, the parish minister. Excavation showed that the butt of the slab had been earthfast and 'rested on the substratum of rock which underlies the churchyard'. The contrast with the nearby roadside slab in its socket-stone was noted in the minister's brief but lucid letter.[3]

We may sympathise with Allen's preference for the sculptured bases of Irish crosses, with their rich figural iconography. The tall base of the cross at the Columban monastery of Moone (Co Kildare) bears a charmingly naive series of religious subjects. Crosses at other sites, such as Ahenny (Co Tipperary), Clonmacnoise (Co Offaly) and Kells (Co Meath), show fantastic animals, hunt-scenes and processions of riders and chariots which Allen compared with Pictish art.[4] A further parallel, for the group of clerics on the North Cross of Ahenny, was discovered in 1943 at Papil (Shetland Islands), where a shrine-panel shows a procession of clerics approaching a free-standing cross on a massive basal block.[5]

In contrast to this wealth of sculpture on many Irish cross-bases, their counterparts in Scotland are unornamented and much evidence remains concealed in the soil, as in Allen's time. Nonetheless, in the past half-century greater attention to structural aspects of Scottish sculpture, and excavations on behalf of Historic Scotland and its predecessors, have exposed much new evidence (Chapter 7). Many uncertainties of interpretation remain, but it is clear that early medieval sculptors faced major technical problems as the ambitions of their patrons drove them to create ever larger carvings. The new evidence for the collapse and re-erection of the Hilton of Cadboll cross-slab parallels my own interpretation of St John's Cross, Iona, published in 1982.[6] This paper provides a brief overview of the symbolism and structure of cross-bases, with particular attention to western Scotland.

Although Allen did not discuss their non-figural iconography, the basal structures of crosses and cross-slabs were symbolic as well as functional. Raised bases represented the Mount of Calvary where Christ's crucifixion took place, and the cross itself linked earth to heaven. This concept was expressed in the poem of Mugrón, abbot of Iona and Kells (d 981),[7] whose linked monasteries displayed so many notable crosses in prominent bases:

> Cross of Christ up to broad heaven,
> Cross of Christ down into the earth.
> Let no evil or hurt
> Come to my body or my soul.

The Mount of Calvary was represented in naturalistic form in the 5th-century apse-mosaic of S Pudenziana, Rome, and on pilgrim flasks from Jerusalem itself. More symbolic versions with crosses on stepped plinths appeared on Byzantine and western coins, and one of these was incorporated in the 7th-century Anglo-Saxon pendant known as the Wilton Cross.[8] The stepped 'Calvary' base occurs frequently as steps cut into the basal blocks of Irish and Iona crosses (Figure 6.1). Although almost universal on later medieval graveslabs, it was uncommon in early medieval two-dimensional sculpture but is among the many remarkable features of the newly excavated lower portion of the Hilton of Cadboll cross-slab (Figure 3.1).

Some of the simplest cross-marked stones, including an inscribed example at Peebles and others of similar form on Iona,[9] were naturally tapered boulders or pebbles, selected to allow easy fixing in the soil. Probably the majority of upright sculptures, even some as large as Aberlemno 2 (see above), were supported only in this way, or perhaps strengthened by a buried packing or a visible pile of stones. A special development of the latter was the rough stone-built platform or open-air altar bearing one or more cross-slabs, known in Irish as a *leacht*. Well-known examples are those associated with the local pilgrimage on Inismurray (Co Sligo) and at St Patrick's Chair (Isle of Man).[10] A more substantial stone-built base which may have an early origin carries the tau-cross beside the boat landing on Tory Island (Co Donegal), and a comparable structure of mortared stone supports the pierced socket-slab of the 15th-century MacLean's Cross on Iona.[11] Such socket-slabs were used from an early time, and a millstone adapted for this purpose is described in Adomnán's 7th-century *Life of Columba*.[12] Some were built into more complex structures whereas others

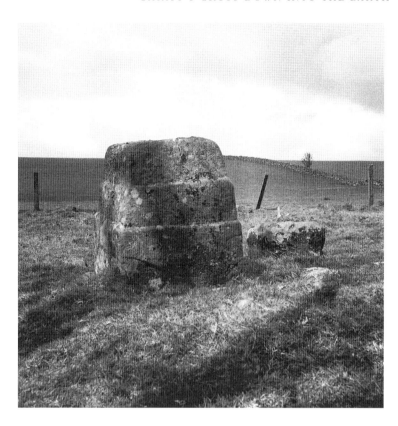

Figure 6.1 Machrikil (South Ayrshire), tall cross-base with high-spaced steps but no surviving cross. (Curle Collection, Crown copyright: RCAHMS)

were sufficiently massive to provide adequate support unaided, such as those of Aberlemno 3 (the roadside cross-slab) and the Irton Cross (Cumbria).[13] Additional stability for the sandstone socket-stone of the Canna Cross was provided by a kerb of edge-set slabs of the same imported material.[14]

Such socket-slabs are pierced right through, allowing the butt of the carving to receive additional support from soil or masonry below, but where the base remains *in situ* it is often not possible to ascertain whether this is the case. An example is the massive socket-stone of the Mugdrum Cross, recorded by Allen as measuring 1.68m x 1.22m and 0.46m in height.[15] Many crosses were set into taller socketed blocks, of the type represented on the Papil shrine-slab, which added to their impressive height and emphasised the Calvary symbolism. A much-weathered example is the large base that remains at the hilltop site from which the Barochan Cross was removed to its present home in Paisley Abbey (Figure 9.4).[16] A similar large block supports Scotland's tallest cross-slab, Sueno's Stone at Forres, whose re-erection by Lady Ann Campbell, Countess of Moray (d 1734) is perhaps the first recorded conservation exercise on an early medieval monument. She added the circular stepped support, repaired in the 19th and 20th centuries, which conceals not only the original base but also the lowest panel of carving on the east face of the slab. The sandstone base-block was partially exposed during investigations for the Office of Works in 1926, and again during Rod

McCullagh's 1990–91 excavation.[17] These investigations are described by James (Chapter 7), along with those at Shandwick where an upper collar had also been added to an older socketed base-stone.

The base of the 9th-century Dupplin Cross, formerly almost completely concealed in the soil, was exposed in 1990 for the making of a cast and is now displayed with the cross in Dunning Church. It is a more sophisticated development of the plain block, a truncated pyramid whose angles bear a series of grouped incisions which have been tentatively identified as an illegible ogham inscription.[18] The cross, within an interlaced frame, was set across one end of the rectangular top, forming a platform which was perhaps intended for kneeling or for offerings. Bases of similar pyramidal form, both plain and ornamented and usually with angle-mouldings or strips, are common in Ireland and Wales, as in the Tall Cross at Monasterboice (Co Louth) and those at Coychurch and Llandough (Glamorgan).[19] A fine and early example of the type, with figure-sculpture matching that of the shaft above, supports the late 8th- or early 9th-century cross at St Andrew Auckland (Co Durham), and there are plain examples at Lindisfarne.[20] However, the most celebrated of Northumbrian crosses, that at Ruthwell, has no associated base and the original form of its lower part is controversial. Robert Stevenson's suggestion that the crucifixion carved in this area is a later alteration has not gained general acceptance. Nevertheless, the architectural form, with the shaft curving out to a wider butt at the level where vinescroll ornament begins on the edges, strongly supports his proposal that it was designed to be buried in the soil in the same way as it stood in the manse garden for much of the 19th century.[21] On this analysis, the base-tenon seen by the sculptor J W Dods who moved the cross in 1887 would also have been an early alteration.[22]

A recent survey of early medieval sculpture in the West Highlands and Islands has shown the variety of cross-bases in the area.[23] Its principal monastic centre, the Columban monastery of Iona, has eight complete or fragmentary bases which are probably of early rather than late medieval date.[24] The most prominent examples are two very similar triple-stepped blocks of Mull granite supporting St Martin's Cross, probably of the late 8th century (Figures 17.5 and 17.6), and St Matthew's Cross which is at least a century later. The latter base shows no similarity to those of the Kells crosses, to which the cross itself was closely related, and it is probably an older one that has been reused. The undecorated character of these bases may be ascribed to their early date in relation to the Irish series, as well as the intractable nature of the material.

Another granite socket-stone, now split across, remains earthfast in the burial-ground Reilig Odhráin, at a possible entrance through the monastic vallum.[25] The socket is scarcely deep enough to have supported a cross of the scale indicated by its other dimensions, and it may have been used in conjunction with an upper socket-slab. The two elements of a composite slab of appropriate size (Figure 6.4C) were identified in Reilig Odhráin during the RCAHMS's survey, and are now reunited in the abbey museum.[26] They were held together by metal cramps, but were separated during the early medieval period and one half was reused as a graveslab bearing a ringed cross. The dimensions suggest that the base may have been intended to support

the composite St Oran's Cross, whose massive fragments were first recorded in the same area.[27]

A similar two-piece socket-slab secured by cramp-holes was part of the complex structure supporting St John's Cross, one of the earliest and largest of Irish stone crosses.[28] The existing base is a skilful reinstatement of the external elements shown in Erskine Beveridge's fine photograph of 1895 (Figure 6.2).[29] The surviving half of the socket-slab, supplemented by a modern replacement, is supported on four L-plan corner-posts which were slotted or rebated to hold side-slabs. Excavation in 1970, when the damaged shaft was replaced by a concrete replica of the complete cross, showed that the underside of the top slab is rebated to fit securely onto this box. It also revealed two socket-slabs within the box, which are now preserved separately. The upper one was a massive slab roughly shaped to fit between the corner-posts, and grooved on the upper face to receive the side-slabs. It lay directly on the smaller second slab, which is roughly rectangular, and the two stones combined to clasp the whole height of the base-tenon of the cross-shaft (Figure 6.3). Examination of the tenon itself by the RCAHMS showed that one face was smoothly tooled and projected beyond the line of the shaft, whereas the other face had been lost through a rough oblique break. Further evidence of damage to the cross itself, and replacement of some areas of the cross-head with local stone, suggested repair after a catastrophic fall, perhaps during the original erection of this carving of unprecedented span and weight. It was further proposed that the 'Celtic' ring was introduced for the first time as a structural necessity in these repairs, but that its symbolic significance was quickly recognised. On this hypothesis the first form of the cross-base is uncertain, since the two lower socket-slabs were shaped to hold the tenon in its damaged condition and it is not known whether the box arrangement was original. As well as its value in providing additional support to the shaft, the box formed an open-air altar at the base of an ambitious monument which stood close to the reputed burial place of Columba himself, and was undoubtedly a station for processions and other liturgical events. The technique of construction is closely related to that of the composite stone shrines known from Iona itself and from other sites in Shetland and eastern Scotland, as well as from Co Kerry.[30]

A remarkable feature of the upper of the slabs concealed within the base of St John's Cross is a circle, 1.15m in diameter, incised on the upper face. Its position, offset in relation to the cross-socket, probably indicates that the slab was about to be converted to a millstone when it was requisitioned for new use, rather than being a purely symbolic link to the Columban tradition of millstone cross-bases. Adomnán in his description of Columba's last days recorded that the saint rested between the barn and the monastery, where 'a cross was later set up, fixed in a millstone'.[31] This may have been a small timber cross set in a worn quernstone, but a circular base, probably a millstone, was depicted at the foot of a large ringed cross on the grave-slab of Eogan.[32] A masonry cross-base of late medieval type on Tòrr an Aba incorporates what appears to be a reused millstone 1.1m in diameter, and a larger edge-running stone, adapted to support a wayside cross, was excavated in 1979 north of Reilig Odhráin.[33] An early medieval example, 0.84m in diameter, remains at St Blane's, Kingarth (Bute), and Angus Graham suggested an ingenious reconstruction of the

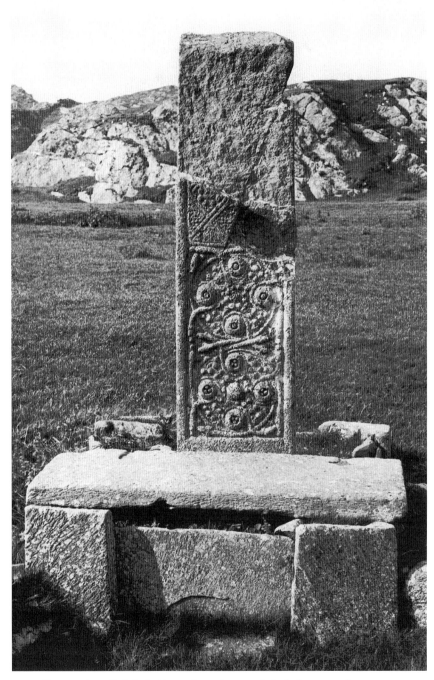

FIGURE 6.2 St John's Cross, Iona, base and shaft-fragment from east, photographed by Erskine Beveridge, 1895. (Crown copyright: RCAHMS)

CHRIST'S CROSS DOWN INTO THE EARTH

FIGURE 6.3 St John's Cross, Iona, cross-base. (Crown copyright: RCAHMS)

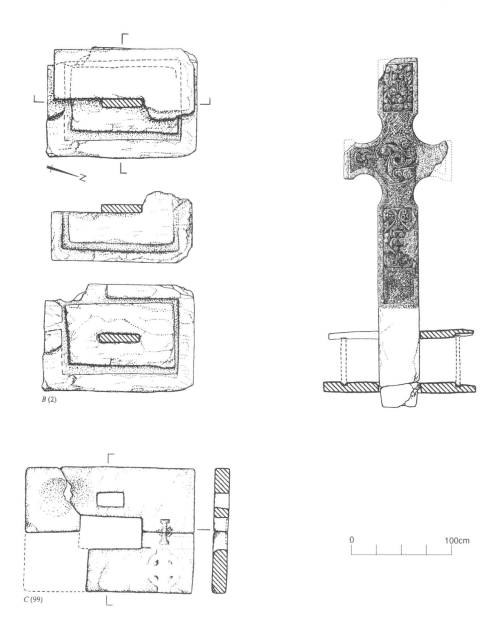

FIGURE 6.4 (B) Kilnave Cross, Islay, cross-base, (C) Composite socket-slab, Iona. (Crown copyright: RCAHMS)

complex millstone-base of the large cross at Ray (Co Donegal), near the Columban monastery on Tory Island.[34] However, the most remarkable parallel for the base of St John's Cross was found in 1990 during Conleth Manning's excavations round the North Cross at Clonmacnoise. This pillar stood in a circular stone 1.2m in diameter, rebated on the upper surface for side-slabs and notched for obliquely-set corner-posts.[35] Although smaller and differing in some details from the box-base of St John's Cross, it provides a much closer parallel than the crude composite base carrying a small late cross at Noughaval (Co Clare), which has been cited as evidence for a 12th-century date.[36]

Two slabs survive from the composite base of the 8th-century Kilnave Cross (Islay), the substantial lower slab being excavated in 1981 immediately below the cross, which at some period had been replaced in the soil with a packing of stones.[37] Its upper face bore continuous although irregular grooves for side-slabs, and these were matched on the underside of the thinner and incomplete upper slab, which had previously been identified in the churchyard by the Royal Commission (Figure 6.4B). The lack of corner-posts is puzzling and the structure may have been stabilised by an internal masonry packing, represented in the modern reconstruction by concrete. If this was done it proved inadequate, for the lowest 0.25m of the shaft had broken off and remained fixed in the lower socket-slab while the upper socket-slab was also broken irregularly.

James (Chapter 7) describes her 2001 excavation of the lower portion of the Hilton of Cadboll cross-slab. This had also suffered a disastrous fall like St John's Cross, for the present foot of the slab terminates in a crescentic break which cuts deep into the bossed key-pattern filling the stepped 'Calvary' pedestal of the vanished cross itself. In contrast to the Iona cross, the measures taken to re-erect it were surprisingly makeshift, with packing-stones set into the surrounding sand. A rectangular block against the east face of the slab separated it by a few centimetres from an incomplete socket-stone or 'collar-stone', which may be an original one *in situ*. A shallow rebate in this stone in line with the south end of the socket may have been intended to house some structural feature on the still-missing butt of the slab, but can hardly be related to the stumpy projections at the sides of the new fragment. The sight of the newly excavated stone wrapped in slings and suspended from a crane suggested that these projections, and perhaps those on the Meigle 2 cross-slab (Figure 15.3), may have served as anchorages for ropes or timbers in moving and erecting slabs of unusual scale.[38] Other parts of collar-stones were found on the site, and these await detailed analysis which may help to reconstruct the original form of the cross-base.

Dupplin and Hilton of Cadboll are only the latest of a series of excavations which have transformed our understanding of the crucial supporting structures of the great sculptures of the early medieval period. Continuing conservation and research, and greater awareness of the significance of stray socketed stones, offer the prospect of further knowledge of this neglected subject.

ACKNOWLEDGEMENTS

The drawings are by Ian G Scott, to whom I am grateful for many years of scrupulous delineation and perceptive interpretation of Scotland's historic sculpture. I am indebted to

John Barber for access to and friendly argument about excavations on Iona and at Kilnave, and to Heather James and Sally Foster for similar facilities during the removal of the Hilton of Cadboll slab-fragment from its setting.

NOTES

[1] *ECMS* III, 191, 367, 382–3.
[2] *ECMS* III, 293–4.
[3] *ECMS* III, 213–14.
[4] Allen 1887, 136, 182–235; Harbison 1992. Many Irish cross-bases are plain, and Harbison (1992, Vol 1, 395) also lists about 50 other socket-stones which no longer contain crosses.
[5] Harbison 1992, Vol 2, Fig 16; Moar and Stewart 1944, 91–9; Small *et al* 1973, Vol 1, 26, 39; Fisher 2002, 52–4.
[6] RCAHMS 1982, 17–19, 197–204; Fisher 2001, 15–16, 133.
[7] Murphy 1956, 32–5, 186–7.
[8] Volbach and Hirmer 1961, 336–7, Fig 130; Weitzmann 1979, 585–6 (No 524); Webster and Backhouse 1991, 27–8 (No 12), 106–7 (Nos 77a, b).
[9] Steer 1969, 127–9, Pl 9a; RCAHMS 1982, 180 (Nos 5, 6, 9).
[10] Thomas 1971, 168–75; Wakeman 1893; Kermode 1907, 102–3.
[11] Lacy 1983, 297, Pl 61; RCAHMS 1982, 239 (No 224).
[12] Sharpe 1995, 227, 373.
[13] Bailey and Cramp 1988, 115, Fig 358.
[14] Fisher 2001, 99.
[15] *ECMS* III, 367, Pl 75.
[16] *ECMS* III, 454–6, Fig 475D.
[17] McCullagh 1995.
[18] Forsyth 1995b, 237–9.
[19] Harbison 1992, Vol 2, Figs 488–9; Nash-Williams 1950, Nos 194, 206.
[20] Cramp 1984a, Part 1, 37–40, 201–2; Part 2, Pls 1–4, 13, 15, 1103–9.
[21] Stevenson 1993, 20–2.
[22] Farrell and Karkov 1992, 38–9.
[23] Fisher 2001, 16–17, Figs 54–5.
[24] RCAHMS 1982, 213–16 (Nos 96–103).
[25] RCAHMS 1982, 215–16 (No 103).
[26] RCAHMS 1982, 214–15 (No 99).
[27] RCAHMS 1982, 192–7 (No 80).
[28] RCAHMS 1982, 197–204 (No 82), 213–15 (No 96); Fisher 2001, 133, 135.
[29] *ECMS* III, Fig 399B; RCAHMS 1982, Fig 214; Fisher 2001, Fig 32B.
[30] RCAHMS 1982, 19, 216–18 (Nos 104–5); Fisher 2001, 17–18, 135; Thomas 1971, 150–63; Small *et al* 1973, Vol 1, 14–28, Vol 2, Pls 3–7, 13–14, 57; Thomas 1998; Herity 1993, 191–3.
[31] Sharpe 1995, 227, 373.
[32] RCAHMS 1982, 186–7 (No 45).
[33] RCAHMS 1982, 239–40 (Nos 222, 225); Fowler and Fowler 1988, 182–7, 197, 199; Barber 1981a, 308, Pl 19a. The Fowlers (1988, 186) refer to another 'mill-stone slot cross-base' being excavated in 1956 in the abbey cloister, an area for which no excavation records have been available to RCAHMS.
[34] Fisher 2001, 75–6; Graham 1953; Lacy 1983, 287–8.
[35] Manning 1992, 8–9.
[36] Barber 1981b, 101–2; Harbison 1992, Vol 2, Fig 526.
[37] RCAHMS 1984, 222; Barber 1981b; Fisher 2001, 54, 139.
[38] This is not to deny the symbolic significance of the projections at Fahan Mura (Co Donegal), which are aligned with the crosses on both faces of the slab (Harbison 1992, Vol 2, Figs 276–7). Ian G Scott has identified traces of projections in a corresponding position on the Hilton of Cadboll cross-slab (pers comm).

CHAPTER 7

PICTISH CROSS-SLABS: AN EXAMINATION OF THEIR ORIGINAL ARCHAEOLOGICAL CONTEXT

By HEATHER F JAMES

For decades, Pictish sculpture has enthralled art-historians and archaeologists in a search for its meaning. Both disciplines inform one another, and contribute to the development of an interpretation. One strand of the archaeologists' enquiry is the meaning these monuments hold in the landscape, and it is therefore unfortunate that many Pictish carved stones are not found in their original settings. This paper examines the evidence for the original settings of Pictish cross-slabs and crosses, specifically by reconsidering the results of archaeological excavations that have taken place prior to remedial work.

SHANDWICK, EASTER ROSS

The potential significance of the group of monumental cross-slabs on the Tarbat peninsula in Highland has already been discussed (Chapter 2). Of these, the Pictish cross-slab at Shandwick is the only one still standing in what is possibly its original setting. This scheduled ancient monument, in private ownership, stands in a field near a Bronze-Age cist cemetery, and a burial ground last used in 1832. The setting within a protective glass and metal display, is on the crest of a hill overlooking the sea (Figure 11.1). The process of change, from cross-slab in the landscape to cross-slab within a glass pavilion, has been documented (Chapter 11), but little is known of its history prior to the 19th century. The available records and historic maps, including Pont, have not produced any depictions or suggestions that it was moved to this site in the past.

Prior to its conservation in 1988 by Historic Scotland's predecessor body, Historic Buildings and Monuments (HBM), the Shandwick stone was supported by two square collar-stones, held with iron bars that obscured the lower part of the decoration. The top part was held in place with metal clamps. This repair work took place after the stone blew down and broke in two in a storm in 1846.

When HBM lifted the stone out of the base it was clear that the tenon had already broken, and that there was little of the stone left below the decoration. The

Figure 7.1
Shandwick during
excavation in 1988.
(© Highland Council)

two supporting collar-stones were removed, and beneath was a large socket-stone (Figure 7.1). It had a rectangular mortice-hole within which the cross-slab had been sitting and several other large slabs surrounded the setting, providing some support.

Bob Gourlay, then the Highland Council archaeologist, undertook excavations around the base after the cross-slab and socket-stone were removed.[1] The following information is based on the interim statement and the excavation record held in the Highland Council Archives, Inverness. The excavation extended only 5m x 8m, and the work took 5 days. It was undertaken in segments to natural subsoil. The plan shows the archaeological features after the socket-stone had been removed (Figure 7.2).

Beneath the socket-stone was a level surface of small sandstone fragments. This layer sealed a mound of ploughsoil (context 005), and had protected it from the erosion caused by cattle and sheep congregating around the stone. Two substantial post-pits on either side of the mound (015 and 008/010) were interpreted as the remains of post-holes from the original lifting mechanism. A third shallow pit (006), filled with charcoal and ash layers, lay to the west. Gourlay thought it was much later in date, possibly associated with the smelting of lead dowels for the 19th-century re-setting.

The mound of ploughsoil contained 'small quantities' of 19th-century pottery sherds, but these had probably found their way into the soil though natural disturbance, as the mound was unfortunately riddled with rabbit and mouse burrows. Despite the tradition that a 19th-century cemetery lay near the stone, no human remains were found. Gourlay concluded that there was no archaeological evidence for, or against, this being the original Pictish setting.

This excavation was on a very limited scale because of the lack of resources. It focused on the setting and its immediate surroundings, and did not attempt to examine the archaeological context of the setting in the wider landscape, nor its relationship with the Bronze-Age cist or the 19th-century cemetery.

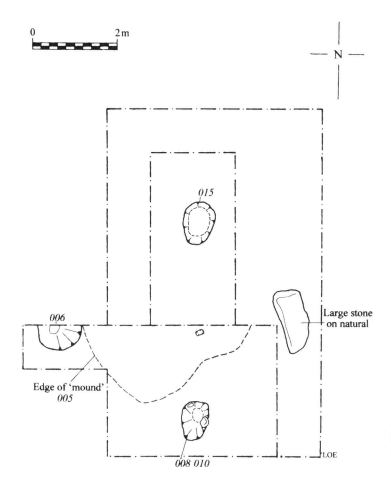

Figure 7.2 Plan of 1988 excavations at Shandwick, redrawn from archive plans. (© GUARD)

HILTON OF CADBOLL, EASTER ROSS

Just a few kilometres north of Shandwick are the ruins of a medieval chapel, from where the Hilton of Cadboll cross-slab was removed in the 19th century. The upper portion of the cross-slab, on display in the National Museums of Scotland, is a large rectangular block of sandstone, possibly carved at the beginning of the 9th century AD (Figure 3.3). Historic Scotland, which has responsibility for the chapel site, had commissioned Kirkdale Archaeology to undertake excavations to the west of the ruins in 1998 and in 2001. They retrieved several thousand carved fragments of the back of the cross-slab, which had been defaced on this site in the 17th century to create a memorial to Alexander Duff and his three wives. At the end of the excavation, the missing lower portion was found *in situ*, just west of the chapel.

Further excavations were undertaken by GUARD in the summer of 2001. The specification from Historic Scotland was very focused on retrieving all the remaining fragments of Pictish sculpture (which were then understood, on the basis of the earlier

FIGURE 7.3 Hilton of Cadboll and its two settings during the course of excavation in 2001. (© GUARD)

work, to lie in a discrete layer just beneath the turf) and revealing the extent of the lower portion. It also included an exploration of the relationships between the setting, the chapel wall and the enclosure wall. After a detailed topographic survey an area about 9m x 9m was opened around the lower portion (Figure 7.4).

The setting in which the lower portion (008) was found consisted of large, thin slabs that provided support on the west side and several large sandstone blocks on the east side (Figure 7.3). There were flat paving slabs (053) laid around the north side of the setting, that may once have encircled it. The discovery that the lower part of the design was obscured by packing stones indicated immediately that this was not its original setting. Further excavation of the lower portion revealed an earlier setting within which the tenon had broken off and a discarded collar-stone had been pushed to one side. The archaeological interpretation of the setting is made more complex by

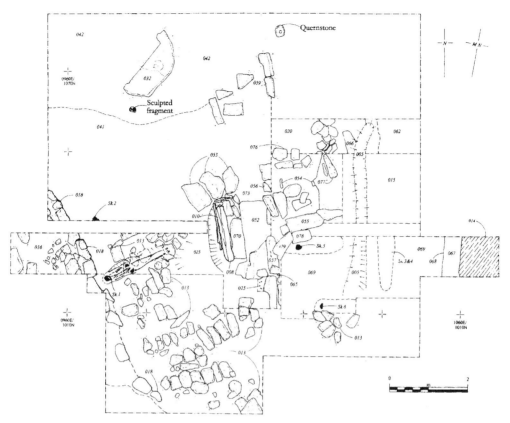

FIGURE 7.4 Composite plan of excavations at Hilton of Cadboll, lower portion of cross-slab in centre. (© GUARD)

the digging of a pit on its west side in the post-medieval period, in an attempt to remove the cross-slab, which was probably still attached to the lower portion at this time.

A programme of radiocarbon and Optically Stimulated Luminescence (OSL) dating has provided some insight into the chronological sequence of sand deposition and erection of the cross-slab. A charcoal sample from a layer cut by this setting returned two residual Pictish dates and a radiocarbon date of the first half of the 11th century. This setting therefore post-dates the mid-11th century. The OSL dating programme indicated that the sand below this setting was being deposited in the late first millennium AD, which is consistent with the radiocarbon dates.[2] This dating method also returned dates that strongly suggest that the slab's lower portion was placed into the setting in which it was found in the early 12th century.

An earlier setting for the 9th-century cross was uncovered just 0.3m to the east of the *in situ* lower portion (008). This setting consisted of half of an upper collar-stone with a massive sandstone block beneath. It was clear from the iron-stained sand beneath that this setting had been in place for a substantial length of time. On the

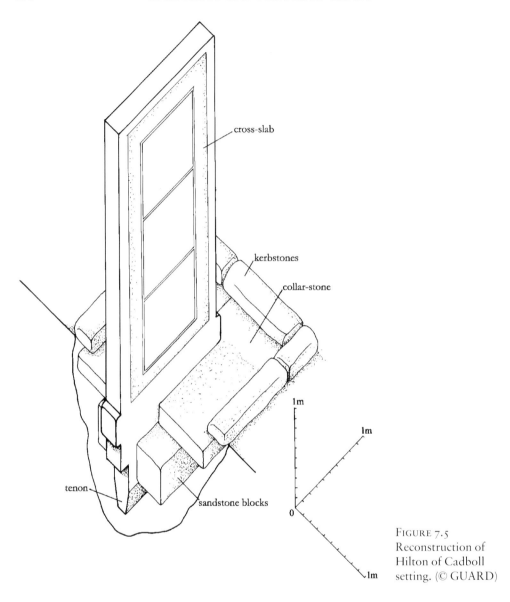

FIGURE 7.5
Reconstruction of Hilton of Cadboll setting. (© GUARD)

surface the collar-stone was edged with a kerb of oblong boulders (056 and 057), similar perhaps to the Canna Cross. A reconstruction of the earlier setting is possible, with the cross-slab lowered through a rectangular socket-hole in the collar-stone and held firm by massive stones on either side of the tenon, and the setting then surrounded by kerbstones (Figure 7.5). This is based on the archaeological evidence alone, and the engineering practicalities have not been taken into consideration. A fragment of what may be a tenon was found used as a packing stone at the southern end of this

setting indicating that the cross-slab had fallen and broken. It is not known for how long the cross-slab stood before it fell and required to be re-erected.

No further excavation took place around the earlier setting and so we have no material at present with which to date it. The stones are, however, still *in situ*, and OSL samples could be taken from beneath the collar-stone. The sand layers immediately above the collar-stone contained pottery dated between the 13th and 15th centuries, suggesting that the setting was visible on the surface until the medieval period, when it was deliberately covered up.

The relationship between the settings and the chapel wall were partly obscured by the presence of a medieval cemetery (Figure 7.4, Skeletons 3, 4 and 5). The author, however, made a tentative field interpretation of the stratigraphy, which suggests that the earlier setting pre-dates the building of the chapel, although the author thinks that it is unlikely that it is Pictish in date (Chapter 2).

The medieval chapel was dedicated to the Virgin Mary, and there may be a connection here with the female hunting scene depicted on the back face of the cross. Both of the settings are several degrees off being parallel with the chapel wall. Perhaps the earlier setting was aligned with another feature in the landscape, and this alignment was retained when the cross was re-erected despite the addition of the chapel into the landscape.

The horizon that contained thousands of carved fragments chipped off the back of the upper portion of the cross-slab (007) returned an OSL date of AD 1570 + 25, and also contained medieval pottery of the 13th to the 15th centuries. This suggests that the damage to the cross-face of the stone could have occurred earlier than its use as a gravestone in the 17th century. This perhaps raises the issue of whether the stone was in fact defaced as a result of the zeal of the Reformation.

In conclusion, two settings for the early 9th-century cross-slab were found. The earlier of the two settings is pre-12th century in date, and it is certainly unlike other early medieval cross settings that appear to consist of a massive socket-stone (Chapter 6). This leaves the possibility that the slab was brought here from another site or from a more deeply buried setting. A technical assessment of the sculpture's condition has revealed a complex history which includes the possibility that the cross-slab could have had more than these two settings.[3] There were no other distinctive Pictish artefacts found, the only material uncovered by the excavations from potentially Pictish layers being nails, a few animal and human bones and residual charcoal. One of the limitations of this excavation has been the inability, given the constraints, to examine the possibility of a buried Pictish horizon.

The project is also attempting to reconstruct the lost face of the cross-slab through detailed art-historical study of the surviving faces and the many thousands of fragments. This information is being integrated with the location of each individual fragment when excavated, into a database (to be made publicly available).

Other aspects of the project include a study of the geology of the stone (NMS) and a community study (Chapter 3). There is still, however, great scope for examining the setting of the cross-slab in its immediate context within the chapel enclosure, and within the wider landscape of the Tarbat peninsula.

SUENO'S STONE, FORRES

An opportunity to undertake more extensive excavation around Sueno's Stone was offered prior to the construction of a protective glass pavilion in the 1990s (Figure 11.2) and was led by Rod McCullagh.[4] Sueno's Stone, a cross-slab, stands in a field, on a level terrace on the north-east side of Forres. Just over 6.9m tall, it is thought to date from sometime between the 9th and the 11th centuries.

There is a local tradition that the stone was found buried lying flat during reclamation of the field, and that it was then raised into its present position. This tradition is refuted by McCullagh, who suggests that Sueno's Stone is one of two rectangular obelisks shown standing alongside each other on Pont's map of 'Murray' dating to the late 16th century. Again in Ainslie's map of 1789 there are two stones, this time depicted as pointed obelisks and described as 'Curious Carved Pillars'. The fact that the shape has been changed does suggest that Ainslie did not just copy the earlier Pont map.

Repair work on the stone is recorded in the *Old Statistical Account*, when Lady Ann Campbell arranged for the stone to be 'set upright and supported by several steps of freestone'.[5] Further repair works, including the construction of an octagonal fence, took place later in the 19th century. The stone was taken into guardianship in 1923, and in 1926 excavations were undertaken on behalf of the Inspectorate of Ancient Monuments. The hired workmen dug 'deep and well' and discovered that it was supported in a massive socket-stone weighing about 10 tons. Apparently the 'base was in part removed and the tablet thrown across the fence' implying that Sueno's Stone was lying out of its base for about a year.[6] After some local criticism the damage was repaired.

The size and shape of the 1990s excavation area reflected the anticipated extent of disturbance by the construction work. Area 1 measured around 8m x 15m, with the stone (F7) in the northern half surrounded by a hexagonal fence-line (F10) (Figure 7.6).

Several groups of post-holes and shallower features were seen. These groups had little stratigraphic connection with the sculpture or with each other, and so were grouped predominantly on morphology and location. They represented several episodes of activity, the number of which was not ascertained. The features (F) hatched NE–SW are all post-holes (Fs 3, 4, 5, 17, 18 to 21 and 33) and are particularly massive on the west side. These are probably the remains of some form of supporting structure used to erect the stone. Charcoal has produced a radiocarbon date of the 8th century AD for one of the pits, F3 (this was a small piece of roundwood), and the early 11th century for another pit F5 (a large angular fragment of elm). While these dates are unlikely to belong to the same event, it is quite possible that the large elm fragment is from a supporting timber, while the small piece of roundwood was a residual fragment. It would be tempting to suggest from this evidence that the date of the erection of the stone could be as late as the 11th century, and that Sueno's Stone was therefore a late Pictish work.[7] This would, however, depend on the elm fragment being related to the date of the setting, which would also have to be the primary setting.[8]

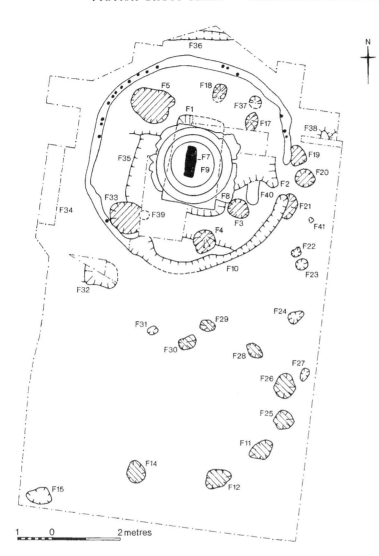

FIGURE 7.6 Plan of the excavated features at Sueno's Stone. From McCullagh 1995, Illus 5. (Crown copyright: Historic Scotland, by kind permission of the Society of Antiquaries of Scotland)

The features hatched NW–SE (Fs 11, 12, 14, 15 and 25 to 31) are shallow pits which seem to form a penannular pattern to the south of the stone setting. McCullagh has put forward the possibility that these have been truncated by plough action and were once post-holes. He has also tentatively suggested that these may represent the supporting structure for another stone, such as the one depicted in the historic maps. The unshaded features (Fs 22, 23, 24, 32, 36 and 38) are those which did not fit into any of the other groups. A sherd of post-medieval pottery was retrieved from gully F36, suggesting that some of these could be late features.

The removal of the 18th-century stepped collar-stones (F9) revealed a massive socket-stone, which was set into a large pit (F1). Further excavation beneath the

socket-stone was not attempted and so no dating evidence for the erection of the socket-stone was recovered. McCullagh concluded that it was improbable that the stone and its massive socket-stone had ever been moved, although it had tilted several times. The concentration of activity around the stone, as shown by the other unshaded features (F2, F40, F35, F8 and F10) reflected several attempts to right it, excavation (F2) and later attempts to display and protect it (F10).

A limited amount of attention was also directed towards the surrounding landscape. Geophysical surveys had already been carried out in 1978 and 1990, but unfortunately the 1978 survey produced no features and the 1990 survey detected anomalies that could not be explained by the excavation. During separate seasons the excavated area was extended beyond Area 1 by two trenches along the line of the access track, but no archaeological features are described. Seven small test pits (Figure 7.10) revealed no evidence of burials or other features, and confirmed that all the archaeological activity was focused around the stone itself. A deep topsoil in Area 5 in the north suggested that the original ground surface had become deeply buried as a result of cultivation, and that the stone may have once stood on a more prominent mound than it does now. More extensive excavations would be required, however, to confirm and quantify this.

THE DUPPLIN CROSS

The Dupplin Cross stood, until 1998, on Dupplin Moor (Perth and Kinross), on a terrace above the River Earn. It is a ringless cross, dated to the first half of the 9th century (Figure 14.3). It is about 2.5m high, set into a massive dressed trapezoidal block. By 1998 it had been decided that the cross would be removed indoors on conservation grounds; Historic Scotland organised its removal, and Kirkdale Archaeology undertook the associated excavations and historical research.[9]

The Dupplin Cross was believed by antiquarians to have been re-erected as a memorial, on the site of the battle of Dupplin Moor in 1332, when the forces of Edward Balliol defeated those of the Scottish regent. This site is less than 2km north of the palace of Forteviot, thought to have been the residence of several Pictish and Scottish Kings, and possibly the original location of the cross.[10] James Stobie's map of 1783 depicts the cross on the moor, which indicates that the stone has been in this approximate location at least since the late 18th century. By 1832 the cross was reportedly leaning over, and in 1925 it was put back in an upright position; a concrete collar was laid around the base and a fence constructed around it.

The first phase of excavation took place in 1998 just before the removal of the stone for conservation. The trench measured 4m x 2.9m.[11] The concrete ringbeam around the base was uncovered along with some modern iron objects. Unfortunately, any original cut into the underlying deposits for the insertion of the socket-stone had been removed by the concrete construction in 1925. Removal of some of this concrete revealed the socket-stone to be a massive block over 0.5m thick on one side. There was a circular hole in the base of the socket-stone that had been cut for a supporting metal bar as part of the works in 1925.[12]

A second phase of excavation took place after the removal of the cross and involved excavation of a slightly wider area (3m x 2m, with two extensions) looking for other features in the vicinity. The socket-stone was found to be sitting directly onto natural subsoil and when the socket-stone was removed four small tubes of concrete were found beneath it. These had presumably fallen through the circular hole when the cross was being re-erected in 1925.

The excavation was extended again, this time to the north with an area around 6m x 5m with two further extensions, one to the north and one to the east (Figure 7.10). This uncovered an oval-shaped compact stone surface at a distance of 5m north of the socket-stone, beneath 0.5m of ploughsoil. The stone surface was unfortunately not investigated further, and there were no finds to help date this feature. It was interpreted as either a viewing platform for the cross or perhaps the site of an earlier setting. A gully for a fence line had clipped the south side of this surface. A sherd of 18th- or 19th-century pottery from a post-hole in this gully indicated that this fence-line, perhaps surrounding the cross, was fairly modern. There were also two concrete foundations for modern post-settings.

These excavations revealed the setting for the cross was a large socket-stone sitting directly onto natural subsoil. It also highlighted the damage caused by earlier remedial works. Disappointingly, no evidence was retrieved that would support or argue against the tradition that the cross was brought to this site in the 14th century. The removal of the cross from its landscape location has raised the issue of whether this site is adequately protected, given that there is clearly archaeological evidence remaining here.

CAPELRIG

In contrast with these recent excavations the Capelrig Cross was examined in 1924 when it was dug up and removed to Glasgow Museum (Chapter 9).[13] Until then the shaft of the cross stood partially buried in a field north of the Auldhouse Burn in the south of Glasgow, and was often used as a rubbing stone by cattle.[14] The cross was found standing in its original socket-stone that consisted of a large boulder, laid on a pavement of stones with a cairn built up around its base, reminiscent of the Dupplin Cross. Something of the nature of the 'excavation' undertaken by workmen with a pick and shovels can be detected in the photograph (Figure 7.7). No dating evidence was retrieved, except for a small incised cross with expanded terminals carved on the socket-stone.

Clearly the attention of these antiquarians was on the cross itself, and there was no attempt to explore its setting more widely. Despite the removal of the cross from this site, the area should still be a priority for protection so that it is available for further examination, perhaps by geophysics and excavation, to see if there are any associated structures.

KEILLS CROSS, KNAPDALE

The Keills Cross in Argyll and Bute is a 9th-century cross which originally stood 50m to the north-east of a medieval church and burial ground, before it was moved

FIGURE 7.7 Capelrig cross-base during excavation in 1926. (© Glasgow Art Galleries and Museums)

inside.[15] In a 19th-century photograph the cross is shown surrounded by a boulder plinth. An examination of this setting by Trevor Cowie in 1979 revealed it to be a rather informal construction that did not utilise a massive socket-stone, as was usual for the period.[16] The plinth was up to 0.4m above the surrounding ground level, and was constructed of drystone-work sitting partly over turf and partly over natural subsoil and bedrock (Figure 7.8). A sub-circular hole for the cross was rock-cut to a depth of about 0.5m, filled with two or three possible packing stones and some disturbed soil. The cross is known to have fallen down on at least two occasions in the recent past, hence the disturbed soil within the hole.

Cowie considered the plinth to be of no great antiquity as it partly sat over former turf. This is also supported by Ingval Maxwell of the SDD (Scottish Development Department, now Historic Scotland), who thought the base of the cross would have sat in a mortice base-stone.[17] It is likely therefore that this is not the original location of the cross, but that it has been brought here and set into its informal base. No dating evidence for this was retrieved from the excavation. Over the years the cross probably toppled slightly and required more support, so a plinth was created round the base. While the excavations showed that the plinth was not an original feature, there is no way of knowing if the sub-circular rock-cut hole had been enlarged or recut from an original, smaller mortice hole.

Keills was dedicated to a Leinster saint, Abbán Moccu Corbmaic,[18] and was the parish church for Knapdale until the 17th century.[19] A chapel on Eilean Mor (Argyll and Bute) has a similar dedication, and a cross there has been dated to the 10th century.[20] There is also a cave which has an Early Christian chi-rho cross and a marigold, suggesting that it was used for 'aesthetic meditation'.[21] An investigation of the Leinster saint suggests that the foundation in Argyll may have been as early as the

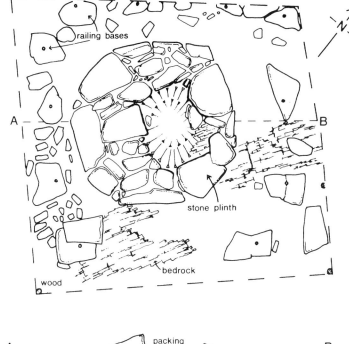
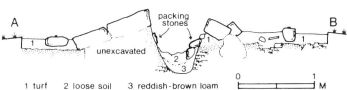

FIGURE 7.8 Keills, plan of the area excavated around cross in 1979. From Cowie 1980, Fig 1. (Crown copyright: Historic Scotland, courtesy of Glasgow Archaeological Society)

7th century, perhaps by one of Abbán's disciples, or that the dedication is a hypocoristic form of the name of Colum (Cille), Columba.[22] It is thought that these two sites were linked, perhaps the island site being established in the 7th century and the Keills site some time later, their status becoming reversed with Keills becoming the principal church and the island site acting as a hermitage.[23]

It is possible that there was either an earlier chapel or church at Keills, associated with the cross in the early medieval period, or that the cross was brought here from Eilean Mor in the medieval period, when the church was dedicated. The visible foundations of other structures, identified as a 'substantial depopulated settlement', have been noted in the vicinity of the chapel.[24] These remains would be worthy of further investigation, given that they may include or be sealing pre-improvement remains, an investigation of which would throw light on the origins of the mainland site.

KILNAVE, ISLAY

Another decorated cross, this time of 8th-century date, stood outside a 12th-century church at Kilnave, Islay (Argyll and Bute). By 1981 it had become unstable

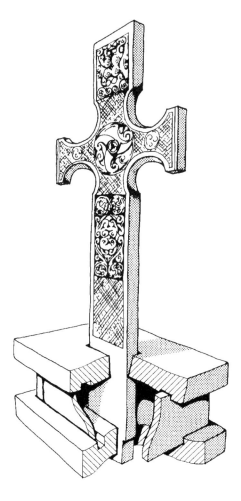

FIGURE 7.9 Reconstruction of the Kilnave Cross in its cist-type base. From Barber 1981, Fig 5. (Drawing by Angie Townshend. Crown copyright: Historic Scotland, courtesy of Glasgow Archaeological Society)

and so the SDD arranged for it to be lifted and re-bedded in concrete. Excavations were carried out by John Barber, then of the Central Excavation Unit.[25] After the cross was removed a small area was de-turfed, revealing what was described as a 'crude arrangement of stones', 0.45m thick, which had supported the cross. Beneath these stones was a large grooved slab with a rectangular hole, in which the broken tenon of the cross-shaft was firmly wedged. This showed that this was an earlier setting incorporating the grooved slab as the base stone of a composite, cist-like, supporting structure (Chapter 6). It is thought that this cist-like base would have been filled with earth or stones and was intended to be visible (Figure 7.9; see also Figure 6.4). A small step had been cut into the tenon which was not required for the slab in which it was found, and so Barber suggests that the cross was originally set within another setting, such as the pyramidical blocks as found on Iona. The layers of sand beneath the grooved slab were investigated, and beneath them was a group of stones and an earlier post-pit cut into sand. Little was made in the discussion of the earlier

pit 'in which an upright of some type had been held in place by a packing of stones'.[26] This would suggest that this setting was preceded by an earlier one, perhaps for a timber precursor.

The potential complexity of settings and the difficulty of dating them have been highlighted by this example. The presence of the 8th-century cross does raise the possibility of there being an Early Christian church on this site, but again the limitations of the excavations within the graveyard have not allowed for any investigation of this possibility. A consideration of the cross in its wider context would take account of the 'kil' place-name, the chapel and oval-shaped enclosure on Nave Island, and the excavations of the nearby multi-period site at Kilellan Farm which date from the Mesolithic to the Early Historic period.

FOWLIS WESTER

Excavations of a cross-slab at Fowlis Wester (Perth and Kinross) took place in 1991.[27] The Fowlis Wester 1 cross-slab (Figure 10.1) was being moved from the centre of the village to inside the nearby church, and so excavations tried to determine whether the cross-slab was in its original setting. The cross-slab was surrounded by a small enclosure of iron railings that were set into sandstone and concrete, and the socket for the stone had been cut into bedrock. The cross-slab was secured into this by mortared rubble, which appeared to have been reused from another building. This rubble packing material showed that this setting was not original. However, it is impossible to know when the rock-cut hole was first created and how much alteration had taken place to keep the cross upright.

This excavation was again quite limited and there was no consideration of the wider archaeological context. This includes another finely carved cross-slab and two other fragments that were found in 1932 during the church's restoration, and which are now displayed inside it.[28]

CRIEFF BURGH CROSS

In contrast, the Crieff Burgh Cross Project was truly multi-disciplinary. This late 10th- to early 11th-century cross was located in Crieff High Street, Perth and Kinross, until it was removed for conservation and re-display in Crieff Tourist Information Centre in 1998.[29] The limited excavations of the settings found that the stone was set in a hole in the subsoil and packed with small stones that contained late 18th- and early 19th-century pottery. The base of the cross had a tapering undecorated tenon, indicating that it would originally have fitted into a socketed base.

Although it was clear that the stone had only been displayed in Crieff High Street since the 18th century, the associated project explored the cross's inscription, its art-historical and landscape contexts, especially the geology, place-name and wider archaeological evidence. It also explored the 19th-century references to the cross being brought from Strowan a century or so before. It was concluded that the cross had probably been moved from its original setting in the curvilinear graveyard of St Ronan's Parish Church to the market-place at Strowan, from where it was moved to

Crieff in the 18th century. Both Strowan and Fowlis Wester were suggested as early Strathearn thanages with associated early churches that may have provided the secular and ecclesiastical impetus for the creation of these crosses.[30]

DISCUSSION

The excavations of the settings of the massive Pictish cross-slabs and crosses have produced some varied results but, from this admittedly small sample, it can be seen that both utilise massive socket-stones, set on a prepared surface of stones, such as Shandwick, Dupplin and Capelrig. At Dupplin, there was a suggestion that this could have been a viewing platform. This is comparable to the socket-stones found at unexcavated sites, such as the Kildalton Cross, Islay, Argyll and Bute, where the socket-stone is now hidden by a 19th-century stepped base. The Kilnave excavation provided evidence for a cist-like setting that would have been visible above the ground, like the earlier of the Hilton settings with its collar-stone and kerb. It has not been proved, however, whether either of these are early or later or medieval in date.

The excavations have also revealed post-holes left by the temporary lifting mechanisms. Over time these settings either start to lean, as at Sueno's Stone, or suffer sudden collapse, perhaps in a storm, as at Shandwick, and have required remedial work to keep them upright. This remedial work has, in the past, tended to be undertaken without archaeological supervision, and so evidence for the original setting, as well as associated stratigraphical and chronological evidence, has been destroyed without the advantage of modern recording techniques. Even when the surrounding horizons have not been destroyed, dating evidence can still be difficult to retrieve. Pottery does not generally appear in significant quantities from these excavations until the later medieval period and datable artefacts are extremely scarce. Radiocarbon dates have a wide probability range that hampers the identification of individual chronological events. One potentially successful avenue is OSL dating that has produced some interesting results at Hilton of Cadboll.

The area of the excavation trenches has generally been dictated by the extent of the anticipated disturbance during remedial works. The relatively large (e.g. Hilton of Cadboll) or extremely limited (Kilnave and Keills) nature of the excavations has affected the nature and quantity of data retrieved, and influenced to what extent the crosses can be seen in their wider contexts (Figure 7.10). Where it is quite clear, from documentary sources or other means, that the monuments are not in their original location or are displayed in a medieval cemetery (e.g. Kilnave), it may be less imperative or not be feasible to excavate a wider area, as well as being undesirable to disturb human remains. However, when the possibility remains that the setting is original, or that there may be contemporary ground surfaces or associated archaeological evidence in the vicinity, then the excavation should be more wide-reaching to take these factors into account and relate them back to the setting. To date there have been no research-led excavations that were established with the explicit intention of exploring the significance of a place where sculptures have survived as monuments in the landscape. Martin Carver's ongoing work at Portmahomack (Chapter 2), Chris Lowe on Inchmarnock (Argyll and Bute) and Peter Hill at Whithorn are the only

PICTISH CROSS-SLABS — ARCHAEOLOGICAL CONTEXT 111

FIGURE 7.10 Comparison of excavation trenches around carved stones. (© GUARD)

examples to date of significant, research-driven excavation of early medieval sites known to have produced important early medieval sculptures.[31]

The benefits of an in-depth consideration of the wider aspects of the sculptures' context have been well illustrated by the Crieff Burgh Cross Project, despite the limited extent of the excavations around the 19th-century setting. It is anticipated that the current Hilton of Cadboll project will address many of these aspects of context, although more work could be done on the associated medieval settlement of Catboll-fisher (Chapter 2). There is still potential for a thorough landscape investigation at Shandwick. At Nigg, however, the intrusive investigations would be limited by the presence of the medieval church and cemetery.

Future approaches to the study of Pictish sculpture in the landscape should take account of the several models for the original erection of the sculptured stones (Chapter 2), and also the several contexts in which they are found, including churchyards, fields or reused in secular buildings,[32] which relate to the sculptures' loss or evolution of meaning. A multi-disciplinary and flexible approach to each individual setting, involving geophysical survey, suitably scaled excavation, historical and place-name research would help to bring the two sides of this equation together. It would provide a consideration of the context and biography of each of these complex monuments.

ACKNOWLEDGEMENTS

The author would like to thank Historic Scotland per Sally Foster for initiating this research, and Stephen Driscoll and Ian Fisher for their comments on this paper. The line illustrations are by Gillian McSwan. The 2001 Hilton of Cadboll excavations were commissioned by Historic Scotland and also sponsored by the National Museums of Scotland, Ross and Cromarty Enterprise and Highland Council.

NOTES

[1] Gourlay and Pollock nd.
[2] Sanderson and Anthony 2004.
[3] Hill 2003b.
[4] McCullagh 1995.
[5] Stephen 1795, 346.
[6] *Forres, Elgin and Nairn Gazette*, 3 August 1927.
[7] Stephen Driscoll pers comm.
[8] Rod McCullagh pers comm.
[9] Kirkdale Archaeology 1998b; 1999.
[10] Alcock and Alcock 1992.
[11] Kirkdale Archaeology 1998b.
[12] Stephen Gordon pers comm.
[13] Batey 1994.
[14] Lacaille 1927.
[15] Fisher 2001.
[16] Cowie 1980.
[17] Cowie 1980, 110.
[18] Fisher 2001, 4.
[19] MacLean 1983.
[20] Fisher 2001, 4.
[21] Fisher 2001, 4.
[22] MacLean 1983, 59–60.
[23] MacLean 1983, 61.
[24] Reported by the OS in 1973.
[25] Barber 1981b.
[26] Barber 1981b, 98.
[27] Scotia Archaeology 1991.
[28] Waddell 1932.
[29] Hall *et al* 2000.
[30] Hall *et al* 2000, 176.
[31] http://www.headlandarchaeology.com/Projects/Inchmarnock/Inchmarnock_main-page.html; Hill 1997.
[32] Mack 2002.

CHAPTER 8

HIC MEMORIA PERPETUA: THE EARLY INSCRIBED STONES OF SOUTHERN SCOTLAND IN CONTEXT

By KATHERINE FORSYTH

INTRODUCTION

The *earliest* of the 'Early Christian monuments of Scotland' are the dozen, upright, Latin-inscribed pillars of the lands between Solway and Forth,[1] which date from the 5th, 6th and early 7th centuries (Figure 8.1).[2] They are among the least glamorous of Scottish early medieval sculptured stones: four have no decoration at all, five have only simple, incised forms of the chi-rho symbol, one bears a small incised cross. A further two were lost without illustration. Despite their visual plainness these stones have an exceptional historical significance and play a pivotal role in our understanding of northern Britain in the initial, crucial, post-Roman centuries.[3]

As is well recognised, these Scottish stones constitute the most northerly branch of a sculptural phenomenon which ranges throughout the western part of the Brittonic-speaking world: in the Isle of Man, in Wales, in Somerset, Devon and Cornwall, and even across the Channel in northern Brittany.[4] In his corpus of the Welsh examples, Victor Nash-Williams labelled this class of 5th-7th century inscribed monuments 'Group I'. It seems appropriate to apply the same term to such monuments in whichever region they occur. There are just over 240 examples of Group I monuments, so as a proportion of the total, the 13 from Scotland are very few indeed, no more than 5%. Despite their small numbers, however, the collection is notably diverse. Between them these dozen monuments encompass the full date-range of Group I, they bear texts of various lengths, which employ several different formulae, and are laid out both horizontally and vertically. The one thing they have apparently lacked is any ogham, and, as discussed below, even that deficit now appears to have been remedied. The Scottish group is thus not a single school, reflecting a discrete moment of influence. Rather it implies at least episodic and possibly enduring contacts with the main centres of the epigraphic tradition further south and exposure to their evolving habits over a long period of time.

Previous studies have tended to lump the southern Scottish stones into a single group. This is a natural consequence of the fact that modern studies of Dark-Age

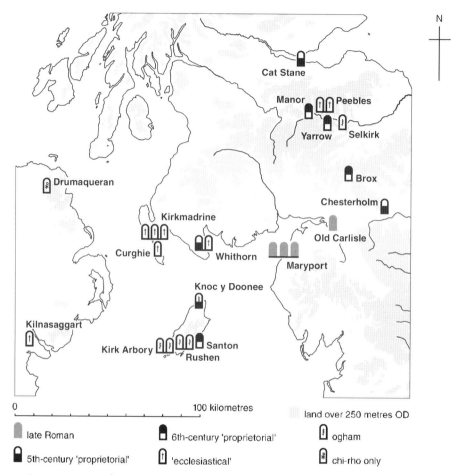

FIGURE 8.1 Early inscriptions in southern Scotland and adjacent areas. Based on Thomas 1968, 106 (Drawing by C Unwin. Crown copyright: Historic Scotland).

sculpture tend to be sponsored by national or regional bodies and therefore follow modern boundaries. A less arbitrary distinction is the obvious hiatus in the Group I distribution map between the most southerly of the Scottish examples and the most northerly of the Welsh. From a landward perspective, the gap is considerable — 225-odd km — although, by sea, the Isle of Man provides a crucial geographical and cultural bridge between these two stone-erecting areas. Nonetheless, the geographical separation should not obscure the fact that the Group I stones are, in essence, a unitary phenomenon.

The Scottish stones have been studied in isolation, and explained in purely Scottish terms. While the Manx, Welsh and Dumnonian ones tend to be viewed in largely secular terms — as the monuments of a sub-Roman secular elite, under strong Irish influence — the Scottish ones have been viewed primarily in a religious context, specifically that of the Conversion. Charles Thomas's view was that the Scottish

stones offered 'a faint trail ... of the northward diffusion of Christianity', from a western, Solway focus, either at Whithorn or Kirkmadrine (Dumfries and Galloway) whose ultimate source was a late Roman bishopric at Carlisle.[5] I wish to argue that the group encompasses two discrete strands, only one of which is properly ecclesiastical. The other, though Christian, is primarily secular. These two distinct types of monument had different functions which they performed in different social and physical contexts. Each has quite different historical significance.

THE LATINUS STONE, WHITHORN

We begin with the famous 5th-century memorial to Latinus, the first Christian in Scotland whose name we know, and to his unnamed daughter (Figure 21.1). This is an explicitly and emphatically Christian monument. At its summit is the chi-rho monogram in its early, six-armed, Constantinian form,[6] and its text opens with the triumphant declaration: TE LAUDAMUS DOMINUM, 'We praise You, the Lord!'. This is a funerary monument but it does not bear the usual funerary formulae such as *hic iacet*, or *hic requiescit*, or *in tumulo*. Instead it has the unique phrase *(h)ic sinum fecerunt*, 'they made this sign', the *sinum* in question being the chi-rho above.

The horizontal layout and comparative length of the inscribed Latin text links the Latinus Stone to a group of about a dozen so-called 'extended Latinate'[7] inscriptions from western Britain. These are arguably the earliest sub-group of the Group I stones, dated by Tedeschi on palaeographic grounds to the 5th century.[8] In addition to the classically-inspired horizontal layout, and early forms of roman capital script, the 'extended Latinate' inscriptions are united by the fact that in each case the text is a 'one off'. Although a common pool of phrases and formulae is drawn on to convey similar information, each composition is unique and there is considerable textual variation — in contrast to other, later Group I sub-groups which are more narrowly formulaic.

Several aspects of the 5th-century 'extended Latinate' inscriptions hark back to the Roman period. In the case of the Latinus Stone, there is the Constantinian form of the chi-rho — found in Romano-British contexts,[9] and very rarely thereafter; also the commemoration of a young child, common in Roman funerary epigraphy;[10] and the stating of the age at death of the deceased. Life-span is frequently noted on Roman monuments, both Christian and non-Christian, from the 3rd century onwards,[11] but occurs in post-Roman Britain on only three other stones: the monument to the 13-year-old Rustica, daughter of Paterninus, at Llanerfyl, western Montgomeryshire (421/294);[12] and the monument to the 33-year-old *Cunaide* at Carnsew, Hayle, on the north coast of west Cornwall (479/Ok 16).[13] The latter is of particular interest for our understanding of the context of the Latinus Stone for it came from a secular rather than an ecclesiastical site. It once stood on a mound over an oriented cist-grave, just outside and below the small coastal fort of Carnsew.[14] Tellingly, Carnsew, with its commanding view of the Hayle estuary, is no more than 1.6km from the important early church site of Phillack,[15] which, in addition to a Group I stone of its own (471/Ok 39), has produced one of only two other Constantinian chi-rho symbols from

non-Romano-British contexts (-/Ok 40), the other being the lost plaque from St Just (Cape Cornwall) (-/Ok 50).[16]

While the Latinus Stone *could* have stood in an early cemetery and, even, beside an early church, it need not *necessarily* have done so.[17] It is equally possible that, like Cunaide's stone at Hayle, it marked a 'special grave' at a *secular* power centre. The 5th-century 'extended Latinate' inscriptions of Wales come typically from places with strong Roman associations: Rustica's memorial and that of Porius at Trawsfynydd, for instance, stand at nodal points in the Roman road system.[18] Unfortunately, the excavated Roman evidence from Whithorn is weak and inconclusive.[19] It can be no coincidence, however, that one looks out from the Isle of Whithorn more or less directly towards Maryport on the Cumbrian coast, visible on even a moderately clear day. The Roman fort at Maryport, probably the garrison of the Solway fleet, was occupied certainly into the second half of the 4th century[20] and possibly beyond.[21] That there were Christians at late Roman Maryport is demonstrated by a funerary plaque, known only as a fragment and now sadly lost, incised with a Constantinian chi-rho monogram (*RIB* 856). Two further stones from Maryport (*RIB* 862–3) form a possible bridge to the Whithorn Latinus Stone. Although included in Collingwood and Wright's 1965 *Roman Inscriptions of Britain* (*RIB*) but not in Macalister's 1945 *Corpus Inscriptionem Insularum Celticarum* (*CIIC*) and, perhaps as a result, largely ignored by students of the Early Middle Ages,[22] they occupy a liminal position between the two corpora, and thus underscore the danger of drawing down a disciplinary iron curtain between Roman and Dark-Age studies.

The tombstones in question are undecorated rough blocks, and like the similar one from Old Carlisle (*RIB* 908), lack the usual formalities of Roman funerary monuments, even late ones. Their short texts straggle across the face of the stone as wayward in layout as they are in orthography. The people commemorated have, significantly, Celtic rather than Latin names and, interestingly, at least two of the three are women. No kinship information is given. The script, though informal, is nonetheless typically late Roman and the text employs the characteristic late Roman formula *vixit annos* to introduce the deceased's age at death, as found on the Cornish Cunaide stone. It is a very short distance, epigraphically, from these Cumbrian stones to the 5th-century 'Brigomaglos' stone (*CIIC* 498), found by the late Roman fort of Vindolanda, on Hadrian's Wall (Chesterholm, Northumbria),[23] which, in its use of the *hic iacet* formula is more obviously a British 'Group I' monument.[24] Brigomaglos is, of course, a purely native Celtic name — like Rianorix (Maryport) and Tancorix (Old Carlisle).[25]

Given the strength of this Roman background to the Whithorn stone, can we say then that Latinus was a Roman? He has a very Roman-sounding name, but what exactly does that signify in this period in this region, beyond the limits of the old Empire? We know that Latin names were adopted with enthusiasm by Romano-Britons. Many of these names were absorbed into British, became naturalised as British names, and thus continued to be given to the children of Welsh-speakers well into the medieval period and, indeed, beyond. Sims-Williams's analysis has quantified the considerable popularity of such continuing-Roman names among the stone-erecting classes of western Britain in the 5th and 6th centuries: a full 23% of the names

recorded on the stones are Latin in origin.[26] That these retained some air of *Romanitas* is borne out by the marked drop in the frequency of these names in the inscriptions of the 7th century onwards (down closer to 6%) and a resurgence in the popularity of traditional Celtic names. Latinus itself is one of the names which was adopted into Welsh (it survived into medieval Welsh as *Lledin*)[27] and indeed, turns up on a bilingual Latin/ogham stone from north Cornwall, at Worthyvale, near Tintagel (470/Ok78). Despite the obvious continuing-Roman aspects of his monument, the Celticity of the Whithorn Latinus is underscored by the fact that he is identified in native fashion according to his kindred, named for the fully Celtic *Barrouados*. It is telling also, that the relationship specified is that of *nepos*, 'grandson, descendant'. There is only one instance of this word on a Roman inscription from Britain, on the dedication plaque of Lossio Ueda, the early 3rd century Caledonian at Colchester (*RIB* 191). In Irish Latin sources *nepos* is used as equivalent to Old Irish *aue*, gen *auí* (ogham *avi*) and is a standard way of expressing membership of a kindred.[28] The chances are that Latinus was a local magnate, but, given the form of his ancestor's name it is possible that his family were of Irish origin.[29]

THE 'CAT STANE'

Roman names also appear on another 5th-century 'continuing-Roman' monument the so-called 'Cat Stane' from Kirkliston (City of Edinburgh) (*CIIC* 510).[30] Both the person commemorated, Vetta, and his/her[31] father Victr(icius) have names of Roman origin. The horizontal layout of the Kirkliston inscription and the form of capital script used hark back to the late Roman tradition, as discussed above. The phrase IN (H)OC TUMULO IACET is unique within the Group I corpus but links the Cat Stane with the *hic in tumulo iacit / requievit*, of other 5th-century 'extended Latinate' inscriptions (e.g. Porius, Rustica, Cunaide, discussed above).[32]

In archaeological terms, the continuing-Roman context of the Brigomaglos stone is obvious. It was found in a secondary context near the Roman fort of Vindolanda by Hadrian's Wall, occupation of which continued into the 5th century,[33] at least.[34] The Roman associations of the Cat Stane are less direct. The monument stood beside a crossing of the River Almond which flows to the sea only 5km or so to the north. Significantly, at the river-mouth stood the former Roman coastal fort of Cramond.[35] The fort, with its extensive extra-mural settlement and possible harbour, was evacuated in the 210s, but pottery and coin evidence attest to continued Roman activity of some sort at the site, dated securely to the late 3rd century and probably into the mid-4th century.[36] The site was important again in the early medieval period, as reflected in the discovery of an Anglo-Saxon runic-inscribed ring and an ecclesiastical enamel mount of 8th- or 9th-century date, and in the fact that it was the centre of the medieval parish.[37] The issue of continuity, if any between the late Roman and immediately post-Roman periods, is difficult,[38] but the deliberate siting of the medieval parish church directly over the administrative centre of the Roman fort implies, at least, some lingering sense of prestige.[39] Note also that a building interpreted as a church was built over the praetorium area at Vindolanda.[40]

FIGURE 8.2 *Remarkable ancient stone, on the Kirkliston road, called the 'Cats Stane' from nature by A. Archer July 1836.* (Crown copyright: RCAHMS)

A closer look at the immediate context of the Cat Stane is rewarding. It stood marking a special grave in a long-cist cemetery in an area of prehistoric ritual activity. It may itself be a reused Bronze-Age standing stone,[41] though this is not certain.[42] As is made clear by Proudfoot and Aliaga-Kelly's map,[43] the cemetery lay beside an old road close to the point where it crossed the boundary of the medieval parish, en route to the river crossing (Figure 8.2). It is becoming increasingly clear that many of the medieval parishes of Scotland had their origins in pre-existing units of secular administration[44] and there may well be a much older estate boundary underlying the Kirkliston parish boundary at this point. If so, then, as one travelled west along the road towards the river, more-or-less the first thing one would see as one entered the estate would be the cemetery and its prominent upright monument. The early importance of (Kirk)Liston is reflected in the name itself, which incorporates a Cumbric element cognate with Welsh *llys* 'court, hall', Gaelic *lios* 'domestic enclosure'. In eastern Scotland this element appears to connote an important aristocratic residence and administrative centre.[45] Like the Latinus Stone, the Cat

Stane thus appears to reflect a post-Roman world in which emerging militarised elites were forging a new identity as a landed aristocracy. Their prestige was drawn in part from their appropriation of lingering *Romanitas*, reflected in, for instance, their fondness for Latin names and in the adoption of the Imperial religion, Christianity.

THE 6TH CENTURY: BROX, YARROW, MANOR

The names on the stone from Brox, Liddesdale (Dumfries and Galloway) (*CIIC* 514)[46] are of Roman origin too, but *Carantius* son of *Cupitianus* belonged to a later generation than *Latinus nepos Barrouadi* or *Vetta fili(us/a) Victr(icius)*. His memorial is written in a form of capital script which may be dated to the early 6th century.[47] It displays two features — vertical layout and the ungrammatical use of the genitive case — which derive ultimately from the Irish ogham tradition.[48] These two features are widespread in contemporary monuments throughout the Brittonic world, even as far away as Brittany. Their appearance at Brox is therefore to be considered secondary, by which I mean derived from a Group I tradition which already exhibits these features, rather than independently inspired by direct exposure to ogham. Verticality and the use of the genitive also characterise the two other 6th-century stones from southern Scotland: the memorial to Coninia, from the Manor valley (*CIIC* 511)[49] and the Yarrow Stone (both Scottish Borders) (*CIIC* 515)[50] to the brothers Nudus and Dumnogenus. Despite consisting of elements and formulae which can be paralleled further south, each of these texts is unique in its precise formulation. This individuality indicates not slavish imitation of, but active participation in, a tradition which encompassed a certain degree of diversity.

The 6th-century Brox and Yarrow stones were erected by and for Christians but assertion of faith does not appear to have been their primary motivation (unlike, say, the memorials to Porius and Latinus which make explicit declarations of Christianity). Rather they were erected by members of the lay elite of an already Christian society, not simply as an act of personal piety but as a statement of authority. The emphasis on lineage and the setting at significant points in the secular landscape reflect the sources of political power to which these monuments appeal: the kin-group and its control of land. They tell us less about the state of Christianity in a given region than about patterns of power: not how Christian the commemorands were, but how powerful.

The landscape context of these 5th- and 6th-century 'proprietorial' stones is telling. Only two, the Whithorn Latinus Stone and Coninia's stone from Manor, come from ecclesiastical sites, in the case of the latter a very obscure one which did not become a parish centre.[51] Interestingly, these are also the only two to bear any Christian symbols, a small chi-rho and cross respectively. The Cat Stane (Figure 8.2) and perhaps the Yarrow Stone (Figure 8.3) stood in long-cist cemeteries, the former at least, forming a focal point for later burials, but there is no evidence of a church at either site. From a modern perspective places like Yarrow and Manor might seem like the back-of-beyond, side valleys of the upper reaches of tributaries of the River Tweed. But, like Brox, they apparently relate to the post-Roman secular political landscape, a landscape of power which was superseded in the period after the 7th

FIGURE 8.3 The landscape setting of the Yarrow Stone, photographed in 1965. (Crown copyright: Historic Scotland)

century. Again the contrast with the explicitly ecclesiastical monuments — Whithorn Peter Stone, Kirkmadrine 1–3, and Peebles Cross Kirk — is marked. The latter group seems to be 'about' something else entirely. None of them gives any information about parentage or the wider kin-group, all make prominent use of Christian art, and all are from sites which became medieval parish churches.[52] They reflect continuity in the ecclesiastical landscape. The Whithorn Peter Stone and the three Kirkmadrine stones remained standing, probably in or near their original positions, until the 19th century, yet, of the others, only the Cat Stane remained standing till modern times.

Treating the eastern stones as the reflection of a single diffusionary process, has obscured the geographical distinctiveness of the group in the upper Tweed basin, which also includes the contemporary uninscribed monument from Over Kirkhope, Ettrickdale (Scottish Borders), with its strange *orans* figure.[53] The exceptional status of this group is even clearer when viewed in comparison with the many areas of southern Scotland which have no 'secular' Group I stones: Dumfriesshire, Ayrshire, the whole of the Clyde basin, Berwickshire and eastern Lothian. Of course, arguments from silence are weak, especially since survival is likely to have been patchy. Nonetheless it is striking that the upper Tweed group fall within the bounds of the medieval royal forest of Ettrick, a territory which appears to be a very old secular political unit.[54] Place-name evidence may support the view that this area to the west of Dere Street remained under British control long after the lower Tweed was in Anglian hands,[55] although further work on this is required. One might argue that the current distribution reflects better preservation in these remote upland locations and that the lack of them further down the Tweed valley is due to the violent nature of the earlier Anglian take-over of the coastal area and consequent lack of ecclesiastical

continuity there. But this would not explain the lack of sculpture from other British-ruled areas, say on Clydeside or the Ayrshire coast. A wider geographical perspective is required.

Being a Christian was not sufficient reason to erect a Group I monument. There are many parts of Britain which were Christian at this time and yet where there are no such stones, and, as Alex Woolf has discussed, it is not simply a question of the Anglo-Saxons getting in the way.[56] Britain in the 5th and 6th centuries may be divided into three zones: in the west a zone in which Group I monuments were erected; in the east a zone of furnished, arguably pagan, Anglo-Saxon burials; and, between the two, a substantial zone which, until the 7th century at least, was politically, linguistically and culturally British and Christian, yet which is devoid of Group I stones. However power was articulated in these central and eastern zones it was not done through the medium of funerary epigraphy.

The question then is what did the upper Tweed basin have in common with other areas producing such stones — Pembrokeshire, Anglesey, the Isle of Man, northern Brittany — which it did not share with, say Herefordshire, Lancashire, or Ayrshire. This question is far from resolved and can be addressed only briefly here, but one thing which has recently been thrown into sharp relief is the key importance to the whole Group I tradition of the Irish settlements in western Britain. Irish involvement in the Welsh, Manx and Cornish Group I's has long been clear from the presence of the Irish ogham script on numerous stones and, more widely, in features such as vertical layout and the use of the genitive case which derive from the ogham tradition. Handley has argued that the fundamental shift from the primarily memorial stones of the 5th century to the 'genitival', or 'proprietorial', stones of the 6th century was brought about through the example of Irish ogham stones.[57] More recently Patrick Sims-Williams has brought out just how strongly the Irish are implicated in the whole epigraphic tradition in the West. He analysed the 5th- and 6th-century stones in Wales and counted those with an 'Irish connection', defined as at least one definitely Irish name and/or ogham, as opposed to those with a definitely Welsh name and no ogham. He thus left aside Latin names, which were adopted by both British and Irish at this period, and also Celtic names which are linguistically ambiguous and could be either Welsh or Irish. His statistics show stones with an Irish connection in a clear majority — 70% overall average for Wales, rising higher in areas such as Pembroke and Anglesey where Irish settlement is known to have been denser. There seems strong evidence to suggest that to at least some extent the Group I tradition has its origins in contact between Irish settlers and Romanophile local elites.

On the face of it, the Scottish material would seem to pull against this explanation. There are no stones of Group I in Argyll and Bute, the most successful of the Irish-speaking colonies in western Britain,[58] yet there are Group I stones in the south, where there is no historical evidence of Irish settlement. Having said that, there are some tantalising hints of Irish connections among the southern Scottish inscriptions. It has been noted already that Latinus's ancestor had a name which could be Irish. Similarly, one of the names on the Tweed stones *could* be Irish. This is the woman Coninia commemorated near the head of the Manor valley. This name is difficult to analyse in British terms, but could, quite straightforwardly be the Irish

Conin with a Latin grammatical ending.[59] Jackson rejected this interpretation because he thought an Irish name is 'scarcely likely to be relevant in this geographical context'.[60] Yet a very recent find suggests that the possibility of an Irish presence across the watershed in the upper Tweed valley is perhaps not as far-fetched as Jackson feared.

In June 2002 a most unexpected discovery was made in the Deer Park, Selkirk (Scottish Borders), by the landowner Mr Alastair Moffat.[61] While dog-walking he found lying loose at the base of some old thorn bushes what appears to be the tip of an ogham pillar. Only a few letters have survived and these are not easy to interpret, but whatever the reading, the lettering does seem to be genuine ogham. The finder was of the opinion that the fragment, which is about the size of a brick, had tumbled down the steep slope, having been dislodged by livestock. The findspot is at the upper edge of the medieval royal deer enclosure, close to its impressive boundary ditch, and beside the main road to Hawick, an old route which itself follows the boundary between the royal land and Selkirk Common. From the summit one looks down on the site of the royal castle and on the town of Selkirk, and is afforded panoramic views in all directions, including ones a distance of several kilometres up the valleys of Yarrow and Ettrick. Archaeological investigation of the immediate context of the find may help clarify its context, but it is clear that this was a significant point in the landscape. Whatever its precise circumstances the Selkirk ogham provides some quite unanticipated evidence suggestive of Irish settlement in the upper Tweed basin.

ECCLESIASTICAL MONUMENTS: KIRKMADRINE

The three inscribed stones from Kirkmadrine, in the Rhinns of Galloway, have often been bracketed with the Latinus Stone, and there are many superficial similarities: horizontal layout, comparatively lengthy text, a chi-rho symbol. There are, however, several important differences. The long text on Kirkmadrine 1, the memorial to Viventius and Mauorius, is laid out horizontally, but the lines are neater and straighter than at Whithorn and the letters more uniform in size and spacing (Figure 8.4). The decorative aspect of the small chi-rho on the Latinus Stone is minimal, it does not compete visually with the text. The later monogrammatic, or 'looped cross', chi-rhos at Kirkmadrine are pictorial (i.e. an independent visual element) rather than textual (i.e. incorporated within the lines of the text, as at Manor), and they dominate the upper half of each stone. The Latinus Stone and its fellows resemble nothing so much as Roman milestones.[62] The Kirkmadrine stones are closer to the aesthetic of 5th- and 6th-century memorial plaques of the mainstream Latin West (although on these the cross or chi-rho is proportionately smaller, rarely occupying more than the top third).[63] The men commemorated on Kirkmadrine 1 are explicitly stated to be clerics and on none of the stones is any information given regarding the men's family affiliations. Given the important role proposed for Group I stones in staking family claims to ownership of land[64] this is an important contrast with the Latinus Stone, which spells out the deceased's membership of the dynasty of Barrouadus.[65]

EARLY INSCRIBED STONES

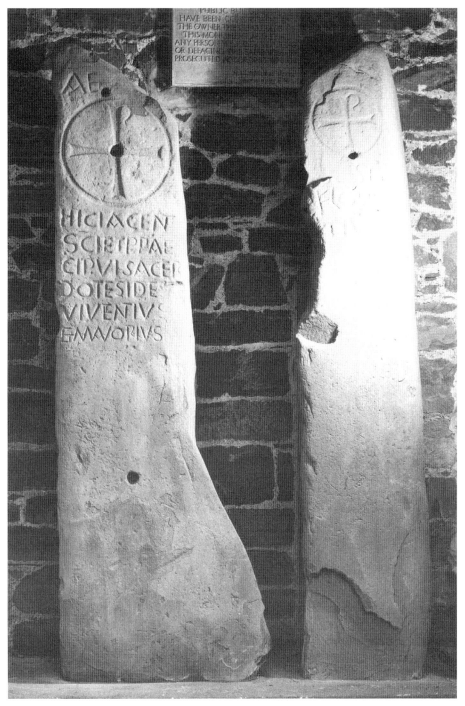

FIGURE 8.4 Kirkmadrine 1 and Kirkmadrine 2, as displayed in 1961. (Crown copyright: Historic Scotland)

Charles Thomas has argued that various aspects of the Kirkmadrine stones are to be understood as 'intrusive' features, brought to Galloway by missionaries from Gaul shortly after around 500.[66] He highlights the names of the men themselves, the encircled form of the chi-rho monogram, the use of an abbreviation bar, and two specific letter forms, so-called 'angle-bar A' and 'sideways R'. In the case of the latter, Handley and Tedeschi have shown conclusively that he is mistaken: 'angle-bar A' is not an import but is known in Roman Britain from the 2nd century onwards;[67] 'sideways R' (R with slanting stroke perpendicular to the first stroke) is an entirely Brittonic phenomenon,[68] the slant being a tendency which begins in the 5th century and is well established by the first half of the 6th century.[69]

Far from being exotic, Viventius is a name already known from Roman Britain,[70] and according to Sims-Williams, Mauorius is not, as had been thought, an otherwise unattested Latin name, but, in fact, a readily explainable Celtic name with Latinised ending, a form of *Magurix*.[71] Either man could have been a Gaul, but there is no reason to think they were not Britons. Sims-Williams's re-interpretation of the name is potentially of great significance because it affords the possibility of a phonological dating of the text. The name, if correctly interpreted, reflects the change of /γ/ > /w/, which characterises Period 5 in Sims-Williams's schema,[72] but not the final *i*-affection of Period 6. It must therefore post-date the beginning of Period 5 and pre-date the beginning of Period 6. Unfortunately both periods are insecurely dated.

Period 5 could have begun by as early as *c* 520.[73] The earliest witness to the Period 5 change /γ/ > /w/ is a source of this date relating to Brittany. It is a moot point whether such changes were happening at the same rate throughout the Brittonic-speaking world but, perhaps more significantly, this source was written by a non-Breton scribe and thus is probably precocious in its spelling (scribes from outside being expected to reflect shifts in pronunciation more swiftly than native-speakers who would be more likely to persist, for a while, in the 'correct', i.e. traditional, spelling despite a shift in the spoken language). In other words, Kirkmadrine 1 need not be quite as early as *c* 520, but could be any time after, up to the beginning of Sims-Williams's Period 6. Unfortunately the latter has not yet been closely dated, although Period 7 appears to have been underway by the early 7th century.[74] Linguistically, then, Kirkmadrine cannot be given a date less vague than '6th century', but the 5th century[75] and 7th centuries may be ruled out with relative confidence.

The use of an abbreviation bar is, indeed, highly unusual on Group I stones. It occurs elsewhere only on the two stones from Aberdaron (Capel Anelog), at the very tip of the Llyn Peninsula, Caernarvonshire (391/78 and 392/77).[76] It is worth pursuing this parallel further for the two groups of stones have other features in common. The inscriptions on the Aberdaron stones are also laid out horizontally and commemorate, using the same *hic iacet* formula, men without patronymics who are stated to be clerics, in this case *presbyteri* rather than *sacerdotes*. One of these, Senacus (391/78), is said to lie *cum multitudinem fratrum*, 'with a multitude of brothers'. Here then, we have a stone standing, by implication, in the burial ground of a coenobitic community, with a text which is perhaps as much about corporate memory as individual commemoration. Taken together, the two Aberdaron stones may represent memorials to successive heads of a monastic community.

The first two Kirkmadrine stones commemorated between them four men, two of them stated to be *sacerdotes*, perhaps bishops rather than simply priests.[77] The usual rule on Group I stones is one person = one monument. Exceptions are few[78] and in every case the relationship between the commemorands is made explicit. Thomas imagined that the four were contemporaries, part of a band of Gaulish missionaries. Perhaps more likely is that they were successive leaders of the ecclesiastical community at Kirkmadrine.[79] Certainly, there is a retrospective air about Kirkmadrine 1 with its panegyric tone[80] and unique syntax which names the subjects only in a sub-clause introduced by *id est*. The Kirkmadrine syntax, like the use of the abbreviation bar, is bookish and sets it apart from the more straightforward 'extended Latinate' inscriptions.

Fundamental to the dating of the individual Kirkmadrine stones is the question of their relationships to one another. The traditional view is encapsulated by Thomas when he states that the date of Kirkmadrine 1 is '500[AD]-plus', Kirkmadrine 2 'copies it, within decades' and Kirkmadrine 3 'belongs to the 7th century'.[81] Kirkmadrine 1 is an exceptionally well-carved monument, confident, elegant and controlled. There are differences between it and Kirkmadrine 2 (Figure 8.4) — for instance in the treatment of the cross terminals — which suggests that the two monuments were not carved by the same hand. The script of the latter is less even and square, it has touches of the 'higgledy-piggledy' layout seen to a greater degree on Kirkmadrine 3, the two stones from Aberdaron and on the Whithorn Peter Stone (see below), and it employs a different form of the letter R. Kirkmadrine 3 is different again, the arms of its cross are shorter and the terminals more widely expanded (Figure 8.5). Its script is quite different from that of the other two. With its little wedge-shaped serifs and minuscule forms of M, N, and U, it has been generally dated to the 7th century,[82] along with the very similar script on the memorial to Avitus at Santon, at the southern end of the Isle of Man (505/Kerm.34).[83] Sims-Williams considers the latter text to reflect his Period 6 but not yet Period 7, in other words, it is likely to pre-date the early 7th century.[84]

If Kirkmadrine 3 really is significantly later than the other two, then it must have been very consciously modelled on them. The three have the same overall design: prominent encircled chi-rho monogram in the upper half, horizontal lines of text in the lower half. The basic shape of the three chi-rhos, with their outward-turning, crook-like rhos, is identical. The 'beginning and end' concept, with its potentially liturgical significance, is expressed in words on Kirkmadrine 3, and using the symbols alpha and omega on Kirkmadrine 1. The three even share the detail of the same boxed-in form of ET ligature with the bar of the T prolonging the middle bar of the E.[85]

Despite the uncertainties and elasticities of the linguistic chronology, perhaps we now have licence to take Kirkmadrine 1 a bit later towards 550, and bring Avitus, and thereby the palaeographically-similar Kirkmadrine 3, a bit earlier, possibly back into the 6th century. This closer chronological proximity sits well with recent work by Derek Craig which has thrown doubt on the older, more attenuated sequence.[86] Detailed detective work has allowed him to piece together the recent history of the Kirkmadrine group and to establish that all three stood, perhaps in their original positions, in the churchyard at Kirkmadrine until the 1840s when they were pressed

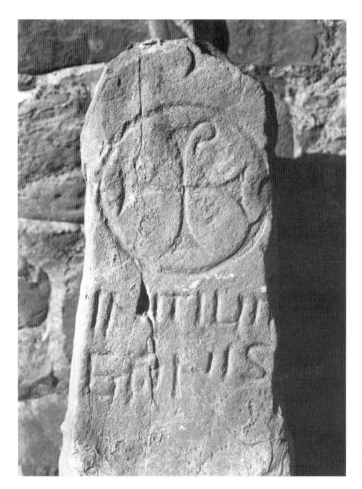

FIGURE 8.5 Kirkmadrine 3, detail. (Crown copyright: Historic Scotland)

into service as gate-posts. To facilitate this reuse Kirkmadrine 3 was trimmed very severely. If due allowance is made for this cutting-down it can more readily be seen just how similar the three stones must have been in general physical terms of overall size and shape. That 100 or even 150 years separates these monuments strains credulity, and Craig argues that all three belong to a single generation. Certainly all three seem to fit together within a single monumental scheme. To recap then, the differences between the three Kirkmadrine stones suggest some passage of time between the erection of Nos 1, 2 and 3 (probably in that order), but perhaps of the order of only a few decades.[87] This was a culturally dynamic period and stylistic change may have been occurring rapidly. It would be possible to have all three sitting in a period which encompassed the mid-to-late 6th century, or perhaps stretched into the early 7th.

THE PETER STONE, WHITHORN

The three Kirkmadrine stones are thus quite unlike the Latinus Stone. A more appropriate Whithorn parallel is its later fellow, the so-called Peter Stone (Figure 21.1). This monument, inscribed *Loci Petri Apustoli*, 'of the *locus* of Apostle Peter', once stood by the old road to the Isle of Whithorn, probably marking a cemetery on the edge of the settlement which was hallowed by some relic of the apostle himself.[88] Previous writers have taken the dedication to Peter as diagnostically Anglian and thus dated the stone to the foundation of the Anglian bishopric around 730.[89] This is a needless assumption. We lack contemporary evidence from western Britain, but devotion to Peter was strong within the Irish Church long before the adoption of the Roman Easter. Tírechán, writing around 684, refers to certain relics of the apostles Peter and Paul at Armagh in his day, which were believed to have been brought from Rome in Patrick's time, and so had probably been there for several generations at least.[90] Further evidence of the cult of Peter in Co Armagh, comes from the cemetery of Kilnasaggart (*CIIC* 946) which is marked by an inscribed stone, the earliest non-ogham inscription in the Irish language. The inscription states that the site was *er cul Peter Apstal*, 'under the protection of the apostle Peter'.[91] It names the benefactor, someone known to have died in 716, and refers to the site as *in loc so*, 'this *locus*'. The juxtaposition of these two roughly contemporary *loci* dedicated to Peter on opposite sides of the North Channel has not been sufficiently acknowledged.

Latin *locus* was a deeply significant word in this period throughout the Christian West. It meant 'place' in a general sense, but also a very specific kind of place: a burial ground where the physical remains of a holy person rested. The word is well attested in Celtic Latin literature with a developed range of meanings, including 'consecrated place', 'burial place', 'church', and 'monastery', and was also borrowed into the vernacular with a similar range of meanings.[92] From the 11th century onwards it was productive in the ecclesiastical place-nomenclature of Brittany, with the meaning 'secondary chapel'.[93] Recent work by Thomas Clancy on Logie place-names in north-eastern Scotland suggests that *loc* was in use there before the mid-9th century as a word for 'church'.[94] Andrew Breeze has recently identified a lone example from southern Scotland, Locquhariot by Borthwick in Midlothian.[95] Clancy suggests two other possible examples.[96]

In this context it is intriguing that the only other epigraphic examples of the word *locus* are also from southern Scotland. The Cross Kirk at Peebles was founded to commemorate the discovery in 1261 of a stone, now lost, which was alleged to have read LOCUS SANCTI NICHOLAE EPISCOPI.[97] Whatever was actually on the stone to prompt such a reading by 13th-century antiquarians, its position, not at the parish church but by the side of a road leading out of the settlement, suggests a similarly early burial ground under the protection of some saintly person whose relics it contained. The inscribed memorial to the two sons of Liberalis at Yarrow, which stands by a putative inhumation cemetery, beside an important route-way, also refers to its site as a *locus*. These four inscriptions are hardly a cluster, but the fact that there are, as far as I am aware, no other examples from anywhere else in the British Isles

raises at least the possibility that *locus* had a specific resonance for Christian communities in southern Scotland and adjacent parts of Ireland.

It has long been recognised that the Peter Stone and the three stones from Kirkmadrine are part of a distribution of a dozen or so chi-rho-inscribed stones along the western seaboard of Ireland and Scotland from the Iveragh Peninsula to Raasay.[98] These chi-rhos are formed on various kinds of crosses, including equal-armed, latin, and arci-form. The closest parallel for the Kirkmadrine form of chi-rho, in fact the only other example formed on an encircled equal-armed cross,[99] is the pillar from Drumaqueran, Kilraughts (Co Antrim).[100] Like Kirkmadrine 1, the Drumaqueran stone has the monogram on both faces.[101] Another stone with the comparatively unusual feature of encircled crosses on both sides is the ogham-inscribed pillar from Arraglen on the Dingle Peninsula (Co Kerry) (*CIIC* 145).[102] The cross on its front, which has expanded terminals, is distinguished by a chi-rho hook. As on Kirkmadrine 1, the person commemorated at Arraglen is identified as a Christian cleric,[103] making this stone highly unusual in an Irish ogham context. Linguistically, the Arraglen inscription is a late pre-syncope ogham, thus one of the latest, and dates to the second half of the 6th or very early 7th century.[104]

Like the Whithorn Peter Stone, the Arraglen pillar is part of a tradition of encircled crosses and crosses-of-arcs, examples of which are legion in western Ireland.[105] The dating of these is slippery, but Swift argues sensibly that they range from the 6th and 7th centuries into the 8th century.[106] The context is not always clear, but a number, including Kilnasaggart and Reask, Dingle Peninsula (*CIIC* 914),[107] have been shown through excavation to have stood at significant positions within inhumation cemeteries. The chi-rho hook seen by Herity on the pillar at Loher, on the Iveragh Peninsula is doubtful,[108] but the AW pendant from the arms of the cross echo the AW above the cross on Kirkmadrine 1.

The distribution of chi-rhos is not exclusively Atlantic, of course. There are also examples from the eastern rim of the Irish Sea. A particularly close parallel for the Whithorn cross-of-arcs chi-rho is provided by the fragment of a shrine panel or altar slab from Maughold, Isle of Man.[109] The Kirkmadrine form of chi-rho, with a hook on the upper element of an equal-armed cross, is paralleled without the circle on two stones from Caernarvonshire. The earlier, the monument to Carausius at Penmachno (393/101), has been dated to the 5th century on the grounds of its script[110] and is part of the 'extended Latinate' group. It is one of a cluster of four inscriptions from Penmachno which have continuing-Roman features, the nearby Porius stone brings the local total to five. The second chi-rho monument in this part of Wales is the somewhat later monument to Iaconus, from Treflys (398/106). The text reads vertically, an orientation derived ultimately from the Irish ogham tradition. More significantly, the name *Iaconus* is most readily explained as Irish.[111] It is a very late pre-syncope form and probably not, therefore, later than the mid-6th century. Most conclusively of all, however, this stone also bears traces of an ogham inscription.

Further south in Cornwall there are, in addition to the two Constantinian chi-rhos already mentioned, four monogrammatic chi-rhos on Group I inscriptions.[112] The one from west Cornwall is early, possibly 5th century (St Just 2, 483/Ok 51). The other three, from east Cornwall and Devon, have been variously dated to the second

half of the 6th century: Southill (486/Ok 56), St Endellion (aka 'Doydon') (478/Ok 48), and Sourton Down (491/Ok 55). All four inscriptions read vertically downwards, a feature of ultimately Irish origin. Stronger evidence of an Irish connection is provided by the names inscribed on the St Endellion stone, *Brocagni* and *Nadotti*, which, according to Sims-Williams, are, respectively, 'probably' and 'possibly' Irish names.[113]

The distinctive script of the Whithorn Peter Stone has been labelled a Gaulish import.[114] It is found elsewhere only on the two stones from Aberdaron mentioned above, dated by Tedeschi to the first half of the 6th century.[115] In fact, Tedeschi emphasises the *lack* of Continental influence on Insular scripts in this period, and this form is more appropriately placed within the indigeneous evolution of Insular decorative capitals.[116] Since we are on the lookout for Irish connections, it is worth noting that one of the men commemorated at Aberdaron has a name, SENACVS, which could be the common Irish name *Senach*.[117]

Correspondences between the ecclesiastical monuments of western Ireland and western Britain need not be the result of direct links between these two zones. It is quite possible that instead they reflect parallel responses to a common stimulus, derived from Christian north Africa and Gaul, and transmitted along the same routes which brought B-, D-, and E-ware to both regions, not to mention concepts of monasticism. In the more specific case of possible 6th-century links between Galloway and north-eastern Ireland, we are perhaps on surer ground. The career of the Briton Uinniau, known to the Irish as Finnian, epitomises the dynamic intellectual and cultural interaction of the 6th-century Insular Church. A bishop and scholar at the forefront of the monastic movement, Uinniau's career straddled the North Channel before his death in 579.[118] Later Irish tradition stated that he had studied at Whithorn in the company of others who, like him, went on to found monasteries in eastern Ireland.[119] Certainly, Uinniau had a widespread and early cult in south-west Scotland.[120] A generation later, Uinniau's pupil Columba emulated his teacher, albeit in the reverse direction, travelling from Ireland to found a monastery of his own on the Scottish side of the Channel.

The view of the Galloway stones as exotic Gaulish imports reflects the traditional view of British 'Group I' inscriptions as a whole, as propounded by Ralegh Radford, Nash-Williams, Charles Thomas and Jeremy Knight.[121] Their view was that these monuments were, in essence, a post-Roman phenomenon, inspired by the Christian epigraphy of Merovingian Gaul, knowledge of which was brought to western Britain direct from Continental centres such as Trier, Lyons, Vienne, and Bordeaux. However, in a recent article Mark Handley has taken Thomas, Knight *et al* to task over their insistence that Christian monumental commemoration in Britain was a post-Roman introduction. Instead he emphasises the extent to which 5th- and 6th-century monumental practice grew out of the local 4th century tradition.[122] Handley has shown that in a number of respects British practice is more in line with the wider Late Antique world than was previously thought. He demonstrates that various features present in the British inscriptions, be they memorial formulae or individual letter forms, were not, as has been asserted, characteristic of and therefore borrowed from specific parts of Gaul, but, in fact, were widespread across the Late Antique

world, including Spain and north Africa. The British 'Group I' inscriptions do not, he argues, reflect cultural isolation from the Continent enlivened only by restricted contact with the Christian Church in western Gaul, but rather demonstrate epigraphically that Britain was still at this time participating in the common culture of the Late Antique West. Handley's view is supported by the independent work of Carlo Tedeschi on the palaeography of the Group I inscriptions in which he charts a 'consistent evolutionary line' from the scripts used epigraphically in 3rd- and 4th-century Roman Britain to those of the Early Christian monuments of the 6th and 7th centuries.[123]

In bringing out the Irish parallels and downplaying the scenario of 'intrusive' Gaulish influence in Galloway in the 5th and 6th centuries I do not deny that there were links between western Scotland and Atlantic Gaul in this period. To do so would be absurd. For a start, such connections are amply demonstrated by the imported pottery and glass recovered in ever-increasing quantities from high-status sites in the west.[124] What I am trying to cast doubt on is the hypothesis that Christianity in this region was sparked, or even nurtured, by directed missionary efforts by isolated groups of Merovingian churchmen, sent beyond the former limits of Empire to convert the heathen. Rather I want to emphasise that it grew organically out of a late Roman background. Links with Gaul were themselves part of that background, not just in Galloway, but throughout western Britain and Ireland in the Late Antique period. The motor driving these links, however, was not exclusively, or even primarily ecclesiastical.[125] The imported glass and ceramics are now understood to reflect 'sustained, regular, directed trade' between these regions and Atlantic Gaul throughout the 6th and 7th centuries (and more restrictedly with the Mediterranean in the first half of the 6th).[126] Whithorn, for example, appears to have been receiving 'regular shipments of Mediterranean and Continental wares' as they were found in most of the 18 sub-phases deposited between 500 and 700.[127]

CONCLUSION

I have tried to argue that these dozen or so inscriptions do not all fit into a single story about the development of Christianity in southern Scotland. Instead what we have are two separate epigraphical strands, one proprietorial, the other ecclesiastical. The former grows out of the late Roman memorial tradition and in its early phase retains numerous features of late Roman monumental epigraphy. This 5th-century 'continuing-Roman' group encompasses the Whithorn Latinus Stone, the Cat Stane at Kirkliston, the Brigomaglos stone from Chesterholm, and, arguably, also the stones from Maryport and Old Carlisle. These are the funerary monuments of an emerging secular elite which was Romanophile and Christian. Similar monuments were erected in similar circumstances in parts of Wales and Cornwall at this time. These are primarily memorial, women are well represented and references to family or lineage are often absent.

The proprietorial strand continues into the 6th century, a phase which comprises the 'genitival' stones from Brox, Manor and Yarrow, and the new Selkirk ogham. By then there has been a shift in emphasis in the Group I tradition as a whole, occasioned

in some way by the impact of Irish settlement in western Britain. The etymology of certain names and, especially, the discovery of the Selkirk ogham indicates that this impact may have been felt in Scotland more directly than previously thought. Like their fellows further south, these 6th-century monuments take Christianity for granted and place increased emphasis on lineage. We have seen how the Scottish ones appear to have stood not at churches but marking 'special graves' in traditional family burial plots, at significant points in the secular landscape. While they performed a memorial function, they are, in a sense, more strongly 'proprietorial', in that they demarcated boundaries and asserted ownership and authority.[128] They reflect a particular moment in the emergence of the medieval landed aristocracy. This monumental practice died out in the 7th century, perhaps because the Church was by then able to claim a monopoly on burial, or because the elite had found other ways to demonstrate its authority and legitimacy, or perhaps indeed because the social transition of which these stones were a part had already been accomplished.

Contemporary with but distinct from this proprietorial strand are a group of monuments which are 'about' something quite different. They make prominent use of Christian art; either they are dedicated to clerics, about whom no kinship information is given (as with Kirkmadrine 1–2 and Curghie),[129] or they are not funerary monuments at all (as with the Whithorn Peter Stone, Peebles 'Nicolai', and Kirkmadrine 3). Their physical context too, is strongly ecclesiastical. They all appear to have stood at cemeteries at or near important early churches. These 'ecclesiastical' inscribed monuments also reflect knowledge of Irish practices, though perhaps in a more diffuse way, and not to the exclusion of influences from elsewhere in the Brittonic-speaking world, or from the Continent.

Neither of these two strands is homogeneous. On the contrary, the stones are scattered and diverse. Only at Kirkmadrine is there evidence of a sustained vogue, and even that may have lasted no longer than a generation or two. The apparent isolation of the Scottish inscriptions has prompted previous commentators to explain them in terms of isolated contacts with Gaulish missionaries and the subsequent diffusion of the Christian faith northwards. But monumental epigraphy is not a natural and inevitable by-product of Christianity. The punctuated and discontinuous nature, and regional specificity, of early medieval sculptural traditions in general, shows that the decision to commission a monument was the result of the interplay of many social and cultural factors, and often boiled down to the ebb and flow of local politics. It is not the cultural milieu which needs explaining, but the urge to express it in stone. Ultimately the pulses of sculptural energy which produced the inscribed stones of southern Scotland may tell us little about the presence or absence of outside catalysts, but potentially may reveal a great deal about the broader social forces which shaped the epigraphic habit among the Britons of both north and west.

ACKNOWLEDGEMENTS

I am most grateful to my colleague Dr Thomas Clancy for his generosity of time and ideas and for access to materials in advance of publication. I would like to thank Alastair Moffat, finder of the Selkirk ogham stone, for sharing his discovery with me. Also Dr Ross Trench-Jellicoe for his helpful advice on Kirkmadrine and the chi-rho tradition. Above all, I

would like to thank Stephen Driscoll who accompanied me on most of the site visits and who freely gave me the benefit of his knowledge and judgement. I acknowledge the generous support of the Society of Antiquaries of Scotland for the award of a Young Fellows Bursary which enabled aspects of this paper to be presented at the International Celtic Congress, Aberystwyth, 2003.

NOTES

[1] That Chesterholm is within the modern boundaries of England is, for our purposes, merely a technicality!

[2] See handlist in Thomas 1992a. The 'Neitan' stone from Peebles (Figure 4.2) is a tiny cross-slab of late 7th or early 8th century (Steer 1969) and therefore not properly part of this monument class.

[3] As repeatedly emphasised by Thomas (1992a, 9; 1997, 40–1).

[4] Isle of Man: Kermode 1907; Wales: Nash-Williams 1950 (a new corpus is currently in preparation: *Corpus of Early Medieval Inscribed Stones and Stone Sculpture in Wales*, Vol 1, *South and South-East*, John Lewis and Mark Redknap; Vol 2, *South-West*, Nancy Edwards; Vol 3, *North*, Nancy Edwards, Cardiff, forthcoming); south-west England: Okasha 1993; Brittany: Davies *et al* 2000.

[5] Thomas 1992a, 8.

[6] Though noted in correspondence by the stone's discoverer, the presence of the, now very worn, chi-rho was never noted in publication and, remarkably, its existence was lost sight of through most of the 20th century until 'rediscovered' by Derek Craig (1997, 615). Though not mentioned by Allen and Anderson in their text it is quite discernible in their photographs (*ECMS* III, 497, Figs 538–9) and can be seen, in the right light, at the top of the stone today.

[7] This is Thomas's phrase (1994, 68, 200–5), but I use it here in a slightly more restricted sense to refer only to longer horizontal texts, not longer vertical inscriptions such as the 6th-century Yarrow Stone (see below).

[8] Tedeschi 1995; see also Tedeschi 2001, 17–18, 24.

[9] Thomas 1981, 87–8, and numerous examples at 105–8, 110–16, 122–7, 220.

[10] The indexes to *RIB* (Collingwood and Wright 1965) list more than 30 examples commemorating those stated to be aged ten or less.

[11] Keppie 1991, 122.

[12] Following Sims-Williams 2003, inscribed monuments are identified by their number in *CIIC* (Macalister 1945; 1949) followed by their number in Nash-Williams 1950 (for Wales), Okasha 1993 (for Devon and Cornwall) and Kermode 1907 (for Man).

[13] Formerly, Cunaide was thought also to be a British woman, but Sims-Williams now argues that 'she' is an Irishman (2003, 192 n1174).

[14] Thomas 1994, 190–4.

[15] Thomas 1994, 198–9.

[16] There is one other instance in Early Christian British epigraphy of the use of the Greek letters XP to signify Christ, though as part of a continuous text not isolated as a monogram. The memorial to Porius, at Trawsfynydd, Merioneth (420/289) states HOMO XPIANVS FVIT, 'he was a Christian man'. For this reading, *pace* Nash-Williams, see Gresham 1985. The Constantinian chi-rho on the much later Jarrow dedication slab, self-dated 685, 'represents an arcane use, a revival harking back to earlier centuries', 'it is an archaic form whose immediate source probably lies in continental Europe' (Trench-Jellicoe 1998, 502, 504); see Cramp 1984a, Jarrow 17, 113–14, Pl 98, 524; Okasha 1971, 85–6, Pl 61; Higgitt 1979, 343–74, Pl 60.

[17] The dating of the earliest graves (Phase 1.5) at Whithorn is problematical. There appears to have been a cemetery for a mixed population in use in the decades before *c* 550 (Hill 1997, 27–8, 69, 70, 86–8). The relation, if any, between it and the Latinus Stone is unclear. Subsequent archival discoveries have shown that the findspot proposed for the stone by Hill (1997, 619–20) is that of a later cross and, though the Latinus Stone was certainly found during Galloway's excavations within the churchyard, its precise findspot is not known (Watt 2001). Close inspection reveals the top of the stone has been trimmed, presumably for reuse as building stone, so the findspot would, in any case, have been a secondary location.

[18] For the context of the Rustica stone, see Knight 2001, 10–11.

[19] Hill 1997, 26–7, 293.

[20] Jarrett 1976.

[21] Dark (1996, 63) argues that it was part of a functioning post-Roman defensive system.

[22] Only very recently have they been treated as potentially early sub-Roman rather than Late Roman (McCarthy 2002, 137): they are included in University College London's *Celtic Inscribed Stones Project* on-line database (http://www.ucl.ac.uk/archaeology/cisp/database), and

[22] Sims-Williams 2003 study of post-c AD 400 British inscriptions.
[23] Jackson 1982; Thomas 1992a; illustrated by McCarthy 2002, 139.
[24] It is listed but not illustrated by Macalister 1945–9.
[25] Sims-Williams 2003.
[26] Sims-Williams 2002, 15–22; 2003, 185.
[27] Sims-Williams 2003, 185.
[28] Charles-Edwards 1993, 155–6.
[29] Sims-Williams 2003, 120.
[30] Rutherford and Ritchie 1974; Cowie 1978.
[31] There is uncertainty over the commemorand's gender. On the face of it, Vetta is linguistically feminine but Kenneth Jackson's unpublished opinion (cited by Sims-Williams 2003, 135 n795) was that the name was a masculine a-stem. Unfortunately, the ending of the word *fili(us/a)*, 'son/daughter', does not survive. Women are more frequently commemorated on 'continuing-Roman' inscriptions than on later 'genitival' Group I monuments (Handley 1998, 359–60), so we need not be surprised that this important monument marked the grave of a woman, cf Rustica's stone, but, not now that of Cunaide (see above n13).
[32] *in hoc tumulo* appears elsewhere only on the 6th-century vertical inscription from Abercar Brecknockshire (331/41): N. *filius hic iacit* N. *in hoc tumulo*.
[33] Bidwell 1985, 38, 45–6, 75.
[34] Dark 1992, 111–20.
[35] RCAHMS 1929, 27–8, No 37.
[36] Although doubts have been expressed that the relevant coins are a modern loss (Casey 1984, cited by Cessford 2001).
[37] Cessford 2001.
[38] A single mid-6th-century Byzantine coin was found at the site, but may not be a genuinely ancient loss (Casey 1984, see above).
[39] Cessford 2001.
[40] This process is mirrored at other former Roman forts in Scotland, e.g. Carpow and Inveresk, and is seen famously at York Minster and Caerleon (Knight 2003, 119).
[41] Rutherford and Ritchie 1974.
[42] Cowie 1978.
[43] Proudfoot and Aliaga-Kelly 1997, 44, Fig 8.
[44] Rogers 1997.
[45] MacDonald 1982, 50–1.
[46] RCAHMS 1956, 88–9, No 78.
[47] Tedeschi 1995.
[48] Handley 1998.
[49] RCAHMS 1967, 176, No 379.
[50] RCAHMS 1957, 110–13, No 174.
[51] 'St Gordian's Chapel': RCAHMS 1967, 376, 379, 527; Cowie 2000, 26–8, 45.
[52] The Curghie stone was found in a secondary position at a distance of several kilometres from the medieval parish church. There are, however, place-names in the vicinity — Kildonan, Kilstay, Hallyholm (MacQueen 2002, 47, 79, 82), which may reflect a lost church site.
[53] Now in the National Museums of Scotland; *ECMS* III, 431.
[54] Gilbert 1985; see also Gilbert 1979, 11.
[55] Elliot 1985, 14.
[56] Woolf 2003, 360.
[57] Handley 1998, 361.
[58] Though, of course, neither was there a Roman-ophile local elite.
[59] Sims-Williams 2003, 155, 175.
[60] RCAHMS 1967, I, 176.
[61] I hope to publish a short account of this stone: 'A fragment of ogham from Deer Park, Selkirk'.
[62] A point made by Thomas 1981, 274, Fig 52; indeed one Group I example 407/258 is a reused Roman milestone (*RIB* 2254).
[63] Diehl 1931. For Gaul, see Le Blant 1856–65, which is being superseded by the various volumes of the *Recueil des Inscriptions Chrétiennes de la Gaule antérieures à la Renaissance carolingienne*. For Spain, see Vives 1969. For bibliographic references to the other regional corpora, see Handley 2001, 183. A selection of such monuments from Gaul and Spain are conveniently illustrated by Swift 1997, 75; see also Knight 1999, 111 (Spain).
[64] Handley 1998.
[65] I see no justification for Radford's assertion that NEPVS BARROVADI is a later addition (Radford and Donaldson 1957).
[66] Thomas 1994, 96–9 and Fig 7.5; 1997.
[67] Handley 2001, 192; Tedeschi 2001, 19.
[68] Known from Britain and Brittany only. Handley (2001, 190) could find only one, probably unrelated, Continental example, from Tarragona, in eastern Spain.
[69] Tedeschi 2001, 24.
[70] Interestingly, the name of a bishop, cast onto a lead brine-pan from Shavington in Cheshire (Penny and Shotter 1996; Tomlin and Hassall 1998).
[71] Sims-Williams 2003, 32.
[72] Sims-Williams 2003, 84.
[73] Sims-Williams (2003, 282) cites a 7th-century Welsh source (dated post *c* 605) as possibly *not* showing this innovation, but the name in question is, he notes, more probably interpreted as Irish and therefore irrelevant.
[74] Sims-Williams 2003, 251, 282–3.
[75] Proposed at one time by Thomas 1968, 102.
[76] Superscript bars appear on a handful of Group I stones in Brittany but puzzlingly none seem to mark abbreviation/contraction (Davies *et al* 2000, 57–8).
[77] The precise significance of the term in this period is much debated; see Dowden 1898; Clancy forthcoming a.

[78] For example, Latinus Stone (father and daughter), 419/284 (mother and daughter), 329/42 (a man and his father), a married couple (320/26; 323/32), Yarrow, discussed below (two brothers), Tregony 461/Ok66 (three brothers).

[79] In the version of this paper presented at the seminar I placed these paired clerical commemorations in the context of the joint cults of early martyrs so common on the Continent (Pearce 2003) (and known in Britain with the cult of Julian and Aaron at Caerleon) (Knight 2003, 120), and suggested that the stones mark the tomb-shrines of the translated remains of saintly confessors, possibly figures from Kirkmadrine's own history, but also potentially the imported relics of saints who had no personal connection with Galloway at all. On reflection, while this remains a possibility, I consider it more likely the inscriptions commemorate a series (not necessarily consecutive) of early bishops.

[80] Cf the famous 7th-century Welsh Catamanus stone (970/13), not erected until some decades after that person's death.

[81] Thomas 1992b, 9 (superseding an earlier dating proposed in Thomas 1968, 102). Radford saw the stones as ranging from the 5th century to c 600 (Radford and Donaldson 1957, 43–4).

[82] '7th century' (Radford and Donaldson 1957, 36); 'c 600' (Thomas 1992a, 7).

[83] '7th century' (Tedeschi 1995); 'early 7th century' (Jackson, cited by Sims-Williams 2003).

[84] Sims-Williams 2003, 283.

[85] Thomas 1992a, 2.

[86] Craig 1997, 617–18.

[87] Another possible factor is that a different script is signalling a different kind of text in a manner akin to the 'hierarchy of scripts' employed in manuscripts, whereby, for instance, decorative capitals might be restricted to initials, titles, or other important sections.

[88] Craig 1997, 616.

[89] For example, Collingwood 1925, 212; Thomas 1992a, 7.

[90] Bieler 1979, 123; see Doherty 1984, 92, 96. Similarly the *Vita Tripartita* of Patrick, written c 900 from earlier materials, claims that the 5th-century Palladius left a casket containing relics of Peter and Paul at the church of Cell Fine (Killeen Cormac, Co Kildare); Mulchrone 1939, 19; Stokes 1887, Vol I, 30; Doherty 1984, 91; Ó Floinn 1994, 5.

[91] Hamlin 1982.

[92] See Clancy forthcoming b.

[93] Jankulak 2000, 76–8. The sole Cornish example, Luxulyan (Padel 1985, 151), is probably an offshoot of this phenomenon.

[94] See Clancy forthcoming b.

[95] Breeze 2003.

[96] Clancy forthcoming b.

[97] RCAHMS 1967, i, 176–7.

[98] Hamlin 1972; Herity 1995b; Trench-Jellicoe 1998.

[99] I know of only one further example of an encircled monogram chi-rho, in this case with closed 'P'-shaped hook, on a little pebble from Kilcorban (Co Galway) (Herity 1995b, 242, Pl 4.8).

[100] Hamlin 1972.

[101] Note also that Kilnasaggart has encircled crosses on both faces.

[102] Hamlin 1982, Fig 17.1; Cuppage 1986, 248–50. The significance of this monument is emphasised by Swift 1996.

[103] In this case QRIMITIR (gen), *cruimther*, 'priest' (< Latin *presbiter*).

[104] MacManus 1991, 96–7.

[105] See examples in Henry 1937; Cuppage 1986; also pertinent discussion of dating in Swift 1997, 70–83.

[106] Swift 1996, 70–83.

[107] Cuppage 1986, 342; Okasha and Forsyth 2001, 175–8.

[108] Sheehan 1990, 164; O'Sullivan and Sheehan 1996, 307; Okasha and Forsyth 2001, 171–4.

[109] Trench-Jellicoe 1981; 1998, 500, Illus 5f.

[110] Tedeschi 1995.

[111] Sims-Williams 2003, 80–1, 317.

[112] Langdon 1893.

[113] Sims-Williams 2003, 423, 432.

[114] Radford and Donaldson 1957, 36.

[115] Tedeschi 1995.

[116] Tedeschi 2001; Charles-Edwards 2003.

[117] Sims-Williams 2003, 142.

[118] See Clancy 2001 for discussion and further references.

[119] Discussed, with undue scepticism, by Wilson 1969.

[120] This is indisputable, whether or not one accepts Clancy's arguments that the cult of Ninian at Whithorn represents an 8th-century re-working of an earlier local cult of Uinniau (Clancy 2001).

[121] For instance: Radford 1937; Nash-Williams 1950; Thomas 1968; 1971; 1981; 1994; Knight 1981; 1992; 1997.

[122] Handley 2001.

[123] Tedeschi 2001, 17.

[124] Discussed by Lane 1994 and Campbell 1996: the quantity of imported glass and ceramics at Whithorn is truly exceptional, but it is found at several other sites mentioned, e.g. Reask (Bii ware; Fanning 1981, 155), and Phillack (Phocaean Red Slip, Form 3; Thomas 1994, 198).

[125] See discussion by Campbell 1996.

[126] Campbell 1996, 81.

[127] Campbell 1996, 82. For detailed discussion, see Hill 1997.

[128] Handley 1998.

[129] The later Peebles Neitan Stone may be thought of as a continuation of this strand.

CHAPTER 9

THE GOVAN SCHOOL REVISITED: SEARCHING FOR MEANING IN THE EARLY MEDIEVAL SCULPTURE OF STRATHCLYDE

By STEPHEN T DRISCOLL, OLIVER O'GRADY *and* KATHERINE FORSYTH

Govan might seem an unlikely source for insights into early medieval sculpture, given its strong associations in the contemporary mind with ship-building and post-industrial decline. Nevertheless recent scholarship has elevated Govan to the epicentre of artistic practice within the obscure post-Viking-Age British kingdom in Strathclyde. The Govan corpus is extraordinary — only Iona and St Andrews have produced larger collections — so it is perhaps understandable that it has dominated consideration of the north British sculpture. In this paper we wish to assess what a 'Govan School' might represent, and consider the historical significance of the term. We pursue these ends by reviewing the development of scholarly thinking on the subject and by presenting the results of new research on the historical and landscape contexts of a selection of these monuments.[1] The industrial transformation of Strathclyde has been so great that it is generally difficult to appreciate the significance of the original settings of these monuments. In thinking about the positioning of the sculpture we have been influenced by the insights of landscape archaeologists[2] and have drawn upon our own experience of the Strathclyde landscape. Although we have not studied the landscape settings systematically or attempted the sort of phenomenological analyses advocated by Ingold[3] and Tilley,[4] landscape position emerges as one of the key attributes for understanding the original significance of the Strathclyde sculpture. Moreover, we believe that an appreciation of the significance of landscape position is also critical for the management of these monuments as a cultural resource, particularly if they are to regain some value in the modern world.

AN UNDERDEVELOPED SCHOLARLY TRADITION

The sculpture from Strathclyde (used here to refer to pre-1975 Lanarkshire, Renfrewshire and Dunbartonshire) is probably the least familiar of all Scotland's Early Christian monuments. With the exception of the Govan collection,[5] the Strathclyde monuments are poorly recorded and little-known. This lack of detailed

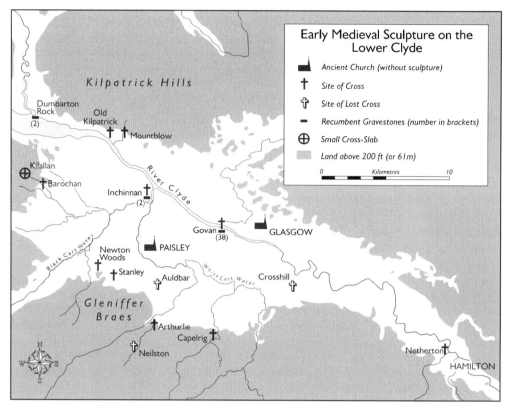

FIGURE 9.1 Map of the distribution of early medieval sculpture on the lower Clyde, including 'lost stones'. (Drawing by Lorraine McEwan. © University of Glasgow)

analysis notwithstanding, the sculpture has come to be recognised as central to any understanding of the British kingdom in Strathclyde during the 10th and 11th centuries. In this paper we focus upon monuments found at 15 sites on the middle stretch of the Clyde, roughly from Hamilton to Dumbarton (Figure 9.1).

Scholarly interest in the monuments considered here has been sporadic. Before the mid-19th century most were known only to local communities, who recognised them as marking public spaces — as at Netherton, Hamilton (South Lanarkshire) — and appreciated them as suitable markers for high-status burials, as in 17th-century Govan. Few are mentioned in either the *Old* or *New Statistical Accounts*, so the inclusion of 15 monuments in John Stuart's *Sculptured Stones of Scotland*[6] marks the first great scholarly advance (Figure 9.2). Stuart's attention, in a volume heavily weighted towards the north-east, was perhaps influenced by the timely discovery of the Govan Sarcophagus only the year before publication. Stuart's short accounts of the sculptures convey a sense of excitement at new discoveries and an interest in the original location of the monuments, in some cases even investigating their context archaeologically. Comprehensiveness was not, however, one of Stuart's objectives. He recorded less than a quarter of the Govan monuments then extant and offered

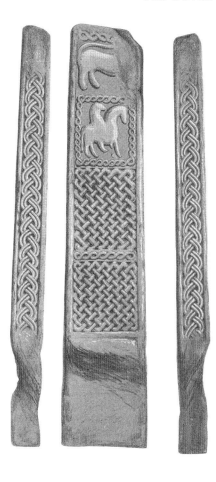

FIGURE 9.2 This image of the 'Mountblow Cross' is typical of the lithographs in Stuart's *Sculptured Stones of Scotland* (1856, Pl cxx). Although attractive, it shows little detail and the image is reversed.

little comment about their formal differences or their associations with other Clyde monuments.

The situation did not improve markedly until the end of the 19th century when a comprehensive photographic record of the sculptured stones at Govan was commissioned by the local MP, Sir James Stirling Maxwell of Pollok House.[7] Excellent photographs were taken in the famous Annan studio of plaster casts of the 46 sculptures. These were published with no explanatory text: the volume is a celebration of the intrinsic antiquity of the monuments (Figure 9.3), but perhaps their historical significance was thought to be self-evident. The only accompaniment to the plates was a map of the kirkyard showing the positions of the monuments at the time. Despite this minimalist approach and a print run of only 75, the book had a wide influence, not least because of its lavish photography.

Romilly Allen was extremely impressed by the clarity of the images and thought that technique so effective that he felt moved to give 'a public expression of gratitude . . . for the signal service . . . rendered to Scottish archaeology'.[8] In his 1902 discussion of the 'Early Christian Monuments of the Glasgow District' in the *Transactions of the*

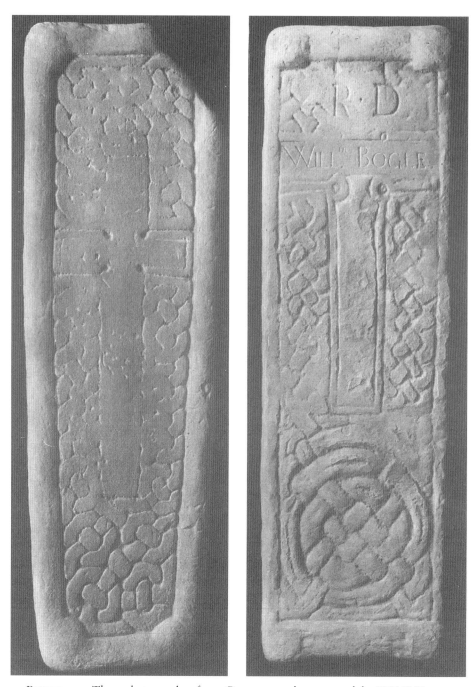

FIGURE 9.3 These photographs of two Govan recumbent cross-slabs (*ECMS* Nos 35 and 7) show the high definition that Annan achieved with plaster casts in the studio. From Stirling Maxwell 1899, Pl 14.

Glasgow Archaeological Society, Allen drew attention to links between the Govan material and the other sculpture in the region, most of which had previously been published by Stuart, but his remarks were very general. With respect to context and origin he added little to Stuart's observations. There is little comment about landscape setting other than the suggestion that the Barochan Cross (Renfrewshire) may mark 'the limits of a sanctuary' (Figure 9.4).[9] Allen and Anderson's *ECMS* appeared the following year and reproduced Stirling Maxwell's photographs of the Govan material. Far from suggesting that the Strathclyde material might represent a coherent artistic movement, Allen and Anderson offer virtually no general commentary on the British sculpture. This set the tone for much of the 20th century. Perhaps because it lacked the mysterious, visual appeal of the Pictish sculpture or because it has never enjoyed the detailed scrutiny of the RCAHMS, the Strathclyde sculpture languished until the late 1960s.

Modern scholarly interest was rekindled by Ralegh Radford, who drew the sculpture into sustained discussions of the organisation of the early medieval Church in Scotland.[10] By using the sculpture as historical evidence, Radford changed the status of these monuments from antiquarian relics to historical resources.[11] Radford held the view that prior to the 12th century the Welsh (including the northern British) ecclesiastical landscape was dominated by mother churches based at monasteries.[12] This led him to conclude that Govan and Inchinnnan with their multiple monuments were probably monasteries,[13] although it seems to have bothered him that there was no sculpture older than around AD 900 at a site as important as Govan.[14] Radford did not offer a view on the more widespread occurrence of single monuments at other sites, but he did introduce the term 'Govan School'.[15]

A comprehensive appraisal of the Govan sculpture did not take place until 1992 when the Revd Tom Davidson Kelly, then minister of Govan Old, organised a conference involving art-historians, archaeologists and historians.[16] It followed close upon Alan Macquarrie's important discussion of the 'Govan School',[17] which made a serious effort to provide a historical context for the Govan collection and the rest of the sculpture in Strathclyde. The conference constituted a major advance in the study of northern British sculpture because each type of sculpture was given due consideration by a leading expert. For example, Rosemary Cramp assessed the numerous, but neglected, recumbent cross-slabs, while Jim Lang revised his earlier study of the hogback monuments.[18] Perhaps most significantly, Derek Craig was asked to provide a regional context for the collection and produced a detailed hand-list of the Strathclyde monuments, mapping their distribution for the first time.[19] The historical contexts of the sculpture were explored in several of the papers,[20] which moved discussion away from Radford's notion that ecclesiastical organisation provided the only motive for the propagation of the monuments. The new consensus was that the sculpture of the Govan School reflected secular political influences and the turmoil at the end of the Viking Age, and that the Govan assemblage might be best accounted for as royal cemetery. The conference and its proceedings effectively demonstrated the importance of the Govan material, but also served to highlight the poor state of the recording of the sculpture and the lack of detailed research. The conference also stimulated new archaeological research in Govan, including a series

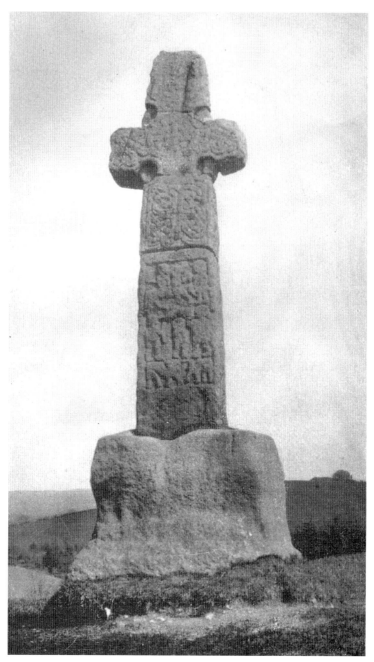

Figure 9.4 Allen's fine view shows the Barochan Cross in its landscape context, although by this time (1902) the cross had been moved from its older location. From *ECMS* III, Fig 475D.

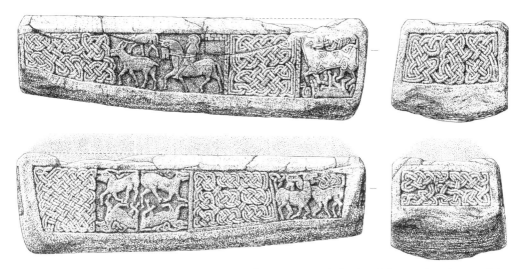

FIGURE 9.5 This drawing of the Govan Sarcophagus was made by Ian G Scott, who pioneered the fine stipple style adopted by the RCAHMS. (Crown copyright: RCAHMS)

of trial excavations,[21] and experiments in digital recording of the monuments.[22] Subsequent conservation work provided the opportunity for Ian G Scott to make new drawings of the sarcophagus (Figure 9.5).

WHAT IS THE 'GOVAN SCHOOL'?

Although the concept of a Govan School was introduced by Radford, the first sustained effort to link the Govan collection with the other Strathclyde sculpture was made by a medieval historian, Alan Macquarrie, whose discussion remains the clearest definition of the extent and nature of the 'Govan School'.[23] The thrust of Macquarrie's argument is that the sudden appearance of sculpture in Strathclyde coincided with a period of Gaelic influence as the dynasty established by Cinaed mac Ailpín expanded southwards. It is in the light of the late 9th-century 'political and ecclesiastical developments that we should view the flowering of this fertile and productive school of Early Christian art in Scotland'.[24] Art-historians and archaeologists have been more circumspect, although the notion was considered by several of the contributors to the 1992 conference: Fisher refers cautiously to a 'Strathclyde style'[25] and Spearman qualifies it as the 'Govan/Inchinnan school'.[26] Craig was most forthright in expressing reservations about the term 'Govan School', because the most common monument at Govan, the recumbent cross-slab, is only found at two other sites: Inchinnan (Renfrewshire) and Dumbarton (West Dunbartonshire).[27] Nevertheless, the idea of a school is attractive, if only as a convenient shorthand (which Craig himself finds difficult to avoid).[28]

In an art-historical context 'school' is used to describe works which share common aesthetic themes, forms, decorative treatments and techniques and it implies the existence of a central workshop where artists are trained. Such arrangements are

known to have existed in well-documented periods, and the products of these schools can be identified with greater or lesser degrees of confidence using art-historical methods. In applying the term to early medieval sculpture, where there are no documents to substantiate the presence of a central workshop or a network of related workshops, the existence of a school can only be inferred through the identification of common technical attributes, themes, materials and findspots. As a result early medieval art-historians have been cautious in making such claims, except where the evidence seems overwhelming, as Craig has argued for Whithorn.[29] Despite the intrinsic difficulty of working with fragmentary and eroded evidence, which is recorded to different standards, there are aspects of the Strathclyde monuments that encourage thinking about a common tradition and perhaps a school. For instance, the preference for median-incised interlace suggests a restricted chronology, and there is a consistency in the ornamental schemes of interlace panels employed on free-standing crosses and on the recumbent cross-slabs. At first glance the distribution is suggestive, with the large collection at Govan appearing to dominate its hinterland. However, if we wish to distinguish between a genuine central workshop and looser, shared artistic tastes, if we want the school we construct to be of value in wider historical discourse, then we also need to consider the social, political and ecclesiastical mechanisms that a school implies. As a preliminary to this consideration we will examine four cases with a particular emphasis on landscape context, which we believe throw additional light on the purpose and historical significance of the sculpture.

CHRONOLOGY: ESTABLISHING CONTEMPORANEITY AND RECOGNISING LIMITS OF CONFIDENCE

Joseph Anderson's proposal[30] that the Govan sculpture be dated to between the Viking Age and the Romanesque has been refined, but has been neither challenged nor independently substantiated. Romilly Allen[31] deferred to Anderson, and although Radford considered more monuments, he came to the similar conclusion that the Strathclyde sculpture was created approximately between AD 900–1150. His understanding of the chronology has not been significantly altered: although some would prefer an even earlier starting date,[32] all are agreed that it had ended by around 1100.

In the absence of inscriptions or dated excavations, the chronology is fundamentally an art-historical construct, the precariousness of which is illustrated by Ian Fisher's reasoning with respect to the Govan cross-shafts. He is 'inclined towards the 10th to 11th-century date suggested for the much-debated Donegal carvings by Robert Stevenson,[33] it provides a general context for the examples at Govan, although these are completely local in their stylistic expression'.[34] Rosemary Cramp, through comparison with recumbent monuments from outside Strathclyde, concludes that the production of recumbent cross-slabs spanned the 10th and 11th centuries, and allows that some might be of 9th-century date.[35] There is little archaeological evidence to be brought to bear on the question. The radiocarbon dates from the excavations[36] are scarcely relevant, although they do establish the presence of a cemetery at Govan from the 6th century. Coin evidence from Dublin has been used to suggest that the

'West Viking' style of ring-knot decoration seen on the earliest of the hogbacks may have been current towards the start of the 10th century.[37]

While the dating arguments are hardly overwhelming, there is no reason to question the chronological framework in general. Whether this framework can be applied with confidence to the rest of the Strathclyde group requires a closer art-historical consideration, which is not our concern here. Perhaps the most interesting point about the chronology, as Radford noted,[38] is that there is no sculpture from the Strathclyde region from much before AD 900. Similarly, the sculpture tradition ends abruptly at the end of the 11th century. The significance of both of these horizons invites further consideration.

TYPOLOGY

On a classificatory level the typological scheme for the Strathclyde sculpture is unproblematic: there are recumbent burial monuments (hogbacks and cross-slabs), upright crosses and the unique Govan Sarcophagus. There has been, however, little *functional* consideration of the monument forms, particularly with respect to the crosses found away from the major churches. The most numerous category is the recumbent cross-slabs which served as grave-covers, although these are confined to three sites: Govan (34), Inchinnan (2), and Dumbarton (2). Despite the large number at Govan, Cramp makes the important point that although many are similar, all are unique, which implies that they were individually commissioned rather than mass-produced. In this area there is no architectural sculpture apart from the Govan Sarcophagus, which in addition to the obvious funerary function must be regarded as church furnishing. The other main category, the free-standing cross, is much more widespread geographically and has been found both within churchyards and in the countryside, where its purpose or purposes is less clear-cut. This latter group of 'landscape' crosses presents particular analytical problems, because recovering original locations and interpreting locational significance requires concentrated historical effort and good local knowledge.

Above all it is the great sarcophagus that sets Govan apart from other churches in Strathclyde. Now it is probably impossible to determine whether it was made to house the bones of a king, as the mounted warrior implies, or the relics of the royal patron, St Constantine. The essential point is that here we have a monument to be displayed *within* a church that had developed into the pre-eminent dynastic centre in Strathclyde. It is noteworthy that all three sites with recumbent monuments are at or near royal centres (Dumbarton itself, Inchinnan just east of Renfrew, King's Inch, and Govan opposite Partick). In this respect, Macquarrie's comparison of Govan with the Columban cult-centre at Dunkeld seems particularly apt and reminds us that the early medieval creative process was embedded in the relationship between church and dynastic elite.

STYLE: ESTABLISHING LINKS THROUGH ARTISTIC COMPARISON

From an art-historical perspective the most thoroughly studied monuments in Strathclyde are the hogbacks, which have been investigated as part of national studies

of Viking-Age sculpture.[39] The rest of the sculpture has been studied in much less detail. Hogbacks are understood to be modelled on buildings, either a church or timber hall, and have well-established Anglo-Norse associations. The Govan ones correspond to types found in Cumbria, and link the Clyde into the wider Irish Sea province of the 10th century. Although the Govan hogbacks are recumbent burial monuments, there is little to link them to the recumbent cross-slabs there apart from function. Similarly although recumbent gravestones appear at various times and places during the Middle Ages, there are few close analogies to the designs shared by Govan, Inchinnan and Dumbarton.

There are, however, close links between the decorative treatments on the recumbents and the free-standing crosses at these three sites. These exhibit features familiar elsewhere in Scotland, Ireland, Wales and Northumbria, but follow a distinct Strathclyde tradition. The locally available raw material, sandstones and other sedimentary rocks, are suitable for high relief and three-dimensional sculpting. Consequently, the free-standing crosses tend to feature rectangular shafts thick enough to carry ornament on all four sides.[40] Only three crosses survive complete — the Govan 'sun-stone', the Netherton Cross and the Barochan Cross — and each is of a distinctive form. The 'sun-stone' cross is executed in false relief and its arms are contained within the roughly shaped slab. The chunky arms of the Netherton Cross scarcely project from the shaft at all (Figure 9.6). The Barochan Cross, however, is more ambitious and the most representative of the rest of the group. Its head is encircled by a ring contained within small round armpits. Macquarrie sees the Barochan Cross as an archetype for the free-standing crosses of the Govan School, and has identified vestigial remains of a ring on the headless shaft found at Inchinnan.[41] Unfortunately the standard of recording does not permit this to be demonstrated without further detailed work. Given that Cramp suggests that the cross forms on the recumbents derive from free-standing crosses, it is interesting that rings do not feature at all on the recumbent cross-slabs.

In general, the free-standing crosses are highly decorated, most available surfaces are arranged into panels filled with abstract interlace and key-pattern ornament or representations of men and beasts. Technically the abstract ornament is competent, but most commentators observe that the figural images are not of the highest quality. The most familiar images are of mounted warriors, but there are also a few panels which may represent scriptural scenes or commemorate other historical events. The frequent representations of mounted warriors have invited comparison with Pictish sculpture, but the analogies are not close. It is true that none of the Strathclyde sculpture exhibits the technical expertise or artistic vision seen in the finest sculpture from Pictland or Argyll. Even if we put to one side dubious value judgements associated with realism in early medieval art, we must acknowledge a more limited technical ability. The flatness and lack of detail on the worn surfaces may indicate that the stones were finished with paint, but they also point to different traditions to those which prevailed at St Andrews, Meigle or Iona. The implications of this are perhaps bound up in the post-Viking ecclesiastical institutions which no longer produced the great manuscript art of previous centuries. Perhaps it is not too much to

FIGURE 9.6 The Netherton Cross in its present location, east of the Hamilton New Parish Church. (© Oliver O'Grady)

suggest that this is indicative of the political disruptions of the Viking Age and a consequent change in the patterns of patronage.

The characteristic forms of interlace in Strathclyde, which rely heavily upon 'stopped plait' and free-ring knotwork, are of particular interest, because they are the prominent features of the 'Whithorn School'.[42] These patterns are not unknown elsewhere but they are nowhere else as popular as in Strathclyde, Galloway and Cumbria. This popularity raises interesting questions, not the least of which is how to account for these connections. A preference for these interlace styles was a defining feature of post-Viking sculpture in the British-speaking world from north Wales to the Clyde, even though the monument forms differed significantly. Perhaps this is a stone manifestation of the phenomenon of shared saintly dedications which spread across the British cultural zone.[43]

LOCATION ANALYSIS: FINDING MEANING IN THE LANDSCAPE

From the preceding discussion it will be clear that the Govan material has dominated previous considerations of the Strathclyde sculpture. In terms of a putative

'Govan School' we must think about the relationship between Govan and the other sites with sculpture. Derek Craig's analysis of the contemporary 'Whithorn School' of monuments on the Wigtown peninsula, provides an important model. Craig has convincingly argued that the distribution of these closely related disc-headed crosses reflects the proto-parochial structure of what was to become the medieval deanery of Farines, with Whithorn at its centre (Figure 21.1).[44] Sculpture of the 'Whithorn School' is found almost exclusively at church sites, but the picture in Strathclyde is more complex. Several crosses come from ancient churchyards, for example one each at Inchinnan, Old Kilpatrick (West Dunbartonshire), and four at Govan, all of which became medieval parish churches. The remainder, however, came from varied landscape settings the significance of which is not so readily understood.

The principal early documentary sources for the church in Strathclyde are the registers of Glasgow Cathedral (founded 1114–18) and Paisley Abbey (founded 1167).[45] These cartularies began to be compiled in the 12th century, and for Strathclyde they mark a historical horizon beyond which we can rarely glimpse. Nevertheless, they provide one of the keys to reconstructing the ecclesiastical landscape of Strathclyde.[46] The various charters relating to the area make no direct references to the sculpture, but allow us to identify specific places of significance to ecclesiastical and secular authorities in the central Middle Ages. For instance, Cadzow is well known from 12th- and 13th-century charter evidence as a royal centre and the site of a church with royal patronage.[47] The parishes, although not formally constituted before the 12th century, derive from existing political and landholding interests, and some of these later medieval territorial units appear to be of great antiquity in this region, as elsewhere in Scotland.[48] For instance, the exceptionally large parish of Old Kilpatrick (later divided into Old and New Kilpatrick) probably originally included Dumbarton Rock and thus represents the core of the British kingdom centred on Clyde Rock. An understanding of the 12th-century landscapes of Strathclyde allows us to work backward and reflect upon the earlier significance of places associated with early medieval sculpture.[49]

None of the Strathclyde crosses survives in its original location, although plain, socketed, rectangular bases have been recorded in or near to where four of the crosses formerly stood (Barochan, Stanely, Inchinnan, Capelrig). In most cases we are reliant on antiquarian accounts of varying degrees of precision to identify original locations. In this paper we wish to highlight the problems of determining the significance of location through a series of case studies; firstly by considering two isolated monuments: the Barochan Cross, which stood in the countryside, and the Netherton Cross, from the heart of a settlement. Then we shall explore two contrasting groups of apparently related monuments: the Kilpatrick group, and a group found in the hinterland of Paisley.

THE BAROCHAN CROSS

This fine cross, which now stands inside Paisley Abbey, was noted in the *Old Statistical Account* and illustrated in *Descriptions of the Sheriffdoms of Lanark and Renfrew*,[50] before being included in Stuart's corpus, where the cross was said to have

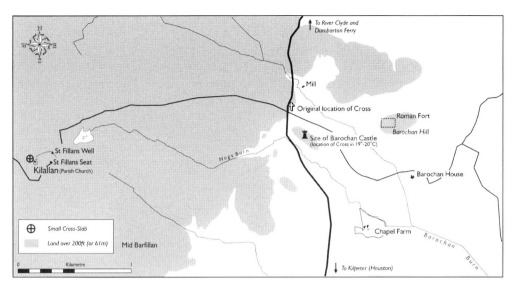

FIGURE 9.7 Map showing the landscape setting of the Barochan Cross. (Drawing by Lorraine McEwan. © University of Glasgow)

originally 'stood a few score yards south of the Mill at Barrochan' (Figure 9.7).[51] Topographically the area around Barochan consists of low hills, divided into shallow valleys by parallel systems of burns, including the Barochan Burn which flows southeast into the River Gryfe. The mill is situated by a ford on this burn at a point were the land begins to rise steeply. Directly downstream from the shingle ford, the burn descends over a waterfall into a wooded gully.

The cross stood in a sheltered position by the road close to the crossing place over the burn. Although this is now a minor road, the B789 follows the route of the old high road Johnstone to Langbank, which linked Strathgryfe with the Clyde at the crossing-point to Dumbarton. In its original location the cross would have looked south to the adjacent low hillock which was the site of the old castle of Barochan, seat of the barony before its replacement by Barochan House in the 16th century. Recent aerial photographs reveal that this prominent flat-topped knoll is enclosed by a triple-ditched rampart which may be of Iron Age date or later (NMRS NS46 NW3, 23, 62).

The cross was, in fact, moved to the top of this knoll sometime in the 19th century, and its base is still there, overlooking the west entrance to the estate policies. This Victorian setting dominating the approach to the 'big house' reflects contemporary upper-class values about landscape and authority. It is tempting, however, to consider that the cross's previous setting might have stood in an analogous relationship to the knoll, marking the final approach to the old castle and its predecessors. The prominent martial imagery on the cross itself may lend credence to the notion that its original context was primarily secular.

The relationship of the Barochan Cross to the local ecclesiastical landscape is not obvious. It was situated within the medieval parish of Kilallan, which was co-terminus with the barony of Barochan. The ruined old parish church of Kilallan

stands some 2.4km west of the cross's original location. Built into the east wall of the aisle is a small cross-incised slab of possibly early medieval date.[52] A similar distance to the south of the cross is the parish church of Kilpeter (Houston), which was united with the parish of Kilallan in 1760. The interrelationship of the two parishes is complex and, according to Innes, they 'lay in some places much intermixed with the other'.[53] It is curious that the original position of the Barochan Cross was roughly equidistant from both parish churches, although it does not appear to coincide with a known boundary between the two. The farm-name 'Chapel' only 1.3km to the south, may constitute evidence of another ecclesiastical site even closer. However, although there are reports of burials at the site, these are of unknown date, and the status of the site remains uncertain.

The older significance of this area is reflected in the Roman fort sited on the nearby Barochan Hill, less than 1km to the east (NMRS NS46 NW17). The fort has been identified as the site named by Ptolemy as *Coria* of the Damnonii. If correct, this name is potentially significant because it derives from a Celtic word meaning 'hosting place' and may thus imply that in the Roman period Barochan was some kind of tribal centre.[54]

THE NETHERTON CROSS

The Netherton Cross was erected at the heart of Cadzow, modern Hamilton, the most important early political centre on this stretch of the Clyde. A substantial motte, probably the site of the royal castle used occasionally by Scottish kings in the 12th and 13th centuries (David I and Alexander III), stands 60m to the south of the cross's original location near to the confluence of the Cadzow Burn and the Clyde (Figure 9.8). In the Later Middle Ages the focal point of the settlement shifted south as the new castle, later to become Hamilton Palace, and a collegiate church were built. The collegiate church replaced the old parish church in 1451 at the petition of Lord Hamilton, and survived partially until the 19th century.[55] The form and history of the earlier church near to the cross site will remain unknown, as it appears to have been lost to the construction of the M74 and the diversion of the River Clyde in the 1970s.[56]

As settlement shifted away from the cross and motte towards Hamilton Palace, the new focus became known as the *Hietoun* in distinction from the earlier centre of *Netherton*. It was the *Hietoun* which became a burgh of barony in the mid-15th century and host to a regionally important market.[57] The ancient power centre continued to be important, however. In the *Old Statistical Account* the cross was identified as the market cross and said to stand near the 'moat hill' (the old earthwork castle),[58] which was described as a 'seat of justice' in the *New Statistical Account*.[59] The cross remained a local landmark alongside the road to Bothwell Bridge and Glasgow, and a reminder of the continued importance of the ancient site.[60] In 1926, at the time of the demolition of the great Hamilton Palace, the cross was removed to the kirkyard of the new parish church, built by William Adam in 1732, where it now stands in a modern commemorative base.

The Barochan and Netherton Crosses have contrasting biographies, in the sense that the former stood in a quiet, out-of-the-way location and lost its social

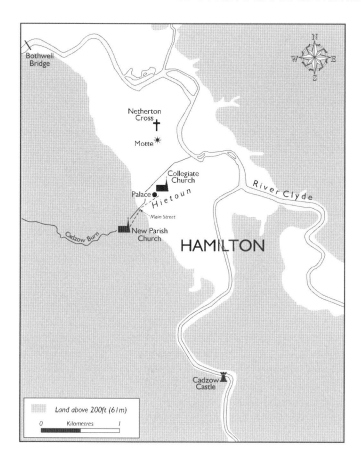

FIGURE 9.8 Map showing landscape setting of the Netherton Cross, which now stands beside the new parish church. (Drawing by Lorraine McEwan. © University of Glasgow)

significance, eventually being reduced to a landscape ornament, whereas the latter remained at the centre of the community throughout the Middle Ages, the one stable feature in an evolving social environment. Presumably, the Netherton Cross originally served as a focal point in what was already an important political centre before the 12th century. Its subsequent association with mercantile and judicial proceedings, associations which help to account for its survival, testify that the meanings of monuments evolve even as they stay still.

The crosses from Barochan and Netherton are singletons. We turn now to two examples of groups of sculpture: one distributed within the ancient parish of Kilpatrick, and the other spread more diffusely in the hinterland of Paisley.

THE KILPATRICK GROUP

In several respects the medieval parish of Kilpatrick invites comparison with Govan Old. Both parishes covered large swathes of the Clyde and included royal centres. Both churches occupied ancient, raised churchyards which have produced early and later medieval sculpture. On topographic and historical grounds, there is

FIGURE 9.9 Map showing landscape setting of the Kilpatrick Group. (Drawing by Lorraine McEwan. © University of Glasgow)

little doubt that Old Kilpatrick was the most important church on the north shore of the lower Clyde during the Early Middle Ages.[61] Prior to the foundation of the burgh of Dumbarton in the 13th century and the creation of New Kilpatrick (Bearsden) in the 17th century, Kilpatrick parish ran from the Leven to the Kelvin, an exceptionally large area even making allowance for the wilderness of the Kilpatrick Hills. In art-historical terms, the various pieces from Kilpatrick are closely linked to the Govan collection. From the churchyard comes part of a finely carved shaft which shares aspects of form and decorative treatment with Govan's 'Jordanhill' Cross (City of Glasgow).[62] Not far away stood the 'Mountblow' Cross (West Dunbartonshire) and from the citadel of Dumbarton itself come two recumbents. These four sculptures enrich our understanding of the structure of the parish.

The original position of the so-called 'Mountblow' Cross bears many similarities to that of Barochan. It formerly stood on the main road west to Old Kilpatrick, at Sandyford, where it crossed the Lusset (or Dalnottar Burn) (Figure 9.9). Although the original location is now under the Erskine Bridge access road, its setting can be reconstructed with some confidence. The 18th-century road, beside which the cross stood, probably followed the line of the Roman Military Way of the Antonine Wall. This route was of fundamental importance providing an overland link between Glasgow and Dumbarton. At the Sandyford crossing there was an expansive view from the lower slopes of the Kilpatrick Hills over the Clyde estuary. More specifically

this point, less than 1km from the parish church, appears to have been an important ecclesiastical boundary. In the 12th century the Lusset Burn was the eastern boundary of a parcel of land occupied by one of the church's key tenants.[63] It is tempting to surmise that formerly it had constituted the *termon* of the church lands, with this exceptionally large monument positioned to inform those passing by that they were approaching the sanctuary of the church. In the modern era, like so many of the crosses of the area, it was appropriated into the policies of a landed estate, Mountblow House, having been retrieved from use as a footbridge in around 1757.[64]

Dumbarton Rock was, of course, the pre-eminent royal centre on the Clyde prior to its destruction at the hands of the Dublin Vikings in AD 870.[65] The precise discovery circumstances of two fragments of recumbent cross-slabs are not well recorded, but they were certainly recovered from within the castle, possibly from the chapel known to have been dedicated to St Patrick.[66] Although they have been cut down for reuse as building material, these fragments survive well enough to reveal that they were similar in design and technique to recumbent cross-slabs from Govan and Inchinnan, so similar, in fact, that it is possible that they were produced in the same workshop.[67] Nothing is known about Dumbarton after the Viking attack, until it reappears as a royal castle in the 12th century.[68] The parish of Dumbarton did not appear until the 14th century,[69] when the burgh was established and the parish was presumably carved out of Kilpatrick.[70] The slabs, however, point to a continuing British noble presence at Dumbarton beyond the catastrophe of 870, and specifically to high-status burial there in the 10th or 11th century. The close physical resemblances between the Dumbarton recumbents and those at Govan are suggestive of a political linkage between those buried in the 'royal cemetery' at Govan and the 'constables' of Dumbarton castle.

The Kilpatrick group of monuments, although stylistically related, is of distinct types from different settings. One of the things we learn from Kilpatrick is that a major church need not be located precisely at the centre of political power, and conversely that the requirements of a high-status cemetery might be readily satisfied outwith the principal church of a district. These are both points that have relevance as we turn to Paisley.

THE PAISLEY GROUP

The second group we are considering is more extensive, stretching over several parishes to include a number of single monuments and the collection at Inchinnan. At the centre of this group is Paisley, a major church which, like Glasgow itself, has produced no early sculpture. As with Glasgow, however, there are reasons to believe that it was a significant church from a very early date. The name Paisley, earlier *Passlec*, derives from Latin *basilica*, probably via British (cf Welsh *basseleg*).[71] Churches with such names in Wales and Ireland are recognised as occupying an important position in the early phases of Christianity, where they appear as relic-churches housing the remains of universal saints or early martyrs.[72] The antiquity of the church at Paisley has been impossible to substantiate archaeologically because of

FIGURE 9.10 Map showing location of sculpture around Paisley. The parish boundaries are taken from *Origines Parochiales Scotiae* (Innes *et al* 1850–5), as is the ancient extent of Paisley. (Drawing by Lorraine McEwan. © University of Glasgow)

subsequent development, and is obscure historically, because of the complete re-appropriation of the site in the 12th century by the Stewarts.[73] In addition to its own extensive parish, the medieval Abbey of Paisley enjoyed possession of a large number of parishes, with 30 being listed in 1265.[74] Paisley's core area of influence was south of the Clyde and extended east along the White Cart as far as Rutherglen, and west along the Gryfe Water to Kilmacolm (Figure 9.10). Within this vast swathe only two notable parishes were excluded from Paisley's control in charters of David I: Inchinnan and Govan.

About 4km north of Paisley, the medieval church of Inchinnan stood until 1828 when it was replaced.[75] The early medieval sculpture appears to have been discovered at this time. The collection comprises a free-standing cross, a recumbent cross-slab similar to the Govan examples, and a unique recumbent monument with animal ornament on its top and sides (Figure 9.11). Inchinnan's topographic situation is very striking. This church was located just above and to the west of the confluence of the Black Cart with the White Cart Water, 1.6km from where the Cart empties into the Clyde. The church was situated at the eastern border of its medieval parish, adjacent to the important river crossing to Renfrew on the opposite bank.

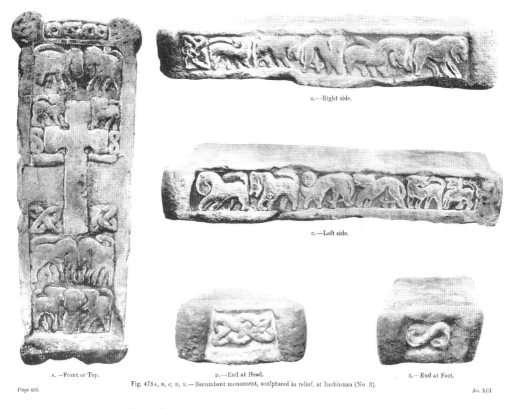

FIGURE 9.11 View of the Inchinnan recumbent 'shrine'. From *ECMS* III, Fig 478.

A socketed cross-base known as St Conval's Chair was discovered near the bridge over the Cart.[76] If this is the base of the free-standing cross at Inchinnan, it may indicate the cross's original location, a position which echoes the wayside location of the Barochan and 'Mountblow' Crosses. As with Dumbarton, the recumbent cross-slab invites close art-historical comparison with examples from Govan. The ornamented slab is thought by some to be a tomb shrine, and it is interesting to note that in the 15th century Fordoun refers to the existence of a shrine to St Conval at Inchinnan. It could equally, however, be an elaborate secular burial memorial. David I took particular care to keep Inchinnan out of the Paisley sphere. This, and its proximity to the royal centre at Renfrew, may indicate a royal association with this church whose original dedication to Finnian suggests a very early foundation.[77]

In addition to the cluster of monuments at Inchinnan, five free-standing crosses are known to have stood isolated in the landscape around Paisley: the crosses of Arthurlie and Capelrig (East Renfrewshire), Stanely, Newton Woods and Auldbar (Renfrewshire). The Auldbar cross is now lost and known only from a brief description, but the others are typologically very similar, both in form and decorative treatment, which is probably indicative of a narrow chronological range. Derek Craig has noted that these crosses 'lie in an arc south-west of and parallel to the Clyde, 8km

inland from Govan and Inchinnan'.[78] By looking more closely at the topographical settings of the individual monuments we can give this arc some historical significance. To begin with, none were located at or near medieval churches of any significance, but all were conspicuously positioned along the south side of the valley of the White Cart Water on the high ground overlooking the Paisley basin.[79] Several of the crosses were located where locally important routeways crossed boundaries. The best preserved example, the Arthurlie Cross (Figure 9.12), commanded extensive vistas over the south side of Glasgow and along the valley systems of the Levern Water. The cross appears to have originally stood by the Kirkton Burn, not far from the southern limit of Paisley parish and close to an important road leading south-west towards Irvine. Like Mountblow, Arthurlie was used for a time as a footbridge.[80]

Further west towards the foot of the Gleniffer Braes stood the Newton Woods and Stanely Crosses. The stone from Newton Woods, near Elderslie, was discovered in a well, near the old mansion of Newton overlooking the Old Patrick Water, a tributary of the Black Cart Water, at the point where the steep-sided valley opens out. Less than 2km away to the east stood the Stanely Cross on the frontier between the good arable and the forest of Forineise on the Gleniffer Braes. From the cross-site there is a restricted view towards Paisley.[81] The cross is most closely associated with the castle of Stanely,[82] a significant Stewart estate in the 12th century that was bestowed upon Paisley Abbey. Neither cross can be linked with a medieval church. Continuing east, next is the lost cross of Auldbar about 4km distant. The precise setting of the Auldbar cross, carved with 'only wreathed work',[83] is not known but appears to have stood on or near the boundary between Paisley and Eastwood parishes on the high ground overlooking the valley of the White Cart. Moving a further 4km south-east, the Capelrig Cross also commanded an excellent view over the upper reaches of the White Cart Water until it was removed to Glasgow Museum in 1926 (Chapter 7).[84] There is some doubt as to the original configuration of the medieval parishes of Eastwood, Pollock and Mearns, and it is possible that the Capelrig Burn served as the southern boundary of Eastwood parish. Cosmo Innes states that the district of Eastwood was probably originally subsumed within the parish of Paisley.[85]

It would require detailed study of the sculptural ornament and carving techniques of these monuments to determine whether they were made in the same workshop at the same time, but their immediate visual similarities suggest that they could be considered at least part of a single monumental scheme. More intensive landscape study and historical legwork would undoubtedly enhance our appreciation of these original settings. Nevertheless, even at this preliminary stage it is clear that this distribution is of some considerable significance for understanding the early medieval ecclesiastical landscape of the middle Clyde. In recent years, the possibility that large ecclesiastical districts existed in Scotland prior to the 12th-century introduction of the parochial system has been discussed both by Macquarrie, in terms of minster-like structures,[86] and by Clancy in the context of 'mother churches' with *annat*- place-names.[87] On the basis of his study of the charter evidence Cosmo Innes suggested that Paisley was the centre of a territory much larger than the parish itself including Renfrew, Lochwinnoch, Eastwood and Kilmacolm.[88] The Paisley-centred distribution

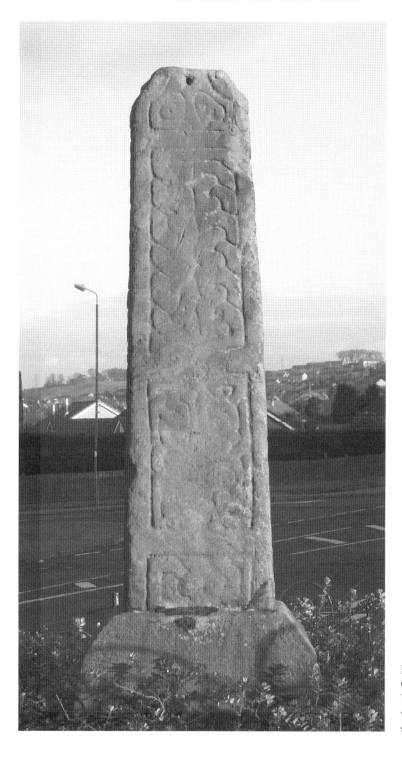

FIGURE 9.12 The Arthurlie Cross in its present location. The stump of a ring is just visible at the shoulder of the shaft. (© Stephen Driscoll)

of these isolated crosses adds substance to the arguments for an important early medieval ecclesiastical centre at Paisley.

CONCLUSIONS ABOUT THE GOVAN SCHOOL

What might a 'school' of sculpture represent in early medieval Strathclyde? It could be a single workshop providing sculpture for the whole region, as the term 'Govan School' implies. Alternatively, it could represent a group of related workshops employing craftsmen trained in a common tradition supplying their local district. Or perhaps the similarities are simply the consequence of separate workshops drawing inspiration from a few key monuments. Until more detailed work is done on the carving techniques and design concepts of the Strathclyde sculpture, it will not be possible to come to a definitive conclusion about the 'Govan School'. We would offer, however, some provisional observations about degrees of relatedness within the corpus and workshop locations. Some of the characteristic features, such as the widespread use of relatively simple interlace patterns and median-incised interlace, have a wide currency beyond Strathclyde and probably reflect no more than rough contemporaneity. Some more distinctive and less widespread features, such as the forms of certain free-standing crosses or the panels with outline crosses set in a field of interlace, imply closer connections. A few specific features, such as corner knobs on recumbent cross-slabs, are unique and imply very close connections. In this paper we have drawn attention to a connection between royal power centres and those cemeteries with Govan's 'signature monument', the recumbent cross-slab. At Dumbarton, Inchinnan and Govan, specific shared features suggest that a single workshop, presumably based at Govan, could account for this distribution. In the case of this particular category of monument we can probably talk of a 'Govan School', perhaps with a single workshop. However, in the case of the free-standing crosses the influences are more complex and are not necessarily consistent with Govan as the sole production centre. Indeed, although the presence of a free-standing cross at a major church could reflect royal patronage, the form and ornament of the Netherton Cross shows that royal involvement did not produce standardised sculpture. More importantly, a significant proportion of the free-standing crosses in the countryside can be linked more readily to Paisley than to Govan. We should, therefore, resist lumping all the free-standing crosses into the 'Govan School'.

Rather than think of the 'Govan School' in terms of a single production centre analogous to the 'Whithorn School', we should acknowledge that in Strathclyde the picture is more complex with a greater diversity of monument type, decorative motifs and landscape location. It seems likely that there were two or more centres producing sculpture for a range of purposes, under different types of patronage, both secular and ecclesiastical. Although we believe that such a multi-centred model has significant implications for our understanding of the British kingdom or kingdoms in Strathclyde during the 10th and 11th centuries, this is not the time or place to develop them.

Perhaps the strongest conclusion that we would draw from our consideration of these monuments is that there is a real need for better recording. The early medieval sculpture of Strathclyde is now the least well documented of any regional group in

Scotland. It is in much the same scholarly condition as the pre-Norman sculpture in the south-west was prior to Derek Craig's PhD research,[89] which is to say it lacks both basic records and scholarly analysis. Thanks to Craig, we have the first coherent list and distribution maps for Strathclyde, but few stones are adequately recorded and in some cases Stuart's figures remain the most accessible illustrations. All of this material, including the Govan monuments, would benefit from more detailed analysis of find locations, stylistic affiliations and chronology. The uneven nature of the current record suggests to us that the Strathclyde group would be a useful starting place for a new corpus of Scotland's early medieval sculptured stones.

Our final thoughts are less academic and relate to the value of these monuments in modern society. We feel that a greater appreciation of the historic landscape setting through the exploration of monumental biographies, such as we have outlined for Barochan and Netherton, and Mark Hall and colleagues[90] have delivered for the Crieff Burgh Cross, is essential if the monuments are to have any social value in the 21st century. As a way of reinforcing the ancient significance of the landscape, and to complement the scholarly effort, replica crosses might be reinstated in the landscape.

ACKNOWLEDGEMENTS

Stephen Driscoll was first introduced to this material by Leslie Alcock; this interest was stimulated by the 1992 conference and given further encouragement by the Revd Tom Davidson Kelly when excavating at Govan Old in 1994–6. The foundation research for this paper formed part of Oliver O'Grady's MPhil dissertation, which was jointly supervised by Dauvit Broun. In its final form this paper has been shaped by Katherine Forsyth, who has drawn upon her recent experience with the Whithorn collection. The figures were prepared by Lorraine McEwan.

NOTES

[1] O'Grady 2003.
[2] Bradley 1997; Knapp and Ashmore 1999.
[3] Ingold 1993.
[4] Tilley 1994.
[5] Ritchie 1994.
[6] Stuart 1856.
[7] Stirling Maxwell 1899.
[8] Allen 1902, 394.
[9] Allen 1902, 400.
[10] Radford 1967a; 1967b.
[11] Radford 1967a, 184.
[12] Radford 1967a, 187.
[13] Radford 1967b, 117–18.
[14] Radford 1967a, 188.
[15] Radford 1967b, 125–6.
[16] Ritchie 1994.
[17] Macquarrie 1990.
[18] Lang 1974.
[19] Craig 1994.
[20] Crawford 1994; Davies 1994; Macquarrie 1994.
[21] Driscoll 1998c; 2003.
[22] Jeffrey 2003.
[23] Macquarrie 1990, 1–5.
[24] Macquarrie 1990, 17.
[25] Fisher 1994b, 51.
[26] Spearman 1994, 41.
[27] Craig 1994, 75–7.
[28] Craig 1994, 80.
[29] Craig 1992.
[30] Anderson 1881, 73.
[31] Allen 1902, 402.
[32] Cramp 1994.
[33] Stevenson 1985.
[34] Fisher 1994b, 47.
[35] Cramp 1994, 58–9.
[36] Driscoll 2003, 79–80.
[37] Lang 1994, 125.
[38] Radford 1967b, 126.
[39] Lang 1974.
[40] Craig 1994, 91.
[41] Macquarrie 1990, 2–3.
[42] Craig 1992; Bailey 1994, 117.
[43] Cf Bowen 1969.
[44] Craig 1991; 1992, 212–14; Hill 1997, 53–4.

[45] Innes 1832, 1843.
[46] Broun in press; Dowden 1910.
[47] Innes *et al* 1850–5, 105–7.
[48] Rogers 1997; cf Taylor 1995.
[49] O'Grady 2003, 48–9.
[50] Monteath 1791, 326–7; Hamilton 1831.
[51] Stuart 1856, 35–6, Pls CXV and CXVI.
[52] Lyle 1975, 58.
[53] Innes *et al* 1850–5, 81.
[54] Rivet and Smith 1979, 317–19.
[55] Innes *et al* 1850–5, 105; Torrie and Coleman 1996, 14–15.
[56] Torrie and Coleman 1996, 72.
[57] Torrie and Coleman 1996, 15.
[58] Naismith 1792, 209–10.
[59] Meek and Buchanan 1845, 270–1.
[60] Waddell 1918.
[61] Macquarrie 1996, 44.
[62] *ECMS* III, 452.
[63] Innes 1832, 166.
[64] Bruce 1893, 179–82.
[65] Alcock and Alcock 1990.
[66] MacIvor 1958, 6.
[67] Higgitt 1990.
[68] Bruce 1893, 61–4, 93–6; Innes *et al* 1850–5, 25.
[69] Cowan 1967.
[70] Macquarrie 1996.
[71] Watson 1926, 194.
[72] Sharpe 2002, 141.
[73] Innes 1832; Malden 2000.
[74] Innes *et al* 1850–5, 69–70.
[75] Innes *et al* 1850–5, 78–9.
[76] MacFarlan 1845, 17–18.
[77] Clancy 2001, 18–19.
[78] Craig 1994, 78–9.
[79] O'Grady 2003, 84–5.
[80] Cooke 1872, 451–2.
[81] Anderson 1889, 349–51, Fig 7; O'Grady 2003.
[82] Topen 2002.
[83] Burns and Macnair 1845, 196–7.
[84] Lacaille 1927; Batey 1994, 65–6.
[85] Innes *et al* 1850–5, 67.
[86] Macquarrie 1992; Cowan 1961.
[87] Clancy 1995.
[88] Innes 1832; Innes *et al* 1850–5, 67–73.
[89] Craig 1992.
[90] Hall *et al* 2000.

CHAPTER 10

SCOTLAND'S EARLY MEDIEVAL SCULPTURE IN THE 21ST CENTURY: A STRATEGIC OVERVIEW OF CONSERVATION PROBLEMS, MAINTENANCE AND REPLICATION METHODS

By INGVAL MAXWELL

BACKGROUND

Subtitled *A Classified, Illustrated, Descriptive List of the Monuments, with an Analysis of their Symbolism and Ornamentation*, ECMS by J Romilly Allen and Joseph Anderson still presents us with the most definitive overview of the subject 100 years after it was first published in 1903. The *Able Minds and Practised Hands* seminar has provided a timely opportunity to reflect on what we can learn about the physical condition of sculptures from *ECMS*, the technological advances in conservation that have occurred in the intervening century and potential future directions.

When it made its recommendations in 1890 for what a national survey should entail, the Committee on Sculptured Stones of the Society of Antiquaries of Scotland's list included a record of the condition of the monument, and if poor, whether the deterioration had been caused by weather, injury or another cause. The value of photography to record the monuments was also recognised.[1] A significant part of the stimulus for this was concern about the deteriorating condition of these sculptures. Allen expressed his concern about some of the individual monuments in his published descriptions, and went out of his way to make a special report on the Iona monuments, whose condition he considered to be a national disgrace.[2]

Allen and Anderson illustrated by means of photographs or drawings nearly all the sculptures that they recorded. In the interim many of the stones have been subjected to 100 years of further exposure and weathering, and there is an increasing concern about the environmental impacts on their fabric. Climatic influences, increased rainfall levels, chemical threats from agricultural usage, enhanced biological surface-colonisation and increasing physical threats from mechanised sources, such as grounds-maintenance equipment, all provide anecdotal support for the understanding that the sculptured stones are increasingly decaying in front of our eyes. But is

that uniformly the case? If decay and erosion were to be proven to be significant factors, a direct comparison of the 'then and now' situation should provide some clues as to what the degree of loss of carved surface amounts to. A reappraisal of Allen and Anderson's visual material should therefore provide a rewarding introduction to the question of whether or not the stones are deteriorating at a faster rate.

INTERPRETING THE *ECMS* ILLUSTRATIONS

Allen and Anderson used a variety of media and techniques to illustrate the sculptures, and their drawings do not compare favourably with modern drawing standards as set by the RCAHMS (Chapters 13 and 14). This means, for instance, that considerable surface detail is not depicted, notably on worn areas, as at Dupplin and Crieff.[3] The badly eroded Fowlis Wester 1 cross-slab (Figure 10.1) is represented by the application of interpretative drawn outlines on reproduced photographs. In the latter case, how well surface detail is interpreted can be directly compared with the two options that now exist on-site: the relocated original stone, positioned inside the nearby parish church, and the replica synthetic monolith that replaced the stone in the village square.

In illustrating how circumstances have changed, in the last decade or so all three of the above examples have been moved, on conservation grounds, from the sites where *ECMS* recorded them. The 1991 replacement of the Fowlis Wester 1 original with a replica is also an example of the type of approach that modern technologies and materials now make possible. At the same time, the surrounding railing, and the slated, timber open canopy associated with the Crieff Burgh Cross, before its relocation to the former Tolbooth in Crieff, introduce the complex processes that need to be considered when adopting the protective-enclosure route.

Both line drawing and on-site photography were used in *ECMS* to reveal the surface detail of St Martin's Cross, Iona (Figure 10.2). The near-photographic quality of the detailed drawing of the Kildalton Cross (Figure 10.3) illustrates, through close comparison with the original (Figure 17.2), that degrees of artistic licence were tolerated. This is particularly evident in the overall proportions, and on the representation of the three-dimensional forms of the figural and votive work.

Taken collectively, it might perhaps be considered that the wide variations in the illustrative processes that were used raise doubts about how well the original illustrations can be used to determine the degree of stone erosion and decay that has occurred since *ECMS* was first published. In other words, it is not consistently possible to rely on a straight comparison of *ECMS* and modern images to try to determine exactly what has happened to the physical state of the stones over the past century. Nonetheless, it is possible to extrapolate some findings in this area of interest.

Turning to the published *ECMS* photographs, direct visual comparison with more modern views of Aberlemno 3,[4] the Maiden Stone (Aberdeenshire), Kilnave Cross, and the Glamis 2 cross-slab are revealing.[5] In particular, the sculptured surface of the latter is revealed in crisp detail, with good highlights on the upper surfaces and intense shadow emphasis across the recessed planes. To a lesser degree, this is also apparent on the Maiden Stone, while the Aberlemno and Kilnave examples are less

CONSERVATION, MAINTENANCE AND REPLICATION 161

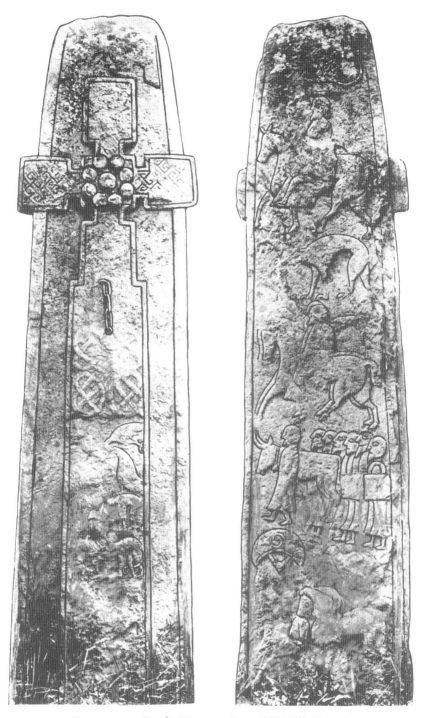

FIGURE 10.1 Fowlis Wester 1. From *ECMS* III, Fig 306.

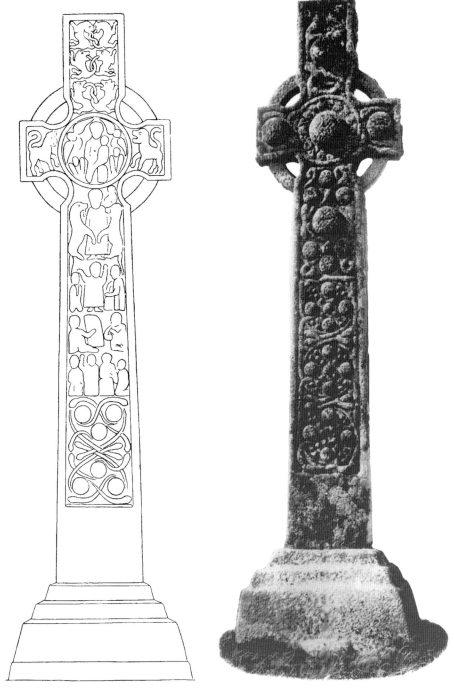

FIGURE 10.2 St Martin's Cross, Iona. Contrast this with Figures 17.5 and 17.6. From *ECMS* III, Fig 397.

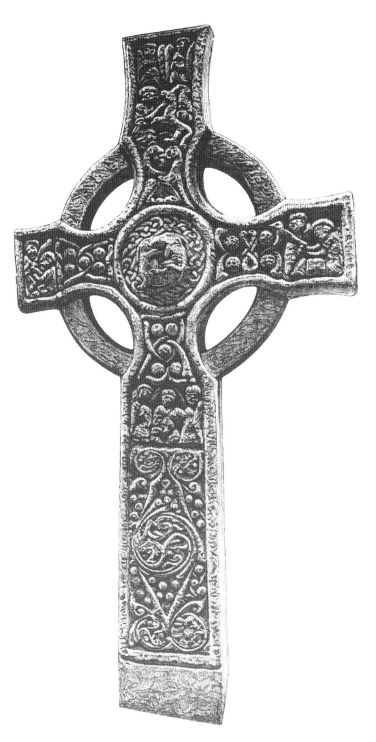

Figure 10.3 Kildalton Cross. From *ECMS* III, Fig 410A.

easily interpreted due to the amount of surface biological growth that the photographs also capture.

In offering a general view of the stones that are represented, there is little doubt that the photographs printed in *ECMS* were at the cutting edge of the technology of their time. Their quality is good enough to be scanned by modern electronic means, so that their contrast, brightness and presentational characteristics can be enhanced to aid their interpretation (the approach that was adopted in the preparation of this paper).

While good advice on how to take excellent modern photographs is offered in Tom Gray and Lesley Ferguson's *Photographing Carved Stones*,[6] there are some limitations that need to be borne in mind when trying to use photographs of different dates to assess the levels of erosion and decay. Different cameras, lenses, shutter speeds, and the types and ratings of films used all contribute to the complexity of making comparisons. Equally importantly, the prevailing weather conditions, time of the year, and hour of day that the photograph was taken can, inevitably, all contribute to our inability to make direct and straightforward comparisons.

Both Aberlemno and the Maiden Stone are in State care. The degree of surface colonisation has been significantly reduced as a result of the application of biocides. In effect, these stones are now virtually free of harmful growth. On the other hand, in private ownership, Kilnave and Glamis 2 have not been treated on a regular basis and, consequently, biological surface activity has been allowed to flourish, to the extent that it visually confuses the interpretation of the sculptured detail.

From the natural heritage's point of view, compelling arguments can be put forward to retain, untouched, any biological activity that may reside on the face of carved stones. From a wider perspective that view can be challenged, as it can be frequently seen that such activity can lead to degrees of distress. Left unattended, there is a hierarchy of symbiotic surface colonisation that develops. This extends from bacterial growths, through algae, lichen, fungus and mosses to liverworts. In worst case scenarios, this activity can lead to local disintegration and loss of stone matter.[7]

STONE DECAY

An investigation into any graveyard ably illustrates that stone decay does, of course, occur and that the threat remains a real concern for those important stones of all periods that are still exposed to the elements. The processes that are involved are by no means straightforward. Primarily, the type of stone plays a large part in how well it can survive the ongoing threats.

Granite slabs, such as those at Picardy and Brandsbutt (Aberdeenshire),[8] appear to survive well given the visual comparisons of the surface that is made possible by *ECMS*. However, a catastrophic fragmentation of the Brandsbutt Stone (possibly resulting from a direct lightning strike, fire or deliberate breaking-up), and an inherent weakness running vertically through the thickness of the Picardy Stone, illustrate that risks remain. At Picardy, a technique of pinpointing (using a fine mortar mix to infill the open edge of the fracture) has been used to try to keep as much rainwater as

possible from penetrating the split. This tries to eliminate the risk of water freezing in the crack, expanding and levering it wider open. Since *ECMS* was published, additional pieces of the broken monolith at Brandsbutt have been secured into a single block, but an unsympathetic make-up of the missing central segment has been recreated with a cement-based mortar infill. Again, the remaining danger lies in water penetration of the fractures, resulting in freezing levering the pieces apart. When compared to sandstone, however, the relative hardness of granitic stones gives less cause for concern.

Sculptured slabs created from various sandstones are subjected to the greatest range of decay mechanisms and weather-induced problems. In simple terms, in geological times, sandstone was created from pre-existing rock that had weathered and decayed, to be subsequently laid down as loose sediment, layer upon layer, and re-cemented with binding minerals to create a homogenous mass under intense heat and pressure. Viewed under high magnification, the stone's surface illustrates how individual sand grains are cemented together at their various contact points. This process can result in voids, and an interlinked pore-structure, extending through the stone's thickness. Through the mechanism of water flowing in and out through the open pores, pollutants, and other agents in solution, can penetrate, concentrate and migrate to trigger a variety of mechanisms that can physically break up the stone's structure. Dependent upon the type of minerals that 'glue' the stone particles together, the processes involved are complex and varied. With a continuation of these cycles over a period, the visual consequences of decay become evident in two distinct groupings. The first is minor but persistent disaggregation, which leads to physical loss of grains of sand from the surface (resulting in a visual blurring effect), and the second is catastrophic surface loss, often in the form of thick veneers peeling away from the body of the stone. The combined effects of all these mechanisms result in the degradation and loss of the artistic surface detail.

Although now protected from the elements by an enclosure, the Allen and Anderson illustration of the Eassie cross-slab (Angus) (Figure 10.4) reveals evidence that all of the principal decay mechanisms have been at work. Compared with recent photography, the situation does not appear to have been exacerbated. However, it can be interpreted that previous exposure to the elements has resulted in surface disaggregation (triggered by direct rainfall on the upper half), and structural delamination on the lower half (due to persistent direct contact with wet ground; a related form of surface delamination has also occurred on Fowlis Wester 1, although this is much more widespread over the exposed face due to the poorer physical properties of that stone).

The 'fresh' clean structural break that led to the uppermost third of the St Orland's cross-slab being physically broken off illustrates a brutal human act.[9] Amongst others, a similar incident also befell Shandwick.[10] Both monuments were previously re-attached with iron clamps. Allen and Anderson show that a face-clamp was originally used on St Orland's, while lead-run stapled edge-clamps were used to re-secure the Shandwick pieces. St Orland's receives regular conservation attention because it is a monument in State care, and Historic Scotland has advised and

Figure 10.4 Eassie cross-slab. From *ECMS* III, Fig 231B.

undertaken stone conservation work on behalf of the private owners of Shandwick, a scheduled ancient monument (Chapter 11).

Recognising that iron can rust, expand and thereby exert additional pressures that could further fracture stone, the preferred conservation approach of the State is the use of non-ferrous material (usually phosphor bronze or, more recently, stainless steel or carbon fibre) to re-secure broken stone pieces together. In the case of St Orland's, the fixing points of the earlier face-clamps have been subsequently plugged with mortar patches, but the original approach has left disfiguring holes in the stone's surface. Here, a lesson can be learnt from the fact that any new hole drilled or cut into the remaining original surface will result in a permanent physical disfigurement. Any intended new fixing therefore needs to be very carefully considered and the results fully appreciated before any associated action is taken.

JOINTING TECHNIQUES

The development of lengthy drill-bits, accurate masonry drilling techniques through the use of guiding-jigs, and the availability of high-strength stainless-steel fixing dowels has enabled a more robust way of securing broken stone pieces together. By setting and aligning the dowel holes in the broken planes, a fractured stone can both be strengthened and given back its visual and artistic integrity. This approach also avoids the need to further disfigure the exposed outer carved faces, but, to be effective, requires the broken stone pieces to be at least 150mm thick. If thinner, it is impossible to adopt this technique without adding to the risks due to the need to have sufficient strength left in the stone on either side of the inserted dowel. It is also a difficult technique to use when there are missing stone sections between the remnant fragments without additional support.

In such cases, alternative structural jointing methods have been devised. These can include fixing a profiled, non-ferrous metal U-channel along each side-edge to support the shaft over its length (as with the 16th-century cross at Kilbride); the encasing of exposed dowelling across the missing section to re-connect the remnant pieces (as at the 16th-century cross at Kilmartin, Argyll and Bute); and the solid infilling to the overall stone profile with a synthetic, unsculpted material (as at Meigle 4).

Various approaches have also prevailed during different eras of care. This is evident when reflecting upon the solutions adopted for the St John's Cross on Iona. Originally reconstructed in 1927, it twice collapsed in the 1950s. During the 1960s a concrete replica was created and placed in the original base outside the abbey. During the 1990s the fragmented original remains were pieced together, and brought inside the Infirmary Museum for display. The re-joined cross shaft was positioned in the centre of the floor space, and the reassembled crosshead parts were suspended in a cradle from the roof structure directly over it. Profiled pieces of frosted glass were positioned between the two sections, to reflect the missing head-parts and to give the assembly an aesthetic continuity.

ENCLOSURE

Water is the 'engine' that drives the decay processes of stone. It has long been recognised that if direct rain- and ground-water contact is prevented, carved stones (particularly sandstone) will survive in a better state of preservation if they are also enclosed, within a sufficient internal volume, so that they exist in as stable an environment as possible. The challenge has been to create the best possible set of conditions, in often-conflicting circumstances, when the actual site layout and legal constraints are not always conducive to achieving that ideal. Such a situation emerged at Dunfallandy (Perth and Kinross), where the thin, finely carved sandstone cross-slab is set on top of a steep escarpment, along a narrow pathway, and adjacent to a small burial ground enclosed by a wall. Overshadowed by mature trees, the banking was suffering from ground erosion, while overhanging branches posed a significant risk of falling on the stone, should they suffer wind-blow. With no agreement being possible to effect the stone's repositioning, an enclosure was constructed with two sides of masonry to deflect any potential falling branches. The cross-slab's main faces are to be seen through outward-opening plate-glass doors. It was also intended that these could be unlocked and hinged open under supervision, for closer examination of the monument. Consequently, the preferred policy of keeping the stone in its locality was achieved. However, the casual aesthetic appreciation of the stone in the enclosure, on such a tight site, is less than satisfactory due to the reflections that the glass panels create.

Inspection of Allen and Anderson's photograph of Sueno's Stone reveals early attempts to secure the base and protect the shaft-head. Here, a tight-fitting metal cap is seen to be profiled and secured to the eroded shape of the uppermost stonework. At the base, a segmental masonry-bracing course is added to the stepped circular base, but this covers some of the lower sculpted detail. To prevent direct access, a low-walled enclosure with cast-iron railings was subsequently erected round the stone. Unfortunately, none of these measures actually addressed the scale of the environmental risks to which the monument was subjected.

Sueno's Stone stands inclined some 1.5 degrees off the vertical into the prevailing weather conditions. Its upper quarter was badly eroding, and the potential of a catastrophic delaminating separation of the weak bedding plane in the stone's structure risked losing the entire front (west) face. Following a detailed analysis of these conditions (Figure 10.5), it was clear that some significant positive action was required to secure the monument's future well-being. Following production of a design brief, in 1991 the glazed enclosure that presently protects the sculpture was constructed in accordance with the winning entry of an architectural competition (Figure 11.2).

As is often the manner of such a process, the submitted design had to be significantly modified in its functional details. This was required to ensure that the enclosed volume in the enclosed structure did not create an unnecessarily detrimental 'greenhouse' effect, that might inadvertently damage the stone through thermal gain. Consequently, a tinted-glass roof was incorporated in the final works, as were cooling ventilators around the foot of the wall and top of the glass box to promote the escape

CONSERVATION, MAINTENANCE AND REPLICATION

FIGURE 10.5 Close inspection of Sueno's Stone by Historic Scotland staff in 1987. (Crown copyright: Historic Scotland)

of heated air, by creating a naturally flowing ventilation pattern driven by the fact that warm air rises. At the same time, the vents had to be designed to prevent a direct cross-flow of air from creating localised eroding effects at the top and bottom of the stone, and the direct penetration of rainwater (Chapter 11).

COLLECTION OF SCULPTURES

Historic Scotland curates a number of local sculpture collections that have been gathered together and displayed in a range of available structures near their findspots: for instance, the former school at Meigle (a collection founded in 1869 at the initiative of the local laird); a porch added to Kirkmadrine in 1899; a cottage beneath the church at St Vigeans; a building adjacent to Whithorn Priory; and the St Andrews Cathedral warming house and undercroft. Collections are also gathered under the protection of patent glazing 'inverted roofs', inserted below the wallhead profile of ruined chapels at Kilmory Knap (Argyll and Bute) and on Iona. In the late 1960s and early 1970s, the second wave of 'collecting and presenting' adopted the erection of

purpose-built enclosures to house local sculpture collections on location, such as those at Kilberry, Saddell Abbey and Glendaruel (all Argyll and Bute).

At Keills, in Knapdale, the relationship of exposed carved stones (of various dates), the ruined chapel and its surrounding graveyard, and the free-standing cross remained much as Allen and Anderson photographed it until the early 1970s. On its being taken into State care, it was a requirement of the owner that the chapel be roofed, and that the free-standing cross, together with three other crosses and associated early medieval grave markers, be repositioned inside the chapel for safekeeping. Here, a more traditional approach was adopted, with the completion of the masonry wallheads, and the construction of a pitched, slated roof to the gable profiles. To effect an appropriate display for the stones, however, a continuous-strip glazed rooflight was set into the south-facing roof slope. With no electricity being supplied to the restored building, the rooflight was designed to maximise the day-lighting effect in order to illuminate the carved detail to best advantage. Slabs were vertically set upright on base blocks and secured to timber runners on the wall, so that those displayed on the south wall had direct vertical lighting, while the light spread across the building to illuminate those set against the north wall. The collection of four free-standing sculptures, including the large cross, was then displayed on new foundations in the floor space at the east end.

The conservation philosophy that lay behind all of the exercises carried out during the 1960s and 70s, particularly with regard to where monuments should be sited, was effectively that which General Pitt Rivers established in the 1880s-90s, as enshrined a century later in Historic Scotland's 1992 *Carved Stones Policy* and 2005 *Carved Stones: Scottish Executive Policy and Guidance* (Chapter 1).

REPLICATION

One of the fundamental concerns that is often raised in cases where the re-siting of a sculpture is considered to be in its best long-term physical interest, is the loss of community identity and associations (Chapter 3). The provision of a replica, although never a full substitute for the original, is nonetheless one of the options to consider in any re-siting proposals.

The overall size, shape, form and profile of stones give them their presence in the landscape, yet it is the actual carved surface detail that gives them their true artistic and historical worth, quality and value. Inevitably the visual appreciation of the sculptured detail wanes proportionally with the viewing distance. Within touching distance the observed detail is intricate and exquisite. At 2–3m away the overall sculpted form takes over, and at 10–15m distance, it becomes blurred as other distractions compete. At this point, and beyond, the overall profile of the stone emerges as the dominant factor. Yet the health of the stone and any concern for its well-being rests on the surface detail.

At Keills Chapel (Figure 10.6) the external free-standing cross was replaced with a plain-profiled replica stone, cut to match the overall dimensions and shape of the original cross. No sculpted details were incised into the face of the stone. The profiled

Figure 10.6 Keills Chapel, replica cross. (© Ingval Maxwell)

replica was intended to simply act as a 'marker' in the landscape. The level of detail to be included in any such replica has to be decided on a case-by-case basis.

A further consideration is how to fill in the gaps on replicas. During the 1960s informed speculation was used to decide what the missing parts of the St John's Cross looked like (see above). The large size of this cross necessitated the use of complex casting techniques. Consequently, section joints are readily evident on close inspection.

With the advent of more modern casting technology, an applied latex rubber skin, held in place by a reinforced glass-fibre outer shell, was used by the National Museums of Scotland in the replication of Aberlemno 2. Such an approach is problematic where the carved surface is friable and at risk of being detached when the cured latex skin is peeled off the stone. The physical 'hold' that latex can have on the surface detail is considerable, especially if there is any undercutting or localised fracturing. That risk apart, until recently this has been the most accurate way of getting a true three-dimensional likeness of the detailed stone surfaces. In employing the technique a careful assessment has first to be made as to where the risk of surface detachment could emerge, and preventative pre-treatments carried out. Where this risk is judged high, the process, which should only be undertaken by appropriately skilled conservators, is not recommended.

For similar reasons, it is generally the case that taking surface rubbings of carved ornament is also high-risk. Here, the dilemma arises from applying undue surface pressure to the high points on the carved stone face. This can create an inward flexing of loose material leading to it being broken off the stone's body.

Recently, the advent of laser scanning technology, and the production of 'clouds of points' images that are capable of being computer manipulated, has proved to be a very useful technique (Chapters 24 and 25). Although some caution has to be aired regarding what actually happens when the laser beam hits each contact point on the

FIGURE 10.7 Aberlemno 2, detail. Highly reduced version of an original, high resolution scan, to show how finer detail is lost at lower resolutions. (© Archaeoptics Ltd, courtesy of Historic Scotland)

stone, given the relative non-invasiveness of the approach, it is highly likely that this will emerge as a favoured contender for the taking of detailed survey records in the future. It also provides the ready means for replicas to be created. There is also no doubt that it provides an excellent overview of the artistic quality of carved stones, and its capability of three-dimensional manipulation is second to none (Chapter 25). It is essential, however, that scans are undertaken, and used, at a resolution appropriate to capturing the level of detail required. This is particularly important when monitoring subtle surface erosion patterns where a greater intensity of surface-scanned detail and appropriate reference points are needed. Aberlemno 2 has, in fact, been scanned at high resolution, but if we used a decimated (reduced) version of this data we can illustrate how surface detail becomes lost in the triangulated make-up of the image between the cloud of points frame when the data is used at a low resolution (Figure 10.7).

A case might therefore be made, in this centenary year of *ECMS*, to start a new national survey of stones at risk that includes using laser scanning devices. That way,

FIGURE 10.8 A synthetic stone replica lies ready to be carefully sited over the carved bedrock at Dunadd in 1979. (© Ingval Maxwell)

the nation would build up a permanent three-dimensional archive of each sculpture. In addition, this would provide a reasonably accurate record of the stones' actual physical state for use as a reference point, against which quantifiable monitoring of the future rates of decay might be better effected. A rationale for continuing the programme of effecting relevant protection for the range of stones still at risk from the elements could also stem from this.

BEDROCK CARVING

Significant other problems have to be considered regarding the conservation of bedrock carvings. In addition to being subjected to the extremes of erosion caused by a wide variety of natural forces, bedrock carving also has the disadvantage of potentially being abraded and worn away as a direct result of foot and animal traffic, as well as other human agencies.

At Dunadd (Argyll and Bute), a small armour-plate glass shield set in a non-ferrous metal frame for many years protected the shallowly incised boar near the top of the hill-fort. To secure it in position the frame was dug into the bedrock at six fixing points creating, in consequence, a permanent disfigurement of the bedrock itself. Although not directly disturbing any surface carvings, the fixing holes created irreversible damage to the surface that had survived reasonably intact since the last Ice Age.

To overcome the dilemma of further putting the surface at risk of damage, the use of a latex-based moulding technique was adopted in 1979 (Figure 10.8). From this, a synthetic stone replica was created that was placed directly on top of the original bedrock markings through having its underside contoured to reflect this. To assist it to blend into its surroundings, imported turf made up the surrounding ground to hide the exposed edges of the replica, so that it visually registered as an outcrop.

A more extreme example arose of how to cope with the problem of threatened bedrock carvings, in this instance prehistoric, at Auchentorlie Quarry (East Dunbartonshire). Historic Scotland granted scheduled monument consent to the National Museums of Scotland to remove these carvings because their continued preservation

in situ, within a working quarry, was sadly not feasible. Using diamond-encrusted cutting-wire apparatus, the top layer of the carved areas of stone was sliced off the exposed bedrock so that it could be removed from the site.

CONCLUSIONS

Over the last 50 years a variety of techniques has increasingly been used to save the physical remains of the carvings that were so expertly analysed by Allen and Anderson over a century ago. But such conservation issues are not unique to early medieval sculpture. In particular, thousands of Scottish gravestones, monuments of high social, cultural and economic value, are at risk. Predominantly brought about through the extremes of erosion, a far more significant factor has recently emerged to create widespread concern. As a result of some fatalities caused by falling headstones, many local authorities are exercising their duty of care under Health and Safety legislation, by laying flat on the ground thousands of unstable upright stones. In conservation terms this option is, of course, the worst possible solution, due to the likely increase in erosion that the stones will be subjected to. In considering the needs of early medieval sculpture, therefore, the opportunity has arisen to take a much broader perspective and to seek positive benefits for carved stones of all periods.

Throughout this paper a variety of technologies has been identified for the well-being of the sculpture. But, perhaps given the scale of what is still at risk, the top priority needs to be ensuring that there is an accurate, modern record of each individual monument, and an objective assessment of its physical health. This will enable the top priorities for conservation action, and the concomitant scale of urgency to be identified. If the centenary of *ECMS* was to lead to this, then this would indeed be a legacy that Allen and Anderson would have been proud of.

NOTES

[1] Henderson 1993a, 20.
[2] Henderson 1993a, 37; Allen 1901.
[3] See, for instance, Dupplin and Creiff, *ECMS* III, Figs 334 and 328.
[4] *ECMS* III, Fig 221.
[5] *ECMS* III, Figs 207, 412 and 234a.
[6] Gray and Ferguson 1997.
[7] Cameron *et al* 1997, 2–6.
[8] *ECMS* III, Figs 178 and 551.
[9] *ECMS* III, Fig 230.
[10] *ECMS* III, Fig 66.

CHAPTER 11

THE CONTAINMENT OF SCOTTISH CARVED STONES *IN SITU*: AN ENVIRONMENTAL STUDY OF THE EFFICACY OF GLAZED ENCLOSURES

By Colin Muir

INTRODUCTION

The awareness that a major factor in the deterioration of Scottish carved stones was their environments has led to attempts to provide these resources with more controlled settings to extend their survival. In some cases this has led to their removal to the National Museums of Scotland or local museums, churches, libraries or council headquarters. In other instances, where feasible and appropriate, shelters have been erected over *in situ* monuments so that they can retain their local, geographic and historic context. Those responsible for erecting such structures range from state organisations such as Historic Scotland and local authorities through to charitable trusts and private landowners.

In 1890 the Spalding Club (an antiquarian society) constructed one of the earliest protective monument shelters in Scotland, attached to the Chapel of St Fergus, Dyce. It was designed to house two Pictish sculptures found in the graveyard wall.[1] By the 1930s and 1940s monument shelters generally consisted of supported roofs or 'lean-tos' constructed of a variety of materials of varying durability. Supports tended to be constructed of steel, timber or concrete with roofing often of lead, felt or corrugated iron.[2] The concept behind these structures continued to develop, and glass panels started to be used as a partial covering. These were first utilised in 1945 to protect the front of the sacrament house at Old Deskford Church (Grampian).

By the mid-1970s stainless steel, toughened glass and perspex became more commonly used in architecture. These materials offered the opportunity to create durable, low-maintenance, stable, inert structures that could provide an endangered *in situ* monument with maximum protection with minimal maintenance. In the 1970s and 1980s, the predecessor body of Historic Scotland, Historic Buildings and Monuments (HBM) enclosed a small number of the monuments in State care that were deemed to be especially at risk from environmental deterioration, including the Pictish cross-slabs at Dunfallandy (1975)[3] and Eassie (1987) (Chapter 10).[4] Both these

structures were glazed on only two elevations with their remaining elevations being constructed of stone. The proposals to encase historic sculptures in protective glass and steel were standard practice within a museum setting, but a project outside, on or near the subject's findspot, was unconventional. It was not until 1989 that a proposal to enclose a major monument in a completely glazed structure was initiated, thereby ensuring 360° viewing. While this technique provided protection from wind, rain, frost and vandalism, there was concern that such an approach could prove detrimental by putting monuments at risk due to temperature extremes or artificially created conditions. Two of the main concerns were the crystallisation of previously soluble salts and the wicking of contaminated groundwater into the stones. These damaging processes can occur in environments where the internal temperatures are high, and humidity is low. The unknown conditions of these structures' interiors prompted an environmental monitoring programme run by Historic Scotland's Conservation Centre (HSCC). The subjects of monitoring were enclosures at the Historic Scotland site at Sueno's Stone and the non-Historic Scotland site at Shandwick. The erection of an enclosure over the sculpture at Shandwick had been grant-aided by Historic Scotland, and as a result HSCC also undertook monitoring of the structure to ensure it was fulfilling its purpose. Data from electronic data loggers were used to record the internal temperatures (°C) and relative humidity (%RH) within the structures to better evaluate the risk to the monuments within them. This paper is based on my MSc dissertation which evaluated data recovered from HSCC's ongoing monitoring of these sites.[5]

THE ENCLOSURES

Criteria for enclosure design

The concept of a complete enclosure around an *in situ* ancient monument offered a new solution to the removal of stones from their external location for conservation purposes. This new type of glass and stainless steel enclosure sought to provide the following benefits to the monument:
— to retain the monument *in situ* where it has most significance and context;
— to protect from the damaging effects of the wet/dry cycle;
— to protect from the damaging effects of frost expansion;
— to protect from mechanical erosion by wind and rain;
— to minimise fluctuations of temperature and humidity;
— to minimise the effect of atmospheric pollution;
— to allow visitors to view, but not to touch or damage the monument;
— to lower structural maintenance cost through use of modern materials;
— to lower ongoing remedial conservation costs.

Though there are a number of sheltered and partially enclosed monuments throughout Scotland, only two have yet been enclosed in fully glazed structures, at Shandwick and Sueno's Stone, both situated in northern Scotland. These enclosures were evaluated against the above criteria to gauge how effectively they were protecting their stones.

Shandwick

The sculpture at Shandwick (Figures 16.1 and 16.2) is a symbol-bearing cross-slab carved in local pale sandstone, also known as the Clach a'Charridh or 'the stone of the burying ground'.[6] It is situated on the edge of a break in slope near the village of Shandwick. The location is exposed and maritime, with the sea 175m to the south. The stone is fully 3.23m high x 1.02m wide x 0.19m deep (though only 2.75m is visible above ground) and is thought to date from the 8th century.

The enclosure installed over the stone is a glass pavilion, re-adapted from its previous use at the Glasgow Garden Festival in 1988 (Figure 11.1). The Shandwick Stone Trust, the organisation that owns and maintains the scheduled ancient monument, purchased this structure from Robert Gordon University. As the pavilion's dimensions were not sufficient to accommodate the sculpture's height, the structure was installed on walls of concrete block-work. These walls were then hidden beneath an encircling earthen mound. The enclosure consists of a large tubular frame, with 10mm thick toughened-glass panels attached to it. Soon after installation further ventilation was necessary to combat condensation. To better facilitate airflow and heat convection, two of the opposing glass panels were drilled with 50 holes of 20mm diameter.

Sueno's Stone

Sueno's Stone (Figure 11.2) is a cross-slab of pale sandstone, in the care of Scottish Ministers, located on the outskirts of the town of Forres. It stands 6.5m high x 1.14m wide x 0.35m deep and its weight is estimated at around 7.5 tonnes. It is the tallest of all extant Pictish stones and is thought to date from the 9th or 10th centuries.[7]

The Sueno's Stone enclosure resulted from an architectural competition run through HBM and the Royal Incorporation of Architects in Scotland. Completed in October 1991, the selected design addressed specific issues of the Pictish sculpture and its protection. It consists of a steel and glass pavilion measuring 4.8m x 4.8m in plan, and 10.3m high. The structure consists of four vertical, tubular, galvanised-steel columns of 300mm diameter. Installed at the top and bottom of every elevation are stainless steel louvred vents. Between these vents are attached toughened-glass panels 12mm thick. On each elevation there are eight panels (two across, and four high) each measuring 2.4m x 2.4m.

ENVIRONMENTAL MONITORING

The requirement for monitoring

Changing the environment of stone subjects that have been in exterior settings for centuries can cause problems to the material as it dries permanently. As all stone in an outside setting has a water content held within its pore structure, once the stone dries completely there can be risks related to the crystallisation of previously mobile soluble salts. Additionally, as the stone's moisture content evaporates there can also be surface flaking and disaggregation related to the structural stresses inherent in the

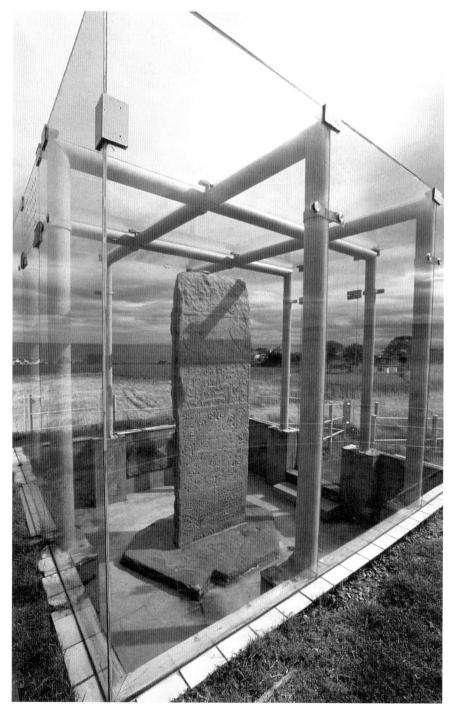

FIGURE 11.1 Shandwick Stone in its enclosure. (Crown copyright: Historic Scotland)

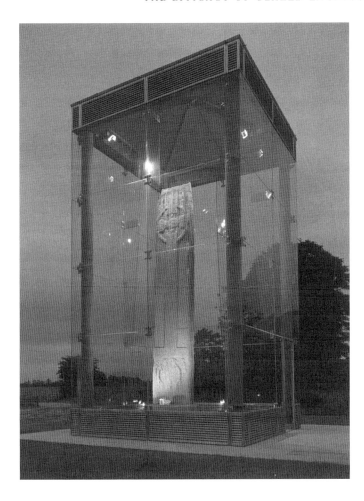

FIGURE 11.2 Sueno's Stone in its enclosure, illuminated at night. (Crown copyright: Historic Scotland)

wet-dry cycle.[8] There was also the particular concern in the case of Sueno's Stone that it might 'wick' groundwater, as there was no damp-proof membrane beneath the stone. This wicking can occur as the upper parts of the stone dry; water and soluble salts are drawn up from the groundwater and can harmfully crystallise further up the stone. It is these concerns for the sculptures, and the uncertainty that their environment could hasten such negative processes, that are the basis of this long-term monitoring programme. This action was seen both as part of a preventative conservation approach and a base-line study of the enclosures' environmental characteristics.

Monitoring Shandwick Stone and Sueno's Stone

The interior environments of these enclosures have been digitally monitored since 1992 (Sueno's Stone) and 1994 (Shandwick). The surfaces of the stones were visually inspected every nine months when the data loggers were downloaded. For

this study, the external conditions were used as a control against which the interior conditions were compared.

The equipment used in the enclosures was 'ACR Smart-Reader Plus 2' stand-alone data loggers, powered by ten-year batteries and set to record data readings every 30 minutes. Two data loggers were installed at the Sueno's enclosure, enabling the recording of both interior and exterior readings for temperature and relative humidity. Only one logger was installed at the enclosure, to track interior temperature and relative humidity. The data for these two locations was downloaded on-site to a laptop computer and converted into colour-coded graphs to display the information recorded by the loggers, either over a period of months or even hours. When calibrated, this type of logger is accurate for temperatures between −20°C and 40°C. The humidity data is accurate to ± 3%, between 10% and 90%RH. At the extremes, beyond 10% and 90%RH, the data is discounted due to lack of precision.

Sueno's Stone

Before construction of this enclosure, a computer model was made by Strathclyde University to help predict potential problems within its interior environment. This programme was designed not only to model heat fluctuations within the enclosure, but to allow assessment of hypothetical modifications. This allowed the design to include components for the sculpture's needs, prior to any costly structural fabrication. One of the main goals of this programme was to simulate the convection of warm air around the sculpture and to gauge how roof and ground level vents could prevent extreme heat gain. The final structure was designed for wind to move over the exterior vents at the top, raising the internal pressure of the structure to draw out hot air that had risen to the top of the enclosure. The corresponding drop in pressure would then draw cool air in through the low vents to create a through-flow. Attempts have been made to compare actual readings from this site with the computer programme to evaluate its merits and deficiencies. The programme, however, is no longer accessible at this time.

By 1993 the stone had been within the structure for two years, and displayed no visible signs of salt efflorescence on the surface to support concerns that it might be wicking salts from the ground. As a precautionary measure, tests were carried out to ascertain if there were non-visible, but measurably high levels of soluble salts within the stone.[9] Poultices prepared using inert acid-free paper pulp soaked in de-ionised water were applied to the stone surface at various heights on all four faces. After one hour the poultices were removed, fluid was expressed from them and tested for salts using a conductivity meter. These tests showed that what salts were present were at minimal levels, suggesting that there was no tangible wicking from the base.

Comparisons of trends in temperature and relative humidity

In the collation of data pertinent to the two sites, certain trends became apparent in both locations. These trends were compared to each other to understand their underlying principles. The graphs in Figures 11.3 and 11.4 chart the seasonal cycle from both sites. These appear as a wide range of temperature and humidity readings during the summer and a narrower, more constant range during the winter. This was

THE EFFICACY OF GLAZED ENCLOSURES

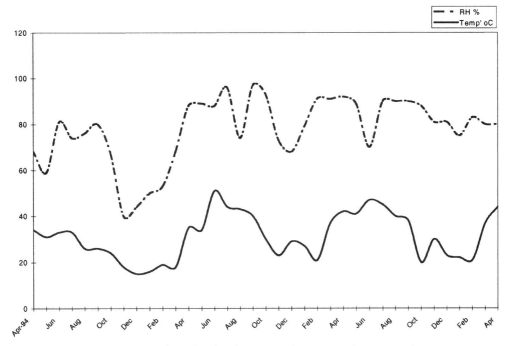

FIGURE 11.3 Graph 1: Shandwick Stone enclosure: April 1994–April 1997.

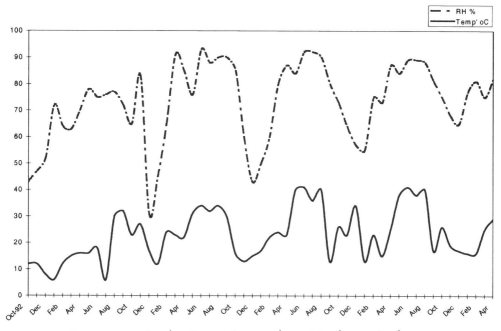

FIGURE 11.4 Graph 2: Sueno's Stone enclosure: April 1994–April 1997.

due to the solar gain (known as the greenhouse effect) where sun-warmed air becomes an insulator. Over an average 24-hour period during the summer this effect led both sites to have internal temperatures often above 45°C during the day, falling to 10°C or below at night, that is covering a range of 35°C. In winter the solar gain was less evident due to seasonal reductions in temperature and decreased hours of daylight. As a result, the difference between day and night readings is less drastic, usually in a range of 15–20°C between the extremes for a daily cycle.

Figures 11.3 and 11.4 plot the range of monthly temperature and humidity readings. This is represented as a range of change and was calculated by subtracting the lowest reading for a set period from the highest reading for the same period. The graphs illustrate the variations of the internal conditions and the rapidity of change and when it occurred. The closer a point or line gets to zero on the Y-axis, the more constant are the environmental conditions. A point on that line of constant temperature or humidity could either be within a low or high temperature environment.

Humidity within these structures was linked to temperature in inverse proportion. This meant that when the internal temperature was high, the humidity dropped. Conversely, when the internal temperature readings were lower the percentage of relative humidity rose. Due to this association, the line of relative humidity (%RH) range mirrors that for temperature, but shows more extreme fluctuations due to the rapidity with which the humidity changes occurred. Fluctuations between the measurable extremes of 10–90%RH often occurred within 24 hours, particularly during hot summer weather.

The thermal characteristics of the two enclosures became evident when the extremes of internal temperature readings were compared. The highest temperatures recorded at both sites were in June 1995. At the Shandwick enclosure, the temperature reached 58.5°C, while on the same day the Sueno's Stone enclosure rose to 50°C. This comparison records the very high temperatures generated in both structures and indicates that the Sueno's Stone enclosure was marginally the more efficient at regulating its upper temperature. This may be due to variable factors of the two structures such as glass area, internal volume, the style and adequacy of ventilation, or to localised weather conditions.

To analyse the hourly fluctuations of the multiple parameters in each enclosure, data from internal loggers were combined with external wind speed, temperature and humidity readings from local weather recording stations and charted on graphs. The summer was selected for the sample period as it showed the greatest range in readings and the most distinct results. Figures 11.5 and 11.6 chart these parameters over the three-day period of 17–19 July 1996.

By charting multiple variables on the above graphs, it is possible to see the simultaneous external changes in temperature and humidity and how wind speed was related to them. The charts show how rapidly the external conditions were transferred to the interior. Additionally, the internal conditions often magnified the external fluctuations of temperature and humidity. In the case of temperature, the enclosures provided some insulation as it remained on average 3–4°C higher inside even during

THE EFFICACY OF GLAZED ENCLOSURES

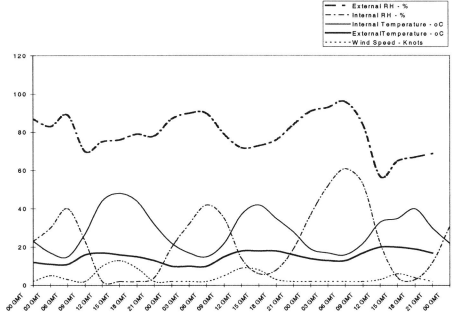

FIGURE 11.5 Graph 3: Shandwick Stone enclosure: 17–19 July 1996.

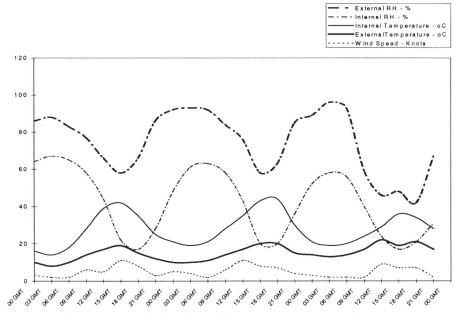

FIGURE 11.6 Graph 4: Sueno's Stone enclosure: 17–19 July 1996.

the night. Additionally, the internal humidity readings for this three-day period were at least 10–15%RH lower than the exterior readings.

Periods of magnified environmental change within the enclosures usually occurred during mid-afternoon when the external temperature reached 20°C or higher. At this exterior temperature, the Shandwick enclosure's internal temperature was typically 30°C higher than that outside, due to the effects of solar gain; this compared to only 20°C higher at Sueno's Stone. Simultaneously, the associated internal humidity levels were 65%RH lower than those recorded externally at Shandwick and only 35%RH lower at Sueno's Stone. The difference in these comparable internal readings indicated that the Sueno's Stone enclosure was better able to regulate the build up of higher temperatures than that at Shandwick. Based on these findings, this was likely to be due to the fact that this structure was designed specifically for the function it fulfils, incorporating broad ventilation panels.

Significance of wind speed on ventilation

The role of wind speed on the drawing of air through the vents, designed to decrease the internal temperature, was also investigated. Hourly wind speed readings were collated from the closest weather stations to the sites (Invergordon for Shandwick and Kinloss for Sueno's Stone) for 17–19 July 1996.[10] On the Sueno's Stone graph (Figure 11.6) there was a slight reduction in the rise of internal temperature as wind speeds rose. When wind speeds reduced, the temperature rise rapidly increased (its line steepened), suggesting the vents had some effect. At Shandwick (Figure 11.5) the rise and fall of wind speed appeared to have no effect on the rise of internal temperatures. Any temperature change at that location could be attributed to fluctuations in the external temperature. Based on these readings, the vent holes that had been drilled into the glass panels at Shandwick appear inadequate to produce any significant decrease in solar gain.

Summary of findings

While the intention of object conservation within a museum setting is to maintain an optimal temperature and humidity range for an object's material and condition, these enclosures were not designed to provide such controlled environments. The conditions within these structures do not match the stable environment expected in a museum setting. There is no indication, however, that these more variable conditions have had any direct negative effect on the carved stones. At the inception of these enclosures there were concerns with regard to efflorescence and the wicking of further soluble salts from the soil. While the long-term effects of these sculptures' encapsulation may not become evident for many years, after a ten-year period and investigations with existing technology, there is no evidence of salt-related damage on the sculptures. With the exception of insect detritus, the stones are in comparable condition to what could be expected after a similar period in an environmentally-controlled museum. Neither wicking nor efflorescence has appeared and no surface loss through drying or cryptoflorescence has been observed or reported. Currently the extremes of the internal conditions within these enclosures do not appear to have had any detrimental effect on the stones; efforts could be made, however, to stabilise the temperature and

humidity fluctuations as a precaution. A more stable environment could prevent excess solar gain causing undetected or future problems, such as micro-cracking of the substrate from surface thermal stress. This stabilisation of the temperature and humidity extremes could be achieved through increased ventilation.

RECOMMENDATIONS

In order to fully evaluate the efficacy of the structures used to protect Shandwick Stone and Sueno's Stone, it is important to better understand the acceptable range of temperature and humidity fluctuation for such carved and weathered sandstone. The use of enclosures has provided some of the advantages of a museum environment without removing the stones from their local contexts. These structures provide similar protection from rain, wind, frost and vandalism as would a museum, though not as stable an environment in terms of temperature or humidity. To achieve a museum-like controlled environment in such a structure would be prohibitively expensive and potentially unnecessary. In order to regulate the upper extremes of temperature and increase ventilation, it is necessary to replace larger volumes of internal, solar-heated air with cooler outside air. Recommended options for the current stone enclosures are as follows:

— A: Continued monitoring of the current structures. As there is no evident damage to the monuments within their present environments, the minimal approach would be to continue monitoring the internal conditions and study the monuments for any signs of deterioration. Should changes be noted, further intervention could begin at that time.

— B: Increase of passive ventilation. The most cost-effective method to increase ventilation would be through the installation of further vents until excessive temperatures were equalised to exterior levels. Computer modelling of the environment could make the placement of such vents more thermally effective.

— C: Installation of active ventilation. Another option is the installation of a reactive system that would utilise thermostats to regulate the interior environment. The thermostats would function to trigger the electronic opening of additional vents or hinged glass, a method used to regulate temperatures in large greenhouses.

A final alternative is the installation of sizeable fans within the fabric of the structures to better regulate thermal convection. These fans could also be thermostatically controlled, though this more expensive option is likely to be cost-prohibitive.

Which of the above recommendations should be implemented depends on the long-term success of these structures as a display and conservation solution. No course of action in conservation can ever be seen as the only, or the ultimate solution, but with hindsight some are viewed more favourably than others. If these structures can maintain their monuments safely in their original locations and ensure that the public can view and understand them, they create a viable alternative to removing the stones to a museum or other interior setting.

CONCLUSIONS

The original intention of enclosing monuments in shelters was to retain historical and cultural works in their present-day findspots. Current conservation philosophy places a high importance on the relationship of subjects with their context. This is a philosophy that is likely to lead to further developments in the protection of *in situ* monuments.

The enclosures studied succeed in their original goals of offering tangible benefits of protection from pollution, the elements and human interference. There is, however, the need to improve the stability of their internal environments due to possible future damage related to excess solar gain. Due to the different materials and conditions of Scotland's many stone monuments, each future intervention will continue to require site-specific solutions that address their individual circumstances.

The glass and steel structures studied were intended to retain carved stones in their original locations. Though the public's response to their physical and visual impact has been mixed, they have improved a number of the problems of earlier shelters but may have created new ones of their own. As our understanding of these structures and their environmental control continues to improve, it may be possible to protect other sensitive cultural resources *in situ*, such as timber subjects or archaeological sites.

ACKNOWLEDGEMENTS

I am indebted to the following individuals for their input, experience and opinions: Stephen Gordon, Historic Scotland, whose previous work in this field, this paper builds on; Jean McKenzie, Shandwick Stone Trust; Ian G Scott, JMH, Mrs E Kerr and E Fullerton.

NOTES

[1] Foster 2001, 8–14.
[2] Adams 1953.
[3] Adams 1972.
[4] Gentles 1988.
[5] Muir 1998, 1–110.
[6] *ECMS* III, 68.
[7] Stuart 1856, 9.
[8] Ashurst and Ashurst 1988, 3.
[9] Gordon 1993.
[10] Meteorological Office records 1994; 1996.

CHAPTER 12

THE RUNIC INSCRIPTIONS OF SCOTLAND: PRESERVATION, DOCUMENTATION AND INTERPRETATION

―――――――――――――

By Michael P Barnes *and* R I Page

PREAMBLE

Discussion of runic inscriptions in the context of a seminar on Scotland's early medieval stone sculpture entitled *Able Minds and Practised Hands* throws up several questions. What does the term 'runic' cover? What does one mean by Scotland? How is a fairly precisely defined corpus to be established in other respects? Is it helpful or unhelpful to exclude inscriptions that are not 'early medieval' or those that are not on stone? And, not least, can the corpus truthfully be described as the work of able minds and practised hands?

The remarks we offer here arise from our work in compiling an edition of the Scandinavian runic inscriptions of Britain.[1] We will therefore solely be discussing inscriptions written in Scandinavian runes. The broader justification for excluding the English variety is that they belong to a separate tradition, runologically and linguistically. The narrower justification is that the monuments in English runes now north of the border, the Ruthwell Cross and the Whithorn stones, for example, link more obviously with northern English than with Scots sculpture.

This observation leads on to the question of what precisely one means by Scotland and Scottish. Most of the runic inscriptions of Scotland show clear links with Scandinavian tradition. That is obviously true of the cluster on Holy Island off Arran (North Ayrshire) (SC 3–7, 9, 12–13) almost certainly made by Scandinavian passers-by, but it also applies to an object like the Kilbar cross-slab (Western Isles) (SC 8; Figure 12.1).[2] The inscription on this latter monument, although presumably a local product, can only be interpreted in the light of our knowledge of Scandinavian runic writing and Scandinavian languages. Many of the inscriptions from Orkney and Shetland may have been made by locals (although it seems fairly clear that the majority, if not all, of those in Maeshowe, Orkney Islands, were the work of Norwegians),[3] but how far can any of these be regarded as Scottish? The Orkney earldom was a purely Scandinavian province, and those carving runic inscriptions there were continuing or imitating practices common back in the homeland.

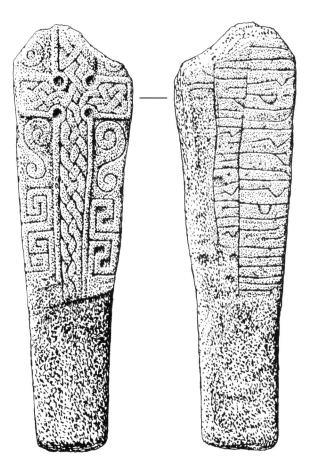

FIGURE 12.1 Kilbar 4 cross-slab (SC 8), with runic inscription on rear face. (Crown copyright: RCAHMS)

We might, of course, ignore these difficulties and decide arbitrarily that the Scandinavian runic inscriptions of Scotland are those discovered within its present-day borders. That is the path we have followed in compiling our forthcoming edition. But problems remain.

AUTHENTICITY AND FIND REPORTS

Runes are by and large made up of vertical and diagonal lines. In theory, perhaps, it should be simple to distinguish between a series of haphazard lines reminiscent of runes and the genuine article. Often it is. Sometimes, however, there can be considerable doubt. We offer three examples from the Orkney Islands: OR 6 Birsay I, from the Brough of Birsay (Figure 12.2); the Belsair Guest House find; and †OR 2 Unstan.

The Birsay I stone in its present state consists of three sections: (i) a series of damaged runes or perhaps only rune-like symbols; (ii) a number of faint, but undoubtedly carved, lines, which have something of the appearance of runes but few

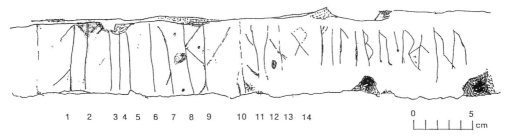

FIGURE 12.2 The Birsay I rune stone (OR 6), with its three sections of inscriptions: (a) graphs 1–9, (b) graphs 10–14, (c) the runes. (Drawing by R I Page)

of the distinctive features that would enable us to identify them as such; (iii) a sequence of bolder, indubitably runic characters that nevertheless contains one uncertain shape — ↑ — and serious problems of interpretation.

The Belsair find is named after a guest house in Kettletoft, Sanday. While staying there, a custodian of Tankerness House (now Orkney) Museum noticed among a collection of beach pebbles lying on the windowsill of his room a fragmentary piece of stone bearing incised lines. Enquiry revealed that the assemblage had been left there by a previous visitor, the fruits of a stroll at Whitemill Bay in the north of the island. The incisions on the carved stone are somewhat suggestive of a runic inscription and do not look recent. However, the lines are unusually deep for runes, and it is by no means impossible they form part of some other type of carving. If the piece could be reunited with whatever it broke off from, it is possible we should discover the 'runes' are not in fact written characters at all. In view of these doubts, and the uncertain find circumstances, we have omitted the piece from our corpus. It does, though, receive mention in an introductory chapter alongside other enchanting and enigmatic objects that at one time or another have been thought runic.

The carvings in Unstan cairn look on the whole less rune-like than those on the Birsay I stone and the Belsair fragment, even if allowance is made for the presence of twig runes (a manifestation of a cipher whereby individual characters were identified by group and number within the group). Indeed, so aberrant are the Unstan markings that one wonders what they do represent. In part the answer may be relatively straightforward. A 1934 field notebook of the RCAHMS includes drawings showing the inscribed surface as it presumably was then. A figure of a bird and some supposed runes beneath it do not feature, and it is therefore a reasonable assumption that they were put there after the RCAHMS's visit. Most of the verticals and twigs further along the stone, on the other hand, are portrayed. But that, of course, in no way guarantees that they had been there for long. The fact that these marks were not noticed by the excavators of Unstan in 1884, together with their un-runic appearance and the suggestion of modern activity on the same slab, makes us very wary of accepting them as medieval. A possible piece of counter-evidence to the above scenario is provided by rubbings of the inscribed surface in the National Archives of Scotland showing all the carvings as they are today. Unfortunately the rubbings are undated, but circumstantial evidence suggests they may have been made prior to

August 1935. Even were this the case, we see no reason to view any of the carvings discussed as medieval runes. They are not very rune-like, they give no obvious sense and they have no discernible context.

The Unstan experience urges caution and scepticism in the case of inscriptions where clear evidence of a medieval genesis is lacking. But can one do more than express scepticism? Jonas Nordby, the author of a recent thesis on post-Reformation runic inscriptions in Norway,[4] has suggested to us that modern carvings will often reveal their true nature through the use of modern language, anachronistic combinations of rune forms, and orthographical oddities — as well as linguistic mistakes where the carver tries to write in an ancient language. We would add to Nordby's list inscriptions that closely resemble material readily available to the rune-writing public. For example, the name **ingibiorh** now decorating two sites in Orkney, Cuween cairn and the Ring of Brogar, copied from a postcard illustrating part of Maeshowe inscription No 9.[5] So far, so good. Matters are less straightforward, however, when the runologist has to determine the age of an inscription with enigmatic runes and an incomprehensible text. Several from Orkney fall into this category. Traditionally counted part of the medieval runic corpus, for example, are five brief inscriptions on stone consisting wholly or partly of twig runes, of which no absolute interpretation can be made (OR 1 Stackrue; OR 4 Ring of Brogar I; *OR 5 Ring of Brogar II; OR 7 Brogar Farm; OR 13 Skara Brae). Only one has anything approaching a satisfactory find report, although it does seem all were discovered within an 11km radius of Maeshowe — a site where, since 1861, the visitor has been able to admire prominent displays of twig rune versatility that are readily comprehensible.[6] Two further factors increase doubt about these five inscriptions. First, twig runes are much easier for the uninitiated to carve than their plain counterparts: all one needs to do is draw a vertical line with branches coming off either side. Second, among the 600 or so inscriptions from medieval Bergen about 2% are written using twig runes or some other form of the common runic numerical cipher; in Orkney the figure is 25%. Yet none of this is proof of modern origin. While we are deeply suspicious, we cannot show conclusively that any of the five inscriptions is not medieval.

The Orkney twig rune material shows how crucial to the establishing of a corpus are clear and unambiguous find reports. Unfortunately, the RCAHMS field notebook detailing what was and was not carved in Unstan cairn in 1934 is the exception. It is surprising how imprecisely contextual information was recorded until quite recently, even by official bodies like the RCAHMS. Once again we turn to Orkney, to three stone fragments discovered on Birsay bearing what are almost certainly the remains of runes. There is no published excavation report giving details of the finding of these stones. All we have is a group of slender notes. A letter dated 16 March 1938 from the Inspector of Ancient Monuments for Scotland, J S Richardson, preserved among Bruce Dickins's papers, reports: 'We recovered at the church two stones bearing part of a runic inscription — another such fragment is built into the wall of the apse near ground level'. Three accompanying photographs (mounted on a single card) show these fragments to be our OR 8 Birsay II (already then broken in two), OR 9 Birsay III and OR 16 Birsay V. The 1946 RCAHMS *Inventory*, commenting briefly on another Birsay inscription (OR 6 Birsay I), adds casually that 'two others [*videlicet* rune

stones] were found immediately outside during the excavations of 1934'.[7] 'Outside' seems to refer to the chancel of the church on the Brough of Birsay. Minimal detail is added in the Ministry of Public Building and Works *Official Guide-book*: 'In the course of clearing the Cemetery area fragments of Runic inscriptions were found. Two of these had been split longitudinally and reused as building material in the earliest part of the Cathedral'.[8] The emphasis on the figure two in the published literature has led many scholars to ignore Birsay V. Thus, it is absent from Marquardt's bibliography of the runic inscriptions of the British Isles,[9] and from Liestøl's account of the runes of the Northern and Western Isles.[10] It is presumably also in part because of the poverty of the documentation that Liestøl refers to Birsay II and III as 'two fragments [of runic inscriptions] found on the wall of Earl Þorfinn's church in the Brough of Birsay'.

The further back in time we go, the less likely we are to be blessed with clear and informative find reports. SC 8 Kilbar, for example, discovered in Barra in the 1860s, is rumoured to have been brought there from Iona.[11] Considerable uncertainty surrounds the find places and dates of SH 1 Cunningsburgh I and SH 2 Cunningsburgh II. Unearthed in the 1870s, one or both of these stone fragments seem to have become confused with other carved stones.[12] There appears at least little justification for the confident caption accompanying a drawing of Cunningsburgh I in the 1946 RCAHMS *Inventory*: 'Stone with runic inscription from Mail, Cunningsburgh'.[13]

Even the best find reports tend to indicate only what has been found — not what has not been found. Yet we live in an age of graffiti, and that, coupled with the rise in interest in runes in recent years, has led to the making of new runic inscriptions. The modern inscription, as we have sought to show, will often reveal itself for what it is, but in some cases it may not. Together with the spurious **ingibiorh** in Cuween cairn is a sequence of four twig runes, reported as possibly medieval (though with considerable reservation) in the annual *Nytt om runer*.[14] Like the finder, we think it highly probable these runes are modern. If, however, detailed photographs had been available of the walls of Cuween, we might have been able to prove this; at least we would have known what did and did not exist at a particular point in time. An early picture of part of the vertical slab that flanks the west buttress of Maeshowe makes it clear that the two, or possibly three, <R>s that stand beneath Maeshowe inscription No 3 were put there in the 20th century.[15] Clearly, it would be a huge task to photograph all places likely to attract the attention of the runic graffiti artist, but the more prominent sites in Orkney seem prime candidates for treatment. Visitors to the islands are confronted with runes almost wherever they go: in Maeshowe itself, at other historic monuments, in the Orkney Museum, on jewellery, knitwear, postcards, and now even on chocolate bar wrappers. It is scarcely surprising some feel the urge to have a go themselves.

PRESERVATION

The defacing of historical sites introduces the more general question of preservation. Fortunately not many of the inscriptions we deal with have suffered

serious damage since their discovery — but one or two have, and some seem to us currently at risk.

As is well known, Maeshowe inscription No 17 scaled off the wall shortly after the 1861 excavation. In the late 1980s it looked as though No 3 was to suffer the same fate, but remedial action was taken in the nick of time. The disintegration of Maeshowe 17 (some two-thirds of which are preserved in the Museum of Scotland) may be considered an act of God. The disappearance at some point of *OR 5 Ring of Brogar II is presumably to be put down to carelessness. For reasons that are unclear, SC 3 Holy Island I was attacked and largely obliterated at some time between 1863 and 1882.[16] In Unstan cairn the erroneous announcement 'PICTISH MARKS' has been added to the carvings discussed above, and most recently (post-1995) some agency has scrawled over the rune-like sequence depicted in the field notebook of 1934.

Where the vandal can work unmolested by a custodian there is regrettably always the risk of damage or destruction. More easily preventable is the slow deterioration of some inscriptions from the actions of wind and weather. SC 15 Thurso II still sits exactly where it was found in 1987 — in one of the outer walls of the ruinous Old St Peter's Church, some 6m above the ground, and completely open to the elements. This despite the fact that we alerted the Highland Regional Archaeologist and Historic Scotland to the inscription's parlous state as long ago as the mid-1990s, at which time both expressed concern and agreed to try to get something done. SH 6 Eshaness II, a medieval grave-slab engraved with both runes and Roman capitals, was discovered in the churchyard of Cross Kirk by George Low in 1774.[17] In the 19th century it was regarded as lost; in 1946 the RCAHMS *Inventory* declared it 'a typical 17th-century tomb-slab'.[18] In 1955, however, it was recognised as medieval and in part runic by Anders Bæksted (field notes), and a few years later published as such.[19] Comparison of Low's manuscript drawing of the inscription with what can be seen today shows that parts of the text have been lost in the intervening years. What is left has also clearly suffered, since little at all can now be made out without the help of artificial lighting. Efforts to have the stone removed to a museum where it can be conserved, and subjected to more thorough examination, have met with a sympathetic response from the authorities, but determined local resistance. So the Eshaness slab still lies in Cross Kirk graveyard. It is fairly certain that if nothing is done, all traces of carving will eventually disappear from the surface of the stone, and a unique monument will be lost.

INTERPRETATION

There is unfortunately little we ourselves can do to preserve the inscriptions except to urge action by the relevant authorities. However, by documenting them thoroughly we can at least ensure that reasonably detailed and accurate accounts exist. It is also our task to offer interpretations. Most readers, we suspect, want answers first and foremost to the questions: what does the inscription say and how old is it?

Being cautious runologists, we are inclined to lay out the data as we see them and let the reader judge. We are not much given to issuing authoritative statements. There are a good many inscriptions which because of their fragmentary state, our dullness of wit, or the incompetence, or cunning, of their carvers, have not yielded an obvious text. In such cases we limit ourselves to suggesting possibilities. This may not appeal to those who want a quick fix, but we hope it will encourage non-runologists to take more seriously than they sometimes have the problems involved in reading and interpreting runic inscriptions. As regards dating, we are equally circumspect. Broadly, we use four criteria: (i) the archaeological context; (ii) the forms of the runes and the orthography; (iii) the language; (iv) the inscription type. Seldom are all four applicable, and sometimes none at all. We may, where appropriate, look further afield, but then we are likely to rely on assertions whose authority we are not trained to assess. Let one example suffice. SC 8 Kilbar (Figure 12.1) is said by Olsen to be 'presumably the oldest runic memorial in the Norse settlements over in the west',[20] apparently on the basis of Shetelig's unproven assertion that it is a 'first and crude attempt'.[21] Some 40 years later, Holman reinforced her linguistic and typological discussion of an early genesis 'by the decoration of the slab, which Shetelig dates to around 900',[22] though in fact Shetelig is not as precise as that. To confuse the issue, some have seen Kilbar as an offshoot of Manx artistic tradition,[23] and thus perhaps a product of the late 10th or early 11th century, and there are also features in the inscription itself indicative of an 11th-century date. Adding to the uncertainty is Bæksted's firmly held view (field notes) that artwork and inscription are by different carvers, the lines of the cross being in his opinion considerably more even and regular than those of the runes. The problem of combining interpretations put forward tentatively by experts in different disciplines is clear. We approach here a well-known dilemma. Scholars in one field support their datings by conclusions of colleagues in another, not realising (or at any rate admitting) that those conclusions may derive from earlier datings emanating from their own field.

ABLE MINDS AND PRACTISED HANDS?

A different, but no less important, matter affecting our corpus is whether it is indeed the work of able minds and practised hands. There is a group of problems that arises from the competence, or otherwise, of the rune carver. These are the opportunities his material provided; the source of his text; the care he brought to his task; his literacy in runes and other scripts. All must be kept in mind as we study our examples. Here are some questions.

Competence

This varies considerably, and is likely to be linked to the context of the inscription. Can we speak of the rune carver of, say, the casual chunk of stone from Gungstie, Noss (Shetland Islands) (SH 7; Figure 12.3), in the same breath as the Kilbar cross-slab or Inchmarnock cross fragments (SC 8, 10; Figures 12.1 and 12.4)?[24] The latter are formalised texts for public purposes. What the intent of the Gungstie rune carver was, we have no idea. We could make little of his text, though its letters were

FIGURE 12.3 The Gungstie rune stone (SH 7). (Drawing by R I Page)

fairly clear. It looks more like a casual graffito than anything formal, whereas the surviving (even though fragmentary) memorial inscriptions of the two crosses are for public reading and presumably comprehension. Even where there is no decoration on the stone and we do not know its intended position, as with the SH 3 Cunningsburgh III (Shetland Islands) example, there is elegance of layout, if not of carving. On the other hand, in the case of the SC 11 Thurso I cross (Figure 12.5), which is an obvious public memorial, the inscription looks sloppily added. And what do we make of the SC 14 Iona cross-slab (Figure 12.6),[25] whose inscription was not laid out in advance, and had a correction made towards its end? An able mind but not a practised hand?

Opportunity

We think here about the shape of the stone, the space available, etc. This obviously links to competence, above. Was tidiness of layout important, or did the carver simply set down his materials and carve away, without any attempt to ensure his text was properly spaced? In some cases he obviously did the second, as we have seen on Thurso I, whose text overruns the cross-shaft and intrudes untidily onto the cross-head. But of course we cannot assess, with any clarity, the full intent of a carver. What was the important point of a memorial text? Was it the name of the sponsor, the commissioner of an inscription, or that of the commemorated dead? SC 14 Iona is our best example to study here, for it is the most complete of the Scots runic memorial texts:

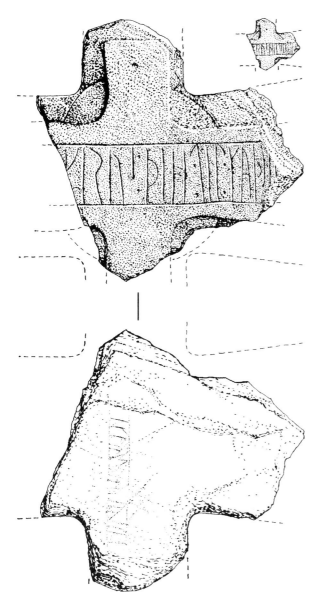

FIGURE 12.4 Inchmarnock 13, cross with runic inscription (SC 10). (Crown copyright: RCAHMS)

×kali×ouluis×sunr×laþi×stan×þinsi×ubir×fukl×bruþur[
'Kali son of Ǫlvir laid this stone over Fugl (his) brother'

From the point of view of spacing, Kali certainly gets the bigger share, but then he presumably paid for the slab to be carved. Further, however, though the text is divided into its individual words by separation marks, saltire crosses, it is fairly clear that some of these were added after the sentence was completed. That is, the carver apparently did not work out in detail and in advance how his text would look on the

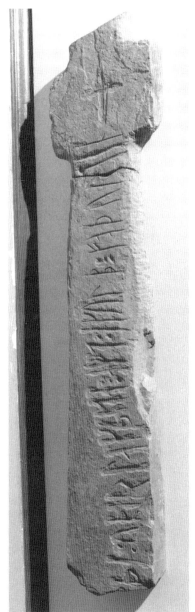

FIGURE 12.5 Thurso I, cross-slab with runic inscription. (Crown copyright: RCAHMS)

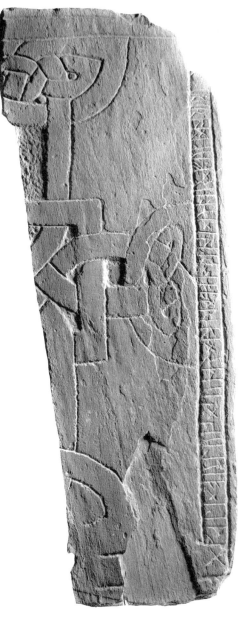

FIGURE 12.6 Iona 69, cross-slab with runic inscription (SC 14). (Crown copyright: RCAHMS)

stone — he did not mark it in roughly before cutting it. Why were the separation marks added at all? Did the carver read over his sentence and decide it needed more punctuation? Or did the commissioner say, 'Wait a minute. Shouldn't the words *laþi* and *stan* have separation marks after them? Kindly put them in'. Or, in other words, which of the two was literate and observant? Which had an able mind? Carver or commissioner, or some third person such as the brother's widow? We can see that the carver made an error towards the end of the inscription, and neatly corrected it — in the word **bruþur** where he missed out an important letter and had to recut the text to improve its spelling. Is the form **stan** (a somewhat unusual one, though not unique) for 'stone' a similar error? Or does it represent a local dialectal usage? Again, how able is the mind at work?

Literacy

From this set of questions there arises the problem of literacy. What do we mean by it when dealing with a medieval inscription? Should it mean more than an elementary ability to form individual letters and join them into meaningful sequences? Was there any degree of standardised spelling, and did spelling represent pronunciation? The Iona form **stan** is a case in point. Historically, the vowel element is in fact a diphthong, and is recorded as such; in normalised Old Norse the word appears as *steinn*. Monophthongisation occurred in medieval times in some Norse dialects. Is **stan** an attempt to reproduce a monophthongised form? Or does it just indicate somebody, carver or commissioner, who couldn't spell? Here it is interesting to look up reference works. Take Lena Peterson's *Svenskt runordsregister* which lists the forms the word assumes in the very extensive Swedish material.[26] Digraphic spellings, presumably representing diphthongs, are certainly very common there (e.g. **stain**), and there are spellings with single vowels (**stan** is not that rare). But there is also a whole range of most peculiar spellings, some at least of which must arise from plain incompetence or ignorance: **itin**, **sitin**, **skin**, **istn**, etc. Naturally, all of these must be seen in their contexts, to check whether there are other reasons for their peculiarities. All we need observe is the fact that word forms are not standardised in Scandinavian runic inscriptions; it is therefore sometimes difficult to establish why a particular, apparently aberrant, form was used. Is **stan** a mistake or not? We must not automatically assume that a monument which was obviously designed and carved with some care would be lettered with the same care — that an able and practised stone carver necessarily was, or had as an associate, an able and practised rune carver.

Tools

What do we know about the tools our rune carvers used? And were they the same tools the carvers of monuments used? Do they emerge from the archaeological investigation? Were they specifically designed to produce the slimline letter forms that runes need, or did the carver pick up whatever tool happened to lie available, and do the best he could with that? The point is stressed when we consider the use of dots, either to distinguish one rune form from another, e.g. ' and ' s, or to act as word separation symbols in continuous text. One sometimes reads in accounts of inscriptions that such dots are 'drilled', but what did the writer think he meant by this

verb? We all know what drills look like because we can buy them in any DIY shop. But did the craftsman of the Early Middle Ages know what a drill looked like? Did he distinguish it from what we would call a centre-punch? And was that distinguishable from a small-headed chisel? How much study has gone into this type of work on our surviving monuments? We ask out of ignorance. But we suspect that there has been too little awareness of practical considerations such as this by runologists and other desk-ridden creatures. The method of cutting an inscription may affect the resultant text. You are not likely to get overcuts of stave junctions in a text punched in. On the other hand, the use of a punch for letter forms might encourage the carver to make his word separation symbols of dots or groups of dots, rather than crosses. Or awareness that the rune carver used a punch might encourage us to accept as separation symbols marks on the surface that we would otherwise think accidental, or the effect of weathering.

Statistics

This has already been touched upon above, but it needs a little more stress here. If we consider the Scottish sculptured stones with runic inscriptions, the total number is, say, 22. It is hard to establish the figure with exactness since, as we have observed, there is uncertainty about the identification of some items, and also about whether they are to be included as 'sculptured stones'. This number does not include the obvious graffiti on rock faces, as on Holy Island, and those in Maeshowe, which must be considered part of a different tradition. Let us, for the purposes of discussion, accept the number as 22. This group spreads over, shall we say, two centuries (though it is almost certainly more), which would give us an average of just over one every ten years; and a wide geographic range from the farthest north, Eshaness I and II, to the farthest south, Inchmarnock, a distance of 600km (or more). What precise or rather detailed information, of language, of culture, of technical competence, of political and ethnic relationships, can be sensibly obtained from such scanty material? It should be clear that any conclusions we may come to will be provisional and tentative. When we further note that of the 22, 8 examples were found after 1980, or at least drawn to scholarly attention after that date, the statistical frailty of any discussion becomes immediately obvious. It becomes even more evident when we compare this situation to that of the Isle of Man. Here there are, shall we say, 23 runic memorial stones or fragments of them, on an island less than 50km from north to south; and spread over perhaps less than a century.

One of the chapters in the introduction to Barnes and Page, *A Corpus of the Scandinavian Runic Inscriptions of Britain*[27] is called 'Questions but no answers'. Perhaps our present paper should have some similar title. It does, nevertheless, seem possible to settle two of the questions posed at the outset: whether it is useful to exclude inscriptions that are not 'early medieval', or those that are not on stone. From our perspective it makes little sense to divide a corpus based on the presence of Scandinavian runes into 'early' and 'late medieval', or 'Viking Age' and 'later'. Apart from anything else, it is, as we have seen, impossible to put a firm date on many of the inscriptions. Nor does there seem to be much advantage in separating rune stones from the rest of the material. The Scandinavian runic inscriptions of Scotland are first

and foremost an extension of the wider Scandinavian runic corpus, and are best studied, read and interpreted as such.

NOTES

[1] Barnes and Page forthcoming.
[2] The identification system used for the Scandinavian runic inscriptions of the British Isles is that introduced in Barnes 1992. OR = Orkney Islands, SC = Scotland, SH = Shetland Islands. Within these regions, inscriptions are numbered as far as possible according to find date. SC 8 is also known as Kilbar 4 (Fisher 2001, 107–8). The symbol † is used to signal doubt about the medieval origin of the inscription; * = lost.
[3] Barnes 1994, 40–1, 60. We spell Maeshowe as a single word since that is the form found in almost all runological and much other literature and one which conforms better to the stress pattern of the pronunciation we have heard in Orkney (with heavy stress on the first syllable, lighter on the second).
[4] Nordby 2001.
[5] Barnes 1994, 95–102. We use the spelling Brogar in preference to Brodgar since it conforms better to the supposed etymology of the name (ON Brúgarðr 'Bridge farm').
[6] Barnes 1994, 95–102, 144–58, Pls 24 and 48.
[7] RCAHMS 1946, II, 3, and see also 36.
[8] Radford 1959, 18.
[9] Marquardt 1961, 26.
[10] Liestøl 1984, 225–7.
[11] Stephens 1884, III, 315 n1.
[12] Barnes and Page forthcoming.
[13] RCAHMS 1946, III, 14.
[14] Jesch 1990.
[15] Barnes 1994, 68–70.
[16] Wilson 1883, 48–9.
[17] Low 1879, 136.
[18] RCAHMS 1946, III, 89.
[19] Calder 1961.
[20] Olsen 1954, 177.
[21] Shetelig 1954, 125.
[22] Holman 1996, 204.
[23] Wilson 1983, 183.
[24] SC10 Inchmarnock is also known as Inchmarnock 13 (Fisher 2001, 79).
[25] SC14 is also known as Iona 69 (Fisher 2001, 130).
[26] Peterson 1994, under *stœinn*.
[27] Barnes and Page forthcoming.

CHAPTER 13

UNDERSTANDING WHAT WE SEE, OR SEEING WHAT WE UNDERSTAND: GRAPHIC RECORDING, PAST AND PRESENT, OF THE EARLY MEDIEVAL SCULPTURE AT ST VIGEANS

By JOHN BORLAND

INTRODUCTION

The sculptured stones at St Vigeans have been recorded graphically (and photographically) on numerous occasions.[1] In 1999 Historic Scotland asked the RCAHMS to record them 'to modern standards'. What is to be gained by recording these stones again?

Early medieval (and particularly Pictish) sculpture was one of the first categories of ancient monument to be systematically recorded in Scotland. From the early days of this process, through the work of 18th-century antiquarians such as Gordon, Pennant and Cordiner, a visual representation of the monument was a common feature. As first Chalmers, then Stuart and finally Allen and Anderson attempted to be both comprehensive and scientific in their studies, a visual record became central to the recording process.

The history of recording early medieval sculpture in Scotland is well documented[2] and this paper does not seek to retell that story. By putting the recent RCAHMS record of the St Vigeans stones into the context of past records, however, I hope to show the value of re-recording, not only in relation to St Vigeans, but the wider implications for early medieval sculpture as a whole. After briefly outlining each source's approach to recording, and assessing the overall effectiveness of that record, I will present case studies examining in detail to what degree each author/illustrator has understood what they have seen, or whether they have merely seen that which they understood. The list of sources cited above is not comprehensive, but represents those who sought to document the collection either in its entirety, or as new items were discovered.

This paper follows the numbering system in *ECMS*, as this was adopted by Historic Scotland for its museum at St Vigeans in the 1960s and is still in use. Given

that some fragments are or should now be joined, that other stones and fragments were omitted from *ECMS* or have subsequently been discovered since 1903, and that Allen's numbering system does not cater for the discovery of any other symbol-bearing stones, rationalisation of that numbering system is now overdue. This issue has, however, obvious implications for the entire corpus of early medieval sculpture and requires further consideration.

ST VIGEANS: A BRIEF RÉSUMÉ OF PREVIOUS GRAPHIC RECORDS

Arguably the first systematic attempt to record a defined group of early medieval sculptured stones, Patrick Chalmers's *The Ancient Sculptured Monuments of the County of Angus*, was published in 1848. Chalmers's stated intention was to create a comparative set of drawings. He was not concerned that they should be reproduced at a consistent scale, only that they should be 'of sufficient size to exhibit all the details'.[3] Using lithographs, the volume illustrates the four stones known at that time from St Vigeans at three different scales.

Building on Chalmers's county-based work, John Stuart's two-volume *Sculptured Stones of Scotland*, published in 1856 and 1867, aimed for nationwide coverage. Again using lithographs (and indeed the same artist as Chalmers for much of the first volume's illustrations) the first volume records the same four stones from St Vigeans, each at a different scale. In addition to a newly discovered fifth stone, Stuart's second volume re-records a previously illustrated stone, for reasons that we shall examine later. Once again, both stones are illustrated at different scales.

The Revd William Duke, energetic minister of St Vigeans from 1865 to 1911, was instrumental in instigating a major restoration of the church in the early 1870s, leading to the discovery of a large number of carved stones and fragments. His article, published in 1872, describes 29 stones but illustrates only 12.[4] Compiled to fill four plates, the lithographs are not reproduced at a consistent scale. In 1888, Duke recorded a further three new discoveries.[5] Two are illustrated by very fine engravings, reproduced at a scale of 1:4, the third by a rather sketchy line-drawing.

With the publication of *ECMS* in 1903, J Romilly Allen and Joseph Anderson returned to a comprehensive nationwide record of early medieval sculpture. It had been their intention to use photography as the principal medium to illustrate *ECMS*, preferring its 'absolute truthfulness ... and ... rugged realism ... to illustrations more picturesque in character'.[6] As the results were often less than satisfactory, however, the volume includes a mixture of pictorial media, but relies heavily on Allen's bold line drawings, with which it has become synonymous. At some point prior to publication, Anderson handed the task of preparing the line-drawings to F R Coles, his assistant in the museum. Working from Allen's marked-up rubbings and in the same bold style, Coles was responsible for most of the drawings from page 212 onwards, making him the likely illustrator of the St Vigeans material.

The volume describes 29 stones at St Vigeans but illustrates only 26. Thirteen are illustrated by line-drawing, 8 by photography, 1 by both line-drawing and photography, and 4 by previously published engravings. Allen was also unconcerned about reproducing images at a consistent scale and uses at least five different scales for the

St Vigeans material. Although the precedence of the written word over illustration in *ECMS* has been noted, the significance of the drawings should not be underestimated. Allen's 'structured description of each stone',[7] directly correlates to its illustration, and any detail not recorded in the latter goes unnoted in the former.

The Early Christian and Pictish Monuments of Scotland by Stewart Cruden was first published in 1957 as an 'illustrated and descriptive catalogue'[8] of a selection of stones, including the then Ministry of Works's collection at Meigle. Revised and expanded in 1964, it gives a brief description of the collection at St Vigeans and includes a photographic record of seven stones.

St Vigeans 1, the so-called 'Drosten' stone, is illustrated in six out of the seven sources listed above. A brief examination of those images not only enables us to compare each volume's approach to depiction, but also gives us a good yardstick against which to measure the quality of the visual record. Only the lower portion of this cross-slab was known when Chalmers's volume was published. The lithographs, by Polish artist P A Jastresbski, illustrate the front, back and inscription-bearing right-hand side of the stone. The left-hand side is not illustrated although its vinescroll ornament is significantly different to the rest of the carving. This is a strange omission and quite at odds with Chalmers's professed aim to illustrate 'all the details of the sculpture'.[9] Although these drawings depict the major components of the sculpture's ornamentation, they are essentially schematic, not particularly well observed and lack detail.

Jastresbski also drew the lithographs of St Vigeans 1 published in Stuart Vol 1.[10] These illustrations follow exactly the same pattern (omitting the left-hand side) and repeat the same errors as those published in Chalmers; for example, both illustrations show a lopsided crescent symbol and an overly long, thin comb. It would appear that the illustrations in Stuart's volume were redrawn from the earlier images rather than from any re-examination of the stone itself. When Stuart published his second volume, he took the opportunity to have St Vigeans 1 redrawn, this time by A Gibb, so as to record 'the ornaments on the other edge'.[11] In addition to now depicting all four carved surfaces of the stone, including a detail of the inscribed panel, these new lithographs delineate more accurately the components of the ornament and record much of the stone's finer detail.

Duke's article of 1872 records the discovery of the top portion of St Vigeans 1. The lithographs, by an unnamed artist, accurately depict the front, back and left-hand side (bearing the top of the vinescroll ornament). The short section of the right-hand side is not illustrated, as the carved surface is entirely defaced. Although the article's title refers to the illustrations as photographs, there is no obvious sign of any photographic image, and indeed other drawings in the volume are similarly referred to. Given the very accurate proportions of these illustrations it is almost certain, however, that they were drawn using photographs as a template (see below).

St Vigeans 1 is recorded photographically in *ECMS*. Two pictures portray the lower portion *in situ* in the churchyard,[12] between them showing three of the four carved faces (once again, the side with the vinescroll ornament is omitted). Although reasonably well lit, their angled viewpoint means that they do not show any fine detail and serve only as an *aide-mémoire*, rather than a detailed record of the stone.

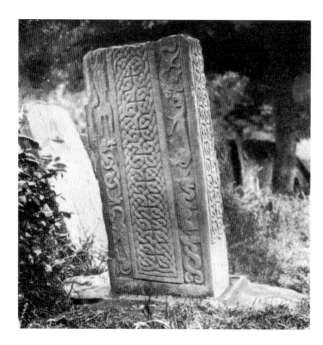

FIGURE 13.1　St Vigeans 1 (lower section) *in situ* in the graveyard, showing possible socketed base. From *ECMS* III, Fig 250a.

Chalmers notes the lower portion of St Vigeans 1 as standing in the churchyard but states that, along with St Vigeans 2, it once formed 'part of a pavement . . . in the Church'.[13] He goes on to recount a story that part of an interlaced cross 'forms the footstep in which [St Vigeans 1] is placed'.[14] Duke's article of 1872 states the intention to take St Vigeans 1 into the church, where St Vigeans 2 was already 'built into the inner face of the wall'.[15] Therefore, the photographs in *ECMS*, one of which shows St Vigeans 2 in the background,[16] must pre-date 1872 (Figure 13.1). They both show St Vigeans 1 set in what appears to be a socketed stone base with a raised collar. There is no account of any such feature being recorded, but nor is there any account of a fragment of a cross-slab being recovered when St Vigeans 1 was removed from the churchyard.

The three photographs of the upper section of St Vigeans 1 in *ECMS*[17] offer a straight-on view of each carved face but, taken under a diffuse directional light, they lack definition. These photographs bear a remarkable resemblance to, and were likely to have been used as a template for, the lithographs in Duke's article of 1872.[18]

Cruden publishes photographs of the front and back of St Vigeans 1, with both sections reunited.[19] Strong directional light emphasises the relief carving of the stone but drowns out the finer detail.

CASE STUDIES

St Vigeans 2

Jastresbski's lithograph of St Vigeans 2 in Chalmers[20] shows the stone to be rectangular with a small break in the top left-hand corner (Figure 13.2a). The drawing

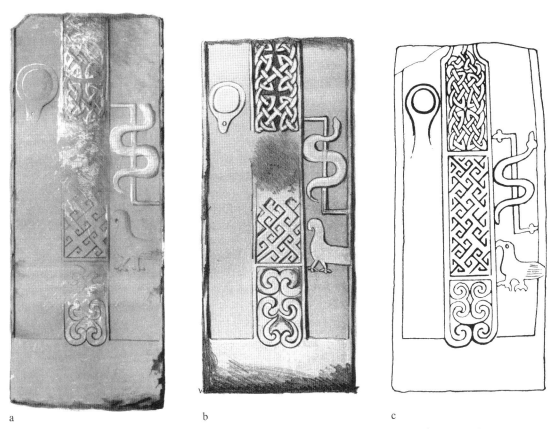

FIGURE 13.2 St Vigeans 2 from (a) Chalmers 1848, (b) Stuart 1856, and (c) *ECMS*. (Crown copyright: RCAHMS)

does not register the taper that begins towards the top of the stone and wrongly shows the margins at the stone's outer edges as thin beads. The proportions of the panel at the bottom of the cross-shaft are wrong and the detail of its spiral ornament is poorly observed. The top half of the panel of key-pattern above is shown as completely abraded, ignoring the faint vestiges of the ornament that survive. Above this, two knots of interlace are drawn correctly, if somewhat sketchily. This panel is shown as continuing at the same width up to the broken edge at the top of the stone, and the surface above the knots shown as worn and abraded.

The panel to the left of the cross-shaft shows the mirror symbol minus the worn, but still discernible, rounded butt of the handle. The mirror's inner disc is shown standing proud of, rather than recessed into, the frame. In the panel to the right of the cross-shaft, the eagle and the serpent and Z-rod symbols are both poorly observed and lack detail. Relative to the scale-bar accompanying the illustration, the overall dimensions of the stone are fairly accurate.

The lithograph of this stone in Stuart Vol 1 is also by Jastresbski (Figure 13.2b).[21] In the Preface to the volume, Stuart outlines how, on occasion, some of Jastresbski's drawings were found 'to be deficient in minute accuracy, apparently from their hasty execution' and subsequently required redrawing.[22] This one was obviously not found wanting. In overall appearance it is very similar to the image in Chalmers, if anything apparently benefiting from being more boldly executed. However, on closer examination, the same errors are merely repeated in a more confident manner.

The stone is once again shown as a non-tapering rectangle, this time without the broken top-left corner. The margins, here more clearly defined, are still too narrow. The decoration on the cross-shaft is drawn more boldly than in the earlier illustration, but no more accurately. To the left, the handle of the mirror symbol is shown as a pointed stump, the inner disc again standing proud of the frame. To the right, the eagle and the serpent and Z-rod symbols, although now prominently outlined, are poorly observed and lack detail. The scale-bar accompanying this illustration is clearly wrong and makes the stone more than twice its actual size.

The line-drawing of St Vigeans 2 in *ECMS* (Figure 13.2c)[23] reflects a much greater understanding of the nature of the ornament and, as it is derived from a rubbing, the stone and its components are accurately delineated. It records the stone's broad margins and shows its taper, but makes too much of the small break in the top-left corner. Examination of Allen's rubbing, preserved in the British Library,[24] shows that it loses definition in this corner and has been wrongly interpreted. The drawing clearly defines the panel of spiral decoration at the bottom of the cross-shaft. The panel of key-pattern is shown as complete and, above this, the two knots of interlace are depicted accurately and in proportion. This illustration, for the first time, shows the two round hollow angles of the cross and the interlace emerging from the two knots.

The mirror symbol, clearly outlined on the rubbing, has its lower half omitted from the drawing. The eagle symbol is accurately defined and records the bird's eye and tail-feather detail. The serpent and Z-rod symbol is also accurately outlined, recording the Z-rod's terminals. The stone is reproduced at a scale of 1:12 (i.e. 1 inch = 1 foot).

Given that the drawing of St Vigeans 2 in *ECMS* accurately delineates the stone and its components, and that the nature of those components is clearly understood, what is to be gained by drawing it again? Although praised by some as 'confident' and 'masterly',[25] the line-drawings in *ECMS* do not convey any sense of the third dimension. So would a redraw merely add the missing sense of modelling? This in itself should not be underestimated. The fact that the worn yet discernible handle of the mirror is omitted when equally worn key-pattern is portrayed as complete is a good example of the problem of depicting often abraded and damaged carved stones with stark line drawings. A feature must either be shown or ignored, with little or no scope to hint at something or to leave vague. This style is bold, but unsubtle.

Indeed, many of the new details recorded by RCAHMS rely on the ability to recognise and depict subtle nuances, which are arguably too delicate to be portrayed in Allen's style. For example, the remnant of the margin of the right arm of the cross, which survives as a small ridge on the stone's broken edge. It does register on Allen's

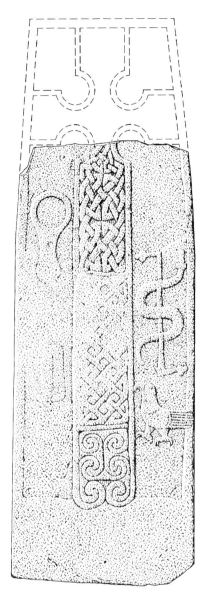

FIGURE 13.3 St Vigeans 2, recorded by RCAHMS in 2000, showing conjectural reconstruction of the cross. Scale 1:10. (Crown copyright: RCAHMS)

rubbing but is too subtle to be depicted by the *ECMS* drawing. Others details, such as the vertical and horizontal divisions in the panel of spiral decoration, the incised curves on the eagle's wing and scalloped feathers on its neck are perhaps the result of closer observation. This is certainly the case with the serpent and Z-rod. The depiction in *ECMS* of the serpent superimposed over the Z-rod is unlikely. Examination of the stone shows quite clearly that the rod passes over the serpent's lower and then behind its central coil. Although badly worn, it is likely that the rod passes over the serpent's upper coil.

The most significant detail brought to light by the Commission's survey is also the subtlest: namely, the existence of a comb symbol on the panel to the left of the cross-shaft, below the mirror (Figure 13.3). The pattern of wear on St Vigeans 2 is consistent with earlier accounts of its reuse as a paving stone. Although at its most worn in the centre of the left-hand panel, traces of the comb can still be made out. Its right-hand and part of its lower edge survive as a faint incised line (the lowest point of the background, adjacent to the raised symbol), defining a slightly raised surface, the corners rounded like a playing card. The left-hand edge is completely worn away but the dimensions of the comb would have been approximately 95mm wide x 150mm long.

The comb is discernible on Allen's rubbing, registering as a light outline defining a darker area within, although the rubbing's folds and the overlaps of its composite sheets make it less obvious. Interestingly, it can also be detected on a Historic Scotland photograph taken in 1960, prior to the setting up of the museum, despite the fact that it pre-dates the use of oblique peripheral flash.[26]

St Vigeans 4

This small fragment, the top left-hand corner of a cross-slab, was first published in 1872 by Duke (Figure 13.4a).[27] Subsequently incorporated into the interior of the church, obscuring the side with the cross, Duke accurately describes the ornament on both faces but only illustrates the reverse. The lithograph, by an unknown artist, accurately depicts the proportions of the stone and its straightforward components: the upper part of a hooded figure, a staff and a simple double-disc symbol, bounded on two sides by a broad margin. The illustration also records finer detail, such as the figure's incised eye and mouth and even the small notch on his hood.

By the time Allen came to record the stone, it was no longer built into the church wall and both faces are illustrated in *ECMS* (Figure 13.4b).[28] In clean outline the same features are portrayed on the reverse (minus the small notch on the figure's hood). The front shows part of the top arm and connecting ring of a cross, both filled with key-pattern. Allen classifies the cross as having either double-square or round hollow angles.

The top arm of the cross projects just below the connecting ring before the carved surface breaks away. *ECMS* depicts the diagonal key-pattern filling the arm as being truncated by this break, but RCAHMS records the key-pattern continuing beyond this point, curving in an arc (Figure 13.4c). This is in fact the key-pattern respecting the now missing margin of a round, not a double-square hollow angle of the cross. This feature clearly registers on Allen's rubbing but was for some reason omitted or misinterpreted.

St Vigeans 21

This small fragment of a cross-slab was also first published by Duke in 1872 (Figure 13.5a).[29] It too was built into the church wall but, unlike St Vigeans 4, Duke had no knowledge of the hidden face and wrongly describes it as being blank. The lithograph illustrating his article accurately depicts the ornament on the reverse of the stone: the head and foreleg of a bridled horse, a single spiral and a short length of

FIGURE 13.4 St Vigeans 4 from (a) Duke 1873, (b) *ECMS*, and (c) RCAHMS 2000 survey. Scale 1:10. (Crown copyright: RCAHMS)

broad margin. Duke and his illustrator both miss the significance of the margin in defining a straight edge and the stone is oriented with the horse's head held upright, the margin lying diagonally.

Allen had full access to this stone and both sides are described and illustrated in *ECMS* (Figure 13.5b).[30] In addition to the horse on the reverse, the drawing of the front records part of two arms and the connecting ring of a cross with double-square hollow angles. The carving on the front is less well defined and does not respond to Allen's drawing style. He notes the existence of the straight edge and makes this the top of the cross-bearing side. Bizarrely, the reverse is illustrated on a completely different orientation, similar to Duke's drawing. Neither orientation is correct.

The recent survey carried out by RCAHMS records the key-pattern in the arms of the cross and in the connecting ring more accurately, and shows that the cross has round and not double-square hollow angles (Figure 13.5c). In addition, by making the

FIGURE 13.5 St Vigeans 21 from (a) Duke 1873, (b) *ECMS*, and (c) RCAHMS 2000 survey. Scale 1:10. (Crown copyright: RCAHMS)

straight edge the side and not the top of the cross-slab, the reverse now shows a horse walking with its head down, as on St Vigeans 22.

Following recent geological analysis, it has been suggested that St Vigeans 4 and St Vigeans 21 could be respectively the top left and top right-hand corners of the same cross-slab (Figure 13.6) (Chapter 18). The imagery on the reverse of the stones marries up well, placing the hooded figure on horseback, coincidentally reinforcing the parallel Allen draws between St Vigeans 4 and the St Madoes cross-slab.[31] However, although we can now define both fragments as bearing part of a cross with round hollow angles, there are differences between the details of both crosses that remain unresolved. The connecting ring on St Vigeans 4 consists of a central panel of diagonal key-pattern with distinctive rounded terminals. This panel is 40mm wide and is bounded by a 10mm margin. Although damaged and showing some signs of possible reworking, the panel of key-pattern in the connecting ring on St Vigeans 21 is only 30mm wide and does not appear to have the same rounded terminals or margin.

FIGURE 13.6 St Vigeans 4 and 21, reconstructed, as supported by petrological analysis. Scale 1:10. (Crown copyright: RCAHMS)

St Vigeans 6

This small and superbly sculpted fragment of a cross-slab was discovered in 1888 and published by Duke (Figure 13.7).[32] The engravings, by an unnamed artist, are accurate and sensitively executed. Duke refers to the symbol-bearing face as the front and presents the stone as tapering towards the bottom. The illustration depicts the double-disc symbol, filled with spiral-decorated bosses, and the central bar of the Z-rod, between two raised margins. The engraving of the reverse shows a panel of interlace bounded on three sided by a margin. It picks up on the presence of some faint incised lines on the top margin. Duke's article ends: 'It was pointed out, when the stone was brought to the Museum, that certain incised lines on its edge were probably a portion of an ogham inscription, but so much defaced as to be illegible'.[33]

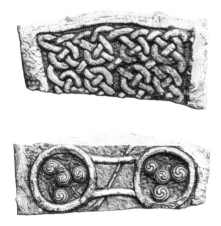

FIGURE 13.7 St Vigeans 6, from Duke 1888 and *ECMS*. Scale 1:5. (Crown copyright: RCAHMS)

FIGURE 13.8 St Vigeans 6, ogham inscription on edge. Scale 1:2 for (b).
(Crown copyright: RCAHMS)

Allen reproduces Duke's illustrations in *ECMS*,[34] perhaps in the knowledge that a fragment so small and so finely carved would not respond well to his style of drawing. He retains the same orientation as Duke, but reverses the order of the two engravings. On what he now defines as the front, Allen identifies the faint incised lines on the top margin as a border of square key-pattern. In a footnote, he dismisses Duke's mention of a probable ogham and attributes the 'incised lines' to this border.[35]

St Vigeans 6 is now exhibited in the museum tapering upwards. Although the nature of the missing sections of this stone is far from certain, the recent graphic survey carried out by RCAHMS also orientates it in this way. The most significant result of this survey is the confirmation of a short fragment of an ogham inscription, not on the front but on the stone's right-hand face (Figure 13.8). This surface, which measures only 65mm wide x 80mm high, has many broad diagonal notches, running down from right to left, probably dating from when the cross-slab was broken for reuse as building stone. Clearly different from these notches and sloping in the opposite direction are the much finer strokes of the ogham, comprising two incomplete groups of five diagonal strokes and an incised stem, transliterating as R R. The stem runs up the length of the face, just to the left of centre. Reading upwards, only the upper tip of the first stroke of the first R survives. The second stroke breaks just before its intersection with the stem. The third stroke is almost complete, lacking only its lower tip. The fourth and fifth strokes are complete. There is a gap of about 12mm before the first stroke of the second R, the upper half of which is partly destroyed by one of the notches. The second stroke is complete and curves slightly, showing possible signs of double cutting at its upper end. The third stroke is complete and has a pronounced curve. The fourth and fifth strokes both curve slightly and are

complete. The stem continues beyond the last stroke of the second group for about 10mm, up to the broken edge of the stone, where it too shows possible signs of double cutting. The stem and strokes of this ogham are only about 1mm wide and deep. This, in conjunction with the possible double cutting and the curved nature of some of the strokes, may imply that it was cut with an implement such as a knife.

We have no way of telling whether Duke's article refers to the square key-pattern, as Allen asserts,[36] or to the ogham recorded by RCAHMS. However, given that the faint lines of the key-pattern are actually illustrated by Duke, on balance it seems likely that he was indeed referring to them. As Allen's survey took place only a few years after the publication of Duke's article it is unlikely there would have been confusion over two different sets of marks. Furthermore, the strokes and stem of the RCAHMS ogham are faint and fine, but are not 'so defaced as to be illegible'.

If that is indeed the case, then the discovery of a genuine ogham on this small fragment is all the more remarkable. In addition to the more sophisticated 'Drosten' inscription, it reaffirms a literary presence at St Vigeans. With less than 50 ogham inscriptions known of in Scotland today and few of them in Angus, any addition to that number is significant.

CONCLUSION

When comparing the illustrations of one source with another, it may appear that one is merely criticising the work of others. That is not the aim of this paper. Each scholar and his illustrator has added something to our knowledge of early medieval sculpture, creating a platform upon which others could build. In preparing detailed scale drawings of sculptured stones, RCAHMS carries on the tradition of Chalmers, Stuart and Allen.

At St Vigeans, we have a collection of early medieval sculpture which has been examined, analysed, described and recorded on many occasions, and which has been in State care for over 40 years. Yet re-examination has yielded new information. Some of it may be considered as merely correcting minor inaccuracies, but some, such as the discovery of a previously unrecorded symbol and ogham inscription, is of greater significance. It is astonishing to realise that this collection has never been fully illustrated and that the most comprehensive record, that in *ECMS*, uses five different scales and three different media to illustrate the stones — hardly the best way to facilitate an accurate study of the material.

Most people would agree that, from the somewhat schematic and impressionistic illustrations of Chalmers, there was steady progress towards a more accurate visual record, coupled with a gradual development of our understanding of the ornament on early medieval sculpture. Many believed that these two elements combined and reached an acme with the publication of *ECMS* in 1903. As R B K Stevenson wrote of *ECMS*, it 'had the effect by its very thoroughness . . . of inhibiting further study of its subject for more than a generation'.[37] The present author has outlined how RCAHMS was content to defer to it on matters concerning early medieval sculpture for well over 50 years.[38] Without detracting from what is undoubtedly a masterly work, it is apparent that *ECMS* is not the last word, or indeed the last drawing, on the subject

(Chapter 14). As the case studies above show, re-examination can shed light on significant new details.

Nor has this experience been limited to the RCAHMS survey at St Vigeans. For example, the small animal head and fish-like tail which start and end the interlace on the back of the Rossie Priory cross-slab, were first recorded by RCAHMS during its survey of south-east Perthshire.[39] The survey of the early medieval sculpture in the care of Angus Council noted for the first time an ogham inscription, of similar character to that on St Vigeans 6, on one of the often-recorded Kirriemuir stones.[40]

New information recovered by detailed graphic recording will better enable the art-historical analysis of early medieval sculpture and allow for the compilation of more accurate distribution data. It is clear that the task ahead does not merely involve recording the many carved stones and fragments that have come to light since 1903, but requires the examination of the corpus of early medieval sculpture as a whole and to that end, RCAHMS aims to make a graphic (and photographic) record of all such carved stones.

ACKNOWLEDGEMENTS

The author thanks: Graham and Anna Ritchie and Ian Fisher for taking the time to read over early drafts of this paper and for making many helpful suggestions; colleagues Steve Wallace (who carried out the Commission's photographic survey of the St Vigeans collection) for his tireless work, Alan Leith (Manager, Survey and Graphics Section) and Jack Stevenson (Head of Archaeology) for their support during the survey and during the preparation of this paper; Sally Foster and the Historic Scotland staff at Arbroath Abbey for their assistance and co-operation during the survey; Katherine Forsyth for her advice on interpreting the ogham inscription.

This paper is dedicated to the memory of Dr Graham Ritchie.

NOTES

[1] Chalmers 1848; Stuart 1856; 1867; Duke 1872; 1888; Allen and Anderson 1903; Cruden 1964.
[2] Henderson 1993a; Ritchie 1998.
[3] Chalmers 1848, Preface, iii.
[4] Duke 1872.
[5] Duke 1888.
[6] Anderson 1881,vi.
[7] Ritchie 1998, 17.
[8] Cruden 1964, title page.
[9] Chalmers 1848, Preface, iii.
[10] Stuart 1856, Pl LXIX.
[11] Stuart 1867, Notice of plates, 70.
[12] ECMS III, Figs 250A and B.
[13] Chalmers 1848, Notice of plates, 7.
[14] Chalmers 1848, Notice of plates, 7.
[15] Duke 1872, 494.
[16] ECMS III, Fig 250A.
[17] ECMS III, Figs 252A, B and C.
[18] Duke 1872, Pl XXXIII, Fig 5.
[19] Cruden 1964, Pls 46 and 47.
[20] Chalmers 1848, Pl III, Fig 3.
[21] Stuart 1856, Pl LXXI.
[22] Stuart 1856, Preface, XVI.
[23] ECMS III, 239, Fig 253.
[24] British Library Ref 37561–80.
[25] ECMS III, 239, Fig 253.
[26] Historic Scotland photograph A/1061/12; Quick 1975.
[27] Duke 1872, Pl XXXIII, Fig 14.
[28] ECMS III, 240, Figs 225A and B.
[29] Duke 1872, Pl XXXIV, Fig 16.
[30] ECMS III, 277, Figs 292A and B.
[31] ECMS III, 241.
[32] Duke 1888, 145, Fig 3, 146, Fig 4.
[33] Duke 1888, 146.
[34] ECMS III, 242, Figs 257A and B.
[35] ECMS III, 242 n1.
[36] ECMS III, 242; Duke 1888, 146.
[37] Henderson 1993a, 32.
[38] Borland 2002.
[39] RCAHMS 1994.
[40] RCAHMS 2003.

CHAPTER 14

THE BULLS OF BURGHEAD AND ALLEN'S TECHNIQUE OF ILLUSTRATION

By Ian G Scott

To celebrate 1903, and Romilly Allen's momentous contribution to the study of early medieval sculpture in Scotland, it seemed to be worthwhile re-uniting, graphically, the six remaining bulls from Burghead.

Allen wished to have photographs specially taken to illustrate his observations.[1] As originally envisaged, these would have clarified the notes taken in the field.

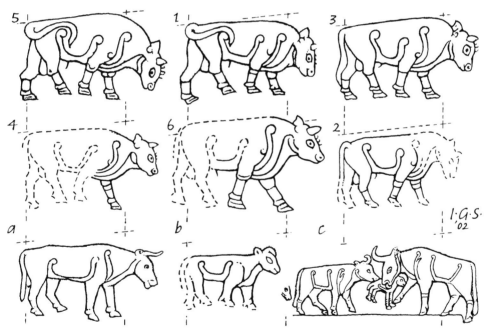

Figure 14.1 Line drawing of the bulls of Burghead (1–6) and cattle from the Moray Firth area (a–c). (1) National Museums of Scotland IB95; (2) Moray Council MORMS 1896.6b; (3) Elgin Museum ELGNM 1871.4; (4) Moray Council MORMS 1896.6a; (5) British Museum MLA1861, 10–24.1; (6) Elgin Museum ELGNM 1886.1; (a) Lochardill (Inverness 2); (b) Kingsmills (Inverness 1); (c) Portmahomack (National Museums of Scotland). (© Ian G Scott)

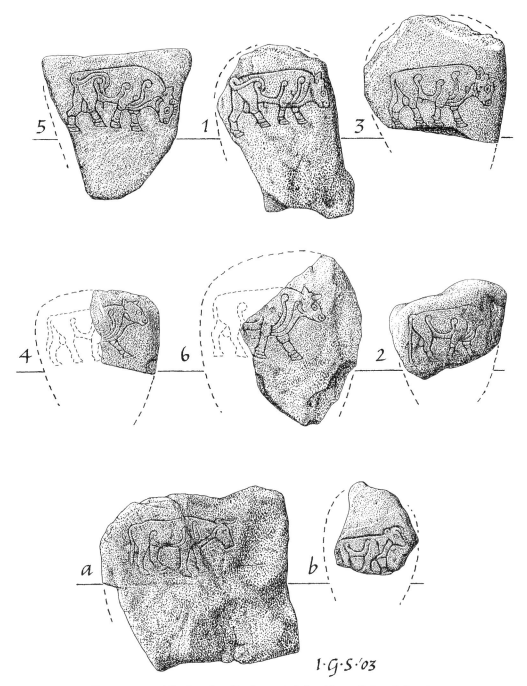

FIGURE 14.2 The Burghead bulls on their boulders. (© Ian G Scott)

However, the prints as supplied often required retouching. For much of the work, he used rubbings instead, as the basis of ink line-drawings. He aimed to show his interpretation of the recessed areas identified by the rubbings,[2] later tracing this with a firm, even line to produce his illustration.

For the bulls this technique is demonstrated in *ECMS* III, 119–23. With the kind co-operation of Inverness Museum, and the owners, I have added two more (Figure 14.1) for comparison with these, which also appeared in *ECMS* but under the heading Inverness.[3] The recently excavated slab from Portmahomack (NMS but presently displayed in the Tarbat Discovery Centre) makes an interesting extension to the range of depictions of cattle from this area (Figures 2.8 and 14.1c).

Each of my drawings is at the same scale and set, as far as I could judge, with its backbone at about 6° to the horizontal. It is notable that the hooves are then seen to be fairly regularly disposed and, as arranged here, the heads gradually rise from the lowered charging position. The first two examples also have curling tails.

It seems most likely that, if the natural boulder surface continued (Figure 14.2), these bulls from Burghead were incised on approximately kite-shaped boulders. They were presumably to be used as markers either set in the ground or on top of a built wall.[4]

I have added my recent illustrations of the Dupplin Cross (Figure 14.3)[5] because admiration of Allen's achievement should not blind us to the limitations of his system (Figure 14.4). Both figures have been placed on facing pages here to ease comparison.

Alcock makes the case for line instead of stipple.[6] He states that he used earlier records and photographs supplemented by inspection of the stones. This we have in common, but to go on to suggest that a line drawing is less subjective than other techniques seems illogical. Line is surely the uncompromising statement of belief, ignoring the third dimension and sharpening the perception. If Alcock, following Allen, wanted that effect, then line is the appropriate technique. It is not the technique which will fully record our interpretation of a carved stone. There is some chance of doing that using all presented information, especially the stone itself in a varied light, to produce a stippled elevational drawing or similar computer image (when this system is developed).

A hundred years after Allen's basic record we should be paying tribute to it by updating and fully illustrating the record of one of Scotland's greatest treasures (Chapter 13).[7]

ACKNOWLEDGEMENTS

My acknowledgements should be longer than my article but, even briefly, I must thank Historic Scotland, and my former employer, the RCAHMS, for their encouragement to continue the study of Early Christian monuments and, in particular, for helping me to have access to the British Library to list the Allen collection. The National Museums of Scotland not only allowed access to their bull and the Portmahomack slab, but also the Dupplin Cross, when it was in their care, and its cast. The other drawings were made possible by the forbearance of Susan Bennett (Elgin Museum), Kris Sangster (Moray Council, collections), Susan Youngs (British Museum), and Patricia Weeks (Inverness Museum). I am also much indebted to the support of the Hunter Archaeological Trust.

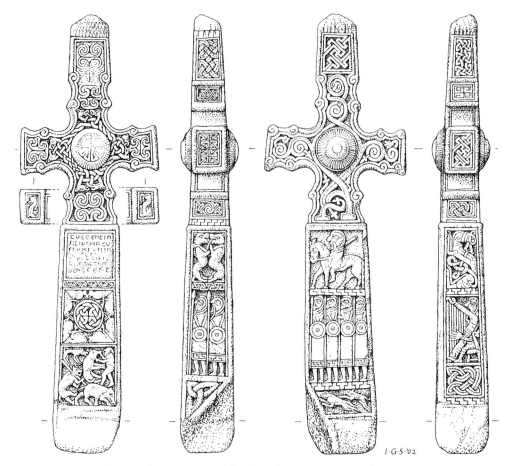

FIGURE 14.3 The Dupplin Cross, simplified line drawing. (Drawing by Ian G Scott. Crown copyright: Historic Scotland)

NOTES

[1] Henderson 1993a, 17.
[2] British Library Additional MSS 37573.2–9, 100; see Henderson 1993a, 18.
[3] *ECMS* III, 102–3.
[4] Contrary to, for example, the reconstruction drawing in Carver 1999, 30–1.
[5] Dupplin Cross depicted following conservation by Historic Scotland.
[6] Alcock 1998, 533.
[7] Scott 1997, 132.

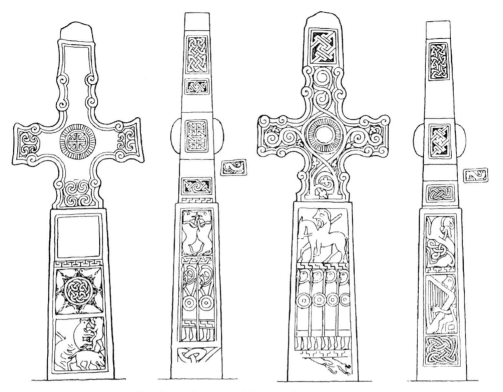

FIGURE 14.4 Romilly Allen's drawing of the Dupplin Cross. From *ECMS* III, Fig 334.

CHAPTER 15

'A PERFECT ACCURACY OF DELINEATION': CHARLOTTE WILHELMINA HIBBERT'S DRAWINGS OF EARLY MEDIEVAL CARVED STONES IN SCOTLAND

By DAVID HENRY *and* ROSS TRENCH-JELLICOE

This paper is dedicated to the memory of Basil Megaw, 1913–2002, a generous friend and mentor, and champion of Manx and Scottish studies.

INTRODUCTION

Samuel Hibbert (Hibbert Ware from 1837), 1782–1848, was an important figure in the intellectual life of Edinburgh in the first half of the 19th century. He graduated MD in 1817, but chose not to practice medicine, instead devoting his life to mainly geological and antiquarian studies. Hibbert was a member of several learned societies, and served for a period as Secretary to the Society of Antiquaries of Scotland from 1823. A significant archive of his antiquarian studies survives (hereafter SHWMSS, Appendix 15.1), including drawings executed by his second wife, Charlotte Wilhelmina Murray, 1790–1835.[1] Some of these sketches illustrate her husband's work but most are of 'figured monuments', her own field of study. This paper explores the background to the creation of these drawings of early medieval carved stones and attempts to evaluate their significance in their contemporary context.

CHARLOTTE AND SAMUEL

Charlotte Wilhelmina was born on 10 August 1790, the eldest daughter of Lady Elisabeth and Lord Henry Murray (d 1805),[2] a younger brother of John, fourth Duke of Atholl and Governor of the Isle of Man. Charlotte, her brother and four younger sisters doubtless enjoyed the comfort and privileges accorded to the family who had ruled the island as Lords of Man until its revestment to the crown in 1765, and whose power and influence was still being exercised by their uncle, who notoriously filled official posts with his dependants to the detriment and resentment of the native Manx. This unashamed nepotism must have benefited Charlotte too when, on her 18th birthday, in 1808, she married William Scott, Receiver-General of Customs on the Isle

of Man. William died in 1818, however, leaving Charlotte and their three young children probably wholly dependent on her uncle's beneficence.

In the spring of 1824, Charlotte borrowed a particular book from friends in Douglas, little realising that this seemingly insignificant act would dramatically change the course of her life. The volume was Samuel Hibbert's *A Description of the Shetland Islands* (1822), and her favourable reaction to it was swiftly communicated by the lender to her brother-in-law, the book's author: 'A lady ... a friend and favourite of ours, a very clever woman, has just been reading your work on Shetland, which she borrowed from us, and is quite delighted with it. She has studied geology, and found much information on that head in your book, and was particularly interested in the history of the Udallers'. This brief introduction concludes with a sentence so charged that it could have been plucked from a contemporary romantic novel: 'The lady I speak of, my dear brother, is a widow!'[3]

Dr Samuel Hibbert was also a single parent with three children, his wife Sarah having died in April 1822, shortly after publication of the Shetland volume. No doubt inspired by his sister-in-law's barely disguised matchmaking effort, Hibbert made several journeys to the Isle of Man that summer on the pretext of visiting his brother Robert, but 'he was, more than ordinarily his wont, particular about his attire', no doubt intent on making a good impression on the clever and discerning widow who had shown an interest in his work.

Charlotte and Samuel obviously had much more in common than their family circumstances, and their relationship flourished. Not only did they possess 'ties of the deepest affection', but also 'a striking similarity of tastes and inclinations'. They married on 8 January 1825 and Charlotte, her two sons, Henry and William Douglas Scott, and her daughter moved forthwith to Edinburgh to begin a new life with Samuel and his children, Titus, William and Sarah.

After their marriage, Hibbert 'resumed his literary labours with, if possible, greater zest than before; for he found in Mrs Hibbert a zealous participator and invaluable assistant in his toils'.[4] A new order was established, husband and wife working as a team with occasional contributions from other members of the family. In March 1825, he communicated a paper on vitrified forts,[5] a pet subject of his, which became one of the principal elements of their joint studies. Hibbert must have been pleased to have as collaborator not only a companion who shared his interests, but a like-minded enthusiast who was also capable of illustrating his papers, and who influenced and encouraged others in the family to follow suit. Charlotte formed a close bond with her stepdaughter Sarah who displayed an equal talent to hers. A poignant example of their co-operation is evident in two folios,[6] where they have shared the task of sketching the cross at Eyam, Derbyshire.[7]

Not only did Charlotte illustrate Samuel's work, but she also helped to write certain publications, as attested in a letter from her husband: 'The third task I had to do was to alter my paper on the Tings, adapting it to the additions you made. This work I did with far greater pleasure, because at every line I had to refer to your writing'.[8] Instances of her input to other Hibbert publications are detectable, as in the following extract from his paper on the Kilmichael-Glassary Bell: 'Again all the ornamental engravings on the various faces of the bell are Scandinavian. Many of

them are made to imitate well-known runic knots. A peculiar plaiting, which is here represented, may be traced on several Scandinavian monuments of the 12th or 13th centuries in the Isle of Man'.[9] This passage is illustrated by a drawn detail of the type of interlace, and another drawing from this period, a view of the Tynwald on the Isle of Man, is reproduced in another publication.[10]

In May 1826 Charlotte gave birth to a son. The following year, it was announced that Hibbert was 'in considerable forwardness' in preparing his *System of Geology* for publication. For this he needed to visit the volcanic regions of the Continent with the purpose of 'satisfying himself on some important questions connected with the subject of rocks of igneous formation'. Consequently he had to resign his office as Secretary to the Society of Antiquaries of Scotland.

Hibbert's second journey to Shetland in 1818 had prompted his first wife to let it be known that 'whilst her husband was benefiting others by his laborious researches, his own family was neglected'. In a letter to her (17 July 1821) he wrote that

> the troublesomeness of this book on Shetland has been so great ... never again will I embark on such an undertaking ... for never do I look again to be so chained as I have been ... My delay is not uncommon. Many persons have, like myself, embarked in a work, and instead of finishing it in five or six months, as they thought, it has lasted them years.

He concluded, 'With love to my little children, whom I will not again neglect for any books of my writing'.[11]

Six years on, his circumstances had changed and his family had increased (as an indirect consequence of his labours on that book), but now they all travelled with him, setting sail from Leith to Rotterdam accompanied by two servants and cases of books. Renting part of an old château at Leutersdorf on the Rhine, Hibbert first busied himself with his *History of the Foundations of Manchester*. Later he and Charlotte left to travel over the volcanic districts around Andernach and almost to the French border. Mrs Hibbert obviously enjoyed the opportunity to 'rough it',

> for few ladies ever voluntarily underwent more hardships and privations than did she in the pursuit of science — now toiling up pathless and rugged precipitous heights or scrambling down rocky hillsides; often drenched by a heavy shower, and then exposed to a broiling sun; and many a time, after a fatiguing ramble of many miles, having no other refreshment than a little coarse bread and water diluted with brandy.[12]

The two 'geologising wanderers' would take shelter for the night where they could, even in a charcoal burner's hut, and they would sleep in their clothes either wet or dry. Charlotte was obviously made of stern stuff and the description of their hardships and privations, by Hibbert's biographer,[13] underlines just how unusual it was at that time for a woman to be involved in such an undertaking and emphasises her remarkable qualities: 'Never, certainly, had a man a more patient or contented companion, or one with more indomitable courage in persevering under the greatest difficulties; yet Mrs Hibbert, though tall, was of slight make'. Experiencing these rigours was useful training for their subsequent travels in Scotland.

Soon Hibbert travelled to Manchester to deliver a series of lectures on geology, leaving Charlotte in charge of the family at Hanau on the Rhine. In his five-month absence, she must have spent some time drawing, as he reassures her in a letter (28 December 1827) that he was 'getting all the articles you wish for, — lead pencils, etc'.[14] When they were reunited, Samuel and Charlotte continued their geological explorations. Not only was Charlotte coping with the hardships, and identifying and extracting geological specimens, but 'during these expeditions her talent for sketching was of the greatest service'. Some of her drawings were published in Hibbert's account of the geology of the region[15] and her unique contribution was acknowledged in the preface:

> while the trouble taken by the companion of my journey to construct from these observations the geological map which appears in the frontispiece[16] was a task still more formidable which ladies in general do not, I believe, often impose upon themselves. To Mrs Hibbert I likewise owe the whole of the geological sketches which are interspersed throughout the volume.[17]

Her skill as a recorder is affirmed by the following testimony: 'these sketchy views are very accurate, as . . . has been assured by one who has visited the beautiful neighbourhood of Laach, that he can readily recognise the scene from Mrs Hibbert's sketch'.[18] From Germany they went to France to study the volcanic area of the Auvergne, then they crossed the Alps into Italy, and travelled to Rome, there meeting up with Hibbert's old army friend, the antiquary and artist Captain Edward Jones, a great favourite of the two girls 'who frequently accompanied him when sketching'. After visiting Vesuvius and other volcanic regions in northern Italy, the Hibberts returned home via Germany towards the end of 1829, having been away for about three years.

Back in Edinburgh, at the last meeting of the year of the Society of Antiquaries of Scotland, Hibbert's health was toasted and a hope expressed 'that he would be prevailed upon to resume the office of secretary, which he had formerly held with so much credit to himself and benefit to the Society'.[19] Perhaps remembering promises to devote more time to his family, he declined to serve again, but he did hold office as Vice-President (1831–2). Several papers resulted from his researches on the Continent, and in 1830 the first volume of his *magnum opus*, the *History of the Foundations of Manchester* was published.

In June 1831 the Hibberts set off again on a 'very extensive and prolonged tour through the Highlands, and even as far as the remote Thule. Their object was to examine, not only the vitrified forts, but the sculptured stones, crosses, and suchlike which abound in the North of Scotland'. Unsurprisingly, 'in this journey Mrs Hibbert's skill as an artist was called into requisition'.[20] They travelled up the east coast and to Orkney and Shetland, and, despite encountering the familiar hardships and dangers on land and sea, 'they succeeded . . . in the object of their tour, for they examined several vitrified forts, and Mrs Hibbert filled her portfolio with sketches of sculptured stones'.[21]

In December, Hibbert read a memoir on the discovery of extensive vitrified remains at Elsness in the Island of Sanday. Charlotte had drawn a panoramic view of

the area, which was published alongside two other views of the Tap o'Noth at Rhynie and its hill-fort.[22] Another significant product of their journey was a paper read by Hibbert on 21 May 1832 to the Society of Antiquaries of Scotland: 'Incidental remarks as to the era when, and the people by whom, the ancient carved pillar, near Forres, called *Sueno's Stone*, was put up'. Accompanied by 'an accurate drawing of the monument by Mrs Hibbert', it seems likely that this unpublished paper was written by her and delivered by Samuel on her behalf, as, at that time, women could take no part in the proceedings of the Society.

The study of carved stone monuments was now a serious focus of their partnership and, at the end of 1832, 'the two indefatigable ramblers in the cause of science had planned a journey to Denmark and Norway in order to examine the Scandinavian sculptured stones and cairns of those countries'.[23] Unfortunately, this venture, which surely must have been at Charlotte's instigation, was abandoned in Paris when, rather unexpectedly, she gave birth to a daughter. A new life, therefore, thwarted this attempt to undertake comparative studies in Scandinavia, but it was her own untimely death in 1835 that cheated her of a planned visit to Ireland for the same purpose, and of her intention to ultimately publish her drawings. She had, however, taken account of similar material in the Isle of Man (Figure 15.1) and in parts of England, particularly Derbyshire (Figure 15.2), and her all-encompassing enterprise is a salutary lesson to those of us, especially in Scotland, who still adhere to a rather parochial approach to the study.

In March 1833, Samuel made some significant geological discoveries in the limestone quarry at Burdiehouse where he identified saurian fossil remains leading him to conclude that the formation was a freshwater one belonging to the Carboniferous group of rocks, the existence of which had previously been doubted. Afterwards the 'reptilian monster', whose two-inch tooth and other fossil remains he had discovered, was named after him, *Megalichthys hibberti*.

The fossils had to be illustrated, of course, and Charlotte, Titus and Sarah shared the task.[24] The British Association met in Edinburgh in 1834 and Hibbert's Burdiehouse discoveries became the principal focus of attention. In November, Charlotte gave birth to another son. Among letters of congratulation was one alluding to the fossils: 'My correspondent does not mention whether the young Hibberti has got a large head and conical tail. I beg you will enlighten me on the subject'.[25] The birth, however, marked a decline in Charlotte's health and Hibbert resolved to leave Edinburgh to find somewhere suitable for his wife to regain her strength. They settled in a cottage at Harrogate, but Charlotte continued to fail until, prostrated by a 'nervous fever', she died tranquilly but suddenly on 1 August 1835. Hibbert decided that 'Where the tree falls, there let it lie', and she was buried in a vault close to the altar of Knaresborough Parish Church.

Although regarded as being very clever, 'she was ever most unassuming and retiring in society, and never made a display of her knowledge', and her relatives 'judged highly of her merits'. She apparently assumed the role of stepmother with aplomb and was never partial to her own children, and, although she was never known to have any altercation with Samuel, she did sometimes intervene on behalf of her stepchildren. In a letter of condolence, Lord Strathallan wrote, 'A more amiable

FIGURE 15.1 Crosses at Maughold, Isle of Man (MAU 2:70(39)A and MAU 4:90(55)A), with a rudimentary sketch of an unknown 'broken cross' with double-cusp armpits. SHWMSS 5:126. (Manchester City Libraries)

and excellent person never existed, which, at her period of life, renders her loss more deplorable, — especially for those dear little ones; and we can only hope they may inherit a share of their mother's spirit and partake of those attainments for which she was so distinguished'.[26]

CHARLOTTE WILHELMINA'S DRAWINGS OF SCULPTURED MONUMENTS

Before meeting Hibbert in 1824, Charlotte had already been sketching archaeological sites and monuments on the Isle of Man and studying and drawing Manx sculptured stones. Being 'possessed of a superior intellect, which she had improved by study',[27] she appears to have been less whimsical in her choice of subject matter than her younger sister 'Emily' (Amelia Jane) who is now known for her 'fairy' paintings.[28] It is open to question that Charlotte had any formal training in drawing. Lionel Lambourne, in his introduction to Amelia Jane's work, states:

> there can be little doubt that she did receive some expert tuition in drawing, sketching and the use of watercolour medium. There is an unverifiable family tradition that she was taught by the landscape artist John 'Warwick' Smith

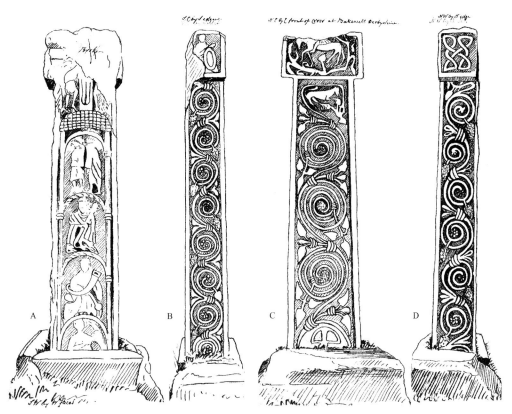

FIGURE 15.2 Bakewell Cross, Derbyshire. A composite of all four faces made up from three of Charlotte's drawings (SHWMSS 5:43/44/45). She drew the main faces A (5:45) and C (5:43) separately and the two narrow faces D and B side by side (5:44). (Manchester City Libraries)

(1749–1831) who in 1795 was commissioned by her uncle the Governor to paint a series of watercolour views of the Isle of Man.[29]

One can imagine that the four Murray sisters were well provided for in attaining what were then regarded as desirable accomplishments for young ladies.

The most important single source of information about Charlotte's drawings is a letter about them written by her husband some ten years after her death (Appendix 15.2). It was sent to David Laing, Treasurer of the Society of Antiquaries of Scotland, a long-standing friend of the Hibberts, whose election to the Society was promoted by Hibbert, apparently to the extent of threatening resignation if he were blackballed a second time.[30] The letter was communicated to the Society at a meeting on 24 February 1845 and six accompanying drawings were exhibited, which almost certainly survive in the Manchester archive:

1. *Stone of Forres* (SHWMSS 5:79, all four sides of Sueno's Stone.)
2. *Meigle (marked reverse of No 2)* (SHWMSS 6:68, Meigle 2C; see Figure 15.3 for face A.)

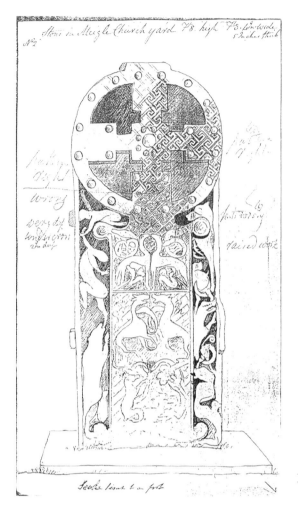

FIGURE 15.3 Meigle 2A. SHWMSS 6:6. (Manchester City Libraries)

3. *Do. Representation of Carnage* [recte Carriage] *&c* (SHWMSS 6:65 or 6:71; Figures 15.7a-b respectively; probably the latter, the lost Meigle 10 and its depiction of a horse-drawn wheeled vehicle.)

4. *Aberlemno (at Cross Stone)* (SHWMSS 6:42 [A], Figure 15.4; 6:70 [C], Aberlemno 3, but face not specified, perhaps both.)

5. *Do. Double Sketch* (SHWMSS 6:59, both faces of Aberlemno 2; Figure 15.5)

6. *Near Shandwick (Ross-Shire)* (SHWMSS 6:60, Hilton of Cadboll, not the Shandwick cross-slab; Figure 15.9a.)

The drawing of Sueno's Stone was possibly the same one that had been exhibited to the Society in May 1832, and it is probable that the paper read on that occasion formed the basis of the text of the 1845 letter. In the letter, Samuel is at pains to emphasise that the study of carved stones was his wife's preserve, 'these sculptured remains of an early period, became *with her* an object of historical inquiry', and to

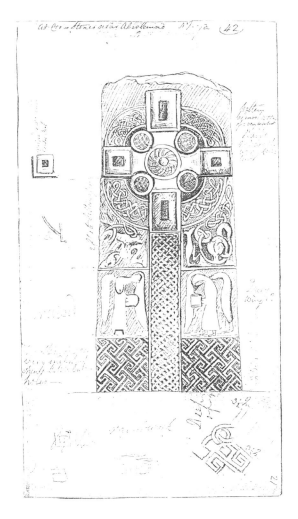

Figure 15.4 Aberlemno 3A. SHWMSS 6:42. (Manchester City Libraries)

repeatedly credit her with the views expressed, such as: '*she* endeavoured to class them . . .' and, '*she* considered as attributable to . . .', and '*she* also regarded them . . .' (Appendix 15.2). Nowhere does he lay claim to any of the observations made, and, like the earlier paper, it should be regarded as a synthesis of Charlotte's ideas resulting from *her* study of the sculptured stones.

In October 1845, Laing wrote to Hibbert expressing the hope that 'some plan might be devised for bringing out the late Mrs Hibbert's drawings of the sculptured stones'. In January 1849, in Samuel's obituary, he refers to her work as 'a series of elaborate and beautiful drawings of the sculptured stones and runic inscriptions that exist in Forfarshire, Ross-shire, and other parts'.[31] But by 1857, when Hibbert's letter was eventually published, Laing had recognised that considerable advances had been made in the study and he sensibly appended a note to the letter explaining why it

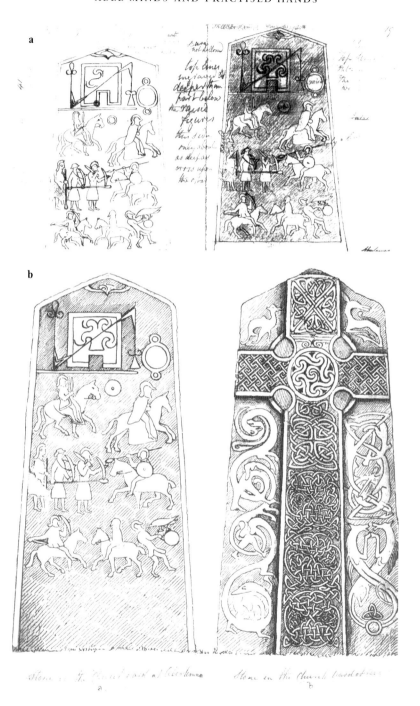

FIGURE 15.5 Aberlemno 2. (a) preliminary sketches of face C (SHWMS 6:41). (b) finished drawings of faces C and A (SHWMSS 6:59). (Manchester City Libraries)

FIGURE 15.6 Kincardine (Highland). Sketch of a fragment of an otherwise unrecorded symbol stone. SHWMSS 6:13. (Manchester City Libraries)

would no longer be practicable or appropriate to publish Charlotte's work (Appendix 15.2).

In the intervening period, Patrick Chalmers's impressive volume for the Bannatyne Club, *The Ancient Sculptured Monuments of the County of Angus . . .*, had appeared in the summer of 1849. Printed on imperial folios, its huge, bold, lithographed images dramatically revolutionised the recording and presentation of sculptured stones, and this same approach, in a slightly less extravagant format, was continued by John Stuart in both volumes of the Spalding Club's *Sculptured Stones of Scotland*.[32]

Cosmo Innes, who had been instrumental in promoting Chalmers's volume, also played a significant role in the Spalding Club's publication. Writing to Laing, in June 1851,[33] he advised him that the Club's 'continuation of the sculptured Stones of the east coast of Scotland is progressing fast and it would be very desirable, if we are to have the benefit of Dr Hibbert's drawings or notes, that they should be communicated soon'. He added, 'I need not say that a copy of the work shall be set aside for Dr Hibbert's family'. Laing acted promptly on behalf of Titus Hibbert Ware in making Charlotte's drawings available to John Stuart, while compiling what he called his '*Big Beuk*'.[34] Stuart, following Innes, wrongly attributed the sketches to Hibbert himself, but he testified to '*his*' thoroughness in having recorded stones which were still not generally known about 20 years on.[35]

Even today the value of the archive is again graphically demonstrated in recognising that one of Charlotte's sketches records a lost and otherwise unrecorded symbol stone. The drawing, apparently made in the churchyard at Kincardine (Highland),[36] is of a fragment containing part of an incised triple-disc with bar (Figure 15.6).

Stuart also gleaned some useful snippets of information from Mrs Hibbert's annotations. For instance, 'by an account furnished to Dr Hibbert, the [Dunnichen] stone is said to have been brought from a place near Restennot'.[37] This interesting possibility does not accord with the already rather confused tradition regarding the stone's findspot (Chapter 22), but it demonstrates that there is much valuable information contained in Charlotte's notes to augment the individual biographies of many stones.

Charlotte's concern about the preservation of carved stones gives us an insight to attitudes towards ancient monuments in the first half of the 19th century, as she had 'occasion to lament that the number of these national monuments were gradually diminishing. Their adaptation to the purposes of gravestones, or even to those of husbandry, particularly when they occurred near farmyards, was a frequent cause of their mutilation or destruction'.

On a drawing of a cross-slab at Maughold, Isle of Man,[38] a note reveals that the Hibberts were actively involved in conservation: 'This Monument we engaged persons to set upright it formed when we were there a step to the Sundial or Horseblock'. On her drawing of Meigle 10 (Figure 15.7a),[39] Charlotte notes: 'Stone removed from Meigle Churchyard to Mr Murray's'. Patrick Chalmers acknowledged that the 'preservation of the monuments at Meigle, is chiefly due to the care and good taste of Mr Murray of Arthurstone'.[40] Had Meigle 10 remained at Arthurstone, some 3.2km from Meigle, it might have survived to this day, but, ironically, it was returned to the church for safekeeping where it was destroyed in the disastrous fire of 1869. Charlotte's drawings of it also serve as a check on other extant illustrations,[41] and the annotations on her preliminary sketch, together with specific measurements, convey her direct contact with the stone, lending a palpable air of reality to it.

This hands-on approach is apparent throughout her drawings, which, for the most part, are working drawings done in the field, often enhanced with details and notes containing descriptive information about the sculpture that she would require later when attempting finished versions in the absence of the subject. Understandably, a recurring theme of the notes is 'this part indistinct', but the immediacy and vitality of these annotated drawings allow real insight to Charlotte's response to the sculpture and provide invaluable evidence of her working methods.

The Meigle 10 drawings, a working sketch in pencil (SHWMSS 6:65; Figure 15.7a), and a smaller scale, finished drawing in ink (SHWMSS 6:71; Figure 15.7b), also show how Charlotte might have prepared her drawings for publication and how they might have been presented. The latter suggests that she envisaged a modest format, to a uniform scale, 1:12 (her preferred scale for drawing), suitable for reproducing all but her several drawings of 'Sueno's Stone',[42] which is more than twice the height of the tallest of the other cross-slabs, presenting a perennial problem for those wishing to publish images in a standard format.

Charlotte's self-discipline in completing the panels of 'Sueno's Stone' with such a degree of uniformity (Figure 15.8), also evident in many other examples of her work, can only be commended. Generally the drawings show her to be fairly obsessed with extrapolating and illustrating the 'mazy perplexity' of interlace and geometric patterns, but to be less interested in figural work. She deliberately attempted to rectify

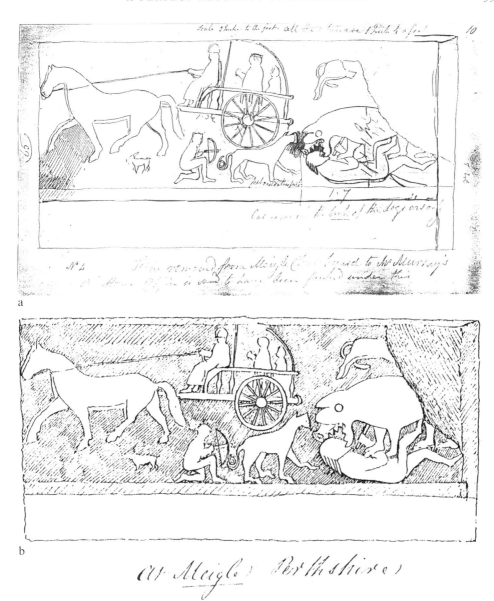

FIGURE 15.7 Meigle 10. (a) preliminary pencil sketch with measurements and annotations, originally drawn to a scale of 1:6. (b) Finished drawing in ink, originally drawn to a scale of 1:12. SHWMSS 6:65. (Manchester City Libraries)

the complete lack of understanding of the ornament displayed in the published work of others, but, as Hibbert commented, it was 'at the expense of considerable labour' and that 'a single monument has often cost her three or four days of continued employment'. This reckoning surely accounts for time spent altogether working on a

FIGURE 15.8 Upper part of Forres A. Part of one of Charlotte's many drawings of Sueno's Stone. SHWMSS 6:66 (detail). (Manchester City Libraries)

drawing, rather than time spent in front of the monument. Hibbert, however, did 'not underrate the attempt which she made to ensure a perfect accuracy of delineation'.

Hibbert also records Charlotte's intention to publish the drawings 'in a sort of fasciculi'. This could mean that they would have been printed and issued in parts, a common practice then, especially with illustrated work which required time to engrave, but which also had advantages for the letterpress, or text pages, as compositors did not like to have their types locked up for long periods awaiting printing and making them unavailable for setting other jobs. Or, if 'fascicule' is

intended, one imagines a collection in a portfolio rather than a bound volume. Charlotte was not short of ideas about the monuments and was capable of expressing them, and she probably also would have provided an accompanying text.

With a fairly conservative approach to publishing, she was not going to break the mould, like Chalmers, who was determined to accomplish Pinkerton's desideratum of publishing 'plates of a just size'.[43] Her main aim was to attempt to have accurate representations of a reasonable size for study. This in itself was a fresh approach for the time, but it is not surprising that her work appeared to have little relevance once Chalmers's impressive lithographic plates[44] had eclipsed the old-style engraved work — an approach so powerful and successful that it would have a pervasive influence in the field for the next 40 years before photographic reproduction became the norm.[45]

Charlotte's linear style lends itself to reproduction by engraving, or by etching, like some of her published work, rather than by lithography. Although her illustrations of the Burdiehouse fossils had been lithographed, these, in common with much early lithographic output, had the accustomed look and character of engraved plates. Lithography is capable of a great range of techniques and effects, including extremely fine work, which facilitated the tendency to imitate the prevailing aesthetic of the medium with which at first it was competing. The essential character of lithography, however, is in its ability to render tone and faithfully reproduce drawings made directly onto the surface of the lithographic stone, hence its adoption as the favourite medium of many artists who enjoyed the freedom and control it gave them over the final printed results, and the reason why it became the preferred method for publishing images of early sculpture.

Our perception of early medieval carved stones is, to a great extent, dictated by images of them that have been made by others. Visualisation by proxy is an essential part of the study of monuments with such a wide distribution, but it should only ever be an adjunct to direct examination of the stones themselves. In the 19th century, new drawings and illustrations of carved stones were invariably accompanied by a guarantee of their accuracy, but, as each succeeding generation gained more knowledge of the subject, previous work was usually found to be wanting in this respect. The cycle continues today, and we should still be cautious about reaching conclusions from images alone. We should resist being smug about modern technology, too — despite Joseph Anderson's belief in the 'absolute truthfulness' of photography, and the growing collections of excellent photographic prints and negatives — there are too many variables in the mechanics and techniques of that medium, and the conditions in which it is employed, to sustain this creed. The camera (particularly when linked to a computer) is no more an agent of the truth, than is a skilled and experienced illustrator, there is no such thing as a definitive photograph, or, for that matter, a perfect laser scan. The discerning human brain and co-ordinated hand cannot yet be replaced. By their very nature, however, drawings, engravings, etchings, lithographs, woodcuts, photographs, laser scans, holograms, casts, or even carved stone reproductions can never substitute for an original carved stone or replicate its inherent qualities. Like Mrs Hibbert, we still strive for 'a perfect accuracy of delineation' — a worthy ideal, however unrealistic and unattainable the goal.

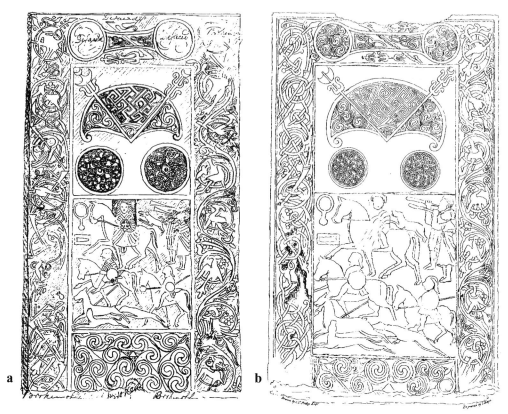

FIGURE 15.9 Hilton of Cadboll. (a) Charlotte Hibbert's drawing of 1831. SHWMSS 6:60. (Manchester City Libraries). (b) Charles Petley's drawing made about 20 years before (1811–12) and etched by L Hays (Petley 1857, Pl 20).

CONCLUSION

Charlotte was seeking to improve on earlier efforts.[46] She drew to a bigger scale allowing more detail to be shown, and it is immediately evident that she succeeded in achieving better-observed and more trustworthy drawings. Comparing her drawing of the Hilton of Cadboll cross-slab[47] with Petley's done 20 years before (Figure 15.9),[48] shows hers to be much superior, not only with regard to detail but to the proportions of the stone as well.

Charlotte was determined to be comprehensive and record stones not only in Scotland but elsewhere in Britain, and she intended to extend her studies to Scandinavia and Ireland (Figure 15.10). For one person even to contemplate all of this is astonishing, but to actually attempt to achieve it, faced with the difficulties of travel at the time, the responsibilities of a large family (notwithstanding having servants to look after them), and, meanwhile, coping with bearing three more children in the space of a few years, almost beggars belief.

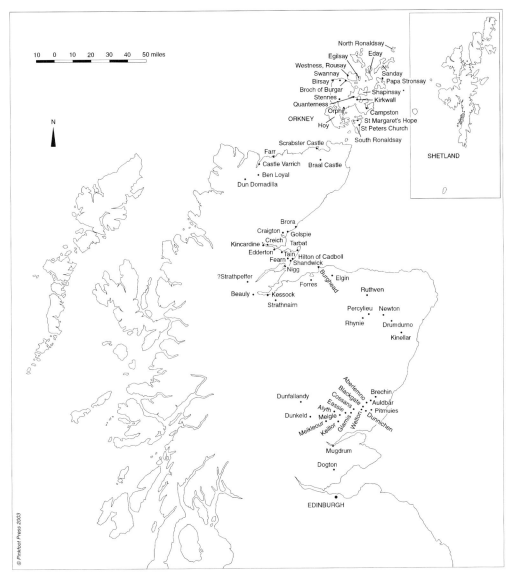

FIGURE 15.10 Location map of places visited by Charlotte and Samuel Hibbert. (© Pinkfoot Press)

The recording of early medieval carved stones in Scotland has a distinctive and reasonably well-documented history,[49] but some revision will be required to take account of Charlotte's drawings. This unique collection is all the more valuable in that other drawings of the monuments known to have been made around the same period, by artists such as Charles Roger[50] and William Ross,[51] have been lost. Although Charlotte's intention to publish her drawings was never realised, it is hoped

that this partial resurrection of her sincere and determined efforts goes some way towards fulfilling her wish and that Mrs Hibbert will attain her rightful place as a pioneer and major participator in the history of recording early medieval sculpture.[52]

ACKNOWLEDGEMENTS

The authors are very grateful for help given by: Jane Anderson, Blair Castle; Lesley Ferguson, RCAHMS; Sally Foster, Historic Scotland; Pat Griffiths and Andrew Johnson, Manx National Heritage; John Hodgson, John Rylands University Library, Manchester; Sheila Noble, Special Collections, Edinburgh University Library; Nigel Ruckley; Katharine Taylor and staff of Manchester Local Studies Archive. The illustrations have been reproduced by kind permission of the City of Manchester Libraries and Theatres Department. Historic Scotland grant-aided this project.

NOTES

[1] Hibbert compensated for his extreme absent-mindedness by methodically collating and binding the family's papers and correspondence into portfolios and volumes, which has contributed greatly to their survival. The Scottish material in the Hibbert Ware archive, Manchester Local Studies Unit (here designated SHWMSS), is the subject of a report (Henry and Trench-Jellicoe 2003), copies of which are held by Historic Scotland, NMRS, and the Local Studies Unit, Manchester Central Library. The report includes a catalogue of Charlotte's drawings, any of which when referred to here uses the same method of listing: source followed by volume and folio number (e.g. SHWMSS 6:65).

[2] Lord Henry was Lieutenant-Colonel Commander of the Royal Manx Fencible Infantry. He is commemorated by an obelisk in Old Braddan churchyard erected by his fellow officers.

[3] Hibbert 1822; extract from a letter to Samuel Hibbert from his sister-in-law, Mrs Robert Hibbert, Douglas, Isle of Man, 7 April 1824 (Hibbert Ware 1882, 330).

[4] Hibbert Ware 1882, 342.

[5] Hibbert 1857b.

[6] SHWMSS 5:42/46.

[7] Similar to the Bakewell Cross (Figure 15.2). At Eyam, Charlotte drew two faces of the cross, Sarah the other two. The surviving drawings are Charlotte's, but she acknowledges the two faces which she based on Sarah's sketches, and on one (5:42), after the credit, 'From a drawing by Miss Sarah Hibbert,' she adds, 'with a few alterations made on the spot'. Hibbert's sons learned their craft more formally at the High School in Edinburgh and William became a remarkable draughtsman; he was ambidextrous, hence his nickname 'Cawry Paw', and he could actually draw simultaneously with both hands.

[8] 28 December 1827 (Hibbert Ware 1882, 386).

[9] Hibbert 1857a, 120. Read to the Society of Antiquaries of Scotland on 29 January 1827.

[10] *View of the alting or Tynwald, Isle of Man*, wood engraving by Gall (Hibbert 1831, 197). Read to the Society of Antiquaries of Scotland in 1823, but later amended to include Charlotte's 'additions'.

[11] Hibbert Ware 1882, 285.

[12] Hibbert Ware 1882, 375.

[13] Mentioned again in relation to the Hibbert's 1831 tour in Scotland: 'The same fatigues and hardships and privations, as had on former occasions been undergone by Dr Hibbert, were now again encountered; but on this occasion a lady suffered along with him' (Hibbert Ware 1882, 408).

[14] Hibbert Ware 1882, 385.

[15] Hibbert 1832.

[16] *The volcanic district of the Lower Rhine (constructed and drawn by Mrs Hibbert from observations taken by Dr Hibbert)*, a hand-coloured and folded engraving.

[17] Hibbert 1832, vi.

[18] Hibbert Ware 1882, 415.

[19] Hibbert Ware 1882, 390. As joint secretary, Hibbert had specific responsibility for obtaining a continuous supply of communications for the Society's meetings and editing them for presentation and publication. He was so successful in overcoming the dwindling interest that was threatening the existence of the Society that 'no dearth of papers, whether in the form of casual notices or regular dissertations, was from this period experienced' (Hibbert and Laing 1831, App xxiii-xxiv).

[20] Hibbert Ware 1882, 407–8.

[21] Hibbert Ware 1882, 408.

[22] SHWMSS 2:161; 4:8; 4:7. Hibbert, 1857c, Pl 11, Figs 1–3

[23] Hibbert Ware 1882, 418.

[24] Hibbert 1835, Pls 5–12.

[25] Hibbert Ware 1882, 438.

[26] 15 August 1835 (Hibbert Ware 1882, 450).

[27] Hibbert Ware 1882, 450.

[28] Dating to the 1820s, these remarkable little watercolours, which were inspired by the folk-lore of the Isle of Man, show great sensitivity and finely detailed observation from nature of insects, animals, birds, shells and the like, and the juxtaposition of these natural forms with the fairies gives them a highly surreal air. They were not widely known until published by Collins in 1985 at a time when interest in the genre was growing (Murray 1985; Nahum 1997).

[29] Murray 1985, 10. 'Emily' followed Charlotte in coming to Scotland in 1829, becoming Lady Oswald on marrying General Sir John Oswald of Dunnikier, near Kirkcaldy in Fife. She was then aged 29 and he was 29 years her senior. Faced with the immediate task of being step-mother to the six children of his first marriage and then having two of her own, it is hardly surprising that her marriage also marked the end of her fairy painting, although she did continue sketching domestic scenes and portraits of the children.

[30] Ash 1981, 90.

[31] *The Scotsman*, 13 January 1849.

[32] Chalmers's volume was dated 1848 on the title page, but publication was delayed until June 1849. Stuart 1856; 1867.

[33] Edinburgh University Library (EUL): La.IV.17. Letter from C[osmo] Innes to David Laing re Hibbert Ware's drawings of sculptured stones, 30 June 1857.

[34] This must have been particularly helpful when planning the itineraries of Chalmers's artist Jastrzebski, who, following his earlier success, had been commissioned as illustrator for the Spalding Club's proposed volume. For Innes, who, appears to have had responsibility for the artist's movements, 'even bare lists of the localities of the symbolical monuments would be acceptable', and his urgency to consult the Hibbert material is explained thus: 'Our artist [Jastrzebski] is about finishing Ab[er]d[ee]n and Banff — and I am now giving him letters for Moray and Ross' (EUL: La.IV.17).

[35] Stuart 1856, xvi.

[36] SHWMSS 6:13.

[37] Stuart 1856, 35; SHWMSS 5:145.

[38] SHWMSS 5:137.

[39] SHWMSS 6:65.

[40] Chalmers 1848, 10.

[41] Several reproductions of drawings done from direct observation of this stone have been published: Gordon 1726, Pl 60, 2; Moses Griffiths (Pennant 1774); Jastrzebski (Chalmers 1848, Pl 18); and Gibb (Stuart 1856, Pl LXXVI).

[42] SHWMSS 5:76/77/79/143/153, 6:45/66.

[43] Pinkerton 1814, x.

[44] Chalmers 1848, Pls 1–24.

[45] For example: Graham 1895; Stirling Maxwell 1899; Allen and Anderson 1903.

[46] Principally those published by Gordon (1726), Cordiner (1780; 1788–95), and Petley (1857). Although not published until 1857, Petley's drawings were made in 1811–12, and subsequently etched by L Hays. Following Petley's death in 1830, his widow Ellen presented the etching plates and a set of proofs to the Society of Antiquaries of Scotland. These were exhibited to the Society on 23 May 1831, when the paper on the carved stones in Ross-shire was read. The Hibberts left for the north in the following month!

[47] SHWMSS 6.60.

[48] Petley 1857, Pl 20.

[49] For example, Allen 1894; 1897; Henderson 1993a; Gray and Ferguson 1997; Ritchie 1997; 1998; 2003; RCAHMS 1999, 7–11.

[50] Roger 1880, 270–1.

[51] Shortland 1995, 151–2.

[52] The Hibbert Archive is appropriately located in Manchester, the hometown of its original owner and compiler, but, as its rich content of material relating to Scottish antiquarian studies is not readily accessible to scholars in Scotland, it has been proposed that the Scottish material, at least, be copied and made available in the NMRS (Henry and Trench-Jellicoe 2003, 67).

Appendix 15.1

THE HIBBERT WARE MANUSCRIPTS

An archive entitled *Antiquarian fragments and memorials by the late Sam[ue]l Hibbert Ware, MD, FRSE, Hale Barns, Cheshire, 1848* (Hibbert Ware MSS, Msf 091 H21) is held in Manchester Local Studies Archive Centre, Central Library, St Peter's Square Manchester M2 5PD. Here referred to as SHWMSS, it comprises 12 cloth-bound, paginated volumes containing miscellaneous drawings, paintings, some correspondence and copies and originals of published works all relating to the Hibbert family's archaeological/antiquarian studies, including many

drawings of early medieval sculpture executed by Charlotte Wilhelmina Hibbert. It was presented to Manchester Free Library in 1891 by Mrs Mary Clementina Hibbert Ware, widow of Titus Hibbert Ware, eldest son of Samuel Hibbert Ware, following the death of her husband in 1890.

Another collection of MSS (Hibbert-Ware Papers [R.91695.]) is to be found in the John Rylands University Library of Manchester, Manuscripts and Archives. It comprises 33 (of 35) bound volumes [990–1022] containing correspondence and domestic papers mainly relating to Samuel Hibbert (Ware) and covering the period 1796–1849.

Appendix 15.2
Letter from Dr Hibbert-Ware, on the sculptured stones of Scotland

[This was sent to David Laing, treasurer of the Society of Antiquaries of Scotland, and read to the Society at a meeting on 24 February 1845. Published in Hibbert Ware 1857.]

My Dear Sir.

Last year, when you presented a report of the unfortunate state of neglect befalling that noblest of Scottish monuments of the earlier times, the Stone of Forres, my friends Mr Trevelyan and Mr Macdonald, with yourself, expressed the great desire, that I would lay before the Society the drawings which the late Mrs Hibbert had accomplished of the elaborate sculpture characteristic of this relic.

I was then unable to comply with your and their request, as Mrs Hibbert's very extensive collection of drawings of the architectural [?archaeological] remains of Scotland, were at my house in Cheshire. But I promised that, on my return to Scotland, I would bring with me a drawing of the Forres monument, along with a very few other sketches of the Figured stones of Scotland.

You are well aware, from what you may have remembered of the late Mrs Hibbert, of the great interest which she felt in early Scottish history. It was at the time when I was intent upon visiting as many of the Vitrified Forts of Scotland as possible, in order to arrive at some clue regarding their mysterious structure, that she accompanied me in the various tours which I made to the Highlands for this purpose; rendering me, at the same time, the greatest assistance in the drawings and plans which she prepared for me, of these wonderful remains. It was during these excursions that she derived the most interest, from meeting with the variety of figured stones, for which Scotland is distinguished, of a character more or less approximating to those which she had previously studied, during her long residence in the Isle of Man.

These sculptured remains of an early period, became with her an object of historical inquiry, and she endeavoured to class them in reference to a date of origin, which either preceded the introduction of Christianity into this country, or was subsequent to this event.

The number of figured stones, however, that may be supposed to be anterior to Christianity are very few, and of a very simple kind.

Much the greater number she considered as attributable to the very earliest labours of Christian Missionaries, who, in gaining converts from Paganism, either engraved the Cross upon the rude stones which had been used for Pagan worship, or, in the place of them, substituted a highly embellished pillar of stone, indicative of the holy site, where Christian proselytes were invited to bow themselves before the Cross, and to be taught a purer system of faith and morals. She also regarded them not only as oratories, but as sepulchral monuments, consecrated to the illustrious dead, or as memorials of victories, of treaties, or of landed boundaries.

Again, other distinctions were remarked by her. When these figured stones were exclusively dedicated to the purpose of the oratory, they would contain, along with the form of the Cross, the figure, probably, of the Missionary himself, with a book of the gospels under his arm, like that of the Book of Kells, attributed to Saint Columba, of which the original exists in Trinity College, Dublin; or some emblem of the Eucharist; or the incident of some holy legend, &c., &c.

But when they had little or no reference to Christianity, the Cross would be absent, and in the place of it would be found representations of battles, or the sports of the chase, or even of domestic occupations.

In many instances, however, it would appear that, along with Christian emblems or representations, were united the figures last described, namely of battles, the chase, or of husbandry, &c., &c.; which mixture of character frequently prevails in the Scottish figured stones, to whatever special purpose they might have been devoted.

And, again, some sculptured stones, though very few, appear as the antagonists of such as are Christian, being indicative of Pagan, rather than of Christian worship, having been set up probably during the struggle for pre-eminence between contending faiths.

There was again another class of figured stones, where Pagan and Christian emblems and customs were so blended as to show that Christian missionaries, or teachers, in order to win over, in some degree, reluctant proselytes, strangely combined, or rather jumbled together, the great emblem of Christianity, the Cross, with representations of Pagan rites, among which was the horrid sacrifice of prisoners taken in battle, to such sanguinary deities as Odin or Thor. To such a description of monuments, the stone of Forres may be confidently referred.

In taking this very general view of the figured stones of Scotland, Mrs Hibbert naturally supposed, that she could read, in these sculptures, the customs, both warlike and religious, as well as the domestic manners of a very remote age, the details of which could be learned from no other source whatever.

Having adopted this view of the historical importance of the figured stones in Scotland, her exertions to obtain a complete collection of drawings were very great. She visited a considerable portion of the east coast of Scotland, where they are perhaps the most abundant, as well as the north (as far as Sutherland and Caithness), and even the Orkneys. In the south of Scotland these monuments are more rare. She also, for the sake of comparison, delineated the figured stones of the Isle of Man, and some parts of England, where they are met with, particularly in Derbyshire.

During these excursions she had occasion to lament that the number of these national monuments were gradually diminishing. Their adaptation to the purposes of grave-stones, or even to those of husbandry, particularly when they occurred near farmyards, was a frequent cause of their mutilation or destruction.

But the labour of journeying from place to place did not form the whole of the cost. The very intricate traceries and configurations which are sculptured on these stones, were evidently copied from high-wrought embellishments by which the ancient books of the Gospels used by Irish Missionaries were distinguished, of which evidence may be seen in the *Book of Kells*, and other MSS. of an early date, in Trinity College, Dublin.

Now, many of these ornaments, as they are transferred to the figured stones of Scotland, will be found so difficult, from their mazy perplexity, to delineate, that several artists have shrunk from the task, and have left us engravings of which nothing more than a sort of general effect is intended to be produced, while the details, if attempted, are most unfaithful to the originals. If Mrs Hibbert has succeeded, at least in most instances, in overcoming this difficulty, it has been at the expense of considerable labour; and when I state that a single

monument has often cost her three or four days of continued employment, I do not underrate the attempt which she made to ensure a perfect accuracy of delineation.

It had been the intention of Mrs Hibbert to have published these drawings in a sort of fasciculi, but the object was prevented by her death, and at my advanced time of life, I fear the opportunity may not be afforded me to fulfil the intention of her who is no more.

Believe, my Dear Sir,
Yours very faithfully,
S. HIBBERT WARE

To David Laing, Esq.

After Dr Hibbert's decease, 30th of December 1848, the drawings and sketches to which he alludes, with his notes and explanations, were found in such a dispersed and unfinished state, that no use could be made of them in the view of ultimate publication. Much however has since been accomplished for preserving accurate representations of the Sculptured Stones of Scotland; and it is only necessary to refer to two works on the subject, one of them, the large and splendid volume, presented to the Bannatyne Club by the late Mr Chalmers of Aldbar; the other, and more comprehensive volume, recently printed for the Members of the Spalding Club, by Mr John Stuart, now Secretary of the Society of Antiquaries. (D. L.)

CHAPTER 16

BIRD, BEAST OR FISH? PROBLEMS OF IDENTIFICATION AND INTERPRETATION OF THE ICONOGRAPHY CARVED ON THE TARBAT PENINSULA CROSS-SLABS

By KELLIE S MEYER

INTRODUCTION

The individual cross-slabs located on the Tarbat peninsula (Figure 2.2) have excited a great deal of scholarly interest in the past, focused primarily upon the Hilton of Cadboll slab and the slab at Nigg. However, the complete collection of Pictish monuments on the peninsula, which includes the enigmatic Shandwick stone and fragments from at least three additional cross-slabs originally located at the Tarbat Old Church, Portmahomack, have yet to be considered as a related group.[1] Since the cross-slabs and the fragments display several related motifs, decorative details, and carving styles, it is highly likely that they were all the products of a 'school' of stone carvers probably located at the monastery and, as such, express a coherent political and/or spiritual programme.[2]

In order to determine this programme, several different, but interrelated, research areas have been investigated. The first is a determination of the original location of each stone and its relationship with both the environment and the ecclesiastical or secular estate with which it is associated. Studies, such as those by James and Carver (this volume), highlight some of the difficulties, as well as the progress, made in this area in terms of the Portmahomack cross-slabs.[3] The theoretical relationship between the sculptors and their patrons, an assessment of the role of the monastic estate in regards to pastoral care and secular rule on the peninsula, and a study of the possible relations between the Portmahomack estate and other Insular and Continental religious centres, have also all been considered. The results of these studies have both contributed to and been illuminated by the final area of investigation: a close analysis of the figural and decorative ornament carved upon each monument. Otherwise known as iconology, the interpretation of these images reveals a great deal about the intellectual, religious and political climate of the period during which they were carved. In lieu of any detailed written records

left by the Picts themselves, they may be the best clues remaining with which to fill out the sparse historical picture known only from the king lists and brief accounts in the works of Bede and Adomnán.

It is outside the scope of this paper, and somewhat premature, to present a full account of my conclusions in this matter, as my research is ongoing. A discussion of the iconological methodology can, however, serve to illustrate some of its potential, as well as exemplify a few of the more interesting problems that it involves.

ICONOGRAPHY AND ICONOLOGY

According to Panofsky, who pioneered the study and applied it to Renaissance art, iconology is the interpretation of iconographic images.[4] As such, it depends both upon the correct identification of the images in question and also upon an in-depth knowledge of the cultural context within which the artistic work was created. Both of these require familiarity with specific themes or concepts as they are transmitted through literary sources, whether acquired by purposeful reading or by oral tradition. The work must then be placed in context with other works with the same or similar themes. Therefore, both the artistic tradition and the advent of literary ideas must be taken into consideration when interpreting iconography.[5]

As Hawkes (Chapter 17) points out, iconology has proved a useful tool with which to study the figural carving in Anglo-Saxon England, though it is only beginning to be applied to other areas of the Insular world. One of the reasons for this discrepancy may be the problematic nature of the Pictish material; namely that due to damage, wear, the fragmentary nature of some of the carvings, or even just the obscure nature of the image, correct identification is often extremely difficult. In addition, the cultural context of Pictland, in contrast to both Ireland and Anglo-Saxon England, is relatively unknown.

To confront this problem it has been necessary to gain a familiarity with the contemporary art of Anglo-Saxon England and Ireland, as well as their known liturgical practices, ecclesiastic and monastic organisations, their knowledge of biblical exegesis and other literary sources, and their awareness of, and participation in, the current religious debates and movements upon the Continent and in Rome. With this in mind, it is necessary to infer that the Picts, at least those upon the Tarbat peninsula, which probably hosted a major monastery, were exposed to some, if not all, of the same cultural currents and artistic trends affecting the rest of the Insular world. If this is true, then their figurative and decorative images can be interpreted accordingly (Chapter 2).[6] Further difficulties arise, however, even once the various cultural sources are known. A great deal of work has been done with regard to the literary sources known to the Anglo-Saxons and to the Irish but large gaps still exist. It is particularly frustrating to find that sometimes the best interpretation for an image relies upon a source for which there is no current evidence of circulation in the Insular world.[7] At the same time, sometimes the literary sources were in circulation, but there was no Insular artistic tradition of portraying the images in the manner informed by these sources.

In order to exemplify some of these issues I will consider a few selected images from the Portmahomack group of monuments that have proven problematic, focusing on several figures carved on the Shandwick cross-slab (Figures 16.1 and 16.2). Shandwick is the primary stone under consideration, not only because the images on this monument serve so well to highlight the difficulties inherent in an iconological investigation, but also because this monument has received so little attention compared to the Nigg and Hilton of Cadboll cross-slabs. At the same time, several related images from other stones in the Portmahomack collection will be brought into consideration.

DISCUSSION

The cross-slab at Shandwick features several visual conundrums, not the least the so-called hunt scene (Figure 16.3) on the reverse of the slab, which contains domestic as well as wild animals, a humanoid figure riding a goat, and armed warriors fighting over a sheep. This is not a typical hunt scene, and its significance most likely transcends the secular and Christian interpretations usually assigned to this popular Pictish subject. As such, it may refer to local myths, of which, unfortunately, we have no knowledge.[8] On the other hand, the figures on the front, cross-face, of the slab can probably be assumed to convey a Christian meaning, but first they must be identified correctly before their significance can be understood.

For instance, the two quadrupeds on either side of the cross-shaft were initially identified by Allen and Anderson as lions.[9] A closer look at the right-hand beast (Figure 16.4) suggests that this is quite likely, although they did not account for the amorphous form hanging from its open jaws. This could be viewed in a variety of ways: it might be identified as a dangling human or animal figure; it might be seen as a serpent, with which the lion is engaged in conflict; or it could be regarded as an extended tongue or spray of foliage emerging from the mouth of the lion.

In determining the most likely identification, contemporary artistic productions may be cited, provided that the identification of the parallel can be confirmed and that its context is similar. For example, a figure carved to the right of the cross-shaft, and below the cross-arms on the front of Gask 1 (Perth and Kinross) (Figure 19.5),[10] looks very similar to the Shandwick configuration and may be meant to represent the same concept. Identifying a pendant human figure dangling from the jaws of the Gask animal, Trench-Jellicoe investigated the possibility that this image symbolised the mouth of hell enclosing sinners in its jaws.[11] This identification was proposed by Henderson for several related images depicted on the Aberlemno 3, Fowlis Wester 1 (Figure 10.1), and Rossie Priory cross-slabs.[12] These latter representations, however, all depict humans being violently mauled or eaten by a beast, and have little in common with the comparatively demure quadrupeds carved on Gask and Shandwick. On the other hand, Henderson has identified a figure of 'a predator swallowing a serpent' on the reverse face of the Gask cross-slab,[13] in an identical position to the Shandwick beast. She comments that the replication of the motif and the position on the Shandwick cross-slab 'hints at some degree of standardisation in the handling of this kind of imagery, or at the least a sharing of compositional pattern'.[14] If this is

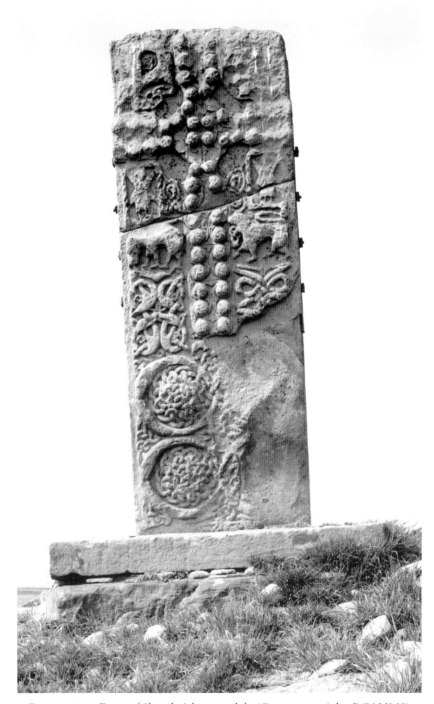

FIGURE 16.1 Front of Shandwick cross-slab. (Crown copyright: RCAHMS)

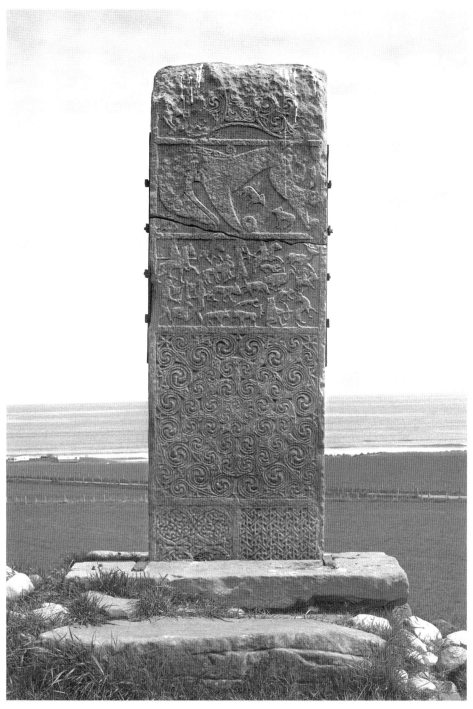

FIGURE 16.2 Back of Shandwick cross-slab. (Crown copyright: RCAHMS)

FIGURE 16.3 Detail of Shandwick 'hunt-scene'. (By kind permission of David Easton)

FIGURE 16.4 Detail of right-hand beast on front of Shandwick cross-slab. (© Kellie Meyer)

FIGURE 16.5 Detail of left-hand beast on front of Shandwick cross-slab. (© Kellie Meyer)

true, then it may be that there is an artistic tradition behind the portrayal of a lion in some sort of conflict with a serpent, although it is not a configuration common in Insular art.[15] Another likely identification may be that of a lion with an extended, curling tongue or with an emerging spray of foliage. Lions with these characteristics are found in several Insular manuscripts, such as in the Book of Kells (Figure 16.6) and in the Durham Cassiodorus, and it may be that this motif can explain the appearance of the Shandwick creature.[16]

Literary sources must also be considered in order to determine the most likely identification. As pointed out above, the relatively docile pose of the Shandwick beast argues against its identification as a visual figuration of the literary topos of the 'hell-mouth'.[17] On the other hand, despite the apparent parallel with the creature figured on the reverse of the Gask slab, the identification of the Shandwick configuration as a lion and serpent in conflict is probably unlikely due to the lack of a specific literary tradition to account for it. It should not be entirely disregarded, however, since the common Early Christian interpretations of Jesus as a lion and Satan as a serpent might well have allowed for a visual configuration symbolising the two in combat. Likewise, although there is no specific literary tradition to account for the depiction of a lion with an extended tongue or spray of foliage, this figuration is believed to symbolise the declamation or flourishing of the Word of God.[18] It is probable that this image resulted from the association of the evangelist Mark with the symbol of the lion, and it is particularly well suited to illuminations of Gospel texts. The motif itself

FIGURE 16.6 Detail of lion contained on folio 285r in the Book of Kells. (© The Board of Trinity College Dublin)

would not be out of place on a public monument which, in and of itself, demonstrates the spread of the Christian message. At the same time, a depiction of a lion with a dangling cub would also be appropriate, and would also be supported by a specific text. According to the Physiologus, a source in circulation in Early Christian England and Ireland, the third nature of the lion is to breath life into its whelp on the third day after its birth; commenting, 'thus did the almighty Father of all awaken from the dead on the third day the first born of every creature. Judah is a lion's whelp; who has wakened him?'[19] While the parallel with Christ's resurrection is not explicitly stated in the text, it is easy to see how an image of a lion carrying its cub, or breathing life into it, came to be interpreted as a symbol of the resurrection since Jesus was also known as the Lion of Judah (Revelations 5:5). A figuration of this image, therefore, would be entirely suitable to a cross-slab.

Any further refining of our understanding of this beast actually depends upon the identification of the animal carved to the left of the cross-shaft (Figure 16.5). Allen and Anderson suggested that it was this creature, rather than that on the right, which actually represented the lion breathing life into its cub.[20] However, although this creature is certainly engaged in some sort of activity with the amorphous form running beneath its paws, this identification is not entirely convincing when it is compared with the creature on the right. It is difficult to believe that both beasts were meant to represent lions when their appearance is so very different. But if it is not a lion, then what is it?

One possibility is that this beast, with its slightly humped back and elongated, squared muzzle, is meant to represent a bear, and indeed, a very similar animal is carved on the reverse of Portmahomack 20 within a panel that also depicts two lions.[21] In addition to possibly being inspired by nature, like the stags and bulls carved on so many Pictish stones, the bear also has a literary tradition behind it, albeit a problematic one. The 12th book of Isidore of Seville's *Etymologies*, a source well known in both England and Ireland, relates how the unborn bear cubs are licked into shape by the mother after 30 days.[22] Later medieval bestiaries assigned a Christian meaning to this and other ursine activities. It is quite possible, therefore, to view the left-hand creature on Shandwick in this light, and interpret it as a depiction of a bear licking the shapeless mass of an unformed cub into shape. Unfortunately, there is no entry within the Physiologus on the bear, and as Isidore's *Etymologies* contain no Christian allegorising, it is impossible to know if the 8th–9th-century Picts would have interpreted this image as a Christian symbol.

On the other hand, bears did convey a biblical significance, which is especially intriguing if one considers the left-hand creature in conjunction with the lion on the right side. Both lions and bears are paired together in various Old Testament passages to symbolise evil or danger.[23] Most significant is the account in I Samuel 17:32–4 that details David's rescue of his father's sheep from the jaws of the lions and bears, an episode taken to foreshadow the salvation of the soul by the victory of Christ over the Devil.[24] This exegetical tradition apparently had a great resonance within the Insular world, judging by the number of times 'David rending the lion's jaws' is depicted on Insular monuments; indeed, the nearest occurrence is figured on the reverse of the Nigg cross-slab (Figure 4.6).[25] Within this context then, it is quite possible to see the Shandwick animals as symbols of the sin and death over which Christ, signified by the jewelled cross-of-victory, has triumphed. The connection to the David scene on Nigg, as well as to the possible bear and lions on Portmahomack 20, not only makes this interpretation extremely attractive but, if correct, also demonstrates the thematic resonances which exist among the Tarbat peninsula cross-slabs.

Another possibility is that the creature on the left was intended as a representation of an elephant. On folios 80v-81r of the Anglo-Saxon manuscript Marvels of the East, an elephant is depicted along with an entry describing the land from which it came.[26] The creature illustrated for this entry is scarcely identifiable as an elephant, as it has tiny ears and no trunk (Figure 16.7). It does, however, have a lot in common with the depiction of the Shandwick beast since both left-facing animals have slightly humped, thickset bodies and heavy legs, and lowered heads with squared muzzles that practically touch the shape running underneath their bodies. This shape is clearly a depiction of the river of the elephant's homeland in the manuscript rendition, and it may be that the amorphous shape in the Shandwick configuration is meant to represent the same. Although this manuscript dates from the mid-11th century, its illustrations are believed to have been based on a now lost exemplar from an earlier date, perhaps as early as the late 8th century.[27] Therefore, it is quite possible that an artist in need of a model for an elephant would have turned to such an exemplar, and carved a creature such as that depicted on the left side of the cross-shaft on Shandwick. Thus, though the end result looks nothing like our conception of an elephant, an

FIGURE 16.7　Detail of elephant contained on folio 81r in Marvels of the East (Cott.Tib.B.V. vol 1 f. 18a no 11). (By permission of the British Library)

elephant might indeed have been intended. Since the entry on the elephant in the Physiologus contains several different Christian allegories, including its classification as a prefiguration of Christ,[28] the elephant would certainly be an appropriate figure to include upon a cross-slab. Its placement across from another animal considered to be a prefiguration of Christ would be especially suitable.

Regardless of the specific identity of the two beasts on Shandwick, consideration of their significance needs also to take account of the setting of the central cross. Since this is placed between the two beasts, it may be that this configuration is a variation of the motif of Christ recognised or worshipped between two beasts; a visual depiction of Habakkuk 3:2 which states 'In the midst of two animals you will be revealed; when the years come to pass you will be known'.[29] This theme was not only explored in the commentaries of Jerome, Augustine and Bede, but was also incorporated into the early medieval Insular liturgy,[30] and therefore, was most likely to be familiar to an Insular audience. If the cross and beasts on Shandwick can be identified as a visual rendition of this concept, then another link can be established with the Nigg cross-slab, where the two beasts placed under Saints Paul and Antony in the pediment have been interpreted as facing the chalice and the host in recognition of Christ.[31] In

addition, a thematic link might also be established with the face of the Portmahomack 20 fragment (Figure 2.9a).

At the start, determining the nature of the composite beast depicted on this fragment was also problematic. Initially identified as a dragon,[32] this creature neither breathes fire nor displays wings, two of the characteristics commonly assigned to dragons. On the other hand, an excursus into the biblical descriptions of dragons reveals a great deal of confusion about their physical attributes, with none of them, not even the flying dragon of Revelations, actually described with wings. At the same time there is also a linguistic muddle between the accounts of dragons, sea-monsters and leviathans, especially once the Hebrew and Vulgate versions of the Old Testament are compared.[33] In the end, both their nomenclature and physical descriptions are often amalgamated. This confusion carried over into the visual realm, as can be seen by representations of whales figured on Early Christian sarcophagi.[34] Identifiable only by their pairing with Jonah figures, these long, serpentine creatures look far more like the Portmahomack 20 beast than our modern conception of whales. Indeed, a creature depicted on the face of the Woodwray cross-slab (Figure 4.5),[35] which bears several characteristics in common with the Portmahomack 20 beast (such as a forward-facing ear, long torso, long, single claws on each foot, and a serpent-headed tail) might also, despite its legs, be intended as the biblical sea-creature, since it is in the act of swallowing or disgorging a human figure. On the other hand, it is equally likely that the Woodwray figuration is a representation of the 'hell-mouth' mentioned earlier. Unfortunately, neither of these identifications can be assigned to the Portmahomack 20 beast because it is not engulfing or disgorging a human figure or limbs.

What becomes clear, however, after an investigation of the Insular literary and artistic sources, is that while fire-breathing, winged dragons figured in the Germanic and Scandinavian literary sources (most notably as those killed by Beowulf and Sigurd), they were not visually depicted with such attributes until the late Anglo-Saxon or Anglo-Scandinavian period.[36] Therefore, while it is quite possible that the Portmahomack 20 beast may represent a generalised sea-monster or other dangerous beast, it is equally likely that it does indeed represent a dragon, despite its wingless, fireless, state. In the end, it is its crouching, submissive posture and likely placement to the left side of a cross-shaft (rather than below the cross) which is the most indicative of its probable meaning: as one of a pair of beasts recognizing or worshipping Christ. Support for this view can be found in Psalm 148:7, and Isaiah 43:20, both of which refer to dragons worshipping or honouring the Lord.[37] In addition, apocryphal material available to the Insular world also related legends of dragons worshipping the Infant Christ.[38]

Returning to the Shandwick cross-slab and a consideration of the same theme, it may be argued that the outward-facing position of the left-hand beast precludes an interpretation of worship or recognition of Christ. While this stance complicates a straightforward analysis, however, it does not necessarily invalidate this reading, since a complex array of potential meanings was often intended by medieval artists, and these were quite likely to have been understood by the Insular audience.[39] Furthermore, it has been argued that even though these multiple layers of meaning may seem antithetical to modern viewers, they were understood and encouraged by

the medieval audience.[40] Therefore, while the position of the left-hand beast is awkward, it need not negate interpretation of the configuration as a depiction of Christ recognised between two beasts.[41]

Indeed such an interpretation is even more attractive as it coalesces with one of the multivalent meanings conveyed by the pair of winged figures, most likely cherubim, which are figured directly above the animals. In his commentary on Habakkuk 3:2, Jerome specifically likens the concept of Christ recognised between two beasts to God as he spoke to Israel while between the two cherubim which were set over the Ark of the Covenant. In addition he equates this figuration to God revealed between the Old and New Testaments, and to God the Father made known in the Trinity between the Son and the Holy Spirit.[42] It can be seen, therefore, that one message (though certainly not the only one) that is conveyed by the iconography carved on the cross-face of the Shandwick slab is that of the recognition and revelation of God and Christ, a theme that a learned audience, such as that associated with a monastic estate, would certainly have been familiar with and able to distinguish.

CONCLUSION

In such an investigation the possibilities and restrictions of the iconological methodology with regards to the Tarbat peninsula material are apparent. With each unknown, it is necessary to propose several different identifications, check the validity of each of these against the known artistic parallels, and then investigate all possible written sources to determine the legitimacy of each identification and how the individual images work together to convey an overall message. At the same time, it is necessary to keep in mind the likelihood that more than one meaning was intended by each individual image, and that any interpretation was likely to work on several different levels at once.

Unfortunately, since I focused on the more problematic images, I was unable to show the range of exegetical knowledge and cultural understanding possessed by the Picts on the Tarbat peninsula, or their sophistication in transferring these ideas onto the monuments. It may be, however, that this brief outline served to highlight one of the unexpected rewards of an iconological investigation. As stated earlier, determining the cultural context within which the works of art were produced is particularly problematic in terms of Pictish art, since no native records exist, and all must be inferred from the records of the Anglo-Saxons and the Irish. In a sense then, Panofsky's methodology must be turned on its head when analysing the Pictish cross-slabs. Rather than using known factors of historical, religious, or political attitudes to interpret the significance of the Pictish images, the images themselves are used to shed light upon the probable cultural context of the early medieval period in Scotland. In other words, by analysing the images in terms of their significance to the rest of the early medieval world, and determining their context by their appearance on other works of art, particularly Insular art, it may be possible to construct a cultural history of Pictland.

ACKNOWLEDGEMENTS

I would like to thank Martin Carver and Jane Hawkes, my supervisors at the University of York, as well as Isabel Henderson, Sally Foster, Rosemary Cramp, Anna Richie and all the other wonderful women without whom any investigation of Pictish art would be impossible.

NOTES

[1] Extensive study of the sculptural fragments relating to the Portmahomack site has led me to believe that they originate from at least three different cross-slabs as well as from architectural contexts. See Meyer forthcoming.

[2] Meyer forthcoming.

[3] The assertion that the Shandwick cross-slab is quite possibly associated with a medieval chapel and/or burial ground has been made by MacDonald and Laing 1970, 137; Close-Brooks 1986, 126; and Mack 2002, 18.

[4] Panofsky 1955, 26–54.

[5] See Panofsky (1953; 1955) for a practical demonstration of these issues.

[6] See Carver forthcoming for archaeological evidence pointing to the monastic character of the 6th–9th-century settlement undergoing excavation at Portmahomack.

[7] For an introductory survey of the literary sources known to the Insular world, see Dumville 1973; MacNamara 1975; Breen 1984; Lapidge 1985; Biggs *et al* 1990; and, most recently, the *FONTES* database on the web (Fontes Anglo-Saxonici 2002; http://fontes.english.ox.ac.uk).

[8] The most common interpretation assigned to Pictish hunt scenes is that they were realistic portrayals of the secular elite. At the same time, these scenes have been seen as an allegory for the pagan 'divine hunt' or as a Christian allegory of the soul, wherein the deer represents either the soul or Christ persecuted by devils in the shape of the hounds and huntsmen, or the deer represents Christ and salvation pursued by the Christian soul. See Green 1992, 52–65, for a discussion of artistic representations of the 'divine hunt'; and Alcock 1993, 232–3 and Carrington 1996, 153–7, for Christian interpretations of hunt scenes.

[9] See Anderson 1881, 169; *ECMS* III, 69.

[10] The face of the Gask cross-slab is not reproduced in *ECMS*. See Trench-Jellicoe 1997, Fig 4, for an artist's interpretation of the figures carved on the slab.

[11] After consideration, Trench-Jellicoe (1997, 166–7) rejects the possibility that the Gask configuration is a representation of the 'hell-mouth'.

[12] Henderson 1997, 46–7. For the Aberlemno 3, Fowlis Wester 1, and Rossie Priory slabs see *ECMS* III, Figs 228A, 306A, 322A. See also Ritchie (1989, 26) for a clearer image of Aberlemno 3, and Henderson (1997, Figs 5 and 7) for a sharper reproduction of the Rossie Priory slab and a drawing of the 'hell-mouth' figure on Fowlis Wester 1.

[13] *ECMS* III, Fig 307A.

[14] Henderson 1997, 31–2, Fig 4.

[15] To date, the only other possible renditions of this motif that I have found are on folios 124r and 290v of the Book of Kells (Dublin, Trinity College MS 58 A1.6).

[16] See also folios 19v, 29r, 114r, 129v, 188r and 292r, in the Book of Kells. Folio 81v in the Durham Cassiodorus (MS Durham Cathedral Library BII.30) features two lions with elongated, curling tongues in the border decoration.

[17] As Henderson points out (1997, 48–9), scenes such as those portrayed on Fowlis Wester 1, Aberlemno 3 and Rossie Priory are quite likely expressions of the popular 'Vision of Hell' literature available to the Insular world. In particular, specific accounts contained in Gregory's *Homilies* and *Dialogues* may lie behind the configuration on Fowlis Wester, in which a man's head is wrenched back and engulfed by the jaws of the beast. While Hurst (1990, 76, n3) has pointed out that the dialogues were not actually written by Gregory the Great but by a 7th-century author familiar with Gregory's *Homilies*, there is no question that both were known and used in an Insular context. For instance, Aldhelm used the second book of the *Dialogues* in *De Viginitate* (Lapidge and Herren 1979, 178), while Bede used Gregory's *Homilies* in his *Commentaries on the Epistles of the Apostles* (see Hurst 1985). The *Homilies* were most likely known in Britain by the late 8th century (see Clayton 1985, 217–19), though it is possible that they were available even earlier since 7th-century Hiberno-Latin exegetes cite them frequently (Breen 1984, 210). Bede also made extensive use of the *Dialogues* (see Hurst 1990, *passim*, and the *FONTES* database). Both Homily 19:7 (*PL* 76:1158) and Dialogue 4:38 (*PL* 77:389–92) relate the story of a sinful man near death who tells the praying monks grouped around him that 'I have been cast out to be devoured by the dragon. Your presence keeps him from doing so, but he has already taken my head into his jaws . . .'. An

episode in the second book of the *Dialogues* (2:25) which was also circulated separately as the *Life of St Benedict* (PL 66:182) describes a dragon with gaping jaws that prevents a monk from leaving the monastery. See Zimmerman (1959, 95, 245) and Hurst (1990, 83–4) for English translations.

[18] Meehan 1994, 64.

[19] See Physiologus 1979, 4. Henderson (1997, 2–13) has argued for a rather limited Pictish knowledge of the Physiologus, consisting primarily of four chapters, one of which is the lion.

[20] *ECMS* I, xliv; III, 69.

[21] See the reverse of Portmahomack 20 in the sculpture catalogue attached to *Tarbat Discovery Progr Bull* 3. Bears may be portrayed on a number of other Pictish monuments including Murthly St Vigeans 1 Dupplin, Meigle Nos 10, 11, 22 and 26 (*ECMS* III, Figs 250B, 321, 334A, 344, 345B, 350, and 354) and Old Scatness (Henderson and Henderson 2004, 229).

[22] André 1986, 107.

[23] See Proverbs 28:15, Amos 5:19, 2 Kings 2:24, II Samuel 17:18, Hosea 13:8 and Isaiah 11:17, for just a few examples of lions and bears as symbols of death, danger, and/or evil.

[24] This standard interpretation, as initially expressed by Allen (*ECMS* I, L) has surprisingly little textual evidence to back it up, considering the number of Insular artistic renditions of the theme. Though in no way made explicit, the typology is believed to have originated with Augustine's commentary on Psalm 7 (see Hawkes 1997b, 156), as well as Psalms 33 and 51. See 7.2, 33.1–4, 51.1–5 in *CCSL* 38: 36, 273–6 (Dekkers and Fraipont 1956a), and *CCSL* 39: 623–6 (Dekkers and Fraipont 1956b). English translations can be found in *NPNF* 8:20, 73–4, 189–90 (Schaff 1888). Augustine's *Enarrationes in Psalmos* were known by Bede (see Hurst 1985; and *FONTES*), but he does not make the relationship between the two episodes any more explicit than does Augustine. It may be that the idea was fully explored in a popular, but now unknown, Anglo-Saxon or Irish homily.

[25] See Henderson 1986 for the most complete survey of David imagery contained on Pictish stones.

[26] Marvels of the East, British Library MS Cotton Tiberius B5. The elephant is portrayed on fol 81r while the descriptive entry is contained on preceding folio. See James 1929, fol 80b-81a, for both the miniature and the text.

[27] James 1929, 51.

[28] See Physiologus 1979, 29–32, for the attributes of the elephant contained in the Physiologus.

[29] The Old Latin text reads '*In medio duorum animalium innotes ceris; dum appropriaverint anni cognosceris*'.

[30] Habakkuk 3:2 was recited weekly at *Lauds* in the Roman liturgy and during the ninth hour of the Veneration of the Cross Ceremony on Good Friday. See Ó Carragáin 1989, 4–5.

[31] Ó Carragáin 1989, 11.

[32] *Tarbat Discovery Progr Bull* 2, 1996, 19.

[33] In the Old Testament, several related words (*tannoth* or *tannin*) are today translated as dragon, following the Latin Vulgate. While *tannoth* can also be translated as jackals, or simply 'howlers' and refers to wild beasts in the desert (see Malachi 1:3; Job 30:29; Psalm 44:19; Isaiah 13:22, 34:13, 35:7, 43:20; Jeremiah 9:11, 10:22; Ezekiel 29:3; and Micah 1:8, for just a few examples), *tannin* can also be translated as serpent or sea-serpent (cf Deuteronomy 32:33; Psalm 74:13, 90:13, 148:7; Isaiah 27:1, 51:9; and Jeremiah 51:34). At the same time, what we now know as the whale was also listed as *tannin* in Matthew 12:40, wherein Jesus refers to the Jonah episode. In the actual book of Jonah itself, the 'whale' is listed as either *dag* or *dagah*, both translated as 'great fish'. Further confusing matters is the *livyathan* or leviathan in Job 41:1, Psalms 74:14 and 104:26, and Isaiah 27:1, wherein it is alternately translated as dragon or crooked serpent. Indeed, only the dragon in Revelations (12:3–4, 13:1) is listed as *drakón* in the Bible, and this beast has seven heads and ten horns with no mention of wings. Without delving too deeply into the problems inherent in translation from Hebrew to Greek to Latin to English and the various redactions of the Vulgate (see Fischer *et al* 1983, xx-xxi), it seems safe to say that since there are no exact descriptions of any of the aforementioned beasts (with the exception of the dragon with seven heads and ten horns described in Revelations), any early medieval artistic depiction of a dragon, or a whale, or a leviathan was likely to look vaguely similar; with a wingless body and serpentine head.

[34] Jonah and very serpentine whales are carved on early medieval sarcophagi from S Maria Antiqua, Rome, and Le Mas d'Aire Church in Landes (see Panofsky 1964, Figs 162 and 163) as well as on the 'Jonah Sarcophagus' currently in the Vatican Museum in Rome (Lowden 1997, Fig 13).

[35] *ECMS* III, Fig 258A.

[36] See Thompson forthcoming.

[37] Isaiah 43:20 predicts that 'the wild beasts will honour me, the dragons and the ostriches; for I give water in the wilderness, rivers in the desert . . .'. Psalm 148:7 instructs, 'Praise the Lord from the earth, you dragons and all deeps'.

[38] Pseudo-Matthew 18 relates how the Infant Jesus was worshipped by dragons during the flight out of Egypt when the Holy Family wished to rest in a cave. 'Suddenly a number of dragons came out of the cave, and all cried out in fear. Jesus got down from his mother's lap and stood before the dragons, which worshipped him. Thus was fulfilled the words, "Praise the Lord out of the

[39] earth, ye dragons and all deeps"' (James 1924, 74–5). See Biggs *et al* 1990, 43–4, for knowledge of this work in Britain.

[39] Neuman de Vegvar (1997, 170–2) argues that the medieval audience was trained to interpret images on several different levels all at once, and since the Old Irish *Treatise on the Psalter* refers to the historical, allegorical, typological and moral senses of scripture, there is no reason why imagery for a monastic audience should be any less complex. See also Ó Carragáin 1989, 38; and Meyvaert 1971, 411, which argue for interpretation based on a knowledge of liturgical forms and other aspects of monastic spirituality.

[40] In regards to the multiple meanings assigned to animals in the medieval bestiaries, Benton (1992, 112) states that 'what seems like irreconcilable conflict today was not only acceptable to the people of the Middle Ages but intentionally cultivated. Not only were layered meanings common, there was also a deliberate attraction to the kind of iconographic intricacies that encouraged the creation of contradictory connotations'.

[41] The stance might also be explained by an overly close adherence to a model such as that depicted in the Marvels of the East, which also faces left.

[42] See Jerome *In Abacuc* 2:3:2 (Adraien 1970, *CCSL* 76A: 619–21, lines 52–114). While not specifically referring to cherubim, both Augustine and Bede repeat these ideas, thus demonstrating their popularity and their currency in the Insular world. See Augustine *Civitate Dei* 18:32 (Dombarat and Kalb 1955, *CCSL* 48:623, lines 5–10) and Bede *In Canticorum Abacuc* 3:2 (Hudson and Hurst 1983, *CCSL* 119B: 383, lines 60–8). English translations can be found in *NPNF* 2:37 (Schaff 1887), and in Connolly 1997, 67.

CHAPTER 17

FIGURING SALVATION: AN EXCURSUS INTO THE ICONOGRAPHY OF THE IONA CROSSES

By JANE HAWKES

INTRODUCTION

When considering the figural carvings of Early Christian Scotland, it is notable that scholarly interest in their iconographic significance, which has enjoyed a steady increase during the last 30 years in pre-Viking Anglo-Saxon sculptural studies,[1] has not been as evident in studies of the sculpture surviving elsewhere in the Insular world. Thus, the extensive literature on the major figural monuments that were erected in and around Iona during the mid to late 8th century (namely the crosses of St Martin and St Oran on Iona, and the Kildalton Cross on Islay)[2] pays little attention to the iconographic significance of either the figural carvings themselves, or the iconographic programmes underlying their selection.

Interest in the non-figural motifs has, of course, been extensive, and their association with such motifs extant elsewhere in Insular art has been closely scrutinised in attempts to establish the relationship of the Iona monuments with artwork produced elsewhere in the region.[3] In such studies, consideration of the figural carving has not been entirely ignored, but it has been investigated primarily as a means of further consolidating the perceived cultural links suggested by the non-figural motifs. Thus Curle was able to identify the Iona carvings of the Virgin and Child as 'Northumbrian', and those of Abraham and Isaac and Daniel in the Lions' Den as 'purely Irish', while Isabel Henderson has considered the Iona depictions of David as also suggestive of Irish connections.[4] Nevertheless, although such studies have highlighted the pivotal situation of the Iona crosses in the Insular world, and included the figural decoration in this process, it remains the case that the iconographic significance of the carvings has been largely ignored.[5]

ICONOGRAPHIC CONSIDERATIONS

In turning to consider this aspect of the decoration of the Iona crosses, it is worth reiterating that the range of figural images is relatively restricted.[6] They consist of the iconic image of the Virgin and Child flanked by angels, and a limited number of Old Testament narrative scenes: the Sacrifice of Isaac, Cain killing Abel, Daniel in the Lions' Den, and David — combating the Lion, fighting Goliath, and as the Psalmist.

Restricted though this selection is, the scenes have, nevertheless, been selected and arranged (along with the non-figural motifs), in such a way that each monument presents an iconographic programme that is specific to it. Thus on the Kildalton Cross the Virgin and Child are accompanied by Cain and Abel, Abraham and Isaac and David combating the Lion (Figure 17.2). On St Oran's Cross, only David (as Psalmist and combating the Lion) survives to accompany the Virgin and Child (Figures 17.3 and 17.4),[7] but on the cross of St Martin, the Virgin and Child are set alongside the scenes of Daniel, Abraham and Isaac, David the Psalmist and David with Goliath (Figure 17.5).

Furthermore, not only does the selection of figural images vary across the three monuments, their situation in relation to each other also varies. Thus, on the Kildalton Cross the figural scenes are limited to the east face, with the Old Testament scenes being set in the centre of the cross-arms, and the Virgin and Child at the point of transition between the shaft and cross-head. On St Oran's Cross the Virgin and Child fill an almost comparable position (at the interstice of the lower cross-arm), but the Old Testament images are found on both sides of the cross-head, in the interstices of the horizontal arms. On St Martin's Cross the figural panels are confined to the west face of the monument, but the Virgin and Child are positioned at the centre of the cross-head and the Old Testament scenes fill the shaft (Figures 17.2–5).

Thus, in the immediate context of each monument various combinations of images are selected from a limited range of scenes, and their arrangement on each monument differs considerably. Within this, the Virgin and Child are a notable constant,[8] as are the lions that are positioned in and around the cross-head of each monument. On the Kildalton Cross they confront the central medallion on the west face,[9] while on St Oran's Cross they are set in the interstice of the upper cross-arm, complementing the Virgin and Child below, and on St Martin's Cross they surround the Virgin and Child, filling the upper and horizontal cross-arms on the west face, with others being set in the upper cross-arm on the east face (Figures 17.1, 17.3 and 17.5–6). In addition, all three crosses present the figural carvings in association with a specific selection of non-figural motifs, the serpents and bosses, and these are arranged in such a way that the viewer is repeatedly presented with a series of patterns comprising cross-shapes (Figure 17.7).[10]

In seeking to explain the possible motives underlying this deliberate selection and arrangement of the carvings, it is clear that consideration should be given to both the dominant role played by some of the images and motifs (in that they are repeated across the monuments), as well as the Old Testament scenes that were chosen to accompany them, for they are the variables that give each monument its individual iconographic import.

THE ICONOGRAPHY OF ST MARTIN'S CROSS: THE FIGURAL PANELS

In the light of these considerations, an examination of St Martin's Cross, which displays the largest selection of Old Testament scenes, is quite informative.[11] Generally, discussions of such images, particularly in the context of the Irish high crosses where they proliferate, have tended to regard them primarily as illustrating

FIGURE 17.1 Kildalton Cross, Islay, west face. (Crown copyright: RCAHMS)

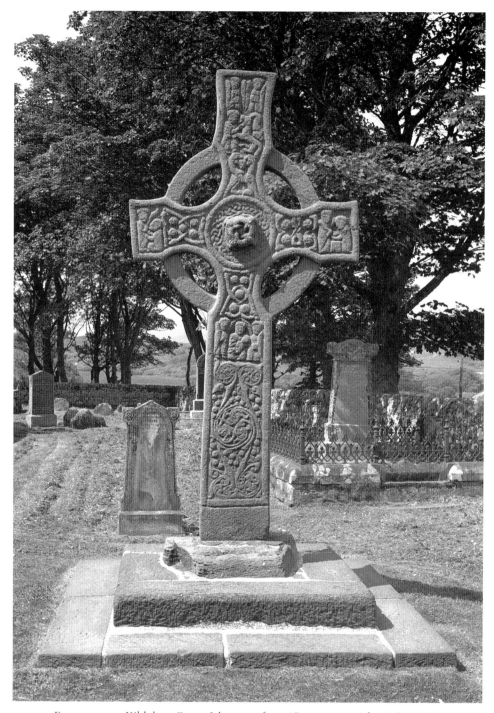

FIGURE 17.2 Kildalton Cross, Islay, east face. (Crown copyright: RCAHMS)

FIGURE 17.3 St Oran's Cross, Iona, 'front'. (Crown copyright: RCAHMS)

FIGURE 17.4 St Oran's Cross, Iona, 'back'. (Crown copyright: RCAHMS)

the Help of God.[12] It is an explanation that has been largely inspired by the survival of Old Irish versions of the prayer for the dying (*Ordo commendationis animae*) in Irish manuscripts such as the 9th-century Stowe Missal and the Martyrology of Óengus.[13] The existence of these texts and the prominence given to them in the scholarship has resulted in a general failure to consider other potential explanations for the presence of Old Testament images on the high crosses. Nevertheless, while the *Ordo* (in its Latin and Old Irish versions) does cite divine intervention in the lives of a number of Old Testament figures, other literary sources, such as patristic exegesis, invoke the same figures in very different contexts. Thus, Isaac is described in the *Ordo* as being saved from the hand of his father, but in patristic literature it is Abraham's willingness to sacrifice his son that is generally considered laudable.[14] Such different approaches to the Old Testament subjects depicted on St Martin's Cross suggest considerations other than the Help of God might well have played a part in the selection and arrangement of the scenes. Certainly the use of Old Testament subjects on Anglo-Saxon sculpture indicates they could be open to other frames of reference.[15]

On St Martin's Cross the lowermost figural panel has been identified as comprising the encounter between David and Goliath (described in I Samuel 17), with David overcoming the Philistine on the left of the panel, and standing before Saul on the right.[16] In patristic contexts David's encounter with Goliath was regarded, not

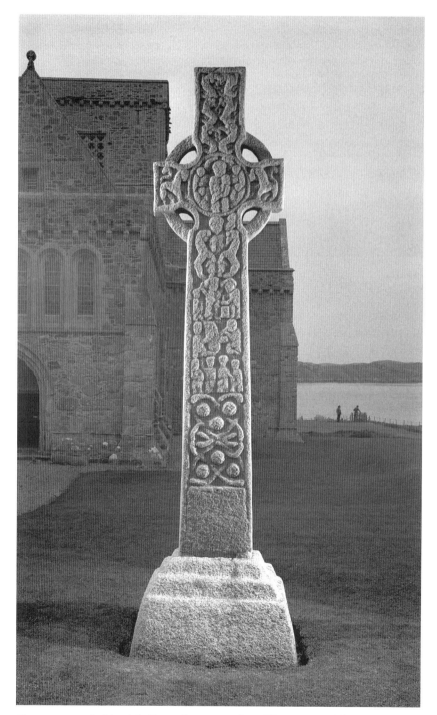

FIGURE 17.5 St Martin's Cross, Iona, west face. (Crown copyright: RCAHMS)

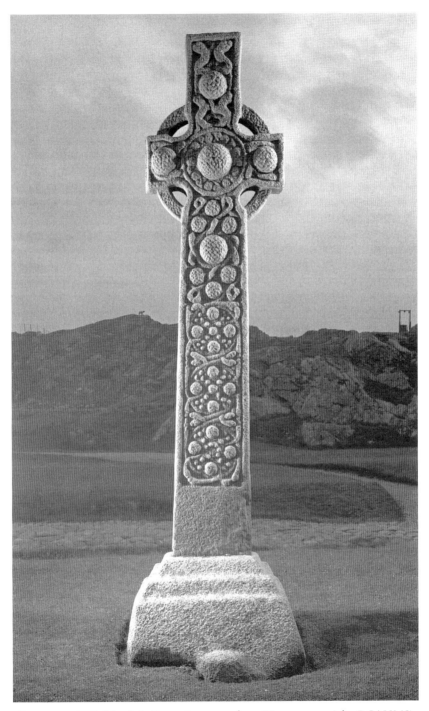

FIGURE 17.6 St Martin's Cross, Iona, east face. (Crown copyright: RCAHMS)

FIGURE 17.7 Cross-shapes on (a) the Kildalton Cross, (b) St Oran's Cross, (c) St Martin's Cross. (Drawing by Amanda Denton)

just as an instance illustrative of God's help, but as an event symbolic of Christ's victory over Satan. Thus, for Augustine, David functioned as 'the figure of Christ' while Goliath was 'a figure of the Devil' for, 'as David overthrew Goliath, so Christ defeated the Devil'.[17]

This identification was part of a wider discussion that tended to equate David with Christ in an almost pervasive manner. For Christ, as 'the son of David' (Matthew 1:1), could always be figured in his forefather David, the author of so many of the psalms. Likewise, his baptism by John could be understood as being foreshadowed in David's anointment by Samuel, his struggles with the Devil as prefigured in David's struggles with the lion and Goliath, and his eternal kingdom, the heavenly Jerusalem, as anticipated by David's kingdom on earth, centred on Jerusalem. So well established were these associations that Cassiodorus, in his Commentary on the Psalms, regarded it as axiomatic that the name of David should be mentioned 'whenever the glorious struggles of the Lord's passion are recounted . . . for by his [Christ's] enduring he laid low the prince of darkness. He overcame death by dying, he freed the captive human race by the dispensation of his crucifixion'.[18] Indeed, the relationship between Christ and David was so conventional that when the encounter between David and Goliath was illustrated in Psalters, it often formed the visual counterpart to Psalms 50 and 51.[19] Set between them it functioned, not simply to mark the division between the first and second grouping of psalms, but rather to highlight the understanding that they were regarded as foretelling the coming and destruction of the Antichrist.[20]

Thus, whatever David and Goliath may have indicated in terms of demonstrating the Help of God, it was also well established in the Insular world as an incident that

would have been understood very immediately to refer to Christ's defeat of death and the Devil at the crucifixion.

Above David and Goliath is the depiction of David the Psalmist. This was a subject that was popular in Insular art, being perhaps most familiar in the 8th-century Vespasian Psalter and the early 9th-century column at Masham (North Yorkshire).[21] In these instances, however, the images depict David dictating the psalms; they are complex aulic compositions that include a number of musicians, scribes and dancers accompanying David with his harp. The Iona scheme, on the other hand, includes only one other musician with David. This means it is unlikely to refer specifically to David dictating the psalms; rather, like the miniature in the 8th-century Durham Cassiodorus, it was intended to present a more generalised set of references to Christ and his salvation through the figure of David.[22]

Thus, like all images of David as Psalmist (whether specific depictions of the dictation, or more general portrayals), the Iona panel illustrates the understanding that the psalms were directly inspired by God, and that the overall theme of the psalms was the soul overcoming evil. In addition, however, it has the potential to illustrate the wider notion that the words of the psalms were those of Christ and his Church living under the New Covenant. It thus functions as a powerful visual mnemonic recalling Christ and the range of actions involved in the achievement of his salvation. In this way the scene on St Martin's Cross continues, but with a more wide-ranging and universal application, the theme of 'Christ in David' that is articulated in the specific incident of David and Goliath below.

In the panel above that of David the Psalmist is the scene identified as Abraham sacrificing Isaac (Genesis 22:1–13), another Old Testament event that was widely reproduced in Insular art.[23] It is also an event that was established in the literature as a figure of the crucifixion, and so had a clear Christological significance. Augustine, for instance, invoked Isaac as a figure of Christ in order to explain Paul's statement that God 'spared not his own son, but delivers him up for us all' (Romans 8:32): for, Isaac 'carried to the place of sacrifice the wood on which he was to be offered up, just as the Lord himself carried his own cross'.[24] Then there is the well-known example of Bede who, drawing on such works, described the image of Abraham and Isaac set up in the church at Wearmouth, as being paired with the crucifixion in order to demonstrate the concordance between the Old and New Testaments.[25] Elsewhere, the connection is preserved in manuscripts such as the Stowe Missal which mentions 'the sacrifice of our father Abraham' as a type of the sacrifice of the mass.[26]

The indication is, that the scene on St Martin's Cross presents a subject that would have been understood to illustrate not just an Old Testament incident, but also the actions of Christ, specifically the sacrifice of his crucifixion with its references to the eucharist and, more universally, the salvation of the New Covenant.

At the top of the shaft is the illustration of Daniel in the Lions' Den (Daniel 6:16–24; Bel 29–42), another Old Testament subject that enjoyed considerable popularity in the Insular world,[27] and one that refers to more than the notion of God intervening in the life of men. In fact, most scholars have understood it to signify Christ's death and resurrection.[28] As Kellie Meyer has demonstrated (Chapter 16), however, this association is made neither commonly, nor clearly, in patristic

literature. Rather, it was made laterally and implicitly through the liturgy, through the verses of the Old Latin *Canticle of Habakkuk* (3:1) that were recited every Friday morning at lauds, the office intended to bring to mind the notion that it was at dawn that Christ rose from the dead. The recitation of these verses, with their reference to Christ being recognised 'in the midst of two animals' (*in medio duorum animalium innotes ceris*), was well established by the 8th century as a celebration of the death and resurrection of Christ.[29]

Their relevance to the depiction of Daniel in the Lions' Den, is that this image, as much as any other in Early Christian art, had the potential to refer, not just to the Old Testament figure, but also to Christ 'in the midst of two animals', particularly when Daniel was portrayed, as on St Martin's Cross, in the midst of two lions. Like the other Old Testament scenes illustrated in the panels below, this image of Daniel would thus have functioned, not just as a visual means of illustrating a 'historical' event, but as one that, through the celebration of the daily liturgy, would have recalled Christ and his crucifixion, with all its attendant associations.

Above Daniel, in the central medallion of the cross-head, is the image of the Virgin and Child enthroned and flanked by angels. Like all such images, it was intended to refer to both the human reality of Christ Incarnate and the eternal nature of his divinity.[30] Set against the scenes on the shaft below, it acts as proof of all that is implied and foretold in the Old Testament regarding the nature of Christ and his salvation. This, however, is probably not the sole iconographic function of the scheme. As noted above,[31] it is distinguished by the inclusion of four attendant angels (not the two featured on the Kildalton and St Oran's Crosses); this, together with the manner in which the wings of the upper two extend over the heads of the Mother and Child, serving, together with the bodies of all four angels, to frame, enclose, and present them, draws attention to the group, and particularly to the role of the angels within it.

In such images in Early Christian art generally, angels function primarily as attendants on the heavenly throne to emphasise the hierarchic aspect of the scheme and the divine nature of the Child. However, they also have the potential to act as reminders to the viewer of the most appropriate manner in which the figure of Christ is to be contemplated. For, while angels were regarded as heavenly creatures, they were also seen, alongside men, as the 'fellow-servants' of God. This was one of the truths revealed to John in his vision of the second incarnation (Revelation 19:10), and it was a revelation noted by exegetes, such as Gregory the Great, who admonished that we 'be worthy of their [the angels'] respect and fellowship'.[32] This 'fellowship' was based, in part, on the understanding that angels, like human beings, had been given the power of free will, and so were able to choose whether to persist in humility and remain in the sight of God, or sink in pride and fall from happiness.[33] Thus, while the role of angels as messengers depended on their being attendants to the heavenly throne,[34] their function as figures of contemplation, equally important in an Early Christian context, depended on both their physically-close relationship to the godhead and their fellowship with human beings. And it was through their role as figures of contemplation that their relationship with humanity was most clearly expressed; it was their contemplation of God that made them colleagues of men in prayer.

Indeed, it is no coincidence that almost every prayer in the *Common* of the mass is an angelic prayer, the *Gloria* being composed around the angelic praise at the Nativity, the *Sanctus* echoing the Seraphims' praise in Isaiah's vision, and the *Agnus Dei* recalling the angelic worship of the Lamb of the Apocalypse. All were prayers that had been established in the mass by the 8th century. In fact, the whole mode of antiphonal singing was deemed, from a very early date, to derive from angelic worship in heaven.[35]

Thus the dominant presence of the angels in the scheme at the centre of the cross-head of the Iona cross, would probably have reminded the viewer in the ecclesiastical complex of Iona, not just of the divine nature of the Christ Child, but also of the link between men and angels and their shared obligation of rightful contemplation of that nature, such contemplation being the necessary precondition of right action.[36]

The iconographic significance of the narrative and iconic figural panels of the cross of St Martin might, therefore, be understood as conveying a sense of the nature of Christ which made salvation possible, and the importance of contemplating that process. These panels, however, do not exist in isolation on the monument; they co-exist with a number of non-figural motifs which, in their arrangement on the cross suggest that they too may have had an iconographic role — one that served to further confirm the themes presented by the Old Testament scenes.

THE ICONOGRAPHY OF ST MARTIN'S CROSS: THE NON-FIGURAL MOTIFS

The lions, for instance, which cluster around the cross-head on both faces of the monument are, as Carol Neuman de Vegvar has pointed out, a recognised symbol of Christ's resurrection in the extensive exegetical material on the subject.[37] Thus Gregory the Great, in his *Homily on Ezekiel*, refers to Christ as:

> The only-born Son of God [who] was himself truly made man, and himself considered it worthy to die ... for our redemption, and himself rose up as a lion by virtue of his strength. [For] the lion is also said to sleep with its eyes open; thus, in the same death in which through his humanity our Redeemer was able to sleep, he was awake through being infused with his immortal divinity [author's translation].[38]

Such perceptions indicate that not only was the lion regarded as a symbol of Christ's resurrection, it also encompassed a matrix of ideas involving his nature and divine power. Set around the Virgin and Child in the cross-head, therefore, the lions not only confirm the ideas surrounding Christ's divine and human aspects conveyed in that scheme, but also serve to repeat, emphasise and extend the ideas surrounding his incarnation, death and resurrection expressed in the Old Testament scenes below.

Then there are the serpents whose bodies frame and intertwine with the bosses set on both faces of the cross. Kellie Meyer's work on these creatures (Chapter 16) has demonstrated that while scholars commenting on them have emphasised a supposed set of references to the resurrection (the serpent being, by virtue of its tendency to shed its skin, a symbol of rebirth),[39] this was, perhaps, not its main iconographic function.[40] Rather, the ability of the serpent to shed its skin was more commonly

regarded as an exemplar of wisdom to be followed. Augustine's sermon on Christ's mission to the apostles (Matthew 10:16), for instance, exhorts the Christian to emulate the serpent who 'lays aside his old coat of skin that he may spring forth into new life', in order to fulfil Paul's demand that we 'put off the old man with his deeds, and . . . put on the new man' (Colossians 3:9–10). In thus imitating the serpent the Christian sets aside the 'temporal good' and embraces the new life of eternal truth.[41]

Certainly the way in which the serpents are presented on the cross is evocative. Set at the eye-level of the viewer below the figural panels on the western face of the shaft, and filling the entire face of the other side of the monument, they are, as noted, arranged so as to present the viewer with a series of highly elaborate cross-shapes (Figure 17.7). Given the manner in which most of the carved surface of the monument is filled with these patterns, it is worth considering the manner in which they might have been understood to function.

Deciphering such designs is, admittedly, not something that is immediately obvious to modern viewers trained in the 'classical' western artistic tradition of naturalism. Yet equally dominant artistic traditions based on linear patterns exist, and investigations into the manner in which they operate has established that they function by means of conventions as formal as those deemed to govern the classical tradition of representational art. They can involve, among other considerations, a deliberate invocation of movement from foreground to background; the layout of the designs can capitalise on what we might call 'optical illusion', forcing the eye to shift its focus from one shape to the next, so that an understanding of one pattern is elucidated in the light of the other.[42]

Clearly, presenting (hidden) patterns in the decoration of an artefact is a common, indeed prevailing tendency of Insular art.[43] It is a practice found in metalwork (of 'Celtic' and Germanic origin) predating the advent of Christianity in the region, and in a Christian context it was adopted for, and established in, the decoration of both manuscripts and sculpture. Elsewhere, I have looked at the way this practice functions in Anglo-Saxon sculpture, and more recently Emmanuelle Pirotte has demonstrated how it was appropriated in the carpet pages of manuscripts as a specific aid for meditation — or 'contemplation'.[44] Of note here is the fact that whether in pre-Christian or Christian contexts, the function of this art was to compel the viewer to decipher the shapes hidden in the patterns, and in so doing, to understand their meanings.

While such consideration of the ways in which the non-figural patterns covering most of St Martin's Cross might have functioned may appear rather speculative, it is at least possible that any distinction a modern viewer might make between 'decorative' and 'symbolic' was perhaps not a distinction that would have been recognised by an Insular audience. The design techniques of traditional metalworking and their continued use in manuscript and sculptural contexts give a fair indication of this, and suggest the repetition of the cross-shapes on St Martin's Cross might indicate that these same conventions were perhaps intended to operate here. If so, what is set at eye-level on one face of the cross, and what dominates the other, would have provided the spectator with, arguably, the most traditional form of representation in an Insular setting. The cross-shapes invoke ways of seeing that would have been long familiar to

the viewer, and in a Christian context, would have inspired an awareness that what was being viewed needed to be fully contemplated in order to achieve a real understanding. Furthermore, it would imply that this monument, the high cross, was intended to function as a field of ornament presenting the viewer with elaborate variations on the theme of the cross — the sign of Christ and his Church. Understood in this way, the use of serpents (potential signs of the new life of truth), to form the cross-shapes, would be a very potent mnemonic.

THE ICONOGRAPHY OF ST MARTIN'S CROSS: THE OVERALL PROGRAMME

Whether this is indeed the case, the cross-patterns considered in the context of the overall design of St Martin's Cross do serve iconographically to both anticipate and confirm themes presented in the figural carvings, in that by their very shape they invoke the sacramental eucharistic references implicit in those scenes. In Daniel, these references lie in the various allusions to Habbakuk and his Canticle; with the Sacrifice of Isaac, they lie in the fact that that abortive sacrifice foreshadowed the sacrifice of Christ; and in David the Psalmist, they can be understood in as much as the Psalter was regarded as the foremost of the prophetic books recalling the crucifixion;[45] while in David's encounter with Goliath, they are implicit in so far as that scene recalls Christ's victory at the crucifixion.

Further consideration of this lowermost figural panel is particularly instructive in this respect because, in addition to David and Goliath, it includes the figures understood to represent David and Saul. Admittedly, it is not immediately obvious how this pair can be included in a eucharistic frame of reference. Nevertheless, if the eucharist is understood in the light of the Early Christian term *sacramentum*, it is likely that these two were regarded as integral to the iconographic programme, and moreover, given their setting nearest to the viewer, it is even possible that they were essential to gaining a fuller understanding of the overall significance of the programme.

As discussed elsewhere,[46] *sacramentum* functioned both as a synonym for *mysterion* (mystery), and held its original Latin sense involving contractual obligation — oath taking. Thus, in biblical contexts, it referred both to God's design to save humanity through Christ (because Christ embodied God's will to save humanity, he was the mystery, the sacrament), and by extension, it referred to the Church, the body of Christ, which was the means by which each believer gained access to that mystery.[47] The central concern of patristic debates on such matters was the manner in which this could be accomplished; the answer, was through symbolic participation in Christ's salvation — participation in the sacramental liturgy (of baptism and eucharist).[48] This involved, not just observing the rituals of that liturgy, but being part of the transaction through which each believer was bound to God in sacred commitment. So, by means of symbolic participation in the mystery of Christ, each Christian was as much a figure in his salvation as those who in the past (in the Old Testament) had foreshadowed those events. In the words of Augustine, because Christ:

> ... is both Head and Body, we ought neither to speak of ourselves as alien from
> Christ of whom we are members, nor to count ourselves as if we were any other

thing, because 'the two shall be in one flesh' [Genesis 2:24]. 'This is the great sacramentum . . . [and] I speak of Christ and the Church' [Ephesians 5:32]. Because the whole Christ is 'Head and Body', when we hear . . . 'David himself', we understand ourselves also in David.[49]

Thus, on St Martin's Cross, above the serpents and crosses, the depiction of David standing before Saul with his hand on his knee can be understood at one level to depict an Old Testament subject affirming the fulfilment (the slaying of Goliath) of his contractual obligation, his oath, to his king. As such it functions as a powerful reminder to the viewer, encouraging them to contemplate their own obligations. At another level, the image also serves to remind to the viewer of other contracts (past, present, and future) made and fulfilled. Because of his willingness to sacrifice his son, God promised Abraham that his heirs would establish a great nation. That covenant was fulfilled in David and the foundation of his kingdom, centred on Jerusalem.[50] The New Covenant, between God and his people, was realised in the human reality of Christ Incarnate and his crucifixion. All that remains, in terms of the iconographic programme of St Martin's Cross, is the fulfilment of each believer's obligation to Christ and his Church — through participation in the sacramental liturgy. Indeed, it may even be that the figures of David, his hand upraised, and Goliath, falling to his knees with his hand held to his head, were also relevant to this process. For, as Bede outlined in his *Commentary on Samuel*, it was deemed to be entirely appropriate that David struck Goliath on the forehead, because this was the manner in which the stupidity of those who nurture false dogmas is exposed.[51]

Considered overall, the west face of the cross thus presents an iconographic programme that, whether read upwards from the 'traditionally familiar' lowermost panel of cross-shapes, or downwards from the cross-head with its angelic presentation of Christ Incarnate, includes the viewer as an active participant in the necessary process of contemplation, understanding, and right action in the daily observation of the mysteries. For, as Gregory put it: 'Which of the faithful can have any doubt that at the moment of the immolation, at the voice of the priest, the heavens are opened; that in that mystery of Jesus Christ, the choirs of angels are present, the lowest are bound to the highest, the earthly are joined with the heavenly, and out of the visible and the invisible a union is created'.[52]

EPILOGUE

Certainly, the literature known to have been circulating in the Insular world, and available to the Iona community (and so to those responsible for the design of St Martin's Cross), suggests such explanations of the iconography of the monument are not entirely inappropriate. Set in the same situation as it now stands,[53] the figural decoration of the cross would have been viewed by all those entering the main church of the ecclesiastical centre, while the east face, with its array of decorated crosses, would have been one of the first sights encountered by those leaving the building. Furthermore, if this monument, like so much Anglo-Saxon sculpture, was painted,[54] these schemes and patterns would have been highly visible, the cross-shapes

particularly functioning as permanent (stone) versions of the jewelled crosses contained within the church.[55]

This prominent, polychromed, aspect of the monument would, of course, have been that which initially struck most (secular) visitors to the centre.[56] Indeed, the cross, even in its present monochrome condition, is still clearly visible when approaching the island by boat; it is hard to underestimate its impact, standing as a tall, brightly coloured stone shaft by the road before the church. As such, a full understanding of the iconographic significances of the carvings would not have been necessary to appreciate the statement made by the monument at a very immediate level.

Nevertheless, the figural decoration on St Martin's Cross was also intended to play a part, and as such presents a coherent set of references that were common in biblical and exegetical thought, to Christ, his death, resurrection and salvation, and which, in the cross-head, culminate in an (angelic) celebration of the nature of Christ Incarnate. Together with the way the non-figural motifs are arranged, these iconographic references serve to draw the viewer in to actively participate in that process of salvation. Considered together, the figural and non-figural can perhaps be understood to offer an extended iconographic programme expressing the complexities of Christ's nature and sacrifice, his Church with (crucially) its sacramental liturgy, and above all, their relevance to the Christian community on earth — and particularly that of Iona.

NOTES

[1] See Ó Carragáin 1978; 1986; 2003; Bailey 1990; 1996a, 58–76; 1996b; Hawkes 1993; 1995; 1996; 2002a.

[2] Not considered here because of their fragmentary condition and comparative lack of figural material are the cross of St John, which has no figural decoration, St Matthew's cross-shaft, with its damaged image of the Fall, a fragment with the remains of the Three Hebrews (all on Iona), and the Keills Cross in Knapdale (RCAHMS 1982, 197–204, 208–11; MacLean 1986).

[3] For a selection, see Curle 1940; Radford 1942; Stevenson 1955; 1956; 1971; Robertson 1975; Henderson 1982; 1987a; RCAHMS 1982, 18–19, 192–209; 1984, 209–10; Calvert 1983, 160–7, 246–55; MacLean 1986; 1993; Fisher 1994a, 42–6.

[4] Curle 1940, 96; Henderson 1986; see also Calvert 1983, 160–6; MacLean 1986.

[5] Although see Henderson 1986; MacLean 1986; Ó Carragáin 1989; Hawkes 1997a.

[6] See Hawkes forthcoming. For a summary of the wide range of Old Testament scenes available in the Insular world, see Harbison 1992, I, 187–229; Hawkes 1997b, 149–51, 157.

[7] A figural carving set in the horizontal arm facing David the Psalmist is too damaged to be identified with any certainty (see Figure 17.4); RCAHMS 1982, 196; Henderson 1986, 94–5.

[8] The number of angels featured in the Virgin and Child schemes does vary: two are present on the Kildalton and St Oran's Crosses while St Martin's Cross includes four. Otherwise, the Old Testament scenes are repeated versions of each other, with the Psalmist and the Sacrifice of Isaac being depicted as abbreviated versions (on the crosses of St Oran and Kildalton, respectively) of the expanded scenes on St Martin's Cross where the central figures (of David with his harp and Abraham and Isaac), are accompanied by a further witnessing figure (see Hawkes forthcoming).

[9] Hawkes 2001, 267–71.

[10] See MacLean 1993, 251.

[11] Much of the following discussion of the Old Testament scenes has been presented elsewhere (Hawkes forthcoming), and I am grateful to the editors of that volume for the opportunity to repeat it here.

[12] See, for example, Flower 1954, 91–2; Roe 1966, 13; 1981, 45–6; Henry 1967, 142–4; Harbison 1992, I, 330–1; 1999, 157; although see Fisher 1994a, 46.

[13] Warner 1906–7; Stokes 1905.

[14] See summary in Botterweck and Ringgren 1977, 56–7.

[15] Bailey 1977; Hawkes 1997b, 155–6; 2002b, 341–3.

[16] For discussion of issues surrounding the identity of the figures, see Henderson 1986, 95; Hawkes forthcoming.

[17] '*In figura Christi Dauid, sicut Golias in figura diaboli; et quod Dauid prostrauit Goliam, Christus est qui occidit diabolum*' (*Enarrationes in Psalmos* XXXIII 4, Dekkers and Fraipont 1956a, 276). English translation, author's own. For the presence of this text in the Insular world by the 8th century, see Hurst 1985, 121; Gneuss 2001.

[18] '*Et quando tale nomen debuit poni nisi com passionis dominicae gloriosa certamina referuntur? . . . qui per tolerantiam suam prostrauit principem tenebrarium, qui mortem moriendo superauit, qui humanum genus captinum crucifixionis suae dispensatione liberauit*' (*Expositio in Psalmum* XXVII 1, Adriaen 1955, 243). English translation: Walsh 1990, 271. For knowledge of this text in the Insular world by the 8th century, see Bailey 1978.

[19] Hourihane 2002, 128–48.

[20] Adriaen 1955, 477, Cassiodorus, *Expositio in Psalmum LI, conclusio psalmi*: '. . . *et per hos geminos psalmos, ne occultus terreat Antichristus, indicatur*' (and through these psalms the Antichrist is exposed and prevented from covertly imposing fear), English translation: Walsh 1991, 7.

[21] Alexander 1978, 55–6, Pl 146; Hawkes 2002b, 342–3, Pl 10; see also Wright 1967.

[22] Alexander 1978, 146, Pl 74; Bailey 1978, 5–12.

[23] Bailey 1977; 1990, 11–12; Harbison 1992, I, 187–229; Hawkes 1997b, 157.

[24] '*Propterea et Isaac, sicud Dominus crucem suam, ita sibi ligna ad uictimae locum, quibus fuerat et inponendus, ipse portauit*' (*De Civitate Dei* XVI.xxxii, Dombarat and Kalb 1955, 537). English translation: Knowles 1972, 694. For knowledge of this text in the Insular world by the 8th century, see Hurst 1985; Lapidge 1996; Gneuss 2001.

[25] *Historia Abbatum* 9: '*imagines . . . de concordia veteris et novi Testamenti*' (Plummer 1896, 373).

[26] Fol 28v, '*sacrificium patriarche nostri Abrache*' (Warner 1906–7, 13); see also Ó Carragáin 1989, 15.

[27] Harbison 1992, I, 187–229; Hawkes 1997b, 157.

[28] Henry 1967, 150; Roe 1981, 62; Harbison 1992, I, 339; Hawkes 1997b, 155.

[29] Ó Carragáin 1986, 383–7; 1989, 19–20.

[30] Hawkes 1997a, 121–33; see also Fisher 1994a, 46.

[31] See above, n8.

[32] '*Curemus ergo . . . ne que nos immunditia polluat, qui in aeterna praescientia et Dei ciues et angelis aequales sumus*' (*Homilia VIII: Lectio sancti evangelii secundum Lucam: die Natalis Domini* 3, Étaix 1999, 56); Mayr-Harting 1998, 11. By the 9th century this homily had been adopted as the first lesson of the third *Nocturn* in the Christmas office of the Western liturgies (Nilgen 1967). For evidence of its circulation in the Insular world by the 8th century, see Breen 1984, 210; Hurst 1985; 1990, 53; Walsh and Ó Cróinín 1988, 216–83; Ó Corráin 1994, 20–1; Martin 1989; Lapidge 1996; Gneuss 2001.

[33] See for example, Gregory the Great, *In Hiezechihelem* I: *Homilia* VII.18 (Adriaen 1971, 94). For summary, see Clancy and Márkus 1995, 54–6. For the currency of this text in the Insular world by the 8th century, see Hurst 1985; Martin 1989; Gneuss 2001.

[34] For this motif in Insular literature see, for example, Colgrave 1940; 1956; Sharpe 1995; see also Mayr-Harting 1998, 8–14.

[35] Mayr-Harting 1998, 14.

[36] For example, Gregory the Great, *Moralia in Job* XXX.*19* (Adriaen 1985, 1534–5); *In Hiezechihelem* I: *Homilia* VII (Adriaen 1971, 94); Mayr-Harting 1998, 16. See also Henry 1967, 141; Hurst 1985; Lapidge 1985; Martin 1989; Gneuss 2001, for evidence of the circulation of these texts in the Insular world by the 8th century. For the theme in the literature of Iona, see Carney 1964; Clancy and Márkus 1995.

[37] Neuman de Vegvar 1997, 172–6; see also Ó Carragáin 1989, 19–20; Hicks 1994, 108; Hawkes 2001, 270–1.

[38] '*Ipse enim unigenitus Dei Filius ueraciter factus est homo, ipse in sacrificio nostrae redemptionis dignatus est mori ut uitulus, ipse per uirtutem suae fortitudinis surrexit ut leo. Leo etiam apertis oculis dormire per hibertur, quia in ipsa morte in qua ex humanitate Redemptor noster dormire potuit, ex diuinitate sua immortalis per manendo uigilauit*' (*In Hiezechihelem* I, *Homilia* IV, Adriaen 1971, 47).

[39] Although see MacLean 1986, 176–7; 1993, 251–2.

[40] This is currently the subject of an extensive study in Kellie Meyer's doctoral thesis. I am grateful to her for the opportunity to review her work.

[41] *Sermon LXIV: De verbis Evangelii Matthaei*, x.16, '*Serpens . . . deponit tunicam ueterem, ut novus exultet. Imitare illum, christiane, qui audi . . . Paulis apostolus tibi dicit: 'Exuite uos ueterem hominem cum actibus suis, et induite novum'. Habes ergo quod imiteris in serpente. Noli mori pro vetustate, sed pro veritate. Qui moritur pro commodo temporali, pro vetustate moritur. Cum autem exutus fueris omni ista vetustatae, imitatus es austutiam serpentis*' (Migne 1844–64, Col 426); see also Ephesians 4:22–4.

[42] Hudson 1962; Cole and Scribner 1974, 64–7; Julesz 1975; Deregowski 1984, 47–58, 71–99; Eysenck and Keane 2000, 26–30, 84–6; see also Deregowski 1980.

[43] See for example, Stevenson 1974; 1982; 1983; Webster 2003.

[44] Hawkes 1997c; Pirotte 2001, 204.

[45] Ó Carragáin 1989, 15.

[46] Hawkes 2003b, 364–5; forthcoming. A detailed examination of these issues is to be published shortly by Éamonn Ó Carragáin; I am grateful to him for discussions on the subject.

[47] See particularly the Pauline epistles, Romans 6:1–11; I Corinthians 2, 4; Ephesians 3. For summary see Ferguson 1990, 1011–14.

[48] For example, Leo the Great, *Tractatus LXXIV: Item Alius de Ascensione Domini* 2 (Chavasse 1973, 457); Augustine, *Tractate VI: in Iohannis Evanglium I:* 32–8 (Willems 1954, 57).

[49] Schaff 1888, 209–10. '*Christus autem . . . et caput et corpus est, nec nos a Christo alienos dicere debemus, cuius membra sumus, nec nos quasi alterum computare; quia "erunt duo in carne una. Sacramentum hoc magnum est," . . . "ego autem dico in Christo et in ecclesia." Quia ergo totus Christus capus et corpus est, cum audimus: ". . . ipsi Dauid," intellegamus et nos in Dauid*' (*Enarrationes in Psalmos LIV* 3, Dekkers and Fraipont 1956b, 656).

[50] See II Samuel 7:27 ('Thou hast made this revelation to thy servant saying, I will build you a house'). For summary, see Botterweck and Ringgren 1977, 56–7; 1978, 164–9.

[51] *In I Samuhelem III, xvii*.49 (Hurst 1962, 160); Mayr-Harting 1972, 140. It may also be the case that the figures accompanying David the Psalmist and Abraham and Isaac can be understood as witnesses to the events, and that they function, along with the angels in the cross-head, and David with Saul and Goliath in the lowermost panel, as a visual means of drawing the viewer into a fuller understanding of such implications.

[52] '*Quis enim fidelium habere dubium possit ipsa immolationis hora ad sacerdotis uocem caelos aperiri, in illo Iesu Christi mysterio angelorum chorus adesse, summis ima sociari, terram caelestibus iungi, unum quid ex uisibilibus atque invisibilibus fieri?*', *Dialogues IV*.60 (Vogüé and Antin 1980, 202); Mayr-Harting 1998, 25. See Lapidge and Herren 1979, 178; Lapidge 1985; 1996; Walsh and Ó Cróinín 1988, 216–83; Ó Corráin 1994, 21; Gneuss 2001 for knowledge of this text in the Insular world by the 8th century.

[53] RCAHMS 1982, 204–5. See also Barber 1981a; Fowler and Fowler 1988; McCormick 1993, Fig 13; Fisher 1994a, 40–41.

[54] Bailey 1980, 25–9; 1996a, 6–7; Lang 1990; Hawkes 2002a, 146–7; 2003a, 26–30.

[55] Herbert 1996.

[56] See in particular, Byrne 1973, 156–7, 250; Enright 1985; Ó Cróinín 1995, 57; Sharpe 1995, 62–3, for discussion of royal visits to the centre, its perceived role in the late 7th and 8th centuries in the establishment of royal succession, and the retirement to and death on Iona of kings from Ireland (the High King Niall 'Frossach' mac Fergaile, d 778, and Artgal mac Cathail, king of Connacht, d 791).

CHAPTER 18

THE ROLE OF GEOLOGICAL ANALYSIS OF MONUMENTS: A CASE STUDY FROM ST VIGEANS AND RELATED SITES

By Suzanne Miller *and* Nigel A Ruckley

INTRODUCTION

The aim of this work is to examine the geological characteristics of early medieval sculptures in Angus and Perth and Kinross (at St Vigeans, and related local collections) and evaluate the use of these data in sourcing the stone used. In addition, the geological characteristics have been used to identify which, if any, carved fragments are likely to have come from the same monument. It is hoped that this, in turn, will aid future interpretation and presentation of the St Vigeans and related collections. A petrological and magnetic susceptibility measurement survey has been carried out on 112 early medieval sculptures found in the area. The lithological characterisation of the sculpture is compared to that of the outcrops in the area.

Strategy

Following (non-destructive) geological analysis of the carved stones located at St Vigeans (both early and later medieval examples), Aberlemno, Arbirlot (Angus), Arbroath (Angus), Meigle, the Meffan Institute, Fowlis Wester, Dunfallandy, St Orland's, Eassie and Dupplin, the sculptures have been categorised according to their petrology. This included mineralogical composition, sedimentological and structural features and their magnetic susceptibility values.

Potential sources of suitable stone were identified throughout the relevant area following reviews of the *New Statistical Account*,[1] the *Memoirs* of the British Geological Survey and other geological publications.[2]

A geological survey of the area under investigation included collection and petrological identification of representative samples from quarries/outcrops and measurement of magnetic susceptibilities at 150 locations. Thin sections of the geological samples were examined. Sites chosen to reflect the range of rock types included: Aberlemno, Airlie, Arbroath, Auchloy, Auchmithie, Balmashanner, Cairnie, Carmyllie, Carnoustie, Chapelbank, Cultoquhey, Dodd Hill, Dunnichen Hill, Dupplin Estate, Finavon Hill, Forfar, Hillhead of Burghill, Hill of Baldowrie, Kilpurney Hill, Kinnettles, Kingoodie, Kirriemuir, Laggan, Leysmill, Lumley Den, Middleton,

Newtyle, Pitairlie, Stonehaven, Trowan Hill, Turin Hill, West Haven, Wester Rochelhill and Woodside.

An extensive survey of the immediate St Vigeans area was undertaken, but no obvious quarry or other stone sources (natural outcrop) were identified there.

All outcrops and sculptures are categorised according to their petrology (mineralogical composition, sedimentological, and structural features) and their magnetic susceptibility values. All measurements, including the petrological classifications (mineralogy and colour) were verified independently to avoid any 'operator bias'.

GEOLOGY OF THE ANGUS AND PERTH AND KINROSS AREA

A literature and field survey has been conducted on the geology surrounding St Vigeans and other local early medieval sculptures (Figure 18.1).

The oldest rocks belong to the Dalradian Supergroup and crop out to the northwest of the Highland Boundary Fault zone. They were deposited as sandstones and mudstones (principally marine) which were subsequently metamorphosed to cleaved grits, shales, phyllites and schists. They are considered to be of Cambrian age (540–490 million years old) and were subjected to polyphase deformation during the Caledonian Orogeny. During this period, Dalradian rocks were elevated into a mountainous area higher and more extensive than the present Highlands.

During the Lower Devonian (409–386 million years ago) vast quantities of sediment were eroded from these mountains and carried by large rivers to subsiding low ground in the area of the present Midland Valley. Coarse detritus was deposited in large conglomerate fans, while sandstones and siltstones were deposited on extensive alluvial plains by braided rivers, in a semi-arid environment. This dominantly arenaceous and commonly red-coloured, non-marine succession is known as the Lower Old Red Sandstone (LORS) and is approximately 9000m thick. The term 'Old Red Sandstone' has been used in the UK since 1822[3] to denote the terrestrial sediments which are roughly equivalent in age to the Devonian marine deposits in south-western England and continental Europe. These are approximately 400–360 million years old, although the exact age of the Scottish ORS is debatable.[4] Associated with the sedimentary units are a number of volcanic rocks (particularly lavas) of similar age. No sculptures comprised volcanic rocks, therefore the ORS lavas will not be considered further here.

Lower Devonian sedimentation and volcanism in the area was terminated by the onset of earth movements (from around 386 million years ago) producing two asymmetric folds with a NE/SW trend: the Strathmore Syncline and the Sidlaw Anticline. Younger sequences were subsequently deposited and eroded, leading to the LORS forming the principal country rock.

The sculptures in question, in the north-eastern part of the Midland Valley, lie almost entirely within LORS strata, with one sculpture (the Dunfallandy Stone) sited on Dalradian metasediments (Figure 18.1). The Dunfallandy Stone is within Dalradian metasediments, north of the Highland Boundary Fault but its lithology is of LORS and so Dalradian outcrop is not considered further.

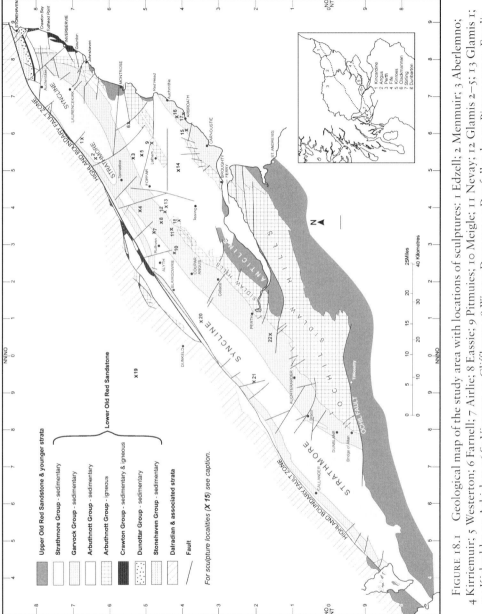

FIGURE 18.1 Geological map of the study area with locations of sculptures: 1 Edzell; 2 Menmuir; 3 Aberlemno; 4 Kirriemuir; 5 Westerton; 6 Farnell; 7 Airlie; 8 Eassie; 9 Pitmuies; 10 Meigle; 11 Nevay; 12 Glamis 2–5; 13 Glamis 1; 14 Kirbuddo; 15 Arbirlot; 16 St Vigeans; 17 Cliffburn; 18 Wester Denoon; 19 Dunfallandy; 20 Pittensorn; 21 Fowlis Wester; 22 Dupplin.

We identified rocks from three of the six major lithostratigraphical divisions of the LORS (Stonehaven, Dunnottar, Crawton, Arbuthnott, Garvock and Strathmore groups) with various subdivisions at formation level. The stratigraphy of the LORS is based on Armstrong and Paterson.[5] The sedimentary rocks in these units comprise conglomerates, sandstones, siltstones, mudstones and shales. Only the Arbuthnott, Garvock and Strathmore Groups are likely to have been utilised for these stone sculptures.

METHODOLOGY

Petrological analysis

All available sculptured stones have been examined using non-destructive petrological techniques, in order to provide a 'field identification' of the rock type. This provided a basic identification of rock type and distinguished between general rock types. All examination includes the following measurements:

— colour (with reference to Munsell standard colour charts). Colour measurements from all weathered surfaces were obtained. Occasionally, observation of the unweathered colour of the sculptures was possible;
— grain size (with reference to standard grain size measurements on the µm scale);
— macroscopic mineralogy (i.e. mineralogical content that can be ascertained by hand-specimen examination with hand lens);
— textural and structural characteristics such as bedding, cross-bedding, jointing, other planar fabric, grain size variation;
— clast distribution and composition;
— weathering characteristics.

Division of the specimens into 'rock types' has been primarily based on the textural characteristics. Colour has been used only as a general guide to overall appearance since varying degrees of weathering and/or cleaning could have significantly altered the surface colour.[6]

In addition to the measurements taken for the sculptures, all examinations of outcrop specimens included microscopic mineralogy, that is, mineralogical content from thin section examination.

All sandstones are classified according to their mineralogy and Folk's scheme,[7] whereby all rocks containing less than 15% fine-grained matrix are grouped by their three principal components: quartz, feldspar (plus granite and gneiss clasts) and other rock fragments.

Sediment maturity is based on a combination of mineralogical maturity (content of chemically stable and physically resistant minerals), and textural maturity (content of fine-grained matrix and the sorting and roundness of the grains). The assessment of textural maturity is based upon the schemes of Folk[8] and Pettijohn and others.[9]

Magnetic susceptibility

Background

Most igneous and metamorphic rock types contain varying amounts of ferromagnetic minerals such as magnetite. To a lesser extent, sedimentary rocks,

especially if derived from igneous and metamorphic rocks, also contain some ferromagnetic material.

Measurements of magnetic susceptibility are related to magnetite and other iron mineral content and can be used in characterising rock outcrops. Magnetic susceptibility and the physical properties of outcrops, when compared to those of the carvings, enable their source(s) to be evaluated.

This technique has been employed in the provenancing of igneous rocks, for example Roman granite columns,[10] greenstone axes,[11] and Charlemagne's 'black stones'.[12]

Published material on the use of magnetic susceptibility data has virtually always referred to igneous and metamorphic rock types. Floyd and Trench[13] employed a Kappameter Model KT-5 in evaluating magnetic susceptibility contrasts in Ordovician greywackes. Recent work on West Highland sculpture[14] has shown that the KT-9 Kappameter has an important role in provenancing standing and carved stones.

Magnetic susceptibility methodology

The magnetic susceptibility was measured with an Exploranium KT-9 Kappameter (manufactured by Exploranium G S Ltd) giving a measurement of the true susceptibility.[15]

The KT-9 was used in 'pin operating mode'. The KT-9 handbook recommends that the 'pin mode' is used 'for all measurements where an uneven surface and weathering are present — effectively all field samples'. The instrument is held like a torch, is powered by a 3V battery and gives a digital read out of susceptibility in non-dimensional SI units factored by 10^{-3}. A rubber pin is held touching the stone and gently pressed until an automatic reading is recorded. The accuracy on a flat rock is estimated to be $\pm 3\%$ in the 'pin mode'.[16]

Twelve readings, representing one data set, were taken from the front and rear faces of the carved stones away from all possible sources of magnetic contamination. Over 290 individual data sets were taken, and the average and standard deviation of each set determined. From all the non-contaminated data, a representative value has been chosen for each stone. Almost 150 data sets, from quarry or outcrop locations, have provided a magnetic susceptibility data base.

Effect of weathering on magnetic susceptibility readings

It is important to match weathered carved stone faces with weathered natural outcrop, as very fresh faces from outcrops will give a different reading. Differential weathering (due to temperature, wind and water) can effect readings from differently orientated faces of a standing stone. Especially in sedimentary rocks, there is also the natural differential weathering between the face and edge of a stone.

Subtle magnetic susceptibility differences were sometimes detected not only laterally along beds, but also between different beds. This was very conspicuous where sedimentary beds varied in grain size.

Contamination of data

Magnetic contamination of the readings was noted at St Vigeans, the Meffan Institute and the Pictavia Centre. Its sources were the method of mounting, the repairs to the sculpture and the floor and path at St Vigeans.

The metal pins or clamps holding the stones upright, or the shelves on which the objects are located, can affect the measurements. Readings can be low, negative, or higher than usual. A stone's faces can show readings on entirely different scales. The concrete path leading to St Vigeans Kirk, on which the newly found cross was laid, influenced the readings taken from the thinner parts of the stone. Similarly, higher readings were recorded when taken close to the floor at St Vigeans.

Many Meffan Institute and Pictavia Centre readings were discarded owing to the metallic mounting methods employed there. As there are no tables for adjusting the readings from thin rock units, all stones with a thickness of less than 6cm were treated as suspect.[17]

As all the measurements have been taken with the same KT-9 instrument, there is a good degree of comparison between data without any inter-instrument effects.

RESULTS

Stone outcrop

Petrologically, significant differences between sandstones from the Arbuthnott, Garvock and Strathmore Groups can be discerned. Within Groups and Formations, and even within outcrop localities, there can be significant differences in grain size and gross texture (e.g. cross-bedding, lamination, ripples, etc). The overall mineralogical and sediment maturity characteristics are, however, generally consistent within outcrop. From the examination of thin sections, it is clear that there are very recognisable differences between outcrops on a microscopic scale.

The magnetic susceptibility data suggest that some of the units studied display a relatively confined range of readings, for example each of the Garvock Group units and the Strathmore Group (Figure 18.2).

All petrological analysis was undertaken independently of the magnetic susceptibility measurements to ensure that no bias was recorded in the grouping of the rock types.

Arbuthnott group

The sandstones examined from the Arbuthnott Group all belong to the Dundee Formation. They are generally arkosic sandstones and litharenites. They are characteristically drab-coloured (grey to pinkish-grey) although the outcrop at Kingoodie is a dull red colour, due to very late stage weathering and development of haematite cement. Generally, the Arbuthnott sandstones contain a much more significant proportion of chlorite, compared to both Garvock and Strathmore sandstones.

The range of magnetic susceptibility measurements in the Dundee Formation of the Arbuthnott Group is very varied (Figure 18.2), suggesting that magnetic

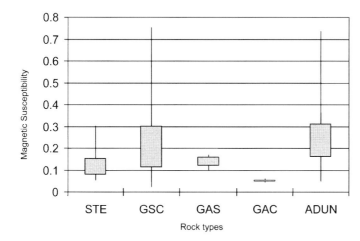

FIGURE 18.2 Range of magnetic susceptibility values for stratigraphical groups (STE: Strathmore Group, Teith Formation; GSC: Garvock Group, Scone Formation; GAS: Garvock Group, Arbroath Sandstone; GAC: Garvock Group, Auchmithie Conglomerate; ADUN: Arbuthnott Group, Dundee Formation).

susceptibility cannot distinguish these rocks independently. However, the readings in this group varied from sandstones to much finer, silty sandstones, and micaceous flagstones. The finer material, often with an increase in mica, generally results in higher readings. It is therefore possible to characterise different lithologies within the formation.

Garvock group

Sandstones from the Garvock group cropping out to the north-west of the Sidlaw Anticline lie within the Scone Formation. South-east of the Sidlaw Anticline, they belong to one of the Red Head Formation, Arbroath Sandstone unit or Auchmithie Conglomerate unit. The Scone Formation Sandstones are predominantly litharenites (containing very little or no calcite). The sandstones of the Red Head Formation and Auchmithie Conglomerate are sub-arkosic while the Arbroath Sandstone units are calcareous litharenites. The Scone, Red Head and Auchmithie units are a distinctive red colour and are very immature (being poorly sorted and rich in feldspar and mica). The Arbroath Sandstone units are very characteristic matrix-supported, calcareous litharenites. They are grey in colour and contain very significant quantities of calcite.

Magnetic susceptibility measurements in the Red Head Formation, Auchmithie Conglomerate and Arbroath Sandstone of the Garvock Group show a restricted range of values, whereas the Scone Formation rocks showed a much wider range (Figure 18.2). The readings in this group varied from sandstones to much finer silty sandstones, and micaceous flagstones. This unit subdivides into lithologies with more characteristic magnetic susceptibility values.

Strathmore group

Sandstones from the Strathmore Group all belong to the Teith Formation, and are generally sub-arkosic. They are red in colour, and contain a significantly higher proportion of feldspar and significant rim and pore-fill opaque (haematite) cement.

Strathmore Group rocks generally display low magnetic susceptibility readings (Figure 18.2).

Carved stones

Based on the examinations carried out, there are remarkably few megascopic differences in the stone types used for the sculptures at all of the sites examined. With the exception of two sculptures at Meffan (a pillow-stone of granite, and a cross-slab of siltstone), they are all composed of sandstone. There are, however, a number of different sandstones present, and an attempt has been made to characterise the general groupings based on petrology and magnetic susceptibility.

Fourteen general rock types (arbitrarily termed A–N) were recognised, as follows:

— A: Coarse to very coarse-grained sandstone with clasts of quartz and/or clay and/or siltstone and/or granite. These rocks are typically pinkish-grey to red in colour. All these rocks have a close grouping of magnetic susceptibility measurements.

— B: Fine-grained grey flagstone-type sandstone without clasts. There is no discernible magnetic susceptibility measurement that is characteristic of this rock type. Rather, the measurements show a reasonably confined range of values.

— C: Medium- to coarse-grained sandstone with clay and/or quartz clasts. They are bedded and are typically dark red to pinkish-red in colour. This rock type displays a small range of magnetic susceptibility measurements.

— D: Medium-grained sandstone with no clasts and generally pinkish-grey to brownish-grey in colour. The range of magnetic susceptibility measurements is large.

— E: Fine- to medium-grained, without clasts and typically pinkish-red in colour. The magnetic susceptibility measurements show a small range of values.

— F: Coarse- to very coarse-grained sandstone with clay and/or siltstone clasts. Typically pinkish-grey in colour and displaying bedding. This rock type displays a small range in magnetic susceptibility measurements.

— G: Fine- to medium-grained, grey to pinkish-grey sandstone with no clasts. This rock type displays a small range of magnetic susceptibility values.

— H: Coarse-grained, pinkish-grey sandstone with either minor quartz granules or no clasts. This rock type displays a very small range in magnetic susceptibility values.

— I: Fine-grained with no clasts and a distinctive purple colour. One sculpture from St Vigeans falls into this category.

— J: Coarse- to very coarse-grained sandstone with quartz clasts. Displays bedding and is typically brown-grey in colour.

— K: Fine- to medium-grained, dark reddish-brown sandstone that displays a small range of magnetic susceptibility measurements.

— L: Very fine-grained, laminated, dark olive-grey siltstone. Only one of the sculptures examined falls into this category (Kirkbuddo Church cross-slab on display at the Meffan Institute).

— M: Very fine-grained pale pinkish-grey sandstone. Only the Wester Denoon (Angus) slab falls into this category.

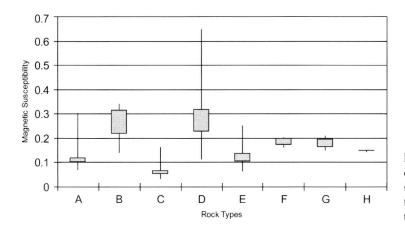

FIGURE 18.3 Range of magnetic susceptibility values for sculpture rock types.

— N: Granite. Only one stone was shown to be of this rock type: the Cliffburn pillow-stone (on display at the Meffan Institute).

Each of the sculptures was allocated to a rock type. Subtle differences in the mineralogy and structure, however, are not entirely constrained by the general rock types. Combined petrological and magnetic susceptibility data show that some rock types have closely grouped magnetic susceptibilities (Figure 18.3). For example, rock types A, C, E, F, G, H and K show a small range in values, while rock type D displays a very large range. Therefore, the rock type classification has been further subdivided, as arbitrarily indicated by numbers. This shows where the source of a group of sculptures is thought to be the same. For example, the A1 type is most probably sourced from the Arbroath sandstone of the Garvock Group, while A2 is also characteristic of that group, but more probably sourced from the Finavon Hill sandstone, further to the west.

Magnetic susceptibility readings from individual museums also indicate that the highest readings are from Meigle, while stones with the lowest readings are at St Vigeans. This is generally consistent with the range of readings taken at quarries and outcrops local to the different sites from the lowest values around Arbroath and higher readings moving west. These data are consistent with the subtle but significant differences in the predominant rock types of building stone used when travelling west from Arbroath.

It should be noted that none of the sculptured stones of rock type J were suitable for magnetic susceptibility measurements.

The outcrop sandstones also fall into the sandstone type groups A–M, although not all sandstone types were represented by outcrop specimens. Sandstone types B (various stones), I (VIGMS1), L (Kirkbuddo Church cross-slab) and M (Wester Denoon symbol-bearing cross-slab) were not seen in any quarry or outcrop examined.

The stone type is often (unsurprisingly) related to the level of carved detail and/ or relief. Fine-grained, finely laminated stone is a poor material for deep relief as laminae may flake off, while the more coarsely laminated sandstones can sustain such deep relief. The flaggy, fine-grained sandstones are, almost without exception, much

Category	St Vigeans sculpture number	Stratigraphic classification
A1 (5 stones)	13, 18, 20, 28, A2	Garvock: Red Head Fm or Arbroath Sandstone
B1 (7 stones)	3, 4, 5, 11, 21, 22, 23	Arbuthnott: Dundee Fm (Turin/Carmyllie type)
C1 (10 stones)	2, 6, 7, 9, 10, 12, 16, 19, 24, St Vigeans Kirk	Garvock: Red Head Fm or Arbroath Sandstone
D2 (7 stones)	A1, VIGMS2, VIGMS4, VIGMS6, VIGMS7, VIGMS8, VIGMS9	Arbuthnott: Dundee Fm
E (2 stones)	17, 27	Arbuthnott: Dundee Fm (Middleton type)
F (3 stones)	14, 25, A3	Arbuthnott: Dundee Fm (Balmashanner/Dodd type)
G (6 stones)	1, 8, 15, 29, VIGMS3, VIGMS5	Arbuthnott: Dundee Fm (Balmashanner/Dodd type)
I (1 stone)	VIGMS1	?

FIGURE 18.4 Sources of stone for St Vigeans sculpture. VIGMS numbers refer to later medieval sculpture.

thinner than the coarser-grained ones, reflecting the natural tendency of the fine-grained stone to break into thin units.

Little evidence was seen of the early reuse of stones. There was, quite clearly, an abundant supply of local, easily obtained material. This corresponds with other published work on local sculptured stones.[18]

St Vigeans

The data indicate that all of the St Vigeans sculptures are composed of sandstone, with a source from the LORS. They fall into eight stone categories. All of the St Vigeans sculptures are most probably sourced locally. Comparison between the eight St Vigeans stone types and the outcrop rocks is used to assign these sculptures to potential sources in various stratigraphic groups (Figure 18.4). With the exception of VIGMS1, all the rock types are consistent with a Garvock or Arbuthnott Group source, both groups outcropping in the vicinity (Figure 18.1). The similarity between the sandstones of the St Vigeans sculptures and the local building stone is further evidence.

Rock type A is similar in all respects to rock outcropping locally in the Arbroath sandstone.

Rock type B is characteristic of fragments St Vigeans 3, 4, 5, 11, 21, 22 and 23. These fragments are petrologically very similar to one another, and are almost certainly from the same source — fine-grained, grey flaggy sandstone. This rock type source was not identified by us. St Vigeans 4 and 21 are petrologically identical and almost certainly represent fragments of the same sculpture, as has been noted on art-historical grounds by several observers (Figure 13.6).

Rock type C is particularly characteristic of the sculptures and local building stone, inferring a nearby source. It is consistent, both petrologically and in its magnetic susceptibility measurements, with the rocks outcropping along the Arbroath cliffs. A distinctive dark pinkish-red, it commonly contains granules and pebbles of other rock types. Rock type C1 is unique to the St Vigeans site.

Rock types D, E, F and G are also seen in limited use as local building stones. Their characteristics are consistent with a source in the Arbuthnott Group (i.e. to the west of St Vigeans; Figure 18.1), similar to the sandstone of Middleton Quarry. Of the miscellaneous later medieval sculpture fragments, VIGMS7, VIGMS8 and VIGMS9 resemble one another, and are almost certainly from the same local source.

VIGMS1, a distinctive purple colour, is the only sandstone in category I. This uncharacteristic rock type has not been identified at any other site, quarry or outcrop. Purplish sandstones are recorded from localities within the LORS, so the source for this sculpture fragment may be relatively local.

Petrological and magnetic susceptibility evidence clearly shows that a range of sandstones from different, but local, sources was used for stone carving.

Meigle

The sculptured stones at Meigle show broad similarities to those at St Vigeans. Rock types A, C, D and F were all identified and, again, can be sourced in the Garvock or Arbuthnott Groups. The data suggest, however, that although the general rock types are similar at St Vigeans and Meigle, they almost certainly have a different source area. Meigle lies in Garvock Group units and is close to outcrops of Arbuthnott Group units. But, due to the overall regional structure of the LORS in this area (i.e. large-scale NE-SW trending folds), the Garvock and Arbuthnott Group rocks that crop out in the Meigle area are not identical units to those around St Vigeans.

Additionally, the dark red St Vigeans material — identified as Arbroath sandstone — is not evident at Meigle. Also, two of the Meigle stones (30 and 33) may be from the Strathmore Group, which crops out to the west of Meigle. Five of the Meigle stones have a source quite distinct from any other site examined. Meigle 5, 8, 15, 20 and 25 are characteristic of sandstone from Dodd Quarry, exhibiting very high magnetic susceptibility measurements.

Meffan

The Meffan sculptures studied include Kirriemuir 1–17, Nevay cross-head, Cliffburn pillow-stone, Kirkbuddo Church cross-slab, the Dunnichen symbol-incised stone and the Wester Denoon symbol-bearing cross-slab (all from Angus). Their range of rock types includes two types unique to Meffan, each represented by only one sculpture. The Cliffburn carving is of granite, and that at Kirkbuddo is of siltstone.

Pictavia

The stones studied at Pictavia include Menmuir 1–5, Farnell and Edzell 1 (all Angus), demonstrating quite a variety of sandstone types. The Menmuir, Edzell and Farnell sculptures lie within, and are consistent with a source in the Strathmore Group. The sandstones are typically fairly coarse-grained and brownish-grey in colour.

St Orland's

St Orland's Stone is classified as F2, in keeping with a local source similar to the Balmashanner sandstone.

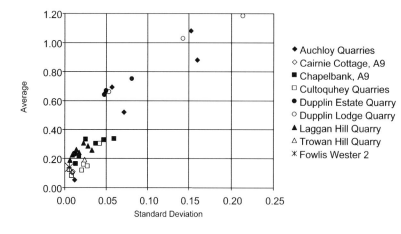

FIGURE 18.5 Magnetic susceptibility values: comparison of Fowlis Wester 2 with potential local stone sources.

Eassie

The Eassie Stone exhibits a brownish-grey colour, is coarse-grained and is classified as type F2. Like St Orland's, the source is similar to that of the Balmashanner sandstone.

Dunfallandy

Dunfallandy Stone is type J and, unlike the majority of other sculpted stones examined, is most definitely not local to its present position, where the country rock is schist. Neither is it local to its alleged previous situation, approximately half a kilometre south-west of Killiecrankie, nor similar to the sandstone used in Dunkeld Cathedral. Dunfallandy is pinkish-brown sandstone, similar to Farnell and Edzell 1. Its most likely source is the Strathmore Group.

Fowlis Wester

Fowlis Wester 1–4 are all classified as rock type K, and are quite distinct from any other sculptured stones examined in this study. The rock is dark reddish-brown and displays characteristic non-laminar bedding. The same sandstone type is seen used extensively as local building stone, indicating a local source, from the Strathmore Group.

A thin section of a flake from the lower part of the slab of Fowlis Wester 2, from the petrology collections of the National Museums of Scotland, has been used for comparison with local potential sources.

Comparison of the magnetic susceptibility measurements of the sculpture with stone cropping out in the local vicinity (Figure 18.5) suggests a number of possible sources. These include Cultoquhey and Auchloy quarries (both Teith Formation, Strathmore Group) or Cairnie Cottage outcrop, Chapelbank outcrop, Trowan Hill Quarry, and Laggan Hill Quarry (all Scone Formation, Garvock Group). The gross petrology is in keeping with a source from the Strathmore group, i.e. Cultoquhey or Auchloy type sandstone.

Comparing the detailed petrology of the cross-slab with that of the local outcrops, the source corresponds to the rock exposed at Cultoquhey. The close petrological match shows in thin sections of the cross-slab and the Cultoquhey outcrop.

Dupplin Cross

The Dupplin Cross is classified as sandstone type J, medium to coarse-grained and brownish-grey in colour. This is consistent with a local, Strathmore Group source.

Aberlemno

The four sculptures standing at Aberlemno are all consistent both in geological characteristics and magnetic susceptibility with a local source in the Aberlemno-Finavon Hill area, which belongs to the Scone Formation of the Garvock Group.

Arbirlot

The carved sculpture at Arbirlot is consistent with a local source in the Red Head Formation of the Garvock Group.

Arbroath Signal Tower Museum

The geological analysis and the magnetic susceptibility measurements of both stones from Arbroath Signal Tower Museum are consistent with a very local source, probably from the Auchmithie Conglomerate unit of the Garvock Formation that crops out on the coast at Arbroath.

CONCLUSIONS

The geological analyses of the sculptures indicate that all the sculptured stones are sandstone, except one siltstone and one granite. For the sandstones, the features are consistent with sources in the LORS of the area and indicate that various different geological units within the LORS have been utilised.

From the geological survey, sampling and thin section analysis of rocks cropping out, distinctive lithological differences between stratigraphical groups, and even between formations are apparent. This is encouraging for potential identification of sources of carved stone. There is also considerable variation within groups, however, even on an outcrop scale. Landscape changes have meant that some infilled quarries are now inaccessible. Nevertheless, the samples collected form comprehensive comparative material from potential sources of LORS.

From mapping around St Vigeans, we have found no immediately local (approximately 1km radius) source of stone for the sculpture there, although within a few kilometres of St Vigeans are outcrops of rock that are lithologically compatible with the carved stones. The medieval and non-medieval St Vigeans carvings have used different sources, both of which are probably local.

Comparing the St Vigeans, Meigle Museum, Meffan Institute, and Pictavia material and other individual stones, some sculptures from individual sites could be from the same source. Also, some rock types at each locality appear to be site-specific.

The feasibility of local production of the sculptures at each site is supported by local quarrying evidence. There are a number of sandstone quarries surrounding our sites, and a detailed study of the history of quarrying throughout the area suggests there were once many more. In addition, the nature of the LORS units would allow very local, non-quarry sources, such as river-cuttings, to be exploited.

This study has shown the potential benefits of combining hand specimen petrological identification and magnetic susceptibility measurements of sculptures, with thin section analysis and magnetic susceptibility measurements of outcrop specimens. Only by using this combination of techniques can a potential source be identified with any reasonable degree of certainty.

Future geological investigations will require to be carefully assessed in the light of any art-historical interpretations of the material. Any study of the economics of procuring the raw materials, and their place of carving clearly involves considering their places of origin. By concentrating on more detailed identification of the geological features of the sculptures, links between sites could be assessed. More detailed petrological examination of the sculptures, for example from thin sections, would yield more detailed comparisons, and potentially more robust matches between sculptures and source rocks. In addition, depending on the sculptor's desired outcome, consideration of the carving properties of the different stone types may indicate preferences for particular materials.

Destructive analysis would involve the removal of a 10mm diameter core of approximately 10mm length from a broken or uncarved face. The hole could be filled and replugged with a small piece of the core. The extent of any appropriate destructive analysis of sculpted material would need assessment in the light of the requirements of art-historical interpretation. Indeed, such destructive analysis may prove unnecessary and/or undesirable.

ACKNOWLEDGEMENTS

The authors would like to thank Suzie Stevenson for preparation of hand specimens and thin sections, Fiona McGibbon for verifying field identifications of outcrop specimens and proof-reading the manuscript and Diane Mitchell for preparation of the digitised geological map. The authors would also like to acknowledge the kind assistance given by staff at the various organisations and institutions whose collections were examined as part of this study. This work was carried out with grant-aid from, and in collaboration with, Historic Scotland.

NOTES

[1] Armstrong et al 1985; NSA 1845a; 1845b.
[2] Braithwaite and Jawad 1978; Campbell 1911; Craig 1991; Hall et al 1998; Hickling 1908; Jowett 1913; Mackie 1980.
[3] Conybeare and Phillips 1822.
[4] McKerrow et al 1985.
[5] Armstrong and Paterson 1970.
[6] The petrological identification of sculpture specimens can be found in Miller and Ruckley 2001.
[7] Folk 1974.
[8] Folk 1951.

[9] Pettijohn *et al* 1973.
[10] Williams-Thorpe and Thorpe 1993; Williams-Thorpe *et al* 1996; Williams-Thorpe *et al* 1997.
[11] Markham 1997.
[12] Peacock 1995; 1997.
[13] Floyd and Trench 1988.
[14] Caldwell *et al* 2002.
[15] The magnetic susceptibility measurements for the sculptures can be found in Miller and Ruckley 2001.
[16] *User's Guide KT9* 1997, 74.
[17] Williams-Thorpe *et al* 2000a.
[18] Hall *et al* 1998; 2000.

CHAPTER 19

THE EARLY MEDIEVAL SCULPTURES FROM MURTHLY, PERTH AND KINROSS: AN INTERDISCIPLINARY LOOK AT PEOPLE, POLITICS AND MONUMENTAL ART

By MARK A HALL, ISABEL HENDERSON *and* IAN G SCOTT

> The past and present always disagree
> The claims of ruin is what used to be . . .
> The very churchyard . . . remains not as it was . . .
> (John Clare, *The Parish*, stanza 1726–9)

INTRODUCTION

In an earlier paper[1] the fragment of early medieval sculpture from Pittensorn Farm, Murthly (Perth and Kinross), was described and contextualised. It recognised the art-historical parallels with sculpture at nearby Meigle; a further link between Pictish sculpture and the Book of Kells; the aptness of a tomb-shrine function and the possibility of an ecclesiastical centre within a 4.8km radius of Murthly/Gellyburn. This paper seeks to address more fully the comparison between the Pittensorn fragment, the Murthly panel and the Gellyburn cross-slab[2] (all three were found within 0.8km of each other) (Figure 19.1). Their function, site context and wider landscape context is discussed. This interdisciplinary approach once more asserts the importance of early medieval sculpture in Scotland as a clue to acculturation rather than as a flag of permanent ethnic identity.[3] Dr Isabel Henderson authored the art-historical context section and the descriptions, Mark Hall the remainder (with place-name advice from Dr Simon Taylor) and Ian G Scott contributed the drawings and much useful comment.

DESCRIPTIONS

Pittensorn

The Pittensorn fragment (Figure 19.2) is composed of grey, cross-bedded sandstone. It is weakly micaceous and massively bedded, with some lamination. The

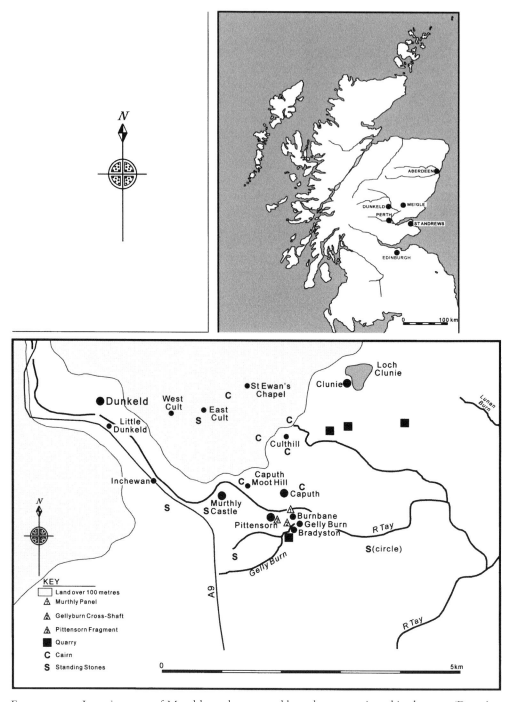

FIGURE 19.1 Location map of Murthly sculptures and key places mentioned in the text. (Drawing by Dave Munro. Courtesy of SUAT Ltd)

FIGURE 19.2 The Pittensorn fragment. (Drawing by Ian G Scott. Crown copyright: RCAHMS)

fragment measures 335mm (max) in height x 250–350mm in width x 100mm (max) in thickness. The carving is sculpted in relief, on one side only, and is set within a frame varying in width from 20 to 23mm. For the full description and its links with the Meigle sculptures, readers are referred to the previous Pittensorn paper,[4] though we repeat the illustration here for purposes of comparison. The Pittensorn fragment is part of a horizontally-set panel, carved on one face only. The top edge shows no trace of fracture, the left edge is dressed, and the back of the panel undressed. Neither edge shows scars of pre-existing rebates and there is no grooving on the back.[5] The preparing of the surface of the slab to accommodate the carving of motifs in one-plane relief produces a marginal flat band moulding. The dimensions of the carved area of the panel when it was complete are irretrievable, but the probable extent of the figurative motif, two wrist-holding men whose attenuated limbs interlace with

FIGURE 19.3 The Murthly panel. (Drawing by Ian G Scott. Crown copyright: RCAHMS)

serpents, and of the animals whose hindquarters are seen moving to the right, provide minimum dimensions. The figural motif abuts the top margin and its completion is likely to represent the vertical dimension of the carved field. Horizontal panels often have substantial areas of uncarved stone beneath the carved area and one would expect this to have been a feature of the Pittensorn panel.

Murthly

The Murthly panel (Figure 19.3) is composed of pink sandstone. It is weakly micaceous, massively bedded and weakly laminated. It measures 575mm (max) in height x 1015mm in width x 105mm in thickness (max). The carving is sculpted in relief, on one side only, and set within a frame varying in width from 20 to 25mm. The Murthly panel preserves a complete carved field enclosed in a moulding, that runs along the top edge and down the sides. The bottom edge, as is frequently the case with cross-slabs, has no moulding, and is markedly uneven. Beneath the carved area is a section of roughly dressed stone rounded at the corners. Although the contours are reasonably symmetrical, its depth suggests that the panel was set into the ground rather than inserted into a socketed plinth. The lateral mouldings show surface wear, but they appear to be intact on the external edges of the panel. As with the Pittensorn panel, no residual scarring suggests that rebates have been trimmed off, but the possible neatening of such panels, whether for reuse or display at later periods, must always be borne in mind. As a format for carving, horizontal panels were comparatively common both south and north of the Grampians, and all merit individual re-examination on all faces.[6] They may have been multi-purpose, forming

FIGURE 19.4 The Gellyburn cross-slab. (Drawing by Ian G Scott. Crown copyright: RCAHMS)

units in architectural sculpture, defining internal or external spaces, or forming sides of box-shaped monuments of varying construction and function. The carving on the Murthly panel consists of three modules, a centrally placed pair of confronted hippocamps, flanked, to the viewer's left, by a pair of animal-headed combatants, and to the right, by a naked man pursued by a lion-like beast, with an adjacent amphibian.

Gellyburn

The Gellyburn cross-slab (Figure 19.4) is composed of (pale) grey, fine-grained, micaceous sandstone. It comprises two conjoining fragments together measuring 775mm in height x 265mm (max) in width x 95mm (max) in thickness. The worked area of the slab has a width of 260mm, whilst the tapering tenon varies from 150 to 265mm in width. The tenon has a maximum thickness of 95mm, the sculptured area has a maximum thickness of 90mm. It is sculpted in relief on both sides. When complete the Gellyburn symbol-bearing cross-slab would have had a carved area around 600mm in height (slightly less on the reverse), and around 100mm in width. The slab is therefore unusually small, although these measurements should be compared to only slightly larger cross-slabs such as Meigle 5 and Meigle 23, and to the fragment Meigle 8, which is part of a slab slightly narrower than Gellyburn. All these small slabs are of high quality.[7] The noteworthy feature of the Gellyburn slab is not so much its size, but the sophistication of its design. It is the only slab of such small dimensions to have pierced armpits — a device found only on a handful of cross-slabs, of which the most notable is from Gask, Perth and Kinross (Figure 19.5).

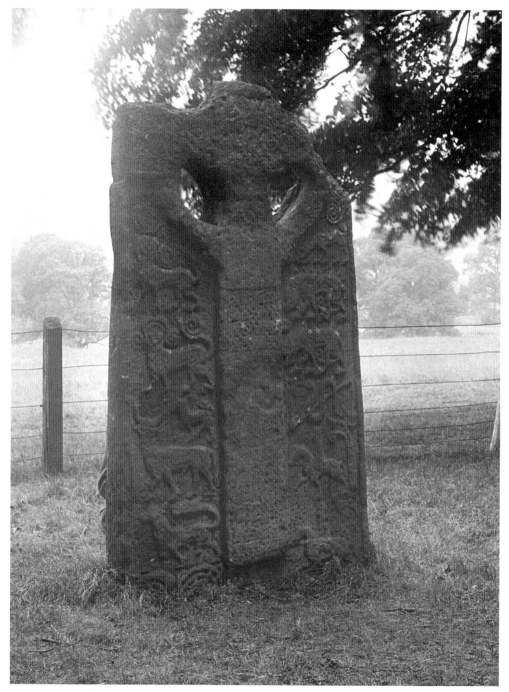

Figure 19.5 The Gask 1 cross-slab (*c* 1920). (© Perth Museum & Art Gallery, Perth and Kinross Council)

It is frequently said that such piercing represents a move towards the format of the free-standing cross but this can scarcely have been the motive of the Gellyburn sculptor. The slab certainly has something of the look of a model for a large free-standing cross, but the substantial tenon suggests that the cross-slab had a primary function to fill that had nothing to do with making a visual impact in a landscape or in a spacious internal setting. On the other hand, it does look as though it might have acted as a cross associated with a larger structure, for it is designed to be seen at eye level.

Piercing the armpits of a cross on one face of a slab with carving on both sides, brings with it the necessity of carving a second cross on the reverse. The Gask sculptor chose a cross of basically similar shape for both sides. The Gellyburn sculptor ingeniously made the piercings of the Latin cross on the front also function as the armpits of an encircled, equal-armed cross on the reverse. The cross on the front stands out in relief about 12mm, its tapering shaft terminating outside an enclosing incised frame. All these features serve to enhance the effect of a small-scale, free-standing cross positioned, perhaps indoors, where light passed through the cross-head. Calder, who first published the slab, reconstructed the head of the Latin cross as having its rounded armpits edged with a moulding, so as to form a quadrilobate ring round the cross-head, in the manner, for example, of the cross on Aberlemno 2 (Figure 15.5). Within the tight format of Gellyburn there is no space for a circular panel at the crossing, and Calder's conjecture that decoration on the arms simply ran into the crossing is probably correct. His geometrical reconstruction of the Greek cross with triquetra-like interlace on all four arms is based on what has survived of the design. His suggested decoration for the centres of both crosses is wholly conjectural, as are the positioning of triquetras in the spandrels in the corners of the reverse of the slab.[8] The form of the piercing, however, provides ample evidence for the general appearance of the two crosses when the slab was complete (Figure 19.4).

GEOLOGY AND PHYSICAL COMPARISON

The geology and the laying-out of the sculptures are closely comparable, particularly the Murthly panel and the Pittensorn fragment, which may be from the same monument. This last suggestion is not supported by perhaps the most telling physical, layout difference, the median line present on the border of the Pittensorn fragment, but absent from the border of the Murthly panel. To help facilitate their closer comparison, a table of measurements has been drawn-up (Figure 19.6), which though demonstrating significant anomalies clearly shows that these are outweighed by the similarities. The anomalies are themselves somewhat exaggerated by the decay of use and burial, and the recovery of the sculptures. Thus, the Murthly panel has much greater surviving surface detail and its texture is different, due to differential erosion: slower and more powdery for the Murthly panel, and flaking and more abrasive for the Pittensorn fragment. This has the consequence of a greater surface-loss for the Pittensorn fragment. Further, a detailed visual geological comparison by Mark Simmons (Perth Museum) suggests they could have been carved from the same sandstone — of the Strathmore or Garvock groups.[9] Potential quarrying sites in the

Assessment Criteria	Pittensorn fragment	Murthly Panel
Border thickness	20-23mm	20-25mm
Border depth	0.9-1.0mm	10-12mm
Relief depth	1mm	10-12mm
Width of motif-scenes	15mm	13-15mm
Overall height	365mm	575mm
Height of sculpture zone	335mm	350mm
Overall thickness	60-110mm	99.2-104.8mm
'Human'-head sizes (front-of-head to back-of-head first, then chin to top-of-head)	Head on left: 48.2mm 46.1mm Head on right: 48.6mm 47.9mm	Backward-facing figure: 43.7mm 52.4mm

FIGURE 19.6 Table of physical comparitors for the Murthly panel and the Pittensorn fragment.

Murthly area were discussed in the previous Pittensorn paper, and it was concluded that the probability of local production for all three sculptures is high. Both the Murthly panel and the Pittensorn fragment are weakly micaceous and contain small quartz grains, well rounded and often pink. This colouration is probably due to iron oxide staining. Both sculptures are structurally from a massive, laminated sandstone bed. The Murthly panel has an unweathered surface, whereas the Pittensorn fragment is heavily weathered (leaving an outer, thin crust of quartz grains with its surrounding matrix weathered out). This is likely to be due to greater exposure to the elements. The only obvious geological difference between the two sculptures is colour. Pittensorn is grey and Murthly pink, but the latter may well be exaggerated by the lighting conditions of the NMS display-setting. Both pieces have been conserved, and side effects of the processes involved may also have an exaggerative effect on the colour difference.

How does the Gellyburn piece compare to the other two sculptures? Because of its very even weathering it was difficult to locate a fresh surface, and its observed colour of pale grey may only be the colour of the weathered surface. It is composed of very fine-grained sandstone and is, like the other two sculptures, micaceous and has even finer laminations in its bedding. There is evidence of some even surface-staining, which may be a localised pollution effect (possibly from when it was built into the foundations of Rose Cottage). The variation between the three pieces is consistent with the variation that could be expected between beds in the same sandstone formation, or even laterally across the same bed of sandstone. Ultimately, the only sure way to confirm the apparent similarities would be through comparative thin sections.

ART-HISTORICAL CONTEXT

The connections between the figural imagery on the Pittensorn fragment, and other representations of the theme of wrist-holding men in both Pictish and other Insular works of art, in all media, were fully demonstrated in the earlier paper. Its relationships to anthropomorphic motifs in the Book of Kells and with sculpture at

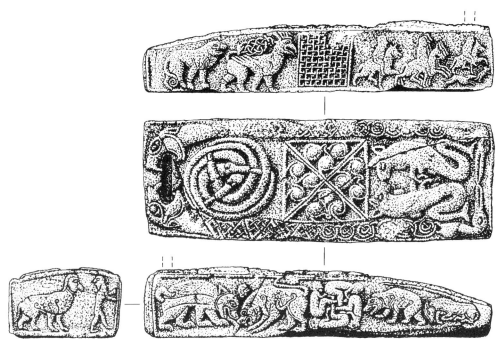

FIGURE 19.7 Meigle 26. (Drawing by John Borland. Crown copyright: RCAHMS)

Meigle were shown to be particularly close.[10] Two of the motifs on the Murthly panel, the confronted hippocamps and the naked man pursued by a fierce beast, are so similar to imagery on the heavily decorated recumbent monument Meigle 26 (Figure 19.7), that they provide clear evidence for the existence of a mechanism that allowed direct repetition of motifs. Confronted hippocamps appear widely in Pictish sculpture, from the graphic elegance of the pair on the front of Aberlemno 2, to plastic renderings such as those at Murthly and Meigle 26. The connection here is not just that of subject-matter, but of design and style. Even the odd body markings surviving on one of the Murthly hippocamps — an attempt to give the exotic creature the traditional body scrolls — are paralleled on the creatures on Meigle 26, which include another classical hybrid, a griffin.

The motif of the naked pedestrian looking back at a pursuing beast has the same identity of connection in theme and style, but there are significant variations. The appearance of the naked man, his gestures and movement, are identical in the Meigle and Murthly sculptures, albeit in reverse. There is, however, a creative difference. On Meigle 26 the pursuing beast has a human head held upright in the manner of human beings. There is, therefore, the opportunity for eye-to-eye contact that heightens the drama of the situation. The Murthly sculptor wanted the animal hunting its prey to have open, fanged jaws, but animals hold their heads down. He therefore angled his lion-like creature so that, without having to alter the pose of the naked man, the two could be in direct confrontation. This device had the further benefit of leaving space for the additional motif of a lizard-like amphibian on the ground line. The lizard

appears as interlinear ornament in the Book of Kells, and the type of carnivore selected by the Murthly sculptor appears elsewhere on Meigle 26.[11] Such alterations give insight into the creation of individual works of art out of shared elements.

The confronted men of Pittensorn is such a universal motif, that there is no difficulty in ascribing a meaning to it — the fate of the lustful in hell. How to interpret the motifs on the Murthly slab is more difficult, and raises important issues about Pictish art and culture. Because of the frieze-like format of the sides of the recumbents and the horizontal panels, it is tempting to suppose that such motifs are eclectic curiosities, laid on surfaces to decorate and amuse, literally superficial in intention. Alternatively, some of these enigmatic motifs have been interpreted as 'learned', important evidence that the Picts were responsive to the contemporary animal-lore more evident in literature than in art. It is certainly the case that some motifs, such as fully articulated griffins seizing domesticated animals, are learned, in that they form part of the evidence that the Picts were, by some means, exposed to Late-Antique animal iconography, and responded enthusiastically to it. This must account, for example, for the appearance of such creatures as the griffin, the hippocamp, the centaur, and *ketos* (the sea dragon), all in surprisingly accurate forms.[12] To recognise this classical vein in Pictish art, and to speculate how the Picts came by it, is only part of the problem it presents. A more fundamental question is why they wanted to represent such imagery? To display erudition, and an awareness of the exotic, would be a reasonable motive for some cultural centres, but carving such themes, in stone, at widely dispersed sites, suggests a pervasive scholarly preoccupation which is scarcely credible.[13] When considering the problem of the significance of marginalia and drolerie in late medieval manuscripts, Meyer Schapiro pointed out that in the search for meanings for such art we are not limited to the alternatives of merely decorative or intentionally symbolic. There were other kinds of meaning, for example, metaphor, parody and humour.[14] It is perfectly possible, indeed probable, that all these types of meaning were simultaneously in play in works of art of this period. They certainly were all employed in the Book of Kells.

The fear of the naked man on the Murthly panel could be a parodic reversal of the hunter and the hunted, which always raised a smile, as it invariably does nowadays. However, if as seems possible, the Pittensorn slab belongs with the Murthly panel, then we are obliged to assume that the imagery is compatible — hell imagery and a parody of hunting belong to different contexts. A gospel text has within it many discrete contexts, a panel has only one. The selection, by the Murthly sculptor, of a ravening beast with a hungry maw to pursue the victim, brings one even closer to universally recognised hell imagery, than do the entangled men. The overwhelmingly favoured metaphor for hell-mouth was the mouth of a lion — the metaphoric 'lion's mouth' from which all Christian souls wished to be saved. In Anglo-Saxon, the double meaning of 'to swallow' as 'to be consumed by fire' added a further layer of meaning. The accompanying amphibian could then be seen, not as an additional denizen of hell, but as the salamander of Physiologus whose nature was to quench fire, a nature compared in that text to the stopping of the mouths of lions.[15]

The location of the hippocamps on the top of the recumbent Meigle 26, shows that they belong with the other paired animal-guardians positioned there, kept apart

from the scenes of animal savagery depicted on the sides below. These protective classical hybrids became metamorphosed in some Pictish sculpture into entirely non-naturalistic S-shaped dragon-headed reptiles, often placed on either side of the cross-shaft, or arching over a figure, invariably without menace. It would seem that these classical hybrids, and the related S-dragons, were being used not just as a display of an exotic touch of decorative animal art, but with the full intention of conveying protection in terms of animal imagery. On the Murthly panel the hippocamps are well suited to be the goal of the naked soul, aware of the oncoming menace of animal jaws. The fact that the amphibian shares with the hippocamp the form of its body, lends support to the view that this creature too has a protective, salvatory meaning.[16]

The motif of hybrid men fighting gives the Murthly panel a particularly arcane look. Why should there be such an image on what might have been part of a tomb shrine, or other church furnishing? Armed men with beast or bird-heads are a feature of Pictish sculpture. They are shown either as single portraits, or in conflict. The Murthly image is significant, for here the hybrids wield not the clubs or archaic-looking axes depicted elsewhere, but weapons and shields which appear contemporary, such as those used in the Aberlemno 2 battle-scene, and in the depiction of a battle-array on the horizontal panel from Dull, Perth and Kinross.[17] The Murthly image is explicitly of contemporary men fighting wearing masks, enacting some ritual connected with folk heroes, who were believed to have the supernatural strength of hybrids. This, then, may also be a metaphor, an image of age-old intractable conflict between opposing forces, transferable to contemporary life. Whether the fighting hybrids are to be regarded as an example of human folly, or still carry with them the heroic overtones of military might, can only be guessed at. It seems apparent, however, that the motif is to do with life on earth, not a remote past, an intentional contrast with the 'last things' symbolised in the hell scene. An important aspect of the new evidence afforded by the imagery of the Pittensorn panel is, therefore, that it allows us to reassess the intellectual and spiritual weight of the striking animal imagery on the Murthly panel. The exploitation of animal imagery, both naturalistic and non-naturalistic, to express the nature of the human condition is a leading characteristic of Pictish art.[18] The Pictish church had ample precedent in the rhetoric of the scriptures, biblical commentaries and the practical discourse of homiletic literature, to justify this means of expressing the concepts of Christianity in its public art.

It is important to remember that the kind of imagery discussed above is not just found on recumbents and horizontal panels. It is widely used on cross-slabs throughout Pictland. It is only because many of these monuments have lost their Christian component that they appear more secular than the cross-slabs.[19] The proposed Pittensorn/Murthly monument, with its imagery concerning this world and the next, also lacks the symbol of the cross, but it was made at a site producing sculpture in the cross-slab format. To some extent this also helps to normalise the apparently bizarre imagery of the Murthly panel.

Certainly the slab from Gellyburn, in spite of the loss of its upper portion, matches the quality and artistic range of the panels. On the front face most of the decoration on the cross-shaft has survived. It is divided into two fields, but unlike

many Pictish crosses there was no decorative distinction between the lower cross-arm and the shaft. The lower field is filled with two-and-a-half roundels of circular interlace, Allen pattern 711.[20] Above, is what Calder called 'debased vinescroll', a description which does not do justice to its interest. The surviving elements consist of three linked S-shaped scrolls, with a remnant of a fourth scroll at the top of the shaft. At the bottom, a single scroll engages with the lowest S-shaped scroll to terminate in a long-snouted animal head which lies horizontally across the width of the shaft. Calder's reconstruction of how a similar head pointed upwards to meet a circular element at the crossing is conjectural. Two of the spandrels created by the S-scrolls contain pellets. Opposite are what appear to be leaf shoots in the manner of 'drop-leaf' scroll, a type that features on St Vigeans 1.[21] The pellets are likely to be stylised, detached berries, such as are found associated with vinescrolls on sculpture at Rosemarkie and Hilton of Cadboll.[22] The introduction of these foliate traces on linked S-shaped scrolls creates an impression of vinescroll, although the continuous stem has been eliminated, a compression of the motif dictated by the scale of the field available. The ends of the spirals second from the bottom are treated as birds with interlinking beaks, a feature not recognised by Calder. This treatment of spirals occurs on a small group of widely dispersed of Pictish monuments (Chapter 5). Given these foliate and animal elements in vertically-stacked interlinked scrolls, it seems that what we have here is not so much a debased vinescroll, but an interesting variant of foliate scroll with the inhabitants reduced to animal heads. The design is comparable to the animal-headed plant-scroll volutes identified in deluxe works of art, notably in metalwork, of the 8th and 9th centuries. These were themselves 'degenerate', in the sense of remoteness from the fully expressed inhabited vinescroll, but full of conscious reinvention, to decorative effect, of an old theme.[23] For the Gellyburn sculptor, the ascending scroll on his cross-shaft was still intended to carry the full eucharistic symbolism of John, 15:1. The sculptor was clearly intent on emphasising the shape of the cross and its decoration, without further distraction, and so left the background plain.

The obvious formal analogies for the encircled, equal-armed cross with expanded interlace-filled terminals on the reverse of the slab, are the circular openwork mounts such as were used for book-covers.[24] There is a group of similar crosses in the sculpture of the far north, with a close analogy carved on the large (1.5m high) cross-marked slab in the churchyard of St Thomas Chapel at Skinnet (Highland) (Figure 19.8). It is, of course, the geometry of the four circular piercings which controls the shape of the Gellyburn equal-armed cross. Most of the crosses of this general type have what Allen described as parabolic hollow angles. The cross on the base of the Ormside Bowl (an object noted for the quality of its inhabited-vine decoration), with its bosses concealing rivets in the angles, creates the same shape as Gellyburn, for similar practical reasons.[25] The question arises of whether the carving of the two distinct types of cross had the additional benefit of conferring different meanings. The cross on the front, with its long shaft, and decoration redolent of the means of salvation brought about by Christ's death on the cross, could well have been seen as an instructive contrast with the encircled, equal-armed cross, with its ultimate

FIGURE 19.8 Cross-marked stone in St Thomas Chapel, Skinnet by Halkirk, Caithness. (Crown copyright: RCAHMS)

overtones of a triumphal cross garlanded with a wreath, and its general acceptance as a mark of consecration.

The choice of a contrasting equal-armed cross on the back face, whether or not motivated by a differing symbolic significance, was certainly to some degree conditioned by the need to make room for the display of the Pictish symbols. The extent to which cross and symbols are displayed in close conjunction on cross-slabs undermines the commonly held, simplistic view that the Picts put their crosses on one side and the symbols on the other. The particular interest of the Gellyburn Pictish beast symbol is its similarity, in cut and design, with the same symbol on the side of Meigle 5 (Figure 19.9). The jut of the brow, the beaky snout, the sharp angle of the lappet, the broad ungainly limbs, are all similar. Most significant of all is the shared use of the body scroll system appropriate to quadrupeds, rather than to the beast symbol. This anomaly is on a par with the use of identical terminals for the V-shaped rod of the crescent symbol at Gellyburn. Here, it is the basic symbol shape that matters, not the minor design characteristics. The connection with Meigle 5 is reinforced by its display of an equal-armed cross on the front face. The Meigle cross is set on a base filled with interlace of the same pattern as that used for the lower section of the Gellyburn cross-shaft. The long-snouted beasts with pricked ears, that decorate the corners of the Meigle base, also resemble the head of the creature that terminates the pseudo-vinescroll of Gellyburn. These close connections with a Meigle monument are exactly what was found when considering the context of the Murthly

FIGURE 19.9 Meigle 5. (©Tom Gray. Tom and Sybil Gray Collection)

panel, and confirm that the cross-slab and the Pittensorn/Murthly monument were produced in the same sculptural milieu. A final observation concerns the economical way in which the sculptor prepared the back of the slab. He cut back only those parts of the surface that were between the symbols, giving them the effect of relief without additional labour. This has nothing to do with being unfinished work, but is simply a mark of the intelligence that characterises the work of the Gellyburn sculptor, whom we should now, more correctly, describe as a sculptor working at Murthly.

LANDSCAPE CONTEXT

Previous discussion of the Pittensorn fragment addressed its landscape context through an examination of sites, artefacts and place-names in the vicinity. A broad case was made for a hitherto-unrecognised church centre in the Murthly area. The proximity of the findspots of the three pieces of sculpture from Murthly, and their immediate landscape situation, makes a very persuasive case for a local site, and the veracity of this we will now examine.

Lost and found

The Pittensorn fragment was found in the garden close to the west wall of Pittensorn farmhouse around 1990. The Gellyburn cross-slab was found, in two pieces, in 1949 during house renovations at Rose Cottage, Gellyburn,[26] and the Murthly panel was found in 1885 in a field belonging to the Gellyburn Farina Works, Murthly.[27] The field is probably that centred on NGR NO 0938 3928 (now wooded land beside the improved B9099 Caputh road, the woods extend over the site of the Farina works and down to the River Tay), or NGR NO 0909 3928 (running up to Pittensorn Farm). The circumstances of the discovery, as recorded by Hutcheson,[28] indicate that the slab was accompanied by a second, plain slab, a supporting setting of stones and possible traces of a human burial, which he took to be a secondary use of the panel. This and the fact that the panel's original purpose is most likely to have been as part of a tomb-shrine certainly argue for a church site in the immediate area.

In the place-name analysis carried out by Simon Taylor, probably the nearest early ecclesiastical association that could be recognised was through the name Inchewan, some 5km up the Tay from Murthly. 'Inch Ewyn' is marked on Pont's 16th-century map of Lower Strath Tay,[29] but it is not clear whether a chapel is indicated. The name itself need not indicate a chapel site. It could simply indicate that the produce from this land went to support some aspect of the cult of St Ewan (the name Inchewan contains the Gaelic personal name Ewan, 'from Eoghan', presumably a reference to St Ewan).[30] His cult may be indicated in the Stormont-Strath Tay area by the presence of the similarly named Innishewan Farm on Loch Tayside.[31] Nearer to Inchewan, an unlocated St Ewan's chapel is recorded for Caputh parish (NMRS NO04 SE28), possibly that at Kincairney (NGR NO 0840 4399). It would be feasible for this to be the church which the lands of Inchewan supported.[32] While these clues help to indicate a probable early church presence in the vicinity (and could offer a context for the Celtic hand-bell held by Little Dunkeld Church), they seem to be not quite close enough to Murthly to account for the three sculptures. There may have

been a nearer church. Pont's map referred to above, clearly indicates a chapel on the eastern side of Murthly Castle, which is close to the Murthly findspots. Though its position in relation to Murthly Castle is wrong, it is most likely that this is intended to indicate the Castle chapel. The present chapel was built as an extension of an older mortuary chapel in 1846, and given a new dedication to St Antony the Eremite.[33] Its earlier history is opaque but presumably of some longevity, like that of the estate of which it is part. The barony of Murthly may have originated as a thanage, before it passed to the de Ireland family in the 14th century.[34] Any earlier chapel attached to the estate may then have become proprietorial and moved, if necessary, nearer to the new castle residence.

Returning to Hutcheson's account of the Murthly panel, he also records the tradition of a chapel standing in the field where the panel was found.[35] No trace of this building has ever been found, but it may have been removed by the Farina Mill that occupied the supposed site from the mid-19th century. The Mill ruin still stands within a curtain of its demolition rubble, at NGR NO 0947 3928. An excavation programme at the site could potentially clarify the question of a chapel. It may be that this was the original chapel site later moved nearer to Murthly Castle.

When the Gellyburn cross-slab was found in 1949, it was recorded by Charles Calder of the RCAHMS. Correspondence in Perth Museum and Art Gallery shows that Calder visited the site, and also Pittensorn Farm, to enquire about a further piece of sculpture. The occupier recalled a sculptured stone lying about the farm, but it could not be found when Calder visited, a cause for surprise for the occupier, as she said it was a large stone. Her description of it included a pair of shears carved on it, and she also spoke of an 'old graveyard' in a nearby field. The graveyard may have been no more than a received memory about the discovery of the Murthly panel, some 70 years previously. The stone carved with shears, Calder observed, implies a much later burial tradition, that of the 17th–18th centuries, and would seem to be at odds with a memory of the Murthly panel discovery. A simple description of 'shears', however, could describe a grave-slab of any date from the 9th to the 18th centuries, shears being a common motif in medieval and later grave-slab art.[36] A stone fitting this basic description was seen by Mark Hall in 1999. It was one of two fragments of two 17th–18th-century grave-slabs set in the ground beside the farmhouse at Broompark, Murthly, less than 1km from the Gellyburn findspots. Local enquiries failed to elucidate the original location of the slabs or any surviving tradition of a graveyard in the immediate vicinity, though the originating of the slabs in the old graveyard of Caputh cannot be discounted. Physically, of course, such sites can easily leave no trace, particularly when demolished. Witness the church of Inchadney, near Kenmore, demolished in the early 19th century,[37] but still remembered in solid oral and written traditions. The tradition at Murthly is much more elusive, and strangely so if there were burials in its graveyard in the 17th or 18th centuries. In the early 19th century, Joseph Chalmers comprehensively surveyed the Murthly estate lands. The relevant maps for the Murthly area[38] make no record of a church or graveyard. This is puzzling in the context of a very detailed survey and of a tradition, if authentic, of a church or graveyard recognised at the end of the 19th century and in the middle of the 20th century.

Places of assembly: naming your ground

If we shift the focus slightly, we cannot resolve this conundrum, but we can see that a local site is probable. Perhaps the most significant place-name to come out of Simon Taylor's Pittensorn analysis is that of Murthly.[39] It derives from Gaelic *mòrthulach*, meaning 'big mound, big hillock'. In Irish Gaelic *tulach* besides having the same meaning as Scottish Gaelic *tulach*, seems also to have meant 'assembly mound, mound of judgement', presided over by a judge appointed either by church or state,[40] and this may also have been the case in Scotland. The Scots word for such mounds is *moothill*,[41] and two particularly important examples are the moothills of Scone and Govan. Examples of the same broad phenomenon occur, but with varying lines of cultural development: Gaelic for Scone (cf Dunadd, Argyll and Bute, and Tara, Co Meath, Ireland) and Scandinavian for Govan (cf Tinwald, Dumfriesshire; Tynwald, Isle of Man and Thingmote, Dublin).[42] A striking contiguity has been demonstrated at both sites for their combinations of church and mound.[43]

The Murthly area has further indications of meeting places. Just across the River Tay, north by no more than 1.5km is Caputh. Here, the newly erected parish church (Caputh was originally part of Little Dunkeld Parish) for the newly created parish of about 1500, was built on top of the *Mutehill*.[44] The account is repeated in the *OSA* where it is also recorded that the Mute Hill is now the Kirk Hill and that it was a place for administering justice, situated 238m from the bank of the River Tay.[45] This church was abandoned in the 19th century, in favour of a new church built a short distance to the east of the mound. Close beside the old church stood a cairn, still visible at the time of the *OSA* and the *NSA*,[46] known as the Crosscairn. This name appears on the first edition OS map of 1867 but disappears thereafter, though it continues on the 1:10,000 maps as Crosscairn Cottage. The proximity of a cairn that may have carried a cross, to a moothill site, surely confirms its importance as a place of assembly. Though not in the same league, it recalls the similar combination of mound and cross at Scone, as depicted in Alexander III's coronation scene at Moot Hill, in the *Scotichronicon*.[47] Nothing of the original Caputh church stands today but the very large mound, still used as a graveyard (Figure 19.10). Its large size, steepness and proximity to the River Tay suggests a natural mound, but one that has been heavily landscaped (perhaps, in the first instance, to serve as a prehistoric cairn). The graveyard wall sits on top of the mound (except on the north where it runs down to the roadside, so as to encompass more land), and is of at least two distinct phases on two separate lines. Flat-topped, it is broader at the eastern end, tapering markedly to the north. Less than 30m separates it from the Crosscairn (still discernible as a low mound).

Murthly and Caputh are situated opposite each other, approximately east–west, across the River Tay. Both are set within a once-rich prehistoric landscape of standing stones, stone circles and cairns. This is less evident than at the time of the *OSA*, when it was recorded that the district around Caputh could boast several very large cairns, including Cairn Muir (from Gaelic *càrn mòr*, 'big cairn'), with a circumference of 139m and which is now a very denuded pile of stones.[48] Commanding the bend of the Tay which unwinds between Murthly and Caputh is the Iron-Age hill-fort at Stenton,

FIGURE 19.10
Caputh mound.
(© Perth Museum &
Art Gallery, Perth and
Kinross Council)

known as Kemp's Hold. Kemp is a legendary figure from the ON *kempa*, meaning champion or fighter (best known from the later Scottish ballad of Kemp Owyne), and his name applied to a hill-fort implies a vigorous reinterpretation of the prehistoric landscape.[49] On the Murthly side of the river, there still survives a very large standing stone near Murthly Castle, and on the outskirts of Murthly is the stone circle known as the Druid's Circle. The Murthly area later saw a seemingly high concentration of thanages, notably Murthly, Caputh and the neighbouring (to the east) Kinclaven.[50] The latter had a 'court hill', an important feature of estate and political administration, again reflecting the importance of places of administration. Often their place-names are a variation of *cuthill* (from the Gaelic *comhdhail*, 'assembly, meeting, conference'). These have been identified as popular courts,[51] often using ancient cairns, standing stones, stone circles or prominent natural places for their siting.[52] Near Caputh, one has been identified at *Culthill* (NGR NO 097 418). The *cuthill* in question may have been held at Cairn Muir (NGR NO 098 423) or an unnamed tumulus at NGR NO 099 413.[53] Wherever it was held, it must have been on the lands of Gourdie as the reconstructed early forms of this place-name are *Cuthilgourdie.

Are we seeing, around Murthly and Caputh the conscious reuse of the prehistoric landscape along the lines suggested by Driscoll? He cited Forteviot and Scone as prime examples, but suggested their occurrence at a range of socio-political levels.[54] In the initial Pittensorn paper it was noted that the Tay seems to have been the boundary between the territories of Fortriu/Fortrenn, Atholl and Gowrie.[55] This may have given the situational opposition of Murthly and Caputh additional significance. The poorly documented development of the parishes in the Dunkeld area offers no help in clarifying this relationship.[56]

East of Murthly there are early church sites on mounds in St Vigeans, Eassie and Kirkinch (near Nevay), Angus. Nevay is part of the *nemeton* group of place-names, which in Scotland, as in Gaul and Ireland, have the meaning of 'sacred place', originally pagan, often with a meeting-place, judgmental purpose.[57] The present

church ruin at Kirkinch is a later medieval chapel. An early church site is possible, and only 1km or so to the east is the important early medieval church centre of Meigle, whilst a similar distance to the north-west lies Eassie Church, with its early medieval cross-slab. In the earlier Pittensorn paper Taylor drew attention to the mound and church indicated by the name Mortlach, Moray, which means the same as Murthly, 'big mound, big hillock'. Caputh Church is much later, but still significant — was Dunkeld giving a pedigree of longevity to its new parish of Caputh by siting the church on the assembly mound, which may have had an old relationship with the Church? At Struan, in Atholl (Perth and Kinross), the mound (*Tom an Tigh Mhor*, 'knoll of the big house') is seen as a motte or lordly residence. But, as the mound incorporates a natural spring, venerated as a holy well, and sits on the scarp of a river-bank, this would seem highly unlikely. The adjacent church of St Fillan's (from where come three early medieval sculptures and a quadrangular handbell), itself sits on a natural knoll overlooking the confluence of two rivers. An ancient fair, *Féill Faoláin*, was held between the two mounds, and its presence is suggestive of a suite of activities at such sites: the dispensing of law and justice, the association with ecclesiastical authority and the holding of a fair.[58] Similarly, one could cite the remains of the former parish church at Tulliebole, near Crook of Devon. Tulliebole derives from the Gaelic for '(place of) the mound of the church'. A partially quarried-away mound stands close-by on the north side of the churchyard, which also houses a 10th–11th-century hogback tombstone, and formerly housed an 8th–9th-century cross-slab. Some 3.2km east of the church is Coldrain (now Wester, Middle and Easter Coldrain), a *comhdhail* place-name, meaning 'moot or small court of (the) thorn', and associated with Thorn Knowe, just south of Easter Coldrain.[59] The potential smaller scale of some mounds, and an ecclesiastical linkage, is suggested by the Glen Lyon mound *Tom à Mhóid* ('the moot-knoll'), bearing an upright, plainly incised cross-slab.[60] Some 7th–8th-century minster churches were built on prominent, elevated places, including that built on the mound raised on the spot of St Boniface's martyrdom in Germany.[61] In thinking about these associations, we should also keep in mind that the crucifixion took place on a mound, frequently symbolised by sculpted crosses mounted in pyramidal and stepped bases (Chapter 6). The association of churches physically on top of mounds could have reflected the same symbolism.[62] The importance of mounds and their associations with the Almighty was also reflected in the cult of relics. The *Old English Relic-list* of Exeter Cathedral, listing the relics donated by King Athelstan, includes earth 'From Mount Sinai whereupon God led the holy man, Moses, and revealed to him the old law', '. . . from the mount upon which our Lord fasted' and 'From Mount Olivet, upon which the Saviour himself prayed to his heavenly father . . . and afterwards he ascended into heaven from the same hill'.[63]

CONCLUSION

The weight of the evidence of all three pieces of sculpture, from a tightly focused series of findspots in the Murthly area, implies their dispersal from a local source. This seems more plausible than the sculptures having achieved dispersal-proximity from a number of more distant centres, or one such centre, such as Dunkeld. The

austerity and sophistication of the Gellyburn cross-slab may appear very different from the bold, explicit imagery on the panels from Pittensorn and Murthly. The kind of imagery used on the panels is, however, found in all media, on high quality sculpture and in manuscript art. All three carvings reveal the presence of discerning patrons, able to command sculptors who could produce work suitable for high-status monuments, functioning possibly in different ways, but most probably sharing a concern with life after death. The geological linkage strengthens the argument that all this sculpture is a product of local manufacture at or for a hitherto undocumented, unrecognised church of some importance.

A fresh examination of the landscape context lends weight to the Murthly-Caputh area having been territorially and administratively significant enough to support such a church site. Analogy with other sites allows a persuasive case to be made for a church site associated with the infrastructure indicated for Murthly-Caputh, and possibly linked to the Murthly thanage by way of patronage, and possibly with a mound of assembly. The examples of mounds cited in the text demonstrate that further work is needed to clarify both the different types of mounds and any relationships with the Church. At a broader, more speculative level, we can contextualise the development of a church site in this area with the general growth of the Church, as associated with the transformation of Pictland and its provinces into Alba and its mormaerdoms. Its demise may possibly be linked with the growing authority of the church at Dunkeld, and to the changing tastes of a new generation of Murthly patrons.

ACKNOWLEDGEMENTS

Advice, information and other assistance was gratefully received from Mark Simmons (Perth Museum), Iain Fraser (RCAHMS), Katherine Forsyth (Glasgow University), Nigel King (former Murthly Estate factor), Jerry O'Sullivan, Ross Trench-Jellicoe and Alison Sheridan (NMS). Steve Driscoll kindly showed Mark Hall a draft of his paper on Scone, forthcoming, in what promises to be an important volume on the study of assembly mounds from across Europe. Mark Hall would like to offer special thanks to our 'silent partner', Simon Taylor, without whose comment and consideration the place-name analysis could not have been woven in. Any remaining deficiencies are, of course, mine and not his. As editor of the paper any remaining errors are my responsibility.

NOTES

[1] Hall *et al* 1998, 129–44.
[2] The Pittensorn and Gellyburn sculptures are in Perth Museum and Art Gallery, accession numbers 1995.319 and 6/1949 respectively. The Murthly panel is in the National Museums of Scotland, accession number 1B/101.
[3] Compare Alkemade 1997, 180–93, and Geary 1985, especially 48–9. For a useful muddying of the waters in weighing up questions of status, identity and the desire for the exotic, in an Insular context, see Graham-Campbell 2001, 27–38.
[4] Hall *et al* 1998, 129–31.
[5] Information about the nature of the back of the panel was kindly supplied by Jim Wilson of the National Museums of Scotland.
[6] The necessary dismantling of the display of Pictish sculpture in Groam House Museum revealed many unrecorded grooves and rebates. This information is available on the Scottish Cultural Resources Access Network, http://www.scran.co.uk
[7] *ECMS* III, 300, 337, 303.
[8] Calder 1951, 175–7, Pl 18.

9. Miller and Ruckley 2001, Fig 1; Armstrong *et al* 1985, 94.
10. Hall *et al* 1998, 131–6.
11. Meehan 1994, Illus 104.
12. Henderson 1997, 25–7.
13. The new finds of sculpture at Portmahomack, Tarbat, confirm, what was already becoming evident, that there is no difference in format and taste between the sculpture of the Pictish regions to the north and south of the Grampians.
14. Schapiro 1980, 197–8.
15. On the Anglo-Saxon verb '*swelgan*', see Clemoes 1995, 64. For the salamander in Physiologus, see Physiologus 1979, 61.
16. The spotted lizard in the Book of Kells which resembles the Murthly amphibian (referred to in n11), is used as a guide to a run-over line of text within Matthew 14, where Christ comes down from the mountain where he has been praying, and walks out over the sea to reassure the stormbound disciples. The Kells amphibian, slithering down from the word *montem*, may refer to Christ's comparable effectiveness on both land and water.
17. *ECMS* III, 315, Fig 329.
18. Henderson 1997, 51–2.
19. For the view that the recumbents, and the sculpture at Meigle in particular, is less secular than is often claimed, see Henderson and Henderson 2004, 198–202.
20. *ECMS* II, 282.
21. Cramp 1984b, xxv; Henderson 1983, 265, Fig 113c.
22. For Rosemarkie, Henderson 1983, 261, Fig 112a; the lower border of vinescroll with detached berries, on the front face of the Hilton of Cadboll, is not fully published, but see Figure 3.1.
23. Webster and Backhouse 1991, 171.
24. Webster and Backhouse 1991, 141–2.
25. Webster and Backhouse 1991, 172.
26. Calder 1951, 174–5. Whilst the reuse of this significant cross-slab in an 18th–19th century cottage adds little to our understanding of its original context, beyond indicating a local availability of the cross-slab for such reuse, it does raise questions about the nature of that reuse. According to the letter sent to Perth Museum in 1949, by Mr K Rowlands, the finder, it was found 'While lifting an old wooden floor . . . packing up the joists . . .'. Taken at face value and following Occam's razor this looks to be no more than the prosaic, economically expedient reuse of a convenient piece of stone. However, the circumstances of the reuse, as far as we can see them, with the sculpture being used or added to the foundations of the property, may also suggest an individual response to the sculpture, which saw its Christian symbolism as having a protective, apotropaic effect.
27. Hutcheson 1886, 252–4.
28. Hutcheson 1886, 254.
29. Pont 24, see Stone 1989, 136–7.
30. Simon Taylor pers comm.
31. Christie 1892, 58.
32. Simon Taylor pers comm.
33. Macaulay 1997, 33 and Fig 37; Graham and Christie 1850.
34. Rogers 1992, 396.
35. Rogers 1992, 396.
36. For medieval examples, see Steer and Bannerman 1977; and Ryder 1991.
37. Gillies 1938, 54–7; Christie 1892, 16–29.
38. Chalmers 1825, Nos 14 and 15.
39. Simon Taylor pers comm.
40. Swift 1996, 1–26, especially 18–19.
41. Hall *et al* 1998, 139–40.
42. For Scone see RCAHMS 1994, 124–6; Driscoll 1998a, 152–3; 2004. For Govan see Driscoll 1998c, 101–5. For the Scandinavian background in Scotland see Crawford 1987, 206–10. For Tara see Newman 1998, 127–42.
43. Linking churches with mounds and existing places of assembly was politically astute but would surely have had extra resonance through the association of high place with the giving of God's (moral) laws, notably the Ten Commandments (Exodus 33 and 34) and Christ's Sermon on the Mount (Matthew 5). Churches too were meeting places — holy ground where encounters took place between the human and the divine, between the earthly and the heavenly, the natural and the supernatural, the material and the spiritual, the temporal and the eternal. This insight comes from Morris 1989, 4, quoting Cope 1972, 6–8. The cross-mound relationship is depicted in other forms of material culture, notably coins. Between the 6th and 11th centuries a variety of crosses (generally elaborations of a crosslet type of cross) standing on two, three or four stepped bases occurs on the reverses of Byzantine coins, presumably representing Calvary and/or a shrine in Constantinople. For examples see Sear 1987 and Whitting 1973. They certainly echo such manuscript illuminations as that (fol 67) showing the crucifixion in the 9th-century *Khludov Psalter*, produced in Constantinople. The cross is shown on a three-tiered rock or hillock, see Cormack 2000, Fig 57.
44. Myln, *Vitae* in *Dunk Rent* 312.
45. Innerarity 1793, 486.
46. Innerarity 1793, 505; Wilson 1845, 676. The details are repeated, but not extended, in the OS Name Book (Perthshire), No 13, 155.
47. Corpus Christi College MS 171, fol 206; Taylor and Watt 1990, Pl 1, Bk X Ch 2; 435 and especially n4; Higgitt 1998, 172–4.
48. Innerarity 1793, 505; RCAHMS 1994, 15.
49. For Kemp folklore, see Leach 1950, 573; and Sargent and Kittredge 1904, 59–61. At the other

end of Strathmore from Murthly Kemp again appears, at Kemp's Castle, Turin Hill, Forfar. Between the two forts is Kemphill, beside the River Isla, north of Coupar Angus (and where cropmarks indicate the presence of round-houses and a ring-ditch).

[50] Rogers 1992, 377, 393–7. The only known thanage that has come down to us via historical records is the royal one of Kinclaven. Rogers conjectures a complex picture of multiple estates in the Dunkeld area, including Murthly, that were a mixture of royal, church and noble possessions. He suggests Murthly may have been one of several multiple estates 'associated with the abbey of Dunkeld' (and later providing the basis of the parish of Little Dunkeld) 'before falling into lay control, including that of the royal lay abbots, in the period before the 12th century' (Rogers 1992, 397).

[51] Barrow 1981, 1–24; 1983, 27–8; 1992, 217–46.

[52] Significant natural places clearly included river confluences, as the names Strowan (near Crieff) and Struan (Atholl) imply. Both mean 'meeting place of streams'. At Struan, one of the rivers is the Errochty, from the Gaelic for 'meeting place'. Both places have mounds and early churches/sculptures. See Hall et al 2000.

[53] Simon Taylor pers comm.

[54] Driscoll 1998a, 153.

[55] RCAHMS 1994, 124–6; Broun 2000, 24–42 has a full discussion of the possible locations of these territories.

[56] Rogers 1992, 397.

[57] For discussion of the *nemeton* element, see Watson 1926, 244–50; Barrow 1998a, 56–9; 1998b, 25–32.

[58] For Struan see Hall et al 2000, 176; Watson 1926, 439; Kerr 1995, 43; 1992, 3–8. The conjunction of mound, church and fair and all that implies certainly occurred at Tinwald, Isle of Man (Andrew Johnson pers comm). For a fuller discussion and references to fairs and their association with churches and meeting places, see Hall 2004.

[59] I am grateful to Simon Taylor for his elucidation of the Tulliebole and Coldrain place-names and his observations on their respective mounds. For the Tulliebole cross-slab see *ECMS* III, 375 and RCAHMS 1933, 295. For the hogback see Robertson 1991, 71. For Thorn Knowe see RCAHMS 1933, 296. The thorn either refers to a significant tree or, more likely, a significant place delimited by a thorn hedge (Simon Taylor pers comm).

[60] Watson 1926, 27.

[61] Blair 1992, 230 n15. I suspect churches built on top of burial mounds are commoner than has been perceived, for example in Jersey the church of La Hogue Bie is built on top of a Neolithic tomb (see Patton et al 1999), and I am grateful to Niall Robertson for reminding me that the now-ruined church at Faskally, near Pitlochry (Perth and Kinross), which boasts two fragments of early medieval sculpture, is clearly built on top of a prehistoric barrow.

[62] For a more general discussion of the cultural importance of high places, see Schama 1996, 385–513.

[63] Connor 1993, 179 (within the appendix on *The Records of Relics at Exeter*). See also n43 above.

CHAPTER 20

KNOW YOUR PROPERTIES, RECOGNISE THE POSSIBILITIES: HISTORIC SCOTLAND'S STRATEGY FOR THE INTERPRETATION OF EARLY MEDIEVAL SCULPTURE IN ITS CARE

By Sally M Foster

Historic Scotland is fortunate enough to be responsible for over 350 examples of early medieval sculpture (Figure 20.1). This includes some of the most spectacular examples, the oldest Christian memorials in Scotland and the best preserved surviving examples of certain categories of sculpture, notably the free-standing cross. Our Properties in Care (PIC) also include the largest and many of the most significant surviving collections — Iona, Whithorn, Meigle, St Vigeans and St Andrews — as well as a lot of the most significant individual sculptures or small assemblages which are still associated with their original sites. A small but significant number of these are still *in situ*. As a general rule, the cultural significance of nearly all the material for which we are responsible is considerably enhanced by its continuing association with the sites from which it comes.

KNOW YOUR MONUMENTS

With such riches comes enormous responsibility, not simply to protect, but also to promote understanding and enjoyment. To date interpretation has tended, with notable exceptions,[1] to be developed for individual sites as circumstances have permitted and without a long-term strategy in place to develop the links between collections. Recognising that the potential exists for us to take an imaginative lead in the interpretation of carved stones and to develop links between the sculpture we and others care for, an Interpretation Plan for the *Early Medieval Carved Stones in Historic Scotland's Care* has been prepared.[2] This has the objective of demonstrating how these sculptures might be interpreted and presented to the public. It relates specifically to sculpture in Historic Scotland's care, but seeks to identify ways in which we might work with others, not least to maximise opportunities for integrated interpretation, and also to avoid unnecessary or inappropriate duplication of effort. It is an overarching plan that provides a framework within which plans for individual sites might be developed in the future, although it is by no means 'written in stone'.

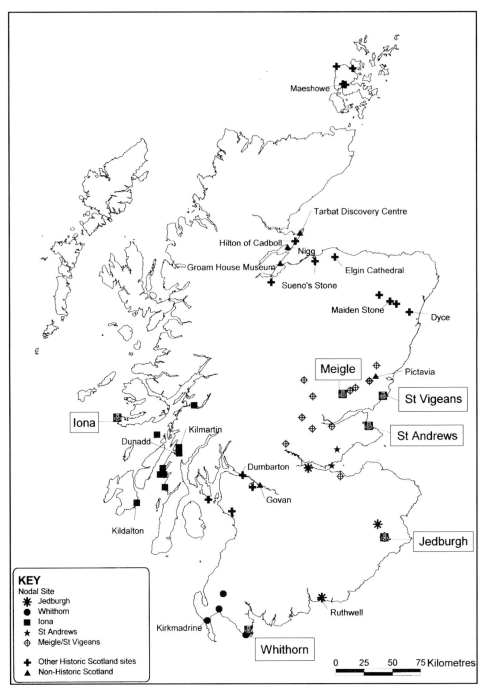

FIGURE 20.1 Distribution of early medieval sculpture in the care of Historic Scotland. (Crown copyright: Historic Scotland)

The need for such a plan was first identified in 1998 as part of a national strategy for PIC prepared by Chris Tabraham, Principal Inspector of Ancient Monuments whose responsibilities then included PIC interpretation strategy. This plan noted that of our sites of early medieval date almost all are unstaffed and with the capacity only for basic interpretation. Over half the sites are carved stones (to which list of 30 monuments we can also add those monuments that simply include some early medieval sculpture). It suggested that interpretation at each site should concentrate on the intrinsic content while ensuring that the visitor is encouraged to visit staffed sites for more in-depth interpretation.[3]

The aim in what follows is to provide an insight into how these initial thoughts have developed and the types of possibilities we have identified (see Chapter 21 for a specific example of how this might work in practice). We hope to have learnt from the types of approaches that have been taken elsewhere by others, notably local authorities and museum services.[4] The Plan identifies what we might practically do at our own hand with the monuments that we are responsible for, while indicating where there is scope for linking with others, whether at their or our own initiative.

In-house production of Interpretation Plans follows the set formula of the time within the context of our internal policy for the monuments in State care.[5] The priorities for action are determined within the overall context of PIC resources and priorities for the Estate of 330 or so monuments as a whole. Since April 2003 the lead for planning and implementation of interpretation now rests with a newly formed Interpretation Unit within our PIC Division, and changes to our interpretative planning process are in progress.

As defined until 2003, an Interpretation Plan was divided into two parts. The first is a succinct, factually-based analysis focusing on three Ps: Property, Public and Price. The second is a more detailed examination of the site and its potential, if any, for interpretation. This seeks to identify and address core issues, highlight constraints and propose possibilities.

Know your Property is a statement of the site's importance, highlighting unique or unusual features but also stressing any significant areas of concern. *Know your Public* is a profile of current visitors, including school visits, where known. In our case there is considerable public interest in the sculpture of the early medieval period, not simply because of an appreciation of its artistic qualities and craftsmanship, but because it creates a sense of place, local identity and engagement with the all too intangible past. Having said that, Historic Scotland's staffed monuments dedicated to early medieval sculpture attract relatively few visitors — around 2500 per annum at Meigle and 5000 at Whithorn. We do not have visitor figures for unstaffed monuments. (Other sites embrace significant stone collections as part of their overall visitor attractions and we cannot dissect how many of the visitors there come because of the carved stones.) *Know your Price* is a statement of the site's value in terms of heritage value and commercial potential sufficient to allow a rough financial appraisal to be made. In the case of early medieval sculpture this calls for a strategy which recognises the wide range of audiences (achieved and potential), the fact that their needs can be met through on- and off-site media, and that the latter has potential retail value. We need to bear in mind that the nature and level of interpretation and any staffing

provided has to be appropriate and commensurate with the Agency's overall priorities.

Core Issues is an identification of the fundamental problems and potential of the site, which is followed by an assessment of how these fundamental issues might be resolved. *Constraints* is an analysis of how any interpretation should respect the conservation needs of the site — in our case, the fragility of the resource, treatment of carved stone surfaces, requirements of statutory protection and consultation, cleaning, avoidance of damage, space for display, mounting, storage and restoration of sculpture. Finally, *Possibilities* is an exploration of the options for interpretation, including management of visitors, selection of topics, choice of media, etc.

Identification of Core Issues, how to address them, and the *Possibilities* are the meaty and most interesting bits of any plan. The intention in what follows is to raise a few of the issues we have identified in the case of early medieval sculpture before summarising what the future possibilities might be.

An obvious point is that the collection in Historic Scotland's care is not fully representative of early medieval sculpture in Scotland, neither in the sense of its geographical diversity nor range. We are not out to stamp-collect and actively fill gaps, but we need to acknowledge that these gaps exist in identifying the future possibilities.

When it comes to linking sites and material, we readily acknowledge that there is no Historic Scotland literature linking early medieval sculpture *as a whole* across our Estate and limited material encouraging visitors to tour Historic Scotland and *non*-Historic Scotland related monuments in a given area.

The greatest service we can provide for our audiences is to start making these connections, thus enabling an appreciation of fully articulated cultural landscapes of our past rather than just a bundle of disjointed, isolated sites. We will return later to the suggested concept of nodal sites as the vehicle for coherent future interpretation.

Taking an overview of the extant Historic Scotland interpretative provision, we can see that the availability of information and interpretation is variable and not fully attuned to the needs of today's different audiences. In the jargon of interpretation, audiences (both on- and off-site) can be categorised as streakers, browsers and studiers. We therefore have the opportunity to consider a revised and expanded range of literature and promotional products, using both conventional media and new techniques. Our aim ought to be to capture and facilitate greater interest through a nested hierarchy of media, with an emphasis on the provision of eye-catching visual information. We also need to recognise and reflect the geographical diversity of this material — the uniqueness of each site and the character of each area should not get lost in any overarching scheme.

What is clear, and only appropriate, is that while there are interpretative materials and supporting promotional structures that Historic Scotland is best placed to provide given our responsibilities, we need not, indeed do not, expect to be the most appropriate body to produce interpretative material for all sculpture. There is much that we and others might work together to produce and that we ought simply to encourage others to do. And of course there is much that others have already done at their own hand, for instance the *Angus* (Chapter 22) and *Highland Pictish Trails*,

welcome local initiatives that embrace some of the monuments we are responsible for.

Interpretation can only be based on the best available evidence, yet scratch beneath the surface and you will discover that a significant number of monuments, including some of the best known in Scotland, are by no means well recorded or understood. What may have seemed wonderful 100 years ago is not fit for today's purposes (Chapters 13 and 14). Historic Scotland obviously has to review its own internal recording standards for carved stones, notably for monitoring purposes. More relevant in this context, in partnership with relevant bodies we suggest there is a case for putting together a prioritised programme for recording and related research — research that embraces not just the content of the sculpture but also its context (Chapter 11). Where this requires additional funds, the sources for this also need to be clearly identified.

Conveying understanding and appreciation is a big challenge. Sculpture is not just an artistic treasure, but an element of the wider archaeological landscape, and its relevance and value vary between different communities. As Joseph Anderson cautioned, it is only a small part of a great field of the art of Christendom.[6] We need to communicate the fact that sculpture was only one of a range of media, and not necessarily that which was most highly prized at the time. It is, of course, the most durable media and our audiences can be forgiven for thinking it might have been the only one. In many publications there is a tendency for it to be used to illustrate the bigger historical picture rather than to tell its own story. Yet sculptures are a source of wonderment and pride to people whose so-called barbarian ancestors produced it,[7] so how we use this medium to shed light on the intellectual horizons and widespread connections of early medieval peoples is important. There is the issue of how we choose to convey the complexity and layers of meaning of these monuments, not least to an audience brought up in a predominantly secular or multi-faith society. Most were designed to be contemplative monuments — see, for instance, the verbal and visual riddles of the Ruthwell Cross — and the modern public needs also to contemplate them. The surroundings ought to be conducive to this end. In addition, on-site interpretative provision will ideally provide sufficient visually-orientated information for the visitor to be able to make their own discoveries. Literature that may be read off-site is invaluable but no substitute for capturing the imagination and interest of the visitor *in front of* the sculpture. We also have the scope for a more ethnographic approach, putting the people back into the sculpture. Likewise, antiquarian involvement in early medieval carved stones (Chapter 15) or the biographies of individual monuments are fascinating aspects of Scottish history in their own right and one usually of particular local interest (see, for instance, Chapters 3, 9, 19). Where the opportunities exist, these angles could also be given more coverage.[8] Legislation reinforces our desire to also address the special needs of those visitors with physical and intellectual disabilities.[9]

The physical presentation of the sculpture is very important if visitors are to appreciate it to its best advantage. Challenges include conveying a sense of the monumentality, original function and historic setting of the material. Much can be done simply through improved lighting or re-display.[10] Having sufficient space to step

back and view from an appropriate distance all sides of a monument is the ideal (however small a fragment, see Chapter 5), and competing historical or visual juxtapositions ought normally to be avoided. Where there is a wealth of material this does mean that consideration has to be given to prime display of key material, while ensuring that the remainder is fully accessible for public inspection (as at Jedburgh, Scottish Borders, and St Andrews).

The tools at our disposal, notably electronic media, are developing rapidly. Advantages include meeting the needs of those who cannot reach a monument, for whatever reasons. It also provides the means (Chapter 24) to reconstruct three-dimensional sculptures in virtual landscapes. How we explain context and encourage visitors to look and think beyond the visitor centre or individual monument to the landscape around them is crucial. Take St Vigeans, an 8th–10th-century centre of secular, probably royal patronage. Here the visitor needs to make the links beyond the walls of the small cottage that a local benefactor donated to house the sculpture, to the prominent church mound where it was found, and beyond that to the related sites of early medieval southern Pictland.

POSSIBILITIES

So where does this leave us in terms of possibilities? The outcome of our review is the suggestion that:

— Historic Scotland seeks to develop five nodal sites as the key vehicle for interpretation of our properties;
— it improves the range of its interpretative material using an expanded, hierarchical range of media;
— it works in partnership with others where appropriate and feasible;
— it encourages others to undertake appropriate works where they are the more appropriate body to do so;
— works are underpinned, where appropriate, by a rigorous recording and research programme.

A number of monuments lend themselves to being obvious places where a sculptural interpretative theme could or should be a high priority, and which might act as a nodal point for associated sculpture in the area: Jedburgh, Whithorn, Iona, St Andrews and Meigle with St Vigeans (Figure 20.1; Appendix 20.1). This attribution is a recognition of the significance of their collection of sculpture, their geographical location in relation to other similar monuments, and the fact that they are staffed. In other words, they have the potential through stewards and retail products to act as nodal centres encouraging visits to related sites. Fortunately, these blocks of nodal and linked sites can be readily related to schools/styles of sculpture and key historical developments, although we recognise that there remain significant areas where Historic Scotland is not responsible for the monuments that would provide the obvious local node.[11] A number of 'lesser' Historic Scotland nodal sites also present themselves. In the case of our northern coverage, although some of the sculpture is spectacular and of international significance, its geographical spread and diversity does not readily lend itself to cohesive interpretation except on a site-by-site basis.

Here, we would be better to articulate the presentation and promotion of our monuments with 'nodal' sites in the care of others.[12]

We have identified that different types of media are appropriate for providing different levels of information about the sculpture and that these different types of media are best accessed from a range of different places (Appendix 20.2). In this scenario, visitors will need to be made aware of this hierarchy, and orientation will be required so that they can readily find the appropriate level of information to suit their individual needs. We recognise the need, indeed opportunities, to work with others to achieve this; equally, we recognise that there are many places where an overarching initiative is best coming locally. Neither do we want to duplicate what already exists; we want to build on existing national and local initiatives.

CONCLUSIONS

How, and on what timescale, we actively seek to implement the resource-intensive elements of this strategy awaits to be seen, but in the meantime it provides an explicit framework within which we can develop individual initiatives and seek to forge partnerships with others. The re-display of Whithorn, including its recognition as a nodal centre is in hand (Chapter 21) and a pilot electronic trail, whereby accessible and lively information leaflets can be downloaded from the Historic Scotland website, is planned for the near future.

ACKNOWLEDGEMENTS

This paper derives from Foster *et al* 2003 which was very much a communal effort. For input on the specifics of this paper I am additionally grateful to Genevieve Adkins, Professor David Breeze, Emma Carver, Doreen Grove, Owen Kelly, Richard Strachan and Peter Yeoman.

NOTES

[1] For example, Ritchie 1989.
[2] Foster *et al* 2003. In its drafting this has taken cognisance of the *National Cultural Strategy* (Scottish Executive 2000).
[3] Meigle Museum (with St Vigeans) for Picts and their art; St Andrews Cathedral Museum and Whithorn Museum for Early Christian art; Maeshowe for Norse runes. The overall objective of the Plan was to show how interpretation at individual sites may be planned within an overall framework, so that each site contributes to the wider picture while retaining its comprehensibility, and most importantly its uniqueness (Historic Scotland 1998b).
[4] See, for instance, Foster 2001.
[5] Historic Scotland nd a; 1998a.
[6] Anderson 1876, 365.
[7] See, for instance, Jones 2004, 29–30.
[8] For example, the complex biography of the Hilton of Cadboll cross-slab (see Chapter 3); the Patrick Chalmers connection at Aberlemno; William Duke and Joseph Anderson at St Vigeans, etc.
[9] Young and Urquhart 1996. For details of the Discrimination Disability Act 1995 see http://www.disability.gov.uk.
[10] For example, the St Andrews Sarcophagus; see Foster 1998a; Welander 1998.
[11] Govan in the case of the Strathclyde sculptures (Chapter 9); Tarbat Discovery Centre/Groam House Museum in the case of the Easter Ross school. Pictavia, near Brechin, is an example of how a local authority has created a 'node' on a greenfield site, bringing both original sculpture and casts to it for display, a model that other local parties might wish to consider adopting (Chapter 22).
[12] The sites involved are Broch of Gurness (Pictish sculpture in site museum), Brough of Birsay (site of reconstruction), Hilton of Cadboll (site of

modern reconstruction only; main upper portion of cross-slab in NMS; future location for display of newly discovered fragments yet to be determined); Knocknagael (in offices of Highland Regional Council). At the time of writing, the transfer of Nigg to State care is being negotiated.

Appendix 20.1

SUMMARY OF HISTORIC SCOTLAND NODAL AND LINK SITES

Key nodal site	Key Historic Scotland link sites
Jedburgh	Dryburgh
	Kinneil
	Ruthwell
Whithorn	Glenluce
	Kirkmadrine
	Laggangairn
	St Ninian's Cave
Iona	Ardchattan
	Dunadd
	Eileach an Naoimh
	Eilean Mor
	Keills
	Kilberry
	Kildalton
	Kilmartin
	Kilmory Knap
St Andrews	Dogton
	Inchcolm
Meigle/St Vigeans	Aberlemno
	Abernethy
	Dunblane
	Dunfallandy
	Dunkeld
	Dupplin
	Eassie
	Edzell
	Fowlis Wester
	St Orland's
	Stone of Destiny (at Edinburgh Castle)

Appendix 20.2

SUMMARY OF DIFFERENT TYPES OF INTERPRETATIVE MEDIA AND WHERE THEY MIGHT BE MADE AVAILABLE TO THE VISITING PUBLIC

Location	Potential type of media (note overlaps)
Remote (services)	HS Photographic Service
Remote (publications)	General guidebooks
	Site specific guidebooks

	Educational Resources
	Posters
	Postcards
Remote (electronic)	World wide web
	CD-Rom
	Finds Collection Database
HS Nodal Site	Steward
	Touchscreen
	CD-Rom
	General guidebooks
	Site-specific guidebooks
	Blue leaflet (to complement existing guidebooks, etc)
	Catalogue
	Educational Resources
	Educational Activities
	Children's guide
	Information panels/biff bats
	Postcards
	HS academic publications
	Academic publications by others
HS Link Site	Blue leaflet/site guidebook
	Information panels/biff bats
	Postcards

CHAPTER 21

PROPOSALS FOR THE RE-DISPLAY OF THE EARLY MEDIEVAL SCULPTURE COLLECTION AT WHITHORN: THE EVOLUTION OF AN INTERPRETATIVE APPROACH

By Peter Yeoman

INTRODUCTION

Excavations at Whithorn (Dumfries and Galloway) between the mid-1980s and 90s produced an important array of discoveries related to the secular and ecclesiastical development of the site from later prehistory and throughout the medieval period.[1] The cult of St Ninian endured here for well over 1000 years, and indeed endures to the present day, with his shrine acting as a focus for pilgrimage. Trade and pilgrimage were interrelated, enabling Whithorn to develop as an important settlement. The historical reality of Ninian is currently the subject of significant new research and debate.[2]

Historic Scotland, in presenting and interpreting the ecclesiastical remains in State care at Whithorn, aims to help visitors and the local community achieve an understanding of the key question that hangs over the place: how and why did Whithorn develop as a pre-eminent ecclesiastical, cultural, and political centre throughout the period of the first 1000 years of Christianity and beyond? The answer partly lies in the sculpture, especially the 'Latinus' Stone, which has a real claim to fame as the oldest known Christian monument in Scotland. Therefore the first step is to improve the presentation and interpretation of the sculptures. The aim is to create a display that will communicate a sense of time-depth, spiritual origins and chronological development, providing a context for the more dominant remains of the later medieval reliquary church.

This paper charts how the approach to the re-display of the sculptures has changed fundamentally through the course of the preparatory stages of the project, not least as a result of the feedback to the initial display concept presented at the *Able Minds and Practised Hands* seminar. This evolution has been significantly influenced by the involvement of Dr Katherine Forsyth as consultant to the Historic Scotland project team (Chapter 8).

Support funding has been secured from the Heritage Lottery Fund (HLF), who have expressed an interest in seeing the adoption of a more holistic approach to improving the visitor experience across the site. Historic Scotland's proposals are fully articulated with the successful bid for funds from the HLF made by the Whithorn Trust to re-design the archaeological displays in their adjoining visitor centre. As of summer 2002, the Whithorn Trust has completed the re-design of the displays in their visitor centre titled *The Whithorn Story*; in contrast the Historic Scotland site museum is now cast in an even worse light. Historic Scotland wishes to continue the successful partnership with the Trust, working within the community, by redeveloping the property in State care. Historic Scotland and the Whithorn Trust will liaise to ensure that the new displays are complementary.

In bringing forward this project, Historic Scotland is following a process firmly based on objectives set out in both its *Whithorn Priory Interpretation Plan*[3] and in the Interpretation Plan for *Early Medieval Carved Stones in Historic Scotland's Care (EMCSIP)*.[4] In the latter the Whithorn collection is proposed as a 'nodal site' (Chapter 20). A handful of such sites within Historic Scotland's care are proposed to serve this purpose 'where a sculptural interpretative theme could or should be a high priority, and which might act as a nodal point for associated sculpture in the area'.[5] This interrelated network of nodal sites will serve not only to send visitors on to the related local carved stones, but will also acquaint them with the totality of the national collections within Historic Scotland's care. The exploration of the emerging relationship between Whithorn and Iona will provide a direct linkage between these nodal sites.

The carved stone collection here has until now been presented as a traditional museum display, that is, as artefacts with labels, providing only the barest minimum of information. This reduces the sculptures within the collection to becoming specimens within the historical process, suppressing their cultural significance along with their identity as expressions of faith. By contrast, this project proposes to create an 'interpreted display', whereby simple strands of meaning will be presented about dating, production, faith, purpose, cultural links, destruction and conservation.

THE CARVED STONES

The 5th-century Latinus Stone at Whithorn commemorates the earliest named Christians in what is now called Scotland (Figure 21.1); it was erected about a century before Columba arrived at Iona. The documented history of Christianity in Scotland therefore begins here, giving the place the justifiable tag 'Cradle of Christianity'. This can also therefore be the starting point for Historic Scotland's role in presenting this nationally important interpretative theme to visitors. The archaeological reality of this, as created by the many generations of Christian communities, is displayed in the Historic Scotland site museum. This comprises a total of about 60 pieces, ranging from small fragments to complete crosses. The majority are from the Whithorn Priory site, with others from elsewhere nearby in the Machars, along with the collection recovered from excavations in St Ninian's Cave close to Whithorn (also a property in the care of Historic Scotland). The majority of the sculptures are derived from disc-

THE EVOLUTION OF AN INTERPRETATIVE APPROACH

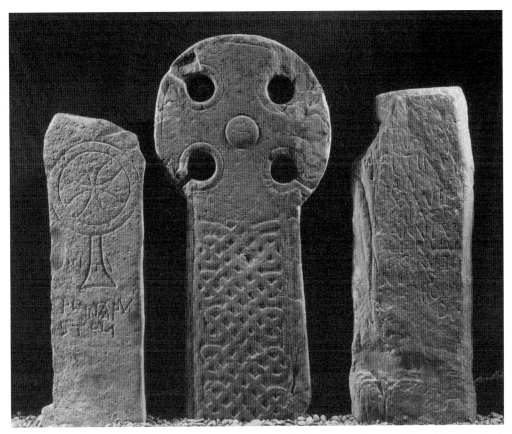

FIGURE 21.1 From left to right: the 'Petrus' Stone, a Whithorn School cross-slab and the 'Latinus' Stone. (Crown copyright: Historic Scotland)

or hammer-headed crosses, and broadly cover the period from the 5th to the 12th centuries. The carved stones had a range of functions: some were grave-markers, some were memorial stones, while a group of four tall, thin crosses are likely to have been monastic boundary markers. They all stood outdoors, in association with early medieval ecclesiastical sites, with the exception of the Monreith Cross (Dumfries and Galloway), which stood at a place of secular lordship.

THE PROBLEM

Historic Scotland cares for the site museum, as an adjunct to the hilltop site, now dominated by the ruins of the late medieval priory church, which served as the seat of the bishops of Whithorn for almost 1000 years. There is currently a dispersed provision with visitor reception, artefact-based interpretation and historical themes being covered by the Whithorn Trust's visitor centre fronting the site on the main street.

FIGURE 21.2 Whithorn visitor circulation route; in future new interpretation and signs will direct visitors on a precise path through the various elements of the site, to aid comprehension. (Crown copyright: Historic Scotland)

The existing site museum is in an extended cottage at the front of the priory. The confusing and poorly presented range of displays dates from the 1950s and 60s, although the origins of the sculpture display dates back to 1912. A tightly packed group of the principal sculptures are displayed, apparently 'growing' out of a gravel bed, and on racks. Many are decorated on more than one face, often impossible to see. The sculptures are concreted into the floor, and therefore it is imperative in the interests of conservation that this situation is rectified. There is no focus provided for visitors on the very important carved stones within the museum. There is no clear site-circulation route, and some visitors miss out the museum altogether (Figure 21.2). The main problem with the current arrangement is that all the Early Christian sculpture is lumped together without differentiation of chronology, style, and significance. The whole collection is thereby diminished. Another problem is that, with the exception of the material from St Ninian's Cave, the material from sites outside Whithorn is not sufficiently distinguished as such. The carved stones have been left to speak for themselves, but the current display allows them no voice. Having said that, there are some good things about the current arrangement, for example the sheer quantity of sculptures on display, and the purpose-built space within which they are located (now historic in its own right!).

INITIAL IDEAS

It was first thought that one of the simplest ways to understand the development of the site would be to use the carved stones to chart the ebb and flow of successive political and cultural groups spanning the period from the 5th to the 12th centuries. This was to be done by concentrating on a selection of the most important sculptured stones. Much of the existing collection would still have been there, but would not be immediately visible, being stored in built-in cabinets (termed 'public access storage'),

and thereby accessible to those with a deeper, specialist interest. The existing uninspiring space was to be transformed into a dramatically lit darkened box. A highly sensory experience was initially considered. Visitors would trigger audio-interpretation and synchronised lighting as they moved along a clear path through the selected sculptures. An atmosphere of awe was to be artificially created around the visually appealing artefacts and media.

THE FINALISED APPROACH

The initial approach has been almost completely abandoned, as influenced by the approach recommended in the *EMCSIP*. The highly sensory approach initially considered has been abandoned in favour of an overarching philosophy, summed up in two words: simple and contemplative. The report commissioned from Dr Katherine Forsyth, reviewing the main sources of scholarly data, has highlighted the fallacy in attempting to use the carved stone collection as chronological and cultural indicators. For example, only five of the sculptures are likely to pre-date 800, while one of the most significant political changes — the growth of the Anglian bishopric from the 8th century — is hardly detectable in the sculptural record. The awe-inspiring darkened space approach has similarly been abandoned, instead retaining the roof-light in the existing space that was purpose-built to accommodate these sculptures almost a century ago. This room is light and airy; as clouds pass over the sun the light changes, creating moving shadows on the sculptures. This is a reminder that they once stood outside in the fresh air. Some carved stones are crying out for strong directional lighting, however, notably the Latinus Stone, while others (especially the Whithorn School crosses) cope well in the natural light. The centrality of the Latinus Stone is such that as soon as visitors enter they will see this monument illuminated in a pool of artificial light, just beyond the introductory displays (this resonates with the experience of medieval pilgrims entering a reliquary church and immediately being offered a distant view of the saint's shrine).

In terms of the original selective approach, Dr Forsyth questioned a display strategy here that removes displayable material from view solely to enhance the focus on so-called 'key' pieces. It is now proposed to display the entire collection. This decision has been made on the basis that each sculpture at Whithorn contributes unique information to our understanding of the collection as a whole. All the pieces are worthy of display, if not because of their immediate visual appeal, then for the light they shed on the artistic or historical relationships between the different pieces and/or on the history of the site. This can be brought out in the way they are grouped. Fragments should be displayed in a way that reflects the shape of the monument from which they came, that is, correctly orientated and at a suitable height (note also that there appear to be multiple fragments from certain monuments).[6] Pieces with multi-faceted decoration should be mounted/fixed on the wall in such a way that both/all sides can be seen.[7]

The original display had a life of more than 50 years, and we should aim for the new display to have a similar shelf-life. The design should therefore have a timeless

quality, while the texts should avoid hostages to fortune, such as getting bogged-down in the current St Ninian debate. It is considered that Ninian's story, which of course should be given due prominence, would be better told at the site of his tomb in the crypt.

INTERPRETATIVE THEMES

The faith ('Cradle of Christianity'):
— The earliest evidence of Christian communities in Scotland has been found at Whithorn: it is thought that there has been a church here since at least the 5th century.
— The conversion to Christianity wrought profound changes on society, the legacy of which affects us all to this day.
— The sculptures are religious monuments and expressions of faith. This comes through strongly at Whithorn where the collection has an almost total lack of figural and secular imagery.

The carved stones:
— Oldest: Whithorn is home to the oldest Christian memorial in Scotland — the Latinus Stone.
— Chronological span: only five sculptures are likely to pre-date AD 800.
— Quantity: the sheer volume of material is impressive and significant, surpassed only at Iona, St Andrews and Govan.
— Diversity: the Whithorn collection contains considerable diversity in terms of chronological span, quality of carving and decoration.
— Patronage: the ebb and flow of patronage, along with skills of production of sculpture, was not constant. This is reflected in the humble, ill-fashioned pieces, as well as in the masterworks.
— Quarrying: geological study has indicated that almost all are of local stone from a single quarry, with the exception of the Monreith Cross that may be from 80km or more away.
— Craftsmanship and artistry: professional workshops and working methods. Exploring the processes of creation makes the sculptures more accessible, and yet more impressive. An appreciation of the creation processes will enable visitors to connect with the people who made them.
— Functions: proclaiming belief, marking graves, demarking space, and providing protection.
— Cultural links, in and out: strong links with Ireland in early period, and with the British west (Strathclyde, Man, Cumbria, Wales, Cornwall) in the later period.
— Inscriptions: messages from the carved stones.
— Location: where they originally stood.
— Destruction: the collection is distinctive in the extent to which the sculptures have been deliberately smashed-up and cut up for reuse. This reflects the political/cultural/economic discontinuities within the overarching continuum of Christian worship at the site.

FIGURE 21.3 The work begins: staff from Historic Scotland's Stone Conservation Centre removing the principal crosses from the concrete bed. (Crown copyright: Historic Scotland)

— Conservation and discovery: the process of gathering-in. Accidents of survival — more fragments await discovery within the fabric of the modern town. The recent conservation programme; why the carved stones are inside. Reconnecting fragments (Figure 21.3).

The people:
— Whithorn played an important part in an international economic network, which made it important and allowed it to thrive over a long period.
— This network pre-dated the conversions to Christianity. Having the patronage of a major saint strengthened its importance, attracting income and countless numbers of pilgrims.
— The monuments were erected by a secular elite to communicate messages to the viewers.
— The carved stones can reveal some information about changes affecting the place and the people at different times.
— In terms of Whithorn's relation to the local area, the collection presents a unique opportunity to use sculpture to trace social organisation in a locality. The 'Whithorn School' sculpture of the 10th and 11th centuries, and its distribution across the Machars, reflects the administrative structure and Whithorn's authority over subordinate sites.

SOCIAL INCLUSION AND EVALUATION

So far only addressing the needs of 'visitors' has been mentioned, but of course there is a much larger constituency on the doorstep — the thousands of people in the local community who should be the group most closely related to these carved stones. Historic Scotland is committed to reconnecting communities with their heritage, as a cornerstone of the sustainable management of the historic environment.[8] Over the

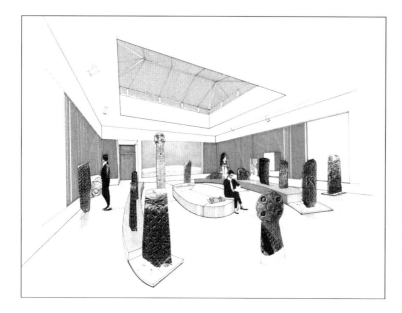

FIGURE 21.4 Perspective mock-up of the proposed stone display at Whithorn, by Studioarc. (Crown copyright: Historic Scotland).

years the sculptures have become dislocated from the local community, the sense of place and social value having been lost. The bonds between the community and the carved stones have been severed, losing any sense of affectionate connection or their role in the folklore of the area. The international cultural significance of the sculptures plays no part in the enrichment of community life and there is literally no access for the community. There are some similarities with the situation at Hilton of Cadboll, in that modern Whithorn now occupies a marginal geographical and socio-economic situation, this marginality being reinforced by recent declines in farming, fishing and tourism (Chapter 3).[9] A sustainable reinvigoration and promotion of the monument will encourage community esteem, reconnecting people with the time-depth of their long and ancient history. Limited sustained growth of visitor numbers will aid economic development in the area, and as such the project is being encouraged by the Dumfries and Galloway Council, by the local enterprise company and by the area tourist board.

Historic Scotland has stated in the HLF application that the project will be guided in part by the results of an evaluation process, whereby relevant audiences tell us what they would be interested in. This process has already begun, with the project manager making presentations to the Community Council and to the Whithorn Trust (WT). In this case the consultees will be firstly the WT representing the community, and secondly local schoolchildren. The process might develop as follows:

 a. Host a commissioning meeting on site, giving the WT members the opportunity to meet the designers and discuss the principles of the project;
 b. Arrange a subsequent discussion meeting with the WT and project team, when plans and visuals have been drafted;

c. HS Education to work with WT and local schools on an art project themed on the re-display of the carved stones. There will also be a future need for HS Education to help provide enquiry pack/educational resources.

At the time of writing (December 2003) the first part of the above process has already been completed, the main points of feedback from the community being that:
— the entire collection should be displayed including carved stones held in distant collections;
— orientation to other local carved stones and collections should feature;[10]
— the displays should make reference to local traditions and alternative histories associated with the sculptures;[11]
— the community should be involved in producing educational programmes linked to the new displays.

It is planned that the local community and visitors will enjoy the new displays, while at the same time gaining an understanding of the time-depth of the place, the significance of the carved stones, and above all how this display relates to the *Whithorn Story*, to the priory remains, and to other sites near and distant. The carved stones are the tangible link with people from the distant past, who shaped the cultural and ecclesiastical landscape that exists today. The displays should ideally enable visitors to feel a connection with these people.

ACKNOWLEDGEMENTS

The author is most grateful to Dr Sally Foster, Genevieve Adkins, and Dr Katherine Forsyth for their invaluable comments, insights and contributions to this paper. Thanks are also due to Professor Geoffrey Barrow who kindly provided the pre-publication text of his Whithorn Lecture.

NOTES

[1] Hill 1997.
[2] Barrow 2004; Clancy 2001; Fraser 2002.
[3] Grove 2000.
[4] Foster *et al* 2003.
[5] Foster *et al* 2003, D1.1.
[6] Foster *et al* 2003, B7.iv.
[7] Cf Foster *et al* 2003, B7.iii.
[8] Historic Scotland 2002.
[9] Jones 2004.
[10] Cf Foster *et al* 2003, B2.
[11] Cf Foster *et al* 2003, B6.vii.

CHAPTER 22

CURATORS OF THE LAST RESORT: THE ROLE OF A LOCAL MUSEUM SERVICE IN THE PRESERVATION AND INTERPRETATION OF EARLY MEDIEVAL SCULPTURED STONES

By NORMAN K ATKINSON

In 1992 Historic Scotland set out its earliest formal policy on carved stones (Chapter 1). It is well written and sets out the organisation's policy to protect carved stones, including post-Roman and medieval carved stones. In this latter section, it addresses measures to be taken to protect stones at risk, and the fifth point in a six-point plan states, 'movement of stones to more remote locations, including museums, should be a last resort'. For non-portable monuments which are likely to stand in or be associated with their original setting, including those in the care of Historic Scotland, and those sculptures protected by scheduling, this is a wise policy. It does not, however, address all early medieval carvings, nor was it intended to. Museums have historically collected early medieval stones, sometimes proactively, although more frequently through passive acceptance of donations or deposits. Using Angus Council Museums as an example, this paper will chart the history of collecting in one part of Scotland and examine the thinking behind it.

HISTORY OF LOCAL MUSEUM INTEREST IN CARVED STONES IN ANGUS

Local museums in Scotland began to spring up in the first half of the 19th century. Preceded by Perth and Dumfries, Montrose was formally set up following a meeting of the Montrose Natural History and Antiquarian Society in 1836.[1] Such local museums in Scotland arose as a result of local enthusiasm, some even with local authority support, but it would be fair to point out that there was no organised network, and that such developments were haphazard.[2] They collected material from all over the world, a role now usurped by television, but more importantly, collected local historical material.

In Angus, and in Montrose Museum, the first donation of early medieval sculpture was not until 1859, however, when the Inchbrayock 1 and 2 sculptures were donated by the 'Craig Kirk Session'.[3] The sculptures had been discovered in the ancient burial ground of Inchbrayock in 1849[4] and 1857[5] respectively, and had been

kept in the lobby at the church of Craig. Interestingly, a third stone found in 1884,[6] and subsequently moved to the manse, was also intended to be given to the museum. It was photographed by the Arbroath photographer, J Milne, and this was published in *ECMS*. Sadly it has never been seen since. Inchbrayock does, however, serve to illustrate the importance of such donations to museums. The two sculptures were not standing monuments when they were discovered, and had they not been moved into the museum from the manse there is every possibility that they would have shared the fate of Inchbrayock 3. A glance at any list of sculptured stones, such as the excellent handlist by the RCAHMS,[7] will reveal the disturbing number noted as lost.

The next stone to be added to the collection was the cross-slab from Farnell. It was discovered in 1849 in Farnell churchyard[8] and, although broken, set up in Kinnaird Castle. In 1865 the Earl of Southesk donated it to Montrose Museum,[9] where it has remained, until a move to Pictavia in 1999. A further two early medieval sculptures were discovered at Farnell in 1870,[10] but they were not donated to the museum and, sadly, neither can be found.

RECENT DEVELOPMENTS

When I arrived in Montrose Museum in 1977 as District Museums Curator, the three sculptures mentioned above were the only early medieval examples in the museum collections. In an area like Angus, rich in early medieval sculpture, this was clearly an imbalance, but what was required from the outset was an objective survey to identify the stones in the district, assess their status, identify the likely risk to their survival and effectively draw up a list of stones which would benefit from being added to the museum collections. Work began on this before the end of 1977, and this developed into an Archaeological Sites and Monuments Register for Angus District. This operated throughout the 1980s and early 1990s when it was used to inform the Development Control Committee regarding archaeological sites of importance. Thanks to a grant in 1997 from RCAHMS a formal Sites and Monuments Register has now been established, administered by Aberdeenshire Council's Archaeology Unit.

The initial survey work, which included photographing the stones, was also used to educate the public about the stones. In 1984 the first *Angus Pictish Trail* was published[11] and an exhibition using the photographic survey was launched in 1985 which toured Angus in the mobile museum. Significantly, it was also on view at Restenneth Library during the 1985 conference *The Picts, A New look at Old Problems*. Most importantly, however, this survey work identified the sculptures most at risk, and informed an unofficial collection policy which was eventually adopted by Angus District Council in 1984. A variety of factors was taken into account when assessing risk, including vulnerability to theft, accidental damage, vandalism, and environmental damage. Only where such risks were considered unacceptable were sculptures considered for moving into a museum.

This collection policy resulted in a number of stones being removed from their unsuitable environments, in full consultation with the owners, and brought into the museum collections. The first of these was Edzell 2, a cross-slab initially discovered in the kirkyard wall in 1870[12] and moved into the Lindsay burial vault, all that remains

of the medieval church of Edzell.[13] Surprisingly this sculpture was ignored by Romilly Allen in *ECMS*, and it is likely that he considered it to be later than the scope of his work. Lost until 1985 when I rediscovered it buried in pigeon droppings on the floor of the vault, it was taken into the Montrose Museum collections in 1987.[14] Although the possibility of it being united with Edzell 1, the arm of a free-standing cross (Chapter 5) displayed in the summer house at Edzell Castle, was explored, there was insufficient space here and it remained in Montrose Museum until 1995 when it moved to the Meffan Museum in Forfar.[15] Since 1999 it has been on display in Pictavia.

Angus Museums adopted the principle of displaying such material in the museum nearest the findspot of the artefact, although this could still be some distance away. All seven Angus Museums are registered by the Scottish Museums Council, so this does give a fair coverage in a rural area such as Angus.

In 1989, the Kirkbuddo cross-slab, which had suffered severe damage from exposure to the elements, was donated to the Meffan by the landowner,[16] and, after substantial conservation, went on display in the Meffan. Interestingly, the present parish church, Inverarity, adopted the design for its new pulpit, and recently jewellery has been produced using the design for the Letham-Monasterboice Twinning Association.

Even more significantly, Menmuir 1–5 were donated to the museum in 1991 by the Kirk Session. All five had been discovered in the kirkyard and environs.[17] The largest, Menmuir 1, a cross-slab, was erected upstairs in the church in 1976, but 2–5 were simply laid out on the pews. Damage from excessive handling, paint, bird and bat droppings all resulted. After the church ceased to be a place of worship in 1991 and the plaster ceiling fell, the Kirk Session decided upon their donation to the museum. Ideally, the Menmuir sculptures would have been displayed in Brechin Museum, but at the time this occupied a room in Brechin Library, and there was simply insufficient space to accommodate them. They moved to the Meffan in 1995, and then to Pictavia in 1999, in keeping with our policy of displaying such artefacts in a museum as near to their findspot as possible.

Stray finds were also added to the museum collections, with Nevay being discovered in 1988.[18] Two carved stones discovered by Niall Robertson were reported, but the second had disappeared before the museum staff visited the site the next day. Small, portable sculptures like the Nevay sculptures do highlight the problem of such artefacts being taken away by people with less acceptable motives than museum curators!

Stones from Arbroath Harbour in 1989,[19] Cliffburn in 1990[20] and St Margaret's Inch in 1992[21] followed, but the most significant acquisition over this period was the collection of five stones from Kirriemuir. Kirriemuir 1–4 were found in the foundations of the old church when it was pulled down in 1797[22] and Kirriemuir 5 was noticed in the churchyard in 1903. All five stones were moved to a purpose-built shed in the new cemetery in 1955[23] but severe frost damage, regular damage due to handling, and indeed painting of the shed all combined to create a far-from-suitable environment. Their status as scheduled ancient monuments only conferred passive

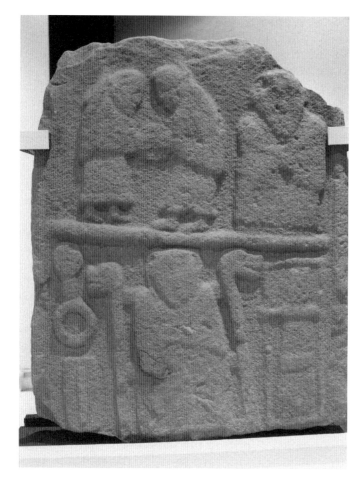

FIGURE 22.1 Under new lighting in the Meffan Institute the back-face of this cross-slab from Kirriemuir has been recognised to include a depiction of an upright loom (bottom right). (Crown copyright: Historic Scotland)

protection and the stones were deteriorating fast through lack of active conservation and management of their internal environment.

In 1989 Angus District Council applied to Historic Scotland to remove the stones for conservation, and also for permission to re-site them in the Meffan. This was granted, and by 1995 they were conserved by the Scottish Museums Council and put on display (Figures 22.1 and 22.2).[24] Historic Scotland subsequently descheduled the stones since they had become portable artefacts and were now in a secure museum environment.

In April 1995, Kirriemuir Parish Church sought planning permission to build a suitable access road from the kirkyard gates to the rear of the church, to enable hearses more ready access to funerals. Permission was granted on the condition that an archaeological investigation would be carried out in advance of the construction, a condition suggested by the Museums Service. The archaeological investigation was carried out by Scotia Archaeology Ltd[25] and no fewer than 12 early medieval

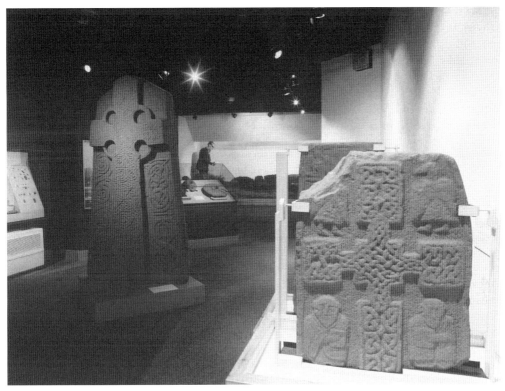

FIGURE 22.2 The Meffan Institute's display of Pictish sculpture, photographed in 1996. (Crown copyright: Historic Scotland)

sculptures, mostly fragments, but including one complete cross-slab, were discovered. The Finds Disposal Panel subsequently awarded these to Angus Museums.

The Treasure Trove Panel added a further exciting piece of sculpture to the collection in 1994. A small, slightly damaged and broken Pictish cross-slab was discovered by the farmer while ploughing at Wester Denoon, Glamis.[26] This was taken to the Meffan, and duly reported to the Treasure Trove Panel secretariat at the National Museums of Scotland. Despite protests from the landowner, in line with Scottish legal practice the Wester Denoon cross-slab was declared Treasure Trove (strictly *bona vacantia*) and claimed by the Crown. Awarded to Angus Museums, upon payment of the appropriate award to the finder, one of the very few cross-slabs with symbols discovered during the 20th century went on display in the Meffan.

Treasure Trove is a very important piece of legislation for museums. Where sculptures are classified as portable artefacts, rather than monuments, it can ensure that new discoveries are taken into appropriate care for the public. It can apply to all finds of worked stone, and can apply even after a lapse of several years since the actual discovery.[27]

Following local government reorganisation in 1995–6, Angus Council re-opened discussions with the City of Dundee Council regarding the Dunnichen symbol-incised

stone which, at the time, was displayed in the McManus Galleries, formerly the Albert Institute, Dundee Museum. Although discovered as a result of ploughing on the Mains of Dunnichen in 1805[28] the sculpture has had a history of moving in its recorded past. It was first erected at the Kirkton, by the church,[29] but was then moved into the garden of Dunnichen House in 1880. In 1966 concerns arose about the safety of the sculpture because of a proposed development in the vicinity, and the owner donated it to the Ministry of Works (MoW). The intention was that it might be displayed at St Vigeans, and in 1967 it was moved to Arbroath Abbey pending extension of the museum to house it.[30] The owner subsequently decided that their intention had been for the sculpture to be given to Dundee Museum rather than the MoW and it was transferred there in 1972, at which point it was also descheduled by the Department of the Environment (DoE; former MoW). Dundee's ownership was only formalised in 1991 after it transpired that the original owner had not been entitled to change their mind about the MoW's ownership. Angus County Council had expressed concerns about the removal of the sculpture from Dunnichen in 1967 and there were further local protests when it moved to Dundee in 1972. The formal transfer of ownership in 1991 re-opened the question of who was the most appropriate owner. Angus Council acknowledged that in the late 1960s–early 1970s there was no museum service in Angus that could have then taken responsibility for the Dunnichen Stone, but since local government reorganisation in 1975 there had been considerable developments. Since 1984, for instance, there had been a published and agreed museum acquisitions policy. After lengthy discussions with Dundee Museum, the sculpture was moved to the Meffan, initially on a ten-year loan, but on the understanding that it would remain in Angus.

The opening of the *Forfar Story* at the Meffan in 1995, with its fine display of early medieval sculpture, brought much acclaim, but more importantly blazed the trail for well-lit displays of such sculpture complete with ample interpretation (Figure 22.2). A multi-media database of the Angus stones, originally started in 1977, was produced and the *Pictish Stones of Angus* went from its second printed edition to a full colour, illustrated, electronic catalogue.[31]

PICTAVIA

During the 1990s the museum service had organised a number of Pictish bus tours and various lectures, and had discovered that there was considerable interest in things Pictish. The *Forfar Story* had been a great success and there seemed to be a general craving for more. The *Forfar Story* dealt with a wider arts and heritage agenda than Pictish or indeed early medieval sculpture alone. In response to this, however, plans were developed to build a Pictish Heritage Centre in Angus whose main purpose would be to alert and attract the public, both locals and visitors, to the varied Pictish heritage in Angus, a project that took some years to fully develop. A site was chosen just off the A90, adjacent to the Brechin Castle Centre, and the 'Pictavia' Heritage Centre was designed to enthuse visitors to Angus and to send them off to look at Pictish sites throughout the country.

Pictavia finally opened its doors to the public in 1999. Its layout gave a general introduction to Pictish symbols, the battle of Dunnichen, and an array of sculpture, both original and casts, accompanied by a flavour of Pictish crafts, music and language. A time-line put events into a historical context, and the multi-media *Pictish Stones of Angus* database was also updated and installed. A temporary exhibition/activity area allowed for changing exhibitions and events.

A third edition of the *Angus Pictish Trail* was produced[32] to encourage visitors to Pictavia to visit sites in Angus, and in 2001–2 a winter series of lectures was jointly held between Angus Council and the Pictish Arts Society in Pictavia. The Pictish Arts Society moved its postal address and library to Pictavia, and a second series of lectures has just successfully concluded, with a third planned for 2003–4. There is a strong Angus flavour to these lectures, but they are designed to attract both locals and those further afield; indeed we have some regular attendees from Inverness, Aberdeen, Glasgow and Edinburgh. The lectures also bring experts in various field to Angus, and hopefully encourage further studies into early medieval sculpture and related fields. Groam House, Rosemarkie and Whithorn in Dumfries and Galloway organise annual published lectures, and this is perhaps an area for development for Angus.

The most recent publication we have been involved in, however, is in collaboration with the RCAHMS, who are currently engaged upon a programme of drawing and photographing Pictish stones in Angus as part of a long-term project to record early medieval sculpture in eastern Scotland (Chapter 13). Their work was undertaken in conjunction with Angus Council and Historic Scotland, with financial support from the Pictish Arts Society. The first product of this collaboration is an RCAHMS broadsheet entitled *Early medieval Sculpture in Angus Council Museums*. This illustrates and describes all the sculpture mentioned in this article.[33]

CONCLUSIONS

The original plan, begun in 1977, is still in operation. There are still early medieval sculptures in Angus which are closely monitored and which may yet benefit from being moved into the museum collections. This, I believe, is a fundamental role of a local museums service and a model for others to follow. Museums have an important role to play in encouraging local parties to look after their sculpture, either where it is located or by transference to a museum. The acquisitions or collection policy, adopted by the museums' governing body (the appropriate Council committee in the case of local authority museums, the board of trustees for independent museums), is an essential part of this. Museums' collecting is not a gung-ho, postage-stamp obsession, but rather a professional activity which needs to be informed by careful study. While we may all wish to see all early medieval sculptures retained *in situ*, it is simply impractical. Standing monuments may well be able to remain where they are, subject to a range of conditions and regular monitoring, but vulnerable portable sculptures and all new discoveries need to be preserved in a secure and appropriate environment where they can be professionally curated and made accessible to the public for generations to come. However well meaning, amateur enthusiasm from a well-intentioned landowner or church minister cannot be depended

upon for any length of time, and a sustainable long-term future for our early medieval sculpture is essential. For most such sculptures, museums are not the last resort, but are an integral part of the way our society can preserve such heritage for future generations to study and enjoy.

ACKNOWLEDGEMENTS

My thanks must first go to all the Cultural Services staff of Angus Council over the years, who have helped in so many ways with this crusade. The original survey work owes much to Gillian Zealand, John Sherriff, David Glenday and Graham Watson. Various others, too numerous to mention, have helped with this work over the years, and I am deeply grateful to the many landowners, ministers and other members of the public who have contributed in so many ways. Encouragement has been given by so many, including staff at the National Museums of Scotland, the RCAHMS, members of the Pictish Arts Society and especially Dr Isabel Henderson, to whom I have turned on many an occasion for advice. David Henry of Pinkfoot Press has collaborated on many publications, and the photography of Tom Gray and Bob Henery has also been of great assistance. Last but not least, I wish to thank my wife, Noreen, for her tremendous patience and understanding over these years.

NOTES

[1] The minutes of the Montrose Natural History and Antiquarian Society record the setting up of a museum in Montrose, which opened on Monday 2 January 1837. See *MNHAS Reports 1858–1914*, especially the report for 1887, 6–7.

[2] See Cochran-Patrick 1890 for the underdeveloped local museum network of this time.

[3] The 'Church of Craig, 28 August 1859 consented to removing the stone from the lobby of the Church to the Montrose Museum'. *Craig Kirk Session Minutes*, National Archives of Scotland CH/616/7.

[4] Inchbrayock 1 was discovered in the old burial ground of Inchbrayock where it had served as a common headstone. The discovery is first noted by Patrick Chalmers (1848, 19, Pl XXIV).

[5] Inchbrayock 2 is a fragment which was found whilst a grave was being dug in 1857 in the same burial ground. It is first described in Stuart 1867, 2 and illustrated in Pl II.

[6] In 1884 a third fragment, now lost, was discovered 'standing two feet beneath the surface near the same site as the other two stones, a little to the east to the old chapel'. The discovery was not published until 1903 when Romilly Allen also included an illustration (*ECMS* III, 245).

[7] The most recent edition was prepared by Iain Fraser and Graham Ritchie; see RCAHMS 1999.

[8] First published and illustrated in Chalmers 1848, 15, Pl XXI.

[9] *MNHAS Report* 1865, 4–5.

[10] Referred to in Warden 1880–5, III, 243. They are described and illustrated by Eeles 1910, 356–7.

I searched for them in vain, see Atkinson and Henry 1998.

[11] Sherriff 1984.

[12] First described by Jervise 1875, iv. I reprinted this illustration, which is difficult to obtain, in Atkinson 1994a, 11.

[13] Eeles 1910, 358–9, and Reid 1915, 296–7 for the first photograph.

[14] Atkinson 1988c, 27.

[15] Murdoch 1995, 94.

[16] Atkinson 1988b, 26.

[17] Atkinson 1995a, 94, and Atkinson 1991, 20–7 for a full account of the Menmuir stones.

[18] Atkinson and Robertson 1988, 26.

[19] RCAHMS 2003.

[20] Atkinson 1990a, 39; 1990b, 8.

[21] Atkinson 1995b, 93.

[22] First published in Stuart 1856, 14, Pl XLIII.

[23] Their new location is noted in Coutts 1970, 61–2.

[24] Atkinson 1988, 26; 1995c, 94.

[25] Atkinson 1995d, 94.

[26] Atkinson 1994b, 82; 1995e, 93–4.

[27] For a recent account of Treasure Trove in Scotland, see Saville 2002.

[28] Patrick Chalmers (1848, 11, Pl XIV) first publishes this discovery. An erratum slip corrects the discovery date to 1805 from the 1811 date referred to on page 11.

[29] Stuart 1856, 28–9, and Warden 1880–5, III, 201–2.

[30] Coutts 1970, 57; Sally Foster pers comm.

[31] Atkinson 1993.

[32] Atkinson and Lafferty 2001.

[33] RCAHMS 2003.

CHAPTER 23

A MUSEUM CURATOR'S ADVENTURES IN PICTLAND

By MARK A HALL

> I am I plus my surroundings, and if I do
> not preserve the latter I do not preserve myself.
> José Ortega y Gasset (1914)[1]

The aim of this paper is to present a review of the last decade or so of Perth Museum's early medieval projects, which, for convenience only, I will refer to as its *Pictish Programme*. It begins with a summary of the key projects that have taken place to preserve and interpret some of Perth and Kinross' Pictish material culture, draws some general remarks from these and concludes with a broader look at the political and professional context in which such work takes place and in which it could take place in the future. It is certainly true that the work described here reflects a strong personal interest on my part in early medieval matters. More importantly however, it reflects the pivotal role of the land unit we now call Perth and Kinross in the Pictish, Alban and Scottish kingdoms and the importance that the local authority museum service of Perth and Kinross attaches to preserving the surviving material culture of those times. The projects highlighted are described individually to minimise repetition and overlaps. The ongoing, prosaic background of museum curatorship (which includes Pictish elements such as the museum's permanent display of Pictish sculpture within the Human History Gallery, an ongoing conservation programme and regular talks and workshops about the Picts for local amenity groups and societies) will not be the subject of this paper other than in passing reference.

ST MADOES CROSS-SLAB

Throughout the 1980s Historic Scotland sought to find a solution to the deteriorating condition of the St Madoes cross-slab[2] sited outside the Kirk of St Madoes, some 8km SSE of Perth. Historic Scotland sought to have the cross-slab — a scheduled ancient monument — moved inside the Kirk, where it would be both protected and publicly accessible. The Kirk Session did not agree with this option. A viewing cover was considered for its external situation but found unacceptable because of the 'greenhouse effect' that would accelerate the disintegration of the fragile surfaces of the sculpture through constant changes of temperature and

humidity (but see Chapter 11). In 1990 a compromise solution was arrived at whereby the cross-slab was descheduled, donated to Perth Museum and Art Gallery and placed on display there in 1991, following conservation treatment by Historic Scotland. It is raised on a low plinth, cross-face outwards with the other face — showing three cowled riders and pairs of symbols — visible via a mirror. Interpretation panels alongside describe the stone and its relocation project.

CRIEFF CROSS-SLAB

The conservation and re-display of the cross-slab known as the Crieff Burgh Cross was part of a wider, Perth Museum-led project tackling three deteriorating monuments on the Crieff High Street. In 1998 a partnership between Perth Museum (acting on behalf of its parent body, Perth and Kinross Council), Historic Scotland, Perth and Kinross Heritage Trust, and the Heritage Lottery Fund provided the resource, planning and interpretative framework by which Edinburgh-based conservator Graciela Ainsworth was employed to uplift, conserve and install the three monuments. The Burgh Cross was installed in one of the former cells of the Crieff Tolbooth, now the Tourist Information Centre, on the High Street. Two interpretation panels give background details on the art of the cross-slab and its Strathearn context.

The project also afforded the opportunity to assemble an interdisciplinary team to research and publish a cultural biography of the cross-slab. The origin and initial purpose of the cross-slab — almost certainly sited in Strowan 4.5km to the west of Crieff — was the primary focus, but crucially the project recognised that such monuments do not have a single identity nor an unchanging, homogenous social context. The name, Burgh Cross, relates to a later phase of its history, following shifts in time, space and meaning, for the cross-slab was relocated from Strowan to Crieff in the late 18th century to serve as the Burgh or Market Cross. The project sought to elucidate something of the life-story of the cross-slab by examining it in the light of the following contexts: art-historical (written by Dr Isabel Henderson, with drawings by Ian G Scott), the inscribed panel (by Dr Katherine Forsyth and Ross Trench-Jellicoe) and the broader landscape context (with place-names discussed by Dr Angus Watson and the geology, artefacts and sites by myself).[3]

PRESERVING THE PICTS

This was the title of a temporary exhibition held at Perth Museum during 2002–3. It had a twofold purpose: to make accessible some of the museum's rich collection of late 19th- and early 20th-century photographs of Pictish sculpture in the Perth and Kinross area and to raise awareness of both where the sculptures were and the problem of their deteriorating condition (for those still outside). Concomitant with this the exhibition distributed large numbers of the Historic Scotland booklet, *The Carved Stones of Scotland — A Guide to Helping in their Protection*, and the Historic Scotland leaflet for the *Carved Stone Decay in Scotland* project. Primarily photographic-based, the exhibition also included the newly conserved Gellyburn

cross-slab (Chapter 19) and the newly discovered fragment from Abernethy (Perth and Kinross)[4] along with two casts (Dunfallandy and Fowlis Wester 2) kindly lent by the National Museums of Scotland.

THE MURTHLY SCULPTURES

In 1995 Perth Museum acquired, via Treasure Trove allocation, a fragment of early medieval sculpture found at Pittensorn Farm, Murthly, Perth and Kinross (some 7km south-east of Dunkeld). This is, so far, the third piece of sculpture from this area, joining the Murthly panel and the Gellyburn cross-slab.[5] Following a photographic request from Dr Isabel Henderson, she and I formulated a research project to set the new fragment in its local context and publish it accordingly. Dr Simon Taylor was approached to research the place-names context (essential for the fullest understanding of the sculpture's social context) and he willingly came on board, as did Ian G Scott, to provide the essential drawing of the fragment. The resulting paper was duly published[6] and the fragment of sculpture was conserved and placed on display at Perth Museum. The initial phase of research recognised that a fuller exploration of the possible links between the three Murthly pieces was required. This had to wait, however, until the Murthly Panel was once more available for analysis (and other pressing projects completed) with the opening of the new Museum of Scotland in 1999 (see Chapter 19).

IMPROVING ACCESS

Having outlined the *Pictish Programme* at Perth Museum over the last decade some general comments are in order concerning its success or otherwise. Taken as a whole, the *Pictish Programme* can be said to be successful. Measured by its outputs in terms of sculptures conserved, papers published, partnerships established and exhibitions presented, this success is undeniable. Further, it is a view validated by public and professional responses to those outputs. Access to the Picts has clearly been improved by the approach adopted by Perth Museum. Some problems however remain. The museum certainly has not solved the problem of displaying early medieval sculpture. The St Madoes cross-slab is currently far more accessible than it was of late at St Madoes Kirk, but several visitors have commented upon how unsatisfactory it is to only be able to view the back of the cross-slab through a mirror. Even the ideal form of display for such pieces, outside in their landscape context, is far from satisfactory. The key problem is long-term preservation, though sometimes physical access can also be difficult even for scheduled ancient monuments in State care (witness the St Orland's cross-slab at Cossans) and the problems are aptly demonstrated by the recent history of the Dupplin Cross (taken into care by Historic Scotland, conserved, displayed in the Museum of Scotland for three years and relocated to St Serf's Church, Dunning, Perth and Kinross, in 2002). Museums are an essential compromise that enables the long-term preservation of such monuments. Site museums, such as that at Meigle, thrillingly keep their important local assemblages local, crucial in helping to understand the sculptures and their

contribution to defining a sense of place. Such museums often have very accessible open displays, but they can, like Meigle, suffer from cramped conditions and under-contextualised display.[7]

In collecting and displaying early medieval sculpture Perth Museum is doing so in recognition of the importance of local retention and preservation of such sculpture close to its findspot. Collection is but one strand of a strategy that includes such initiatives as the Crieff Burgh Cross Project (outlined above) and supporting other initiatives to keep Pictish sculpture within its local context, as the museum did with the campaign to keep the Dupplin Cross in Strathearn. The fact is, as soon as a piece of sculpture is moved or even given a shelter on its 'original' spot it is compromised. Its subsequent display and interpretation, whether as a monument or an artefact (in many ways a purely professional distinction for both are objects, from a human, landscape context, just on a different scale) is never going to be entirely satisfactory. The Crieff Burgh Cross has been successfully conserved and interpreted and relocated in the Tourist Information Office no more than 95m from its former (secondary) location on the High Street. Outside on the High Street it could be seen in its physical entirety, but not greatly appreciated because of its state of decay. In its new location it may not be fully physically accessible (the back cannot be seen) but its decay has been effectively halted and it can be more readily understood.[8] In terms of display, perhaps Perth Museum's most difficult piece of sculpture is the Inchyra stone (again, from St Madoes), which is on permanent display in the Museum's Human History Gallery.[9] The difficulty lies in its being carved on all faces with a mixture of images and inscriptions in different planes and representing several phases of use. It is displayed in a prone position (behind glass) on one of its narrow faces and within a section of the gallery that addresses the theme of communication. Although it is not in a position that reflects how it was used by the Picts, it nevertheless manages to make most of its faces accessible, and demonstrates a form of Pictish communication. The stone underscores how communication modes have changed through time while remaining constant in their social mediation between different hierarchies of power.[10]

It will not have escaped the observant reader that this discussion has focused very much on sculpture, an accurate reflection of the work of the Perth *Pictish Programme*. In part this is due to the key role such evidence plays in understanding the early medieval period and the significant concentration of such sculptures in Perth and Kinross. It is also due in part to a dearth of recent research excavations looking at Pictish questions in Perth and Kinross and due historically to material from such excavations and other discoveries being deposited in either the National Museums of Scotland or the Hunterian Museum.[11] This is compounded by what (from my perspective) feels like a tendency of the legal, policy and administrative framework for archaeology to emphasise the compartmentalisation of the subject. This tends to mitigate against museums being involved in the whole process (and I recognise that there is a debate about whether they should or can be involved). It is, for example, very difficult for museums to plan early for the curation of archaeological archives because Treasure Trove recognises no interest until the point of allocation is reached. This is compounded by the lack of post-excavation work and information that accompanies many finds assemblages and by the splitting of excavation archives so

that finds go to a museum and records to the NMRS (and I understand the practical, resource-based historical reasons behind this). It is also true to say that the problem is further compounded by the fact that there are too few museums in Scotland with the resources and staff to dedicate to archaeology. One consequence of this is that there are often too few close links with museums and local authority area archaeologists, never mind national institutions.[12]

Increasingly museums and other cultural agencies have to be able to do more with fewer and fewer resources, despite operating in the United Kingdom-wide context of the world's fourth-richest economy. Perth Museum is no different, and one of the ways of mitigating this lack of resources and its consequent erosion of capacity, is to pool resources via partnership working. This has its own dangers — principally bureaucratic and short-term project focus — but much of what Perth Museum has achieved in its *Pictish Programme* would not have been possible without the crucial contributions of allied agencies (Historic Scotland, Perth and Kinross Heritage Trust, the Scottish Museums Council, the Heritage Lottery Fund and the Council for British Archaeology) and an array of interested scholars. This has demonstrated the essential vitality and holistic insights to be drawn from an interdisciplinary approach and confirmed that research is the bedrock for the understanding of, and increased access to, any museum collection.

Does this endeavour to understand and communicate more fully the story of the Picts have an effective public dimension? It is of course stating the obvious to say that it takes place in the public domain, but how has it been received? Perth Museum has not, for reasons of stretched resources and consultation fatigue on the part of visitors, embarked upon formative evaluation beyond the general questionnaires visitors are encouraged to complete when their visit to the Museum is over.[13] When visitors do offer comments upon our displays of Pictish material culture it is generally favourable, and certainly as far as the *Preserving the Picts* exhibition is concerned there is also a good deal of favourable word-of-mouth and anecdotal comment. The same exhibition drew from people direct artistic participation that reflected a positive exhibition experience. The exhibition's canvas backdrops (specially painted with Pictish symbols by a local Girl Guide Company) were seized upon by younger visitors as a place to add their graffiti input using the artistic materials provided on the activity table. In addition to this activity table — for stamping, colouring-in and making rubbings from specially-made templates — the exhibition also included a selection of books on early medieval Scotland for visitors to consult. Many visitors were observed doing so and only two of the books were stolen!

More flexible use of early medieval sculpture has demonstrated that it can help audiences engage creatively with their past. During 2000 Perth Museum held two art and archaeology workshops.[14] Through art and poetry participants were encouraged to explore a number of different artefacts from the archaeology collection, including the Pittensorn fragment, which provoked some powerful responses. Such initiatives will play an increasing part in the socially inclusive agenda of museums, and deserve to take their place beside the more typical strategies for promoting access and understanding: exhibitions, lectures, publications, fieldwork, the Young Archaeologists Club, Scottish Archaeology Month and Perthshire Archaeology Week.

FRAMEWORKS AND FUTURE DIRECTIONS

Opportunism and serendipity have clearly played their part in the Perth *Pictish Programme*. But too much reliance should not be placed upon these crutches in preference to a fully resourced, proactive approach. This would also provide a potentially more rewarding framework for partnership working, interdisciplinary research and public access. A further corollary is a crucial and absolutely necessary increase in resources and capacity across all cultural agencies.

It is right that the different agencies involved in archaeology should have different roles and areas of expertise but archaeology has, as a consequence of this (and of chronic under-funding), tended to become introverted within its specialist areas. As a result cohesive, holistic, interdisciplinary projects and thinking can be difficult to achieve. As recently as 2002 an exploration of the state of Scottish archaeology in *Antiquity* could be written without any reference to the role of local museums, either actual or potential.[15] It did usefully review the interplay between archaeology and national consciousness and argued for the continued need to recognise regional diversity in prehistory, but it otherwise neatly side-stepped the political, framework problems faced by archaeology in Scotland. The first term of the Scottish Parliament has bought little clear benefit to archaeology and the Scottish archaeological community has shown itself unwilling or unable to advocate its case in a unified, holistic way. The *Antiquity* review of Scottish archaeology eschews confronting the problems of non-statutory SMRs, the need for greater cohesion between national and local institutions and the general levels of underfunding across all archaeological agencies. These may well be dull matters, but they are essential problems which will become increasingly corrosive the longer they are left unaddressed.

From my personal perspective I can see the advantage and necessity of radical change for the wider archaeological scene in Scotland. The basic building-blocks needed to deliver a cost-effective, accessible archaeology are resources and research. The fundamental requirement is for the formulation of agreed, flexible research frameworks. The need for such is recognised in the 1997 review of *State Funded Archaeology in Scotland*, and more widely by a string of research-focused papers over the last decade, but in Scotland thematic or regional frameworks have been slow to develop (unlike in England, with Wales not far behind).[16] One of the more recent comprehensive and forward-thinking strategies is subject-based and deals with the (mainly pre-Roman) British Iron Age.[17] In the context of Scottish early medieval studies this offers a good model for a national approach. This could also build upon, for example, the *St Andrews Dark Age Studies* conference series and their published proceedings, and the still relevant and significant discussion of research principles and themes aired by Sally Foster in 1997,[18] which could be complemented by regional frameworks to more fully encompass local nuances and identities.[19] In the context of early medieval sculpture a revised corpus would form a crucial element in any framework. When published 100 years ago, *ECMS* led the way forward for national corpora of early medieval sculpture. It is now fair to say that Scotland lags behind England and Wales, where the regional Anglo-Saxon corpus of England and the forthcoming revised corpora for Wales and the Isle of Man are well advanced. The

most fitting tribute to the achievement of Romilly Allen and Joseph Anderson would be a new Scottish corpus, in the form of an electronic and/or paper publication. A key element of such a study should be a visual index of comparative drawings, all at the same scale. The recent publication of *Early Medieval Sculpture in the West Highlands and Islands* serves as an excellent model of a regional approach to this necessity.[20] Ultimately a unified British Isles corpus is also desirable, both to facilitate comparison and to help break down the hindsight-imposed nationalism of today.

In his recent analysis of Scottish identity and nationality, Neal Ascherson questioned the over-emphasis of Historic Scotland on '... preserving everything at the cost of "intrusive" research',[21] an approach followed through by having that same national agency staffed by archaeologists whose day-to-day work does not include research and excavation. This is not by way of a call for a massive increase in excavation programmes at State expense. But the success in Ireland of the *Discovery Programme*[22] shows the great potential Scotland could unlock if policy became more research-orientated. It would require partnership with other national and local agencies. It would be very easy to suggest a rationalised group of key sites from Perth and Kinross which would make suitable research projects within the context of a regional and national early medieval research framework,[23] but on its own this would be little more than a cartoon research strategy. Whilst excavation on such sites would be crucial to a research agenda, a more inclusive approach, including the reassessment of previous excavations and existing museum collections and interdisciplinary collaboration, would be essential.

An interdisciplinary approach to understanding the Pictish or early medieval landscape then and now is essential.[24] Such a strategy has to have room for the contribution of onomastics, historical sources, art-history, geology, folklore and artefact studies. A broad but nuanced vision is required that can encompass the critical concepts of spatial change and social change. By this I include the understanding of the way Pictish places were subsequently viewed and reinterpreted by succeeding generations (for example the reinterpretation of some of the Meigle sculptures in the context of late medieval Arthurian romance).[25] Such an approach does not detract from focusing on early medieval communities in their own right, but would have the holistic advantage of helping to circumvent the periodisation of the past. A research strategy for any given period should be flexible enough to tackle the dynamics of that period but should also facilitate longer, synthetic views. The research projects outlined in this paper have sought to move towards or adopt this approach and the recently initiated project looking at the landscape context for the Dupplin and Invermay Crosses will seek to do the same.

In some respects the widespread adoption of research frameworks would be a radical departure for Scottish archaeology. The long-term future of Scottish archaeology, however, may require more radical change to give it a new structure more attuned to delivering the necessary levels of national-local and cross-cultural agency working. One solution would be a department of culture with responsibility for Scotland's cultural heritage. Many, of course, would balk at such an all-encompassing change. A compromise might be to have a single national agency to bring together the existing separate agencies: Historic Scotland, the RCAHMS, the

National Museums of Scotland, the Scottish Museums Council and Scottish Natural Heritage — with a primarily regionalised structure. At the same time the provision of museums and historic and natural environment records could be made a statutory function of local authorities and restructured at the local level so as to provide the best fit between them and the regionalised national agency. The two would then operate in partnership through a shared funding and policy framework, which would also be linked into education and economic-tourism strategies.[26]

The other framework in which the *Pictish Programme* has operated is the legal one of monument and portable antiquities legislation. The two most recent additions to Perth Museum's collection of early medieval sculpture — the fragments from Pittensorn and Abernethy — were acquired through the Scottish Treasure Trove system. This demonstrates the effective working of the system, for their allocation to Perth Museum meant that important material was retained in Perth and Kinross. With respect to the fragment from Abernethy, a prior agreement was reached between Perth Museum and Abernethy Museum that Perth would bid for the fragment and, if allocated to Perth, make it accessible to Abernethy Museum. Such agreements can help to smooth the troubled waters of community ownership as against Crown or State ownership with which Treasure Trove is legally bound (it is a Crown prerogative). The fragments of sculpture excavated at Tarbat, Portmahomack (Highland), were allocated to the National Museums of Scotland, who then lent them to the Tarbat Discovery Centre for long-term display, a seemingly model compromise. However it is proving somewhat more difficult to resolve a similar problem at Hilton of Cadboll. There is widespread recognition that to reunite the newly discovered fragments with the bulk of the cross-slab is entirely logical. But where should this reunion take place? From the legal standpoint of the system it is a relatively straightforward matter that the fragments should join the cross-slab under the ownership of the National Museums of Scotland. But there are other perspectives, most notably that of the Historic Hilton Trust, which is campaigning vociferously for retention in Hilton, and would ultimately like to see the whole cross-slab return there (Chapter 3).[27]

These issues are complex and intractable and only partly so due to the current legal framework. Any legal process would struggle to resolve them to the satisfaction of all. Treasure Trove as it stands, however, is essentially a medieval law designed to boost the coffers of the Crown. It has been adapted by good intention and dedicated professionals with archaeological protection in mind, but it remains an under-resourced poor fit. A devolved, more democratic Scotland needs a 21st-century law for a 21st-century problem.[28]

ACKNOWLEDGEMENTS

This is very much a personal reflection on the last decade and any errors it may contain are entirely my responsibility. All the agencies and colleagues who have contributed to the projects discussed are sincerely thanked. Special thanks go to Sally Foster for encouraging me to write this piece and for her steely questioning of some loose thinking within it, and in particular to Isabel Henderson without whose kindness, understanding and sharp empathy for Pictish art, my own exploration of the Picts would have been a road less-travelled by.

NOTES

[1] Translated from the Spanish 'Yo soy yo y mi circunstancia, y si no la salvo a ella no me salvo yo' (Ortega y Gasset 1914).

[2] *ECMS* III, 292–6; RCAHMS 1994, 93, 103. The Museum's contribution to this project was supervised by my predecessor, Mike King.

[3] Hall *et al* 2000.

[4] Hall 2003, 90.

[5] For the Murthly Panel, in the collections of the National Museums of Scotland, see *ECMS* III, 305–6; for the Gellyburn cross-slab, in the collections of Perth Museum and Art Gallery, see Calder 1951.

[6] Hall *et al* 1998.

[7] This is not meant as a singling out of Meigle, but as an attempt to address the wider problems. I accept that the situation at Meigle may well change in the future in the light of The Interpretation Plan for *Early Medieval Sculptures in Historic Scotland's Care* (Foster *et al* 2003; Chapter 20). It must be said that Meigle has stood the test of time well, its minimal presentation requiring, and often succeeding, in getting people to look closely at the sculptures, particularly now with the aid of the excellent new guide book (Ritchie 1997b).

[8] Though generally not accessible beyond the glass barrier, which visitors look over into the cell where the cross-slab now stands, permission can be obtained to enter the cell for a closer look.

[9] Stevenson 1959, 33–9; RCAHMS 1994, 92–3, 95.

[10] This is not necessarily an acceptable solution to all. Isabel Henderson has recently noted (pers comm) that the 1950s display of the Inchyra slab, open and upright, was more effective in making it accessible as a piece of Pictish sculpture.

[11] The most recent research excavations were those in the 1980s at Dundurn (Alcock *et al* 1989), Forteviot (Alcock and Alcock 1992) — both of which produced assemblages now in the Hunterian Museum — and Pitcarmick (Barrett and Downes in prep). Examples of Pictish metalwork allocated to the NMS include the brooches from Clunie and Aldclune (Youngs 1989, 113–15). One might also note here the carved fragment found at Collace in 1948 and its significance recognised in the early 1960s by Alan Small (Small 1962), then of Aberdeen University. The fragment was relocated to Marischal Museum; the Collace community are now actively seeking its return.

[12] I have focused here on the problem from my own perspective as a museum-based archaeologist, but I do so conscious of other problem areas that space precludes me from raising in detail. They include the need for statutory SMRs, or rather Historic/Cultural Environment Records; the lack of overall protection for archaeological landscapes as opposed to individual sites; the increasing prevalence of the low-cost option in contract archaeology and the general lack of opportunities for the interested individual to get involved in fieldwork (especially excavation). Finally, even the profession itself seems keen to over-compartmentalise: the Archaeology Training Forum in 2003 issued a document on *The future of archaeological training and career development*, which made no mention of how university archaeology and teaching generally fitted into the scheme of things.

[13] I do not question the value of fuller audience research, as it demonstrates the crucial role museums can play in communicating archaeology; see, for example, Smith and Carr 2002.

[14] *The Art of Archaeology* was a UK-wide initiative of the Society of Museum Archaeologists to explore how art could boost public access to museum archaeology collections. For details of several of the projects, including Perth's, see Wise 2003.

[15] Barclay 2002.

[16] As long ago as 1989 David Gaimster (1991) drew attention to the pivotal role museums should play in archaeological research. More recently for Scotland, see Barclay 1997; more generally, see Carver 1993; 1996; Andrews and Barrett 1999; and Gunn and Prescott 1999. In England, Olivier 1996 has given the impetus to a number of regional and local frameworks.

[17] Haselgrove *et al* 2001.

[18] Foster 1997, 11–14.

[19] It is also worth noting that there is a deeper historical dimension to the setting of frameworks for the understanding of Scotland's past. In 1787 the burgeoning Perth Literary and Antiquarian Society issued a paper, *Subjects for Illustration*, outlining a series of subjects appropriate for the Society's members to address in their search for Scotland's identity. These included 'The various migrations from Britain to Ireland and from Ireland to Britain; The chronology of these events . . .; The introduction of Christianity into this kingdom and the subsequent change of the ancient religion and customs of the People. . .; The history of the Danish invasions . . .' and 'The ancient and modern names of persons and places'. The document is Archive 377 in the Perth Museum collections. For a full discussion, see Allan 2003.

[20] Fisher 2001.

[21] Ascherson 2002, 58. There is of course a contraview, that Historic Scotland does not eschew research but sees a need to combine it with rescue or management. HS does have a track record of grant-aiding research-led invasive projects (see

recent volumes of *Discovery and Excavation in Scotland*, for example).

[22] See, for example, Eogan 2002, 481–3.

[23] The minimum group of sites, for the curious, would be: Scone; Moncrieffe Hill; Dupplin Church; Invermay; Strowan and Tom à Chaisteil; Abernethy; Murthly and Caputh; Meigle and Nevay; St Serf's, Loch Leven; Dull and Fortingall.

[24] There is a growing body of publications demonstrating excellence in early medieval interdisciplinarity, including Foster 1998b and Ó Floinn 2002. The case for the ongoing need to understand how early medieval communities and polities understood themselves through their predecessors has been demonstrated by, for example, Bradley 1987 and Driscoll 1998a.

[25] For the Meigle example, see Hall 2005.

[26] Clearly I am flying a kite here rather than presenting a fully costed and detailed plan. My aim is to promote a fuller debate on how Scottish archaeology could become more joined-up in its institutional and policy frameworks and access increased levels of resourcing, for its better preservation and understanding and for the increased enjoyment and life-long learning of Scotland's citizens and visitors.

[27] See also Foster 2001, 14–16.

[28] Treasure Trove is currently, at the time of writing, being reviewed, something that should be completed by the time of publication. The position as at 2002 is fully stated in Saville 2002, 796–802.

CHAPTER 24

THE MISSING DIMENSION: FUTURE DIRECTIONS IN DIGITAL RECORDING OF EARLY MEDIEVAL SCULPTURED STONE

By STUART JEFFREY

SUMMARY

The centenary of the *ECMS* offers us an opportunity not only to reflect on how the study of early medieval sculpture has developed and matured in the last 100 years, it also marks an appropriate point to look forward to how the recording and presentation of these monuments might develop in the future. The capture and use of three-dimensional (3D) digital records of early medieval sculptured stone is already beginning to take its place in the canon of archaeological and curatorial techniques. This chapter examines some of the nascent technologies that may represent the next stage in the evolution of 3D modelling, and which are likely to reach maturity even before the existing digital recording and modelling technologies are considered commonplace. Techniques discussed include those for controlling the lighting conditions under which models are seen or for changing the context in which they are displayed, as well as new techniques for recreating three-dimensionality from two-dimensional images.

THE MISSING DIMENSION

The advent of the digital age has facilitated a bewildering range of new opportunities for the presentation and dissemination of traditional text and image records of early medieval sculpture. In addition, it has allowed for the first time large-scale distribution of, and general access to, 3D records of 3D objects. This has long been an important missing element from both public and academically accessible records. Unlike photographs or illustrations, a 3D model necessarily encapsulates the shape of the monument. This allows a more natural and less mediated approach to appreciating the three-dimensionality of the artefact. When the user can interact with the model, to manipulate it and thereby change their viewpoint, then the natural process of discerning shape is emulated. Human binocular vision allows distance to be judged because it naturally supplies two points of view from which the brain can interpolate a single image that is perceived as having depth. For certain surfaces, however, visual effects such as foreshortening can mislead the brain; the way this is

compensated for naturally is to change our viewing position by tilting our head or moving about. Photographs and drawings do not allow this to be done. The brain stubbornly tells us that we are looking at a flat object, which indeed we are, requiring depth to be inferred, sometimes consciously, from the captured lines of perspective in the image.

A 3D model has a theoretically infinite number of viewpoints, rather than the limited number offered by a series of photographs. In addition to the gross shape of a monument, the spatial relationships of various elements of sculpture are better understood when they can be viewed together in a single model as opposed to separate images. Elements of sculpture are sometimes visually exclusive, that is, they cannot be seen together at the same time (such as the cross-face and back-face of a cross-slab). We compensate for this naturally in a similar way to the way we understand shape: moving between views of a monument at will, we better understand how various elements relate to each other. Sculptured stones were *intended* to be experienced in three dimensions. They are not simply a medium for the images they carry; the spatial relationship of various carved elements has significance. The size and shape of the monuments also carries its own significance, just as the material used, the location, and the sculptured images employed are significant. The relationship between carved elements on objects that cannot be seen from the same location may be significant, as may the orientation of the carving in space. For example, with cross-slabs the general orientation of the cross side towards the west is deemed significant; similarly the fact that crosses carved on slabs occur both as upright monuments as well as recumbent grave markers means a single image may be hard to interpret immediately. Three-dimensional models offer a more intuitive route into exploring these relationships.

The 3D digital recording of early medieval sculptured stone has already begun to take its place in the suite of methodologies employed by art-historians, archaeologists and curators in order to record, monitor and analyse sculptured stone. This process has been accelerated by the increasing availability of recording devices, such as triangulation scanners and time-of-flight laser scanners, which offer portable recording platforms capable of delivering 3D surface records at resolutions and levels of accuracy in the sub-millimetre range. It is more or less certain that these and similar devices will continue to both improve and drop in price. What is not so certain is what ancillary technologies and disciplines will develop to take full advantage of these technologies and what alternative 3D recording strategies lie around the corner.

REJOINING FRAGMENTS

The ability to manipulate 3D models of fragments from a single object allows several individual models of fragments to be presented together in the same virtual space situated in their correct spatial relationships. A potentially significant development in this form of reconstruction is automated refitting. Just as 'best-fit' computer algorithms have been developed to fit together overlapping sections of a scanning event, it is possible to imagine an algorithmic solution to fitting together fragments based on their surface geometry. Essentially, a computer programme examines the

surfaces of the modelled fragments and identifies which originally belonged together. This is perhaps of less use with an object that has split into two or three pieces, where with such a low number of pieces to refit, the process hardly needs automation. However, in the case of Hilton of Cadboll, the assemblage of fragments, representing an entire carved surface which was deliberately removed, runs into thousands of individual pieces (see Chapter 7). Ian G Scott and Isabel Henderson are currently working on this reconstruction manually, using large sand boxes at the National Museums of Scotland in Edinburgh.[1]

Hypothetically each fragment could be modelled in three dimensions and the refitting process at least partly automated. Although this may seem like a far-fetched scenario, given the complexity and likely cost of such a project, there are archaeological examples of this approach in progress. For example, the *Forma Urbis Romae* or Severan Marble Plan of Rome is an enormous map, measuring approximately 18m x 13m. It was carved between AD 203–11 to cover an entire wall inside the Templum Pacis in Rome, and it depicted the ground plan of every architectural feature in the ancient city, from large public monuments to small shops, rooms, and even staircases.[2] Only around 15% of the map survives and this was broken into 1186 fragments in antiquity. A highly ambitious project, which is still ongoing, intends to refit the giant stone 3D map, thus solving what has been described as a 'great puzzle'.[3] The project has created 3D models of each of the fragments and is designing the software to automate the refitting process with as little human intervention as possible. Major technical issues have been encountered beyond those relating to the scale of the project. The most significant of these is that the surfaces of the fragments have become abraded or otherwise altered since they were originally split apart. This means that the algorithms designed to refit them must be able to cope with a certain amount of 'fuzziness' in the process; such ambiguity is notoriously difficult to programme. If successful, however, the development of the algorithms for surface fitting the *Forma Urbis Romae* could be transferred to similar problems in the field of early medieval sculpture in Scotland (as well as other areas of archaeology, such as lithics and ceramics).

In this context, using 3D models sculptured together with this technique, holds out the possibility of investigating which of the many isolated sculptured fragments and groups of fragments located at numerous different sites, actually belong together without having to physically move the fragments from place to place. Such an approach need not necessarily be able to identify only definite joins, but it could also identify likely or probable joins, allowing testing in the field to be targeted. It may even allow completely unexpected joins to be discovered. It should be noted that such a technique could not be expected to operate well in isolation from other techniques that may identify fragments that were originally associated, such as art-historical and geological approaches, but it could offer a significant additional tool.

RECREATING MISSING FRAGMENTS

The automated refitting of surviving fragments may remain problematic for the moment, but 3D modelling techniques do allow for the creation of hypothetical

FIGURE 24.1 The various elements of the reconstructed head (left). The combined complex shape before re-joining to the model of the existing cross shaft (right). (© S Jeffrey)

reconstructions of fragments that are lost or destroyed. An example of this process is a 3D model of the Govan 'Jordanhill' Cross which has had its missing head and base digitally reconstructed as part of research taking place at the University of Glasgow.[4]

Figure 24.1 (right), a flat-rendered close-up of the reconstructed head, shows clearly that it is constructed of various primitive shapes in combination: the central boss is part of a sphere, the ring a torus, and the arms of the cross are assorted cuboids (Figure 24.1 left). The primitive shapes have been distorted: for example, the cross-arms are tapered in two directions, before being combined into a single complex shape. The whole reconstruction was then scaled to match the size of a polygonal surface model of the original shaft. Although time consuming, the reconstructed head is an adequate approximation of the intended shape. The major difference between the recorded polygon surface and the purely modelled head is the apparent surface texture. Because the head is modelled using geometric shapes, the lines are clean and all the surfaces smooth. In reality, carved stone has a more complex texture at some scale, even where it is intended to be smooth.

The problem of modelling rough and complex surfaces represents an important limitation of the technique. If, unlike the hypothetical reconstruction in Figure 24.1, the area to be reconstructed actually carried complex carving, then the process by which it is modelled digitally becomes similarly complex. Similar levels of skill and artistry to those of the carver who created the sculpture in the first place would be required to create a digital version using computer modelling techniques such as Constructive Solid Geometry. The limits to the sophistication of this type of reconstruction do not lie with the applications: even living creatures can be digitally modelled quite convincingly, as a number of recent films and documentaries have demonstrated.[5] The limitations lie with the skill of the modellers and the time and cost restraints imposed on them.

The complexities of creating a realistic, rather than impressionistic, digital reconstruction mean this process is more closely comparable with physical reconstruction (such as one actually carved in stone) than with sketched or drawn reconstructions. This similarity includes the likelihood that fewer different versions of a reconstruction for a particular monument will be produced in digital format, just as reconstructions carved in stone are not often used for experimental comparison of several possible reconstructions. As electronic publishing and digital modelling will soon start to dominate archaeological information dissemination, the most significant implication of this type of digital reconstruction may well be that fewer, not more, varied interpretations of missing or damaged sections, become available. It is possible that, in the future, as modelling software interfaces evolve and as a larger and larger number of archaeologists engage with digital modelling, this may not continue to be true, but for the moment it remains an important point to consider when selecting a reconstruction strategy.

RECONTEXTUALISATION: RECONSTRUCTING CONTEXT

The sections above have dealt with rejoining and reconstruction of the sculptures themselves, but it is not necessary for the reconstruction process to stop here. For historical reasons, sculptured stones have frequently been studied as artefacts divorced from their archaeological and landscape context: the 3D, physical landscape which they originally occupied. There has been a centuries-long process by which these monuments have been removed from the landscape and deposited in church buildings, museums and other structures. One result of this process is that there is a lack of focus on the monuments themselves and a strong focus on the iconography they carry. We often see illustrations, not of the entire sculpture, but of the images carved on the stone. Archaeologically speaking, this approach concentrates on a small part of a much wider picture, the materiality of the sculpture, its position in the landscape, its relation to other features or monuments in the landscape and the relationship between people in the past and the monuments and landscape in combination. Any technique that encouraged researchers and other audiences to think of the sculptures as part of a wider social and political landscape could be considered a useful tool.

Recontextualisation is an attempt to facilitate this by placing models of sculptures, or digital reconstructions of them, into digitally generated landscapes, with the objective of encouraging and enabling us to think about wider landscape issues, as well as the minutiae of carved detail. Investigation of intervisibility, lines of approach and associations with earlier monuments and other landscape features has so far required a trip to the location of the monument in question (or one of its previous locations). It is fair to say that there is no substitute for this approach, but not all members of potential audience groups are able to make these journeys for a variety of reasons, including geographical remoteness and physical disability. The need for some way of recreating a monument's context is accentuated by the process of institutionalisation of the monuments mentioned in the previous paragraph. This is detrimental to our understanding of those sculptures that were originally intended

as highly visible landscape monuments, a constant presence in the lives of those who shared the landscape.

There are a number of techniques for capturing 3D data from real world landscapes. The Ordnance Survey has traditionally used levels and theodolites, more recently photogrammetry, radar and lidar, and very recently GPS and satellite-based remote sensing. These techniques generate spot heights distributed across the landscape, which in turn can be used to create digital elevation models (DEMs) and digital terrain models (DTMs) in geographical information systems (GIS). These 3D landscape models can also be exported into 3D modelling or Virtual Reality applications. These can allow the viewpoint of the user to approximate that of an individual on the ground, rather than the standard 21st-century topographic representation, where the viewpoint is directly above the landscape and it is seen in plan view, as with maps.

There are problems with 3D modelling as an approach to landscape representation, not least of which is the difficulty in rendering surfaces with sufficient detail and texture to give the impression of a real landscape. The most common approach is to use generic landscape rendering. This, depending on user-defined levels of complexity, can give a very realistic impression of vegetation, rocks and so on. The types of vegetation or the occurrence of outcrops are often generated in relation to the height given by the DEM. In this way, the user can define at what height the tree level might be or at what steepness grass gives way to cliff. The problem, however, is that this realistic impression is only loosely related to what the landscape actually looks like and even more loosely related to what the historic landscape looked like. If there is a rock outcrop at a particular location, and this requires rendering with a different texture map to make it apparent in the model, then this has to be done explicitly by the model builder. What this means is that for a surface rendering that is not just photorealistic, but actually representative of the real landscape, or an interpretation of a historic landscape, a great deal of time and effort is required.

Decisions have to be taken by the modeller at various stages in model construction, regarding the data that will satisfactorily represent a landscape. Visually, good results can be generated with fairly poor-resolution surface models, provided that the rendering is complex enough and effectively breaks up the blocky, geometric impression given by a fairly coarse polygon structure. However, poor levels of surface detail, such as widely spaced points or contours, will obviously result in a less accurate result, no matter how realistic the rendering package makes it look. This problem, in combination with the difficulties of landscape rendering mentioned in the previous paragraph, often means that in all but the most sophisticated models, the landscape is neither highly accurate nor does it have the 'look and feel' of a real landscape.

An even more difficult problem for 3D modelling packages that are intended to represent an archaeological landscape, is the problem of the horizon. If the horizon or far distance is significant to the understanding of the landscape (for example, which hill or mountain tops can be seen, or whether the sea can be seen from a particular location), then a DTM/DEM may have to be very large indeed to cover the entire geographical area that is visible from the area of interest. The fact that the horizon is

FIGURE 24.2 A screen shot from a computer modelling package showing the cylinder used in this recontextualisation technique (left). The three-dimensional model of the Govan 'Jordanhill' Cross with its reconstructed head recontextualised in a hypothetical landscape (right). (© S Jeffrey)

either completely false or impressionistic in many models used for civil engineering or architectural purposes has little relevance to their usefulness. The significance of the horizon for defining a place in anthropological terms and the importance of the visibility of distant places in the historical past[6] means, however, that the inclusion of an accurate horizon could be as crucial in the creation of a virtual world as it is in the social construction of the real world.

An experimental approach to combining a 3D model of an early medieval sculptured stone with a micro-topographical surface and a panoramic image capturing the horizon was developed in order to solve this problem.[7] This technique involves using a 3D modelling package to create a cylinder and then applying a panoramic image (Figure 24.2 right), which has been distorted to allow for parallax effect, onto the inside surface of the cylinder. It is then possible to place 3D models, either of individual monuments and/or parts of their associated landscape, at the centre of the cylinder. Virtual cameras, used by modelling packages to give viewpoints, are then positioned inside the cylinder, and as long as their field of view is normal to the inside surface of the cylinder, this gives the appearance of the model being in the landscape represented by the panorama. The vertical position of the cylinder relative to the model can be manipulated to gain the desired effect. For example, if there is a fairly large landscape surface model inside the cylinder, a combination of camera position, model position and cylinder height can be used to align the model with the landscape projected on the cylinder (see Figure 24.2 left)

This approach presents two obvious possibilities for archaeological landscape reconstruction. Firstly, Quick Time Virtual Reality (QTVR[8]) object movies and panoramas can be generated. Object movies are most simply described as being a single computer file consisting of several images of an object taken from different angles, where the user can interactively switch between images, animating the model,

and creating an illusion of three-dimensionality. The QTVR object movies use the 3D model with the reconstructed monument back in context, without the problems of camera angle control commonly associated with this technique in real world environments. Secondly, 3D guided animations can be created using detailed DTM/DEMs for the local area, but with the far distance represented by the photorealistic panorama, although in this case, care would still have to be taken with the angle of the camera. The fact that QTVR object movies can now be produced (with a genuine photographic landscape panorama) from a series of images generated by the 3D modelling package allows for a fairly high degree of interactivity. The user is able to zoom in and out of any part of the image, and to slide the image in the window when zoomed in. Most significantly, the user is able to 'walk round' the monument by rotating it while at the same time observing the surrounding landscape to the horizon.

Despite the limited success of this approach, the problem remains of integrating real horizons into larger landscape models in which early medieval sculptured stones might be placed. For models presented via interfaces that allow greater freedom of movement around the environment, this is an especial problem as the user approaches the edge of the model. Even though the modelling of real landscapes in three dimensions is not without difficulty it is the only way of visualising 3D models of early medieval sculptured stones in a landscape context that still allows the monument to be fully appreciated in three dimensions.

THREE-DIMENSIONAL MODELS WITHOUT THREE-DIMENSIONAL RECORDING

It is not always necessary to capture 3D measurements of the surface of a monument to produce a 3D model. Image-based rendering is the generic term for 3D models based on photographic images rather than on surface models. QTVR object movies represent one of the simplest and best-developed examples of this technique.[9] Despite the serious difficulties in applying this technique to large field monuments, notably controlling lighting conditions and camera angles, and gaining clear access, the technique's benefits in terms of minimal hardware and ease of production suggest that it will be worth developing. There are two particularly promising developmental approaches: Polynomial Texture Mapping (PTM) and Light Fields. Both these approaches depend on the ability to control the lighting conditions in which the recording phase is undertaken. Until now the practical difficulties of doing this would have been considered to be so serious as to make such techniques unviable except for portable artefacts. If PTM and light field technologies come to fruition as robust useable systems, however, then the advantages may be so great that the practical problem of controlling lighting around field monuments may be tackled in earnest.

POLYNOMIAL TEXTURE MAPPING

PTMs are an ingenious technology for capturing and manipulating reflectance values from the surface of artefacts. Although the mathematics behind the process are extremely complex the basic principles behind it are relatively simple. Using a light dome, such as the one in Figure 24.3, developed by Hewlett Packard (HP)

Figure 24.3 Hewlett Packard's Light Dome. (© HP Laboratories)

Laboratories,[10] a series of images is taken of a target object from a large number of varied lighting conditions, but from the same camera position. The images are then combined in such a way that the colour and intensity of reflected light recorded by each pixel is stored together with the same information from the corresponding pixels in each of the original images. In this way a 'PTM file' is built up, in which the colour and intensity information of each pixel under each lighting position is stored in a single file. This means that in order to render the image from a particular direction, the viewer programme accesses the PTM file and extracts the values stored that represent information about the reflectance of each pixel under different lighting conditions. The number, position, and intensity of virtual light sources can then be manipulated.

This approach offers two major advantages in addition to the ability to render the image under the numerous lighting positions captured in the original recording event. First, it allows for the interpolation of renderings that represent a lighting position between the original lighting positions, presenting the user with the opportunity to light the model from any direction and light intensity whether or not that particular direction and intensity was used in the light dome. Secondly, it facilitates the manipulation of reflectance values consistently across each pixel of the PTM file. This in turn allows for completely novel lighting conditions and reflectance properties that are not native to the target object.

In Figure 24.4 we have a very good example of how this second technique may offer the opportunity to extract information from lightly incised, worn or difficult-to-see surfaces that cannot be extracted by any other technique. Figure 24.4 represents four different renderings of a Sumerian tablet created at the HP Laboratories.[11] Image A is an unaltered digital photograph. Image B is the polynomial texture map that represents lighting conditions identical to those of the photograph (image A). Image C represents an image where surface normals have been extracted from the PTM and

FIGURE 24.4 The Sumerian tablet rendered using a PTM. TL: Image A, TR: Image B, BL: Image C, BR: Image D. (© HP Laboratories)

the reflectance has been altered from diffuse to specular (that is, more light is reflected directly towards the viewpoint, and this makes surfaces appear shiny, rather than light being scattered in diffuse directions, which is what makes a surface appear matt). Image D is a combination of images B and C apparently giving the surface of the tablet the reflectance properties of a shiny material such as polished metal. The self-shadowing properties of the surface are maintained and as a result surface detail that is hard to discern in the original image becomes much clearer in the manipulated one.

The present limitations of this technique include the resolution that digital cameras are currently capable of capturing, and the small size of the target object. The technique obviously has enormous potential for small, detailed objects that can be appropriately captured by the maximum resolution of modern standard format CCD cameras, around five megapixels. The same resolution applied to a large object, such as an entire side of Aberlemno 2, would not give anywhere near the same level of detail. Also potentially challenging would be adaptation of light domes to capture much larger objects.

IMAGE-BASED RENDERING

Clearly the development of PTM technology would offer an extremely useful tool for the recording and analysis of lightly-incised or heavily-worn surfaces. It does not enable, however, the interactive manipulation of the artefact or monument in three dimensions in the way that both 3D surface models and QTVR image-based models allow. QTVR relies entirely on the viewpoints captured in the initial sequence of photographs. The concept of creating interpolated frames between recorded

FIGURE 24.5 A single planar view of light field capture. After Levoy and Hanrahan 1996, slide 8.

frames, in order to allow for smoother transitions and an increased number of view points, is rapidly reaching maturity, however, in the form of light field technology developed by teams at the computer science departments of the University of Stanford and the University of California (Berkeley). The Stanford team, led by Marc Levoy, has already applied the technique in a limited form as part of the Digital Michelangelo Project,[12] while the University of California team's main objectives are primarily the development of cinema and TV special effect techniques.[13]

The basic concept is represented in Figure 24.5. The circles in this diagram represent camera positions, while the blob in the centre of the camera array represents the target object. The diagram itself represents a two-dimensional view of the system, being a single plane seen in plan view. As can be seen from the diagram, with enough cameras the light being reflected from the target object can be captured, no matter which direction it comes from, thus effectively capturing what is known as the light field of the object. The square represents a viewpoint where no physical camera was ever located, but which can be constructed by the selective 'borrowing' of pixels from nearby physical camera positions. This technique frees the viewpoint of the user from being tied to the viewpoint of any of the actual cameras used in the recording process, and allows it to be placed in a theoretically infinite number of locations within the light field of the object.

Currently the main thrust of the effort to create effective light field techniques is directed towards the development of effective software, because the hardware required (cameras and lights) is essentially off the shelf. More recent attempts to incorporate the principles of capturing reflectance values and light fields in combination have used fewer cameras and purpose-built light stages. The current state of development in integrating these two approaches is exemplified by the work of Paul Debevec at the University of California. His project on capturing the reflectance field

of a human face has produced impressive results.[14] The project uses a light stage employing light sources mounted on a dual-axis rig that, over the space of a minute or so, lights the target (a human face) from multiple directions. This process is recorded by several digital video cameras, and the post-processing phase allows for the extraction of a model of the reflectance values of the target on a pixel by pixel basis. This allows it to be lit virtually with complete flexibility, as well as allowing for the interpolation of novel camera positions.

For early medieval sculptured stones it is possible to envisage a form of model generated by image-based rendering techniques that combine and enhance the advantages of three forms of model: the ability to model the monument using only images but allowing the interpolation of novel viewpoints; the ability to interactively light the model from any conceivable direction; and the utilisation of light values extracted from real world light sources using spectral analysis.[15] The combination of these approaches represents the next significant step forward in 3D modelling techniques, but it is important to remember that the technical problem of extracting surface geometry from the base images used in these approaches has not yet been overcome (although if lighting has been effectively controlled during the data capture phase, then the use of topometry concurrently with the capture of reflectance field seems appropriate). Without surface geometry to utilise, image-based rendering techniques do not allow for the deployment of ancillary techniques such as haptic technology (the ability to 'touch' the model with special interface equipment), or the recontextualisation of models in landscapes modelled by other methods as discussed earlier.

None of the techniques discussed above, refitting, reconstruction, recontextualisation, polynomial textual mapping and image-based rendering are going to make the transition from experimental techniques to practically applicable field methodologies in the very near future and some may never do so, being superseded or outmoded by alternatives. Their adoption is predicated not only on their usability, but also on the general acceptance by the public, academics and heritage professionals of digital dissemination of historical, archaeological and art-historical information. This is itself a process which may take some time. Although the potential benefits of these novel forms of record and interpretation, delivered over the new media, are such that a critical assessment of their impact and utility should be engaged in at as early a stage in their development as possible.

It is entirely conceivable that in historical terms, the period in which 3D objects were recorded and analysed exclusively via the use of two-dimensional media may be seen as a short term aberration.

ACKNOWLEDGEMENTS

The author would like to thank Dr Jeremy Huggett and Dr Ewan Campbell for advice and assistance with this contribution, and also Dr Sally Foster for her encouragement and continuing interest in the application of new technologies in the field of early medieval sculpture.

NOTES

1. The Hilton of Cadboll website contains updates on this process: http://www.gla.ac.uk/archaeology/1078.
2. Levoy 2000.
3. Digital *Forma Urbis Romae* 2003: http://graphics.stanford.edu/projects/forma-urbis.
4. This research was one part of the Scotland's early medieval Sculptured Stones project (SEMSS): http://www.gla.ac.uk/archaeology/projects/SSEMS_web.
5. For example, the BBC TV production *Walking with Dinosaurs* or Hironobu Sakaguchi's 2001 film *Final Fantasy: The Spirits Within* (Square USA).
6. For examples, see Ingold 1997, 29–32; Lemaire 1997, 5–22.
7. Jeffrey 2001.
8. QTVR was developed by Apple, for details and examples see http://www.apple.com, and Jeffrey 2001.
9. Warniers 1998.
10. For Hewlett Packard Laboratories see http://www.hpl.hp.com/ptm; or Malzbender *et al* 2001; similar devices have been developed by University of Oslo Museum of Geology: http://www.nhm.uio.no/geomus/engelsk.
11. Malzbender *et al* 2001.
12. Digital Michelangelo Project: http://graphics.stanford.edu/projects/mich; see also Levoy *et al* 2000.
13. Debevec 2002; Unger *et al* 2002.
14. Debevec *et al* forthcoming.
15. See Chalmers 2002; Devlin and Chalmers 2001.

CHAPTER 25

THREE-DIMENSIONAL RECORDING OF PICTISH SCULPTURE

By ALISTAIR CARTY

The physical process of recording Pictish sculpture has changed since its early inception in the mid-19th century, the days of Stuart and other pioneering antiquarians (see Chapters 13 and 14). New techniques, such as stippled drawings, shouldered their way into the recorder's toolbox, beside ink-wash illustrations and engravings, only to be themselves supplemented with the modern technique of photography. Since the pioneering use of photography in *ECMS*, however, little has changed in recording other than more formally specifying and optimising camera setup.[1]

With the advent of faster and cheaper computing power, technologies have materialised which enable not only the surface appearance of sculpture to be recorded in a two-dimensional form, but which also record the surface itself as a collection of highly accurate and fully three-dimensional measurements. This advance expands the possibilities of recording, monitoring and even replicating sculpture immensely.

PHILOSOPHISING ABOUT THE THIRD DIMENSION

The most complex aspect of 3D recording, no matter what the subject matter is, is that of the third dimension. That is, people have an almost schizophrenic way of looking at the world. For example, if you were to place two identical objects a distance apart, it is simple to state that one object is further away than the other due to our perception of depth and the ability to walk around the two objects. If you were to take a photograph or make a drawing of the scene from one point of view, however, it becomes difficult to tell whether two identical objects are placed some distance apart, or if two differently sized objects sit beside one another. The three-dimensionality of the scene is now lost and is available by inference only.

As this paper discusses the recording of Pictish sculpture in a three-dimensional manner, it is worth noting that the images reproduced within the paper are merely two-dimensional representations of fully 3D information! This is exactly the same process that taking a photograph of a stone, or illustrating it, reduces a three-dimensional object to a 'flat' image.

FIGURE 25.1 A single detail scan of St Orland's Stone. The area covered is approximately 350 x 250mm in size and contains over 300,000 measurements. (© Archaeoptics Ltd, courtesy of Historic Scotland)

TECHNOLOGY

There are several technologies available at the time of writing that enable us to record objects in three dimensions (3D) (Chapter 24). The technique discussed here belongs under a wide umbrella called '3D laser scanning'. In a nutshell, a low-powered laser is used to measure the position of a point on an object in three dimensions. As time progresses, many measurements are taken, building up a complex and highly accurate 3D map of the surface of the object. To fully record a complex sculpture, such as a Pictish sculpture, the scanner is manually moved around the object to measure points from many different angles, similar to photographing a stone from different sides to achieve complete coverage.

Within the broader topic of 3D laser scanning, there are essentially two types of device which operate in subtly different ways and produce radically different results.

Triangulating 3D laser scanners

These 3D scanners are so-called due to their use of the principle of triangulation. That is, typically a thin stripe of laser light is projected across the surface of an object and is viewed by a digital camera. Since the positions of the camera and laser emitter are fixed and known, it is simple to compute the position of points along the laser stripe in 3D.

Triangulating laser scanners typically have a very high resolution and accuracy, making them ideal for accurately recording fine details on sculptured stonework (Figure 25.1). In addition to this, the high accuracy also enables us to directly measure changes in the surface of the stone either caused by decay, or perhaps even vandalism. The downside, such as it is, is that extremely large datasets can be generated. For example, recent scanning work undertaken at the Aberlemno sculptures resulted in the following numbers of measurements:[2]

Sculpture	Resolution	Number of measurements
Aberlemno 3	0.4mm	99,295,921
Aberlemno 1	0.3mm	73,464,373
Aberlemno 2	0.5mm	69,126,252
Aberlemno 4	0.4mm	10,737,574

As can be seen from this table, the quantity of raw data is almost overwhelming. In the case of recording fragile surfaces found on outdoor sculptured stones, however, it is always better to acquire more data than not enough.

Time-of-flight 3D laser scanners

Time-of-flight scanners operate on a different set of principles to triangulating scanners. A time-of-flight scanner simply shoots a laser pulse at the object and measures the time taken for the pulse to return to the scanner. Given that the speed of light is constant, the distance from the scanner to the surface of the object can be calculated quite easily. Motors internal to the scanner move the laser emitter backwards and forwards across the object, shooting a laser pulse out at regular time

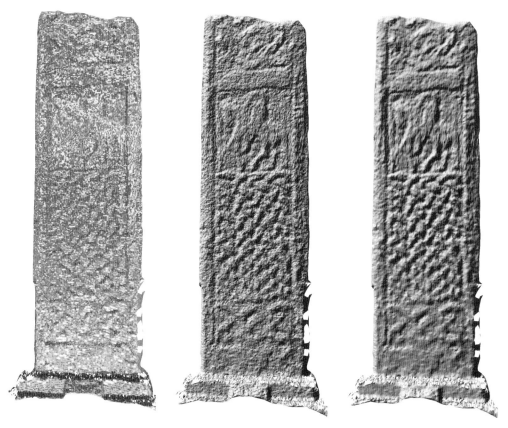

FIGURE 25.2 The Govan 'Jordanhill' Cross scanned with a Callidus time-of-flight scanner. (© Archaeoptics Ltd, courtesy of The Friends of Govan Old (Parish Church))

intervals. Therefore, the 3D points are calculated as a combination of the horizontal and vertical angles of the motors plus the measured distance.

As such, the resolution and accuracy of time-of-flight scanners is quite limited, typically operating at ± 6mm accuracy. With this level of accuracy, the intricate surfaces of sculptured stonework are reduced to a formless blob. Figure 25.2 shows a scan of the Govan 'Jordanhill' Cross using a Callidus time-of-flight scanner. The raw data is shown on the left and is completely indecipherable. The middle image shows the data after one iteration of a smoothing algorithm and some features are now distinguishable. The rightmost image shows the data after two iterations of a smoothing algorithm and is considered to be the 'best' recording of that stone with that type of scanner, albeit still fairly poor in quality and, in reality, useless for recording purposes.

As such, the use of time-of-flight, or terrestrial scanners for recording Pictish sculpture is almost completely pointless with the technologies available at the time of writing. For accurate recording, a triangulating scanner should be used. As technology changes quickly and often, however, it would be better to state that a high-accuracy and high-resolution system be used no matter what its underlying optical principles.

RECORDING, MEASUREMENT AND REPRODUCTION

Once an item of sculpture has been completely scanned, the resulting model can be easily manipulated on a computer in a variety of ways. The following paragraphs discuss a few of the potential uses of this recording technique.

Optimal lighting

The 3D model of a stone, or a section of sculpture, can be loaded into software and manipulated in a manner that enables a researcher to manipulate the lighting around a stone on the computer. For example, we can easily set up digital lighting around the model which simulates the use of two flashguns. This is considerably easier than the complex configuration of flashguns in the field.

Additionally, the lighting can be set such that the model does not cast shadows. For stones such as St Orland's Stone with its complex, multi-level surround on the cross-face, this enables us to generate an image showing all the decoration on a single image, an effect almost impossible in the real world (Figure 25.3).

Finally, the lighting can be changed in real-time. That is, you move the light and the effect of the new light position is seen automatically on the model of the stone. This enables the researcher to minutely tweak the position and intensity of the light to optimally display carvings on a stone (Figure 25.4).

Illustration

One of the more important facets of sculptured stone recording is that of publication. Using software it is possible to generate reasonably effective black and white illustrations of the stones in a semi-automatic manner. This may be suitable for generating good (although not excellent) 2D images suitable for deposition in the National Monuments Record or for publication. It should be noted that these images,

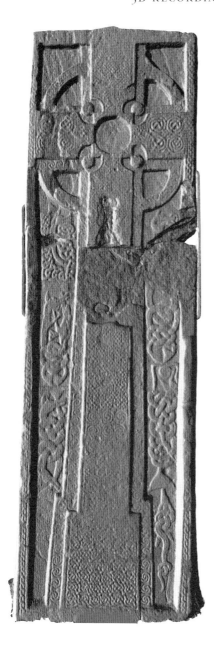 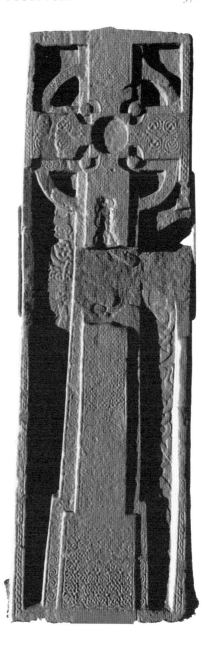

FIGURE 25.3 St Orland's Stone viewed without shadowing and with shadowing. The clarity of the carvings on the deepest areas of the stone are clearly visible on the left-most image, less so on the right. (© Archaeoptics Ltd, courtesy of Historic Scotland)

FIGURE 25.4 The symbols on the Blackford symbol-incised stone at Peterhead Farm near Gleneagles. The very faint goose carving and more clear 'rectangle' symbols can be clearly seen through the use of optimal lighting without ambient light or shadows. (© Archaeoptics Ltd)

although hardly 'perfect', do constitute an excellent starting point for an illustrator to work from, in that the outlines and major details of the stone are already accurately positioned and rendered.

Interpretation

When researching sculptured stones, once areas of interest have been identified through examination of archives, it is not uncommon that recourse be made to the original stone. For example, if studying the tooling used to make particular inscriptions, it would be impossible to measure a cross-sectional profile of an incision from a drawing. Additional measurements may also be required, such as the size of various features from 'how big is that symbol?' to 'how thick are the sandstone bedding planes?'

For research purposes, a 3D model is almost ideal in that the full three-dimensionality of the sculpture can be examined in an interactive manner without visiting the original stone.

Monitoring decay

Our sculptured stone heritage is in constant danger of disappearing forever where such sculpture is outdoors or otherwise open to vandalism or other erosive processes. One of the major problems with this critical issue is qualifying what processes are at work on any given sculptural element, and quantifying exactly how much erosion there is. In the case of stones sculpted in sandstone, the processes include weathering and delamination. Neither are easily spotted unless a substantial piece of sculpture is damaged.

High-accuracy 3D scanning may offer a solution to this issue in that it is possible to exactly measure the difference between two scans of the same object. That is, if a sculptural element is scanned at high resolution one year, and rescanned five years later, a 'difference map' of the two scans can be produced. The difference map can show both exactly where the differences lie and exactly how much difference there is. In the case of delamination, the differences should be fairly substantial, whereas the slower weathering process would only show a minor difference.

Non-contact replica production

A final thorny issue that may be eased by 3D recording is that of outdoor sculptured stones being left in the landscape. The main argument for moving the stones indoors is that it will be possible to control destructive processes by controlling the environment within which the stones are displayed. Additionally, issues such as vandalism or damage by animals can be solved as well.

On the other hand, it can be argued that such sculptured stones form a hugely tangible part of our historic environment and should not be moved. Recent cases, such as the display of the Fowlis Wester 1 cross-slab within a dark corner of the nearby church, and the moving of the beautifully situated Dupplin Cross, lend weight to the argument of leaving stones in their current location.

In the past, several approaches have been taken to resolve this issue of leaving stones *in situ*. For example, the rock art carvings at Dunadd have been covered by a fibreglass replica (Figure 10.8; Chapter 10). Detractors may state that the original casting process could have caused damage to the sculpture, and that the fibreglass itself may cause more rapid deterioration due to microclimates between the original and the cast, although no quantitative data exists to prove or disprove this theory.

Another technique has been to erect glass shelters around stones, most noticeable at Sueno's Stone (Figure 11.2; Chapter 11). Apart from the obvious problem of stones being thrown at the panes, glass-enclosed sculptures are frustratingly difficult to photograph, and can visually look rather poor compared to the majesty of the original sculpture.

The final technique is that used on Fowlis Wester 1 where a replica has been made and the original stone moved nearby (Chapter 10). Excluding the issue of the poor display of the original stone within the church, the replica itself is not even remotely accurate. Damaged carvings have been 'improved', and the actual surface appearance can be uncharitably described as being 'porridge-like'.

To solve this, as laser scanning produces a highly accurate and objective recording of a sculpture in three dimensions, we can directly use this data to mechanically produce a virtually perfect copy of the sculpture in question. The main benefits of this approach are twofold: first, the reproduction is exactly the same as the original; second, the reproduction is completely non-contact. The stone is not touched during the scanning process, nor during the manufacture of the replica.

As such, this technique offers a real possibility of satisfying the desire to move original sculpture into more controlled environments, but simultaneously retains the impact of the sculpture within its local landscape context.

SUMMARY

In short, 3D laser scanning, when used with a suitable resolution and accuracy, offers an extremely powerful and accurate way of recording sculptured stone monuments and artefacts. A single dataset can be used in a myriad number of ways, from aiding traditional illustrative renderings of the sculpture, right up to completely reproducing the sculpture in a non-contact manner.

ACKNOWLEDGEMENTS

The author acknowledges the support of Historic Scotland for enabling him to spend many hours in the field recording Pictish sculptured stones and Viking runes, and John Borland of the RCAHMS for discussion on illustration and lighting techniques.

NOTES

[1] Gray and Ferguson 1997.
[2] Archaeoptics Ltd undertook the 3D laser scanning work at Aberlemno, recording all four stones during March–April 2002 for Historic Scotland. A triangulating laser scanner was used and the stones were scanned at a resolution of 0.5mm with an accuracy of 0.1mm.

CHAPTER 26

TOWARDS A 'NEW *ECMS*': THE PROPOSAL FOR A NEW *CORPUS OF EARLY MEDIEVAL SCULPTURE IN SCOTLAND*

By JOHN HIGGITT

The *Able Minds and Practised Hands* seminar was a fitting commemoration of the centenary of the publication of one of the most significant achievements in the study of early medieval sculpture, *The Early Christian Monuments of Scotland* by J Romilly Allen and Joseph Anderson. The intention behind the seminar was, however, forward-looking rather than retrospective, and the papers in this volume reflect the wealth and range of recent work and current projects that are greatly extending our knowledge and understanding of the early medieval stone monuments of Scotland. It is a measure of the vitality of this field and of the great success of the seminar that a proposal for a new corpus of early medieval sculpture in Scotland arose in the formal discussion period and received enthusiastic support. There was general agreement that a steering group should be set up 'to formulate proposals for an up-to-date corpus of pre-Romanesque early medieval sculpture in Scotland'. The National Committee on Carved Stones in Scotland (NCCSS) was entrusted with the task of initiating this process. It has started to collect information and to explore the issues, and will in due course give its view on the best way forward. At the time of the seminar I was chairman of the NCCSS, but I have since handed over to Mark Hall of the Perth Museum and Art Gallery. This note is therefore a personal view informed by recent discussions in the NCCSS, but not a formal statement on its behalf.[1]

The case for taking the work of Allen and Anderson forward in a new corpus is explored in several of the papers in this volume, and with some force and in some detail by Sally Foster and Isabel Henderson. All are agreed that *ECMS* was an immense, indeed revolutionary contribution to the study of the early medieval sculpture of Scotland (and beyond) and that it is still of great value, but, after a century, it is time to recognise what Henderson rightly calls its 'inevitable limitations' and to take account of all that has happened in this field since 1903. The level of illustration is one of the most serious limitations for the modern user of *ECMS*. The photographic coverage illustrates only selected views of selected monuments. The drawings are to varying standards (Chapters 13 and 14) and include simplified interpretative line-drawings that, in the absence of other illustrations, have acquired

an inappropriately authoritative status. The descriptions in Part III of *ECMS*, Allen's 'Archaeological Survey and Descriptive List, with illustrations of the Early Christian Monuments of Scotland' are still very useful but now show their age in various respects. Much of the information is also of course now out of date: pieces have moved, or have been lost, or have deteriorated.

The main argument for a new corpus is not, however, the shortcomings of *ECMS*. It is something much more positive, the need to draw together, evaluate and make conveniently available, firstly, the great body of work published after 1903 on the monuments known to Allen and Anderson, and, secondly, the very significant number of carved stones and fragments found since their time. There is now a large literature on the early medieval sculpture in Scotland. Much more is now known about many individual monuments and groups of monuments. New and more complex questions are now being asked about the interpretation and wider contexts of individual monuments. Equally, our understanding of Scotland's early medieval sculpture is being transformed by the mass of detailed publication on the early medieval manuscripts, metalwork and sculpture of the British Isles and the Continent. Of particular relevance are the volumes of the *Corpus of Anglo-Saxon Stone Sculpture* and the fruitfully international and collaborative approach taken in recent decades towards the study of 'Insular art'.[2] Ambitious and sophisticated approaches to the interpretation of the Christian subject matter and symbolism of some early medieval sculpture, which have been pioneered on the Ruthwell Cross and extended to other Anglo-Saxon, Irish and Pictish monuments, alert us to the possibility of complexity and subtlety in meaning (Chapters 16 and 17) and is a further argument for thorough description and analysis.[3]

What is now required is a corpus, that is a complete record, of all surviving and recorded sculpture, the value of which is demonstrated by the volumes of the *Corpus of Anglo-Saxon Stone Sculpture* and the inventories of monuments in Argyll published by the RCAHMS.[4] Henderson (Chapter 5) shows how informative even small fragments of sculpture can be, when taken together and viewed in context, an approach that would be greatly facilitated by a corpus. The geographical and chronological scope of such a corpus can probably be agreed without too much difficulty. It should, like *ECMS*, cover the whole of modern Scotland, although its borders do not coincide with those of any political or cultural region of the Early Middle Ages. Any attempt to limit the corpus, for example, to 'Pictish' sculpture or Pictish Scotland would involve a series of arbitrary and subjective decisions. The *Corpus of Anglo-Saxon Stone Sculpture* limits itself to the territory of modern England and so invites a Scottish corpus to take over at the border (and, as far as possible, to adopt an approach to the recording and description of monuments that is compatible with that of the Anglo-Saxon corpus). As a label for the period I prefer the more neutral (and more international) 'early medieval' to the 'Early Christian' of Allen and Anderson, since it avoids taking a view on the religious beliefs of, for example, those who raised the early symbol stones. The period can presumably be agreed to start in early post-Roman times and to end with the introduction of the Romanesque style. It would therefore, in Anderson's words, 'investigate the varieties of sculptured monuments whose types of symbolism, ornamentation or epigraphy are

earlier than those usually associated with the European system of ecclesiastical architecture introduced into Scotland towards the commencement of the 12th century'.[5] The appropriateness of this end-point is confirmed by another current corpus: the *Corpus of Romanesque Sculpture in Britain and Ireland*.[6] This web-based corpus includes the Romanesque sculpture of Scotland and is nearing completion. There will no doubt be a few debatable monuments and perhaps a slight 'overlap' between the two corpora, but in general the distinction between pre-Romanesque and Romanesque is clear enough in Scotland.

The new corpus should be unashamedly scholarly and scientific in its methods and aims and should, as Henderson argues (Chapter 5), avoid over-simplification. Clear guidelines and standards will need to be agreed and followed consistently. The primary purpose of the corpus will be to provide a complete and accurate descriptive and visual record of all of Scotland's early medieval carved stones at a given time. All stones must be fully illustrated to consistent standards. An essential requirement would be photographs of all faces of all monuments and drawings of at least the principal faces. The invaluable role of drawings in the recording and interpretation of early medieval sculpture has been amply demonstrated in the publications of the RCAHMS. The individual descriptions should be accompanied by a full bibliography of all significant references to the monument. Description on its own is not enough. Synthetic discussion and interpretation are also essential in such a corpus, in part because all description entails interpretation — and it is as well to be critically aware of that. Furthermore, the systematic study of all the sculptured monuments in a given location would be sterile without an assessment of context and groupings.

Deciding on the scope and detail of the descriptions and discussions of individual monuments will involve taking a view on the needs of present and future users of the corpus who will come from a wide range of disciplines, both in Scotland and beyond. The form of publication and the timetable eventually agreed upon will also place limitations on the scope of the corpus. Descriptions and, where relevant, discussions must obviously cover the location (identified as precisely as possible), dimensions and forms of monuments and fragments. They will also include the art-historical and epigraphic analysis of sculpture and inscriptions and, in discussion, take account of broader Insular and Continental contexts, and, in particular, affinities with monuments in Ireland, Anglo-Saxon England and Wales and south-western Britain. What other aspects of the stones should be addressed in the descriptions and discussions? Geological analysis is an essential tool, the value of which can be seen in the paper by Miller and Ruckley (Chapter 18) and in the descriptions and introductions of the *Corpus of Anglo-Saxon Stone Sculpture*. A brief assessment of the present condition of the stones, also found in the Anglo-Saxon corpus, would serve to help the reader in evaluating descriptions and illustrations. It would provide an invaluable set of dated information on the basis of which the condition of the stones could in future be monitored (see Chapters 10, 24 and 25). The physical histories of individual monuments since their making have an obvious place, especially where there is evidence of such events as relocation, iconoclasm or restoration. As Siân Jones shows (Chapter 3), local traditions are an important part of the present-day significance of certain monuments, but perhaps only rarely will they be of relevance in understanding

the original significance of these monuments, which is the main concern of such a corpus.

What I have suggested so far is based on the assumption that the new corpus should be published in order to make its information and assessments widely available, and that it should take the form of a printed publication. Decisions will need to be taken on whether the corpus is printed, like the *Corpus of Anglo-Saxon Stone Sculpture*, or takes the form of a web-based database, like the *Corpus of Romanesque Sculpture in Britain and Ireland*, or appears as some combination of the two. A printed corpus has the advantage of being a formal record and assessment at a given date. It is also likely to be less ephemeral than a digital database, which would require continuing maintenance and long-term institutional support and would be vulnerable to technological obsolescence. A digital database is, in theory, easily updatable. But how sure can we be in an uncertain world that any institution will have the long-term stability to guarantee for a digital corpus a longevity equivalent to that already enjoyed by *ECMS*? Some form of digital corpus is probably nevertheless a necessary resource for and adjunct to a 21st-century printed corpus. It would also serve as a repository for illustrative material that cannot be accommodated in a printed corpus and this would probably include new techniques of three-dimensional recording of monuments as these become less prohibitively expensive.

One of the first steps that must be taken in planning a new corpus is to establish what recording work has been carried out since 1903 and also what work is in progress. This will provide a basis for estimating the total number of monuments and stones to be included. Not surprisingly the most important recording project is that of the RCAHMS. In 2003 the Royal Commission estimated the total number of Scotland's early medieval carved stones as 1429, a figure that is constantly being augmented by recent discoveries, and it had by that date recorded well over half of that total. The RCAHMS records would certainly constitute a major resource for a new corpus, although the scope and aims of the corpus would no doubt be rather different. It will be important to avoid unnecessary duplication of work, not least because it might weaken an application for funding. It would also be very helpful in the planning of a new corpus to know how soon the RCAHMS will be able to complete its programme of recording of early medieval carved stones. It is very much to be hoped that it will be within the next few years.

In designing the scope of the corpus and in planning how it might be instituted and funded, it will be necessary to identify and consult organisations (such as the RCAHMS, Historic Scotland and the Museum of Scotland) and other groups that may be interested parties as either contributors or users. It will be particularly important to work out how a new corpus would relate to the ambitious proposal from the Department of Archaeology of the University of Glasgow to create an electronic database of early medieval sculpture using a new standard of 3D recording. It is highly desirable that the Glasgow project (*Scotland's Early Medieval Sculptured Stones*), which is at present in abeyance, and the proposal that has come out of the *Able Minds and Practised Hands* seminar, should be brought together (Chapter 5).[7]

Once it has been formed, the steering group charged with formulating proposals for setting up a corpus will need to think about how the project should be carried

forward. It should draw on the experience of related projects, such as the *Corpus of Anglo-Saxon Stone Sculpture*, the *Corpus of Romanesque Sculpture in Britain and Ireland* and the *Corpus of Early Medieval Inscribed Stones and Stone Sculpture in Wales*, a 'new Nash-Williams' which is now in preparation.[8] The 'Archaeological Survey and Descriptive List' of monuments in *ECMS* was the work of one man, J Romilly Allen. A new corpus will require a team of scholars from a number of disciplines. For practical and methodological reasons it will probably make sense to divide up the work on a regional basis. The corpus will need an institutional base and institutional support, if it is going to be successful in seeking funding. This might be provided by a consortium of university-based groups, perhaps in partnership with an official body. In the first instance funding should perhaps be sought for a pilot project based on a limited region, with a view to extending the corpus to the whole of the country. If this is successful and if the time-table allows, the project should also consider seeking funding for doctoral research students to work on particular aspects of the corpus.

Much of the above, if accepted, may seem like statements of the obvious, but stating the obvious can sometimes be a useful exercise. The NCCSS has started to collect data on the recording of early medieval carved stones in Scotland and to hold exploratory discussions. I wish the committee every success in its fact-finding, its deliberations and its moves towards the setting up of a steering group, and look forward to the inauguration of a new *Corpus of Early Medieval Sculpture in Scotland* and a worthy successor to Allen and Anderson.

ACKNOWLEDGEMENTS

In preparing this note I have benefited greatly from information and advice given by Sally Foster and from suggestions from Mark Hall and other members of the NCCSS.

NOTES

[1] The NCCSS has, however, seen this statement and is happy to support it.
[2] Six volumes of the *Corpus of Anglo-Saxon Stone Sculpture* have so far been published under the general editorship of Rosemary Cramp and under the auspices of the British Academy, the first being Cramp 1984a. See also: http://www.dur.ac.uk/corpus/index.php3. For recent approaches to the study of Insular art see in particular the proceedings of the International Conferences on Insular Art: Ryan 1987; Spearman and Higgitt 1993; Bourke 1995; Redknap *et al* 2001.
[3] See, for example: Saxl 1943; Schapiro 1944; Cassidy 1992; E Ó Carragáin 1978; 1988; Bailey 1996a; Hawkes 2002a; Harbison 1992; Henderson and Henderson 2004.
[4] See n2 above. See also RCAHMS (1971–92) (7 vols).
[5] *ECMS* I, iii.
[6] See: http://www.crsbi.ac.uk
[7] See: http://www.gla.ac.uk/archaeology/projects/SSEMS_web
[8] See: http://www.bangor.ac.uk/history/research/corpus_stones/Corpus%20of%20EMed.htm

ABBREVIATIONS

ACW: *Ancient Christian Writers*
BAR: British Archaeological Reports
CCSL: *Corpus Christianorum: Series Latina*
CIIC: *Corpus Inscriptionum Insularum Celticarum* (Macalister 1945–9)
CSA: Council for Scottish Archaeology
Discovery Excav Scotl: *Discovery and Excavation in Scotland*
Dunk Rent: *Rentale Dunkeldense, being accounts of the bishopric (AD 1505–1517)* (Hannay 1915)
ECMS: *The Early Christian Monuments of Scotland* (Allen and Anderson 1903)
EEMF: *Early English Manuscripts in Facsimile*
FONTES: *Fontes Anglo-Saxonici: A Register of Written Sources Used by Anglo-Saxon Authors*
HBS: Henry Bradshaw Society
HSCC: Historic Scotland Conservation Centre, South Gyle, Edinburgh
MNHAS: *Montrose Natural History and Antiquarian Society Reports*
NERC: Natural Environment Research Council
NGR: National Grid Reference
NMRS: National Monuments Record of Scotland
NMS: National Museums of Scotland
NPNF: *A Select Library of the Nicene and Post-Nicene Fathers of the Christian Church*, Series 1, Oxford and New York
NSA: *New Statistical Account*
ONB: *Object Name Books of the Ordnance Survey*
OSA: *Old Statistical Account*
OS: *Ordnance Survey*
PL: *Patrologia Cursus Completus: Series Latina*
Proc Soc Antiq Scot: *Proceedings of the Society of Antiquaries of Scotland*
RCAHMS: Royal Commission on the Ancient and Historical Monuments of Scotland
RCAHMW: Royal Commission on the Ancient and Historical Monuments of Wales
RIB: *The Roman Inscriptions of Britain* (Collingwood and Wright 1965)
Tarbat Discovery Progr Bull: *Tarbat Discovery Programme Bulletin*

BIBLIOGRAPHY

Adams, W R, 1953 XHSCC_0_1157_ST, unpublished Historic Scotland HSCC file
Adams, W R, 1972 HSCC_C_622_ST, unpublished Historic Scotland HSCC file
Adriaen, M (ed), 1955 *CCSL* 97, *Magni Aurelii Cassiodori Senatoris Opera pars II.1: Expositio Psalmorum I–LXX*, Brepols, Turnholt
Adriaen, M (ed), 1970 *CCSL* 76A, *S Hieronymi Presbyteri Opera pars 1.6: Opera Exegetica: Commentarii in Prophetas Minores*, Brepols, Turnholt

Adriaen, M (ed), 1971 *CCSL 142, Gregorius Magnus Homiliae in Hezechilhelem Prophetam*, Brepols, Turnholt
Adriaen, M (ed), 1985 *CCSL 143B, S Gregorii Magni, Moralia in Job, Librii XXIII–XXXV*, Brepols, Turnholt
Ainslie, J, 1789 *Scotland, Drawn from a Series of Angles and Astronomical Observations . . .*, Edinburgh
Alcock, L, 1993 'Image and icon in Pictish sculpture', in M Spearman and J Higgitt (eds), *The Age of Migrating Ideas: Early Medieval Art in Northern Britain and Ireland*, NMS and Alan Sutton, Edinburgh and Stroud, 230–6
Alcock, L, 1998 'From realism to caricature: reflections on Insular depictions of animals and people', *Proc Soc Antiq Scot* 128, 515–36
Alcock, L and Alcock, E A, 1990 'Reconnaissance excavations on Early Historic fortifications and other royal sites in Scotland, 1974–84: 4. Excavations at Alt Clut, Clyde Rock, Strathclyde, 1974–75', *Proc Soc Antiq Scot* 120, 95–149
Alcock, L and Alcock, E A, 1992 'Reconnaissance excavations on Early Historic fortifications and other royal sites in Scotland, 1974–84: 5A. Excavations and other fieldwork at Forteviot, Perthshire, 1981', *Proc Soc Antiq Scot* 122, 215–87
Alcock, L, Alcock, E A and Driscoll, S, 1989 'Reconnaissance excavations . . . in Scotland, 1974–84: 3. Excavations at Dundurn, Strathearn, Perthshire 1976–77', *Proc Soc Antiq Scot* 119, 189–226
Alexander, J J G, 1978 *Insular Manuscripts: 6th–9th Century. A Survey of Manuscripts Illuminated in the British Isles 1*, Harvey Miller, London
Alkemade, M, 1997 'Elite lifestyle and the transformation of the Roman world in Northern Gaul', in L Webster and M Brown (eds), *The Transformation of the Roman World AD 400–900*, London, 180–4
Allan, D, 2003 'The Scottish Enlightenment and the politics of provincial culture: the Perth Literary and Antiquarian Society, ca. 1784–1790', in *Eighteenth Century Life*, 27.3, 1–30
Allen, J R, 1887 *Early Christian Symbolism in Great Britain and Ireland*, London
Allen, J R, 1894 'Report on the photography of the sculptured stones earlier than AD 1100, in the district of Scotland north of the River Dee, . . .', *Proc Soc Antiq Scot* 28, 150–77
Allen, J R, 1897 'Report on the photography of the sculptured stones earlier than AD 1100, in the district of Scotland south of the River Dee, . . .', *Proc Soc Antiq Scot* 31, 147–52
Allen, J R, 1901 'The Early Christian monuments of Iona; with some suggestions for their better preservation', *Proc Soc Antiq Scot* 11, 79–93
Allen, J R, 1902 'The Early Christian monuments of the Glasgow District', *Trans Glasgow Archaeol Soc* 4, 394–402
Allen, J R and Anderson, J, 1903 *The Early Christian Monuments of Scotland*, 3 Pts, Soc Antiq Scot, Edinburgh (facsimile reprint with introduction by I Henderson, 1993, 2 Vols, Pinkfoot Press, Balgavies)
Amit, V (ed), 2002 *Realizing Community: Concepts, Social Relationships and Sentiments*, Routledge, London
Anderson, A O, 1922 *Early Sources of Scottish History AD 500–1286, Vol 1*, Edinburgh, Oliver and Boyd, re-issued 1990, Paul Watkins, Stamford
Anderson, J, 1876 'Notes on the survival of pagan customs in Christian burial; with notices of certain conventional representations of "Daniel in the den of lions" and "Jonah and the whale", engraved on objects found in early Christian graves, and on the sculptured stones of Scotland, and crosses of Ireland', *Proc Soc Antiq Scot* 11, 363–406
Anderson, J, 1881 *Scotland in Early Christian Times (Second Series)*, The Rhind Lectures in Archaeology for 1880, David Douglas, Edinburgh

Anderson, J, 1889 'Notices of some undescribed sculptured stones and fragments in different parts of Scotland', *Proc Soc Antiq Scot* 23, 344–55

André, J (ed), 1986 *Isidore de Séville: Étymologies Livre XII: De Animaux*, Auteurs Latins Du Moyen Age, Les Belles Lettres, Paris

Andrews, G and Barrett, J C, 1999 'Why cost effective archaeology needs a new research agenda', *Inst of Fld Archaeol Yearbook 1998*, 40

Armstrong, M and Paterson, I B, 1970 'The Lower Old Red Sandstone of the Strathmore Region', *Inst Geol Sci, NERC*, Rep 70/12

Armstrong, M, Paterson, I B and Browne, M A E, 1985 'Geology of the Perth and Dundee district; Memoir for 1:50,000 geological sheets 48W, 48E, 49', *Brit Geol Survey Scotl*, NERC, HMSO, London

Ascherson, N, 2002 *Stone Voices: the Search for Scotland*, Granta Books, London

Ascherson, N, 2003 *Stone Voices: the Search for Scotland*, Granta Books (revised edition), London

Ash, M, 1981 'A fine, genial, hearty band: David Laing, Daniel Wilson and Scottish archaeology', in A S Bell (ed), *The Scottish Antiquarian Tradition: Essays to Mark the Bicentenary of the Society of Antiquaries of Scotland and its Museum, 1780–1980*, John Donald, Edinburgh, 86–113

Ashurst, J and Ashurst, N, 1988 *Practical Building Conservation*, Vol 1 (4th edn), Gower

Atkinson, N K, 1988a 'Kirriemuir New Cemetery', *Discovery Excav Scotl 1988*, CSA, Edinburgh, 26

Atkinson, N K, 1988b 'Kirkbuddo Kirkyard', *Discovery Excav Scotl 1988*, CSA, Edinburgh, 26

Atkinson, N K, 1988c 'Edzell Kirkyard', *Discovery Excav Scotl 1988*, CSA, Edinburgh, 26

Atkinson, N K, 1990a 'Discovered . . . St Ninian's Cross?', *Pictish Arts Soc Newsl* 7, 8

Atkinson, N K, 1990b 'Arbroath, Benedict Road', *Discovery Excav Scotl 1990*, CSA, Edinburgh, 39

Atkinson, N K, 1991 'The Menmuir stones', *Pictish Arts Soc Newsl* 9, 20–7

Atkinson, N K, 1993 *Pictish Stones of Angus*, Angus Libraries Museums Service

Atkinson, N K, 1994a 'The coming of Christianity to Angus', *Book Soc Friends Brechin Cathedral* 43, 3–18

Atkinson, N K, 1994b 'Wester Denoon, Pictish cross-slab', *Discovery Excav Scotl 1994*, CSA, Edinburgh, 82

Atkinson, N K, 1995a 'Menmuir Church (Menmuir Parish), Early Christian cross-slabs', *Discovery Excav Scotl 1995*, CSA, Edinburgh, 94

Atkinson, N K, 1995b 'St Margaret's Inch (Glamis Parish), Stone with cross', *Discovery Excav Scotl 1995*, CSA, Edinburgh, 93

Atkinson, N K, 1995c 'Kirriemuir Parish Church (Kirriemuir Parish), Early Christian cross-slabs', *Discovery Excav Scotl 1995*, CSA, Edinburgh, 94

Atkinson, N K, 1995d 'Kirriemuir Parish Church, Early Christian cross-slab fragments', *Discovery Excav Scotl 1995*, CSA, Edinburgh, 94

Atkinson, N K, 1995e 'Wester Denoon (Glamis Parish), Pictish cross-slab', *Discovery Excav Scotl 1995*, CSA, Edinburgh, 93–4

Atkinson, N K and Henry, D, 1998 *A Sense of Place: Picts and the Early Church in East Angus and the Mearns*, Pictish Arts Soc Field Guide 5

Atkinson, N K and Lafferty, C, 2001 *The Angus Pictish Trail*, Angus Council

Atkinson, N K and Robertson, N M, 1988 'Nevay Kirkyard' (2 entries), *Discovery Excav Scotl 1988*, CSA, Edinburgh, 26

Bailey, R N, 1977 'The meaning of the Viking-age shaft at Dacre', *Trans Cumberland Westmorland Antiq Archaeol Soc* Ser II, 77, 61–74
Bailey, R N, 1978 *The Durham Cassiodorus*, Jarrow Lecture, Jarrow
Bailey, R N, 1980 *Viking Age Sculpture in Northern England*, Collins, London
Bailey, R N, 1990 *The Meaning of Mercian Sculpture*, Brixworth Lecture, Leicester
Bailey, R N, 1994 'Govan and Irish Sea sculpture', in A Ritchie (ed), *Govan and its Early Medieval Sculpture*, Alan Sutton, Stroud, 113–21
Bailey, R N, 1996a *England's Earliest Sculptors*, Pontifical Inst Medieval Stud, Toronto
Bailey, R N, 1996b 'What mean these stones? Some aspects of Pre-Norman sculpture in Cheshire and Lancashire', *Bull John Rylands Lib University Manchester* 78.1, 21–46
Bailey, R N and Cramp, R, 1988 *Cumberland, Westmorland and Lancashire North-of-the-Sands*, Corpus of Anglo-Saxon Stone Sculpture 2, British Academy, London
Baldwin Brown, G, 1905 *The Care of Ancient Monuments*, Cambridge University Press, Cambridge
Balfour, G, 1793 'Parish of Tarbat', *OSA* Vol VI, 417–35
Barber, J, 1981a 'Excavations on Iona, 1979', *Proc Soc Antiq Scot* 111, 282–380
Barber, J, 1981b 'Excavation of the Cross Base at Kilnave, Islay', *Glasgow Archaeol J* 7, 95–102
Barclay, G, 1997 *State Funded Rescue Archaeology in Scotland, Past, Present and Future*, Historic Scotland, Edinburgh
Barclay, G (ed), 2002 'Special section Scotland 2002', *Antiquity* 76, 777–83
Barkan, E and Bush, R, 2002 'Introduction', in E Barkan and R Bush (eds), *Claiming the Stones, Naming the Bones: Cultural Property and the Negotiation of National and Ethnic Identity*, Getty Publications, Los Angeles, 1–15
Barnes, M P, 1992 'Towards an edition of the Scandinavian runic inscriptions of the British Isles: some thoughts', *Northern Stud* 29, 32–42
Barnes, M P, 1994 *The Runic Inscriptions of Maeshowe, Orkney* (Runrön 8), Institutionen för nordiska språk, Uppsala
Barnes, M P and Page, R I, forthcoming *A Corpus of the Scandinavian Runic Inscriptions of Britain*
Barr, A, 1996 *Learning for Change: Community Education and Community Development*, Community Development Foundation and Scottish Community Development Centre, London
Barrett, J and Downes, J, in prep *North Pitcarmick, North East Perthshire: the Early Medieval Inhabitation of a Prehistoric Landscape*
Barrow, G W S, 1981 'Popular courts in early medieval Scotland: some suggested place-name evidence', *Scott Stud* 25, 1–24
Barrow, G W S, 1983 'Popular courts in early medieval Scotland: some suggested place-name evidence. An additional note', *Scott Stud* 27, 67–8
Barrow, G W S, 1992 *Scotland and its Neighbours in the Middle Ages*, London
Barrow, G W S, 1998a 'The uses of place-names and Scottish history — pointers and pitfalls', in S Taylor (ed), *The Uses of Place-Names*, Edinburgh, 54–74
Barrow, G W S, 1998b 'Religion in Scotland on the eve of Christianity', in K Borchardt and E Bunz (eds), *Forschungen zur Reichs-, Papst- und Landesgeschichte*, Part 1, Stuttgart, 25–32
Barrow, G W S, 2004 *Saint Ninian and Pictomania*, Whithorn Lecture for 2003, Whithorn Trust
Basu, P, 2002 *Homecomings: Genealogy, Heritage-Tourism and Identity in the Scottish Highland Diaspora*, unpubl PhD thesis, University College, London

Batey, C, 1994 'The sculptured stones in Glasgow Museums', in A Ritchie (ed), *Govan and its Early Medieval Sculpture*, Alan Sutton, Stroud, 63–72
Bell, D, 1997 *The Historic Scotland Guide to International Conservation Charters*, Historic Scotland, Edinburgh
Bender, B, 1998 *Stonehenge: Making Space*, Berg, Oxford
Benton, J R, 1992 *The Medieval Menagerie: Animals in the Art of the Middle Ages*, Abbeville Press, New York
Bidwell, P, 1985 *The Roman Fort of Vindolanda at Chesterholm, Northumberland*, London
Bieler, L, 1979 *The Patrician Texts in the Book of Armagh*, Scriptores Latinae Hiberniae 10, Dublin
Biggs, F, Hill, T and Szarmach, P (eds), 1990 *Sources of Anglo-Saxon Literary Culture: A Trial Version*, Text and Studies Vol 74, Center for Medieval and Early Renaissance Studies, State University New York, Binghampton
Blair, J, 1992 'Anglo-Saxon minsters: a topographical review', in J Blair and R Sharpe (eds), *Pastoral Care before the Parish*, Leicester, 226–66
Boece, H, 1938–41 *The chronicles of Scotland, compiled by Hector Boece. Translated into Scots by John Bellenden, 1531*, Vol 1: Chambers, R W, Batho, E C and Seton, W (eds); Vol II: Batho, E C and Husbands, H W (eds), Scott Text Soc, Edinburgh
Borland, J, 2002 'The graphic recording of early medieval carved stones by RCAHMS: a brief history', *Monuments on Record, Annual Review 2001–2002*, RCAHMS, Edinburgh, 46–9
Botterweck, G F and Ringgren, H (eds), 1977 *Theological Dictionary of the Old Testament* 1, Eerdmans, Grand Rapids
Botterweck, G F and Ringgren, H (eds), 1978 *Theological Dictionary of the Old Testament* 3, Eerdmans, Grand Rapids
Bourke, C (ed), 1995 *From the Isles of the North: Early Medieval Art in Ireland and Britain*, HMSO, Belfast
Bowen, E G, 1969 *Saints, Seaways and Settlements*, Cardiff
Bradley, R, 1987 'Time regained: the creation of continuity', *J Brit Archaeol Ass* 40, 1–17
Bradley, R, 1993 *Altering the Earth. The Origins of Monuments in Britain and Continental Europe*, Rhind Lectures 1991–2, Soc Antiq Scot, Edinburgh
Bradley, R, 1997 *Rock Art and the Prehistory of Atlantic Europe: Signing the Land*, Routledge, London
Braithwaite, C J R and Jawad, A, 1978 'Heavy mineral distribution in the Old Red Sandstone of the Northeastern Midland Valley of Scotland', *Scott J Geol* 4, 273–8
Breen, A, 1984 'Some seventh-century Hiberno-Latin texts and their relationships', *Peritia* 3, 204–14
Breeze, D, 2003 'St Kentigern and Loquhariot, Lothian', *Innes Rev* 54, 103–7
Broun, D, 2000 'The Seven Kingdoms in *De Situ Albanie*: a record of Pictish political geography or imaginary map of ancient *Alba*?', in E J Cowan and R A McDonald (eds), *Alba: Celtic Scotland in the Medieval Era*, East Linton, 24–42
Broun, D, in press *The Welsh Identity of the Kingdom of Strathclyde ca 900–ca 1200*, Govan Lecture for 2002, Glasgow
Brown, P R L, 1997 *The Rise of Western Christendom. Triumph and Diversity AD 200–1000*, Blackwell, Oxford
Bruce, J, 1893 *The History of the Parish of West or Old Kilpatrick and of the Church and Certain Lands in the Parish of East or New Kilpatrick*, Clydebank District Libraries and Museums Dept (repr 1995)
Burns, R and Macnair, R, 1845 'Parish of Paisley', *NSA* Vol VII, 135–206

Burström, M, 1996 'Other generations' interpretation and use of the past: the case of the Picture Stones of Gotland', *Curr Swedish Archaeol* 4, 21–40

Byrne, F J, 1973 *Irish Kings and High Kings*, Batsford, London

CADW: Welsh Historic Monuments, 2001 *Protecting Early Medieval Inscribed Stones and Stone Sculpture*, Cardiff

Calder, C S T, 1951 'Note on a Pictish cross-slab from Gellyburn, Perthshire', *Proc Soc Antiq Scot* 85, 174–5

Calder, C S T, 1961 'A recumbent grave-slab from Breckon, Esha Ness, Shetland', *Proc Soc Antiq Scot* 92, 114–15

Caldwell, D H, Eremin, K, Miller, S and Ruckley, N A, 2002 'West Highland Sculpture, Scotland. Defining a Gaelic Lordship', in G Helmig, B Scholkmann and M Untermann (eds), *Centre Region Periphery. Medieval Europe Basel 2002* 1, Basel, 84–93

Calvert, J A, 1983 *The Early Development of Irish High Crosses and their Relationship to Scottish Sculpture in the Ninth and Tenth Centuries*, PhD Thesis, University California at Berkley, 1978, Ann Arbor, Michigan

Cameron, S, Urquhart, D, Wakefield, R and Young, M, 1997 *Biological Growths on Sandstone Buildings, Control and Treatment*, Technical Advice Note 10, Historic Scotland, Edinburgh

Campbell, E, 1996 'Trade in the Dark Age West: a peripheral activity?', in B E Crawford (ed), *Scotland in Dark Age Britain*, St John's House Pap No 6, St Andrews, 79–91

Campbell, R, 1911 'Preliminary note on the geology of southeastern Kincardineshire', *Geol Magazine* 8, 63–9

Cant, R G, 1986 'The medieval church in the north: contrasting influences in the Dioceses of Ross and Caithness', in J R Baldwin (ed), *Firthlands of Ross and Sutherland*, Scott Soc Northern Stud, Edinburgh, 47–58

Carman, J, 2002 *Archaeology and Heritage: an Introduction*, Continuum, New York

Carney, J (ed), 1964 *The Poems of Blathmac*, Ir Texts Soc 47, Dublin

Carrington, A, 1996 'David imagery and the chase motif in Pictish sculpture', *Studia Celtica* 30, 147–58

Carver, M O H, 1993 *Arguments in Stone, Archaeological Research and the European Town in the First Millennium*, Oxbow Books, Oxford

Carver, M O H, 1996 'On archaeological value', *Antiquity* 70, 45–56

Carver, M O H, 1998a 'Conversion and politics on the eastern seaboard of Britain: some archaeological indicators', in B E Crawford (ed), *Conversion and Christianity in the North Sea World*, St John's House Pap No 8, St Andrews, 11–40

Carver, M O H, 1998b *Hilton of Cadboll: an Archaeological Assessment and Project Design*, University of York

Carver, M O H, 1999 *Surviving in Symbols: a Visit to the Pictish Nation*, Canongate and Historic Scotland, Edinburgh

Carver, M O H, 2000 'Burial as poetry: the context of treasure in Anglo-Saxon graves', in E M Tyler (ed), *Treasure in the Medieval West*, York Medieval Press, 25–48

Carver, M O H, 2001 'Why that? Why there? Why then? The politics of early medieval monumentality', in H Hamerow and A Macgregor (eds), *Image and Power in the Archaeology of Early Medieval Britain. Essays in Honour of Rosemary Cramp*, Oxbow Books, Oxford, 1–22

Carver, M O H, 2003 'Northern Europeans negotiate their future', in M O H Carver (ed), *The Cross Goes North: Processes of Conversion in Northern Europe, AD 300–1300*, York Medieval Press, Woodbridge, 3–14

Carver, M O H, 2004 'An Iona of the East. The early medieval monastery at Portmahomack, Tarbat Ness', *Medieval Archaeol* 48, 1–30
Carver, M O H (ed), forthcoming *The Early Medieval Monastery at Portmahomack, Tarbat Ness*, National Museums of Scotland and Soc Antiq Scot, Edinburgh
Carver, M O H and Roe, A, 1997 'Excavations in St Colman's Church', *Tarbat Discovery Progr Bull* 3, http://www.york.ac.uk/depts/arch/staff/sites/tarbat
Carver, M O H and Spall, C, forthcoming, 'Excavating a parchmenerie: archaeological correlates of making parchment at the Pictish monastery at Portmahomack, Easter Ross', *Proc Soc Antiq Scot*
Casey, J, 1984 'Roman coinage of the fourth century in Scotland', in R Miket and C Burgess (eds), *Between and Beyond the Walls*, John Donald, Edinburgh, 295–304
Cassidy, B (ed), 1992 *The Ruthwell Cross: Papers from the Colloquium Sponsored by the Index of Christian Art, Princeton University 8 December 1989*, Princeton
Cessford, C, 2001 'Post-Severan Cramond: a Late Roman and Early Historic British and Anglo-Saxon religious centre?', in *The Heroic Age* 4, http://www.mun.ca/mst/heroicage/issues/4/Cessford.html
Chalmers, A, 2002 'Very realistic graphics for visualising archaeological site reconstructions', *Proceedings of the 18th Spring Conference on Computer Graphics*, Budmerice, Slovakia, http://www.sccg.sk/pages/proceedings/2002/, accessed July 2003
Chalmers, J, 1825 *Plans of the Baronies of Murthly and Airntully, Property of Sir George Stewart of Grandtully, Bart*, privately published
Chalmers, P, 1848 [1849] *The Ancient Sculptured Monuments of the County of Angus including those at Meigle in Perthshire and one at Fordoun in the Mearns*, Bannatyne Club, Edinburgh
Charles-Edwards, G, 2003 'The East Cross inscription from Toureen Peacaun: letterform analysis and a suggested reading', *Archaeol Ireland*, Spring 2003, 13–15
Charles-Edwards, T, 1993 *Early Irish and Welsh Kinship*, Oxford
Chavasse, A (ed), 1973 *CCSL* 138A, *Sancti Leonis Magni, Romani Pontificis Tractatus Septem et Nonaginta*, Brepols, Turnholt
Christie, J, 1892 *The Lairds and Lands of Loch Tayside*, Aberfeldy
Clancy, T O, 1995 'Annat in Scotland and the origins of the parish', *Innes Rev* 46:2, 95–115
Clancy, T O, 2001 'The real St Ninian', *Innes Rev* 52:1, 1–28
Clancy, T O, forthcoming a *The Making of Scottish Christianity. A History to 1215*, Edinburgh
Clancy, T O, forthcoming b 'Logie bared: an ecclesiastical place-name element in eastern Scotland'
Clancy, T O and Márkus, G, 1995 *Iona. The Earliest Poetry of a Celtic Monastery*, Edinburgh University Press, Edinburgh
Clare, J, 1986 *The Parish. A Satire* (ed E Robinson), London
Clarke, D, 2002 '"The foremost figure in all matters relating to Scottish archaeology": aspects of the work of Joseph Anderson (1832–1916)', *Proc Soc Antiq Scot* 132, 1–18
Clayton, M, 1985 'Homiliaries and preaching in Anglo-Saxon England', *Peritia* 4, 207–42
Clemoes, P, 1995 *Interactions of Thought and Language in Old English Poetry*, Cambridge
Close-Brooks, J, 1980 'Excavations in the Dairy Park, Dunrobin, Sutherland, 1977', *Proc Soc Antiq Scot* 110, 328–45
Close-Brooks, J, 1986 *Exploring Scotland's Heritage: the Highlands*, RCAHMS, Edinburgh
Close-Brooks, J, 1989 *Pictish Stones in Dunrobin Castle Museum*, Derby
Clough, M, 1990 *Two Houses. New Tarbat, Easter Ross; Royston House, Edinburgh*, Aberdeen University Press

Cochran-Patrick, R W, 1890 'Archaeology in Scotland; its past and future', *Trans Glasgow Archaeol Soc* NS 1, 355–75
Cole, M and Scribner, C, 1974 *Culture and Thought*, John Wiley, New York
Colgrave, B (ed), 1940 *Two Lives of Saint Cuthbert*, Cambridge University Press, Cambridge
Colgrave, B (ed), 1956 *Felix's Life of Saint Guthlac*, Cambridge University Press, Cambridge
Collingwood, R G and Wright, R P, 1965 *The Roman Inscriptions of Britain I: Inscriptions on Stone*, Clarendon, Oxford
Collingwood, W G, 1925 'The early crosses of Galloway', *Trans Dumfriesshire Galloway Natur Hist Antiq Soc* 3rd Ser 10, 205–31
Connolly, S, 1997 *Bede: On Tobit and on the Canticle of Habakkuk*, Four Courts Press, Dublin
Connor, P W, 1993 *Anglo-Saxon Exeter: a Tenth-Century Cultural History*, Woodbridge
Conybeare, W D and Phillips, W, 1822 *Outlines of the Geology of England and Wales*, London
Cooke, T E, 1872 'Notice of a cross-shaft at Arthurlee, Renwfrewshire', *Proc Soc Antiq Scot* 9, 451–3
Cope, G, 1972 'Theological considerations concerning church buildings, vessels and furnishings', in G Cope (ed), *Problem Churches*, Institute for the Study of Worship and Religious Architecture, 6–28
Cordiner, C, 1780 *Antiquities and Scenery of the North of Scotland, in a Series of Letters, to Thomas Pennant, Esqr*, London and Edinburgh
Cordiner, C, 1788–95 *Remarkable Ruins, and Romantic Prospects, of North Britain, with Ancient Monuments, and Singular Subjects of Natural History*, 2 Vols, I and J Taylor, London
Cormack, R, 2000 *Byzantine Art*, Oxford
Coutts, H, 1970 *Ancient Monuments of Tayside*, Dundee Mus Art Gallery, Dundee
Cowan, I B 1961 'The development of the parochial system in medieval Scotland', *Scott Hist Rev* 40, 43–55
Cowan, I B, 1967 *The Parishes of Medieval Scotland*, Neill and Co, Edinburgh
Cowie, T G, 1978 'Excavations at the Catstane, Midlothian 1977', *Proc Soc Antiq Scot* 109, 166–201
Cowie, T G, 1980 'Excavation of the Cross Base at Keills Chapel, Knapdale, Argyll', *Glasgow Archaeol J* 7, 106–11
Cowie, T (ed), 2000 *The Manor Valley*, Peebleshire Archaeol
Cox, R A V, 1999 *The Language of the Ogam Inscriptions of Scotland*, Dept Celtic, University of Aberdeen
Craig, D, 1991 'Pre-Norman sculpture in Galloway: some territorial implications', in R Oram and G Stell (eds), *Galloway: Land and Lordship*, Edinburgh, 45–62
Craig, D, 1992 *The Distribution of Pre-Norman Sculpture in South-West Scotland*, unpubl PhD thesis, University of Durham
Craig, D, 1994 'The early medieval sculpture of the Glasgow area', in A Ritchie (ed), *Govan and its Early Medieval Sculpture*, Alan Sutton, Stroud, 73–91
Craig, D, 1997 'The provenance of the Early Christian inscriptions of Galloway', in P Hill, *Whithorn and St Ninian: The Excavation of a Monastic Town 1984–91*, Tempus, Stroud, 614–19
Craig, G Y, 1991 *Geology of Scotland*, Geol Soc, London
Cramp, R, 1984a *County Durham and Northumberland*, Corpus of Anglo-Saxon Stone Sculpture 1, British Academy, London
Cramp, R, 1984b *Grammar of Anglo-Saxon Stone Ornament. A General Introduction to the Corpus of Anglo-Saxon Stone Sculpture*, Oxford

Cramp, R, 1994 'The Govan recumbent cross-slabs', in A Ritchie (ed), *Govan and its Early Medieval Sculpture*, Alan Sutton, Stroud, 55–63

Cramp, R, 2003 *Forty Years with Anglo-Saxon Stone Sculpture*, unpubl lecture to the Society of Antiquaries of Scotland in commemoration of the centenary of the publication of *ECMS*

Crawford, B, 1987 *Scandinavian Scotland*, Leicester

Crawford, B, 1994 'The "Norse background" to the Govan hogbacks', in A Ritchie (ed), *Govan and its Early Medieval Sculpture*, Alan Sutton, Stroud, 103–12

Crooke, S and McLean, F, 2002 'Our common inheritance? Narratives of self and other in the Museum of Scotland', in D C Harvey, R Jones, N McInroy and C Milligan (eds), *Celtic Geographies: Old Culture, New Times*, Routledge, London, 109–22

Cruden, S, 1964 *The Early Christian and Pictish Monuments of Scotland*, HMSO, Edinburgh

Cuppage, J, 1986 *Archaeological Survey of the Dingle Peninsula*, Ballyferriter

Curle, C L, 1940 'The chronology of the Early Christian monuments of Scotland', *Proc Soc Antiq Scot* 74, 60–116

Dalrymple, W, 1997 *From the Holy Mountain*, HarperCollins, London

Dark, K, 1992 'A sub-Roman defence of Hadrian's Wall?', *Britannia* 22, 111–20

Dark, K R (ed), 1996 *External Contact and the Economy of Late Roman and Post-Roman Britain*, Rochester, New York

Darvill, T, 1997 'Landscapes and the archaeologist', in K Barker and T Darvill (eds), *Making English Landscapes: Changing Perspective. Papers presented to Christopher Taylor at a Symposium Held at Bournemouth University on 25th March 1995*, Bournemouth University School Conserv Sci Occas Pap 3, Oxbow Monogr 93, Oxford, 70–91

Davies, W, 1994 'Ecclesiastical centres and secular society in the Brittonic world in the tenth and eleventh centuries', in A Ritchie (ed), *Govan and its Early Medieval Sculpture*, Alan Sutton, Stroud, 93–101

Davies, W, Graham-Campbell, J, Handley, M, Kershaw, P, Koch, J, Le Duc, G and Lockyear, K, 2000 *The Inscriptions of Early Medieval Brittany. Les Inscriptions de la Bretagne du Haut Moyen Age*, Celtic Studies Publications, Andover and Aberystwyth

Debevec, P, 2002 'The Light Stage: photorealistic integration of real actors into virtual environments', in M Ollila (ed), *Proceedings from SIGRAD 2002, Linköpings Universitet, Norrköping, Sweden*, Linköping Electronic Conference Proceedings, http://www.ep.liu.se/ecp/007, accessed July 2003

Debevec, P, Hawkins, T, Tchou, C, Duiker, H, Sarokin, W and Sagar, M, forthcoming 'Acquiring the reflectance field of a human face', in *SIGGRAPH 2000 Conference Proceedings*, http://www.debevec.org/Research/LS/debevec-siggraph2000-high.pdf, accessed July 2003

Dekkers, E and Fraipont, J (eds), 1956a *CCSL 38, Aurelii Augustini Opera pars X.1: Enarrationes in Psalmos I–L*, Brepols, Turnholt

Dekkers, E and Fraipont, J (eds), 1956b *CCSL 39, Aurelii Augustini Opera pars X.2: Enarrationes in Psalmos LI–C*, Brepols, Turnholt

Deregowski, J B, 1980 *Illusions, Patterns and Pictures: a Cross-Cultural Perspective*, Academic Press, London

Deregowski, J B, 1984 *Distortion in Art: the Eye and the Mind*, Routledge, London

Devine, T M, 1999 *The Scottish Nation 1700–2000*, Penguin, London

Devlin, K and Chalmers, A, 2001 'Realistic visualisation of the Pompeii frescoes', in A Chalmers and V Lalioti (eds), AFRIGRAPH 2001, *ACM SIGGRAPH*, November 2001, ACM Publishing, 43–7

Diehl, E (ed), 1927–31 *Inscriptiones Latinae Christianae Veteres*, Berlin

Doherty, C, 1984 'The use of relics in early Ireland', in P Ní Chatháin and M Richter (eds), *Irland und Europa: die Kirche im Frühmittelalter/ Ireland and Europe: The Church in the Early Middle Ages*, Stuttgart, 89–101

Dombarat, B and Kalb, A (eds), 1955 *CCSL* 48, *Aurelii Augustini Opera pars XIV.2: De Civitate Dei, Libri XI–XXII*, Brepols, Turnholt

Dowden, J, 1898 'Observations and conjectures on the Kirkmadrine epitaphs', *Proc Soc Antiq Scot* 32, 247–74

Dowden, J, 1910 *The Medieval Church in Scotland: Its Constitution, Organisation and Law*, Maclehose, Glasgow

Driscoll, S T, 1998a 'Picts and prehistory: cultural resource management in early medieval Scotland', in R Bradley and H Williams (eds), *The Past in the Past: the Reuse of Ancient Monuments. World Archaeology* 30.1, 142–58

Driscoll, S T, 1998b 'Formalising the mechanisms of state power: early Scottish lordship from the ninth to the thirteenth centuries', in S Foster, A Macinnes and R MacInnes (eds), *Scottish Power Centres from the Early Middle Ages to the Twentieth Century*, Cruithne Press, Glasgow, 32–58

Driscoll, S T, 1998c 'Church archaeology in Glasgow and the kingdom of Strathclyde', *Innes Rev* 49, 94–114

Driscoll, S T, 2003 'Govan: an early medieval royal centre on the Clyde', in R Welander, D Breeze and T O Clancy (eds), *The Stone of Destiny, Artefact and Icon*, Edinburgh, 77–85

Driscoll, S T, 2004 'The archaeological context of assembly in early medieval Scotland. Scone and its comparanda', in A Pantos and S Semple (eds), *Assembly Places and Practices in Medieval Europe*, Dublin, 73–94

Duke, W, 1872 'Notice of the fabric of St Vigeans Church, Forfarshire, with notice and photographs of early sculptured stones recently discovered there', *Proc Soc Antiq Scot* 9, 481–98

Duke, W, 1888 'Notice of a recumbent hog-backed monument, and portions of sculptured slabs with symbols, recently discovered at St Vigeans Church, Forfarshire', *Proc Soc Antiq Scot* 22, 143–6

Dumville, D, 1973 'Biblical Apocrypha and the Early Irish: a preliminary investigation', *Proc Roy Ir Acad* 73, 299–338

Eeles, F C, 1910 'Sculptured stones and crosses at Old Luce, Farnell, Edzell, Lochlee and Kirkmichael (Banffshire) with some late medieval monuments at Parton (Kirkcudbrightshire), Maryton and Wick', *Proc Soc Antiq Scot* 44, 354–72

Elliot, W, 1985 'Prehistoric, Roman and Dark Age Selkirkshire', in J M Gilbert (ed), *Flower of the Forest. Selkirk: a New History*, Selkirk Common Good Fund, 9–18

Enright, M J, 1985 'Royal succession and abbatial prerogative in Adomnán's *Vita Columbae*', *Peritia* 4, 83–103

Eogan, G, 2002 'Archaeology in Ireland during the last 50 years: an outline', *Antiquity* 76, 475–84

Étaix, R (ed), 1999 *CCSL* 141, *Gregorius Magnus, Homiliae in Evangelia*, Brepols, Turnholt

Eysenck, M and Keane, M, 2000 *Cognitive Psychology. A Student's Handbook*, Psychology Press, Hove

Fanning, T, 1981 'Excavations of an Early Christian cemetery and settlement at Reask, Country Kerry', *Proc Royal Soc Antiq Ireland* 81C, 67–172

Farrell, R T and Karkov, C, 1992 'The construction, deconstruction and reconstruction of the Ruthwell Cross: some caveats', in B Cassidy (ed), *The Ruthwell Cross: Papers from the Colloquium Sponsored by the Index of Christian Art, Princeton University 8 December 1989*, Princeton, 35–47

Ferguson, G (ed), 1990 *Encyclopedia of Early Christianity*, Garland, New York
Fernández, J and Herzfeld, M, 1998 'In search of meaningful methods', in H R Bernard (ed), *Handbook of Methods in Cultural Anthropology*, AltaMira Press, London, 89–130
Fischer, B, Gribomont, I, Sparks, H F D and Thiele W (eds), 1983 *Biblia Sacra: Iuxta Vulgatam Versionem*, 3rd edn, Vol 1, Deutsche Bibelgesellschaft, Stuttgart
Fisher, I, 1994a 'The monastery of Iona in the eighth century', in F O'Mahony (ed), *The Book of Kells*, Scolar Press, Aldershot, 33–47
Fisher, I, 1994b The Govan cross-shafts and early cross-slabs, in A Ritchie (ed), *Govan and its Early Medieval Sculpture*, Alan Sutton, Stroud, 47–53
Fisher, I, 2001 *Early Medieval Sculpture in the West Highlands and Islands*, RCAHMS and Soc Antiq Scot Monogr Ser, Edinburgh
Fisher, I, 2002 'Crosses in the Ocean: some *Papar* sites and their sculpture', in B E Crawford (ed), *The Papar in the North Atlantic: Environment and History*, St John's House Pap No 10, St Andrews, 39–57
Fisher, I and Greenhill, F A, 1972 'Two unrecorded carved stones at Tower of Lethendy, Perthshire', *Proc Soc Antiq Scot* 104, 238–41
Flower, R, 1954 'Irish High Crosses', *J Warburg Courtauld Inst* 17, 87–97
Floyd, J D and Trench, A, 1988 'Magnetic susceptibility contrasts in Ordovician greywackes of the Southern Uplands of Scotland', *J Geol Soc London* 145, 77–83
Folk, R L, 1951 'Stages of textural maturity in sedimentary rocks', *J Sedimentary Petrology* 21, 127–30
Folk, R L, 1974 *Petrology of Sedimentary Rocks*, Hemphills, Austin, Texas
FONTES: *Fontes Anglo-Saxonici: a Register of Written Sources Used by Anglo-Saxon Authors*, 2002 (CD-Rom developed by D Miles, R Jayatilaka and M Godden), Oxford, http://fontes.english.ox.ac.uk
Forbes, R, 1845 'Parish of Monymusk', *NSA* Vol XII, 459–74 [pages 468–9 mis-numbered in original]
Forsyth, K, 1995a 'Language in Pictland, spoken and written', in E H Nicoll (ed), *A Pictish Panorama*, Pinkfoot Press, Balgavies, 7–10
Forsyth, K, 1995b 'The inscriptions on the Dupplin Cross', in C Bourke (ed), *From the Isles of the North: Early Medieval Art in Ireland and Britain*, HMSO, Belfast, 237–44
Foster, S M, 1996 *Picts, Gaels and Scots*, Batsford and Historic Scotland, Edinburgh (revised edn 2004)
Foster, S M, 1997 'The Picts: quite the darkest of the peoples of Dark Age Britain', in D Henry (ed), *The Worm, the Germ and the Thorn: Pictish and related studies presented to Isabel Henderson*, Pinkfoot Press, Balgavies, 5–18
Foster, S M, 1998a 'Discovery, recovery, context and display', in S M Foster (ed), *The St Andrews Sarcophagus. A Pictish Masterpiece and its International Connections*, Four Courts Press, Dublin, 36–62
Foster, S M (ed), 1998b *The St Andrews Sarcophagus. A Pictish Masterpiece and its International Connections*, Four Courts Press, Dublin
Foster, S M, 2001 *Place, Space and Odyssey. Exploring the Future of Early Medieval Sculpture*, Groam House Museum, Rosemarkie
Foster, S M, 2002 'Planning for early medieval sculpture: the recovery and recognition of sense, place and setting', in L M Green and P T Bidwell (eds), *Heritage, the North Sea Region: Conservation and Interpretation*, Donhead Publishing Ltd, Shaftesbury, 151–71
Foster, S M with Bridgland, N, Carver, E, Fry, M, Grove, D, Tabraham, C, Yeoman P and Welander, R, and members of the Regional Team, 2003 *Early Medieval Carved Stones in Historic Scotland's Care*, unpubl, Historic Scotland, Edinburgh

Fowler, E and Fowler, P J, 1988 'Excavations on Tòrr an Aba, Iona, Argyll', *Proc Soc Antiq Scot* 118, 181–201

Fraser, A and Munro, F, 1988 *Tarbat: Easter Ross. A Historical Sketch*, Ross and Cromarty Heritage Soc, Evanton

Fraser, J E, 2002 'Northumbrian Whithorn and the making of St Ninian', *Innes Rev* 53:1, 40–59

Frend, W H C, 1965 *The Early Church*, London

Gaimster, D, 1991 'The Museum Collection: a "Junkyard of Curiosities" or a neglected archaeological asset?', Proceedings of the 1989 SMA Conference, Newport, *Mus Archaeol* 16, 46–50

Geary, P J, 1985 *Aristocracy in Provence: the Rhône Basin at the Dawn of the Carolingian Age*, Stuttgart

Gentles, J, 1988 HSCC_C_629_ST, unpublished Historic Scotland HSCC file

Gilbert, J M, 1979 *Hunting and Hunting Reserves in Medieval Scotland*, John Donald, Edinburgh

Gilbert, J M (ed), 1985 *The Flower of the Forest*, Selkirk Common Good Fund

Gillies, W A, 1938 *In Famed Breadalbane: the Story of the Antiquities, Lands and People of a Highland District*, Strathtay

Gneuss, H, 2001 *Handlist of Anglo-Saxon Manuscripts. A List of Manuscripts and Manuscript Fragments Written or Owned in England up to 1100*, Arizona Center for Medieval and Renaissance Studies, Tempe

Gordon, A, 1726 *Itinerarium Septentrionale: or, a journey thro' most of the counties of Scotland, and those in the North of England: Part II. An account of the Danish invasions on Scotland, and of the monuments erected there, on the different defeats of that people. With other curious remains of antiquity; never before communicated to the publick*, London

Gordon, S, 1993 HSCC_N_048_ST, unpublished Historic Scotland HSCC file

Gourlay, R and Pollock, R, nd *Excavations at the Shandwick Stone, Ross & Cromarty District, Interim Statement*, unpubl rep for Highland Council

Graham, A, 1953 'An Irish Millstone Cross', *Proc Soc Antiq Scot* 87, 187–91

Graham, J G and Christie, A, 1850 *The Chapel of St Anthony the Eremite at Murthly, Perthshire, the seat of Sir William Drummond Stewart of Grandtully, Bart*, Edinburgh

Graham, R C, 1895 *The Carved Stones of Islay*, Maclehose, Glasgow

Graham-Campbell, J, 2001 'National and Regional Identities: the "Glittering Prizes"', in M Redknap, N Edwards, S Youngs, A Lane and J Knight (eds), *Pattern and Purpose in Insular Art*, Oxbow Books, Oxford, 27–38

Graham-Campbell, J and Batey, C E, 1998 *Vikings in Scotland. An Archaeological Survey*, Edinburgh

Gray, T E and Ferguson, L M, 1997 *Photographing Carved Stones*, National Committee on Carved Stones in Scotland and Historic Scotland, Pinkfoot Press, Balgavies

Green, M, 1992 *Animals in Celtic Life and Myth*, Routledge, London and New York

Gresham, C A, 1985 'Bedd Porius', *Bull Board Celt Stud* 32, 386–92

Grove, D, with Regional Team, 2000 *Interpretation Plan for Whithorn Priory*, unpubl rep, Historic Scotland

Gunn, A V and Prescott, R G W, 1999 *Lifting the Veil, Research and Scholarship in United Kingdom Museums and Galleries*, Museums and Galleries Commission, London

Gupta, A and Ferguson, J (eds), 1997 *Culture, Power, Place: Explorations in Critical Anthropology*, Duke University Press, Durham, North Carolina

Hall, M A, 2003 'Abernethy, early medieval sculpture fragment', *Discov Excav Scotl 2002*, New Ser Vol 3, 90

Hall, M A, 2004 'Some Perthshire Fairs and Markets AD 700–1900', *Rev Scott Culture* 16, 44–57.

Hall, M A, 2005 'Burgh mentalities: a town-in-the-country case study of Perth, Scotland', in K Giles and C Dyer (eds), *Town and Country in the Middle Ages*, Soc for Med Archaeol Monogr 22, 211–28

Hall, M A, Forsyth, K, Henderson, I, Scott, I G, Trench-Jellicoe, R and Watson, A, 2000 'Of makings and meanings: towards a cultural biography of the Crieff Burgh Cross, Strathearn, Perthshire', *Tayside Fife Archaeol J* 6, 154–88

Hall, M A, Henderson, I and Taylor, S, 1998 'A sculptured fragment from Pittensorn Farm, Gellyburn, Perthshire', *Tayside Fife Archaeol J* 4, 129–44

Hall, S and Jeppson P, 1989 'Culture and conservation', *Eastern Cape Naturalist* 15, 11–18

Hamilton, W, 1831 *Descriptions of the Sheriffdoms of Lanark and Renfrew*, Maitland Club, Glasgow

Hamlin, A, 1972 'A chi-rho carved stone at Drumaqueran, Co Antrim', *Ulster J Archaeol* 35, 22–8

Hamlin, A, 1982 'Early Irish stone carving: content and context', in S M Pearce (ed), *The Early Church in Western Britain and Ireland*, BAR Brit Ser 102, Oxford, 283–96

Handley, M, 1998 'The early medieval inscriptions of Western Britain: function and sociology', in J Hill and M Swan (eds), *The Community, the Family and the Saint. Patterns of Power in Early Medieval Europe*, Brepols, Turnholt, 339–61

Handley, M, 2001 'The origins of Christian commemoration in late antique Britain', *Early Medieval Europe* 10, 177–99

Hannay, R K (ed), 1915 *Rentale Dunkeldense, being Accounts of the Bishopric (AD 1505–1517)*, Scott Hist Soc, Edinburgh

Harbison, P, 1992 *The High Crosses of Ireland: an Iconographical and Photographic Survey*, 3 Vols, Dr Rudolf Habelt GMBH, Bonn

Harbison, P, 1999 *The Golden Age of Irish Art. The Medieval Achievement, 600–1200*, Thames and Hudson, London

Harden, J, 1995a 'A potential archaeological context for the early Christian sculptured stones from Tarbat, Easter Ross', in C Bourke (ed), *From the Isles of the North: Early Medieval Art in Ireland and Britain*, HMSO, Belfast, 221–6

Harden, J, 1995b 'Evaluation to 1993: discovery and preliminary investigations', *Tarbat Discovery Progr Bull* 1, University of York

Haselgrove, C, Armit, I, Champion, T, Creighton, J, Gwilt, A, Hill, J D, Hunter, F and Woodward, A, 2001 *Understanding the British Iron Age: an Agenda for Action*, Trust Wessex Archaeol, Salisbury

Hawkes, J, 1993 'Mary and the Cycle of Resurrection: the iconography of the Hovingham Panel', in R M Spearman and J Higgitt (eds), *The Age of Migrating Ideas: Early Medieval Art in Northern Britain and Ireland*, NMS and Alan Sutton, Edinburgh and Stroud, 254–60

Hawkes, J, 1995 'The Wirksworth Slab: an iconography of humilitas', *Peritia* 8, 1–32

Hawkes, J, 1996 'The Rothbury Cross: an iconographic bricolage', *Gesta* 35.1, 77–94

Hawkes, J, 1997a 'Columban Virgins: iconic images of the Virgin and Child in Insular sculpture', in C Bourke (ed), *Studies in the Cult of Saint Columba*, Four Courts Press, Dublin, 107–35

Hawkes, J, 1997b 'Old Testament heroes: iconographies of Insular sculpture', in D Henry (ed), *The Worm, the Germ, and the Thorn: Pictish and Related Studies Presented to Isabel Henderson*, Pinkfoot Press, Balgavies, 149–58

Hawkes, J, 1997c 'Symbolic lives: the visual evidence', in J Hines (ed), *The Anglo-Saxons from the Migration Period to the Eighth Century: an Ethnographic Perspective*, Boydell and Brewer, Woodbridge, 311–44

Hawkes, J, 1999 'Statements in stone: Anglo-Saxon sculpture, Whitby and the Christianization of the North', in C E Karkov (ed), *The Archaeology of Anglo-Saxon England: Basic Readings*, 403–22

Hawkes, J, 2001 'An iconography of identity: the cross-head from Mayo Abbey', in C Hourihane and C Moss (eds), *From Ireland Coming: Irish Art from the Early Christian to the Late Gothic Period and its European Context*, Princeton University Press, Princeton, 261–75

Hawkes, J, 2002a *The Sandbach Crosses: Sign and Significance in Anglo-Saxon Sculpture*, Four Courts Press, Dublin

Hawkes, J, 2002b 'The art of the church in ninth-century Anglo-Saxon England: the case of the Masham Column', *Hortus Artium Medievalium* 8, 337–48

Hawkes, J, 2003a 'Reading stone', in C Karkov and F Orton (eds), *Theorizing Anglo-Saxon Stone Sculpture*, West Virginia University Press, Morgantown, 5–30

Hawkes, J, 2003b 'Sacraments in stone: the mysteries of Christ in Anglo-Saxon sculpture', in M Carver (ed), *The Cross Goes North: Processes of Conversion in Northern Europe, AD 300–1300*, York Medieval Press, Woodbridge, 351–70

Hawkes, J, forthcoming 'Constructing salvation: the figural iconography of the Iona crosses', in H Damico and C Karkov (eds), *Constructions of Wood, Stone and Ink: Studies in Honor of Rosemary Cramp*, Medieval Inst Press, Kalamazoo

Hay Fleming, D, 1931 *St Andrews Cathedral Museum*, Oliver and Boyd, Edinburgh

Henderson, G, 2001 'The Barberini Gospels . . . as a paradigm of Insular art', in M Redknap, N Edwards, S Youngs, A Lane and J Knight (eds), *Pattern and Purpose in Insular Art*, Oxbow Books, Oxford, 157–68

Henderson, G and Henderson, I, 2004 *The Art of the Picts: Sculpture and Metalwork in Early Medieval Scotland*, Thames and Hudson, London

Henderson, I, 1967 *The Picts*, Thames and Hudson, London

Henderson, I, 1982 'Pictish art and the Book of Kells', in D Whitelock, R McKitterick and D Dumville (eds), *Ireland in Early Medieval Europe: Studies in Memory of Kathleen Hughes*, Cambridge University Press, Cambridge, 79–105

Henderson, I, 1983 'Pictish vine-scroll ornament', in A O'Connor and D Clarke (eds), *From the Stone Age to the 'Forty-Five'*, Edinburgh, 243–68

Henderson, I, 1986 'The 'David Cycle' in Pictish art', in J Higgitt (ed), *Early Medieval Sculpture in Britain and Ireland*, BAR Brit Ser 152, Oxford, 87–123

Henderson, I, 1987a 'The Book of Kells and the snake-boss motif on Pictish cross-slabs and the Iona crosses', in M Ryan (ed), *Ireland and Insular Art AD 500–1200*, Roy Ir Acad, Dublin, 56–65

Henderson, I, 1987b 'Early Christian monuments of Scotland displaying crosses but no other ornament', in A Small (ed), *The Picts — a new look at old problems*, Dundee, 45–58

Henderson, I, 1991 *The Art and Function of Rosemarkie's Pictish Stones*, Groam House Museum, Rosemarkie (repr)

Henderson, I, 1993a 'The making of *The Early Christian Monuments of Scotland*', introduction to reprint of *The Early Christian Monuments of Scotland*, Vol 1, Pinkfoot Press, Balgavies, thirteen–forty

Henderson, I, 1993b 'The shape and decoration of the cross on Pictish cross-slabs carved in relief', in R M Spearman and J Higgitt (eds), *The Age of Migrating Ideas: Early Medieval Art in Northern Britain and Ireland*, NMS and Alan Sutton, Edinburgh and Stroud, 209–18

Henderson, I, 1995 'Pictish art and its place within the history of Insular art,' in E Nicoll (ed), *A Pictish Panorama*, Pinkfoot Press, Balgavies, 15–19

Henderson, I, 1997 *Pictish Monsters: Symbol, Text and Image*, H M Chadwick Memorial Lectures 7, Cambridge University Press, Cambridge

Henderson, I, 1998 '*Primus inter pares*: the St Andrews Sarcophagus and Pictish sculpture', in S M Foster (ed), *The St Andrews Sarcophagus. A Pictish Masterpiece and its International Connections*, Four Courts Press, Dublin, 97–167

Henderson, I, 2000 'Towards defining the function of sculpture in Alba: the evidence of St Andrews, Brechin and Rosemarkie', in S Taylor (ed), *Kings, Clerics and Chronicles in Scotland 500–1297*, Four Courts Press, Dublin, 35–46

Henderson, I, 2003 '*Reflections After Writing an Art-Historical Book on Pictish Sculpture and Metalwork*', unpubl lecture to the Pictish Arts Society

Henderson, I, forthcoming 'Minor ornament on Pictish sculpture: major implications', in M Crozier and M Meek (eds), Festschrift for Ann Hamlin

Henry, D and Trench-Jellicoe, R, 2003 *Items Relating to Scottish Sites and Monuments in the Hibbert Ware MSS, Msf091 H21, Manchester Local Studies Archive Centre: with particular reference to the drawings of early medieval carved stones by Charlotte Wilhelmina Hibbert*, unpubl rep, grant-aided by Historic Scotland

Henry, F, 1937 'Early Christian slabs and pillar stones in the west of Ireland', *J Roy Soc Antiq Ireland* 67, 265–79

Henry, F, 1967 *Irish Art During the Viking Invasions (800–1020 AD)*, Methuen, London

Herbert, M, 1996 *Iona, Kells and Derry. The History and Hagiography of the Monastic Familia of Columba*, Four Courts Press, Dublin

Heritage Lottery Fund, 1998 *Conservation Plans for Historic Places*, London

Herity, M, 1993 'The forms of the tomb-shrine of the founder saint in Ireland', in R M Spearman and J Higgitt (eds), *The Age of Migrating Ideas: Early Medieval Art in Northern Britain and Ireland*, NMS and Alan Sutton, Edinburgh and Stroud, 188–95

Herity, M, 1995a *Studies in the Layout, Buildings and Art in Stone of Early Irish Monasteries*, Pindar Press, London

Herity, M, 1995b 'The chi-rho and other early cross-forms in Ireland', in J-M Picard (ed), *Aquitaine and Ireland in the Middle Ages*, Four Courts Press, Dublin, 232–64

Herzfeld, M, 1991 *A Place in History: Social and Monumental Time in a Cretan Town*, Princeton University Press, Princeton

Hewison, J K, 1914 *The Runic Roods of Ruthwell and Bewcastle with a Short History of the Cross and Crucifix in Scotland*, Glasgow

Hibbert, S, 1822 *A Description of the Shetland Islands, Comprising an Account of their Geology, Scenery, Antiquities, and Superstitions*, Edinburgh

Hibbert, S, 1831 'Memoir on the Tings of Orkney and Shetland', *Trans Soc Antiq Scot* 3, 103–210

Hibbert, S, 1832 *History of the Extinct Volcanoes of the Basin of Neuwied, on the Lower Rhine*, W and D Laing, Edinburgh; Treuttel, Würz and Richter, London

Hibbert, S, 1835 'Memoir on the fresh-water limestone of Burdiehouse, in the neighbourhood of Edinburgh, belonging to the Carboniferous group of rocks; with supplementary notes on other fresh-water limestones', *Trans Roy Soc Edin* 13, 169–282

Hibbert, S, 1857a 'Observations on the ancient bell and chain discovered in the parish of Kilmichael-Glassrie'[sic]', *Trans Soc Antiq Scot* 4, 119–25
Hibbert, S, 1857b 'Observations on the theories which have been proposed to explain the vitrified forts of Scotland', *Trans Soc Antiq Scot* 4, 160–82
Hibbert, S, 1857c 'Collections relative to vitrified sites', *Trans Soc Antiq Scot* 4, 183–201
Hibbert, S and Laing, D, 1831 'Account of the progress of the Society of Antiquaries of Scotland from 1784 to 1830', *Trans Soc Antiq Scot* 3, appendix, v–xxxi
Hibbert Ware, M C, 1882 *Life and Correspondence of the late Dr Samuel Hibbert Ware*, J E Cornish, Manchester
Hibbert Ware, S, 1857 'Letter from Dr Hibbert-Ware, on the sculptured stones of Scotland', *Trans Soc Antiq Scot* 4, 415–18
Hickling, G, 1908 'The Old Red Sandstones of Forfarshire, Upper and Lower', *Geol Mag* 5, 396–408
Hicks, C, 1994 *Animals in Early Medieval Art*, Edinburgh University Press, Edinburgh
Higgitt, J, 1979 'The dedication inscription at Jarrow and its context', *Antiq J* 59, 343–74
Higgitt, J, 1982 'The Pictish Latin inscription at Tarbat in Ross-shire', *Proc Soc Antiq Scot* 112, 300–21
Higgitt, J, 1990 'Early medieval sculpture at Dumbarton', in L Alcock and E A Alcock 'Reconnaissance excavations on Early Historic fortification and other royal sites in Scotland, 1974–84: 4. Excavations at Alt Clut, Clyde Rock, Strathclyde, 1974–75', *Proc Soc Antiq Scot* 120, 139–42
Higgitt, J, 1998 'Decoration and illustration', in D E R Watt (ed), *Scotichronicon by Walter Bower, Vol 9, Critical Studies and General Indexes*, Aberdeen, 157–85
Hill, P, 1997 *Whithorn and St Ninian: the Excavation of a Monastic Town 1984–91*, Tempus, Stroud
Hill, P R, 1996 *Technical Assessment and Report on the Stone known as the Stone of Destiny, also Known as the Stone of Scone*, unpubl rep for Historic Scotland
Hill, P R, 2001 *Abernethy, Dundee, Meigle, St Vigeans: a Limited Technical Assessment of Some Pictish Stones*, unpubl rep for Historic Scotland
Hill, P R, 2003a 'The Stone of Destiny examined: an overview and discussion', in R Welander, D J Breeze and T O Clancy (eds), *The Stone of Destiny, Artefact and Icon*, Edinburgh, 11–31
Hill, P R, 2003b *Hilton of Cadboll Pictish Stone: Technical Assessment*, unpubl rep for GUARD, University of Glasgow
Historic Scotland, 1998a *Site Interpretation at Properties in Care. Historic Scotland Operational Policy No 6*, Historic Scotland only
Historic Scotland, 1998b *A National Interpretation Strategy for Properties in Care*, unpubl rep, drafted by C Tabraham
Historic Scotland, 2000 *The Stirling Charter: Conserving Scotland's Built Heritage*, Historic Scotland, Edinburgh
Historic Scotland, 2001 *The Carved Stones of Scotland: a Guide to Helping in Their Protection*, Historic Scotland, Edinburgh
Historic Scotland, 2002 *Passed to the Future: Historic Scotland's Policy for the Sustainable Management of the Historic Environment*, Historic Scotland, Edinburgh
Historic Scotland, 2003 *Carved Stones: Historic Scotland's Approach*, draft for public consultation
Historic Scotland, nd a *A Manual for Site Interpretation at Properties in Care*, Historic Scotland, internal use

Historic Scotland, nd b *Conservation Plans. A Guide to the Preparation of Conservation Plans*, Edinburgh

Holman, K, 1996 *Scandinavian Runic Inscriptions in the British Isles: their Historical Context* (Senter for Middelalderstudier, Skrifter 4), Tapir, Trondheim

Hourihane, C (ed), 2002 *King David in the Index of Christian Art*, Princeton University Press, Princeton

HSCC files, held at Historic Scotland Conservation Centre, South Gyle, Edinburgh, open by appointment

Hudson, J E and Hurst, D (eds), 1983 *CCSL 119B, Bede Venerabilis Opera, pars II, Opera Exegetica 2B: In Tobiam, In Proverbia, In Cantica Canticorum, In Habacuc*, Brepols, Turnholt

Hudson, W, 1962 'Cultural problems in pictorial perception', *South African J Sci* 58, 189–95

Hurst, D (ed), 1962 *CCSL 119, Bede Venerabilis Opera, pars II, Opera Exegetica 2: In Primam Partem Samvhelis Libri III, in Regvm Librvm XXX Qvaestiones*, Brepols, Turnholt

Hurst, D (ed), 1985 *The Commentary on the Seven Catholic Epistles of Bede the Venerable, Cistercian Stud 82*, Kalamazoo

Hurst, D (ed), 1990 *Gregory the Great: Forty Gospel Homilies*, Cistercian Publications 123, Kalamazoo

Hutcheson, A, 1886 'Notice of a sculptured stone recently discovered at Murthly, and now presented to the Museum by Sir Douglas Stewart, Bart., of Grandtully', *Proc Soc Antiq Scot* 20, 252–6

ICOMOS, 1964 *The Venice Charter*, Venice

ICOMOS-ICAMH, 1989 *Charter for the Protection and Management of the Archaeological Heritage*, Lausanne

Ingold, T, 1993 'Temporality of landscape', *World Archaeology* 25, 152–74

Ingold, T, 1997 'The picture is not the terrain: maps, paintings and the dwelt in world', *Archaeological Dialogues* 4 No 1, 29–32

Innerarity, W, 1793 'Parish of Caputh', *OSA* Vol IX, 485–509

Innes, C (ed), 1832 *Registrum Monasterii de Passelet*, Maitland Club, Edinburgh

Innes, C (ed), 1842 *Registrum Episcopatus Aberdonensis*, Maitland Club, Edinburgh

Innes, C (ed), 1843 *Registrum Episcopatus Glasguensis*, Bannatyne and Maitland Clubs, Glasgow

Innes, C, Anderson, W, Robertson, J, Brichan, J and McNab, J (eds), 1850–5 *Origines Parochiales Scotiae*, Bannatyne Club, Glasgow

Jackson, K H, 1982 'Brigomaglos and St Briog', *Archaeol Aeliana* Ser 5, 10, 61–5

James, H, 2002 *Investigation of the Setting and Context of the Hilton of Cadboll Cross-slab, Recovery of the Stump and Fragments of Sculpture*, unpubl rep for Historic Scotland, Glasgow University Archaeol Res Division

James, M R (ed), 1924 *The Apocryphal New Testament: being the Apocryphal Gospels, Acts, Epistles, and Apocalypses*, Clarendon Press, Oxford

James, M R (ed), 1929 *Marvels of the East: a Full Reproduction of the Three Known Copies*, University Press, Oxford

Jankulak, K, 2000 *The Medieval Cult of St Petroc*, Boydell, Woodbridge

Jarrett, M G, 1976 *Maryport, Cumbria: a Roman Fort and its Garrison*, Kendal

Jeffrey, S, 2001 'A simple technique for visualising three dimensional models in landscape contexts', *Internet Archaeology* Vol 10 Summer 2001, http://intarch.ac.uk/journal/issue10/jeffrey_toc.html, accessed July 2003

Jeffrey, S, 2003 *Three Dimensional Modelling of Scottish Early Medieval Sculpted Stones*, unpubl PhD thesis, University of Glasgow, http://ads.ahds.ac.uk/catalogue/library/theses/index.cfm, accessed May 2005

Jennings, A, 1998 'Iona and the Vikings: survival and continuity', *Northern Stud* 33, 37–54

Jervise, A, 1857 'Notes descriptive of the localities of certain sculptured stone monuments in Forfarshire, etc (Part 1)', *Proc Soc Antiq Scot* 2, 187–99

Jervise, A, 1875 *Epitaphs and Inscriptions from Burial Grounds in the North-East of Scotland*, Vol I, Edinburgh

Jesch, J, 1990 'New finds from Orkney', *Nytt om Runer* 5 (pub 1991), 13–14

Johnston, C, 1994 *What is Social Value? A discussion paper*, Australian Heritage Commission Technical Publications, Ser No 3, Australian Government Publishing Service, Canberra

Jones, S, 2004 *Early Medieval Sculpture and the Production of Meaning, Value and Place: the Case of Hilton of Cadboll*, Historic Scotland Res Rep, Edinburgh

Jones, S, 2005 Making place, resisting displacement: conflicting national and local identities in Scotland', in J Littler and R Naidoo (eds), *The Politics of Heritage: 'Race', Identity and National Stories*, Routledge, London, 94–114

Jowett, A, 1913 'The volcanic rocks of the Forfarshire coast and associated sediments', *Quarterly J Geol Soc* 69, 459–83

Julesz, B, 1975 'Experiments in the visual perception of texture', *Scientific American* 212, 38–48

Keppie, L, 1991 *Understanding Roman Inscriptions*, Batsford, London

Kermode, P M C, 1907 *Manx Crosses*, Bemrose, London (repr with additional material 1994, Pinkfoot Press, Balgavies)

Kerr, J 1992 *The Roberston Heartland Glen Errochty*, Inverness (repr from the *Trans Gaelic Soc Inverness* LVI)

Kerr, J, 1995 *Church and Social History of Atholl*, Perth

Kirkdale Archaeology, 1998a *Hilton of Cadboll Chapel, 3rd August 1998*, unpubl rep for Historic Scotland

Kirkdale Archaeology, 1998b *The Dupplin Cross, Properties in Care Archaeological Monitoring*, unpubl rep for Historic Scotland

Kirkdale Archaeology, 1999 *Dupplin Cross Excavations 1998*, unpubl rep for Historic Scotland

Kirkdale Archaeology, 2001 *Hilton of Cadboll Chapel Site Archaeological Excavation, 7th March 2001*, unpubl rep for Historic Scotland

Knapp, A B and Ashmore, W (eds), 1999 *Archaeological Landscapes: Contemporary Perspectives*, Blackwell, Oxford

Knight, J, 1981 '*In Tempore Iustini Consulis*: contacts between the British and Gaulish churches before St Augustine', in A Detsicas (ed), *Collectanea Historica: Essays in Memory of Stuart Rigold*, Maidstone, 54–62

Knight, J, 1992 'The Early Christian Latin inscriptions of Britain and Gaul: chronology and context', in N Edwards and A Lane (eds), *The Early Church in Wales and the West*, Oxbow Monogr 16, Oxford, 45–50

Knight, J, 1997 'Seasoned with salt: Insular Gallic contacts in the early memorial stones and cross slabs', in K Dark (ed), *External Contacts and the Economy of Late Roman and Post-Roman Britain*, Boydell, Woodbridge, 109–20

Knight, J, 1999 *The End of Antiquity. Archaeology, Society and Religion in Western Europe, AD 235–700*, Tempus, Stroud

Knight, J, 2001 'Basilicas and barrows: the Latin memorial stones of Wales and their archaeological contexts', in J Higgitt, K Forsyth and D Parsons (eds), *Roman, Runes and*

Ogham: Medieval Inscriptions in the Insular World and on the Continent, Donnington, 8–15
Knight, J, 2003 'Basilicas and barrows: Christian origins in Wales and Western Britain', in M Carver (ed), *The Cross Goes North: Processes of Conversion in Northern Europe, AD 300–1300*, York Medieval Press, Woodbridge, 119–26
Knowles, D (ed), 1972 *Augustine: City of God*, Penguin Books, London
Lacaille, A D, 1927 'The Capelrig Cross, Mearns, Renfrewshire; St Blanes Chapel Lochearnhead, Perthshire and a sculptured slab at Kilmaronock, Dumbartonshire', *Proc Soc Antiq Scot* 61, 122–32
Lacy, B, 1983 *Archaeological Survey of County Donegal*, Donegal County Council, Lifford
Laing, L and Laing, J, 1993 *The Picts and the Scots*, Alan Sutton, Stroud
Lane, A, 1994 'Trade in the Dark Age West: a peripheral activity?', in B E Crawford (ed), *Scotland in Dark Age Europe*, St John's House Pap No 6, 104–15
Lang, J, 1974 'Hogback monuments in Scotland', *Proc Soc Antiq Scot* 105, 206–35
Lang, J, 1990 'The painting of pre-Conquest sculpture in Northumbria', in S Cather, D Park and P Williamson (eds), *Early Medieval Wall Painting and Painted Sculpture in England*, BAR Brit Ser 216, Oxford, 135–46
Lang, J, 1994 'The Govan hogbacks: a reappraisal', in A Ritchie (ed), *Govan and its Early Medieval Sculpture*, Alan Sutton, Stroud, 113–22
Langdon, A G, 1893 'The chi-rho monogram upon Early Christian monuments in Cornwall', *Archaeol Cambrensis*, Ser 5, 10, 97–108
Lapidge, M, 1985 'Surviving booklists from Anglo-Saxon England', in M Lapidge and H Gneuss (eds), *Learning and Literature in Anglo-Saxon England. Studies Presented to Peter Clemoes*, Cambridge University Press, Cambridge, 33–90
Lapidge, M, 1996 *Anglo-Latin Literature 600–899*, Hambledon Press, London
Lapidge, M and Herren, M (eds), 1979 *Aldhelm: the Prose Works*, D S Brewer, Ipswich and Cambridge
Larsen, K E (ed), 1995 *NARA Conference on Authenticity in Relation to the World Heritage Convention*, ICOMOS, Paris
Layton, R, 1989 *Who Owns the Past?* Routledge, London
Le Blant, E, 1856–65 *Inscriptions Chrétiennes de la Gaule antérieures au VIIIe siècle*, 2 Vols, Paris
Leach, M (ed), 1950 'Kemp Owyne', in *Funk and Wagnall's Standard Dictionary of Folklore, Mythology and Legend*, Funk and Wagnall, New York, Vol 2, 573
Lemaire, T, 1997 'Archaeology between the invention and destruction of the landscape', *Archaeological Dialogues* 4 No 1, 5–22
Levoy, M, 2000 'Digitizing the Forma Urbis Romae, Presented at the Siggraph 'Digital Campfire' on Computers and Archaeology Snowbird, Utah', http://graphics.stanford.edu/papers/forma-urbis-campfire00, accessed July 2003
Levoy, M and Hanrahan, P, 1996 'Light field rendering talk', *SIGGRAPH 1996 Conference Proceedings: Computer Graphics Annual Conference*, http://www-graphics.stanford.edu/~hanrahan/LightFieldTalk/walk008.html
Levoy, M, Pulli, K, Rusinkiewicz, S, Koller, D, Pereira, L, Ginzton, M, Anderson, S, Davis, J and Ginsberg, J, 2000 'The digital Michelangelo Project: 3D scanning of large statues', *SIGGRAPH 2000 Conference Proceedings: Computer Graphics Annual Conference*, ACM 2000
Liestøl, A, 1984 'Runes', in A Fenton and H Pálsson (eds), *The Northern and Western Isles in the Viking World*, John Donald, Edinburgh, 224–38

Loubser, 1990 'Removals and *in situ* conservation: strategies and problems in rock art conservation at the National Museum, Bloemfontein', *Pictogram* 3 (3), 2–5
Low, G, 1879 *A Tour through the Islands of Orkney and Schetland* (ed J Anderson), Peace and Son, Kirkwall
Lowden, J, 1997 *Early Christian and Byzantine Art*, Phaidon Press, London
Lyle, W H, 1975 *The History of Bridge of Weir*, Paisley
Lyons, C, 2002 'Objects and identities: claiming and reclaiming the past', in E Barkan and R Bush (eds), *Claiming the Stones, Naming the Bones: Cultural Property and the Negotiation of National and Ethnic Identity*, Getty Publications, Los Angeles, 116–37
Macalister, R A S, 1945–9 *Corpus Inscriptionum Insularum Celticarum*, 2 Vols, Stationery Office, Dublin (= *CIIC*)
Macaulay, J, 1997 'James Gillespie Graham and A W N Pugin: some Perthshire connections', *Caledonia Gothica, Pugin and the Gothic Revival in Scotland, Archit Heritage* VII, 22–36
MacDonald, A, 1982 '*Lios* in Scotland', *Ainm* 2, 37–54
MacDonald, A D S and Laing, L, 1970 'Early ecclesiastical sites in Scotland, a field survey', *Proc Soc Antiq Scot* 102, 129–45
Macdonald, J and Gordon, A, 1971 *Down to the Sea. An Account of Life in the Fishing Villages of Hilton, Balintore and Shandwick*, Fort William, Ross and Cromarty Heritage Soc (3rd edn)
Macdonald, J and Gordon, A, nd *Down to the Sea. An Account of Life in the Fishing Villages of Hilton, Balintore and Shandwick*, Ross and Cromarty Heritage Soc
Macdonald, S, 1997 *Reimagining Culture: Histories, Identities and the Gaelic Renaissance*, Berg, Oxford
MacFarlan, D, 1845 'Parish of Renfrew', *NSA* Vol VII, 1–32
MacIvor, I, 1958 *Dumbarton Castle*, HMSO, Edinburgh
Mack, A, 1997 *Field Guide to the Pictish Symbol Stones*, Pinkfoot Press, Balgavies
Mack, A, 2002 *The Association of Pictish Symbol Stones with Ecclesiastical, Burial, or 'Memorial' Areas*, Pinkfoot Press, Balgavies
Mackie, A, 1980 'Sandstone quarrying in Angus. Some thoughts on an old craft', *Edinburgh Geologist* 8, 14–25
Mac Lean, D, 1983 'Knapdale dedications to a Leinster saint: sculpture, hagiography and oral tradition', *Scott Studies* 27, 49–65
Mac Lean, D, 1986 'The Keills Cross in Knapdale, the Iona School and the Book of Kells', in J Higgitt (ed), *Early Medieval Sculpture in Britain and Ireland*, BAR Brit Ser 152, 175–97
Mac Lean, D, 1993 'Snake-bosses and Redemption at Iona and in Pictland', in R M Spearman and J Higgitt (eds), *The Age of Migrating Ideas: Early Medieval Art in Northern Britain and Ireland*, NMS and Alan Sutton, Edinburgh and Stroud, 245–53
Mac Lean, D, 1997 'Maelrubai, Applecross and the Late Pictish contribution west of Druimalban', in D Henry (ed), *The Worm, the Germ, and the Thorn: Pictish and Related Studies Presented to Isabel Henderson*, Pinkfoot Press, Balgavies, Forfar, 173–87
MacManus, D, 1991 *A Guide to Ogam*, Maynooth Monogr
MacNamara, M, 1975 *The Apocrypha in the Irish Church*, Inst Advanced Stud, Dublin
Macquarrie, A, 1990 'Early Christian Govan: the historical context', *Rec Scott Church Hist Soc* 24, 1–17
Macquarrie, A, 1992 'Early Christian religious houses in Scotland: foundation and function', in J Blair and R Sharpe (eds), *Pastoral care before the Parish*, Leicester University Press, London, 110–33
Macquarrie, A, 1994 'The historical context of the Govan stones', in A Ritchie (ed), *Govan and its Early Medieval Sculpture*, Alan Sutton, Stroud, 27–32

Macquarrie, A, 1996 'Lives of Scottish saints in the Aberdeen Breviary: some problems of sources for Strathclyde saints', *Rec Scott Church Hist Soc* 26, 31–54

MacQueen, J, 2002 *Place-Names in the Rhinns of Galloway and Luce Valley*, Stranraer and District Local History Trust, Stranraer

Malden, J, 2000 *The Monastery and Abbey of Paisley*, Renfrewshire Local History Forum, Paisley

Malzbender, T, Gelb, D and Wolters, H, 2001 'Polynomial Texture Mapping', in A Chalmers and V Lalioti (eds), AFRIGRAPH 2001, *ACM SIGGRAPH*, November 2001, ACM publishing, http://www.hpl.hp.com/ptm/papers/PTM.pdf, accessed July 2003

Manning, C, 1992 'The base of the North Cross at Clonmacnoise', *Archaeol Ireland* 6(2), 8–9

Markham, M, 1997 'Geology and archaeology: a search for the source rock used by British Neolithic axe makers', *Open University Geol Soc J* 18.3, 48–57

Marquardt, H, 1961 *Bibliographie der Runeninschriften nach Fundorten 1, Die Runeninschriften der Britischen Inseln* (Abhandlungen der Akademie der Wissenschaften in Göttingen, philologisch–historische Klasse, 3. Folge, Nr 48), Vandenhoeck und Ruprecht, Göttingen

Martin, L T (ed), 1989 *The Venerable Bede. Commentary on the Acts of the Apostles*, Cistercian Stud 117, Kalamazoo

Maxtone, A, 1845 'Parish of Fowlis Wester', *NSA* Vol X, 249–61

Maxwell, I, 1994 'The preservation of Dark Age Sculpture', in E O Bowman and N M Robertson (eds), *Stones, Symbols and Stories: Aspects of Pictish Studies. Proceedings from the Conferences of the Pictish Arts Society, 1992*, Pictish Arts Soc, Edinburgh, 3–18

Maxwell, I, Nanda, R and Urquhart, D, 2001 *Conservation of Historic Graveyards. Guide for Practitioners 2*, Historic Scotland, Edinburgh

Mayr-Harting, H, 1972 *The Coming of Christianity to Anglo-Saxon England*, Batsford, London

Mayr-Harting, H, 1998 *Perceptions of Angels in History*, Clarendon Press, Oxford

McCarthy, M, 2002 *Roman Carlisle and the Lands of the Solway*, Tempus, Stroud

McCormick, F, 1993 'Excavations at Iona, 1988', *Ulster J Archaeol* 56, 78–108

McCullagh, R P J, 1995 'Excavations at Sueno's Stone, Forres, Moray', *Proc Soc Antiq Scot* 125, 697–718

McKerrow, W S, Lambert, R St J and Cocks, L R M, 1985 'The Ordovician, Silurian and Devonian periods', in N J Snelling (ed), *The Chronology of the Geological Record*, Memoirs Geol Soc London 10, 73–83

McRoberts, D 1962 'Material destruction caused by the Scottish Reformation', *Innes Rev* 10, 126–82

Meehan, B, 1994 *The Book of Kells: an Illustrated Introduction to the Manuscript in Trinity College Dublin*, Thames and Hudson, London

Meek, W and Buchanan, W, 1845 'Parish of Hamilton', *NSA* Vol VI, 249–94

Metcalfe, W M, 1909 *A History of Paisley*, Alexander Gardner, Paisley

Meteorological Office, 1994 and 1996 *Climatic Data Collected at Kinloss and Invergordon Weather Stations*, issued by the Meteorological Office

Mewitt, P G, 1986 'Boundaries and discourse in a Lewis crofting community', in A P Cohen (ed), *Symbolising Boundaries: Identity and Diversity in British Cultures*, Manchester University Press, Manchester, 71–87

Meyer, K, forthcoming *Reading the Stones: the Pictish Monuments on the Tarbat Peninsula, Ross-shire*, unpubl DPhil thesis, University of York

Meyvaert, P, 1971, 'Review of O K Werkmeister, 1967, Irish-Northumbrishche Buchmalerie des 8. Jahrhunderts un Monastishe Spiritualität, de Gruyter, Berlin', *Speculum* 46, 408–11

Migne, J-P (ed), 1844–64 *PL 38*, *Sancti Aurelii Augustini Hipponensis Episcopi Opera Omnia*, Brepols, Turnholt

Migne, J-P (ed), 1849a *PL 66*, *S P Benedictus, Tomus Unicus*, Brepols, Turnholt

Migne, J-P (ed), 1849b *PL 76*, *Sancti Gregorii Magni, Tomus Secundus*, Brepols, Turnholt

Migne, J-P (ed), 1849c *PL 77*, *Sancti Gregorii Magni, Tomus Tertius*, Brepols, Turnholt

Miller, H, 1835 *Scenes and Legends of the North of Scotland*, B and W Publishing, Edinburgh (repr 1994)

Miller, H, 1889 'Note on fragments of two sculptured stones of Celtic workmanship found in the churchyard of Tarbat, Easter Ross', *Proc Soc Antiq Scot* 11, 435–44

Miller, S and Ruckley, N A, 2001 *Geological Survey of Early Medieval Sculptures, St Vigeans, Angus — Report on behalf of Historic Scotland*, NMS Report, Edinburgh

Moar, P and Stewart, J, 1944 'Newly discovered sculptured stones from Papil, Shetland', *Proc Soc Antiq Scot* 78, 91–9

Monteath, J, 1791 'Parish of Houston and Kilallan', *OSA* Vol I, 315–31

Morris, R, 1989 *Churches in the Landscape*, London

MNHAS, 1914 *Montrose Natural History and Antiquarian Society Reports 1858–1914*, Montrose

Muir, C A C, 1998 *The Containment of Scottish Carved Stones in situ: a Study into the Efficacy of this Approach*, unpubl MSc dissertn, Architectural Stone Conservation, University of Bournemouth

Mulchrone, K, 1939 *Bethu Phátraic*, Dublin

Murdoch, R, 1995 'Kirriemuir Old Parish Church (Kirriemuir Parish)', *Discovery Excav Scotl 1988*, CSA, Edinburgh, 26

Murphy, G, 1956 *Early Irish Lyrics*, Oxford

Murray, A J, 1985 *A Regency Lady's Faery Bower*, Collins, London

Myln, *Vitae*: Innes, C (ed), 1831 *Vitae Dunkeldensis Ecclesiae Episcoporum*, Bannantyne Club, Edinburgh

Nadel, J, 1984 'Stigma and separation: pariah status and community persistence in a Scottish fishing village', *Ethnology* 23 (2), 101–15

Nadel-Klein, J, 1991 'Reweaving the fringe: localism, tradition and representation in British ethnography', *American Ethnologist* 18 (3), 500–17

Nadel-Klein, J, 2003 *Fishing for Heritage: Modernity and Loss along the Scottish Coast*, Berg, Oxford

Nahum, P, 1997 *Fairy Folk in Fairy Land*, Peter Nahum at Leicester Galleries, London

Naismith, J, 1792 'Parish of Hamilton', *OSA* Vol II, 177–212

Nash-Williams, V E, 1950 *The Early Christian Monuments of Wales*, University of Wales Press, Cardiff

Neuman de Vegvar, C, 1997 'The Echternach Lion: a leap of faith', in C E Karkov, M Ryan and R T Farrell (eds), *The Insular Tradition*, SUNY Press, New York, 167–88

New Statistical Account, 1845 *The New Statistical Account of Scotland by the Ministers of the Respective Parishes under the Superintendence of a Committee of the Society for the Benefit of the Sons and Daughters of the Clergy*, 15 Vols, Edinburgh

Newman, C, 1998 'Reflections on the meaning of a "royal" site in early Ireland', in R Bradley and H Williams (eds), *The Past in the Past: the Reuse of Ancient Monuments*. World Archaeol 30.1, 127–41

Nilgen, U, 1967 'The Epiphany and the Eucharist: on the interpretation of Eucharistic motifs in medieval Epiphany scenes', *Art Bull* 49, 311–16

Nordby, K J, 2001 *Etterreformatoriske Runeinnskrifter i Norge: Opphav og Tradisjon*, University of Oslo magistergradsavhandling

NPNF: *A Select Library of the Nicene and Post-Nicene Fathers of the Christian Church*, Series 1, Oxford and New York

NSA 1845a: Perth, *New Statistical Account*, Vol X, William Blackwood and Sons, Edinburgh and London

NSA 1845b: Forfar and Kincardine, *New Statistical Account*, Vol XI, William Blackwood and Sons, Edinburgh and London

Ó Carragáin, É, 1978 'Liturgical innovations associated with Pope Sergius and the iconography of the Ruthwell and Bewcastle Crosses', in R T Farrell (ed), *Bede and Anglo-Saxon England*, BAR Brit Ser 46, Oxford, 131–47

Ó Carragáin, É, 1986 'Christ over the beasts and the Agnus Dei: two multivalent panels on the Ruthwell and Bewcastle Crosses', in P Szarmach and V D Oggins (eds), *Sources of Anglo-Saxon Culture*, Western Michigan University Press, Kalamazoo, 377–403

Ó Carragáin, E, 1988 'The Ruthwell Crucifixion Poem and its iconographic and liturgical contexts', *Peritia* 6–7, 1–71

Ó Carragáin, É, 1989 'The meeting of Saint Paul and Saint Anthony: visual and literary uses of a Eucharistic motif', in P Wallace and G Niocaill (eds), *Keimeila*, Galway University Press, Galway, 1–58

Ó Carragáin, É, 2003 'Between Annunciation and Visitation: spiritual birth and the cycles of the sun on the Ruthwell Cross: a response to Fred Orton', in C Karkov and F Orton (eds), *Theorizing Anglo-Saxon Sculpture*, West Virginia University Press, Morgantown, 131–80

Ó Carragáin, T, 2003 'A landscape converted: archaeology and early church organisation on Iveragh and Dingle, Ireland', in M Carver (ed), *The Cross goes North: Processes of Conversion in Northern Europe, AD 300–1300*, York Medieval Press, Woodbridge, 127–52

Ó Corráin, D, 1994 'The historical and cultural background of the Book of Kells', in F O'Mahony (ed), *The Book of Kells*, Scolar Press, Aldershot, 1–32

Ó Cróinín, D, 1995 *Early Medieval Ireland, 400–1200*, Longmans, London and New York

Ó Floinn, R, 1994 *Irish Shrines and Reliquaries of the Middle Ages*, National Museum of Ireland, Dublin

Ó Floinn, R, 2002 'Patterns and politics: art, artefact and methodology', in M Redknap, N Edwards, S Youngs, A Lane and J Knight (eds), *Pattern and Purpose in Insular Art*, Oxbow Books, Oxford, 1–14

O'Grady, O J T, 2003 *An Interdisciplinary Re-evaluation of the Early Medieval Sculptured Crosses of the Glasgow Area*, unpubl MPhil dissertn, University of Glasgow

O'Sullivan, J, 1999 'Iona: archaeological investigations 1875–1996', in D Broun and T O Clancy (eds), *Spes Scottorum: Hope of Scots. Saint Columba, Iona and Scotland*, T and T Clark, Edinburgh, 215–43

O'Sullivan, J and Sheehan, J, 1996 *The Iveragh Peninsula: an Archaeological Survey of South Kerry*, Cork University Press

Object Name Books of the Ordnance Survey, microfilm in the National Monuments Record of Scotland

Okasha, E, 1971 *A Handlist of Anglo-Saxon Non-Runic Inscriptions*, Cambridge University Press

Okasha, E, 1993 *Corpus of Early Christian Inscribed Stones of South-West Britain*, Leicester University Press

Okasha, E and Forsyth, K, 2001 *The Early Christian Inscribed Stones of Munster*, Cork University Press

Old Statistical Account, 1791–99 *The Statistical Account of Scotland drawn up from the Communications of the Ministers of the Different Parishes by Sir John Sinclair, Bart*, 22 Vols, Edinburgh

Olivier, A, 1996 *Frameworks for Our Past: a Review of Research Frameworks, Strategies, and Perceptions*, English Heritage, London

Olsen, M, 1954 'Runic inscriptions in Great Britain, Ireland and the Isle of Man', in H Shetelig (ed), *Viking Antiquities in Great Britain and Ireland* 6, Aschehoug, Oslo, 151–233

Olwig, K F and Hastrup K (eds), 1997 *Siting Culture: the Shifting Anthropological Object*, Routledge, London

Ortega y Gasset, J, 1914 'Meditaciones del Quijote', in *Obras Completas* 1946, Vol 1, 322

Orton, F, 1998 'Rethinking the Ruthwell monument: fragments and critique; tradition and history; tongues and sockets', *Art History* 21(1), 65–106

OS 1867: *Ordnance Survey 1867, Perthshire Sheet LXII Caputh*, 1st edn, 6 inches to 1 mile, surveyed 1864 Southampton

OS 1901: *Ordnance Survey 1901, Perthshire Sheet LXII Caputh*, 2nd edn, 6 inches to 1 mile, revised 1898–9 Southampton

OS 1907: *Ordnance Survey 1907, Ross and Cromarty Sheet XXX.14*, 25 inches to 1 mile

Padel, O, 1985 *Cornish Place-Name Elements*, English Place-Name Society, Vol 56–7, Nottingham

Panofsky, E, 1953 *Early Netherlandish Painting: its Origin and Character*, Harvard University Press, Cambridge

Panofsky, E, 1955 *Meaning in the Visual Arts*, Doubleday, New York

Panofsky, E, 1964 *Tomb Sculpture: its Changing Aspects from Ancient Egypt To Bernini*, Thames and Hudson, London

Patton, M, Rodwell, W and Finch, O, 1999 *La Hogue Bie, Jersey*, Societe Jerviaise, St Helier

Peacock, D P S, 1995 'The 'Passio Sanctorum Quattuor Coronatorum': a petrological approach', *Antiquity* 69, 362–8

Peacock, D P S, 1997 'Charlemagne's black stones: the re-use of Roman columns in early medieval Europe', *Antiquity* 71, 709–15

Pearce, S M, 2003 'Processes of conversion in north-west Roman Gaul', in M Carver (ed), *The Cross Goes North: Processes of Conversion in Northern Europe*, AD 300–1300, York Medieval Press, Woodbridge, 61–78

Pennant, T, 1774 *A Tour in Scotland, and Voyage to the Hebrides; MDCCLXXII*, Chester

Penny, S and Shotter, D C A, 1996 'An inscribed Roman salt-pan from Shavington, Cheshire', *Brittannia* 27, 360–5, Pl XV

Peterson, L, 1994 *Svenskt Runordsregister* (Runrön 2, 2nd ed), Institutionen för Nordiska Språk, Uppsala

Petley, C C, 1857 'A short account of some carved stones in Ross-shire, accompanied with a series of outline engravings', *Trans Soc Antiq Scot* 4, 345–52

Pettijohn, F J, Potter, P E and Siever, R, 1973 *Sand and Sandstone*, Springer, Berlin

Physiologus 1979: Curley, M J (trans), 1979 *Physiologus*, Austin, Texas

Piggott, S (ed), 1970 *Early Celtic Art*, Edinburgh University Press, Edinburgh (exhibition catalogue)

Pinkerton, J, 1814 *An Enquiry into the History of Scotland . . .* (new edn), Edinburgh

Pirotte, E, 2001 'Hidden Order, Order Revealed: New Light on Carpet Pages', in M Redknap, N Edwards, S Youngs, A Lane and J Knight (eds), *Pattern and Purpose in Insular Art*, Oxbow Books, Oxford, 203–8

Pitt Rivers, A H, 1889 'Letter to W D Geddes, Principal of the University of Aberdeen and member of the New Spalding Club', repr in Foster, S M, 2001 *Place, Space and Odyssey. Exploring the Future of Early Medieval Sculpture*, Groam House Museum, Rosemarkie, 36–9

Pitt Rivers, A H, 1891 'Paper on models of ancient monuments, and on some points in the development of the Celtic Cross in Scotland', *Proc Soc Antiq London* 2nd ser, 13, 174–81

Plummer, C (ed), 1896 *Venerabilis Baedae Opera Historica*, Clarendon Press, Oxford

Proc Soc Antiq Scot, 1901 'Donation (2) by Rev J E Fraser, Dores', *Proc Soc Antiq Scot* 20, 106–7

Proc Soc Antiq Scot, 1922 'Donations to the Museum', *Proc Soc Antiq Scot* 56, 60–64

Proc Soc Antiq Scot, 1956 'Donations to and Purchases for the Museum', *Proc Soc Antiq Scot* 88, 238–42

Proudfoot, E and Aliaga-Kelly, C, 1997 'Aspects of settlement and territorial arrangements in south-east Scotland in the late prehistoric and early medieval periods', *Medieval Archaeol* 41, 33–50

Quick, G, 1975 'The photography of relief carvings', *Photographic* 115, 272–7

Radford, C A R, 1937 'The early medieval period' and 'The early inscriptions', in RCAHMW, *An Inventory of the Ancient Monuments of Anglesey*, London, xci–ciii and civ–cix

Radford, C A R, 1942 'The Early Christian monuments of Scotland', *Antiquity* 16, 1–18

Radford, C A R, 1959 *The Early Christian and Norse Settlements at Birsay, Orkney*, Ministry of Public Building and Works Official Guide-Book, HMSO, Edinburgh

Radford, C A R, 1967a 'The early Christian monuments at Govan and Inchinnan', *Trans Glasgow Archaeol Soc* 15, 173–88

Radford, C A R, 1967b 'The Early Church in Strathclyde and Galloway', *Medieval Archaeol* 11, 105–26

Radford, C A R and Donaldson, G, 1957 *Whithorn and Kirkmadrine Wigtownshire*, Ministry of Works official guide book, 2nd imp HMSO, Edinburgh (rev edn: Fisher, I and Tabraham, C J, 1984 *Whithorn and the Ecclesiastical Monuments of Wigtown District*, HMSO, Edinburgh)

Ralston, I, 1997 'Pictish Homes', in D Henry (ed), *The Worm, the Germ, and the Thorn: Pictish and Related Studies Presented to Isabel Henderson*, Pinkfoot Press, Balgavies, 19–34

RCAHMS, 1929 *Tenth Report with Inventory of Monuments and Constructions in the Counties of Midlothian and West Lothian*, HMSO, Edinburgh

RCAHMS, 1933 *Eleventh Report with Inventory of Monuments and Constructions in the Counties of Fife, Kinross and Clackmannan*, HMSO, Edinburgh

RCAHMS, 1946 *Twelfth Report, with an Inventory of the Ancient Monuments of Orkney and Shetland*, 3 Vols, HMSO, Edinburgh

RCAHMS, 1956 *An Inventory of the Ancient and Historical Monuments of Roxburghshire*, HMSO, Edinburgh

RCAHMS, 1957 *An Inventory of the Ancient and Historical Monuments of Selkirkshire*, HMSO, Edinburgh

RCAHMS, 1967 *Peeblesshire. An Inventory of the Ancient Monuments*, HMSO, Edinburgh

RCAHMS, 1971–92 *Argyll. An Inventory of the Monuments*, 7 Vols, HMSO, Edinburgh

RCAHMS, 1982 *Argyll. An Inventory of the Monuments* 4: *Iona*, HMSO, Edinburgh

RCAHMS, 1984 *Argyll. An Inventory of the Monuments* 5: *Islay, Jura, Colonsay and Oronsay*, HMSO, Edinburgh

RCAHMS, 1994 *South-East Perth: an Archaeological Landscape*, RCAHMS, Edinburgh

RCAHMS, 1999 [Fraser, I and Ritchie, J N G], *Pictish Symbol Stones: an Illustrated Gazetteer*, RCAHMS, Edinburgh

RCAHMS, 2000 *Monuments on Record. Annual Review 1999–2000*, RCAHMS, Edinburgh

RCAHMS, 2003 *Early Medieval Sculpture in Angus Council Museums*, RCAHMS Broadsheet 11, Edinburgh

RCAHMS, forthcoming *Strathdon: an Archaeological Landscape*, RCAHMS, Edinburgh
Redknap, M, Edwards, N, Youngs, S, Lane, A and Knight, J (eds), 2001 *Pattern and Purpose in Insular Art*, Oxbow Books, Oxford
Reece, R, 1981 *Excavations on Iona 1964–74*, Inst Archaeol Occas Pap 5, London
Reid, A, 1915 'Sculptured sarcophagus and churchyard memorials at Dalmeny, with notes on the Churchyards of Edzell, Lethnot and Stracathro', *Proc Soc Antiq Scot* 49, 285–303
Richards, E, 2000 *The Highland Clearances*, Birlinn, Edinburgh
Riegl, A, 1903 'The modern cult of monuments: its essence and its development', transl and repr in N Stanley Price, M K Tally and A M Vaccaro (eds), 1996 *Historical and Philosophical Issues in the Conservation of Cultural Heritage*, Getty Conservation Inst, Los Angeles, 69–83
Ritchie, A, 1989 *Picts: an Introduction to the Life of the Picts and the Carved Stones in the Care of the Secretary of State for Scotland* (2nd edn), HMSO, Edinburgh
Ritchie, A, 1995 'Meigle and lay patronage in Tayside in the 9th and 10th centuries AD', *Tayside Fife Archaeol J* 1, 1–10
Ritchie, A, 1997a *Iona*, Batsford and Historic Scotland, Edinburgh
Ritchie, A, 1997b *Meigle Museum Pictish Carved Stones*, Historic Scotland, Edinburgh
Ritchie, A, 1999 *Govan and its Carved Stones*, Pinkfoot Press, Balgavies
Ritchie, A (ed), 1994 *Govan and its Early Medieval Sculpture*, Alan Sutton, Stroud
Ritchie, J, 1910 'The sculptured stones of Clatt, Aberdeenshire', *Proc Soc Antiq Scot* 44, 203–15
Ritchie, J N G, 1997 'Recording Early Christian stones', in D Henry (ed), *The Worm, the Germ, and the Thorn: Pictish and Related Studies Presented to Isabel Henderson*, Pinkfoot Press, Balgavies, 119–28
Ritchie, J N G, 1998 *Recording Early Christian Monuments in Scotland*, Groam House Museum Trust, Rosemarkie
Ritchie, J N G, 2003 'Pictish art in Orkney', in J Downes and A Ritchie (eds), *Sea Change: Orkney and Northern Europe in the Later Iron Age AD 300–800*, Orkney Heritage Soc, Pinkfoot Press, Balgavies, 117–26
Rivet, A L F and Smith, C, 1979 *The Place-Names of Roman Britain*, Batsford, London
Robertson, N M, 1991 'Tulliebole Kirkyard (Fossoway Parish) hogback fragment', *Discovery Excav Scotl 1991*, CSA, Edinburgh, 71
Robertson, N M, 1997 'The early medieval carved stones of Fortingall', in D Henry (ed), *The Worm, the Germ, and the Thorn: Pictish and Related Studies Presented to Isabel Henderson*, Pinkfoot Press, Balgavies, 133–43
Robertson, W N, 1975 'St John's Cross, Iona, Argyll', *Proc Soc Antiq Scot* 106, 111–23
Robertson, W N, 1977 'A fragment of stone carving of Early Christian date in the Cathedral Museum, St Andrews', *Proc Soc Antiq Scot* 108, 259–61
Roe, H, 1966 *The High Crosses of Kells*, Meath Archaeol Hist Soc, Longford
Roe, H, 1981 *Monasterboice and its Monuments*, County Louth Archaeol Hist Soc, Longford (repr from *Seanchas Ardmhacha* 1954, 101–14)
Roger, J C, 1880 'Notice of a drawing of a bronze crescent-shaped plate, which was dug up at Laws, parish of Monifieth, in 1796', *Proc Soc Antiq Scot* 14, 268–74
Rogers, J, 1992 *The Formation of the Parish Unit and Community in Perthshire*, unpubl PhD thesis, University of Edinburgh
Rogers, J M, 1997 'The foundation of parishes in twelfth-century Perthshire', *Rec Scott Church Hist Soc* 27, 68–97
Ruckley, N, 1998 'Stone for carving: the Tarbat Geological Project', *Tarbat Discovery Progr Bull* 4

Rutherford, A and Ritchie, G, 1974 'The Catstane', *Proc Soc Antiq Scot* 105, 183–8
Ryan, M (ed), 1987 *Ireland and Insular Art AD 500–1200*, Roy Ir Acad, Dublin
Ryder, P F, 1991 *Medieval Cross Slab Grave Covers in West Yorkshire*, Wakefield
Samson, R, 1992 'The re-interpretation of the Pictish Symbols', *J Brit Archaeol Ass* 145, 29–45
Sanderson, D C W and Anthony, I M C, 2004 *Luminescence Dating of Sediments from Hilton of Cadboll, Easter Ross*, unpubl rep for Historic Scotland
Sargent, H C and Kittredge, G L (eds), 1904 *English and Scottish Popular Ballads*, London
Sauer, E, 2003 *The Archaeology of Religious Hatred in the Roman and Early Medieval World*, Stroud
Saunders, A D, 1983 'A century of ancient monuments legislation 1882–1982', *Antiq J* 63, 11–33
Saville, A, 2002 'Treasure Trove in Scotland', *Antiquity* 76, 796–802
Saxl, F, 1943 'The Ruthwell Cross', *J Warburg Courtauld Inst* 6, 1–19
Schaff, P (ed), 1887 *NPNF* 2, *St Augustine's City of God*, Christian Literature Coy, Buffalo, New York
Schaff, P (ed), 1888 *NPNF* 8, *St Augustine: Expositions on the Book of Psalms*, Christian Literature Coy, New York
Schama, S, 1996 *Landscape and Memory*, Fontana Press, London
Schapiro, M, 1944 'The religious meaning of the Ruthwell Cross', *Art Bull* 26, 232–45
Schapiro, M, 1980 'Marginal images and drôlerie', in M Schapiro (ed), *Late Antique, Early Christian and Medieval Art*, Selected Pap 3, London, 197–8
Scotia Archaeology, 1991 *Fowlis Wester 1991: Report of Excavation (August 1991)*, unpubl rep for Historic Scotland
Scotsman, 1921 'Scottish Relics', *The Scotsman,* 14 February
Scott, I G, 1997 'Illustrating early medieval carved stones', in D Henry (ed), *The Worm, the Germ, and the Thorn: Pictish and Related Studies Presented to Isabel Henderson*, Pinkfoot Press, Balgavies, 129–32
Scottish Executive, 1999 *Treasure Trove in Scotland: Information on Treasure Trove Procedures, Criteria for Allocation and the Allocation Process*, Edinburgh
Scottish Executive, 2000 *Creating our Future, Minding our Past: The National Cultural Strategy*, Edinburgh
Scottish Executive, 2005 *Carved Stones: Scottish Executive Policy and Guidance*, Historic Scotland, Edinburgh
Sear, D R, 1987 *Byzantine Coins and their Values*, London
Sharpe, R (ed), 1995 *Adomnán of Iona. Life of St Columba*, Penguin Books, London
Sharpe, R, 2002 'Martyrs and Local Saints in Late Antique Britain', in R Sharpe and A Thacker (eds), *Local Saints and Local Churches in the Early Medieval West*, Oxford University Press, Oxford, 75–154
Sheehan, J, 1990 'Some early historic cross-forms and related motifs from the Iveragh Peninsula', *J Kerry Archaeol Hist Soc* 23, 157–74
Sherriff, J R, 1984 *Pictish Stones of Angus*, Angus District Libraries and Museums Service
Shetelig, H, 1954 'The Norse style of ornamentation in the Viking settlements', in H Shetelig (ed), *Viking Antiquities in Great Britain and Ireland* 6, Aschehoug, Oslo, 113–50
Shortland, M (ed), 1995 *Hugh Miller's Memoir: from Stonemason to Geologist*, Edinburgh University Press, Edinburgh
Shucksmith, M, Chapman, P, Clark, G M, Black, S and Conway, E, 1994 *Disadvantage in Rural Scotland. How is it Experienced and How Can it Be Tackled?*, unpubl rep to Rural Forum (Scotland) and Scottish Consumer Council

Sims-Williams, P, 2002 'The five languages of Wales in the pre-Norman inscriptions', *Cambrian Medieval Celtic Stud* 44, 1–36

Sims-Williams, P, 2003 *The Celtic Inscriptions of Britain: Phonology and Chronology, c400–1200*, Publications Philological Soc 37, Blackwells, Oxford

Small, A, 1962 'Two Pictish symbol stones (ii) Fairygreen, Collace, Perthshire', *Proc Soc Antiq Scot* 95, 221–2

Small, A, Thomas, C and Wilson, D M, 1973 *St Ninian's Isle and its Treasure*, University of Aberdeen, Oxford

Smith, J K and Carr, D, 2002 'In Byzantium', *Curator: The Mus J* 44.4, 335–54

Spearman, R M, 1994 'The Govan sarcophagus: an enigmatic monument', in A Ritchie (ed), *Govan and its Early Medieval Sculpture*, Alan Sutton, Stroud, 33–45

Spearman, R M and Higgitt, J (eds), 1993 *The Age of Migrating Ideas: Early Medieval Art in Northern Britain and Ireland*, NMS and Alan Sutton, Edinburgh and Stroud

Stanley Price, N, Talley, M K and Vaccaro, A M (eds), 1996 *Historical and Philosophical Issues in the Conservation of Cultural Heritage*, Getty Conservation Inst, Los Angeles

Steer, K A, 1969 'Two unrecorded early christian stones', *Proc Soc Antiq Scot* 101, 127–9

Steer, K A and Bannerman, J W M, 1977 *Late Medieval Monumental Sculpture in the West Highlands*, Edinburgh

Stephen, W, 1795 'Parish of Rafford', *OSA* Vol XVI, 338–47

Stephens, G, 1884 *The Old-Northern Runic Monuments of Scandinavia and England,* Vol III (4 Vols, 1866–1901), Williams and Norgate/Lynge/Gleerup *et al*, London/Köbenhavn/Lund

Stevenson, R B K, 1955 'Pictish Art', in F T Wainwright (ed), *The Problem of the Picts*, Nelson, Edinburgh and London, 97–128

Stevenson, R B K, 1956 'The chronology and relationships of some Irish and Scottish crosses', *J Roy Soc Antiq Ir* 86, 84–96

Stevenson, R B K, 1959 'The Inchyra Stone and some other unpublished early Christian monuments', *Proc Soc Antiq Scot* 92 (1958–9), 33–55

Stevenson, R B K, 1971 'Sculpture in Scotland in the 6th–9th centuries AD', *Kolloquium über Spätantike und Frühmittelalterliche Skulptur, Universität Heidelberg, 1970*, Mainz, 65–74

Stevenson, R B K, 1974 'The Hunterston Brooch and its significance', *Medieval Archaeol* 18, 16–42

Stevenson, R B K, 1981 'The Museum, its beginnings and its development. Part II: the National Museum to 1958', in A S Bell (ed), *The Scottish Antiquarian Tradition: Essays to Mark the Bicentenary of the Society of Antiquaries of Scotland and its Museum, 1780–1980*, John Donald, Edinburgh, 142–211

Stevenson, R B K, 1982 'Aspects of ambiguity in crosses and interlace', *Ulster J Archaeol* 44–5, 1–27

Stevenson, R B K, 1983 'Further notes on the Hunterston and 'Tara' Brooches, Monymusk Reliquary and Blackness Bracelet', *Proc Soc Antiq Scot* 113, 469–77

Stevenson, R B K, 1985 'Notes on the sculptures at Fahan Mura and Carndonagh, County Donegal,' *J Roy Soc Antiq Ireland*, 115, 92–5

Stevenson, R B K, 1993 'Further thoughts on some well known problems', in R M Spearman and J Higgitt (eds), *The Age of Migrating Ideas: Early Medieval Art in Northern Britain and Ireland*, NMS and Alan Sutton, Edinburgh and Stroud, 188–95

Stirling Maxwell, J, 1899 *Sculptured Stones in the Kirkyard of Govan*, Glasgow

Stokes, W, 1887 *The Tripartite Life of Patrick*, RS 89

Stokes, W (ed), 1905 *Felire Oengussu Celi Dei: the Martyrology of Oengus the Culdee, Critically Edited from Ten Manuscripts*, HBS 29, London

Stone, J C, 1989 *The Pont Manuscript Maps of Scotland: Sixteenth Century Origins of a Blaeu Atlas*, Tring
Stuart, J, 1856 *Sculptured Stones of Scotland*, Vol I, Spalding Club, Aberdeen
Stuart, J, 1867 *Sculptured Stones of Scotland*, Vol II, Spalding Club, Edinburgh
Studioarc, 2002 *Whithorn Priory Museum Interpretative Outline*, unpubl rep for Historic Scotland
Swift, C, 1996 'Pagan monuments and Christian legal centres in early Meath', *Riocht na Midhe* 9.2, 1–26
Swift, C, 1997 *Ogam Stones and the Earliest Irish Christians*, Maynooth Monogr Ser Minor 2, Maynooth
Tarbat Discovery Progr Bull 1995–2002, Vols 1–7, University of York, website http://www.york.ac.uk/depts/arch/staff/sites/tarbat/bulletins
Taylor, S, 1995 *Settlement Names in Fife*, unpubl PhD thesis, School Scott Stud, University of Edinburgh
Taylor, S and Watt, D E R (eds), 1990 *Scotichronicon by Walter Bower*, Vol 5 *Books IX and X*, University Press, Aberdeen
Tedeschi, C, 1995 'Osservazioni sulla paleografia delle iscrizioni britanniche paleocristiane V–VII sec. Contributo allo studio dell'origine delle scritture insulari', *Scrittura e Civiltà* xix, 67–121
Tedeschi, C, 2001 'Some observations on the palaeography of Early Christian inscriptions in Britain', in J Higgitt, K Forsyth and D N Parsons (eds), *Roman, Runes and Ogham. Medieval Inscriptions in the Insular World and on the Continent*, Shaun Tyas, Donnington, 16–25
Thomas, C, 1968 'The evidence from North Britain', in M W Barley and R P C Hanson (eds), *Christianity in Britain, 300–700*, Leicester University Press, 93–121
Thomas, C, 1971 *The Early Christian Archaeology of North Britain*, Oxford University Press, Oxford
Thomas, C, 1981 *Christianity in Roman Britain to AD 500*, Batsford, London
Thomas, C, 1992a 'The early Christian inscriptions of Southern Scotland', *Glasgow Archaeol J* 17, 1–10
Thomas, C, 1992b *Whithorn's Christian Beginnings*, Whithorn Lecture 1, Friends of the Whithorn Trust, Whithorn
Thomas, C, 1994 *And Shall These Mute Stones Speak? Post-Roman Inscriptions in Western Britain*, University Wales Press, Cardiff
Thomas, C, 1997 'The conversions of Scotland', *Rec Scott Church Hist Soc* 27, 1–41
Thomas, C, 1998 'Form and function', in S M Foster (ed), *The St Andrews Sarcophagus. A Pictish Masterpiece and its International Connections*, Four Courts Press, Dublin, 84–96
Thompson, V, forthcoming *Dying and Death in Later Anglo-Saxon England*, Boydell and Brewer, Woodbridge
Tilley, C, 1994 *A Phenomenology of Landscape*, Berg, Oxford
Tomlin, R S O and Hassall, M W C, 1998 'Inscriptions: 11 Shavington, Cheshire', *Brittania* 29, 436–7
Topen, D, 2002 *The Castle and Lands of Stanely, Paisley, Renfrewshire*, Renfrewshire Local History Forum, Paisley
Torrie, E P D and Coleman, R, 1996 *Historic Hamilton: the Scottish Burgh Survey*, Aberdeen
Trench-Jellicoe, R, 1981 'A new *chi-rho* from Maughold, Isle of Man', *Medieval Archaeol* 24, 202–3

Trench-Jellicoe, R, 1997 'Pictish and related harps: their form and decoration', in D Henry (ed), *The Worm, the Germ, and the Thorn: Pictish and Related Studies Presented to Isabel Henderson*, Pinkfoot Press, Balgavies, 159–70

Trench-Jellicoe, R, 1998 'The Skeith Stone, Upper Kilrenny, Fife, in its context', *Proc Soc Antiq Scot* 128, 495–513

Trench-Jellicoe, R, 1999 'A missing figure on slab fragment no 2 from Monifieth, Angus . . .', *Proc Soc Antiq Scot* 129, 597–647

Unger, J, Wrenninge, M, Wänström, F and Ollila, M, 2002 'Real-time image based lighting in software using HDR panoramas', in M Ollila (ed), *Proceedings from SIGRAD 2002, Linköpings Universitet, Norrköping, Sweden*, Linköping Electronic Conference Proceedings, http://www.ep.liu.se/ecp/007, accessed July 2003

User's Guide KT-9, 1997 *Kappameter Revision 1. Exploranium Radiation Detection Systems* August 1997

Vives, J (ed), 1969 *Inscripciones Cristianas de la España Romana y Visigoda*, Barcelona

Vogüé, A de and Antin, P (eds), 1980 *Gregoire le Grand. Dialogues* 3, Sources Chrétiennes 265, Paris

Volbach, W F and Hirmer, M, 1961 *Early Christian Art*, Thames and Hudson, London

Waddell, J J, 1918 'The Cross of S Kentigern at Hamilton, and its environment', *Trans Scot Ecclesiol Soc* 5, 3

Waddell, J J, 1932 'Cross-slabs recently discovered at Millport and Fowlis Wester', *Proc Soc Antiq Scot* 74, 83

Wakeman, W F, 1893 *A Survey of the Antiquarian Remains on the Island of Inismurray*, Royal Soc Antiq Ireland

Walderhaug Saetersdal, EM, 2000 'Ethics, politics and practices in rock art conservation', *Public Archaeol* 1, 163–80

Walsh, M and Ó Cróinín, D (eds), 1988 *Cummian's Letter 'De Controuersia Paschali' and the 'De Ratione Computandi'*, Pontifical Inst Medieval Stud, Toronto

Walsh, P G (ed), 1990 ACW 51, *Cassiodorus Explanation of the Psalms, 1: Psalms 1–50*, Paulist Press, New York and New Jersey

Walsh, P G (ed), 1991 ACW 52, *Cassiodorus Explanation of the Psalms, 2: Psalms 51–100*, Paulist Press, New York and New Jersey

Warden, A, 1880–5 *Angus or Forfarshire, the Land and the People, Descriptive and Historical*, Dundee

Warner, G F (ed), 1906–7 *The Stowe Missal: MS. D. II. 3 in the Library of the Royal Irish Academy, Dublin*, HBS 31–32, London (repr 1989, Boydell Press, Woodbridge)

Warniers, R, 1998 'Every picture tells a story', *Computer Graphics World*, accessible archive via http://cgw.pennnet.com, accessed July 2003

Watson, W J, 1926 *The History of the Celtic Placenames of Scotland*, Edinburgh (repr 1993)

Watt, J M, 2001 'William Galloway's excavations at Whithorn, 1886–1897. Selections from unpublished correspondence in the Bute muniments', *Trans Dumfriesshire Galloway Natur Hist Antiq Soc* 75, 133–49

Webster, L, 2003 'Encrypted visions: style and sense in the Anglo-Saxon minor arts, AD 400–900', in G Hardin Brown and C Karkov (eds), *Anglo-Saxon Styles*, Medieval Inst Press, Kalamazoo, 11–30

Webster, L and Backhouse, J (eds), 1991 *The Making of England: Anglo-Saxon Art and Culture AD 600–900*, British Museum and British Library, London (exhibition catalogue)

Weitzmann, K, 1979 *Age of Spirituality: Late Antique and Early Christian Art, Third to Seventh Century*, Metropolitan Museum of Art, Princeton (exhibition catalogue)

Welander, R D E, 1998 'Recent developments in conservation and presentation,' in S M Foster 1998 (ed), *The St Andrews Sarcophagus. A Pictish Masterpiece and its International Connections*, Four Courts Press, Dublin, 63–70

Whitting, P D, 1973 *Byzantine Coins*, London

Willems, R (ed), 1954 *CCSL 36, Sancti Aurelii Augustini: in Iohannis Evangelium Tractatus CXXIV*, Brepols, Turnholt

Williams-Thorpe, O, Jones, M C, Tindle, A G and Thorpe R S, 1996 'Magnetic susceptibility variations at Mons Claudianus and in Roman columns: a method of provenancing to within a single quarry', *Archaeometry* 38, 15–41

Williams-Thorpe, O, Jones, M C, Webb, P C and Rigby, I J, 2000a 'Magnetic susceptibility thickness corrections for small artefacts and comments on the effects of 'background' materials', *Archaeometry* 42 (1), 101–8

Williams-Thorpe, O and Thorpe R S, 1993 'Magnetic susceptibility used in non-destructive provenancing of Roman granite columns', *Archaeometry* 35 (2), 185–95

Williams-Thorpe, O, Tindle, A G and Jones, M C, 1997 'Characterisation studies: magnetic susceptibility', in D P S Peacock and V A Maxfield (eds), *Mons Claudianus, Survey and Excavations 1987–1993, Vol 1. Topography and Quarries*, Institute Francais d'Archeologie Orientale, Cairo, 287–313

Williams-Thorpe, O, Webb P C and Thorpe R S, 2000b 'Non-destructive portable gamma ray spectrometry used in provenancing Roman granitoid columns from Leptis Magna, North Africa', *Archaeometry* 42 (1), 77–99

Willsher, B, 1985a *How to Record Scottish Graveyards*, Edinburgh

Willsher, B, 1985b *Understanding Scottish Graveyards*, Canongate Books, Edinburgh

Wilson, A, 1845 'Parish of Caputh', *NSA* Vol 10, 670–84

Wilson, D, 1883 'Holy Island, and the runic inscriptions of St Molio's Cave, County of Bute', *Proc Soc Antiq Scot* 17, 45–56

Wilson, D M, 1983 'The art of the Manx crosses of the Viking Age', in C Fell, P Foote, J Graham-Campbell and R Thornson (eds), *The Viking Age in the Isle of Man*, Viking Soc, London, 175–87

Wilson, P, 1969 'St Ninian: Irish evidence further examined', *Trans Dumfriesshire Galloway Natur Hist Antiq Soc*, 46, 140–59

Wise, P (ed), 2003 *The Art of Archaeology*, Soc Mus Archaeol Conference Proc, Carlisle 2001, Mus Archaeol 28

Withers, C W J, 1996 'Place, memory, monument: memorializing the past in contemporary Highland Scotland', *Ecumene* 3 (3), 325–44

Woolf, A, 2003 'The Britons: from Romans to Barbarians', in H-W Goetz, J Jarnut and W Pohl (eds), *Regna and Gentes: the Relationship Between Late Antique and Early Medieval Peoples and Kingdoms in the Transformation of the Roman World*, Transformation of the Roman World 13, Leiden, 345–80

Wright, D H (ed), 1967 *The Vespasian Psalter: British Museum, Cotton Vespasian A. 1* (EEMF 14), Rosenkilde and Bagger, Copenhagen

Young, V and Urquhart, D, 1996 *Access to the Built Heritage*, Technical Advice Note 7, Historic Scotland, Edinburgh

Youngs, S (ed), 1989 *'The Work of Angels', Masterpieces of Celtic Metalwork, 6th–9th Centuries AD*, British Museum, London

Zimmerman, O J (trans), 1959 *Saint Gregory the Great: Dialogues*, Fathers of the Church 39, New York

LIST OF CONTRIBUTORS

Norman K Atkinson, Angus Council, Cultural Services, County Buildings, Forfar DD8 3WF

Professor Michael P Barnes, Department of Scandinavian Studies, University College London, Gower Street, London WC1E 6BT

John Borland, Royal Commission on the Ancient and Historical Monuments of Scotland, John Sinclair House, 16 Bernard Terrace, Edinburgh EH8 9NX

Alistair Carty, Archaeoptics Ltd, PO Box 3738, Glasgow G41 4YD

Professor Martin Carver, Department of Archaeology, King's Manor, University of York, York YO1 7EP

Morag Cross, 77 Oxford Street, Kirkintilloch G66 1LQ

Dr Stephen T Driscoll, Department of Archaeology, University of Glasgow, Gregory Building, Lilybank Gardens, Glasgow G12 8QQ

Ian Fisher, Royal Commission on the Ancient and Historical Monuments of Scotland, John Sinclair House, 16 Bernard Terrace, Edinburgh EH8 9NX

Dr Katherine Forsyth, Department of Celtic, Modern Languages Building, 16 University Gardens, University of Glasgow, Glasgow G12 8QQ

Dr Sally M Foster, Historic Scotland, Longmore House, Salisbury Place, Edinburgh EH9 1SH

Dr Iain Fraser, Royal Commission on the Ancient and Historical Monuments of Scotland, John Sinclair House, 16 Bernard Terrace, Edinburgh EH8 9NX

Mark A Hall, Perth Museum and Art Gallery, 78 George Street, Perth PH1 5LB

Dr Jane Hawkes, Department of History of Art, University of York, Heslington, York YO10 5DD

Dr Isabel Henderson OBE, The Old Manse, Nigg, Tain IV19 1QR

David Henry, The Pinkfoot Press, Balgavies, Forfar, Angus DD8 2TH

John Higgitt, History of Art, School of Arts, Culture and Environment, University of Edinburgh, 19 George Square, Edinburgh EH8 9LD

Heather James, Glasgow University Archaeology Research Division, Department of Archaeology, Gregory Building, Lilybank Gardens, Glasgow G12 8QQ

Dr Stuart Jeffrey, West of Scotland Archaeology Service, Charing Cross Complex, 20 India Street, Glasgow G2 4PF

Dr Siân Jones, School of Art History and Archaeology, University of Manchester, Oxford Road, Manchester M13 9PL

Professor R I Page, Corpus Christi College, Cambridge CB2 1RH

Ingval Maxwell OBE, Historic Scotland, Longmore House, Salisbury Place, Edinburgh EH9 1SH

Dr Kellie S Meyer, Centre for Medieval Studies, University of York, King's Manor, York YO1 7EP

Dr Suzanne Miller, National Museums of Scotland, Edinburgh EH1 1JF

Colin Muir, Historic Scotland, Longmore House, Salisbury Place, Edinburgh EH9 1SH

Oliver O'Grady, Department of Archaeology, University of Glasgow, Gregory Building, Lilybank Gardens, Glasgow G12 8QQ

Nigel A Ruckley, The Old School House, Kirkbuddo, by Forfar, Angus DD8 2NQ

Ian G Scott, 3 Saxe Coburg Street, Edinburgh EH3 5BN

Lisbeth M Thoms, President, Society of Antiquaries of Scotland, Royal Museum, Chambers Street, Edinburgh EH1 1JF

Dr Ross Trench-Jellicoe, 101 Sibsey Street, Lancaster LA1 5DQ

Peter Yeoman, Historic Scotland, Longmore House, Salisbury Place, Edinburgh EH9 1SH

INDEX

Peter Rea

(Page numbers in italics refer to illustrations or captions)

Abbán Moccu Corbmaic 106, *107*
Abbotsford 61
Aberdaron 124, 125, 129
Aberdeen Assembly 62
Aberdeen and surroundings: map *294*
Aberdeenshire Council Archaeological Unit 336
Aberlemno churchyard 85
Aberlemno roadside cross-slab, *see* Aberlemno sculptures: Aberlemno 3 cross-slab
Aberlemno roadside symbol-incised stone, *see* Aberlemno sculptures: Aberlemno 1 cross-slab
Aberlemno sculptures:
 Aberlemno 1 cross-slab 58, 60, *63*
 Aberlemno 2 cross-slab:
 battle scene *303*
 cross on *299*
 drawings *230*
 hippocamps *301*
 laser scanning *172*
 replica *171*
 story 55, 60, 63, 65, 85
 support for 86
 Aberlemno 3 cross-slab 87, 160, 164, 228, *229*, 245
 geological analysis 289
 laser scanning 368–9
Abernethy Museum 350
Abernethy stone fragment 345
Able Minds and Practised Hands seminar:
 aim of 2, 375
 background to 1
 condition of sculptures 159
 conservation and 6
 contexts and 13
 display and 325
 occasion of viii, 375
 organisers x
 runic inscriptions and 187
 steering group 375, 378–9
 title's origin viii, 1
Abraham: St Martin's Cross 260, 267, 269, 272
ACR Smart-Reader Plus 2 180

Adomnán, *Life of Columba* 86, 89
Ahenny crosses 73, 85
Ainslie, J: map *102*
Ainsworth, Graciela 344
Airlie: map *279*
Alcock, L 218
Alexander III, King 56, 148, 309
Allen, J Romilly:
 'Archaeological Survey and Descriptive List' 379
 Burghead bulls and 215, 217
 cross-bases and 85
 Dores boar and 70
 drawings 202, 208, *209*, *210*, 212, *213*, 217
 ECMS viii, 1
 Edzell 2 cross-slab 337
 equal-armed crosses 304
 fragments and 69, 77
 Govan sculptures and 142
 Iona monuments and 159
 Mugdrum Cross 87
 Murroes fragment and 78–80
 numbering system 202
 photographs *140*
 Rosemarkie 5 and 77
 rubbings 206–7, *208*, 217
 St Vigeans stones 202, 206–7, *208*, *209*, 212, *213*
 spiral ornament and 71
 Strathclyde sculpture and 137–9
Ancient Monuments Board for Wales 5
ancient monuments legislation 3
Ancient Monuments Protection Act, 1882 3
Anderson, Joseph:
 dating and 376–7
 Dores boar and 70
 ECMS viii, 1
 Govan sculpture and 142
 influence of 3
 photograph *4*
 photography, faith in 235
 Rhind Lectures viii, 1

sculpture, place of curation and 3, 4
sculptures, collections of 3, 4
angels motif 268–9
Anglians 120
Anglo-Saxon sculpture 244, 263, 272
Angus:
 Council 214, 340, 341
 Council Museums 335–42
 sculptures:
 museum interest in 336–40
 photographs 336
 removal of 336
 survey 336
 Sites and Monuments Register 336
Angus, Perth and Kinross: geological survey 277, 278–80, *279*
Angus District Archaeological Sites and Monuments Register 336
Angus Pictish Trail 336, 341
animal imagery 303, 304
Annan studio 137, *138*
Antony and Paul: Nigg 24, 28–9, 61, 252
Antony the Eremite, St 308
Antiquity 348
Antonine Wall 150
Applecross cross-slab fragment 74, 75
Arbirlot sculpture:
 geological analysis 289
 map 279
Arbroath Abbey 340
Arbroath Harbour 337
Arbroath Signal Tower Museum stones:
 geological analysis 289, 337
Arbuthnot group of sandstones 282–3
archaeology:
 agencies, bringing together 349–50
 frameworks for 348–50
 future of 349–50
 reform needed 348
 research 348
 resources 348
 state of 348
 underfunding 348
Archer, A *118*
Ardross 16
Armagh 127
armed men motif 303
Arraglen 128
art historical analysis 7
Arthurlie cross 136, 153, 154, *155*
Arthurstone 232
Ascherson, Neal 349
Athelstan, King 311
Auchentorlie Quarry 173–4

Augustine, St 267, 270
Auldbar cross 136, *152*, 153, 154
Avitus 125

Bæksted, Anders 192, 193
Bail' a'chnuic 25
Bakewell Cross 227
Balintore 25
Balliol, Edward 104
Bannatyne Club 231
Barber, John 108
Barberini Gospels 75, 76
Barkan and Bush 37, 43
Barnes and Page 198
Barochan Cross 87, 139, *140*, 144, 146–8, *147*, 148–9, 150, 153, 157:
 landscape and 147–8
Barochan Hill Roman fort 148
Barrouadus 122
battle scenes 303
bear? 249, 251
Bede 267
bedrock carving 173–4
Belsair Guest House runes 188, 189
Beveridge, Erskine 89, *90*
Birnie 1 symbol stone 75
Birnie 2 74–5, *74, 75*
Birsay runic inscriptions 188–9, *189*, 190, 191
Black, George 4
Black Cart Water 154
Blackford symbol-incised stone 372
Boece, Hector 65
Book of Kells 75, 76, 80, 241, 249, 250, 293, 300, 302
book-covers 304
Borthwick 127
Bourtie church 58
Bradley, Richard 14
Brandsbutt granite slab 164, 165
Brechin Library 337
Brechin Museum 337
Breeze, Andrew 127
'Brigomaglos' stone 116, 117, 130
British Academy xii
British Association 225
Brittany 113, 124
Brocagni 129
Broompark farmhouse 308
Brough of Birsay 188, 191
Brown, Peter 30
Brox inscribed stone *114*, 119, 130
Burdiehouse fossils 225, 235
Burghead 26, 70:
 bulls of 215–19, *215*, 216

Cadboll 25
Cadboll Castle 25
Cadboll Mount 25
Cadboll-abbot 25
Cadzow 146, 148
Cain and Abel:
 Kildalton 260
 St Martin's 259
Cairn Muir 309, 310
Calder, C S T 299, 304, 308
Callidus scanner 369, 370
Calvary 86
Campbell, Lady Ann 64, 87, 102
Canna Cross 86, 100
Canticle of Habakkuk 268
Capelrig Cross 105, 146, 153, 154:
 base 105, *106*
 excavation 105
 map *136*
 removal of 105
 socket-stone 105, 110
Capelrig Burn 154
Caputh 308, 309, 310, *310*, 311, 312
Carantius 119
Carausius 128
Cariblair (Edderton) symbol-incised stone 65
Carlisle: map *114*
Carnsew monument 115, 116
Carved Stone Decay in Scotland 344
Carved Stones: Scottish Executive Policy and Guidance 5, 12, 170
Carved Stones Advisor Project 5
Carved Stones Policy, 1992 170
Carved Stones of Scotland 344
Carver, Martin 7, 110
Cassiodorus:
 Commentary on the Psalms 74, 266
 Durham 249, 267
'Cat stane' *114*, 117–19, *118*, 120, 130:
 context of 118
Catboll-fisher 25, 112
Celtic names 117, 121
Chalmers, Joseph 308
Chalmers, Patrick 201, 202, 203, 204, *205*, 206, 213, 231, 232, 235, 242
Chesterholm *114*
chi-rho monogram 116, 119, 122, 125, 128–9
Christ 250, 251, 252, 266, 268, 269, 270:
 St Martin's Cross 266, 268, 271
 Shandwick cross-slab 252, 254
Christianity:
 burial and 131
 early phases of 151
 Ireland 127

Maryport fort 116
Mediterranean 28
 northward diffusion 115
church organisation 139, 154
churchyards 15
Cille Bharra, *see* Kilbar cross-slab
Cinead mac Ailpín 141
Clach a'Charridh, *see* Shandwick cross-slab
Clancy, Thomas 127, 154
Cliffburn stones 279, 337
Clonmacnoise cross 85, 93
Close-Brooks, Joanna 69–70
Clyde River:
 diversion 148
 see also Strathclyde, sculpture in
Clyde Rock 146
Coldrain 311
Coles, F R 202
Collingwood and Wright 116
Columba, Saint 19, 26, 86, 89, 107, 129, 326
comhdhail 310, 311
computers 217, 235, 367:
 model manipulation 370–4
 programmes 354–5
 see also early medieval sculpture of Scotland: recording: digital
Coninia 119, 121
conservation:
 access and 13
 Historic Scotland and 5
 importance of 6
 public support and 13
 research and 6
 specialised 3
Constantine, St 143
Constructive Solid Geometry program 356
Cordiner, Charles 62, 65, 66, 66, 67, 201
Cornwall 113, 115, 116, 117, 121, 128–9
Corpus of Anglo-Saxon Stone Sculpture 376, 377, 378, 379
Corpus of Early Medieval Inscribed Stones and Stone Sculpture in Wales 379
Corpus of Romanesque Sculpture in Britain and Ireland 377, 378, 379
Cossans, *see* St Orland's cross-slab
Council for Scottish Archaeology 5
Cowie, Trevor 106
Coychurch cross 88
Craig 336:
 Kirk Session 335
Craig, Derek 125, 126, 139, 141, 142, 146, 153, 157
Craigton sculpture 63
Cramond Roman fort 117

Cramp, Rosemary 69, 139, 142, 143, 144
crescent motif:
 Gellyburn 305
 Golspie stone 69
 Hilton of Cadboll 24
 Portmahomack 29
Crieff Burgh Cross:
 conservation 344
 date 109
 display 344
 enclosure 160
 location 346
 Perth Museum and 344
 pottery 109
 project 112, 346
 removal of 160
 value of 157
 worn areas 160
Cromarty Firth 26
Cross Kirk grave-slab, Shetland Islands 192
Cross Kirk (Pebbles) inscribed stone 127
cross-bases:
 base-tenons 88
 Irish 85, 86
 millstone 89, 93
 problems of 85–94
 sculptors' problems 86
 stepped plinths 86
 symbolism of 86
cross-slabs:
 archaeological context 95–112
 orientation 354
 as palimpsest of allusions 14
 reuse 58–9
 stories 55
 see also under names of individual slabs
cross-slabs, recumbent 31, *138*, 141, 142, 143, 144, 151, 153, 156
Crosscairn 309
crosses:
 boundary markers 57
 decoration 144
 Kildalton Cross 266
 St Martin's Cross 266, 270–1
 St Oran's Cross 266
 Shandwick cross-slab 252
 see also under names of individual crosses
crosses, disc-headed 146
crucifixion 311
Cruden, Stewart 203, 204
Cunaide 115, 116
Cunningsburgh runic inscriptions, Shetland Islands 191, 194
cup-and-ring marks 10

cup-marked stones 10, 58
Cupitianus 119
Curle, C L 259
Cuthbert, James 32
*Cuthilgourdie 310
cuthill 310
Cuween cairn, Orkney 190

Dalrymple, William 28
Damnonii 148
Daniel: St Martin's Cross 260, 267–8
David I, King 29, 148, 152, 153
David, King:
 Kildalton Cross 260
 Kinneddar 72, 73
 Nigg 24, 251
 St Andrews Sarcophagus 72
 St Martin's Cross 259, 263–6, 267, 271, 272
 St Oran's Cross 260
Debevec, Paul 363
Deer Park, Selkirk 122
department of culture 349
Department of the Environment 340
Descriptions of the Sheriffdoms of Lanark and Renfrew 146
Devon 113, 128
digital database 378
digital elevation models 358
Digital Michelangelo Project 363
digital terrain models 358
Dingwall symbol-incised stone *16*, 58
Dods, J W 88
dolphin motif:
 Portmahomack 29
 Shandwick 24, 29
Donegal sculptures 142
Dores boar 70
Dores key-pattern 70–1, 72
Dornoch Firth 26
double disc motif:
 Hilton of Cadboll 24, 29
 Logie Elphinstone 58
 St Vigeans 6 71–2
 Shandwick 24, 29
dragons 253, 303
Drainie 3 77
Drainie 8 77
Driscoll, S T 7, 310
'Drosten' stone, *see* St Vigeans sculptures: St Vigeans 1
Druid's Circle 310
Drumaqueran *114*, 128
Drumdurno, *see* Maiden Stone
Dryden, Sir Henry 85

Dublin 142, 151
Duff, Alexander 25, 97
Duke, Revd William 202, 203, 204, 208, 209, *209*, 211, 213
Dull panel 303
Dumbarton *136*, 141, 143, 150, 156
Dumbarton parish 151
Dumbarton Rock *136*, 146, 151
Dumnogenus 119
Dunadd carved bedrock *173*, *173*, *316*, 373
Dundee Museum 340
Dunfallandy cross-slab:
 enclosure 168, 175
 geological analysis 288
 map 237
 Perth Museum and 345
Dunkeld 143, 311, 312
Dunnichen 8, 341
Dunnichen stone 232, 339–40
Dunning: St Serf's Church 88, 345
Dunrobin 2 symbol stone *16*, *63*, 69–70, 279:
 map 279
Dupplin Cross:
 base 88
 conservation 104
 drawings of 217, *218*, *219*
 excavations 93, 104, 105
 geological analysis 289
 locations 345
 moving of 104, 160, 373
 place of curation 345, 346
 socket-stone 104, 105, 110
 worn areas 160
Dupplin Moor 104
Dyce sculptures (Aberdeen City) 4, 175, *316*

eagle motif: Nigg 29
Early Christian Monuments of Scotland (ECMS):
 access to ix, 345–7
 achievement of 2
 aim of viii, ix:
 'Archaeological Survey and Descriptive List' 379
 centenary marked x
 chronology 82
 condition of sculptures 159
 continuing usefulness 82
 corrections 81
 cross-bases and 85
 descriptive register viii
 drawings 159, 160, *205*, *206*, *207*
 Govan material 139
 Hilton of Cadboll cross-slab 25
 illustrations viii, 139, 159, 160–4, 201, 202–4, 204, *205*, 206, *207*, 208, 209, 212, 213, 217, 235, 367
 importance of viii, 2
 Inchbraycock sculpture 336
 information out of date 376
 inhibiting effect of 9, 81, 213
 legacy of 2
 limitations 375–6
 new corpus and 375
 new finds 81, 376
 numbering system xii
 omissions 81, 82
 origins of viii, 1–2
 photographs viii, 139, 159, 160, 164, 204, 367
 publication of viii, 1
 reprint, 1993 ix, 2, 81
 St Vigeans 70, 206
 Shandwick cross-slab 245, 250
 shortcomings 82
 survey work viii
 usefulness continues 82
 see also Able Hands and Practised Hands seminar
Early Christian and Pictish Monuments of Scorland (Cruden) 203
Early Medieval Carved Stones in Historic Scotland's Care (EMCSIP) 315–20, 326, 329
Early Medieval Sculpture in Angus Council Museums 341
early medieval sculpture of Scotland:
 access to 80, 345–7
 antiquarianism and 64–6
 art-historical setting 82
 artefacts/monuments quandary 3
 belonging and 37
 biographies of 157
 casting techniques 171
 chronology 82
 collection of 169–70
 conservation 3, 5, 6, 7, 8, 13, 37, 38
 contexts 13–36, 82:
 reconstructing 357–60
 controversy over 37–9
 cultural contacts and 76–7, 319
 curation, place of 3, 4–5, 7, 8, 11, 37–8, 48, 346
 decay 159, 160, 373
 deterioration of 159, 160–4, 373
 digital recording 353–65, 367–74
 display of 77, 319–20, 325–33
 early references to 55–8
 enclosure 160, 168–9, 175–86, 373:
 design 176

environmental monitoring 177–85
 intention 186
erosion 3, 160, 174, 373
ethnographic approach 319
exposure 159, 164
fragments:
 communication indicators 78–80
 format indicators 77
 quality indicators 69–71
 rejoining 354–5
 status indicators 71–7
 value of 69–71
 whole picture and 80–2
funerary monuments and 59
horizon and 358–9
iconoclasm and 59–64
iconography 14, 259–75
identity and 37
importance of in medieval studies 346
in situ preservation 50
intellectual context 7, 14, 82
intellectual horizons and 319
interpretation 315, 322–3, 325–33
Interpretation Plan 315
interpretative media 322
inventorisation 6, 8
jointing techniques 167
knowing 315–20
as label 376
landscape and 4–5, 8, 14, 38, 80, 143, 349, 357–60, 373:
 digitally generated 357
laser scanning 171–2, *172*, 235, 254, 368–70, 374
lithographs 202, 203, 204–6, 235
local legacy 7, 14–15
local museum interest in Angus 335–40, 341
local/national tensions 38, 40, 49
losses of viii, 1
management 37
monitoring 185, 319, 373, 377
moving 38, 55, 58, 170, 357, 373
museums and 8, 37–8
mythology protecting 64
new corpus needed 80, 81–2, 157, 348–9, 375–9:
 digital 378
 essential features 377
 funding 378, 379
 illustration of 377
 pilot project 379
 publication 377, 378
 purpose of 377
 steering group 375, 378–9

north/south division 78, 80
number of 378
numbering system xii, 201–2
one-face carving 77, 78
ownership 37, 48, 50
painting 144, 272–3
past, engaging with 347
photographs 159, 202, 203–4, 367
place creation of 49–50
protection 2, 11
public interest in 317
recontextualisation 357–60
recording 156–7, 174, 201, 319, 350, 378:
 digital 353–65, 367–74
 publication 370–2
removal viii, *see also under names of individual sculptures*
replication 170–3, 373–4
research 6, 8
reuse 58–9, 151
rubbings 5, 11, 171
settlement and 13, 14
significance of recognised 7–8
social context 7, 13–14
State care, first monuments in 2
stone decay 164–7
stories of 55, 78
study of 6, 8
as study resource 7
subliminal aspect 50
surface growth 159, 164
survey of stones at risk 172–3
symbolic power 50
threats to 159
understanding 201
value of 3, 7
visitors to 317, 319
visualisation by proxy 235
weathering 159
Early Medieval Sculpture in the West Highlands and Islands 349
Eassie: church site 310, 311
Eassie cross-slab:
 decay 165
 enclosure 165, 175
 illustration 166
 map 237, 279
Eastwood 154
ecclesiastical districts 139, 154
Edderton 16, 237
Edderton (Cariblair) symbol-incised stone 65
Edderton cross-slab 65
Edinburgh 16, 237
Edzell 279, 337

Edzell 1 cross fragment 80, 337
Edzell 2 cross-slab 336–7
Edzell Castle 337
Eilean Mor chapel 106–7
electronic media 320, 348, 357, 378
elephants 251–2:
 Maiden Stone 66
 Nigg 66
Elgin 74, 237, 316
Elgin Museum 72, 75
Elsness, Sanday 224–5
Eogan grave-slab 89
equal-armed cross:
 Gellyburn 304–5
 Kirkmadrine 128
 Portmahomack 20
erosion: vulnerability to 3
Eshaness grave-slab 192
Eshaness runic inscriptions 192, 198
estate boundaries 118
Ettrick 120
Ewan, St 307
Ewyne, King 65
excavation 110, *see also under names of individual sculptures*
Exeter Cathedral: *Old English Relic-list* 311
Eyam Cross 222

Farnell 279, 336
Fearn 25
Fearn Abbey 25
Ferguson, Lesley 164
Finnian 129, 153
Fisher, Ian 73, 141, 142
Fishertown of Hilltown 25
Fishertown of Hilton 25
Fleming, Hay 78
Forbes, Revd William 32
Fordoun, Aberdeenshire 153
Fordun, John 55–6
Forres, stone of, *see* Sueno's stone
Forfar Story 340
Forma Urbis Romae 355
Forsyth, Katherine 7, 325, 329, 344
Forteviot 310
Forteviot 1 stone 75
Forteviot palace 104
Foster, Sally 37, 49, 348
Fowlis Wester 1 cross-slab:
 condition 160, 165
 display of 373
 excavations 109
 geological analysis 288–9
 illustration 161
 images 245
 map 279
 original setting 109
 removal 109, 160
 replica 373
 surface delamination 165
Fowlis Wester 2 stone 345
Frisia 18, 30

Galloway 129, 130
Garvock group of sandstones 282, 283
Gask 1 cross-slab:
 animal motif 245, 249
 crosses 299
 photograph 298
 pierced armpits 297
Gaul 130
Gellyburn cross-slab:
 animal imagery 305
 description of 297
 discovery of 30, 307
 drawing of 297
 ecclesiastical centre near 293
 geology 300
 imagery 303–4, 305, 312
 landscape context 307
 map 294
 Perth Museum and 344–5
 physical condition 300
 pierced armpits 297, 299
 sculptor, intelligence of 307
 sophistication 312
geographical information systems (GIS) 358
geological analysis, *see under* St Vigeans sculptures
Gibb, A 203
GIS (geographical information systems) 358
Glamis 237, 279
Glamis 2 cross-slab 64, 164
Glasgow 16, 152, *see also following entries and* Strathclyde, sculpture in
Glasgow Cathedral 146
Glasgow Corpus project 81
Glasgow Museum 105, 154
Glasgow University 356, 378
Glen Lyon mound 311
Glendaruel sculpture collection 170
Gleneagles, *see* Blackford symbol-incised stone
Goliath: St Martin's Cross 260, 263–6, 271
Golspie 16, 26, 237
Golspie cross-slab 63, 64
Golspie symbol-incised stone 69
Gordon, Sir Robert 64
Gordon, Alexander 64, 65, 201

Gourdie 310
Gourlay, Bob 96
Govan:
 cemetery 142
 grave slabs 59
 map *152*
 as monastery 139
 parish 152
 see also following entries
Govan 'Jordanhill' Cross, *see* 'Jordanhill Cross'
Govan Sarcophagus 136, *141*, 143
Govan sculptures:
 commissioning of 143
 conference on 139–41
 corpus 135
 crosses, free-standing 143, 144, 146, 156
 dating 142–3
 first comprehensive appraisal 139
 hogbacks 143–4
 Kilpatrick sculptures and 150
 landscape and 145–6
 location analysis 145–6
 other Strathclyde sculpture and 139, 141, 146
 photographs of 137, *138*
 recumbent cross-slabs 141, 143, 151, 156
 school of 135, 139, 141–2, 156–7
 significance of 135
 style 142, 143–5
 'sun-stone' 144
 see also Strathclyde, sculpture in
Graham, Angus 89, 93
granite slabs 164–5
Grant family 55
gravestones, 17th–19th century 10, 11
Gray, Tom 164
Gregory the Great 269, 272
griffins 302
Groam House Museum 77, *316*
Grove, Barry 40
GUARD 97
Gungstie rune stone, Noss, Shetland Islands 193–4, *194*

Habakkuk:
 Canticle of 268
 Jerome's commentary 254
Halkirk, *see* Skinnet cross-marked slab
Hall, Mark 308, 375
Hall *et al* 7
Hamilton 148
Hamilton, Lord 148
Hamilton church 148
Hamilton New Parish Church *145*
Hamilton Palace 148

Handley, M 121, 124, 129–30
Hayle, *see* Carnsew monument
hell imagery 302
Henderson, Isabel ix, 2, 245, 259, 344, 345, 355
Henry, David ix
Heritage Lottery Fund (HLF) 326, 332, 344
heritage management 38–9, 49
Herity, M 128
Hewlett Packard (HP) Laboratories 360–1, *361*
Hibbert, Charlotte Wilhelmina:
 Aberlemno 2 230
 Aberlemno 3 228, *229*
 Bakewell Cross 227
 biography 221–6
 Burdiehouse fossils and 225, 235
 conservation 232
 death 225
 drawings of 221–39
 Elsness and 224–5
 Elsness vitrified remains 224–5
 Eyam Cross and 222
 geometric patterns and 232–3
 Hilton of Cadboll 228, 236
 interlace patterns and 232–3
 Kincardine stone 231
 manuscripts 239–40
 map of places visited 237
 Maughold cross 226, 232
 Meigle 2 227, 228
 Meigle 10 232, *233*
 publication 234, 235, 237, 242
 skill of 224
 Sueno's stone and 225, 227, 228, 232, 234
 writings 222–3, 232
Hibbert, Samuel:
 biography 221–6
 conservation and 232
 Description of the Shetland Islands 222
 letter on sculptured stones of Scotland 240–2
 manuscripts 239–40
 map of places visited 237
 vitrified forts and 222, 224, 240
Hibbert, Sarah 225
Hibbert, Titus 225, 231
Hietoun 148
Higgitt, John x
Highland Clearances 46–7
Highland Regional Archaeologist 192
Highland Archives 96
Hill, Peter 110
Hilton of Cadboll:
 excavations 25, 40, 44, 45
 intellectual outreach 28
 map of location *16*

as marginal place 46
original site 25, 39
population movement and 46
St Mary's Chapel 15, *17*, 25, 39, 40, 40–1, 47, 101
social context 25–6
see also following entry
Hilton of Cadboll cross-slab:
alienation and 43, 46–7, 48
as 'art document' 43
belonging and 43, 44–5, 48, 49
biography 39–43, 47
boundaries and 45
collapse of 86, 93, 101
collar-stone 99, 101
damage to 39, 64
dating 99, 101, 110
defacement 101
description 24–5
drawing 236, *236*
earlier setting 99–101
excavations 97–101, *98*, *99*
fragments of 49, 355:
 reunion 350
geology of 101
gravestone use 101
Hibbert and 228
as icon for village 45, 48
identity and 45
imagery 304
kerbstones 100
landscape and 45–6, 101
local/national tensions 40–1, 44, 48–9
location 15, 25, 26, 39–40, 47–9
lost face 101
lower portion, excavation of 47, 49, 93
lower portion to Edinburgh 47
map 16, 237, 316
meanings 43–7, 48, 49
movement of 25, 39
original setting 98, 99–101
ownership 41, 43, 47–9
photograph *41*, *42*
place-making and 45, 46, 47, 48
pottery 101
presentation 43
project 112
reconstruction 40, *40*, *42*
reconstruction of setting *100*
reuse 59
settings 98, 99–101
social value 50
stepped base 86
symbolic role 43, 44, 45, 46–7, 47, 48, 49

tenon 100–1
upper portion to London 39, 43
see also preceding entry
hippocamps 301, 302–3
Historic Buildings and Monuments (HBM) 95, 175
Historic Hilton Trust 43, 350
Historic Scotland:
Able Minds and Practised Hands seminar and x, 1
Carved Stone Action Plan 5
Angus Pictish stones 341
Carved Stone Decay in Scotland 344
Carved Stones of Scotland 344
Crieff Burgh Cross and 344
Dupplin Cross moved indoors 104
early medieval sculpture, approach to 2–5, 10–12
Education 333
excavations, Hilton of Cadboll 25
grants given by xi
Hilton of Cadboll chapel 97
Hilton of Cadboll cross-slab and 39, 43
map of distribution of sculptures 316
nodal sites 320–1, 322, 326
policy statement, 1992 2, 10–12, 335
possibilities 320–1
Properties in Care (PIC) 315, 317
questioned 349
recording 319, 320
St Madoe's 343–4
St Vigeans stones 208
sculpture:
 all periods of 2–3, 5
 collections of 169–70, 316
 custodianship of 315, *316*
 policy towards 2, 5–6, 10–12, 41, 315–23
Shandwick cross-slab and 165, 167, 176
suggestions for 320–1
Thurso runic inscriptions and 192
Whithorn sculptures and 315, 317, 322, 325–33
Historic Scotland Conservation Centre 176
hogback monuments 139, 143–4, 311
Holman, K 193
Holy Island, Arran 187, 192, 198
horizon 358–9
hunt motif 245, 248
Hunter Archaeological Trust xi
Hunterian Museum 346
Hutcheson, A 307, 308

Iaconus 128
iconology 243–5

image-based rendering 362–4
images, *see* motifs
Inchadney 308
Inchbrayock sculptures 335–6
Inchewan 307
Inchinnan:
 crosses 146, 153–4
 map *136*
 monastery 139
 recumbent cross-slab 141, 143, 144, *153*
 sculpture collection 151–3, 156
Inchmarnock 110
Inchmarnock cross fragments 73:
 runic inscriptions 193, 194, *195*, 198
Inchyra stone 58, 346
'ingibiorh' 190, 191
Ingold, T 135
Inismurray 86
Innes, Cosmo 154, 231
inscribed stones, early, British 129–30
inscribed stones, early, Dumnonian 114, 115, 116, 117, 121, 128–9
inscribed stones, early, Isle of Man 113, 114, 121, 125, 128
inscribed stones, early, southern Scotland:
 cultural contacts and 130
 distribution map 114, *114*
 ecclesiastical 120, 131
 epigraphic tradition and 113
 evolution from Roman 130
 Group I 113, 114, 115, 116, 117, 119, 120, 121, 122, 124, 125, 129, 130
 historical significance 113
 influences on 113–14, 121, 129, 131
 Irish influence 121, 129, 131
 landscape and 119
 political power and 119
 'proprietorial' 119, 121, 130–1
 religion and 114, 115
 see also under names of individual stones
inscribed stones, early, Wales 113, 114, 116, 121
inscriptions:
 extended Latinate 115, 117, 125, 128
 Latin 29, 81, *see also* Latinus stone
 ogham 81, 113, 117, 121, 128, 212–13
 see also preceding entries and runic inscriptions
Inspectorate of Ancient Monuments 102
interlace 74, 77, 142, 145, 156
Inverarity church 337
Invergordon Castle 39, 41, 47
Inverness 16
Inverness Museum 217
Iona:

C-shaped enclosure 15
Columba's arrival 326
condition of monuments 159
corpus 135
cross-bases 88
crosses 80, 85, 86
 iconography 259–60
Historic Scotland 315
MacLean's Cross 86
map *316*
monastery 88
as nodal site 320
Portmahomack and 18, 19, 20
runes from 191, 194–7, *196*
sculpture collections 169, 315
stone shrines 89
Tarbat Peninsula and 28
Vikings and 64
see also St John's Cross, Iona; St Martin's Cross, Iona; St Matthews Crosses, Iona; St Oran's Cross, Iona
Ireland:
 Christianity 127
 churches 151
 Discovery Programme 349
 Galloway and 129
 high crosses 260, 263
 inscription, earliest non-ogham 127
 Peter, cult of 127
 settlement in western Britain 121, 131
 Tarbat Peninsula and 28
Irton Cross 87
Isaac:
 Kildalton Cross 260
 St Martin's Cross 259, 260, 267, 271
Isidore of Seville 251
Isle of Man:
 artistic influence 193
 runic inscriptions 193, 198
 stone sculptures 226
 see also under inscribed stones, early, Isle of Man

Jackson, K H 122
Jastresbski, P A 203, 204, 206
Jedburgh *316*, 320
Jerome, St 28
Jones, Captain Edward 224
'Jordanhill Cross' 150, *356*, 356, 359, 369, 370

Keill's Cross:
 boulder plinth 106
 chapel/church and 107
 date 105

excavation 106, *107*
location 106, *107*
removal of 105–6, 170–1
replica 170–1, *171*
Keills sculpture collection 170
Kells, *see* Book of Kells
Kells Cross 85
Kelly, Revd Tom Davidson 139
Kemp's Hold 310
Kettletoft, Sanday 189
Kilallan church 147–8
Kilbar cross-slab runic inscription 187, *188*, 191, 193
Kilberry sculpture collection 170
Kildalton Cross, Islay 110, 160, *163*, 259, 260, 266, 316:
photographs 261–2
Kilellan Farm 109
Kilmalcolm 154
Kilmalkedar 26
Kilmartin 316
Kilmartin, 16th-century cross 167
Kilmichael-Glassary Bell 222–3
Kilmory Knap: sculpture collection 169
Kilnasaggart *114*, 127, *128*
Kilnave Cross, Islay:
base 92, *93*
church possible 108
date 107
excavations 108, 109, 110
photographs 160, *164*
reconstruction *108*
surface growth *164*
Kilpatrick parish 150
Kilpatrick sculptures 149–51, *150*
Kilpeter church 148
Kincairney 307
Kincardine *16*, 237
Kincardine symbol stone 231, *231*
Kinclaven 310
Kinellar church 58
King Malcolm's Graveyard 64
King's Inch 143
Kinnaird Castle 336
Kinneddar 26:
sculpture 72–3, *72*, 77:
Kinneddar 10 74
Kinneddar church: sculptured stones reused in 58, *60*
Kintore stone 58
Kirkbuddo 279
Kirkbuddo cross-slab 337
Kirkdale Archaeology 97, 104
Kirkinch church site 310, *311*

Kirkliston memorial stone 13, 117–19:
name 118
Kirkmadrine:
Kirkmadrine 1–3 inscribed stones 120, 122–6, *123*, *126*, 127, *128*, 131
map *114*, *316*
porch added 169
Kirkton Burn 154
Kirriemuir 279
Kirriemuir stone fragments 58, 75, *75*, 337–9, *338*
Knapdale 106
Knight, Jeremy 129

Laing, David 227, 229–31
Lambourne, Lionel 226–7
landscapes, digitally generated 357
Lang, Jim 139
laser scanning 171–2, *172*, 235, 354, 368–70, 374
latex-based moulding technique 173
Latin names 116–17, 121
Latinus stone, Whithorn:
age 326, 330
display of 329
ecclesiastical site 119
'extended Latinate' inscriptions 115
Historic Scotland and 325
Kirkmadrine stones and 122, 127
Latinus' ethnicity 116, 117
name 116–17, 121
original setting 116
photograph 327
Roman tradition and 130
leacht 86
Letham-Monasterboice Twinning Association 337
Lethendy tower-house 58–9
Levern Water 154
Levoy, Marc 363
Liberalis 127
Liestol, A 191
Lindisfarne 88
Lindisfarne Gospels 74
lion motif 245–51, *248*, *249*, *250*, 269
lion motifs? 245–51, *248*, *249*
literacy 197
Little Dunkeld Church 307
Little Ferry Links 4 69, *70*, *70*
Little Ferry Links symbol-incised stones 63
Llandough cross 88
Llanerfyl monument 115, *116*
Lledin 117
Loch Fleet 63
Lochwinnoch 154

Locquhariot 127
locus 127–8
Logie Elphinstone 58
Loher pillar 128
Lossio Ueda 117
Low, George 192
Lowe, Chris 110
Lusset Burn 150, 151

Macalister, R A S 116
McCullagh, Rod 87–8, 102, 103, *103*, 104
Machrikil cross-base 87
Mackenzie family 32
Mackenzie, William 32
MacLean's Cross, Iona 86
Macleod, Captain Roderick Willoughby 39
Macleod, Robert Bruce Aeneus 39
McManus Galleries 340
Macquarrie, Alan 139, 141, 143, 144, 154
Maeshowe, Orkney Islands *316*:
 runic inscriptions 187, 190, 191, 192, 198
Maiden Stone 85, 160, 164, 316
Mail, Cunningsburgh 191
Manning, Conleth 93
Manor 114
Manor inscribed stone 119, 121–2, 130
manuscripts 74, 75, 76, 144, 312, 376:
 carpet pages 270
Marquardt, H 191
Martyrology of Óengus 263
Marvels of the East 251, *252*
Maryculter parish 57
Maryport Roman fort:
 lost plaque 116
 map *114*
 stones 116, 130
Masham column 267
Maughold stone carvings, Isle of Man 128, 226, 232
Mauorius 122, 124
Maxwell, Ingval 106
Maxwell, Sir James Stirling 137, 138
Mediterranean Christianity 28
Meffan Institute 75, 339, 340
Meffan Museum 337, 338
Meffan sculptures: geological analysis 284, 287
Meigle:
 church centre 311
 maps 237, 279, 316
 as nodal site 320
Meigle sculptures:
 Arthurian romance and 349
 clerics on 78
 collection 169, 203

figural imagery 301, 302–3
geological analysis 287
Historic Scotland and 315
Meigle 1 58
Meigle 2 55, 93, 227, 228, *228*
Meigle 4 167
Meigle 5 305, *306*
Meigle 9 76
Meigle 10 228, 232, *233*
Meigle 11 59
Meigle 14 79
Meigle 26 301–2, *301*, 302–3
museum 345–6
as nodal site 320
reinterpretation of 349
visitors to 317
Menmuir 279
Menmuir 1–5 sculptures 337
metalwork 270, 304, 376
Miller, Hugh 73
Milne, J 336
Ministry of Public Building and Works 191
Ministry of Works 203, 340
minster churches 311
Moffat, Alastair 122
Monasterboise Tall Cross 88
monasticism 29, 129
Monifieth sculptures 76
 Monifieth 3 76, *76*
Monreith Cross 327
Montrose 335
Montrose Museum 336, 337
Montrose Natural History and Antiquarian Society 335
monuments:
 artefacts and 3
 biography, understanding 7
 contexts 13–36
 larger monuments and 3
 legislation 350
 ownership 3
 portability 3
 theft of 3
 threats to 2
 vista and 13
 see also early medieval sculpture of Scotland; sculpture
Monymusk cross-slab 55, *56*
Monymusk House 55, *56*
Monymusk Parish Church 55
Moone monastery 85
moothill 309
Moray Firth 24, 26
Moray's Pictish Trail 75

motifs:
 Abraham, St Martin's Cross 260, 267, 269, 272
 angels 268–9
 animal imagery 303, 304
 Antony and Paul, Nigg 24, 28–9, 61, 252
 armed men 303
 battle scenes 303
 bear? 249, 251
 Cain and Abel:
 Kildalton 260
 St Martin's 259
 Calvary 86
 chi-rho symbol 116, 119, 122, 125, 128–9
 Christ 250, 251, 252, 266, 268, 269, 270:
 St Martin's Cross 266, 268, 271
 Shandwick cross-slab 252, 254
 crescent:
 Gellyburn 305
 Golspie stone 69
 Hilton of Cadboll 24
 Portmahomack 29
 crosses:
 Kildalton Cross 266
 St Martin's Cross 266, 270–1
 St Oran's Cross 266
 Shandwick cross-slab 252
 Daniel, St Martin's Cross 260, 267–8
 David, King:
 Kildalton Cross 260
 Kinneddar 72, 73
 Nigg 24, 251
 St Andrews Sarcophagus 72
 St Martin's Cross 259, 263–6, 267, 271, 272
 St Oran's Cross 260
 decorative/symbolic distinction 270
 dolphin:
 Portmahomack 29
 Shandwick 24, 29
 double disc:
 Hilton of Cadboll 24, 29
 Logie Elphinstone 58
 St Vigeans 6 71–2
 Shandwick 24, 29
 dragons 253, 303
 eagle, Nigg 29
 elephant 251–2
 elephants:
 Brodie 66
 Maiden Stone 66
 Nigg 66
 equal-armed cross:
 Gellyburn 304–5
 Kirkmadrine 128

 Portmahomack 20
 Goliath, St Martin's Cross 260, 263–6, 271
 griffins 302
 hell imagery 302
 hippocamps 301, 302–3
 hunt scene 245, 248
 interlace 74, 77, 142, 145, 156
 Isaac:
 Kildalton Cross 260
 St Martin's Cross 259, 260, 267, 271
 lions 245–51, 248, 249, 250, 269
 lions? 245–51, 248, 249
 naked figures 75
 naked man and beast, Murthly panel 301–3
 Old Testament subjects 263
 orans 120
 Pictish beast, Nigg 24
 ring-knot decoration 143, 145
 Satan, St Martin's Cross 266
 Saul, St Martin's Cross 271, 272
 scrolls 304
 serpents:
 Gask 245
 Portmahomack 29
 St Martin's Cross 269–70
 Shandwick cross-slab 249
 shears 308
 spirals:
 Birnie 2 74, 75
 Kirriemuir 75
 St Vigeans 6 71–2
 St Vigeans 7 74
 study of 259
 V-rod:
 Gellyburn 305
 Hilton of Cadboll 24, 29
 Little Ferry 69
 Virgin and Child:
 Kildalton 260
 St Martin's Cross 259, 260, 268, 269
 St Oran's Cross 260
 Z-rod:
 Hilton of Cadboll 24, 29
 Logie Elphinstone 58
 Portmahomack 29
mounds 310, 311
'Mountblow Cross' *136, 137,* 150, 153
Mountblow House 151
Mugdrum Cross 85, 87
Mugrón, Abbot 86
Muir, T S 85
Murroes fragment 78–80
Murthly:
 church centre 293, 307–8, 312

map 294
patrons 312
place-name 309
quarrying sites near 299–300
sculptural milieu 307, 311
thanages 310, 312
see also following entries
Murthly Castle 308, 310
Murthly panel:
assembly places and 309, 310
chapel and 308
description 296–7
discovery of 307, 308
drawing of 296
figural imagery 301–2, 303, 312
geology 299–300
hippocamps 301, 303
landscape context 307, 308, 309–11, 312
location 294
Meigle 5 and 305, 306
naked man and beast 301–3
Perth Museum and 345
physical condition 299–300
Pittensorn fragment and 299–300, *300*
purpose originally 307
Museum of Scotland, *see* National Museums of Scotland
museums:
resources 347
staff 347
thematically-arranged 80
see also following entry
museums, local:
early medieval sculpture of Scotland and 8, 37–8, 335–42, 343–52
national museums and 4
Mwtebill 309

Nadotti 129
naked figures 75
naked man and beast: Murthly panel 301–3
Nash-Williams, Victor 113, 129, 379
National Archives of Scotland 189
National Committee on Carved Stones in Scotland (NCCSS) x, 1, 5, 375, 379
National Monuments Record of Scotland 347, 370:
photographic collection 81
National Museum of Antiquities 3, 4, 4, 38, 39
National Museums of Scotland 8, 10:
Aberlemno 2 171
Auchentorlie bedrock carvings 173–4
Dores key pattern 70
Dupplin Cross 345

Hilton of Cadboll cross-slab 15, 39, 40, 41, 42, 43, 44, 47, 97, 355
Monifieth stones 76
Murroes fragment 78
Portmahomack fragments 73, 350
Wester Denoon cross-slab fragment 339
Nave Island 109
Neitan Stone 56, 57
nepos 117
Netherlains farmhouse 55
Netherton cross 136, *136*, 144, *145*, 148–9, *149*, 156, 157
Neuman de Vegvar, Carol 269
Nevay 279, 310
Nevay sculptures 337
New Kilpatrick 150
New Statistical Account 136, 148
Newton Woods 136, *152*
Newton Woods cross 153, *154*
Nigg:
church 24
maps *16* 26, 237, 316
social context 25–6
see also following entry
Nigg cross-slab:
David scene 251
defacement of 61, 62, 63
figures on 251
intellectual outreach 28
location 15, *16*, 22–4, 26, 49
vista 24
Nigg Old Trust 24
Ninian, St 325
Nordby, Jonas 189
Northumbria 18, 28
Norwegians 187, 190
Noughaval cross 93
Nudus 119

Office of Works 3–4, 87
ogham inscriptions:
genitive use 119, 121
Irish tradition 119
verticality 119, 121
see also under inscriptions
Old Carlisle tombstone 116, 130
Old Deskford Church 175
Old Govan 149–50
Old Kilpatrick 146
Old Kilpatrick church 150
Old Patrick Water 154
Old St Peter's Church, Thurso 192
Old Scatness bear 81
Old Statistical Account 136, 146, 148

INDEX

Olsen, M 193
Optically Stimulated Luminescence (OSL) dating 99, 101, 110
orans 120
Ordnance Survey 55, 358
Orkney Islands:
 Hibberts in 224
 runic inscriptions 187, 190, 191, 192
 see also Cuween Cairn; Maeshowe; Ring of Brogar; Skara Brae
Ormside Bowl 304
Over Kirkhope monument 120

Paisley:
 Abbey 87, 146, 152, 154
 church 151–2
 crosses 153–4, 156
 ecclesiastical status 154, 156
 sculptures 151–6, *152*, 153
Panofsky, E 244, 254
Papil panel 85, 87
parishes 146, 147:
 origins of 118, 154
Paterninus 115
Peebles:
 church 56–7
 Cross Kirk 120
 map *114*
 Neitan Stone 56, 57
 stone (lost) 56, 86, 131
Penmachno inscribed stone 128
Pennant, T 64, 65, 201
Perth and Kinross:
 early medieval sculpture 343–52
 Heritage Trust 344
 map *294*
 role of 343
 see also following entry
Perth Museum 344
 Crieff Burgh Cross and 344
 Gellyburn cross-slab and 344–5
 Inchyra stone 346
 Murthly panel and 345
 Pictish Programme 343–52
 Pittensorn fragment and 345
 Preserving the Picts exhibition 344–5, 347
 St Madoes cross-slab and 343–4, 345
 Treasure Trove and 350
 workshops 347
Peter Stone, *see under* Whithorn sculptures
Peterhead Farm 372
Peterson, Lena 197
Petley, C C 236, *236*
Phillack early church site 115

photographs: scanning 164
Physiologus 250, 302
Picardy Stone 164–5
Pictavia:
 Edzell 1 cross fragment 337
 Farnell stone 336
 geological analysis 287
 Heritage Centre 340–1
 map *316*
 Menmuir sculptures 337
Pictish Arts Society 81, 341
Pictish beast: Nigg 24
Pictish Stones of Angus 340, 341
Pictish symbols:
 stones as boundary markers 57–8
 Hilton of Cadboll 24, 29
 Nigg 24, 28
 Portmahomack 20, 23, 28
 Shandwick 24, 29
Pictland: cultural context 244
Picts:
 animal lore and 302
 Christianity and 28, 130
 classical vein in art 302
 cultural exposure 244, 254
 intellectual contacts 26, 76, 244
 literary culture 78
 places reinterpreted 349
 public's attitude to 347
Picts. A New Look at Old Problems conference 336
Piggott, Stuart 73
Pinkerton, J 235
Pinkfoot Press ix, 2, 81
Pirotte, Emmanuelle 270
Pitmuies 279
Pitt Rivers, General Augustus Lane Henry 2, 3:
 sculpture, place of curation and 3, 4, 49, 170
 sculpture as monument 4
Pittensorn fragment:
 art-historical context 293
 connections network and 77
 description 293–6
 discovery of 307
 drawing of 295
 figural imagery 300–1, 302, 303, 312
 geology 299–300
 hell imagery 302
 landscape context 307–8
 maps 279, 294
 Meigle sculpture and 293, 302
 Murthly panel and 299–300, *300*
 Perth Museum and 345
 previous paper on 293, 300, 310, 311

workshop and 347
Polynomial Texture Mapping (PTM) 360–2
Pont's map 95, 102, 307, 308
Porius 116, 128
Portmahomack:
 cemeteries 18, 20, 29, 30, 31
 church hypothesised 17–18
 cist graves 15–19
 crafts at 18
 cropmark 15, *18*
 excavations 15–18, 19, 34, 63
 intellectual outreach 28
 Iona and 18, 19, 20
 landing beach 18
 local legacy 29–34
 map of location *16, 27*
 mill 18
 monastery 18, 19, 20, 25, 26, 29, 30, 32
 Northumbria, connections with 18
 as port 26
 St Colman's church (Tarbat Old Church) 15, *17*, 18, *19*, 29, 30, 31–4, *31*, 73, 243:
 burials 30, 31–4
 memorials 20, *21*, 31, 32–3
 sculpture 19–22, 34:
 'boar stone' 20, *22*
 'calf stone' 20, *22, 30*, 78, 217
 grave-diggers and 15, 19, 30, 31
 grave-markers 20, *21*, 30, 31
 smashing of 19, 30–1, 63
 see also Portmahomack cross-slabs
 settlement 15, 18
 silver hoard 30
 site character 15–19
 University of York research project 15
 workshops 18, 19
 see also following entry
Portmahomack cross-slabs 31:
 location 26, 31
 Portmahomack 1 20, 23, 29
 Portmahomack 2 23
 Portmahomack 7 73, *73*
 Portmahomack 9 73
 Portmahomack 10 15, 20, 23
 Portmahomack 20 20, 23, 29, 251, 253
 see also Portmahomack: sculpture
post-holes: lifting mechanisms 110
pottery 110
pre-Romanesque sculpture 377
Proudfoot and Aliaga-Kelly's map 118
Ptolemy 148

Quick Time Virtual Reality (QTVR) 359–60, 362–3

Radford, Ralegh 129, 139, 143
Ray cross 92
Reask inscribed stone 128
Reformation 63, 101
Reilig Odhráin stones 88–9
relic-churches 151
Renfrew 153, 154
Restenneth Library 336
Rhind Lectures viii, 1
Richards, E 46
Richardson, J S 190
Ring of Brogar runic inscriptions, Orkney 190, 192
ring-knot decoration 143, 145
Robertson, Niall 24, 337
rock art 4, 10, 38
Roger, Charles 237
Roman period: Dark Ages and 116, 117
Romanesque sculpture 377
Rosemarkie 26, 77, 304, 316, 341:
 Rosemarkie 5 fragment 77
Ross, William 237
Rossie Priory cross-slab 214, 245
Royal Commission on the Ancient and Historical Monuments of Scotland (RCAHMS):
 Angus Pictish stones 341
 Argyll monuments and 376
 drawings 377
 Early Medieval Sculpture in the West Highlands and Islands 81
 handlist 336
 illustrations 206, *207*, 209–10, *210*, *211*, *212*, *213*
 Inventory 192
 ogham 213
 recording 378
 runes 190–1
 St Vigeans 70, 206, *207*
 surveys 10, 88, 206, 208, 209–10, *209*, 214
Royal Scottish Museum 73
runic inscriptions:
 authenticity 188–91
 carvers' abilities 193–9
 dating 193
 damage to 192
 interpretation 192–3
 literacy and 197
 meaning 187
 opportunity 194–7
 preservation 191–2
 Scandinavian 187–8
 statistics 198
 tools 197–8

twig runes 189, 190, 191
Rustica 115, 116
Rutha, King 65
Ruthwell Cross 63, 64, 88, 319, 376:
 Antony and Paul 28
 map *316*
 runes 187

Saddell Abbey sculpture collection 170
St Andrew Auckland 88
St Andrews:
 map 294, *316*
 Museum 78
 Sarcophagus 64, 72, 78, 80
 stones 28, 29, 78, 135, 315, 320:
 St Andrews 29 78
St Andrews Cathedral 58, 59, 169
St Andrews Dark Age Studies conferences 348
St Blane's monastery, Bute 89
St Conval's Chair 153
St Endellion inscribed stone 129
St Ewan's chapel 307
St John's Cross, Iona 86, 89, *90*, *91*, *93*, 167, 171
St Just: lost plaque 116
St Madoes cross-slab viii, 85, 210, 343–4, *345*
St Margaret's Inch 337
St Martin's Cross, Iona 85, 88, 160, *162*, 266:
 figural panels 260–9, 273
 iconography 259–75
 non-figural motifs 269–71
 photographs 264–5
St Matthew's Cross, Iona 85, 88
St Ninian's Cave 326, 328
St Oran's Cross, Iona 89, 259, 260, 266:
 illustrations *263*
St Orland's cross-slab 59, 165, 345, 368, *370*, *371*
St Patrick's Chair, Isle of Man 86
St Vigeans:
 church site 310
 map *279*
 mound 310
 as nodal site 320
 see also following entry
St Vigeans sculptures:
 'able minds and practised hands' 1
 fragments 70
 geological analysis 277–91:
 results 282–9
 sites sampled 277–8
 graphic recording of 201–14
 local production 290
 magnetic susceptibility 277, 280–2, 285, 288
 numbering system 201–2
 petrological analysis 277, 280

 photographs 201
 re-recording 201, 202, 206, 213–14
 reuse and survival 58
 St Vigeans 1 70, 203–4, *204*, 304
 St Vigeans 2 204–8, *205*, *207*
 St Vigeans 4 208, 210
 St Vigeans 6 211–13, *211*, *212*
 St Vigeans 7 28, 74, 204
 St Vigeans 8 70
 St Vigeans 19 70, *71*
 St Vigeans 21 208–10, *210*
 St Vigeans 25 78, *79*
 stag poses 70
 stone sources 277, 286
sandstone 165, 168, 289:
 formation of 165
Sandyford 150
Santon 114
Santon inscribed stone 125
Satan: St Martin's Cross 266
Saul: St Martin's Cross 271, *272*
Schapiro, Meyer 302
Scone 309, 310
Scone Abbey 59
Scotia Archaeology Ltd 338
Scotichronicon 309
Scotland's Early Medieval Sculptured Stones 378
Scott, Ian G 73, 77, 81, 141, *141*, 344, 345, 355
Scott, William 221–2
Scottish Development Department 106, *see also* Historic Scotland
Scottish Museums Council 338
Scottish Parliament 348
SCRAN (Scottish Cultural Resources Access Network) 77
scrolls 304
sculpture:
 access 13
 alienation and 37, 43
 archaeological landscape and 319
 artefacts/monuments quandary 3, 4, 37, 38, 49
 biography of 7, 8, 157
 conservation 5
 display 77
 education 5–6, 11
 erosion 5, 174
 excavation 111
 Health and Safety legislation 174
 Historic Scotland's example and 6
 image identification 244
 importance of in medieval studies 346
 in situ preservation 11, 50, 315
 information propagation 5–6
 jointing techniques 167

knowing 315–23
landscape and 4–5, 80, 112, 349
laying flat 174
legal protection 5
local/national importance 4
ownership 3
painting 144, 272–3
place and 3, 7, 110
place of curation and 3, 8, 346
portability 3
post-Viking 145
production sites 71
research 5–6, 8
rubbing 5, 11, 171
threats to 5, 174
understanding 315–20
vulnerability, raising awareness of 5
water's effect on 168
see also cross-slabs; crosses; early medieval sculpture of Scotland *and under names of individual sculptures*
Sculptured Stones of Scotland (Stuart) 136, 231
Selkirk 122, 279
Selkirk ogham stone 122, 130, 131
Senach 129
Senacus 124, 129
serpent:
 St Martin's Cross 269–70
 Shandwick cross-slab 249
 see also snake
Severan Marble Plan of Rome 355
Shandwick:
 intellectual outreach 28
 map *16*, *27*
 social context 25–6
 see also following entry
Shandwick cross-slab:
 base 88
 breaking of 95, 110
 collar-stones 96
 conservation 95–6
 enclosure of 95, 176, 177, *178*
 excavations 96, *96*, *97*
 images on 245
 in situ 15, 24, 95
 landscape 112
 location *16*, 26, 49
 monitoring 179–84, *181*, *183*
 motifs:
 bear? 249, 251
 Christ 250, 251, 252, 254
 cross 252
 elephant 251–2
 hunt scene 245, 248

 lions? 245–51, 248, 249
 literary sources and 249
 serpent 249
 photographs 246–8
 socket-stone 96, 110
 visual conundrums 245
Shandwick Stone Trust 177
shears 308
Shetelig, H 193
Shetland Islands:
 Hibberts in 224
 runic inscriptions 187
Simmons, Mark 299
Sims-Williams, P 116, 121, 124, 125, 129
Skara Brae, Orkney 190
Skinnet cross-marked slab 304, *305*
Smith, John 'Warwick' 226–7
snake:
 Gask 245
 Portmahomack 29
 Shandwick 249
 see also serpent
Society of Antiquities of Scotland:
 Council viii
 ECMS and viii, 2
 Hibbert and 224, 225, 227
 Proceedings viii
 sculpture, collections of 3–4
 Sub-Committee on Sculptured Stones viii, 159
Society for Medieval Archaeology x, 1
socket-slabs 87, 89, 92
socket-stones 88, 101, 103, 110
Southesk, Earl of 336
Southill inscribed stone 129
Soutron Down inscribed stone 129
Spalding Club viii, 175, 231
Spall, Cecily 18
Spearman, R M 141
spellings 197
spirals:
 Birnie 2 *74*, 75
 Kirriemuir 75
 St Vigeans 6 71–2
 St Vigeans 7 74
Stackrue runes, Orkney 190
'stan' 197
Stanely Castle 154
Stanely Cross *136*, 146, 152, 153, 154
State Funded Archaeology in Scotland 348
Stead/Steed stone, *see* Auldbar cross
Stenton hill-fort 309–10
Stevenson, Robert 9, 69, 80, 81, 88, 142, 213
Stobie, James: map 104
stone shrines 89

Stowe Missal 263, 267
Strathallan, Lord 225–6
Strathclyde: church in 146
Strathclyde, sculpture in:
 burials and 136
 cross-bases 146
 crosses 148
 dating 142
 distribution map *136*
 Govan as epicentre 135, 145
 importance of 136
 knowledge of 135–41
 landscape and 135, 139
 original significance of 135
 painting 144
 public space markers 136
 quality of 144
 scholarly interest in 135–41
 style 143–5
 technical ability 144
 typology 143
 see also Govan sculptures
Strathclyde University 180
Strathearn 346
Strathmartine fragment 75, 76
Strathmore group of sandstones 282, 283
Strowan 109, 344
Struan 311
Stuart, John viii, 58, 136, 139, 146, 157, 201, 202, 203, 206, 213, 231, 232, 242
Sueno's stone:
 collar-stones 103
 conservation (early) 64, 87
 date 102
 drawings 227, 228, 232, 234
 enclosure 102, 168–9, 176, 177, 179, 373
 excavations 102–4, *103*
 Hibberts and 225, 227, 228
 illustrations 169, 179, 227, 228, 232, 234
 inspection of *169*
 landscape 104
 leaning 110
 maps 237, *316*
 monitoring 179–84, *181*, *183*
 post-holes 103
 pottery 103
 repair works 102
 socket-stones 103, 104
Sumerian tablet 361–2, *362*
Swift, C 129
Symbol stones 10

Tabraham, Chris 317
Tarbat: name 26

Tarbat Discovery Centre 32, 217, *316*, 350
Tarbat Discovery Programme 34, 73
Tarbat Historic Trust 15, 34
Tarbat Peninsula:
 Iona and 28
 as mighty centre 26, 33–4
 model of 27
 as monastic establishment 26
 see also following entry and Hilton of Cadboll; Nigg; Portmahomack; Shandwick
Tarbat Peninsula, sculptures on:
 contexts 13–36
 estates associated with 243
 iconography, interpretation of 243–57
 image identification 244, 245–54
 intellectual context 26–9
 landscape and 13, 15
 local legacy 29–34
 map *16*
 motifs 243, 244
 original locations 243
 patrons 243
 relations between 20, 22, 25, 26, 243
 school of stone carvers 243
 sculptors 243
 social context 15–26, 28, 30
 see also Hilton of Cadboll; Nigg; Portmahomack; Shandwick
Tay River 310
Taylor, Simon 307, 309, 311, 345
Tedeschi, C 115, 124, 129, 130
Thomas, Charles 114–15, 124, 125, 129
Thoms, Lisbeth M ix
Thorn Knowe 311
3D modelling 353–4, 360:
 horizon and 359
 lighting conditions 353
 recreating missing fragments 355–7
 rejoining fragments 354–5
 technology 368–70
 third dimension, philosophising about 367
Thurso runic inscription 192, 194, *196*
Tilley, C 135
Tírechán 127
Tom à Mhóid 311
Tom and Sybil Gray Collection 81
toolmarks 8
Tòrr an Aba 89
Tory Island 86, 93
tower-houses 58–9
TR, *see* Portmahomack
Trawsfynydd monument 116
Treasure Trove 339, 345, 346, 350
Treflys 128

Trench-Jellicoe, Ross 245, 344
triangulation scanners 354
tulach 309
Tulliebole 311
Tweed River, Upper 119, 120, 121, 122
Tyrie church 58, 75

Ueda, Lossio 117
Uinniau 129
Unstan cairn runes 189–90, 192

V-rod:
 Gellyburn 305
 Hilton of Cadboll 24, 29
 Little Ferry 69
Vespasian Psalter 267
Vetta 117
Victoria and Albert Museum 3
Victr(icius) 117
Viking Age: turmoil and 139, 145
Vikings:
 raids 63, 65, 151
 runes 187
Vindolanda Roman fort 116, 117:
 church built over 117
Virgin and Child:
 Kildalton 260
 St Martin's Cross 259, 260, 268, 269
 St Oran's Cross 260
Virtual Reality 358
Viventius 122, 124

Wales:
 churches 151
 see also inscribed stones, early, Wales
Ware, *see* Hibbert
Watson, Antony 344
Wearmouth church 267
Wester Cadboll 25
Wester Denoon, Glamis 279, 339

Westerton 279
White Cart valley 154
White Cart Water 154
Whithorn:
 map *114*, 316
 present-day marginality of 332
 trade and 130
 see also following entries
Whithorn Priory 169, 326
Whithorn Priory Interpretation Plan 326
Whithorn sculptures:
 excavations 110, 325
 Historic Scotland and 315, 325–33:
 problem 327–8
 interpretative themes 330–1
 lectures on 341
 local community and 332
 museum 328
 as nodal site 320, 326
 Peter ('Petrus') Stone 56, 120, 125, 127–30,
 131, 327
 plans for 328–30
 runes 187
 school 145, 146
 social inclusion and 331–3
 visitor centre 326, 327
 visitors to 317, 328, 331
 see also Latinus stone, Whithorn
Whithorn Trust 326, 327, 332
Wilton Cross 86
Woodwray cross-slab 58, 60, 61–2, 63, 253
Woolf, Alex 121
Worthyvale stone 117

Yarrow *114*
Yarrow inscribed stone 119–20, *120*, 127, 130

Z-rod:
 Hilton of Cadboll 24, 29
 Logie Elphinstone 58
 Portmahomack 29